ALSO BY MATTHEW SPENDER

Within Tuscany

FROM A HIGH PLACE

FROM A HIGH PLACE

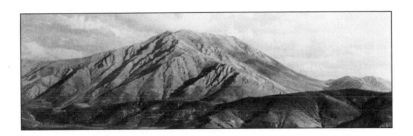

A LIFE OF ARSHILE GORKY

MATTHEW SPENDER

UNIVERSITY OF CALIFORNIA PRESS
Berkeley · Los Angeles

University of California Press
Berkeley and Los Angeles, California

First Paperback Printing 2000

Library of Congress Cataloging-in-Publication Data

Spender, Matthew.
 From a high place : a life of Arshile Gorky / Matthew Spender.
 p. cm.
 Originally published: New York : Knopf, c1999.
 Includes bibliographical references and index.
 ISBN 0-520-22548-1 (alk. paper)
 1. Gorky, Arshile, 1904–1948. 2. Painters—New York (State)—
 New York—Biography. I. Title.
 ND237.G613 S68 2000
 759.13—dc21
 [B]
 00-028715

Printed in the United States of America

08 07 06 05 04 03 02 01 00
 9 8 7 6 5 4 3 2 1

The paper used in this publication is both acid-free and totally
chlorine-free (TCF). It meets the minimum requirements of
ANSI/NISO Z39.48-1992 (R 1997) (*Permanence of Paper*). ∞

To my daughters,
Saskia and Cosima,
in memory of Van

CONTENTS

ILLUSTRATIONS

I AM GRATEFUL to Raymond Kévorkian at the AGUB Nubarian Library in Paris and to Aram Arkun at the Diocese Library in New York for help in tracing photos relating to Gorky's childhood.

Gorky's works are reproduced courtesy Artists Rights Society, New York.

"Amu," Apraham's great-nephew
*with whom Hagop
fled to U. S. in 1908*

Apraham Adoian
m. Youghaper

Manuk Adoian
m. Nanig

Vartan Adoian
k. 1896
m. Gulitzar Poloian

five others

Krikor
k. 1915
m. Baidzer

Yeghus
k. 1915

"Rus" Adoian
k. 1915
*with his
five children*

two others

Azniv
m. Dikran Melikian
*Dikran was a cousin of
Hagop der Hagopian,
father of Gorky's friend
the sculptor Yenovk der Hagopian*

Misak Ado

*daughter and
two grandchildren
k. 1915*

SEDRAK
m. (1) Lucia Amirkhanian
k. 1896

Arax
m. John Hovsepian

two others Marta

Mariam
m. John Hussian
*a painter who lived
in Watertown*

Hagop
m. Helena

Youghaper

Sarkis der Marderosian
k. 1896
m. Hripsime
d. circa 1909

George Charley Dawn Lucia

m. (2) SHUSHAN der Marderosian
d. 1919
m. (1) Tomas Prudian
k. 1896

Nishan
k. 1903

Aharon Sarkissian
m. (1) Antaran Pohan
d. 1919
m. (2) Markrit

Moses
m. Markrit Saroyan

Gail Sarkissian

*five children
k. 1915*

Akabi
m. Muggerdich Amerian

Sima

Gurken ("Jimmy") Thomas Liberty

Satenig
m. Sarkis Avedisian

Vostanig/GORKY
m. (1) Marny George
m. (2) Agnes Magruder ("Mougouch")

Vartoosh
m. Moorad Mooradian

Florence Lillian

Karlen

Maro Natasha

m. (3) Akabi Sarafian
*d. circa 1930
two children by
an earlier marriage*

GORKY'S FAMILY TREE

(limited to those mentioned in the text)

ACKNOWLEDGMENTS

FIRST, I WOULD LIKE to thank the following members of Gorky's family: George and Ruth Adoian, Charles and Anne Adoian, Liberty Miller, Lillian Balian, Thomas Amerian, Florence Avedisian, Arax Melikian, and Gail Sarkissian. Above all, Maro and Natasha Gorky, and Agnes Gorky Fielding.

I am especially indebted to Mel Lader for drawing my attention to many details I might have missed. I could not have completed my research without the help of Alice and Ovsanna Kelikian in Chicago; and Piero Kuciukian and Ani Marderosian in Milan. Judith Jones has helped invaluably in giving the manuscript shape, and Jane Gunther has offered advice and support at every level.

I am grateful to those contemporaries of Gorky whom I interviewed, including Lionel Abel, Will Barnet, Hans Burckhardt, Elena Calas, Nicolas Calas, Lawrence Campbell, Nick Carone, Noma Copley, Maryan Davis, Gaston de Havenon, Dorothy Dehner, Willem de Kooning, Milton Gendel, Nan Greacen Faure, Jacob Kainen, Lillian Kiesler, Katharine Kuh, Gurken Kulegian, Jack Levine, Leo Lionni, George McNeil, David Margolis, Roberto Matta, Mercedes Matter, Dorothy Miller, Isamu Noguchi, Gordon Onslow Ford, Philip Pavia, Eleanor Perényi, David Porter, Milton Resnick, Jeanne Reynal, Faith Rose, Herman Rose, Harold Rosenberg, May Tabak Rosenberg, Helen Sandow, Meyer Schapiro, Bernarda Bryson Shahn, Helen Sloan, Joseph Solman, David Soyer, Hedda Sterne, Henry Taylor, Anna Walinska, and Jean Bijur Weiss.

I would also like to thank Dick Bard, Avis Berman, Hendrik Blom, Martha Clarke, Bill Corbett, Earl Davis, Jeannette Frenster, Leon Friedman, Jon Halli-

day, Anna Hamburger, Justin Harris, Bruce Hooton, Ted Hunter, Salomon Ketz, Hilton Kramer, Jean Levy, Stephen Mazoh, Stanley Mirsky, Gerald M. Monroe, Priscilla Morgan, Francis V. O'Connor, Stephen Policari, Mark Polizzotti, Paul Resika, John Richardson, Jack Rutberg, Christopher Schwabacher, Gaia Servadio, Nadim Shehadi, Wilhelm Vossenkuhl, Christopher Walling, and Richard Wollheim.

Many specialists helped me to understand how Gorky belonged to his Armenian background: Rouben Adalian of the Armenian Assembly of America; Aram Arkun of the Zohrab Information Center at the Diocesan Library in New York; Lilyan Chooljian, editor of *Varak* magazine, Fresno; Paolo Cuneo at the Centro Studi di Architettura Armena, Rome; Raymond Kévorkian at the Bibliothèque Nubar de l'Ugab in Paris; Dikran Koumjian and Barlow der Mugrdechian of the California State University Armenian Studies Program in Fresno; Gary Lind-Sinanian at the Armenian Library and Museum, Watertown, Massachusetts; Minas Lourian at the Centro Studi e Documentazione della Cultura Armena, Venice; Nerses Nersessian at the Oriental Department of the British Library at Blackfriars Bridge, London.

I would also like to thank these public institutions and their librarians:

In the United States: Nancy Malloy at the Archives of American Art, New York; Judy Throm at the Archives of American Art, Smithsonian Institution, Washington; Robert T. Coote of the *International Bulletin of Missionary Research;* Amy Hau and Shoji Sadao at the Isamu Noguchi Foundation, Long Island City; Julie Mellby and Anita Duquette at the Whitney Museum of American Art, New York; Tracey Bashkoff and Diane Waldman at the Guggenheim Museum, New York; Margaret Hedvich at the New School for Social Research Library, New York. Also: the FBI Records Division, Freedom of Information and Privacy Act Section, Washington; the Houghton Library, Harvard; the Inter-Library Loan Scheme in Detroit; the Artists' Records Library of the Museum of Modern Art, New York; the National Archives in Iowa; the New York Public Library; the Metropolitan Museum of Art, New York.

Regarding private collections in the United States, I would like to thank Earl Davis for access to the papers of Stuart Davis; Guy Kaldis at the Aristodemos Kaldis archive, Ossining, New York; Lillian Kiesler, custodian of the Frederick Kiesler papers, New York and Vienna; Malcolm Magruder for access to the Magruder family papers, Millwood, Virginia; Judith Mallin at the Young/Mallin Archives, New York; Roberta and Stuart Friedman for access to the Michael West archives, Yorktown Heights.

Outside the U.S.: François Chapon, conservateur général de la Bibliothèque Littéraire Jacques Doucet, Paris, for access to Agnes Gorky's letters to André Breton; Leonora Bassi at the Biblioteca della Faccoltà di Lettere, Siena University; the Public Record Office in London; the British Library at the British Museum; the Periodical Library at Colindale; and the Library of the Victoria and Albert Museum.

PREFACE

IN THE SIXTEENTH CENTURY, Giorgio Vasari based his *Lives of the Artists* on Plutarch's *Parallel Lives,* written in the first century A.D. Plutarch did not seek accuracy, but gave his readers lessons in their civic duty by extolling the example of heroes. Vasari suggested that artists possessed qualities as admirable in their own way as the patriotism of politicians or the courage of soldiers. Since his time, most historians, and many artists themselves, have seen creative lives in a heroic light. Those who during their lives seemed unhappy misfits redeem after their death the age in which they once lived.

I first saw Arshile Gorky's paintings in 1961, when I was sixteen years old. While on holiday on the island of Crete, I met and fell in love with Gorky's elder daughter, Maro. When we came back to London she took me to meet her family, who lived in a house halfway between the high, walled garden of Buckingham Palace and the huge sycamores of Belgrave Square. The house had a shiny black door and a row of spears for railings. Inside, all was eggshell white. It seemed inhabited entirely by women: Mougouch, Maro's mother, friendly though appraising; Natasha, Maro's sister, dark and elusive; Maro's half sisters, in a flurry of juvenile intrigue, running up and down the stairs, dropping over the banisters white lace petticoats that matched the walls. And on those walls, extraordinary paintings.

The Waterfall hung to the left of the little alcove where I was told to hang my coat. Opposite, by the piano, was a large bright version of *Khorkom*. In the L-shaped sitting room on the first floor, the yellow version of *Garden in Sochi*, its surface as smooth as ivory. Behind glass, *The Limit*, hardly visible but nevertheless discernible. *To Project, to Conjure* hung above a carved eighteenth-century fireplace. I immediately grasped that these paintings were about something, even if I could not understand what that something was. "Well," said Mougouch, "they're landscapes, you see." My book is a long gloss to this first laconic explanation.

The house and its paintings have long since gone, but for five or six years they provided a key to my education. Gorky's library of *Cahiers d'Art* lay in long shelves between the kitchen and the front hall, and over the next few years, on weekends back from school and university, I acquired the taste needed to bridge the gap between his ideas and mine. Legends were repeated at table so often that they acquired the feeling of worn beads. André Breton had compared Gorky to Toulouse-Lautrec: what could that mean? You had to think hard about Lautrec, and also about Breton. Then what about Gorky's aphorisms? So-and-so was "a snake in the grass." Did they have snakes in Armenia? Were they poisonous? "You can't catch flies with vinegar." But flies adore vinegar! Or one preferred by Mougouch: "Beat your mother while she's young." Hard to grasp, but oh so true.

Maro and I were married in 1967. Our daughters, born in Italy, where we came to live soon after, grew up in a house where their dead grandfather was a powerful offstage presence. When our eldest was a child in trouble at school, she used to come secretly into our bedroom and tell Gorky all about her problems. His pencil self-portrait on the wall possessed the ability to commiserate with her when things were bad. The drawing could even express irony toward problems that were merely human. At times, in particular moods—yours, not his—this drawing could even smile.

In 1989 the Whitechapel Gallery in London asked me to write a chapter on Gorky's ideas on art for the catalogue of a show. I reread all his own words, wrote my piece, the exhibition came and went, but a certain doubt remained. Gorky's letters were fluent, but his life was somehow cloudy. Why were his interviews in such a different tone of voice from the one used in his letters? Was it perhaps time to delve deeper into the Gorky papers? Was it time to add substance to a family myth?

A year later, cousin Karlen died. Karlen Mooradian was the only son of Vartoosh, Gorky's younger sister. It was Karlen who had translated and published all of Gorky's letters to his mother, the largest single source of information about Gorky's thoughts on art. On the walls of the tiny apartment in Chicago where he and his mother lived their entire lives hung photos of himself in

poses exactly like the poses that Gorky had assumed at the same age. Karlen never married. His whole adult life was spent in the shadow of his uncle.

Vartoosh survived Karlen by little more than a year. Through the kindness of the executors of their wills, Maro was eventually sent copies of the original letters from which Karlen had made his translations. Studying these documents with the help of two Armenian scholars, we came to the conclusion that many of Karlen's translations were figments of his own fantasy of what Gorky was, or what Gorky should have been. They were extensions of the sad, strange conviction which Vartoosh had wished upon him—that his own life was a continuation of her brother's.

Reading these new translations, I longed to clear away the fantasies and discover for myself the "real" Gorky. Having started my research almost fifty years after Gorky's death, I found the task difficult. It is hard to replace the fables with which Gorky presented himself, for if one adds cold facts to his works, sometimes they distract more than they clarify. I have tried to satisfy Vasari's criteria for what we need to know: a vision of the artist's early life and the confraternity among which he lived. I agree with the conviction that Vasari first expressed, and that Gorky shared: that painting is a heroic act. I feel that my ideal readers are themselves artists, so I have included what interests them: technique, money, and the tension between creativity and the distraction of life swirling around it. I have kept my own ideas about Gorky's paintings to a minimum, but I have included something of what people thought of Gorky's work at the time, as this is an essential part of the quest from day to day.

FROM A HIGH PLACE

KHORKOM

1895–1910

GORKY OFTEN TALKED about his childhood: the beautiful lake on whose banks his village used to stand, its poplar trees like sentinels, the distant mountains whose shoulders supported the sky. Gradually his stories built up into something not quite real, and he always chose a moment when his audience was hardly listening: pupils busy at their work, or friends talking politics in the local café. Nobody kept notes. If anyone tried, Gorky broke off. A note-taker was to him a "book-keeper." Words were free when spoken, but to write them down imprisoned them. To be held to his words made him instantly furious.

In 1936, contributing to a book about some murals painted for the Federal Art Project, he produced a rare written piece. It starts with a description of his family house back in Turkey:

> The walls of the house were made of clay blocks, deprived of all detail, with a roof of rude timber.
>
> It was here, in my childhood, that I witnessed, for the first time, that most poetic of operations—the elevation of the object. This was a structural substitute for a calendar.
>
> In this culture, the seasons manifested themselves, therefore there was no need, with the exception of the Lental period, for a formal calendar. The peo-

ple, with the imagery of their extravagantly tender, almost innocently direct concept of Space and Time, conceived of the following:

In the ceiling was a round aperture to permit the emission of smoke. Over it was placed a wooden cross from which was suspended by a string an onion into which seven feathers had been plunged. As each Sunday elapsed, a feather was removed, thus denoting the passage of Time.

As I have mentioned above, through these elevated objects, floating feather and onion, was revealed to me, for the first time, the marvel of making the common—the uncommon!

The "elevation of the object" was an idea put forth by the French painter Fernand Léger: the artist casually chooses an object and "elevates" it to a higher plane. It was typical of Gorky that he saw an actual object raised on high, rather than a metaphysical transformation imposed by the artist on any found object. It was also typical that a childhood memory should take precedence over a more recent one. He carried his childhood perpetually with him, and its values were forcibly imposed upon the present. "Extravagantly tender" and "almost innocently direct" were expressions he often used, imbued with a deep emotional charge. Tenderness: the ability to make yourself ever more receptive to the outside world. Innocence: that quality which could never be contrived in a painting, but which had to be there.

Arshile Gorky was born Vostanig Adoian, the son of a poor farmer who lived in the village of Khorkom on Lake Van, in eastern Turkey. The house had been built by its owners, and was many times rebuilt after earthquakes or the attacks of Kurds or Turks. The roof was supported by poles of poplar cut from trees that grew on the shore. The ceiling consisted of interlaced branches, some with their leaves still on them, now dried and yellowed from years of smoke. On top of that, there was a thin layer of lakeside mud. In summer the women of the house used to spread apricots out to dry on this surface, shielding them with a ring of prickly bushes so that the goats wouldn't climb up and eat them. Gorky's expression for a man in a nervous state was "He has goats on his roof." An unlikely predicament in Manhattan, but in Khorkom it would have been enough to make anyone fretful.

Khorkom was built near the mouth of the Khoshab river, which flowed into the southeast corner of the lake. The buildings of mud and stones flanked paths running parallel to the river, each family separated from the next by sheep pens and enclosed orchards, wherein a few fruit trees were pruned to a certain height by the teeth of the ubiquitous goats. During the few summer months, everyone lived outside to absorb as much sunlight as possible. The fields were plowed in the autumn and sown with winter wheat. As the weather became colder, the animals were brought into the barns flanking the houses, and their warm breath filtered around the doorways in patient

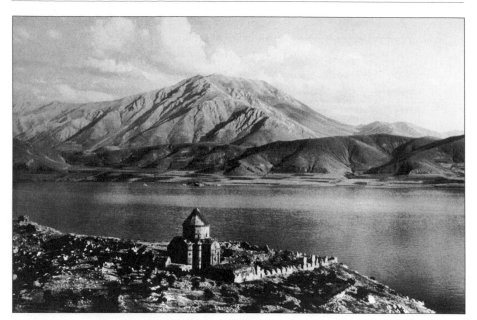

Lake Van, with the island and monastery of Akhtamar in the foreground. The village of Khorkom, Gorky's birthplace, lay on the coast to the left, and the monastery of Chara-han Surp Nishan, where Gorky's mother was born, lay beneath the steep slopes of Mount Ardoz in the center of the photo.

sighs. In winter the snow weighed down the roof. The side rooms where they lived, one room for each family, were abandoned and everyone slept around the hearth at night, their feet toward the embers like spokes converging on the hub of a wheel.

The hearth, a clay vessel called a *tonir* set into the ground, was the center of the house, and the Armenians retained a pre-Christian reverence for fire and for the sun. There was nothing to do in the long winter months but listen to the traveling storyteller, who earned his keep by relaying gossip from the neighboring villages and reciting long epic poems about fiery steeds, whose hooves struck sparks when they pawed the earth, and young heroes of incredible strength and carefree courage. Not many villagers of the generation preceding Gorky's could read or write, but some could recite long passages of verse by heart. A child could doze off by the *tonir* and wake up hours later, and the storyteller would still be reciting.

"It was a simple life," a cousin of Gorky's told me, and when I protested, what about the Turks, the persecutions, the massacres, she smiled and went on talking about the peaceful moments. She, too, recalled its "innocence." Remembering the Adoian front door opposite, Arax Melikian thought that the family must have made some money at some point, for on either side of the

door were two windows of real glass. The village school at Ishkhanikom had no glass in its windows, nor did the library at Akhtamar, the monastery which lay on an island a few miles due west of Khorkom. A British visitor in the 1880s noticed that the monks used oiled manuscripts in place of glass to let in the light. Akhtamar was an important see of the Armenian Gregorian Church, and its buildings are still among the most beautiful of eastern Turkey. Low reliefs of fruits and vines are carved into its warm limestone exterior, surrounded by the peaceful serenity of the lake.

The Armenians of eastern Turkey shared the lands where they lived with Kurds, who since the 1880s had been encouraged to take over their houses and fields. The displacement took place spasmodically, and many of the nomadic Kurds resented the pressure placed on them to give up their pastoral existence and become farmers. Left to themselves, the two sides often came to an agreement whereby a local Kurdish leader gave the Armenian villagers protection in return for tribute. Some villages fared better than others in this respect. Khorkom had no Kurdish inhabitants. On the other hand Vostan, the nearest agricultural center south of Khorkom, was in the process of becoming, by force, an exclusively Kurdish town during Gorky's childhood.

The Turks put more trust in the Kurds than in the Armenians for religious reasons, but the Kurdish idea of Islam involved many strange beliefs borrowed from other faiths. Outside Vostan, for instance, at the little monastery of Charahan Surp Nishan, where Gorky's mother was born, the nearby Kurds revered the Christian saints as their own. Gorky's maternal uncles Aharon and Moses, who often visited Surp Nishan, counted Kurds among their friends. In spite of their persecution at the hands of the Kurds, many Armenians of Van, including Gorky, remembered them not with hatred, but with a certain admiration.

Gorky's childhood was shaped by two disasters. The first was the massacres of 1896, during which his mother and father both lost their first spouses. Had it not been for this tragedy, they would never have met. The second was the genocide of 1915, during which the entire Armenian population was either driven out of the country or killed. Kurds took a leading part in the slaughter on both these occasions, but it was clear to both sides that their participation was dictated from above.

Over the previous century, a pattern had evolved. Whenever a Christian minority in some other part of the Turkish Empire had succeeded in winning its freedom, the authorities would decide to punish those Christians still living within the confines of Anatolia. An increase in acts of banditry by Kurds on Armenians was the first sign that matters were deteriorating. Resistance in such cases only made things worse. As the official report would subsequently put it, an "incident" had taken place, but the Turkish army had succeeded in

restoring "peace and tranquility." The reality behind these bland words was usually terrible.

In 1895, the Catholicos of Akhtamar described in a letter the grave situation building up south of the lake. "The country has been devastated; many of the villages are in ruins. Here and there you find a few half-ruined churches and many graveyards, which are often used by the Kurds as farms and gardens." They had seized a field belonging to the monastery of Charahan Surp Nishan. "There is no monastery, either ruined, deserted, or occupied which is not, directly or indirectly, under the influence of some Kurd."

The letter mentions Gorky's birthplace. "The villages of Khorkom, Kiushk, and Ishkhanikume have been so much oppressed by the Turks of Artamed, that the inhabitants are already planning to move away." Khorkom, Khiosk, and Ishkhanikom were adjacent villages along the bank of the Khoshab river; Artamid lay on the lake road to Van City. "In 1893, in Khorkom, a barn belonging to Nishan Der Simon was burned, and the year following, all the wheat of Mardiros Yaghmainyan in the same village."

The British vice-consul in Van wrote that in the Shadagh region south of the lake, the situation was even worse. There, the Armenians were living under "a regime of organized brigandage of the worst and most intolerable description." A captain of the Kurdish irregular cavalry was constantly provoking them. He had carved the Christian cross on the back of a dog and let it loose in a village, hoping to instigate a riot. He was known to have murdered at least six Armenians of Shadagh with his own hands.

Several months before the massacres of 1896, the Armenians who had been working in Istanbul were told to return to their villages. It was not easy to travel such great distances without being robbed, and the journey was hard. When Arax's father, Dikran Melikian, arrived back, he found that the village had just been sacked. All the men had been assembled in one place, he was told, and offered a chance to change their religion. When they had refused, they were killed. Gorky's uncle Vartan, who had arrived back from Istanbul only a few days before him, had been found dead under a heap of corpses. There was no mark on him: he had died of fright or suffocation. As night fell, Dikran looked around for a place where he could sleep. Beds were broken, blankets and pots and pans had been stolen, sheep driven away. Eventually he found an old blanket with a hole in it. As he lay down to sleep, he used his soft felt cap to plug the hole.

Dikran had arrived back just a few days after the tragedy, yet everyone was already hard at work. After repairing the damaged houses, the villagers went off to search for the stolen animals. One heard from a friend: Oh, I saw your sheep with a Kurd at such-and-such a place. And then one walked, talked.

Sometimes the Kurds gave the animals back, especially if one handed over a lit-
tle money.

Everything had happened before. And it would happen again. There had
been massacres in the time of grandparents, great-grandparents, as far back as
anyone could remember. Over the centuries, a strategy for recovery had
evolved. Across the country, the priests and village elders would arrange mar-
riages between the survivors. At a church celebrating the name day of a saint,
the visiting village priests and the elders sat in the courtyard after the cere-
mony and said: That man comes from a good family and has one child; and she,
too, has two children. They will surely do well together. And so it would be
arranged. In such circumstances, the feelings of those involved were not the
prime concern. Often the bride and groom met for the first time at the altar.

One such marriage was that of Sedrak Adoian of Khorkom, a widower in
his late thirties with a seven-year-old son called Hagop, to Shushan der
Marderosian, a widow aged sixteen or so, with two small daughters.

Gorky's mother, Shushan, was a strong-willed woman of medium height,
with clear, expressive eyes. An English cleric who visited the area described in
these words the Armenians who lived to the west of the lake: "They had the
frank and direct look which we are accustomed to see only in children, and
were quick to detect and resent evil, even with violence, as the intruder would
find to his cost." This observation fits in with what is known of Gorky's mother.
Forthright, but also utterly honest, detesting any devious act, Shushan der
Marderosian had a powerful character and was immovable if crossed.

Shushan's late husband had come from the mountains of Shadagh, south of
the lake. Her father had been a priest, and she was born at the monastery of
Surp Nishan, southwest of Khorkom. Her father had also been killed in the
massacres, outside the church in Van City where he had been serving at the
time. In a dark moment, Gorky told his second wife that his grandfather had
been crucified on the door of his own church.

Shushan had three brothers: Moses, Aharon, and Nishan. The elder two
were placed in the American orphanage in Van after their father's death, while
Shushan went back to her mother at the family monastery. Her marriage to
Sedrak must have been arranged a year or two later. She had no say in the mat-
ter, and there was a condition attached: she would have to leave one of her
daughters behind. Thus her elder daughter Sima was sent to an orphanage in
Van, where a year or two later the child died. Shushan had even less control
over her children's destiny than she had over her own. Had she borne sons to
her first husband, they would have stayed behind with his family in Shadagh,
where they would have been brought up by their paternal grandmother until
they were old enough to cultivate their father's land, inherit it, and continue
the line.

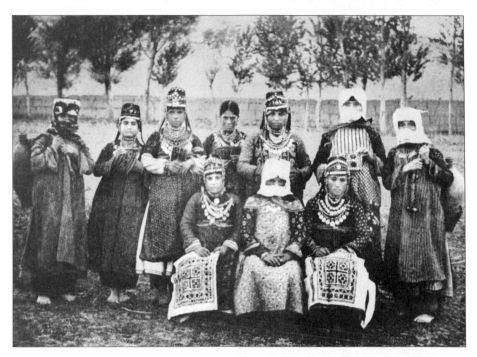

Armenian peasant women from Lake Van with their different aprons. Armenian women married young, and it was not uncommon for a bride of sixteen to have two children, as did Gorky's mother.

Shushan's eldest daughter by Sedrak was called Saten, or Satenig. Then came Gorky, who was christened Vostanig after the city of Vostan, where his mother's family church was situated. Finally her youngest daughter, christened Vartoosh, meaning rose. Behind the back door of the Adoian house, where Shushan lingered before walking down the path to the fountain to collect water every morning, grew a rose of which she was particularly fond.

Shushan was the youngest married woman of the Adoian house, and traditionally this figure occupied a subordinate position in the family hierarchy. She was expected to rise at dawn and pour water for the men to wash themselves, before they went out to work in the fields, then scrub and clean the main room before tackling the needs of her own family. If Shushan ever cooked, it would have been under the watchful eye of her sister-in-law, Yeghus, who was in charge of the house.

In the 1940s Gorky described to his dealer Julien Levy the kind of thoughts that occurred to him as he drew. He said that as he worked, he watched the line travel over the paper and told stories to himself, like a child who explains as he draws: This is the sun, here is a path, this is "a cow in the sunlight."

As he spoke to Levy, a second idea occurred to Gorky: that the thoughtless

narrative without beginning and without end had something to do with the stories his mother had told him as a child, "while I pressed my face into her long apron with my eyes closed." She had possessed two aprons, he said: a plain one and an embroidered one. As she talked, her stories and her embroidery became confused in his head. All his life, said Gorky, her stories and her embroidery were intertwined in his memory.

Shushan's everyday apron had a design of flowers printed on it. The embroidered one was textured, with raised stitches. A child with his eyes closed and his face hidden could have traced the embroidery with his hand. Though the story does not contain any overt act of violence, there is an unsettling aspect to the memory: the child running to his mother in order to bury his face in her apron, the mother speaking words intended to comfort and distract. Vartoosh remembered that her uncle Krikor was a short-tempered man. Once, he hit Shushan so hard that she fell to the ground and cut her head on one of the flagstones outside the front door. Being a woman of strong character, Shushan probably did not accept the humble role the other members of the household imposed on her. If she made her obstinacy too apparent, it would have been considered perfectly normal to teach her a lesson.

With so many responsibilities and three children of her own, Shushan delegated the care of Gorky to Akabi, her daughter by her first husband. Even in later life, Akabi was always his champion and protector within the family. Like many Armenian girls, she went from taking care of younger siblings to becoming a mother herself, with no pause in between. A rich confusion of roles took place in Armenian households. Sisters were like mothers, uncles were like fathers. The father figure for the children was often an uncle, an elder brother, or a grandfather. It was a way of coping with the absence of real fathers who had left to work abroad, or who had been killed.

Not much is known about Gorky's grandfather Manuk, who was the head of the family until Gorky was about four years old. When he died, Gorky was given the name Manuk in his honor, and this was the name used by old friends from Van, even in America. The violence which Shushan occasionally received from her uncle Krikor probably took place after old Manuk's death, when there was a struggle as to which of his two sons was to become head of the family. Krikor, Gorky's uncle and the elder of the two brothers, was the winner. Sedrak, Gorky's father, subsequently kept clear of the house if he possibly could. He used to sail a boat across the lake to sell wood on the northern shore, and often he was absent for weeks at a time.

It does not sound as though Gorky's mother and father ever developed a liking for each other.

■ ■ ■

ESCAPING FROM the chores of the Adoian house, Shushan went to church as often as she could. She used to walk along the path which led from the Adoian house to Khorkom's little schoolhouse, past the village church of St. Vartan, whose bell was a plank of walnut wood. Sometimes she went to the church at Khiosk, the next village along the Khoshab river. In August there was the big festival for the Assumption of the Virgin at Akhtamar, and she took the boat over to the island. The feast was a favorite of the people of Shadagh, so it was a chance to catch up with news of her first husband's family.

Whenever she could, she visited her family church of Charahan Surp Nishan. The town of Vostan emerged as a few scattered houses surrounded by trees as she walked, some two hours away across the river, up a long strip of arable land, through orchards of apricot and almond trees. The path skirted the lower slope of Mount Ardoz on the south side of the big main road. The monastery stood a mile or so up the mountainside. A stone wall surrounded the exterior sleeping quarters, making an enclosure in which to pen the sheep.

Charahan Surp Nishan was not much larger than a chapel. Two heavy columns in the middle supported a cupola pierced by four small windows. The walls were bare, unfrescoed. Within, there was a dark room about twenty square feet, unadorned and perhaps blackened by fire. Outside in the court-

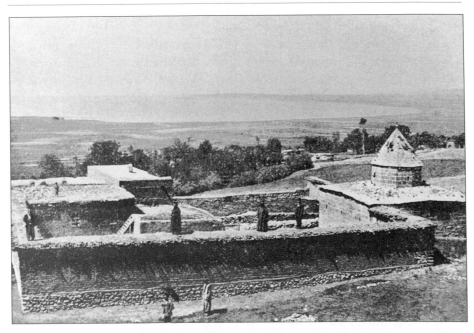

Charahan Surp Nishan, the little monastery which for centuries had been connected with Gorky's mother's family

yard stood a stone with a hole in it, associated with a martyred saint whose headless body had been found on the hillside eight centuries previously. The suppliant whispered prayers through the hole, and the saint, hopefully, intervened. Behind the buildings there was nothing but a hillside covered with rocks and herbs, with a few weathered beehives and neglected fruit trees. The rooms surrounding the courtyard were half abandoned, and during Gorky's childhood the entire property was rented for a small sum to a priest who was not a member of the family.

Shushan was passionately attached to this place, so intimately associated with memories of her father and her ancestors. When her brother Moses married, his wife Markrit wanted to take over the task of caring for the church. She was the wife of the eldest male and the head of the family, and the job was rightfully hers. But Shushan would have none of it. Sweeping the church was her job and hers alone. Her brothers used to say, admiringly, that Shushan had a fearful temper.

South of Charahan Surp Nishan were the slopes of Mount Ardoz, and behind these, a slithering goat path wound in and out of the mountains to the district where Shushan had lived during her first marriage. Shadagh was a country of tall peaks and deep ravines, where the houses clung to the sides of cliffs like swallow's nests, the roof of one acting as the terrace of the house above. The villagers looked out onto a landscape of rock, with just a hint of cool green deep down in clefts eroded by winding tributaries of the Tigris river. Bears plundered their flocks in spring. Wild boar rooted in their gardens. The farmers had to hack out the fields from the surrounding wastes and ring them with stones to prevent them from being washed away. Not even donkeys could reach the more remote wheat fields, whence the harvest had to be brought out on the villagers' shoulders. In the summer, they came down the mountainside bearing huge stoops, like haystacks on legs.

The men of Shadagh were "wide-awake industrious mountaineers," according to one of the American missionaries who later taught Gorky in Van. Both men and women participated in producing *shal*, a cloth woven from a mixture of wools from sheep and Angora goat. The men sheared the wool, which they washed and carded on the roofs of their houses. The women spun it into thread, dangling the spindles over the edge of the houses to take advantage of the height. The men gathered natural substances to use as dyes for flatweaves: lichens for orange, insects for red, the root of a plant for yellow. Men wove the *shal*, while women wove flatweave rugs, called kilims.

Enclosed gardens, the tree of life, flowing water—these were themes the village women wove into their kilims. Each weaver varied her composition using signs whose meanings had been eroded by legends. There was a "dragon" theme, the *vichap*, which may originally have been copied from Chi-

nese silks. Centuries ago, the themes had once possessed recognizable features, but by constant repetition the dragon on the carpet became no more than an evocation. In a similar way, Gorky often used the same sign again and again in his paintings, until it lost its recognizable features and became merely an unexplained symbol within the storytelling atmosphere of the canvas.

Thoughts about places and beasts occupied the minds of the weavers as they worked. If the summer had been arid, the colors tended toward the red and the brown. If it had rained and the pastures had kept their green, then the color green found its way into that year's rug. Like the weavers of Shadagh, Gorky transmitted the light he had absorbed in the open air into his work. His paintings may not be accurate to the day, but they are usually faithful to the season in which they were painted.

IF NOSTALGIA FOR a lost paradise is one of the qualities which sustained Gorky in America, then perhaps he acquired this emotion from his mother's own nostalgia, long before his own fragile world came to an end. Unhappy in her second marriage, Shushan idealized her life with her first husband. She often told her children about the courage of the mountaineers of Shadagh and their passion for dancing, and about the Kurds of Shadagh, who sang when they rested at a fountain, sang in certain valleys to make the echoes respond, sang in celebration and in mourning, head held back, beginning on a high note and descending gradually through slides and quarter tones down to a mumble of half-sung assent among the listeners. There were songs of winged horses leaping the mountains at a single bound, and of maidens kidnapped and revenge dutifully wreaked, down to the last appropriately severed limb.

When Gorky was tall enough, Shushan sent him back into these same mountains of Shadagh to work as a shepherd boy for the local Kurds. "The shepherds there live in the mountains with their sheep and Gorky often remained with them overnight. From them he learned their language which is Kerdman, their folk songs and dances. They are like gypsies." In that part of the world everyone danced and sang.

Tomas Prudian, Shushan's first husband, was one of those who, before the massacres of 1896, had taken up a gun. Probably he belonged to a revolutionary group of some kind, although in Shadagh a man needed a gun merely to protect his flocks from wolves and bandits. A photograph which once belonged to Akabi, Shushan's elder daughter, shows five mountaineer "revolutionists." One of these may be Tomas.

Though they resisted the attacks of the Kurds as best they could, when the time came the Armenians of Shadagh found that there was nothing to be done against the Turkish army. Seizing the villages, the troops held the women and

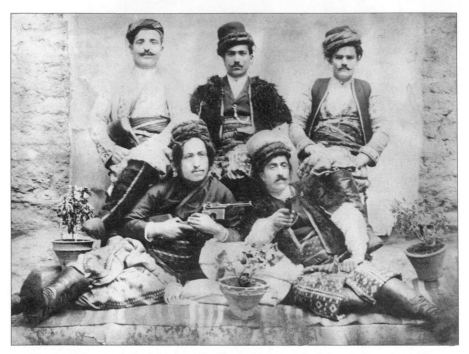

Five Armenian revolutionaries from the Shadagh area, c. 1896. Among them is perhaps Tomas Prudian, Shushan's first husband. Under Turkish rule it was illegal for Armenians to carry weapons, so this photograph suggests an element of bravado.

children hostage until the "revolutionists" came down from the hills and laid down their weapons. In November 1895 Tomas Prudian was lined up with the other men of his family in front of their house in Shadagh. After they refused to change their faith, they were all killed.

SHUSHAN'S DEVOTION TO the monastery of Surp Nishan involved another memory on which she dwelled. Her younger brother Nishan, who had stayed behind with their mother at the family church, was murdered there, around the time of Gorky's birth. When he was about fifteen or sixteen years old, Nishan began courting a Kurdish girl. The girl's brothers felt insulted, and Nishan was killed and his body left at the door of the monastery.

Nishan was Gorky's grandmother's favorite. In her grief, she raised her hands to heaven and cursed God. Her son Moses, still only a young man but now the head of the family, urged her to keep silent. He had been warned in a recurring dream, he said, that if she did not keep quiet, her family would be accursed. Unable to control her grief, she then tried to burn down Surp Nishan. Appalled, the villagers of Vostan rejected her. Behind her back they called her "God-killer," and no one would speak to her. Moses and Aharon had to take her

away, to a part of the country where her sacrilege was not common knowledge.

Gorky's grandmother died when he was still a small child. It must have been one of his earliest memories. At the funeral, he was offered some special delicacy, for a funeral was a feast as well as a sacrament. Politely, he refused. Again food was offered to him, and again he refused. He knew that it was good manners to accept food only when it was offered for the third time. In their confusion, however, his elders failed to offer the plate to him again. The chance to eat well in this part of the world did not occur often, and Gorky often mentioned the fact that he had gone away from his grandmother's funeral still hungry.

He turned the experience into a funny story, though its black humor was not always apparent to his listeners in New York. It was not his uncle Nishan's murder, nor his grandmother's insanity and early death, that was the high point of the story, but his own hungry cravings. The only other event from his grandmother's life which he ever mentioned—and with admiration—was her attempt to burn down Surp Nishan. He thought this was one of those magnificent, carefree gestures which took life right out of its normal cautious round, and he could never make a fire in a hearth himself without creating a tremendous whoosh of flames and sudden heat.

GORKY DID NOT UTTER a word before he was about five years old. He had no disability as far as any of his family could tell: he was merely slow. One story has it that his uncle Krikor forced him into speech by taking him up onto the roof and telling him to jump off. His first words, then, were "No, I won't." Another story has it that a thirteen-year-old cousin tried to frighten him into speaking. Little Manuk took up a stick to defend himself. His cousin pretended to be wounded. He cried out, "*An gu la,*" "He is crying." Bewildered, Gorky ran to his mother Shushan, repeating the words.

In the 1940s Gorky named a painting *Argula*. After this work was sold and given to the Museum of Modern Art, Gorky received a letter asking him what the title meant. He replied, "No specific scene but many incidents—The first word I spoke was Argula—it has no meaning. I was then five years old. thus I call this painting Argula as I was entering a new period closer to my instincts." There was no need to tell the world that "Argula" was a child's garbled version of "he is crying." It would only require a still longer explanation, and one easily misunderstood by those who had no experience of life in that part of the world.

Gorky told friends in New York that his mother used to call him "the black one, the unlucky one who will come to no good end." Sometimes he talked as if his mother's reproaches weighed heavily on his head, and even at an early age, Gorky resisted the stark world of angels and devils at the core of his mother's religion. Her equivalent for "naughty boy" was the formidable "Oh, you child without God."

Once, at a dinner party in 1942, Gorky resurrected a certain incident from his childhood.

> I remember myself when I was five years old. The year I first began to speak.
> Mother and I are going to church. We are there. For a while she left me stand-
> ing before a painting. It was a painting of infernal regions. There were angels
> in the painting. White angels. And black angels. All the black angels were
> going to Hades. I looked at myself. I am black, too. It means there is no Heaven
> for me. A child's heart could not accept it. And I decided there and then to
> prove to the world that a black angel can be good, too, must be good and
> wants to give his inner goodness to the whole world, black and white world.

Apart from the church of Akhtamar, there were no frescoes of the Last Judg-
ment in any church which Gorky visited as a child. But the image was a com-
mon one in the family Bibles of the Van school, and Shushan possessed one of
these, inherited from her father, the priest of Surp Nishan. Being illiterate, she
showed this Bible to her son for their illustrations alone. The line which he
described to Julien Levy as traveling over the paper, making a sun, a path, a
cow in the sunlight, would in this case have traced the image of Mary, Mother
of God, and the angel bringing the Good News. And as Shushan told him the story, there would have been no difference to her between the thing drawn and the angel itself.

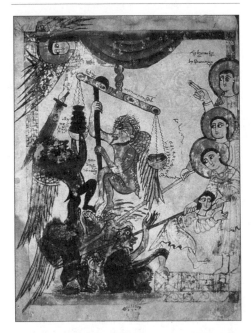

The Last Judgment in a manuscript Bible from Van. The work of the local Van school of illumi-nation is less ornate than that of the Cilician school, which kept in contact with monastic illu-minators of Greece and Italy.

The idea that lines on paper could become as real as facts was something Gorky learned from Shu-shan. In the old Byzantine tradition, a father gave to his daughter when she married a book which he him-self had copied. She was then to pass on the cultural heritage to her children. In Armenian households, it was the mother who transmitted the mystical side of things, whereas the father taught the practicalities of tending the fields. In both cases the transmission of knowledge was physical. Culture was to be touched, was to be shaped by hand.

The illuminated manuscripts of the Van school are simple, "inno-

cent" works, as if the monks who drew them were content to represent the attributes by which the actors of the story could be recognized, without worrying themselves unduly over the composition. St. John the Baptist had to have a hairy coat; otherwise who could recognize who he was? The Magi always carried gifts, and the entry into Jerusalem was recognizable because the picture always included a man perching in a tree. In Van, the gold used in the background of grander volumes produced by the Cilician school was replaced with a yellow color boiled from the root of a plant, and the brown was made from a certain clay, ground between two stones. The miniatures of the Van school are close in spirit to Gorky's description of narrative drawing.

GORKY'S SECOND WORDS WERE more mundane. Walking with his family by the shore of the lake, he turned to Krikor and said, "Money! All you ever talk about is money." They were amazed, not so much by the meaning of his words as by the complicated phrase which unexpectedly had come from his mouth.

Passing near Khorkom along the coast road early in 1908, the British vice-consul thought that the Armenians he saw there were "no better than a set of cringing beggars, ragged and filthy," an observation which is borne out by a photograph of children in a village near the monastery of Narek, some thirty miles from Khorkom. Gorky as a child must have looked very much like one of these boys.

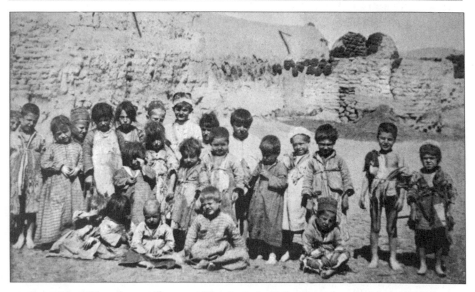

Armenian children from a village near Narek, at about the time when Gorky and his family moved to Van City

It was hardly surprising if Krikor talked obsessively of money. The village had almost nothing in the way of cash. It survived on barter. All cash went to the government, and the farmers were forced to take out loans at exorbitant interest rates in order to pay their taxes. Grain seed was loaned to poor farmers by Kurdish Aghas and redeemed immediately after the harvest. Armed tribesmen stood over the threshing floor and rode off with their percentage as soon as the wheat had been winnowed. If there was any wheat to spare, it was taken into Van to be exchanged for cloth, for there were no looms in Khorkom. Sometimes salesmen used to ride out from the city to sell women needles and thread in exchange for chickens, leaving with the chickens slung across the backs of their mules.

The massacres of 1896 instilled into the Christian minority of Turkey a sense of terrible urgency, and the twenty years preceding the final disaster of 1915 was a period of ferment. The Armenians were engaged in a race against time, to become better educated, better organized, better informed about the outside world than the Turks and Kurds who surrounded them. Two options were open to them, and both were pursued simultaneously. The first was to prepare for an armed uprising as quickly as possible. The second was to make themselves indispensable to those who ruled them. It goes without saying that the two strategies were incompatible, but the state of confusion imposed on them from above was so great that it was impossible to establish a unified front.

In 1904 the local wing of the Dashnak party—the Armenian Revolutionary Federation—took over the island of Akhtamar, where it opened a political school. Their ideology was socialist and initially anticlerical, and there was talk of selling the manuscripts and silver belonging to the monastery in order to dedicate the proceeds to the revolutionary cause. Khorkom was their base, being the closest exclusively Armenian village on the mainland. The villagers had to take sides. Shushan, with her strong attachment to the church, was against the Dashnaks, but her brother Aharon, now teaching in the carpentry department of the American Mission School in Van, used to travel across the water to the island to study there whenever he could.

The American missionaries thought that the "revolutionists," as they called them, were atheists, and they disliked them intensely. The archives of the mission are full of the difficulties they were encountering with Dashnak teachers in their schools, disseminating "atheistical" propaganda. Ironically, whereas the Americans called these freedom fighters "infidels," the Turks called them "Fedayee," meaning those who were prepared to die for their faith. The missionaries began to make their presence felt in the villages outside Van, especially in Khorkom, which "has suffered perhaps more than any other from the baleful influence of Tashnagist infidelity."

Yet, like everything else in that part of the world, there were exceptions and paradoxes and personal solutions to ideological problems. Aharon taught carpentry at the American school in Van, but the missionaries made no objection if he occasionally went over to Akhtamar to learn about the Revolution from the Dashnak teachers. Aharon was a strong, serious man, and the missionaries trusted him. To the end of his days he managed to remain both a Dashnak and a staunch supporter of the church. I possess a hymnal which used to belong to him, filled with hymns written by the missionaries and their wives, and it is a well thumbed, much loved little book.

In 1908, about the time Gorky was beginning to speak, about fifty Armenians in Van City were killed during a three-day clash with the police. The Turkish militia was called out and the surrounding countryside was searched for hidden weapons. So many Armenians were hurt during this action that they gave it a name: the Khozarkutiun, the "Big Search." The British vice-consul noted that the Turkish militia which searched the villages near Van "behaved in an abominable manner, beating, pillaging, robbing, and raping."

Hagop, Gorky's half brother, Sedrak's son by his first wife, was by this time a strong young man and a member of a band of Dashnak freedom fighters. During the Big Search, he was involved in a scuffle with the police. According to his own fantastic version, he "pulled the Turkish Pasha from his horse" and had to take to the hills, where he must have received help from Kurds. He and a cousin called Amu eventually made their way to Cairo, where they obtained money for the fare to America through the help of an Armenian priest.

Van was saved from a general massacre by events which took place a thousand miles west of the lake. An insurrection by Turkish troops in northern Greece turned into a general revolt against the sultanate. Within a few months the Young Turks succeeded in forcing a reform of the constitution. As their ideas on political reform ran parallel to those of the Dashnak party, for a while the two opponents became allies. The Armenian "revolutionists," from having been a troublesome brotherhood perpetually on the brink of provoking another massacre, blossomed into a political party keen to register all Armenians as voters and to return as many deputies as possible to Parliament in Istanbul.

Emigration from Turkey to America suddenly became much easier. Initially the Young Turks approved of emigration, as it brought in cash from abroad. Thousands of Armenians took their chance and left. It was simpler to earn money in Boston or Niagara Falls and send it back via a bank in Van than to go on, year after year, paying new taxes, bribing policemen, making deals with Kurds.

It was at this point that Gorky's father left the country.

Early one morning, Sedrak woke Vartoosh and Gorky. He took them down to the edge of the lake. A soft mist was rising from the surface of the water.

They ate a meal together of flat bread. Sedrak then gave his son a pair of brand-new slippers. After a while he told the two children to return to their mother. Then he mounted a tall horse and rode away into the mist, never to return.

There was no preamble or sequel to the story. Though it was one of Gorky's favorites, he never said a word about the political confusion behind his father's departure. As de Kooning said once, "It was like folklore." When he read Ethel Schwabacher's biography, de Kooning was shocked to discover that Gorky's father had been a man of flesh and blood, who had lived quietly near Boston until 1948. Why had he never heard of him? What else had Gorky kept to himself all those years?

Gorky's mother and father had not developed an affection for each other during their eight or ten years together, but even so, to say good-bye to her husband must have been a hard experience. The Adoian household was now shorthanded. Shushan had to assume a man's role and work in the fields, instead of walking across the river to sweep the courtyard of Surp Nishan. That autumn they had to find a man to help with the plowing. They enlisted the help of an Adoian cousin, nicknamed "Rus" because he had red hair. Only Russians had such coloring. Rus had five children and lived east of the Adoian house, toward the church.

BEYOND THE CHURCH LAY the village school, to which Gorky was sent soon after his father left. The path led past the priest's house, in whose garden stood the best pear tree in Khorkom. A spring bubbled up in the road on the far side of this building and the way became boggy. The children had to hop from stone to stone to keep their feet dry.

Shushan handed over her son to the teacher on the first day with the words "Flesh to you, bones to me. Teach him something." Her son could be beaten in the name of instruction, but no bones were to be broken. The formula was a traditional one, and in later life Gorky repeated it with enthusiasm. The writer Vahan Totovents describes exactly the same experience from his own childhood: "The blows from the stick would only land on the fleshy and tender parts of the body. All the parents were satisfied with this method. It was often they who proposed and encouraged it."

The villagers of Khorkom were proud of their school. It had been built after the massacres of 1896. The head of the village had had a hard time convincing the young hotheads of Khorkom that the money, which had been raised for the good of the village, should be spent on a school rather than on guns. Girls as well as boys studied, and prospective brides in the neighboring villages tried to find husbands in Khorkom so that their daughters as well as their sons could acquire an education. In Gorky's childhood, the fact that

Khorkom had a schoolhouse, and even a little library—just a cupboard with about twenty books in it—gave the village a progressive reputation.

There was only one room, and the teacher taught all grades simultaneously. During their first year, the children copied their alphabet from lettering inscribed on a wooden palette with a handle. Gorky's cousin Arax remembered him as taller than the other children. He sat at the back of the class, out of the teacher's eye, carving a stick with a penknife. Whittling a stick, Gorky used to say later, empties the fretful mind. He told his second wife that at school he preferred to pretend he was stupid as it left him free to dream. "He liked school," according to his sister Satenig, "but was very active, 'fresh.' Every day after school he went swimming in the lake which he loved to do."

The beach lay north of Khorkom, where the women did the washing. The women of Khiosk and Ishkhanikom often joined them, and it was an occasion to exchange all the local news. By the time the surrounding bushes were white with clothes, all the women knew everything about everything. After swimming, Gorky modeled animals from the soft clay found near the shore, or carved tops to spin on rocks, or made frail fans to turn in the breeze at the edge of the fields. He whittled propellers out of poplar, stuck them into an apple, and suspended the toy on a long stick over the irrigation canals so that they would whir and scatter water pleasantly.

The children ran around barefoot and always had cuts on their feet. Pausing in their games, they watched soldiers escorting caravans along the main road on the far side of the Khoshab River. One road led straight over the mountains, inland, and there was also an old coast road around the ridge between Khorkom and Artamid, where more Turks than Armenians were living. Then on to Van, three or four hours away on foot. In Van there were schools, a bank, a telegraph office, newspapers, and government offices. Beyond Van, right at the top of the lake, Mount Ararat, on the frontier with Russia. It was from Russia that the Vanetsis prayed that help would come when times were bad. Russia was *Kedi,* was "Uncle." Their protector. Their savior.

IT WAS OBVIOUS that Gorky was not studying. It worried Shushan. From time to time on her way to the fountain, she took Gorky into a little abandoned garden and tried to lecture him about his future: everyone was busy learning; it was the only way in which Armenians could rise out of the degrading state into which they were so rapidly falling. According to Gorky, she "put him on a marble seat" and urged him to study. Nothing in Khorkom was made of marble, though Khiosk had a marble fountain. The "marble seat" must be Gorky's way of saying "she put me on a pedestal." Making it into a funny story, Gorky implied that scholastic ambition was far from his thoughts as a child.

Shushan wanted Gorky to become a *varbed,* a word which signifies
"instructed," or "capable," in the sense of learning a craft. A "master," in the
sense of "master builder." Even blacksmiths stood a better chance of survival
in that part of the world when massacres started, as Turks and Kurds always
needed somebody to shoe their horses. When, in the mid-thirties, Gorky
painted a portrait of a student of his who was a plasterer, he called the paint-
ing *Master Bill,* because of the grand sweeping strokes with which he covered
a wall. "Master" was a title he gave to anyone who exercised a manual skill
with a certain flourish, even a cook in a little Armenian restaurant he
frequented.

Near the garden where Shushan rested with her children was a fallen tree
whose lateral branches pointed straight up into the sky. The villagers treated
this "tree of wish fulfillment" as an object of worship, tying fragments torn
from their clothing to the branches as votive offerings, returning thanks for
recovery from snake bites or as a prayer for the future. Nearby was a large rock
against which Gorky often saw his mother and other village women rub their
breasts, praying to the saints for intercession on their behalf.

The whole countryside was interlaced with strange pagan beliefs. When-
ever a villager swore a solemn oath, it was not by the authority of God or his
angels but "by the green sun of my life." North of the lake, the village women
practiced a "salute to the sun," walking between the houses holding a loaf of
bread and a special stick under the approving eye of the village priest, who
blessed them as they went by. It was a ritual of Zoroastrian origin that had
been absorbed into Christianity. In one village, during a dry year, the women
were yoked to a plow and together they plowed a furrow in the dried-out bed
of a stream, to encourage the water to flow.

By 1910 these arcane religious practices were no longer followed by the
younger generation or by those who had a wider experience of the world. In
the photo, one or two of the men in the background, grinning not very
respectfully at the piety of their womenfolk, are dressed in hats and cloaks
acquired in Russia. These old beliefs were the domain of women who never
left the village.

Once, Gorky told his friend Aristodemos Kaldis this story. At night, his
mother used to mix flour and water together in order to make bread. Before
putting it in a warm place so that the dough would rise, she made the sign of
the cross over it. She used to say that without the sign of the cross, the dough
would not rise and the bread would be ruined. And when he grew up and
married, he was to choose as his bride a nice Armenian girl with cheeks as soft
and as white as his mother's dough.

What Gorky remembered most of his mother was the simple way in which

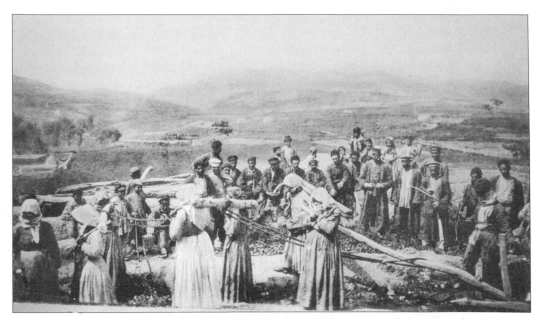

Women plowing the dry bed of a stream in order to bring rain, in a village thirty miles east of Khorkom, c. 1904

she took for granted the extraordinary and the poetic in their lives. Though as a child he resisted her scholastic ambitions for him and doubted the dramatic world of saints and devils in which she believed, from the vantage point of Sixteenth Street in New York, everything about Shushan seemed tinged with poignant emotions. She summed up a whole world of strange but beautiful beliefs which, though he often joked about them, he never abandoned.

Two years after her husband left, Shushan arranged a marriage for Akabi, "to get her out of Krikor's clutches," as Akabi's daughter put it to me recently. Her husband was called Muggerdich Amerian, aged twenty-eight, from Shadagh. Shushan had made friends with the Amerian family during her first marriage. Muggerdich was the only survivor of nine sons. He had been overlooked during the massacres because his mother had dressed him up as a little girl. They were married on February 10, 1910. The bride and groom saw each other for the first time at the altar.

Aharon wanted his sister Shushan to come to Van with her children. As her son preferred carving to studying, she could put him into the mission school, where he could keep an eye on him.

School inspectors from the mission appeared in Khorkom on their annual visit: Miss Grisell M. McClaren and Miss Whittlesey, of New Haven, Connecti-

cut. They stayed in the house of the Melikian family, the Adoians' neighbors. Arax Melikian peeped around the door at them as they recovered from the journey. Here were two tall, strange women: Miss Whittlesey, whose name nobody could ever pronounce, no matter how fond they became of her; and Miss McClaren, always so self-assured. Their clothes—so many folds of beautiful cloth, which rustled so differently and smelled so clean. The next day when they visited the schoolhouse in Khorkom, Miss Whittlesey slipped into Arax's hand a small porcelain doll.

Shushan decided to take Aharon's advice, so they moved to Van City and found rooms near the newlyweds. With her brother's help, Shushan's other children were admitted to the American school. Sitting on a bench in the mission school, Gorky already began to think of Khorkom as a remote paradise, a source of reverie, even before his childhood had ended.

VAN CITY

1910–1915

THE CITY OF VAN in Gorky's childhood consisted of an immense rock that rose steeply from the plain, occupied by soldiers behind battlements which were out-of-bounds to Armenians. Underneath lay a small town where all the commercial activity took place, with tinkers beating copper pots and engravers of silver boxes mixing their sulfur pastes. Beyond this, a straggling suburb stretched northeast: Aikesdan, "the Gardens," where the Armenian population lived.

Every morning those who worked in the walled city walked up the wide central avenue leading through the Gardens. In summer, fine dust rose behind each plodding slipper like a powdery exhaust. Irrigation ditches wound in and out, and the women tended vegetables and fruit trees screened by garden walls. A traveler lodging in the British vice-consulate at the turn of the century compared Aikesdan to the West End of London, because trees took up more space than the buildings. From the mounds beside the irrigation ditches rose "the needle forms of the poplars, forced from the soaking earth with wand-like stems."

Shushan rented a two-story house on the easternmost fringe of the Gardens. There were two small bedrooms upstairs and a larger room below,

containing the *tonir*. Muggerdich and Akabi lived not far off. This part of Aikesdan was filled with people from Shadagh, and she probably wanted to return to the surroundings of her first marriage. Shushan's closest neighbor, Markrit Mooradian, came from Shadagh with her sons, Aram and Moorad, the only two of her twelve children to have survived the massacres. Moorad married Gorky's sister Vartoosh ten years later, in America.

Shushan's life resumed its daily round. She dug every day in her kitchen garden. She collected water from a nearby spring. As in Khorkom, there was a whole hierarchy of springs, some with water more wholesome than others, some even with magical properties. The supernatural pervaded the city. Near the Turkish quarter there was an Armenian who owned a pear tree which produced fruit as big as a boy's head, they said, cupping their hands to show exactly how large.

A stony plain stretched eastward for a couple of miles beneath the mountains, where wild asparagus sprouted in the spring. After the long winter, the eroded gullies suddenly filled with gushing water and the shrub oaks hidden in the clefts in the mountains put out their leaves. Mount Varak became covered with greenery. Courting couples wandered there on Sundays to gather flowers, while kites hovered in the warm air, piercing the murmur of village life with their thin, clear cries.

As in Khorkom, Shushan's life was governed by her piety. She went to church every day. Arakh, where her father had died, lay half a mile to the west of where they lived. Each church had its moment in the passing year. At Christmas and Easter they went to Norashen near the walled city, and the children were told to wear a new piece of clothing, "else Easter will fall upon your heads." On certain weekends, and on the second Sunday of September, she took the children to the monastery of Varak on the hillside opposite. Varak possessed a collection of illuminated manuscripts, and Shushan may have persuaded the monks to show their manuscripts to her son. As in the case of Akhtamar, the monastery of Varak also sheltered a school run by the Armenian Revolutionary Federation. In the hills behind, young "Fedayee" learned how to shoot.

Every evening they turned toward the setting sun outside the house and prayed: God grant peace. Let there be no war. Protect our lives. There were more prayers after the children had gone to bed. On some nights her prayers were so filled with visions of heaven and hell that Gorky cowered beneath the blankets in terror.

Gorky's studies supervisor at the mission school was a tall, black-bearded Armenian, a distant cousin of the Adoian family. According to Karlen Mooradian, he "proved a constant source of pressure for Vosdanig who had to

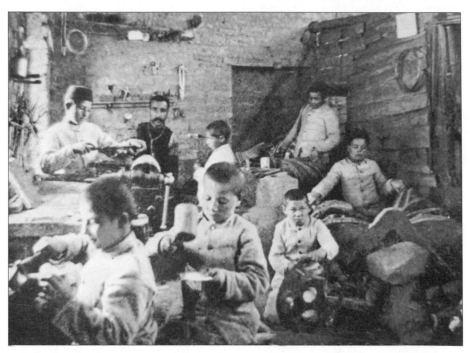

The carpentry department of the American mission, where Gorky learned to carve plows and make saddles. The figure in the background may be Gorky's uncle Aharon, who taught there.

achieve high grades to maintain family pride." In other words, Gorky needed to be pushed. Karlen also states that "frequently the administrator Yarrow beat his soles so severely that the wounded boy could not walk and often missed classes for weeks on end." From the mission archives at Harvard, the Reverend Ernest A. Yarrow emerges as a kind and gentle man. It is unlikely that he made a habit of beating his pupils. Perhaps the story merely underlines the fact that Gorky was inattentive at school.

The missionaries knew that most of their pupils would work on the land after graduating, and practical rather than intellectual studies predominated. Gorky enjoyed working with his uncle Aharon in the carpentry department, where plows and other farm equipment were made. He learned to carve the pegs that held the carved pieces of the plows together, to beat a sickle of low-grade steel so that it would hold an edge, to sharpen a chisel and to plane a plank. Aharon told his daughter that there was no dovetail that Gorky could not make, and he maintained these skills all his life. Whenever he went to stay with his family in Watertown, he used to visit the workshop of Yenovk der Hagopian, the son of the priest of Ishkhanikom. Yenovk was a sculptor,

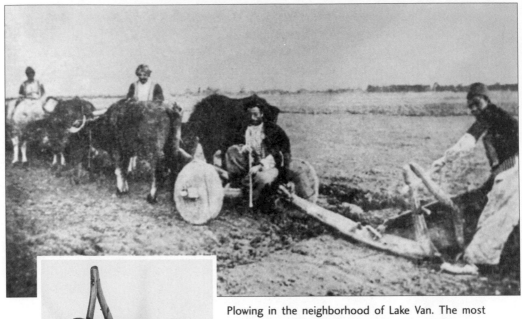

Plowing in the neighborhood of Lake Van. The most common implement made by students in Aharon's carpentry department was the plow. In later life Gorky made miniature versions as a way of revisiting his childhood experiences.

Arshile Gorky, *Wooden Plow*, c. 1942

and they often spent the day together, carving a miniature Van plow just as Aharon had taught them to do when they were children.

The mission school included a "visiting drawing teacher," called Hohannes Baghdasarian. In 1912, after more than forty years' service in Van, the staff gave the principal, Dr. Raynolds, a painting by this teacher, representing Dr. and Mrs. Raynolds "in a small boat, beneath a cloudy sky, rescuing children from the waves." An unusual early Gorky painting sets two figures against a background of water, in a strong narrative context. One brother of Baghdasarian was the mission's representative in Khorkom and Ishkhanikom, and another brother, also a priest, immigrated to America and served at the Park Street Church in Boston. This church was the subject of another of Gorky's earliest paintings—but whether these sparse details add up to a special feeling between Gorky and the painter Baghdasarian or his brothers, we do not know.

About two years after they had moved to Aikesdan, Shushan took Gorky into Van to be photographed. His father in America must see for himself what a fine young man he had become.

There was nothing casual about a portrait photograph in those days. The light came through a skylight such as one might find in an artist's studio and the results were almost as formal as a painted portrait. The poses and props still followed the fashions current in Paris in the 1860s, when photographic portraits first became popular. The backdrop was a painted chimneypiece—a European fixture. The small bunch of flowers indicated a sensitive, poetic character.

Fifteen years later, when Gorky rediscovered this photo in his father's house in Cranston, Rhode Island, it immediately became one of his most valued possessions. It was filled with echoes of Aikesdan, which by then had long since been destroyed, yet at the same time it was saturated with references to the European culture that he had reverentially studied upon his arrival in America. When his studio burned down in 1946, it was one of the few objects he saved.

THROUGHOUT GORKY'S YEARS IN VAN, the Dashnaks continued in their efforts to make their voices heard in Parliament. The British vice-consul in Van viewed their activities with distaste. "The Armenian has become a

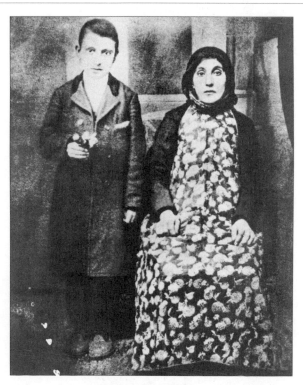

Gorky and his mother

noisy, blatant, overbearing, and insolent imitation of the worst type of politi-
cian," he wrote. In Istanbul, the Young Turk leaders were already beginning to
isolate the Armenian deputies. Locally, "the native Moslems at Van are reac-
tionary at heart, detest the Armenians, and resent seeing them in enjoyment of
the liberty given by the new regime."

The missionaries constantly tried to dissuade the Dashnaks from planning
further confrontations with the Turks. "The circumstances of the country,"
wrote Dr. Raynolds soon after the massacres of 1896, "rendered it quite impos-
sible to carry out a successful rebellion [. . .] If this insane policy is continued
by the revolutionists, the only result possible would seem to be the entire
extinction of the Armenian population of the province."

The Armenians of Van discovered a new way of offending their rulers.
Instead of parading through the suburbs of Aikesdan or in the mountains of
Shadagh wearing cartridge-belts and pistols, they walked through Van wearing
a soft felt hat called a *shapkali* (from the French, *chapeau*)—a gesture to show
the world that they were Europeans, not Ottomans. In 1913 a Kurdish Agha met
some Armenian notables outside a town west of the lake. The sight of them
caused him to burst into a fit of rage. "Everywhere in your villages there are
'shapkali' [wearing a hat] teachers and Daschnak committees. These men are
preaching you false ideas [. . .] You are a turbulent and troublesome element,
and that is the reason why the prisons in Russia are full of Armenian prisoners."

There was a certain amount of truth in what he said. The Caucasian Arme-
nians never fully grasped the idea that to succeed in one country, they needed

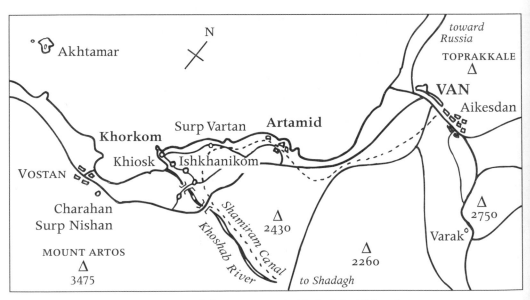

Sketch map of places connected with Gorky's childhood

the goodwill of the other. The revolutionists continued plotting against Russia and Turkey simultaneously.

THE RETURN OF THE SCHOOLCHILDREN from Van to Khorkom every summer was a great event. Grown-ups came up with mules so the smaller children could ride home. They brought luxuries back with them from the city: ribbons woven by machine for the girls to wear in their hair, or pieces of fine material for head cloths.

Gorky was larger now than Ado and Misak, Uncle Krikor's sons, larger than Arshag and his brother, the grandsons of Aunt Yeghus. He became the leader of a band of small boys who raided the orchards and swam in the lake, exploring all summer long. He carved flutes for his gang but kept the finest for himself; the one with a man's head sculpted on the boss. They borrowed the fishing skiffs and glided among the reeds and bamboo along the shore, looking for bird's nests. At dusk they went back to the Adoian poplar grove on the shore, where Gorky prepared omelets for his followers. They slept out in the poplar grove where the villagers cut their roof beams, on improvised mattresses or in hammocks slung between the trees. They added watermelons to their midnight feasts, and Gorky always had first taste to make sure that the melons were not "filled with worms."

The boys often climbed a mound at the mouth of the Khoshab river. At the top stood a dilapidated chapel dedicated to Vart Patrik. It was just a small room with arched cupboards cut into the walls. The body of the saint was supposed to lie beneath it. And, of course, a treasure. If you tapped, the walls gave an exciting hollow ring. The children played at being priests intoning from the altar, holding imaginary crosiers. Nearby in the grass lay carved stones, some of which had been taken to be used as tombstones by the local villagers. Gorky used to run his hands over the surfaces of these carvings, just as he used to touch the surface of the *Khorkom* compositions he made in the 1930s, on whose indented surface the paint had accumulated deep ridges over the years.

The summer grew hot and the air of living within a fable grew stronger. Porcupines scuttled at the edges of the fields. Turtles emerged from the lake and laid eggs in nests in the undergrowth near the chapel of Vart Patrik. The children sat on their backs and beat them to make them release their eggs, which they gave as presents to the older women. Turtle eggs were supposed to be good for the hair.

Shushan once put her hand inside a man's shirt after he had come back from a swim in the lake, and removed a red snake with a large spot in the shape of a diamond on its head. When Gorky's elder sister Satenig was tiny, she was left outside by herself after an illness to absorb the sun. When her elders came in from the fields, they found her sitting quietly with a serpent in her hands.

Animals occupied a role somewhere between fact and fantasy. For instance, there was once a broody hen, famous in Khorkom for her constancy in sitting on her eggs. One day this bird disappeared. The villagers asked each other what had happened to her. Had she strayed? Had she been stolen? A month later, she walked proudly down the crumbling path that wound its way between the houses, and in the dust, wriggling after her, were five small snakes. She had found a serpent's nest with eggs on it and had sat on them until they hatched.

Gorky's sisters remembered his precocity in producing works of art. That a boy could take a lump of clay and turn it into an animal seemed an almost magical gift to them. But the most impressive of Gorky's gifts as a child were his energy and his capacity to lead. Raiding orchards, swimming at night, adventuring on a hill that was crowned with a chapel at the mouth of the estuary, showed to the muscular youth of Khorkom, working to better themselves at school or training for the coming revolution, that there existed an alternative world, more imaginative and carefree.

He was hardly a weakling himself, and could wrestle and throw or be thrown and pick himself up again, laughing. One of the games that Gorky played with his friends was an Armenian version of "King of the Castle." This game was called, naturally, "Turks and Armenians." A heap of stones, called a "fortress," would be defended by one side or the other. The attackers had to touch the "fortress" without themselves being touched by the defenders. Gorky was good at this game, having fast reflexes and long arms and legs. According to his cousin Ado, Krikor's son, Gorky was so quick that the others would beg him to give them a chance. To which he would reply, "One must play hard, hard, so I must strike the castle."

The author Vahan Totovents, born some fifteen years before Gorky in a small town north of Lake Van, wrote, "No one, absolutely no one, ever told us not to play this game. Whenever we did, the grown-ups, men with mustaches, men famed for their learning and for their seriousness, would watch us and smile. And they would usually be delighted when the 'Turks' were defeated." The mood is one of reproach. Why didn't the learned men with mustaches intervene and save the children from their own worst instincts? Even though the scale was so small, it was animosity such as this which led inevitably to the disaster. It was as if Totovents, himself a victim, wanted to assume a personal responsibility for the genocide which ensued. In the same way, Gorky, sinking into despair in his last months, told an Armenian friend, "We did not know what we had." Meaning that we did not deserve such beauty. It was right that it was taken away.

. . .

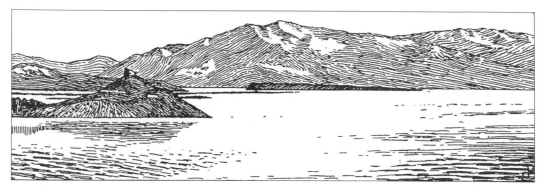

The mouth of the Khoshab river near Khorkom, with Vart Patrik on the promontory in the foreground and the island of Akhtamar beyond it

GORKY'S CHILDHOOD ENDED suddenly. No hint of the imminent tragedy shadowed the optimism of the missionaries, who were trying to upgrade the school into an agricultural college with American standards. Whereas in 1908 only eight schools had existed in the Armenian quarter, by 1914 there were thirty, catering to almost five times as many pupils. Two player pianos arrived at the mission from America, and a choir was formed for the year's graduation ceremony. The future seemed secure.

During the summer, an international supervisor appeared in Van to monitor a new agreement between Turks and Armenians, drawn up with the sanction of the Great Powers. Turkey was about to acquire a new role within the confraternity of Europe, at the price of some small concessions regarding her internal affairs. His arrival coincided with the outbreak of war. Soon German armies advanced east, deep into Russia. About ten days after he had arrived, the supervisor was ordered to leave again, as the Turkish army had received the order to mobilize. The Van militia began scouring the countryside to make sure that no Armenians of military age were avoiding the draft. In some cases the young men were taken straight off the fields and threshing floors, where they were still bringing in the harvest. The Armenian Revolutionary Federation supported the conscription, as the Dashnak leaders had faith in the new constitutional agreement.

In October, Turkey entered the war on the German side. Three armies were put into the field. One advanced toward Russia along the northern route between Lake Van and the sea. A second advanced toward Persia via the road south of the lake. A third was engaged in Egypt. After some initial successes, all three armies ran into difficulties. By February 1915 the Russians had halted the advance in the north, where at Kars the Turks lost two whole army corps. They found Armenian regiments fighting opposite them on the Russian side.

It was at this point, it seems, that the Turkish leaders decided to eliminate the entire Armenian population behind them, which they viewed as a dangerous fifth column. They began by disarming the Armenian regiments in the Turkish army and sending the men to mend roads.

Unaware of the impending disaster, the mission school inaugurated its freshman class on February 15, 1915. The choir sang, the pianos played. Though Van itself was still relatively quiet, by this time the Armenians in the countryside were suffering from the same attacks by bands of Kurds that had preceded the massacres of 1896. The Dashnaks set up strongpoints as best they could. In one case they blew up a bridge in order to halt a Turkish mob which had come out from Bitlis in the southwest to plunder the Armenian villages on the shore of the lake.

In Van, the Dashnak leaders determined to remain on good terms with a new governor, Jevdet Bey, brother-in-law of the Turkish leader Enver. Jevdet was from Van himself. His profound dislike of Armenians was common knowledge, but he was thought to be efficient.

A fortnight later, the Russian armies were withdrawn from the Caucasus to fight on the western front. In March, Jevdet arrived unexpectedly in Van with four hundred soldiers. Fortifications were built around the city, ostensibly to protect it against the Russians, but in fact to prepare for the attack on the Armenian population. Jevdet gave orders that no Kurd was to intervene to protect an Armenian, on pain of being treated as one himself. By Easter he had brought back four thousand men from the front and was insisting that all Armenian men of military age present themselves for conscription. Strange rumors, however, had begun to circulate concerning the Armenians who were already serving in the Turkish army. It was said that they were being taken to remote places in small groups and killed.

It was also rumored that a general massacre of the Armenians in Van had been planned for April 20. During the week before this date, army units joined the Kurds to help complete the destruction of the countryside. On April 16 a leading Dashnak was lured to Shadagh and murdered. The Armenian deputy to Parliament was arrested and taken by carriage toward Bitlis. Before he got there, he was stabbed and his body thrown into a ditch.

By this time the countryside was in a state of chaos. Thousands of refugees had gathered near Ishkhanikom, where the local Dashnak leader was an old friend of the Adoians called "Kerza" Dikran. Keeping off the road, Dikran was able to fend off the Kurds while contacting the survivors from the surrounding villages. He saw bands of Kurds coming up from the south to raid Khiosk, Ishkhanikom, and Khorkom, and twice he plundered them on their way back, retrieving food and blankets. Finally he sent a message to the priest at the

monastery of Surp Nishan on the other side of the valley, where many refugees from Vostan had gathered.

That night, waiting for a reply and knowing that one way or another he would never see this land again, Dikran spent many hours just looking at the lake. "We could hear the harmonious song of the waves on the sands of its shores, unaware of cruelties to human beings, destruction of villages, the cries of thousands of men and women who were murdered. You are always cheerful and in your clear mirror swim the stars." The priest at Surp Nishan preferred to stay where he was, together with the refugees who had gathered there, and the following day they were all killed.

The only chance of survival was to retreat to Van and join the defenders now under siege. There were two routes: via the lake road which went by Artamid, and over the hills which lay behind their backs. A group of eighty-five survivors from Ishkhanikom chose the lake road and were killed by Turks near Artamid. A smaller group was caught in the hills. The men were shut in a barn before being taken out in pairs to be shot. John Hussian, a cousin of Gorky's from Ishkhanikom, stood beside his father and by chance survived, lying among the bodies for two days, wounded in the head. He never forgot the sight of Turkish soldiers riding up and down the road on tall horses above him. Eventually he crawled away and rejoined his mother, who dressed him up as a girl, and thus they made their way to Van.

Kerza Dikran set out later. He was lucky to have delayed his retreat. By the time he took the remaining refugees from Ishkhanikom toward Van, Jevdet had changed his tactics and was driving the surviving villagers into the city instead of killing them, so that the defenders' food supplies would be wasted on the starving refugees.

As Dikran approached Aikesdan with his band of survivors, he was amazed to hear the cheerful sound of a military band. They were boys from the American school playing patriotic marches—including the Marseillaise, to please those revolutionists with a European background.

THE SIEGE OF Van City had begun on April 20. Immediately the defense had been divided into sectors, each with its own commander, its subsection, and its logistical support. There was no doubt in anyone's mind that if the Turks won, the entire population would be killed. Behind every fighter stood an unarmed replacement ready to take his weapon if he fell, and behind these were boys who retrieved the shell casings. Bullets were cast by goldsmiths and remounted in old casings. The problem was the lack of gunpowder, so chemistry teachers and pharmacists were set to work. Lacking potassium

nitrate, the women were told to scrape off the white crystalline material cling-ing to the walls of their stables and dung heaps.

The old city was constantly shelled by the Turkish batteries on the forti-fied rock under which it stood. It was noticed that the Turkish gunners were cutting the fuses of their shells long, so as not to blow themselves up. This gave the defenders a chance to retrieve them before they exploded. Young boys were singled out to do the job. These "ten-to-fifteen-year-olds, with sparkling black eyes, would follow the trajectory as soon as the ball left the gun barrel," and would run forward to pick them up as they fell. Many were killed in this dangerous game.

Gorky stayed with his family in Aikesdan. A circle of trenches marked the front line, battered during the day by shells from the surrounding mountains and rebuilt at night by teams of peasants with spades and those same mud bricks with which their houses were made. His job during the siege—about which he never spoke a word in later life—was to take ammunition and bread up to the front line. He must have been about twelve years old at the time, but his youth meant nothing in the circumstances. Everyone was a combatant.

There were moments of comparative calm, during which the Turkish besiegers came down to the front line to call out greetings to their Armenian friends. During one of these lulls, Shushan made her way back to her little gar-den on the far side of the American mission to collect some flowers she had planted.

Without outside help, the defenders stood no chance. They were saved on May 16 by the advance of a Russian division led by Armenian volunteers. Sud-denly Lake Van was covered with the white sails of the retreating besiegers, like a flock of birds. The lake had never seemed so beautiful. One section of the Turkish army had commandeered all the boats of Van together with their sailors, who were Armenian, and had sailed across to the other side. There, the sailors were taken up to a little hill and made to dig trenches, ostensibly for purposes of defense. They were then killed and buried in the trenches they had just dug.

Jevdet Bey himself retreated southwest. He tried to make a stand at the Khoshab river but was driven back along the road to Bitlis by the Armenian volunteers. The pursuit then slowed to a halt. Reaching Bitlis on June 25, Jevdet imposed a curfew. Facing eight thousand troops, the Armenians knew that resistance was impossible. During the following week, platoons went from house to house arresting the Armenian men one by one. They were kept a day or two in prison without food or water, then taken out of the city and handed over to Jevdet's "butcher battalions," as he himself called them, recruited from the ranks of criminals taken from the prisons. The "butcher battalions" led the Armenian captives a short distance from the town and killed them.

A few days later, the rest of the population was evicted from the town. The young women were distributed among the local Turks and Kurds, if there were any takers, and the remainder were then driven off to the south. The Armenians of Bitlis were among the first to be marched in a wide circle into the deserts of northern Mesopotamia, until they died of starvation and exposure—that is to say, of "natural" causes. To this day the official Turkish explanation for the events of 1915 is that under the stress of war, a "relocation" program was carried out. Naturally, there were some losses, but no more than were to be expected in the circumstances.

THE RUSSIAN TROOPS FOUND the countryside around Van filled with dead. As a hygienic measure, they piled up those who remained unclaimed by relatives and burned them. The figure of fifty-five thousand bodies quoted by Dr. Ussher, the head of the mission hospital, must have been given to him by the Russian officer who supervised their disposal.

Incredible though it may seem, some survivors of the siege started out from Van to return to their villages as soon as the Turks had left. Aharon, Gorky's uncle, went with them. Near the sacked church of Surp Nishan he found the bodies of his little nephews, the children of his brother Moses. He buried them with his own hands.

Shushan stayed in Van. Having heard from Aharon of the death of her nephews and the destruction of Surp Nishan and Khorkom, she had no desire to go back. Too many people had disappeared: "Rus" Adoian, the relative in Khorkom who used to take care of the farm; Aunt Yeghus, who was in charge of the Adoian house, and her daughter, and her daughter's two sons. Uncle Krikor was also killed. Family legend has it that he lost his life while taking guns over the hills from one village to another.

The Melikian family was among those who went back to Khorkom to start up all over again. The villagers had already begun to make repairs, searching the countryside for sheep and animals to return to their rightful owners. Khorkom had been completely sacked. The church was roofless. It was worse than in 1896. Even the doors of the houses had been ripped off and burned— with the sole exception of their own front door, made by a neighbor who later in America used to boast of "the door the Turks couldn't take off its hinges."

Five weeks later, the Russian army was suddenly ordered to retreat. Panic overcame the city. That night as the missionaries lay in Artamid, they listened to the sound of great numbers of people jostling their way forward in the dark on the highway nearby. Houses were already burning in the direction of Van. The entire Armenian population was fleeing toward Russia, on foot or riding in carts, or even riding on their cattle.

Shushan and her children went with them. Gorky walked beside the mule

on top of which perched his nephew Gurken, the firstborn of his sister Akabi. "The day they told us we must escape," said Vartoosh later, "all of the city panicked and the streets filled with people. The Armenian commandos placed those who could not walk on caravans." They reached the road that ran beside the lake. "There was nothing but parched earth when we left Van. We walked day and night with very little rest."

The missionaries, aware that Jevdet saw them as the protectors of the Armenians, set out some three hours before the road north was cut. "All around us on the vast barren plains were a mass of fleeing refugees, our own people, struggling through clouds of dust, in ox-carts, on donkeys or afoot, to reach the Russian border and safety."

The Melikian family left Khorkom at the last possible moment. The young women smeared mud on their faces so that they would look less attractive. They took the coast road, but at Artamid some Turks recognized a little boy dressed up as a girl and killed him immediately. Van City was empty, not a soul to be seen. Further on in the mountains, they were attacked by Kurds. A man approached Arax's mother to steal a bracelet. The bracelet would not come off, so he drew a knife to cut off her hand. Arax was holding her younger sister, Mariam, and the child screamed. A second Kurd turned toward the children and he also unsheathed his knife. Then suddenly both Kurds were called away by a companion who had found richer plunder further down the mountainside.

In a narrow defile north of the lake the Turks and Kurds fired on the people below. According to Dr. Ussher, the bodies of about seven thousand refugees were found the following spring in a gully beneath this spot. A friend from Van who knew Gorky in Watertown remembered coming to a river and finding the bridge down. His family crossed by stepping on the bodies that filled the riverbed.

During the Second World War, Gorky once gave a dinner for the painter Fernand Léger. After supper, Gorky began talking about his childhood. One of the stories he told may have described the retreat from Van. "I remember faces. They are all green. And in my country in the mountains of the Caucasus there is a famine. I see gigantic stones and snow on the mountain peaks. And there is a murmur of a brook below, and a voice sings. And this is the song." At which point Gorky abruptly abandoned the vision he had evoked, the green faces of his dead compatriots, the stony ravine filled with corpses, and began to sing "a song strange and unknown."

Y E R E V A N

1916 – 1919

IT TOOK SHUSHAN and her family eight days to walk from Van to Etch-
miazin. Food was scarce and the sources of water were crowded and dirty.
They dug holes in the ground searching for a little moisture, and tribes-
men sold them ice from the mountaintops. North of Lake Van they were joined
by streams of people who had escaped from central Anatolia along the far side
of the lake. The immediate danger from Kurds and Turks was diminished, but
the hordes of people walking eastward, bending to the ground to look for any-
thing that could be eaten, brought home the scale of the disaster. As Dr.
Ussher put it, the entire plain was "filled with a shifting multitude overflowing
the horizon, wandering aimlessly hither and thither; strangers in a strange
land, footsore, weary, starving, wailing like lost and hungry children."

The local inhabitants began by welcoming the refugees, giving them bread
and water. But the crowd of old men and women and young children was over-
whelming, marching with their sicknesses, burying their dead at every halt,
trampling without being aware of it the small patches of cultivated land, rip-
ping branches from the orchards to make fires at night, "like beasts emerging
from a forest on fire, walking with clenched fists and bloodshot eyes, cursing."

On the far side of the plain, Shushan and her family rested in a vineyard for
a few days, eating the grapes as soon as they ripened. Then they went on. They

crossed the Arax river and walked uphill to the great monastery of Etchmi-
azin, where they camped out for a while in the crowded courtyard.

The refugees gathered around the monastery of Etchmiazin did not want to
move on. The Melikian family arrived with other villagers from the Khoshab
valley. With them were the children of Rus Adoian, the cousin who used to
take care of the Adoian fields before the war. They reassembled village life as
best they could on the open hillside far from home and assembled in little
groups to talk about going back. During the summer, a cholera epidemic broke
out. Arax Melikian's little sister—the child who had screamed as a Kurd was
about to cut off her mother's hand for a bracelet—turned blue and nearly suc-
cumbed. One by one the five children of Rus Adoian fell ill and died.

Though Gorky was hardly a teenager at this point, it was he who grasped
that they should leave this place as soon as possible. Somehow, he obtained a
carriage for his mother so that they could all flee to Yerevan. Shushan said, "At
least we will be together, come what may," a traditional formula for dangerous
journeys. And so they set off. As it happened, except for the fact that they
were now psychologically even further from Khorkom than before, the jour-
ney from Etchmiazin to Yerevan only took a day.

They took refuge in the courtyard of St. Sarkis's Church in the center
of town. Yerevan was crammed with refugees. It was little more than a large
market town at the time, with a few factories and warehouses beside the rail-
way track and one or two grandiose buildings near the station to house the
tsarist bureaucrats. Then the usual mud-brick bungalows stretching up the
flanks of the surrounding mountains. The city was not yet a capital: Armenia
was not yet a country. Until the nation-state was thrust on them by the te-
nacity of its enemies, the only Armenians to foster the idea of nationhood were
the freedom fighters. To the rest of the population, Armenia was a sense of
collective identity, growing under the pressure of recent disasters and those
still to come.

In normal times, the valley between Yerevan and Mount Ararat was filled
with vineyards and fruit trees. The four years during which Gorky lived there
were probably the worst of its existence. There was a desperate shortage of
houses and work. Bands of starving people wandered through the streets in
search of anything green. In winter, every night, sixty or seventy people froze
to death in the streets, and carts collected the snow-covered bodies the follow-
ing day. They called it "white death." So many died and were buried that they
said: Here, the land does not feed the people, but the people feed the land.
Tuberculosis was endemic, and every summer brought typhus and cholera.
Supplies of medicine coming down through Russia, itself on the brink of revo-
lution, were scarce. A fine dust blowing in from the mountains over the crum-

bling buildings brought with it a persistent eye disease, so that some of the
lucky few who managed to immigrate to America found themselves turned
away by the doctors at Ellis Island.

This description by Dr. Yarrow, the administrator of the school in Van,
dates from the year when Gorky left Yerevan, but it could apply to any moment
of Gorky's late childhood: "Thousands and thousands and thousands of dirty,
lousy, half-clad, sick and diseased, cringing, suffering unfortunates of human-
ity; old gnarled grandmothers and grandfathers are here who seemingly never
had the right to survive; then there are the young men who should be strong,
but the strength has gone in the struggle simply to live; but the thing that gets
you is the women and little children, and if you are unfortunate enough to let
yourself go and think, you will be haunted by their mute appeal and you will
think very tenderly of those who are near to you and for whom you would die
a hundred deaths rather than they should ever reach this condition."

Dr. Ussher, Dr. Yarrow, and Dr. Raynolds from the old Van mission immedi-
ately founded a relief organization, called the Near East Relief Fund. Working
with the Russian government, they expropriated the houses of rich Armenians
who preferred living in Tiflis and turned them into orphanages. Everyone was
kept busy. Uncle Aharon found a job in their carpentry department. Even lit-
tle Vartoosh worked in one of the missionary orphanages, where she sewed
name tapes on clothes. For a while Shushan also worked at the orphanage,
until a depression kept her at home, in one room of a house belonging to an
Armenian merchant absent in Tiflis. Her children took turns to stay at home
and keep her company: Gorky, Satenik, Vartoosh, Akabi and her little son. It
was important to be together. For a while they made combs from cow horn.
Gorky split them, then heated and flattened the halves. When they were hard,
he cut the tines by hand, large ones at one end, fine ones at the other.

Vartoosh says that in the autumn after their arrival in Yerevan, Gorky went
to the parish school attached to the church where they first found lodgings—
"a very fine boys' school, in the courtyard of St. Sarkis." The curriculum of
parish schools in the early years of the century consisted of religion, Armenian
language, Russian, mathematics, music, penmanship, and drawing. No sci-
ence, no biology, which his cousin Arax studied when she went to high school
in Yerevan. He may have learned to speak a little Russian at St. Sarkis's
School—not enough to convince real Russians for more than ten seconds that
he was Russian, let alone that he was the nephew of Maxim Gorky, as he used
to pretend, but enough to find himself at home in the circle of Russian émigrés
he later discovered in New York.

After working at home making combs, Gorky joined his uncle Aharon at
the carpentry shop of the Near East Relief Fund. The question of what he

learned in Yerevan does not arise, as he had no time to go to school. Though he was hardly more than a boy, he was now in charge of his family. Learning from books at school was a luxury none of them could afford.

AKABI'S HUSBAND, Muggerdich Amerian, who had immigrated to America about eighteen months before the disaster, returned to collect his wife and son a year after they arrived in Yerevan. Many Armenians made this journey at the time. They would bring back messages from others who had left, helping to knit together the severed branches of many families. All over the city there were touching family reunions, followed by the departure of little groups of relatives for a new and safer world.

Muggerdich brought with him some money for Shushan from Sedrak. When it was counted out, however, they found that there was only enough for one ticket to the United States. A desperate family scene ensued. Shushan could not believe that her husband expected her to leave her children behind. Were they to roam the streets of Yerevan with the other orphans?

Sedrak's movements after his departure from Khorkom in 1908 are not known. It seems that several years passed before he arrived in the United States. He probably spent the time in Istanbul, working at some small business in order to earn money for the journey. When he finally arrived in Boston, he found that his eldest son Hagop had already made a life for himself, and had a good job in an iron foundry. Sedrak went to live with him, and Hagop found him work. Soon Sedrak realized that the initiative had passed to Hagop, and that in the eyes of the Armenian community, he was no longer the head of the family. Hagop kept postponing the idea of sending money to his father's other wife and children, and Sedrak accepted the situation. Just as, in Khorkom, Sedrak had failed to impress his personality on his brother Krikor, in America he was content to obey the rules in Hagop's house.

Nevertheless, in failing to find the money to bring Shushan and her children over, Sedrak did not measure up to the social expectations of the community in which he lived. To bring your family to America was a matter of honor. A man would go into debt in order to bring over his half sister's cousin's husband. In this case it was Sedrak's own wife and children. "A dollar here, a dollar there," as Aharon's daughter told me, "he should have managed it somehow."

In the end, Shushan sent Satenig to the United States instead of going herself. The decision was an obvious one: she was Shushan's eldest child by Sedrak. But the scene when the choice was made was so violent it left deep scars. In Satenig's old age, the memory of this parting became an obsession for her. She kept repeating to her own daughter, "Why did my mother reject me? Why did she send me away?"

Akabi, Muggerdich, their little son Gurken, together with Satenig left Yerevan for the United States in October 1916. Apart from her grief at saying good-bye to Satenik, Shushan felt desolate to see the departure of her eldest daughter Akabi, so staunch and optimistic even in the worst of times. And her only grandchild, Gurken. Shushan managed to be calm and dry-eyed at the station when they parted, but later she wept uncontrollably.

The Melikian family arrived in Yerevan shortly after this separation. Unlike Shushan, they had stayed at Etchmiazin, had seen the cholera epidemic recede and the majority of the refugees continue on their way. Those who remained had set up their own little school, independent from that of the local population. After a year, however, Azniv, Arax's mother, decided to go to Yerevan in order to send her daughters to a better school. Like everyone else, she had trouble finding somewhere to live, but eventually she found lodgings, built herself a little *tonir,* and acquired a handloom and raw cotton from the American missionaries. Azniv possessed a lot of energy. She did not allow her natural optimism to be destroyed by their experiences.

When Azniv and Arax visited Shushan, soon after they had settled down, they found her in a deep depression, "in a very bare room with earthen floor, and just some rags there, and she was sitting in a corner on those rags. I remember her apron like that. I don't know if it was the same apron that Gorky drew, but the aprons were about that shape. She was sitting there very quiet, very sad." She had no loom working, no *tonir* lit. The roof was unmended and the floor unswept. Arax told me, "She seemed so helpless in Yerevan."

In addition to helping Uncle Aharon in the carpentry shop, Gorky began working two nights a week at a little printing press on the street where they lived. Since Shushan refused to leave the house, he returned with books for his mother and sister to bind at home. It was at this point in his life that Gorky acquired the habit of keeping a book with him at all times. His need constantly to hold a book may mean simply that he wanted to learn by heart the things he loved, but it may also mean that he needed to possess physically, night and day, the world of culture and ideas. He had seen with his own eyes how easily destroyed a culture could be.

Gorky also began to carry paper and pencils with him, and he drew constantly whenever he had a spare moment. Vartoosh in later life told two different stories about this habit. To Karlen she said: "When mother was alive in Yerevan, she would encourage him and give him money to purchase paper and pencils." But to Ethel Schwabacher, Gorky's pupil and first biographer, she had said exactly the opposite: "Mother did not think much of Gorky's art and thought he was wasting entirely too much time and especially money on foolishness. But Gorky continued sketching on anything he could conveniently get hold of." The second of these explanations seems more convincing.

Vartoosh hints that part of her brother's job at the printing press was to set type for "a very progressive paper." She describes its program: "That we must be freed from this slavery, that we must fight against the Turks to recover our lands, that we must return to our Van. Of course, Gorky didn't tell me everything, but that was in his mind. The paper was printed secretly." She described a group of intellectuals whom Gorky joined at the printing press: "Gorky and a group of boys from Van were always going there and talking." One of these men, Gurken Mahari, later became a successful writer, and his descriptions of the disasters in Van is one of the most valuable sources available. It looks as if Gorky, seeing his mother give way to despair, threw himself into a world of young men like himself, talented, ambitious for the future, politically aware. These friends, only slightly older that himself, must have provided an alternative to the education he had no time to pursue at school.

Although in later life Gorky seldom intervened in political discussions, it does not preclude a youthful moment when he took sides more freely. Uncle Aharon's side of the family assumed that Gorky was a Communist, but although he occasionally flourished volumes of Marx at his girlfriends, Gorky's politics never went beyond a visceral faith in Russia as the only source of salvation for Van and its people. He was never as politically motivated as his cousin Ado Adoian, Uncle Krikor's son, who was studying in Yerevan when Gorky was working at the printing press. Ado was an early member of the Armenian Communist party, and he rapidly rose through the ranks after the Bolshevik takeover three years later.

The Dashnaks of Yerevan had a tendency to look down on the refugees from Van because of their obstinate allegiance to Russia. Caucasian Armenians knew that Russians were not to be trusted. The massacres of 1896 in Turkey coincided with a ruthless attempt to expropriate the Armenian Church of its possessions in the Caucasus. Russia did not want a strong Armenia, any more than Turkey did. Even now, weren't Russian troops despoiling the countryside they were supposed to protect? But the Armenians from Turkey blocked their ears to the Dashnak idea of a "free and independent" Armenia—free, that is, of both Russian as well as Turkish authority. They were beyond reason in that respect. But then they were only country people.

In the spring of 1917, the long-awaited revolution overwhelmed Russia. During the initial Social Democratic phase, before the Bolsheviks staged their coup in October, much discussion took place as to the possibility of creating a federation of independent states in the Caucasus. The Dashnaks, in preparation for an international settlement, encouraged the refugees from Van and Cilicia to return whence they had come so as to claim these areas for "greater Armenia" when the time came. By the autumn a hundred and fifty thousand

Armenians from eastern Turkey had made their way back to their original homes, sponsored by credits from the provisional government in Moscow.

Gorky and his family did not join the flow of returning refugees. Either Shushan felt too weak to face the journey, or her brother Aharon advised against it.

The next two years saw a crescendo of disasters, each one worse than the last. The Russian troops, who had been stationed in the Caucasus to defend it against Turkey, abandoned their positions and returned to Russia, leaving the Armenian and Georgian populations to their fate. The Young Turk leaders had always dreamed of creating an extended Turkish federation, uniting themselves with the Turkoman peoples living on the eastern side of the Caspian Sea. Without allies, the Armenian militias were unable to withstand the advance of the Turkish regular army. The city of Kars was abandoned in April 1918 amid scenes of wild confusion and fear. Its citadel was found to be stacked with arms and provisions, and the fall of Kars became a source of deep-seated trauma for all Armenians.

The Turkish army continued advancing. One column pushed south toward Yerevan while another continued east toward Baku, the center of the oil fields on the Caspian Sea. Yerevan was saved by three desperate defensive actions fought at its very gates. Georgia declared itself a nation-state and made peace with Turkey. The following day, on May 26, 1918, the Armenian National Council declared itself to be a national government and the state of Armenia came into existence—a land about a third the size of Belgium, whose population was roughly divided between indigenous inhabitants and refugees, with more refugees coming in every day from the areas now occupied by Turkish troops.

Baku was taken by the Turkish army and its Armenian population murdered. In the west, the refugees who had been sent back to Van were driven from their homes for the last time. Of the hundred and fifty thousand who had set out for Turkey, less than thirty thousand managed to make their way back to Yerevan.

At this point Aharon told Shushan that there was a risk both of a siege and of a civil war in Yerevan. She and her children should flee while there was still time. If they got to Tiflis, they could probably find their way to Batum on the Black Sea, and thence by boat to Istanbul. There, she could wait for more money to be sent from Sedrak for the passage to America.

They set out. A few miles from Yerevan they found that the railway lines had been cut, so that they would have to reach Tiflis on foot. Gangs of children were roaming the countryside, almost as wild as the packs of dogs evicted from the houses of the rich, restlessly following their leaders from one place to

another in desperate search of food. They ripped down political posters and licked the flour paste with which they had been glued to the walls. They knew where the recruiters waited during the day hoping to induct the larger boys into the army. They recognized the make of a rifle at night by the sound it made, and could tell whether it had been fired in the air or at a person. They understood which "mauserites," the maverick bands of fanatical freedom fighters, had broken away from the control of their officers. They died of exposure daily, but by living together in bands they at least avoided the despair of solitude. If Gorky and his sisters had been orphans, this might have been their fate.

Shushan and her children decided to climb the mountains in order to make their way to Tiflis without risking the main road. They reached a village about twenty miles north of Yerevan, but stopped, either because the way forward was dangerous or because Shushan was too weak.

It was just after the harvest and the weather was still fine. Vartoosh gathered grains of wheat in the shorn fields nearby. With the last of their money they bought a donkey, and Gorky carried grapes and fruit from the countryside to sell in Yerevan. In later years, the only stories Gorky ever told about his experiences in Yerevan were a few anecdotes about the donkey, and an account of an occasion when he had at last succeeded in earning some money, only to lose it again on a street corner where some children were playing a game. Either Gorky had joined them or he was robbed. He tried to make it sound funny, but it was not entirely clear what had happened.

According to the writer Kostan Zarian, at that time in the marketplace of Yerevan, that "decayed belly of a miserable town," the peasants beat off the starving women and children from their wares with sticks. There was no money to be had, and the farmers exchanged handfuls of chickpeas or lentils for a hat or a shirt or a pair of old shoes. Pots of mutton entrails stood cooking on open fires in the square, "and all sorts of murderous ideas came into the heads of the skeletal orphans" standing nearby. In the afternoon, the inhabitants came out of their houses and went up and down Abovian Street taking in the news of the day. The sun set early behind the surrounding mountains. Long after the valley had turned blue with shade, the clouds above the peaks created immense golden shapes in the crystalline air.

As winter approached, there were fewer goods for Gorky to carry into the city to sell and less food to give the donkey. One day it died.

They were forced to return to Yerevan, where, unable to find other quarters now that the town had been filled with still more refugees, they squatted in the old part of town in a devastated room. Every day when the children left Shushan to look for food, they took their mother to the window where the roof leaked less and she could look out into the streets.

Gorky tried to have his mother admitted to hospital, but she was turned away. The hospital was controlled by the Dashnaks, who said that as Shushan had a husband in America, she could fend for herself. Thousands of people were in a worse situation. There was a certain terrible justice in this. At the time, inflation was so rampant in Yerevan that people were accepting promissory notes on cash held by relatives abroad. The money would turn up someday, and an absent dollar was worth more than several thousand present rubles. She had a husband in America: she was well off.

Vartoosh never forgot. In the same way that Satenig later became obsessed by her mother's "rejection" of her, the incident in which Shushan was turned away from the hospital became a memory on which in her old age Vartoosh constantly brooded. As she remembered the scene, an officer had violently thrown Gorky down the stone staircase of the building. Fifty years later, she became convinced that the cancer from which Gorky had suffered in his final years had been caused by the shock of the fall down the hospital steps as a child. Such was her bitterness that she once said to a Chicago friend: "Better the Turks than the Dashnaks." No worse or more unjust remark could ever have been made by an Armenian from Van.

Vartoosh and Satenik in later life also became obsessed by Aharon's neglect of their mother. He had done nothing. And Aharon was also a Dashnak! In the 1930s Satenig once accused Aharon to his face of having starved their mother to death. Madness and despair overshadow these accusations. In Yerevan, Aharon was in no position to help. His first wife Antaran also died at that time. It was terrible for everyone. During the winter of 1918–19, almost a quarter of the population starved to death.

Vartoosh and Gorky returned from the hospital with their mother to their squalid lodgings, where helplessly they watched her stomach swell with malnutrition. Even when they managed to bring back some food, she preferred to watch them eat rather than touch the food herself.

Somehow, the children kept their mother alive through the worst winter in living memory. Then, one morning in March 1918, just as fresh grass was beginning to liven the earth with blades of green, Shushan asked Gorky to write at her dictation a letter to her husband in America. In it she reiterated her wish never to leave Armenia, and her longing to return to Van. As she said these words, she fell back in her chair and died.

Distraught, the children ran into the street for help. Unknown figures immediately entered the house and took Shushan away. She was buried in an unmarked communal grave, together with all the others who had died that day.

Gorky and Vartoosh must have been sheltered by members of their extended family after their mother's death. Toward the end of the year, Uncle Aharon told them that they had to leave. Armenia was on the point of facing

wars simultaneously with the Turks, the Russians, and among themselves, as the Communist party began to oppose the Dashnaks with arms. Aharon's own position was equivocal. He could not protect them. In fact, soon after Gorky and Vartoosh had left, he changed his name to Sarkissian. When I asked why, his daughter told me vaguely, "Troubles in Russia." Like many Dashnaks, he must have lost out to the Communists in the area where he lived. So he changed his name and rode away to Persia "on a white horse" together with his new wife, Markrit.

Gorky and Vartoosh joined a small group which included Kerza Dikran, the fighter who had looked down on Lake Van asleep in the moonlight during those terrible April days four years previously, and Arax Melikian's sister, Mariam. Dr. Ussher from the old Van mission gave them a covering note for the journey: "The bearers, Dikran der Garabedian [i.e., Kerza Dikran], Manoog Adoian [i.e., Gorky] and Nazlu Shaghoian are worthy Armenians of good character and ability personally known to me. Any assistance to them in reaching their relatives in America will be appreciated and will not be misplaced. C. D. Ussher."

The train station was crowded with refugees who had found no other lodgings, their faces the color of earth, the children little skeletons, the women consumed by sickness, their hands yellow and their breasts flat, the men curled up on themselves lying about the platforms. They were kept in order by a few policemen who hurried to and fro, banging the butts of their rifles on the ground, leaving behind them eddies of louder lamentations. Yet the station was more secure than other places. At night, bandits roamed the streets. It was not safe to wander about.

Vartoosh, Gorky, and their companions found a train to Tiflis, and thence to Batum on the Black Sea. There, they lived for a few weeks in a large hall by the shore with the other refugees until they found a merchant ship which took them to Constantinople.

Five years later, the Armenian author Kostan Zarian took the same sea route along the northern coast of Turkey. Opposite Trebizond, looking across the small stretch of water between the ship and the land, he was disturbed by the memory of the slaughter of the Armenian population there—"very probably by those same ruffians who are now staring at us so insolently." He turned to a fellow passenger standing by his side, an Armenian woman traveling together with a Russian businessman. "To think that in those places," he said, "the blood is not yet dry . . ."

Blood? she said. What blood? What was he talking about?

Shaking with adrenaline, Zarian paced the deck for several hours trying to calm down. Maybe, after all, she was right, this impervious woman. Maybe her soul was stronger than his own.

Not to remember makes one strong. I don't mean to forget, but not to remember. Not to place the awesome wound at the centre of one's being, not to turn into a snivelling woman in perpetual mourning. No words can age as fast and inspire more tedium than words of grief and lamentation. Especially to others. Yes. I have no doubt now that Armenians must free themselves from their graveyards, from the blood that still clings to their flesh, from their tattered clothes and degradation.

As for our dead, our victims and martyrs: Let them forgive us and wait. This is not the time for erecting monuments. We, the living, need the stone and mortar. We Armenians are not a nation of orphans and beggars, but builders and fighters.

Zarian's response reflects, I believe, Gorky's own feelings when he himself left Armenia, never to return. So much had been destroyed. It was impossible to come to terms with the loss. An act of nonremembering, which was not forgetfulness but postponement of thought, was the only response. It was perhaps for this reason that Gorky reacted so aggressively if ever anyone questioned the tall tales with which he later camouflaged the past. Explanations, justifications, dialogue of any kind would have required a mental effort that he could not make without bringing down a whole world of real experience tumbling about his head.

The "snivelling woman in perpetual mourning" is also an image that Gorky kept in mind. In Yerevan, perhaps understandably, Gorky's mother had allowed herself to sink back into apathy and despair. Her attachment to the places of her birth—Charahan Surp Nishan, the Garden of Wish Fulfillment, the monastery of Akhtamar—was too intense for her to accept exile. And her relationship with Sedrak was too pitifully thin for America to appear to her as a land of the future.

Gorky had already begun to break free from his mother's intransigence, even as a child. It was implicit when he refused to accept Shushan's assertion that blond children went to heaven and black ones went to hell. In this respect, Gorky's creative life is paradoxical: his own imaginative re-creation of Khorkom and its gardens was the fuel which drove him forward all his life, and when it no longer functioned, he abandoned himself to a despair which in many ways resembles that of his mother in her final months. But for the time being, he turned his back on Shushan's example.

AFTER THEY ARRIVED in Istanbul, Gorky and Vartoosh lived in tents provided for the refugees. Then Vartoosh was befriended by an Armenian woman who took her in and treated her like a daughter. There was talk of adopting her; Gorky, too. But he ignored the offer and remained with his friends from Van down by the tents on the shore.

The sculptor Raoul Hague, then a student at Robert College, the principal American mission school in Turkey, thought he saw Gorky and his sister near his school. Perhaps Gorky was there to present his note from Dr. Ussher to the head of the school? It would have been natural for Gorky to turn to the principal of Robert College for help. Hague remembered for years this strange gaunt figure striding through a field, even though he had no idea who Gorky was at the time.

Vartoosh and Gorky stayed about six months in Constantinople. At last the money for their tickets came through—from Muggerdich and Akabi, not from Sedrak, their father.

Finally the son of the woman who befriended Vartoosh arranged their passage: Athens, Patras, Naples, and Ellis Island.

In Patras, Gorky met a Greek girl with whom he went out into the fields to gather flowers, and was much frightened by something that happened when the boatmen took him back to the ship.

In Naples, he bought Vartoosh a cheap necklace.

Then came the long passage across the Atlantic, during which Gorky drew, or else sat at the railing of the ship's deck—a tense young man in his late teens, with too many violent experiences to forget, looking at the waves for hours on end, singing.

WATERTOWN

1920–1924

T HE BOAT DOCKED on March 1, 1920.
Gorky was kept under observation on Ellis Island for a few days.
He was unusually thin, and the doctors suspected tuberculosis. They gave him a clean bill of health, but the delay made him anxious.

Akabi and Muggerdich were there to meet them on the quay. Sedrak, their father, was not with them, and that must have been a disappointment. Together, they took the train to Watertown, Massachusetts, where Akabi ran a boardinghouse for Armenian men, catering to those who were not yet married or whose families were still in Europe. She was working hard, cooking and tidying and washing clothes from four in the morning till midnight, seven days a week, and two or three years after Gorky's arrival, she was able to buy a two-story clapboard house on Dexter Avenue.

Though Akabi was relatively secure, Sedrak and Hagop moved twice within a year of their arrival and it was several years before they managed to settle down. Gorky and Vartoosh stayed with them in order to finish their education, and in the fall of 1920 Gorky enrolled at the Old Beacon Street School in Providence. In January of the following year, he enrolled at Bridge-ham Junior High School. He was too old for school and his lack of English set him apart.

It has to be said that Gorky's schooling never added up to much. Two years at the village school in Khorkom, during which he whittled a stick at the back of the class; three and a half years at the American Mission School in Van, where he was happier working with Uncle Aharon in the carpentry shop; St. Sarkis's parochial school in Yerevan, which he attended whenever he wasn't working as a carpenter or a typesetter in a city desperately struggling for survival; finally, one term at the Old Beacon Street School and two terms at Bridgeham High, in Providence, where often his difficulties with his elder brother and his father made him flee to his sister Akabi in Watertown. It hardly added up to an education.

The first years of a new life in America offered Gorky the chance to create a new relationship with his father. Everything about America was foreign to him and he needed guidance. But if he needed emotional support, Sedrak was unresponsive. He was past fifty, and he had last seen these offspring of an unloved wife as a four-year-old who wouldn't speak and a toddler of two. The children with whom he was now reunited consisted of a tall young man with a will of his own and a beautiful but nervous young woman.

The memoirs of Vartoosh and Satenig concerning their early life in America, written for Ethel Schwabacher when she started researching her biography, are highly contradictory with respect to Sedrak. After leaving Khorkom, he had fled to the Caucasus. There he was killed, because he would not join the Russian army. No—he went to France. He died later, in Europe. He came to the United States, but died soon after he arrived. He married again. Then he died. The point they wanted to make was that after Sedrak left Khorkom, none of his children ever saw him again.

Having blocked further questions about Sedrak, they still needed to offer some explanation for Gorky's early years. Vartoosh wrote, "Gorky went to Providence where he stayed with an old friend of his father's (now dead) whom they called 'cousin' but he was not really a relative. He took care of Gorky financially." This was clearly untrue. Hagop was their elder half brother, and he was still alive at the time when Schwabacher was asking these questions. Such was her sense of shame about their background that Vartoosh told Ethel anything that came into her head rather than give her clues that would enable her to track down the truth.

Although Hagop was married with several children, he and his father inhabited an archaic and very male world. A photo taken during the First World War gives an idea of its rigidity: Sedrak seated second from the left, as proud and upright as possible; cousin Amu at the far right holding a bunch of flowers, to indicate a poetic nature; Hagop standing fourth from the left, clean-shaven, hard.

When he arrived, Gorky found that the leadership of the family was in the hands of his half brother. It was Hagop who signed the leases, Hagop who held the skilled job at the factory while Sedrak had the menial one. They worked at the Universal Winding Company, a factory producing cast-iron parts for textile machinery. Sedrak was just an unskilled laborer. His job was to take fresh casts and grind them clean on a wheel. Hagop, instead, poured molten metal into molds, or into negatives pressed in sand on the ground. He was good at his work. Whereas Sedrak was slow and methodical, always careful to cover his mouth with a red bandanna, Hagop went around dressed casually, his mouth unprotected. He wore large, loose overshoes he could easily shake off if they caught fire, which they sometimes did. George, Hagop's son, remembered that there were always fresh burns on his father's feet where drops of red-hot metal had fallen behind the protective lip of his giant footwear.

Sedrak, Gorky's father (seated second from left), and Hagop, Gorky's half brother (standing fourth from left), with Amu (far right), the Adoian cousin who fled with Hagop from Khorkom in 1904, and their Armenian friends in Watertown, c. 1914

Under Hagop's roof, Sedrak's role was to support his son's decisions and keep an eye on the grandchildren, as all good grandfathers should. Hagop had two girls of eight and ten, and two little boys. It was traditional in Armenian houses that whereas you disciplined your children, you spoiled your grandchildren, and Sedrak's grandchildren were more fond of him than his own children had ever been—although if a grandson went too near, he was liable to grab him and keep him for hours while he told him a long story. Always the same story, recounting endless journeys over incredible distances "on a white horse." He was a kind man and he never lost his temper, except once, with a rooster that pecked him. He said: "That's the last time you do that," and they had that rooster for supper.

DURING THE TWENTIES, two large factories dominated Watertown, where Akabi lived: the Arsenal, run by the army, and the Hood Rubber Company. In both places you could secure a job for life. Satenig worked at Hood Rubber for forty-five years. It has now disappeared, but the Arsenal is still there. It adds an ominous New World myth to the Old World stories which today's immigrants from Beirut and Yerevan bring with them, for they say that atomic debris from the early Manhattan Project lies behind the protected gates of the Arsenal, rotting in secret pits.

After giving up school, Gorky joined his sisters at Hood Rubber. Satenig had started there six months before. Gorky hated it. He wanted to become a painter. Though he was ambitious, his path was still unclear. During work breaks, he used to hide away on the roof, where he drew on the black tar-paper squares of the tiles. A floor supervisor called Shirley tried to cover up for him, shouting up the ladder to hurry up or he'd be laid off. He also drew on the frames on which the boots were stored. After a few months they let him go.

He stayed on with Akabi after losing his job, painting the view at the back of the boardinghouse, or portraits of the family. A photo shows Gorky at work on Akabi's porch shortly before she moved. Though it is hard to see the painting clearly, it already looks Cézannesque. The young man painting it does not look happy, but his equipment is immaculate, right down to the maulstick, a traditional instrument to steady the hand while making detailed touches.

Akabi did not necessarily approve of her brother's choice of career, but she was optimistic and unafraid. She had *jedesh,* spirit. Satenig and Vartoosh continued to live with her for years while they worked at Hood Rubber. In their large extended family, she was "definitely the boss." Akabi gave her brother

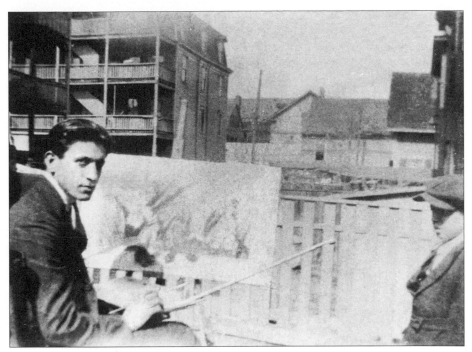

Gorky painting at his half sister Akabi's house in Watertown, c. 1922

canvases and paints, and when he came in from the day's work at the factory, or on weekends from painting in the park, they used to amuse each other, sitting together over on one side of the front parlor telling stories and making jokes.

Muggerdich and Akabi moved to Dexter Avenue early in the twenties. It showed what a wonderful place America was, that you could buy a beautiful home after less than ten years in the country. The street has altered little since they lived there. Clapboard houses with peaked roofs and carved Corinthian columns in front, each house at a slightly different angle from its neighbor. The trees were cut back in the 1930s to accommodate power lines and telephones, and a column of electrical cobwebs today binds Akabi's house to those on either side.

Like all the Armenians of Watertown, Muggerdich re-created the patterns of the old country in the new. "Phillipos," he told his next-door neighbor one day, "if your chickens keep coming into my yard, we're no longer going to be friends." And so he and his neighbor built a fence, one man standing on his side and the other on his own, as in the poem of Robert Frost's, "Good fences make good neighbors." When Akabi and Muggerdich posed for a photo in that same backyard, they might have been the models

Akabi and her husband, Muggerdich Amerian

for Grant Wood's *American Gothic,* a work not yet painted. The gulf between the values of Khorkom and those of the old pioneer frontier of America was not large, but both worlds, by the 1920s, were becoming irrevocably remote.

Gorky was fond of Muggerdich. In the late twenties, when he came back to Watertown from New York for the summer, he often painted him. He used to tell him solemnly: "There is a whole novel in that face." Muggerdich was straightforward and simple, with that quality of innocence which Gorky so much admired.

He gave Akabi about a dozen paintings during the twenties, including a portrait in the style of El Greco of a man in a lace collar and pointed beard. These works were stored in a rack out of sight and were eventually destroyed in a fire. When Gorky heard about it, he was naturally upset. He wouldn't give Akabi any more paintings, he said. To which she replied, as cheerful as ever: "See if I care! I love you anyway."

THOUGH THE CHOICE of a career as an artist was an unusual one, two other members of Gorky's extended family made the same decision at about the same time as he did: John Hussian, the boy from Ishkhanikom who in the disaster of 1915 had stood beside his father outside a barn, waiting to be shot; and Yenovk der Hagopian, the son of the village priest of Ishkhanikom. John Hussian was about to marry Arax Melikian's sister Mariam, who had come over to the United States on the boat with Gorky and Vartoosh.

As an artist, the two themes to which Hussian remained loyal all his life were landscapes, which possess a gentle Renoir-like character, and the memories of the villages he had known as a child. Once, as one of Hussian's friends approached his studio, he heard the sound of someone crying inside. The door opened, and there stood Hussian with tears on his cheeks. He showed his visitor a painting of an Armenian village, saying, "Look at this beautiful village which the Turks destroyed."

Mischa Resnikoff, a Russian artist who knew Gorky later in New York, said that Gorky's earliest paintings were of "Armenian mountains and land-scapes with sunsets and sunrises," as he was traversing "a sentimental period depicting mostly what he recalled from his old country." This sounds as if, during the earliest phase of his career, Gorky took a cue from his cousin John.

Recently an early painting by Gorky has come to light. It shows the meet-ing of two figures by the side of a river. It is so unlike anything by Gorky that the experts are doubtful about attributing it to Gorky, but I find the work convincing. The expression of the eyes, the position of the feet in the figure on the left, have something in common with the photograph of himself and his mother which Gorky studied with such devoted attention for so many years.

This painting may be connected stylistically with works by Hussian; or it may even refer back to the paintings of Baghdasarian, the art teacher from the Van mission school who once gave Dr. Raynolds his portrait showing him in the act of saving children from "watery graves." The work is strongly anecdo-tal, perhaps the only surviving example of a style he assumed right at the beginning of his career, and which he rejected within a year or so of having taken it up.

A few months after losing his job at Hood Rubber, Gorky enrolled at the Technical High School in Providence. This meant going back to live with Hagop. The local tech was not exactly the best place to study art, but it was the nearest thing to an art school in the neigh-borhood.

Hagop's farm lay only a mile or two from the factory where he and Sedrak worked. Both buildings still exist, although the factory failed during the Depression and the farm is now divided into suburban lots. The polarity of these two build-ings, almost within sight of each other, suggests even today a per-fect paradise from an Armenian

Arshile Gorky, untitled painting of two figures by a river, c. 1922

Hagop (front row center, wearing glasses) at work among his colleagues at
the Universal Winding Company, at about the time when Gorky and Var-
toosh came to the United States

point of view, a whole world within the palm of a workingman's hand: a
strong, virile job which brought in the money, and the farm to go back to in
the evenings, without Turks, without Kurds, without depredations and rapes
and murders.

The greatest tensions in Cranston were not so much between Gorky and his
father as between Gorky and his brother. According to Hagop's son George,
Hagop was "always on Gorky's back to get a job, to bring back some money. A
grown man did not spend all day in the park, painting." Art belonged to child-
hood. When a man grew to maturity, as the Bible said, he should "put away
childish things." The world had to be confronted directly, with bending back
and tightening sinew. A survivor from that distant age told me, "Everyone
was used to laugh at him. Hey, Manuk, they said—you gonna be an artist or
something?" Even seventy years later, with Gorky long dead and his paintings
worth millions, the idea seemed ridiculous.

Their eyes were fixed immovably on the past. None of Gorky's siblings
learned enough English to pass the citizenship test until the 1940s, and this
was a serious liability, as during the Depression the relief projects excluded

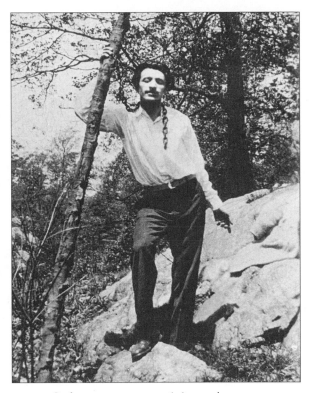

Gorky as a young romantic in a park, c. 1924

resident aliens. There were no books in the house except children's school-books and two or three books in Armenian about the massacres, which Hagop read again and again. Exile is a solitary state, although the men could think their private thoughts in company when they met in the evenings and drank arak and sang the old songs. And when Hagop with his fine tenor voice gave them "*Anush karun, dalai laman,*" Sedrak always broke down and wept.

As if to burn his bridges behind him, Gorky assumed the pose of the most flamboyant artist he could imagine. When Lucia, Hagop's daughter, saw Gorky walking down the street clad in a long, flapping cloak, she laughed and laughed, and thereafter whenever she saw him again, she laughed. I could not see what she thought was so funny. "Well," she said, as if it explained everything, "he looked like Jesus Christ." She was seven years old, so this was in 1923, at a time when Gorky was assuming his new identity and struggling to break free.

ONE OF THE EARLIEST photographs of Gorky after his arrival in America has his signature at the bottom: "Vostanig Amerian." Muggerdich and Akabi

Amerian were the ones who had brought them over. Akabi was the only member of Gorky's family who backed him as he made himself into a painter. Adopting their surname was a gesture of gratitude.

At this early stage, Gorky had not yet decided to leave his Armenian identity behind. What he wanted to leave behind was Sedrak and Hagop. To change an Armenian surname was not a rare practice, but the usual custom was to derive it from a paternal Christian name. Aharon, when he had taken this step, assumed the surname Sarkissian, after his father, der Sarkis. A family legend has it that Gorky toyed with the name Archie Gunn, or Archie Colt, like the hero of a cowboy movie. He was probably trying out a non-Armenian name as a joke, to test his sisters' reaction.

"Arshile" is usually taken to mean "Achilles," but unfortunately Gorky's new Christian name was at first Arshel, which is how he spelled it until the early thirties. "Arshel" may come from "Aysaharel," a word meaning "possessed by an evil spirit," or "blown by an evil wind." In short, accursed. Gorky often told his friends (with relish) that his mother used to call him "the black one, who will come to no good end," so the name "Arshel" conjures up an image of Shushan chiding her errant son as he ran around the village, years before. It would be typical of Gorky to commemorate his mother openly, and humorously, without revealing the connection between the word, the memory, and the name.

As for "Gorky," the easiest explanation is that he borrowed the name from Maxim Gorky, a romantic figure with whom he could have identified as an adolescent in Yerevan. The name Göhk, used instead of "Khorkom" on some old maps, probably has nothing to do with it. Otherwise "Aysaharel Göhk" might signify something like "that accursed man from Khorkom."

Those who knew that Maxim Gorky was itself an assumed name were naturally puzzled to come across Arshile, his putative nephew. As one critic put it, "He is said to be a relative of the novelist Maxim Gorky, in which case he has adopted the pen name of the renowned Maxim Peshkov."

GORKY'S CHANGE OF IDENTITY coincided with disastrous news from Armenia.

The Dashnaks had always fought for the impossible: a "free and independent Armenia," free of both Russian and Turkish interference. In 1923 the worst scenario unfolded: a treaty between Turkey and Russia aimed at curtailing as much as possible the nascent Armenian Republic. Turkey obtained Cilicia and the eastern districts around Lake Van, up to and including Kars. Armenian Cilicia, like Van in 1918, came to as disastrous an end. Russia, instead, obtained Baku with its oil fields. Thus Armenia became what it is today: cramped and landlocked, with a perpetually unsolved frontier problem with its

neighbor, Azerbaijan. As if to rub in the humiliation, Mount Ararat, symbol of Armenia's tenacity over the centuries, was included within the new frontiers of Turkey.

Hagop was a passionate Dashnak, and Gorky's loyalty to Russia, which was underlined when he chose a Russian name for his new identity, added to the difficulties of living under Hagop's roof. The resulting tensions curtailed any chance Gorky had ever had of making friends with Sedrak. For Gorky's part, to see all hope of returning to Van and Khorkom disappear in shameful agreements, thanks at least in part to the obstinacy of the Dashnaks, must have helped to draw an indelible line between himself and the past.

Partly by choice, partly because of various external pressures, Gorky exaggerated the characteristics of his new persona with a series of outrageous gestures. John Hussian remembered one of them. Gorky had set up his easel right in front of the train station in Providence during the rush hour in order to paint the travelers milling around the entrance. Hussian told this story with awe in his voice. Talent was one thing, but was it necessary for Gorky to hold up the traffic while he painted a picture?

Yenovk der Hagopian told a similar story. In this case Gorky had set up his easel on the corner of School Street and Arsenal Street in Providence, at the bottom of Dexter Avenue, where Akabi lived. Eventually a policeman stopped and asked him where he came from. "I come from heaven," he answered. "Where do you think I come from? I'm a man like you." The policeman said, "Don't get too wise or I'll take you in." He asked if he could see the picture. Gorky lifted it up and held it aggressively close to his face. "You know," the policeman said, "I'm not that ignorant, you have to give me more distance to see it." Having seen the painting at a proper distance, he told Gorky that it was beautiful.

Yenovk's story calls to mind an identical incident in the life of Cézanne, who, when stopped in the street by a well-meaning bourgeois of Aix, held his painting up to the man's face with the same emphatic gesture. Perhaps Gorky borrowed the incident from Cézanne's life, just as he borrowed Cézanne's way of painting early in his career. Yenovk might simply have heard the anecdote from Gorky's mouth, and in retelling it implied that he had been there.

These stories were remembered by artists. There would have been no point in dazzling the family or the neighbors with them, for they would only have reinforced the conviction that Manuk had gone crazy. But as a story circulated among fellow artists, it conveyed the dramatic idea that a painter had to battle against the incomprehension of all the world, constantly.

IN 1922 GORKY ENROLLED at the New School of Design, at 248 Boylston Street in Boston. The school offered courses in drawing and painting and a two-year course in design. It would have been a long commute from Hagop's farm or

from Watertown into the city every day. A fellow student at the school says that he earned money washing dishes in a restaurant, which suggests that he moved to Boston in order to study. If so, nothing is known about his life there.

There was another art school which Gorky attended in Boston, probably before joining the New School of Design. This was the Scott Carbee School. Gorky's presence there is known only from a letter an ex-pupil wrote to him in 1946. As this is the only letter Gorky ever kept, the story must have amused him.

> I'll never forget some of the incidents in which you were involved. One day we had a very young girl model, you worked feverishly on your oil painting, you caught the childlike character and soul on your canvas—Carbee did not come near you until the end of the class and then he castigated you & told you if you couldn't paint the way he wanted you to you neednt come to his classes—you calmly took the canvas and smashed it all to hell, packed your paints & left—I never remember seeing you at the classes again.

Monticelli, Frans Hals, Cézanne—these were the painters whom Gorky rapidly assimilated in his early years. What they have in common is a certain craftsmanlike way of accumulating the paint on the surface of the canvas. Hals and Cézanne sometimes have the same hand: three or four almost identical strokes placed side by side, for as long as the brush remained loaded with paint. Gorky, from the beginning, painted fast and with a vivid sense of texture.

At least once, the struggle to become an artist became too much for him. Gorky tried to commit suicide. The attempt is known only because Gorky himself made a funny story about it: a story with a moral. For what saved him was painting itself. Whatever its challenges, whatever the losses and failures it entailed, painting also contained its own reward. "No desire no temptation could ever stand in the way of his painting, not even the temptation to drown in the cold water of Boston's Charles River: suddenly, out in the middle and ready to die, he remembered—what about painting?—and swam swiftly to shore. He was very young then, but he never changed."

One of Gorky's first surviving works was made during the recess in a class at the New School of Design. Painted outside on a clear but cloudy spring day of 1924, it shows the Park Street Church seen from the public garden, looking northeast on Tremont Street. This church had a connection with the Armenian Gregorian Church, which did not possess its own place of worship on the East Coast until two or three years later. The brother of Hohannes Baghdasarian, the art teacher at the mission school in Van, preached there. The choice of this church as a subject for a painting might have had some private significance for Gorky, and the location may have contained a secret association akin to those of the "sentimental Armenian sunsets" which he was trying to leave behind.

According to Gorky, a pass-
ing parishioner offered him five
dollars for the painting, on con-
dition that he make the figures
hurrying into a subway kiosk
"less like peasants." Gorky told
this story after he had come
in from the street, offering the
painting to his class at the same
price. A friend who was study-
ing with him gave him ten dol-
lars for it instead.

The "less like peasants"
remark may be as spurious as
the incident involving the
policeman in Providence. Is it
likely that a Boston parishioner
would say such a thing to a nice
young man quietly working on
a painting in the street? The
story is surely a fragment of

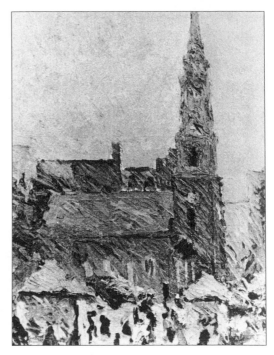

Arshile Gorky, *Park St. Church, Boston*, 1924

Gorky's interior fantasy featuring the lonely artist pitting himself against the
world's antagonism—an antagonism which often did not exist. Gorky's idea of
what a painter should be was formed long before he knew what it was that this
imaginary artist should paint. The first step in escaping from his past and his
background was to create an image of "the Artist" and then live up to it. To
throw the gauntlet down, as it were, in front of fate.

Katherine Murphy, the purchaser of the canvas, remembered him later as
"a tall, serious young man in his twenties of great ambition who spent most of
his free time in museums." It sounds as if she were Gorky's pupil, rather than a
fellow student. "Afternoons we worked in a small portrait class where he
would relax, walking back and forth with intricate dance steps, telling his
long fanciful tales of his boyhood in Russia." Once, she saw the principal intro-
duce him as Maxim Gorky's nephew to a Russian friend of the writer's. This
occupational hazard inevitably cropped up from time to time. The embarrass-
ment of being shown up never had any effect on Gorky. Whenever it hap-
pened, he simply turned on his heel and left the room.

An instructor at the school testifies that Gorky was already an accom-
plished artist when he arrived. He came "very well equipped in drawing. He
liked the truth and wanted to do an honest job and loved beautiful things. He
was determined to be an artist. That was his life and he was planning his life

even then. He never envied anyone anything and possessed great confidence in himself. He never seemed afraid." This teacher was sure that he had learned drawing already in Armenia. "It was noticeable right away that he could draw and knew what he was about and he just got ahead by leaps and bounds."

After a year as a student, his superior at the school invited him to New York in order to help set up a new affiliation. Before he left Boston, he came up to Katherine Murphy as she was working in the classroom. He wanted to say good-bye, he said. He shook her by the hand and told her cheerfully, "I shall be a great artist or if not, a great crook."

SULLIVAN STREET

1925–1930

NEW YORK IN THE EARLY TWENTIES was a frenetic and dispersed city as far as art was concerned. On the one hand, the National Academy on Thirty-first Street vigorously defended an archaic neoclassicism, devoted to anatomically irreproachable paintings taken to a smooth finish. On the other hand, the painters of the "Ash Can" school produced canvases of the people, on behalf of the people, painted in a style deriving from Daumier and early Impressionism. The interiors of bars, figures in the snow of New York, the urban poor—the subjects of the Ash Can school implied a social message, conveyed in spontaneous brushstrokes. Its practitioners, including the veteran John Sloan and the comparative newcomer Stuart Davis, kept in contact with the Socialist movement, occasionally contributing political cartoons to *The Masses,* a periodical which, even before the First World War, "found no trouble in mixing Socialism, Anarchism, Communism, Sinn Feinism, Cubism, sexism, direct action and sabotage."

The great Armory Show of 1913 had suggested that both the academicians and the painters of the Ash Can school were too involved with the "message" of their works. The paintings of Matisse, Picasso, and the other European masters showed that the subject matter was less important than the way in which a

canvas was painted, and that in the future, artists would analyze forms and ways of looking at things, rather than create allegories about the human condition. The Armory Show also convinced everyone that Paris was the city where art flourished best, and many painters—not to mention sculptors, writers, and buyers—crossed the Atlantic to see for themselves.

In the New York of the twenties, there was little official interest in contemporary art. Public taste associated art with velvet-covered walls and ornate gilded frames containing objects they could recognize. The Museum of Modern Art was still a dream in the minds of a few Harvard undergraduates. The Whitney Art Club was not yet a museum, just some rooms behind the studio of its patron, the sculptress Gertrude Vanderbilt Whitney. If you were lucky enough to know both cities, as did Gorky's future dealer Julien Levy, you could compare the attractions of New York with those of Paris: "speakeasies and bistros, women and doxies, men and supermen." Yearning from afar for the glamour of Paris, it was hard for artists in America not to feel that they were living in a provincial backwater.

As there was no question of Gorky going to France, he simply pretended to have studied there already. He was already a teacher, with his own didactic style, and a period of study in Paris gave weight to his authority. He attended the National Academy for a while, to see what the teaching was like. A beginner armed with a piece of charcoal faced a room filled with pieces of plaster casts. After drawing a few lines, he would work them over with a thing called a stump, which reduced the marks to a series of tasteful smudges. The study had to have an ultrasmooth appearance, similar to what we associate today with airbrush drawing, before the student was promoted to the next room, which contained whole statues. After a while Gorky decided this procedure was not for him, and thereafter he went to the National Academy strictly for social reasons.

He also tried the Art Students League. Here, John Sloan taught structure and composition, but his own paintings were often inspired by incidents that took place in the streets. Gorky appropriated one of Sloan's maxims: that if you found yourself acquiring too much skill, then draw with your left hand so as to force yourself to look at the world more attentively. In the streets, however, Gorky's advice to his pupils was the opposite of Sloan's. Instead of pointing out the passersby, Gorky drew attention to the sidewalk, a fire hydrant, the sky between two buildings—anything but the social predicament.

Whenever Gorky intervened in class or at the canteen of the Art Students League, it was usually to stir things up. He praised extravagantly the paint surface of Bouguereau, a successful French academician who might have been a suitable role model at the Academy, but not at the League. Bouguereau's finish

was so beautifully flat, said Gorky, it looked as if it had been licked. It was not the right thing to say to passionate pursuers of the immediate style.

Even at this early stage of his career, Gorky was somewhat peremptory as a teacher. As Mark Rothko, one of his earliest pupils at the New School of Design, put it, "He expected good performance." Rothko added hesitantly, "Perhaps I shouldn't say this, but Gorky was overcharged with supervision." Raoul Hague, who as a fellow Armenian knew Gorky better, said unequivocally that Gorky had "pushed Rothko around" during this time. There was an incident in which Rothko, visiting Gorky's studio, had been made to carry out the garbage. In spite of this, Rothko said that Gorky was "not hard to get along with, provided you had a serious concern about art." He remembered Gorky at his best. As his students were at work, with just the right blend of attention and distraction, Gorky would walk up and down behind them, talking about Armenia. "It was all fantastic and you couldn't believe what he told you if you were a stranger. I mean, for those newly introduced to Gorky, I'm certain it was difficult to tell where reality ended and imagination began when it came to the land of his birth. He had a wild, poetic imagination."

Another of Gorky's pupils at the New School of Design was a tobacco merchant and amateur artist called Nathan Bijur. He watched Gorky paint a vase of tulips during a class at the New School, in one sitting, using just a palette knife. Gorky gave him the painting as he finished it, and Bijur subsequently bought more, including a portrait of a girl which Gorky said he had painted while studying in Paris at the age of twenty. The sitter was an Armenian relative painted in Watertown the year before. Nathan often invited Gorky to Sunday lunch at his house on West Seventy-third Street. His two sons, Arthur and Billy, both went to Brown University in the early twenties. Gorky's subsequent claim to have been to Brown, where he said he studied engineering and won prizes for athletics, was probably taken from stories he had heard at the lunch table at the Bijurs' on Sundays. Nathan Bijur in his day had won a hundred-yard "dash" at Columbia.

The Jazz Age, from the end of the First World War to the stock market crash of 1929, was an exceptionally vital time for America. There were strong tensions between the generations, a burgeoning of mass communications, of new technologies, of new ways of living, all camouflaged by a sudden flush of easy money which came to an abrupt and unexpected end. But Gorky was not a part of American life—or even of New York life, with its "flashing, dynamic good looks, its tall man's quick-step." He had no intention of obliterating his memories of a former country by saturating himself with the realities of the new.

Though there is not much evidence concerning this stage of Gorky's life, I believe he protected himself by joining a circle of Russian immigrants among

whom he felt at home. There must be an explanation, after all, for Gorky's unusual confidence, both as a teacher and as an artist. It would be too much to expect any man to assume such an intransigent attitude toward the world unless he had some support behind him.

Coming from Van, and having lived for some years in Yerevan, Gorky had a natural trust and admiration for Russians. In some cases the experiences of his Russian friends ran parallel to his own. Two Russian-Jewish friends of his, Boris Margo and his brother David Margolis, were survivors of a pogrom which had devastated their village. They had seen their father die, and they remembered his funeral. In front of such friends as these, Gorky was able to come out with his memories of what it had been like to live through a traumatic experience as a child. When, in the street one afternoon, David Margolis for the first time introduced Gorky to his mother, Gorky enveloped her small hands in his huge ones and gazed at her with profound and tender respect. Oh, he said, his eyes filled with emotion, *this* is your mother.

Of all Gorky's Russian friends, the most charismatic was David Burliuk. A hero of the Russian avant-garde long before the Revolution, Burliuk had translated for Marinetti when he came to Moscow in 1914. Burliuk walked about New York in a brightly painted "futurist" jacket, sporting one long ornate dangling earring. He described himself as a Radio-Modernist—in that the world is colored space and the soul of the artist penetrates all objects seen and unseen— a Cubo-Futurist, New Universalist, partial Unanimist, and Minimalist. Sustained by a strain of exceptional vanity, from the twenties to the sixties he published a magazine called *Color and Rhyme,* dedicated almost entirely to himself.

When it came to painting, it did not take much for Gorky to grasp an idea. His intuitive taste did not need theoretical corroborations expressed in words. If he saw that something was good, he preferred a zany explanation of its good qualities rather than hard analysis. In this respect Burliuk's ideas about art were, from Gorky's point of view, perfect. In an interview of 1929, Burliuk maintained, "Everything from the tiny bug to a teaspoon has its specific soul. The whiskey bottle that was on the table is there still forever, but abstract." The ghost of the absent whiskey bottle was all Gorky required in the way of intellectual justification for abstraction. It stimulated the imagination, and was the opposite of the kind of argument a real intellectual would have used. Only a true artist would ever have thought of such a thing!

Gorky heard about futurism, Cubism, and surrealism from Burliuk long before they began to be discussed in American art schools. Burliuk was also extremely generous about introducing his friends to each other, and they sometimes behaved like a large, overextended, uncontrollable family.

Gorky told his second wife that he once met the Russian futurist poet

Vladimir Mayakovsky, and though it sounds like one of Gorky's tall stories, I believe it to be true. David Burliuk had been a close friend of Mayakovsky's in Moscow. He could easily have introduced the two men. Mayakovsky visited New York only once, in the summer of 1925. In August he was interviewed by the well-known writer Michael Gold, and his portrait was drawn by Hugo Gellert, an artist whom Gorky knew in the early thirties. Both Gold and Gellert belonged to the Communist wing of *The Masses*—where, incidentally, they were viewed with deep misgivings by old Socialists such as John Sloan and Stuart Davis.

In Gold's article, Communism is linked by association with Progress. "Let the elevated roar twice as loud as ever, the street cars clang, the taxis rattle and squeal and honk, the riveters spatter and punch, the city is too quiet for Mayakovsky!" New York was not modern enough. "America has gone through a tremendous material development which has changed the face of the world. But the people have not yet caught up." They were living in the past. In the cinemas, the audience applauded "a sentimental love story that would be hissed off the screen in the smallest hamlet of the new Russia." The artists in the city "sit by candle-light, like the Russian peasant." They wrote candlelit poems. They painted candlelit pictures. Their inspiration "burns with a delicate candle-light flame, when it should roar like the blast from a modern furnace." Thus spake Mayakovsky, pacing up and down the room smoking endless cigarettes. He was now living near Washington Square, concluded Michael Gold, whence he emerged at night to shoot pool on Fourteenth Street, complaining about "the peculiar provincialism and small-townishness of New York."

All of this finds a strong echo in the interview Gorky gave a year later, when he became a member of the faculty of the Grand Central School of Art. According to the anonymous writer of this piece, Gorky "gives New York his facile, talented hand and laughs at its blustering pretensions that it is an overpowering city." Grand Central Station was, "after all, a very small thing, like, say, a siding in a little Russian town."

A banner headline announced, "New Member of Local School's Faculty Denounces Craze for Old as Vitiating Influence on Contemporary Creation of the Beautiful." America, according to Gorky, "must always have antique things, always old masters, always big names. Your museums are filled with antiques, your art dealers emphasize antiques and do not become protagonists of the greater modern art."

Art, according to Gorky, "is not in New York, you see; art is in you." The true artist aims for "the universal idea of art" which exists below the surface of the real. "Too many American artists paint portraits that are portraits of a New Yorker, but not of the human being." There had never been a more exciting period than today! Modern art had "gone ahead widely and developed as it

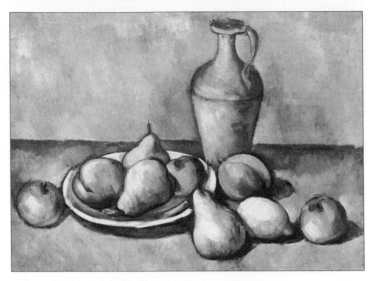

Arshile Gorky, *Pears, Peaches, Pitcher*, c. 1927

never had a chance to in the hands of the old masters." As a result of which, "Cézanne is the greatest artist, shall I say, that has lived." To dismiss modern painting and the works of Cézanne and Matisse and Picasso was crazy.

The flamboyant tone of this text is close to that of the Mayakovsky piece. Where it differs, and where the authentic voice of Gorky comes through, is in the second theme of his remarks: that art grows from the "universal" that lies beyond appearances. It is the opposite of the realism of the Ash Can school, and it probably was inspired by David Burliuk.

GORKY OBTAINED HIS JOB at the Grand Central School of Art in the traditional manner: by going to the principal "cap in hand." He brought with him his copies of Monticelli and Frans Hals, and perhaps already his versions of Cézanne and Matisse. Here was a man who could paint like anybody! He was immediately taken on.

The founder of the school, Edmund Greacen, was an Impressionist painter who had trained himself as a young man by living for a year near Claude Monet. During the 1880s a small hotel at Giverny had been filled with American Impressionists, working from the same subjects and admiring from a distance the great man surrounded by the bright flowers of his garden. On his return to the United States, Greacen came to specialize in what he called "portraits" of gardens. And if the result seemed overly faithful to the here and now, Greacen would respond mildly, "Some of us *like* the fleeting beauty of the moment."

Greacen was not included in the Armory Show of 1913, and he began to

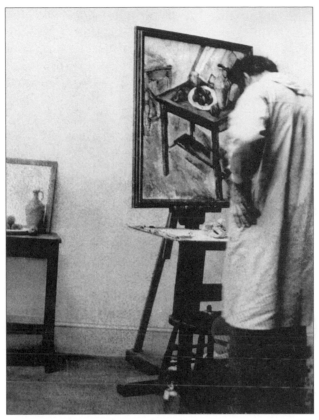

Gorky painting at his studio on Sullivan Street, c. 1927

feel out of tune with the art of his time. In 1922 he founded the Grand Central Galleries, in order to cultivate an audience for himself and his colleagues. The gallery was situated above the train station, and, looking from the window of his office onto the roofscape one day, Greacen saw a row of empty rooms over on the Lexington Avenue side. So he decided to acquire them and found an art school.

According to the prospectus, the teaching at the Grand Central School of Art was not "extreme." Training in "the hard, tight or commonly called academic style" was not encouraged. They were "thoroughly modern and individual." By the time Gorky was admitted to the faculty, only a couple of years after its founding, it had almost nine hundred students and was one of the largest art schools in New York. The twenties were prosperous and the city was full of young people studying art. To paint, to write, to dance, to act, were ways of disengaging from the relentless commercialism of America. Many of the pupils at Grand Central were the children or siblings of entertainers, and the school became famous for its hops. The crooner Rudy Vallee came up from

his nightclub on Eighth Street in order to perform, as his brother was a student. But Gorky kept aloof. As soon as his teaching hours were over, he vanished from the school and quietly kept working at his own paintings at home.

Gorky used to greet his pupils with a speech of inspiring gloom. If they thought they could all become artists, they could forget it! Only one in ten thousand painters ever made the grade. Only one, maybe two, in every generation achieved something truly worthwhile. And how could he explain modern art? Words were only of limited use when it came to painting. He could give an example, but he could not teach. It took artists years to get even to where he had gotten. But where was he? Not even halfway there, still struggling, "out in the middle of the ocean in a rowboat, far from shore."

Courage! All was not lost. They should not listen when teachers said that only those with talent could become true artists. It was not a question of talent. Anyone could learn to draw, with patience and practice. Each person in the world saw things differently and in his or her own way. It was up to you to paint the world as you saw it. If you did, you had a good chance of bringing something out in an original manner.

"Nevermore draw like that," he told his pupil Walter Murch when he showed Gorky his first figure study, made in the style of the National Academy and taken to a high finish. "Don't use a pencil like that." The pencil should not try to become a substitute for something else. The pencil itself should take over, and the lines should not be dirtied with any illusionistic shadows. His students should always use a full sheet of Imperial paper and fill the page with the composition before becoming distracted by details. Drawing wasn't a matter of making things "look real." Gorky could say, in front of nature, "All wrong," and cancel the real by waving his hands. The students should remain honest to what they saw. If, when they were drawing a house, the top of the roof looked bent, they should draw it bent, even if they knew it was straight. If the life model's weight was on one leg, then they should draw it as strong as a column, as strong as a board. If the model looked wider on one side than on the other, they should draw it that way. If they were drawing a dog, they should draw it as if seeing a dog for the very first time, not the way they thought a dog should look. If they arrived at the point where a painting of just a dog on the floor looked good, then they could paint anything.

They should keep their ideas simple. "Only two or three shapes. Don't put in so many shapes." Clarify, simplify. "Form, form, form must be touched." Concentrate on the outline: the edge of paint where one shape met another gave a painting eloquence. The empty "negative" spaces around an object were as important as the "positive" ones where the subject stood.

Gorky could march into class, take a pencil, "and in a few seconds would just show you how this thing was done." He expected his pupils to follow him

after class to the galleries, to the museums, to Weyhe's bookstore on Lexington Avenue, where he exchanged paintings for art books. He showed his students reproductions of Bouguereau, and Meier-Graefe's book on Cézanne, which had just come out. He appeared charismatic to one or two pupils, scary to the rest. It was up to the pupil to listen. "You just sweated it out."

One pupil remembered Gorky showing him a reproduction of a curious early Cézanne, showing a picnic in a wood with a rearing donkey frightening a cluster of reclining women. It struck Gorky as funny. At least, he opened his mouth as if to laugh, showing widely set teeth below his fine mustache. A strange laugh. Somehow too serious to have any humor in it.

Sometimes his audience was put off by him. George McNeil remembered meeting Gorky in the Metropolitan Museum of Art, copying the Parthenon frieze with strong, full colors on a coarse burlap canvas. Gorky said loudly that the Greek friezes were "more modern than the Picasso." When Gorky came across McNeil drawing from a Maillol sculpture, he pretended that he, too, had studied with Maillol, in France. Arshile Gorky, nephew of Maxim. A year later, at an exhibition of Russian icons at the Met, McNeil saw Gorky waving at the exhibits, saying in a loud voice that *this* was modern art. The old was newer than the new. Somehow, McNeil had seen the gesture before.

IN NOVEMBER 1926 Gorky published a poem in the school quarterly magazine. Called "Thirst," it reads as follows:

> My soul listening to the death of the twilight.
> Kneeling on the far-away soil of
> suffering, my soul is drinking
> the wounds of twilight and of
> the ground; and within, it feels
> the raining dawn of tears.
> And all the stars of slaughtered
> lives, so like to eyes grown dim,
> in the pools of my heart this
> evening are dying of despair
> and of waiting.
> And the ghost of all the dead to-
> night will wait for the dawn
> with mine eyes and my soul,
> perhaps to satisfy their thirst
> for life, a drop of light will fall
> upon them from on high.

Unfortunately, the poem is not by Gorky. It is by the distinguished Armenian poet Siamanto.

One can appreciate why Gorky was attracted to such a writer. Siamanto was one of the leaders of a movement toward modernism in Armenian literature, and he, like Gorky, chose to work under an assumed identity. In 1911, Siamanto wrote a series of poems based on a terrible massacre that had taken place at Adana on the Mediterranean coast two years before. The poems grew out of eyewitness accounts, and "Bloody News from My Friend" can be seen as an early attempt to link Armenian identity with the sufferings of the people. As it turned out, the poems were unhappily prophetic, and Siamanto was himself tortured and killed early in the genocide of 1915.

"Thirst" was one of the few poems by Siamanto to be accessible in English at the time when Gorky published it as his own. He probably discovered it in an anthology of Armenian poems "rendered into English" by Alice Stone Blackwell and published in Boston in 1917. In Gorky's transcription, the line breaks make no sense, the word "is" is omitted after "soul" in the first line, "dawn" should be "down"—all mistakes of orthography rather than improvements. Otherwise the poem is exactly as its translator left it.

It is harder to justify the theft of the poem "Thirst" than to discuss the paintings that seem, at first glance, unduly dependent on the models Gorky chose to assume as his own. In the case of the paintings, Gorky always managed to give someone else's style his own personal twist. He passionately believed that ideas should be changed, even as you adopted them as your own—for what was the point of repainting another artist's canvas? Yet in the case of his "Thirst," one is up against a case of barefaced plagiarism, of a kind which would cost most creative artists their reputation if they were ever found out. The risk existed. Siamanto was as central to the idea of Armenia as Yeats to Ireland.

Gorky posed as something of a poet in front of the world, and he certainly possessed a "wild, poetic imagination," as Rothko put it. He lacked, however, the necessary training to commit his verbal improvisations to paper. His theft solved many problems. It gave evidence of his poetic nature, and it declared, in a most cryptic and obtuse way, his allegiance to the past, in all its ghostly suffering.

SOON AFTER TAKING UP his new job, Gorky moved from the rooms where he had been living, around the corner from the New School of Design on Fifty-seventh Street. He took a loft on Sullivan Street, off Washington Square—just one room, with hardly any furniture and a bare, clean floor. Near the window was a cot to sleep in, and a model stand for drawing sessions with private pupils.

The arch on the square, visible from his window, was something of a symbol for the artistic spirit of Greenwich Village. The statues on its flank had

been carved by Stirling Calder, whose son Alexander had been studying with John Sloan until recently, and was now working in Paris. The arch was hollow, and in it lived a policeman who sometimes disappeared at night, leaving his side door open. Once, eight years before Gorky moved downtown, John Sloan, Marcel Duchamp, and a few other kindred spirits had held a midnight feast up there. A Declaration of the Independence of Greenwich Village from the United States was read out, beginning with the satisfying word "Whereas." Soon after the party, Sloan and Duchamp helped to set up the Society of Independent Artists, a group which was ostensibly accessible to anyone who paid the five-dollar annual subscription. Highly idealistic, the group decided that there were to be no prizes, no jury, no restrictions. It was partly to test these parameters that Duchamp made his famous "ready-made" of a urinal signed "R. Mutt." The piece was excluded from the show, which proved various points—that there *were* limits to what could be shown in New York, and that the pursuit of perfection in terms of oil on canvas was already under threat from other alternatives. However modern Gorky may have been in spirit, many other ideas were seething all around him.

The south end of Washington Square bordered on the slums. In the streets the children pursued their minor wars. At first Gorky was an object of persecution. So tall, so foreign, so sinister in his black mustache, he resembled those wicked anarchists Sacco and Vanzetti. It took him time to win the children over, but eventually he was sufficiently accepted to give them drawing lessons, right there on the sidewalk. He loved children's drawings, left in the street to be eroded by the weather. One little boy, Gorky told his sister Vartoosh, could draw just like Paolo Uccello. So saying, he gave the child a piece of chalk and bent down to watch as he worked.

Gorky took her to have supper with the painter Nicholas Vasilieff and his wife. She remembered the meal: boiled fish with celery and onions, with a pat of butter floating on cold water to keep it from melting. So Russian! David Burliuk, who was also there, asked Vartoosh to pose while they were waiting. She kept still for so long she became quite bored staring at his dangling earring. Gorky also drew her. His sketch was done quickly: just one cursive line, no shadows, on a large sheet of paper.

On Saturdays, Nathan Bijur came down to work in the studio. Sometimes he brought his eighteen-year-old daughter Jean with him. On her first visit, she remembered seeing a reproduction of a Cézanne male figure with arms raised, pinned to a bulletin board on the wall. No other ornaments were visible in the room. No crisp black drawings as yet. Not many paintings, either. Jean thought the Cézanne drawing was terrible, "but because I had confidence in Gorky's knowledge I stayed to learn how to see and draw in the new European way."

It was the beginning of Gorky's Picasso period. Quantities of paint were being applied, with brush or palette knife, to a canvas on the easel or propped up against the wall at floor level. Nathan was worried about the problem of keeping Gorky supplied with paint, and he paid him $100 a month for the Saturday tutorials for himself and Jean. Edmund Greacen also tried to help keep Gorky in paint, "until he began to use it by the bucketful." Greacen's daughter remembered an occasion when Gorky put a canvas on the floor, mixed up paint in a bowl, and poured it on, confining the shape within a rough cardboard mold. Fond as he was of Gorky, this was too much for Greacen.

Another friend watched him working at a Cubist painting in a frenzy. "He put on paint with a palette knife, brushes, everything. 'What are you doing?' I asked him once [. . .] 'Arshile, you're nuts,' I said. And he retorted, 'You've got to attack, you've got to attack.' "

IN THE STUDIO in Washington Square he moved from Cézanne toward Picasso. In the country he reverted to Cézannesque structures, and he continued to do so right up until the forties. Living with Hagop and Sedrak in Cranston, he left the house early every morning and settled down in Roger Williams Park. He stayed out all day, with perhaps just a sandwich for lunch.

Although Sedrak was now in his sixties, he came home from the factory in the summer when the hay was high and cut a ten-acre field by hand with a sickle, unaided, and turned it over with a fork in the days that followed, and made bundles of it, and heaved it onto his back with a rope, and walked bowed down to the barn to store it for the winter. The kids enjoyed climbing up and jumping down into the hay, and that made Sedrak mad, for Bessie the cow would not eat the grass, he said, if it had been all trampled by children.

Gorky's half brother still refused to recognize that art was a serious occupation. Compared with a day spent in the factory or plowing a field, to go to Roger Williams Park and put marks on a canvas did not count as "work." Gorky avoided confrontations, either with Hagop or with his father. He did not mind being misunderstood. On the contrary, he collected a whole series of stories which stressed the "nonwork" aspect of art, compared with the "real work" of hoeing or gathering hay. In many ways, he even believed it. His way of painting was always intensely physical. He prepared a canvas with the same patient care with which a man might flatten a patch of earth to make it ready for seeding.

All the same, there were some rough moments. Once, at the end of a summer spent in Watertown, Gorky found that he did not have enough money to pay a small bill he had run up at the Armenian Club. He gave the owner a drawing instead. To show how much he despised art, the man tore it up in front of Gorky's eyes.

In 1926 Gorky's maternal uncle Aharon reached America, bringing with him "the two Markrits": Markrit, the wife of his brother Moses; and Markrit, his own, as well as their small daughter, born in Yerevan. They settled near Niagara Falls, where they found a tiny apartment above a grocery store. It was cramped and they were "dirt-poor," as Aharon's daughter put it to me. In winter the snow came up to the windows. But they were safe.

Moses, meanwhile, had been in the United States since 1908. While living alone in America, he had taken up with a German woman. The two of them had no language in common, but Gorky thought this only improved their relationship. Less chance for the happy couple to disagree! Aharon, however, found his brother's mistress hard to take. As in a fairy story, he warned Moses that he should never appear in public with her. Moses agreed. One day Aharon caught sight of them both on the bus, and that was that. Moses and his wife Markrit were reunited, and the German woman disappeared.

Aharon became a man of authority in the Armenian community of Niagara Falls. Those who suffered from arthritis came to him in the spring, and he used to beat them with a nettle which grew in his backyard. Their arms swelled up, and when the swelling went down, away flew the arthritis. He knew how to cure a headache with a raw potato, and otitis by squeezing a mouse between two stones and dripping the liquid into the sufferer's ear. At Thanksgiving he invited all the Armenian bachelors to the house on M Street and went down the line, giving each of them a glass of raki, and pouring one for himself. By the time he got to the far end, he was cross-eyed.

Gorky visited his uncles four or five times during the late twenties and early thirties. One winter, greeting each other in the snow, Aharon and Gorky slipped and fell and rolled down to the bottom of the hill, clutching each other and laughing. Gorky called Aharon *kedi,* meaning "uncle," and *inganis,* "my soul." They loved each other. They were the same height, their heads had the same flat back to them, and they had the same beautiful hands. When the uncles and Gorky danced together downstairs, with a handkerchief between their fingers and the raki bottle nearby, the whole house trembled.

Now and again, to these brothers of his dead mother, Gorky would at last give vent to the reproaches he held against Sedrak, his father. Such occasions were rare, and to no other relatives was he ever so outspoken. Why had Sedrak abandoned them? Why had he not come back and saved them? If he had, perhaps Shushan would be alive to this day, and they would all be united. Sedrak had brought shame onto their house.

BACK IN NEW YORK, Gorky's circle of friends expanded.

In 1927 at the Gypsy Tavern, a coffee bar he favored for many years, Gorky met the photographer Wyatt Davis and his wife-to-be Maryan, who was

Armenian. For a while Gorky came to the Davises' apartment on the corner of Fourteenth Street and Seventh Avenue "practically every day." Even though he and Maryan never talked Armenian together, never discussed the past, the Davises' apartment was one of the few places where Gorky could put on a record of Armenian music in the evenings and dance. A lively and intense man, Maryan thought; sometimes gloomy, but with a sense of humor.

Two of Gorky's closest friends when he lived in Washington Square were Alexander and Helen Sandow. Dr. Sandow was a scientist specializing in the physiology of muscle behavior, and he may have introduced Gorky to his subject. A number of Gorky drawings exist of "the flayed man," a classic preoccupation of Renaissance artists. Mrs. Sandow was a pianist, and Gorky enjoyed listening to her as she practiced. He liked simple, clear forms, like Mozart. Chopin disturbed him. He said that with Chopin, the emotion came too close to the surface.

The Sandows lived on the south side of the square, and whenever Gorky visited them he usually stayed on to supper. While Helen cooked, Gorky sat at the kitchen table making drawings, most of which he left behind. However

Gorky in his studio posing among his work, c. 1929

flamboyantly Gorky may have spoken when in the mood, Helen saw him as a man of great personal modesty. Once, he drew a little portrait of Helen, and as he finished it, he shielded the lower part with his left hand. When she looked at it later, she saw that the lower part of her torso was nude.

Gorky talked constantly about art, and he was highly critical about many of his contemporaries. When eventually they went to visit Gorky at his studio, Dr. Sandow whispered to his wife in the street, "He'd better be good." Luckily, they were not disappointed.

A little later, in Central Park, they came across Gorky on top of a boulder with his easel and paints all around him. Central Park, so intelligently domesticated, where certain clumps of

pine against rock give the same flickering light as shines through Cézanne's paintings of Provence. Laughing, they asked him what he was up to. "I'm skatching," Gorky replied, and immediately gave them the little canvas board on which he had been working.

Isamu Noguchi told Maro that he met Gorky in a museum funded by a businessman just before the crash of 1929. This was probably a foundation set up for the Russian painter Nicholas Roerich by a rich Wall Street broker. Roerich was a mystic, a follower of Madame Blavatsky, and a man deeply immersed in Hindu spiritualism. Noguchi had been asked to make a portrait of Roerich; Gorky was probably brought there by his Russian friends. Nothing came of Noguchi's commission, or if he finished the bust, it was lost or destroyed soon afterward. He told Maro that he and Gorky ate well at the Roerich foundation, but they gave up going when the talk about communication with "the other side" became, in Noguchi's words, "too spooky."

TOWARD THE END of the twenties, at the National Academy where he still went from time to time to see friends, Gorky fell in love with an Armenian girl, Siroon Mousigian. She was a model in one of the life classes—beautiful, with long dark hair. He came to the Academy and waited for her to finish work. In the dim light of the entrance, hung with somber portraits of defunct academicians, his gaunt figure added to the gloom.

When Gorky heard that Siroon was Armenian, and from Van, "it was like the sun had risen after a million years." But if he hoped for instant intimacy based on shared experiences, he was misled. She was only four years old when she had left Van with her parents, and her subsequent childhood in America had been neglected and unhappy. "I needed love and security, but Gorky did not know how to give that." When she was twelve, her father, in the throes of an insurmountable depression, had shot her, not once but twice, in order to save her from the horrors of this world. She had left home as soon as she could, and her feelings about the past—and about her father—were understandably complex.

She lived with Gorky in the studio off Washington Square for less than a year. He painted a large nude of her and drew her constantly, and as he worked, he talked only of Armenia. "He was living in Armenia in Greenwich Village." He thought that everything in America was "vulgar," and often said so. The studio was so bare it hardly needed her own domesticity, but he allowed her to clean his brushes, which had to be done in a certain way. "There was a routine which had to be done, and washing his brushes was quite a big one."

She became his secret island. Whenever he taught pupils in the studio, Siroon was supposed to stay quietly in the bedroom and pretend she wasn't there. Once, Gorky had to go out on an errand, and the pupil, engaged in some

discreet snooping, was most surprised to find a woman distended on Gorky's bed.

He boasted to his friends that she had the look of "the wild horse." But though the image suggested freedom and independence, what it really meant was that Gorky wanted her to be "pleasant to look at, like a statue, but never interfere with his work." His friends doubted that it could last. "It just seemed that his love for this young girl was not so much his love for her as a human being as it was love of his image of her."

He tried to introduce her to the art of painting, and he told her of Cézanne's observations about seeing nature in terms of the cone, the cylinder, and the sphere. "He was very sweet about me. He certainly talked lots. See, I didn't know anything about painting, then." He would have married her, she thought, but there were too many difficulties involved, and he was unable to take the necessary time away from his painting in order to work things out.

If Siroon had her own difficulties with the past, then surely he did too, she thought. If he was Armenian, she asked, then why did he call himself Gorky? The question was unanswerable. He told her that he had met Maxim Gorky as a child, and that Maxim had somehow wished the name upon him. She did not believe it. "If he hadn't told a lie so much, he could have enjoyed being Armenian."

They spent the summer in Watertown, where they shocked Akabi by sleeping together naked. All day he worked hard in the fields, painting. He grew a curly beard. In New York after the summer, the urchins of Washington Square yelled at him, "Take 'em off, Murphy, we know ya!" Gorky was delighted. It became one of his favorite stories.

Back in the city, she met by chance a former admirer whom she had known in California: a Mexican called Fernando Felix who played the guitar. Felix hardly had time to commiserate with her before Gorky appeared in "Phil's" apartment and "dragged me out by my hair." There was more violence when Gorky found a letter from Felix hidden away in a drawer.

She wanted to end her relationship with Gorky, but it was easier said than done. One day she told him that she was going to leave the studio, just for a few hours. She walked over to the next avenue and caught the first bus traveling uptown. After several blocks she happened to glance back—and was shocked to see Gorky there in the road behind her, running after the streetcar, almost catching up with it at every red light. Thus she discovered that whenever she left the studio, Gorky surreptitiously followed her. Once, he caught up with her on Riverside Drive. When she challenged him, he said he wanted her to come back with him to the studio. She refused. Well then, he would kill himself. He ran toward the river and disappeared. She remembered it as an

example of Gorky's sense of humor—of which, she said, he possessed very little. But the memory of him running down to the banks of the Hudson for some reason made her smile.

She fled to her sister in Buffalo. One day she opened the front door, and there he was.

With complete lack of tact, he worked out a plan which he thought would be unbeatable. Somehow, he discovered where her father was living and made friends with him. Secretly, without hinting what he had in mind, he arranged a grand reconciliation during which the customs of Van—the father authoritarian and the child dutiful—were to be restored. But when Siroon saw her father again, she was merely horrified. Indeed, the experience was so crazy it prompted the unfortunate thought that perhaps Gorky and her father had something in common. "He was like my father. If you asked him something, he'd go into a big lecture and bawl you out."

The situation became worse after this failure. "The only way he could deal with me was to get hysterical and hit me and threaten suicide, because he had no sense of another person [. . .] It takes a lot of time to relate to another person, and he didn't want to take the time." The emotions of possession, jealousy, and violence flowed indistinguishably one into the next. They were his proofs of love. He had learned these responses on the shores of Lake Van as a child, and he never doubted that this was how love was. "He was a tortured man, there is no doubt about it. And I recognized his talents. I did. I just didn't feel like I wanted to sacrifice myself."

Finally, the violence reached an intolerable level. "I guess it was hitting me in the face and knocking me down. I said to him, 'You can call the cops or you can kill me, but I'm never coming back to you.'"

In retrospect she felt relieved that things had gotten so out of hand, or else she might never have found the strength to escape. Freed from his control, Siroon made a new existence for herself in the New York theater world. She was amazed to find that there, life was free and easy. "I didn't know people could be so different!" Fascinating, even admirable though Gorky may have been as a man, to be an object of his love was almost indistinguishable from being its victim.

UNION SQUARE

1931–1934

A YEAR OR SO BEFORE the stock-market crash, Gorky found himself a new studio. Nicholas Vasilieff, who lived above a café on the corner of Union Square, probably told Gorky about these rooms, which were just down the corridor from his.

Gorky's arrival at his new quarters had something epic about it. "The previous painter to occupy this immense studio facing on Sixteenth Street was an academic craftsman who had pulled his battered belongings into a hall room, letting this gigantic Modern sweep into his quarters . . . with his bolts of canvas, his mountain of an easel, his many packets of brushes, his cases of pigments, his stentorian commands to the movers."

In the twenties the studio had been a dance school. On the left as one entered, a huge window rose from two feet above the floor and went up to the ceiling. In the late afternoon as the sun set, the room was filled with a pink reflection from the brick backside of Tammany Hall to the right of the studio window. The floor was parquet; the ceiling, pressed tin. A small room opposite the guest room, on the same side of the studio as the front door, was used as a storeroom for paintings. On the opposite side of the big window where he worked, two long windows faced across Sixteenth Street toward Klein's, the

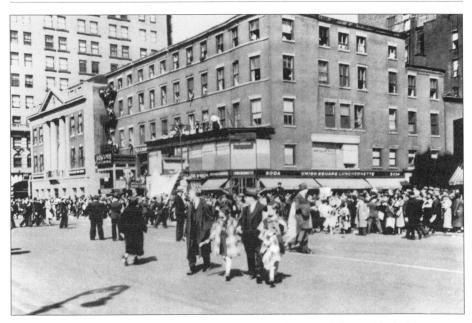

Union Square, May Day 1937. Gorky's studio was on the second floor of the building to
the far right of the photo, on Sixteenth Street.

big department store on the corner. These windows were filled with the zigzag
diagonals of fire escapes and protective iron grills.

His working day was governed by ritual. A certain state of dreamy exhaus-
tion was necessary, he used to say, to create freely and spontaneously. Every
week he pushed all his belongings onto one side of the studio and washed half
the parquet floor with lye, then moved everything over onto the clean side and
washed the other half. After years of this scrupulous habit, the floor acquired
the texture of bleached driftwood.

In the early days, Gorky kept the anteroom dark so that he could remain
invisible when he peeked through the front door, checking to see if those who
knocked were friends or creditors. As a rule, visitors did not just drop in on
Gorky. They tucked a note under the door and made an appointment.

Two or three nights a week Gorky met his friends and colleagues at Romany
Marie's around the corner. Romany Marie was not, in fact, a Gypsy, though she
dressed in long skirts and wore outrageous jewelry: bear claws, and topaz
beads the size of ashtrays. In the thirties when Gorky, Stuart Davis, and John
Graham went there, Romany Marie's was on West Eighth Street, in a converted
brownstone a few doors down from the Whitney Art Club, opposite Rudy
Vallee's nightclub, next to the avant-garde cinema which Frederick Kiesler had
designed. The food was simple. Romany Marie did not serve liquor before Pro-

hibition was abolished in 1933, and thereafter the most you could get was beer. A musician played the accordion in the corner and a model from the Art Students League danced Mexican dances. You could run up a bill at Romany Marie's and pay when you sold a painting, and there was a limit to the debt you could accumulate by drinking tea. Otherwise "everybody just talked, talked, talked all the time." In the early thirties, the talk was of aesthetics. Marie did not approve when in the later thirties the discussions veered to politics.

Stuart Davis was the most mature artist of the regulars at Romany Marie's. He had taken part in one of the earliest group exhibitions at the Whitney Art Club during the First World War. By then he had already achieved a body of work in the style of the Ash Can school. Affected by the Armory Show soon afterward, he turned to cubism. In 1926 the Whitney Art Club mounted a retrospective of his work and Gertrude Vanderbilt Whitney gave him a grant to work in Paris.

Gorky met Stuart Davis in the fall of 1929, after his return from France, through his brother Wyatt. Everything about Gorky was tall, eloquent, poised. Everything about Davis was squat, dry, tough. He spoke out of the side of his mouth, like a gangster in a movie. They met "at all hours of the day or night," Davis wrote later, and they "did not bring each other down." One evening at his brother's apartment, Gorky put some Armenian records on the gramophone and began to dance. But Davis told him firmly, "We don't do that here."

In April 1931 Davis held an exhibition of his recent work, taking care to call the show "The American Scene." The mood of the country was increasingly isolationist. The stock-market collapse in the autumn of 1929 had been followed by an economic recession the scale of which was becoming more intimidating every day. It was not a good moment to follow the School of Paris. Davis—speaking gruffly as usual—later remembered a critic's remark about the exhibition: "It sticks in my craw a little to see a swell American painter painting French." He added, "After you leave Paris you are not supposed to know the French exist."

As most of the paintings consisted of Parisian street scenes, the "American" aspect of the show needed clarification. In December the painter John Graham—another regular client at Romany Marie's—wrote, "Stuart Davis, Gorky and myself have formed a group and something original, purely american is coming out from under our brushes. It is not the subject matter that names painting american or french, but the quality, certain quality which makes painting assume one or the other nationality." He went on to describe one of his own compositions, painted in Paris, of which he had just completed a second version painted in New York. Though the compositions were identical, he wrote, one was French, the other American.

When the magazine *Creative Art* asked Davis who could write an article on his work, Davis told them, "I want somebody who thinks I'm pretty good. Obviously, I don't want somebody to break me down. What about Gorky?"

The article took forever to write. Whenever Gorky came to Romany Marie's in the weeks that followed, Davis would ask him how it was coming along, and invariably heard that it was "almost done." Gorky never showed Davis what he was writing, and when the piece finally came out, Davis thought that Gorky had "laid it on thick—at that time it seemed too thick. The phrase 'mountain-like' as applied to me was particularly embarrassing, and various persons of my acquaintance in Cafeteria Society lost no time in making the most of it."

Gorky's words were: "He, above his contemporaries, rises high—mountain-like. Oh, what clarity. One he is, and one but few," etc. When Gorky spoke about art, he expressed his feelings in absolute terms. What he most wanted to convey to the reader was that art was dramatic, irresistible, irrevocable.

In fact, Gorky's article was built around some remarks which Davis himself had made in an introduction to the exhibition. "I conceive of form (matter) as existing in space in terms of linear direction." Davis thought that the composition of a painting extended outward "in terms of angular variation from successive bases of directional radiation." In other words, the artist imagined that the space surrounding an object was filled with projecting shapes, and that these shapes could be painted onto the canvas as if they were just as real as the objects themselves.

To Gorky, what was attractive in this idea was its precision. He wrote that form, in Davis's canvases, was "clear, more definite, more and more decided." Whatever Davis painted, "whether egg-beaters, streets, or pure geometrical organizations," he "expresses his constructive attitude towards his successive experiences. He gives us symbols of tangible spaces, with gravity and physical law."

Davis and Gorky diverge slightly. Whereas Davis, the practical, down-to-earth artist, saw these forms as solid, for Gorky they were "symbolic." Ideas which in Davis are dry and staccato, in Gorky's version become lyrical. Gorky writes of "tranquillity and expansion as elements of feeling in painting." Even when Gorky makes a mere list of colors used by Davis, his words have a romantic feel: "green, brown and chalk-like white, metallic grays and dull blacks, profound spaces with sky-like blues."

FREDERICK KIESLER, the designer of that avant-garde cinema two doors down from Romany Marie's, came to New York in 1926 with a reputation as a radical theater designer. He stayed on in the city for the rest of his life, always in financial straits, seldom able to carry out his extraordinary ideas about spa-

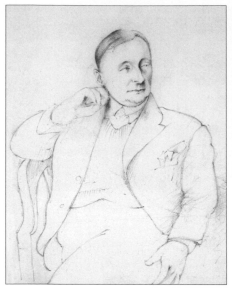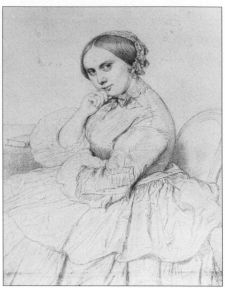

tial relationships in architecture, but always in touch with the latest ideas of the art of his time.

Kiesler and Gorky must have met soon after his arrival in the city, and in 1926 Gorky brought him to the Grand Central Art School to give some lectures. In 1928, Kiesler received a commission for some store windows from Saks Fifth Avenue, and this moment of relative security enabled him to take Gorky out to supper at a Greek restaurant called Pappas. Mr. Pappas liked Gorky, and Armenian and Greek food had much in common.

Kiesler possessed an extraordinary imagination, and he was constantly trying to think of ways to escape from the conventions of architecture and replace them with spaces which were fluid and interactive. Floors, walls, ceilings, furniture, and objects must be conceived as one entity. One should bridge the gap between two-dimensional and three-dimensional art. One could even aim for a four-dimensional art, like the theater, with its action restricted to a specific period of time.

Was the universe a movie, a projection onto a two-dimensional surface? Could a blind man imagine form? What would a blind person's dreams be like? Could one re-create them in two or three dimensions? Does color have a taste? He himself could guess color by touch, or so he claimed, and no doubt many an enjoyable evening at the Pappas restaurant was spent testing this unusual gift. Mr. Pappas, when asked about Gorky and Kiesler many years later, described their evenings together as "long, loud, and full of emotion."

Gorky often drew Kiesler. One drawing that survives indicates the complexity with which Gorky approached portraiture. He copied the head from a

(far left) Arshile Gorky, *Portrait of Frederick Kiesler*, c. 1938

(left) Jean Auguste Dominique Ingres, *Portrait of Madame Ingres, née Delphine Ramel*, c. 1855

(right) Frederick Kiesler in front of his "e. e. cummings Galaxy," New York, 1947

photo and the arm from a drawing by Ingres. He was fond of the pose where one hand is raised to the cheek. Since classical times, this gesture has indicated affection for a friend, and thoughts about eternity. The drawing is as much about antiquity as it is about Kiesler, but Gorky had no problem in imbuing his friend with the characteristics of another culture, another period.

Kiesler was a friend of the French painter Fernand Léger, whom he had invited to Vienna in 1925 during an exhibition of theater design. They often discussed ways in which paintings could be incorporated into an architectural setting. Léger enjoyed the company of architects. He established a long friendship with Le Corbusier, and together they planned for something like fifteen years to create buildings, though they never found a client willing to finance them.

Just as Kiesler wanted to break down the barriers between one spatial dimension and another, Léger was obsessed with the idea of reducing the distance between a work of art and its public. From the late twenties on, an argument developed in the French press concerning Léger's view of the "new realism." The argument changed as it developed, but essentially it was about whether the painter should eliminate the "subject" in a painting and concentrate on the "object" it entailed. A "subject" implied a message for which the painting found appropriate images. Examples: "motherhood," "patriotism," "jealousy." This idea, in Léger's view, was wrong. The image depicted in a painting should have no ulterior function. A leaf was a leaf; an umbrella, nothing but a humble umbrella. Even the emotional overtones of "sensation," with which Cézanne or even Matisse charged such objects when they used them in their paintings, had to be avoided.

Léger came to New York in October 1931 for an exhibition of his drawings, and Gorky could easily have met him through Kiesler at that time. He certainly knew him when Léger returned to New York in 1934. During his first visit, Léger wandered about the city in a daze, overwhelmed by its scale and its energy. Strange fantasies filled his head. The traffic, for instance, reminded him of his native Normandy, because it moved like sheep. He wondered if the authorities would let him paint different avenues in different colors: Fifth Avenue, red; Madison, blue; Park Avenue, yellow. And what about green? Why wasn't New York greener? Doctors of science had proved that the color green was as indispensable to living as fire and water. Maybe the fashion world could cooperate and launch a series of green clothes? Or one could have a color-dictator choosing the colors according to a time scale. The blue trimester; the pink fortnight. It was the kind of zany idea that Gorky would have found both amusing and "innocent."

IN 1929, living in a small room in Paris, Stuart Davis nailed a pressed-tin eggbeater to a board and made numerous drawings from it—a classic exercise, but substituting the modern mass-produced object for the traditional artist's collection of bowls and fruit. In the composition, of which Davis made numerous variants, shapes suggested by examining the little machine were isolated and mingled with shapes taken from the room in which the artist was working. The series had a profound influence on Gorky, both as an image, elements of which he borrowed, and in the implication that something could be learned by making a long sequence of almost identical works.

Gorky's series centered on a composition he later called *Nighttime Enigma and Nostalgia*. It was started in about 1931, around the time when he wrote his article on Davis. Gorky went on with it for at least three years. The composition is made of interlocking shapes, as if Gorky were creating a three-dimensional object. On a base tilting toward the horizon are set three or four vertical shapes, so "clear," as Gorky might have put it at the time, that they look cut-out rather than drawn. It is as if Gorky, in his workshop off Union Square, were making a series of Van plows.

Gorky borrowed from Davis the establishment of hard recessive space using the diagonals of the picture frame, and the creation of lozenges containing fractured elements of the image. But *Nighttime Enigma and Nostalgia* also took some devices from another source: a mural decoration by the French surrealist André Masson, which Gorky discovered in an art magazine. It shows that even in the early thirties, Gorky was aware of surrealist automatic techniques.

Some of the drawings are "empty" and some are "full," in the sense that some are line drawings and some heavily worked, with endless cross-hatching

Arshile Gorky, *Nighttime Enigma and Nostalgia*

André Masson, mural for Gaston David-Weill

in India ink accumulated over days of work. To create a series of almost identical drawings from one basic structure went against the whole aim of "automatism," which was to free the artist from his inhibitions by creating spontaneously, without premeditation or final aim. Although he may have known about surrealism even as early as this, it was another ten years before Gorky was able to emulate its spirit.

One summer in the early thirties Gorky went from Watertown, where he had been staying with Akabi, to Gloucester, Massachusetts, in order to spend a few days with Stuart Davis. I have a feeling that the earliest studies for *Organization,* the key canvas that Gorky painted in the mid-thirties, were made here. Davis was drawing a series of mechanical elements seen at the waterfront: davits and cranes and moving parts, as if the mechanism of real implements could be echoed in the mechanism of a painting. I think Gorky followed

his lead. In the final versions of *Organization* the mechanical infrastructure is not visible, but the photo of Gorky and de Kooning in the Union Square studio taken in the mid-thirties shows an early state of the painting with the mechanical infrastructure still visible.

After the visit was over, Stuart Davis accompanied Gorky back to Watertown. Gorky invited him into the house, and showed him drawings he had made at the New School of Design, seven or eight years before. "A large number of his art-school period drawings were on file," Davis wrote. "These were done in the orthodox life- and portrait-class style. But his genuine talent was clearly expressed within the framework of ideas required in such studies, and I found them stimulating, distinguished."

GORKY OFTEN STAYED with Akabi during the summer. New York was no place to be when the city entered its hot and steamy phase. Besides, Gorky loved the country. He soaked up the sun and derived energy from it, coming as he did from a part of the world where the winters were long and rigid.

From Akabi in Watertown he sometimes went over to Hagop and Sedrak in Cranston. Toward the end of the twenties, he witnessed a strange and disruptive event. Sedrak, his own father, had fallen in love. Soon after, in spite of his advanced age and the protests of his family, he married.

Sedrak's third wife, Akabi Sarafian, ran a boardinghouse in Providence, and Hagop's daughter remembered seeing her there as a child. The meat for the boarders' meals was heaped up in the bathtub on the top floor. She also recalled how this step-grandmother-to-be dressed to go out wearing two hats, one on top of the other. Behind her, the lit-

From left to right: Akabi Serafian, Gorky's father, Sedrak, and a friend, c. 1928

tle girl noticed various strings hanging from underneath her bodice down over the top of her skirt, the untied laces of her old-fashioned stays.

Akabi Sarafian was a widow with two children. Such was Sedrak's love for her that he gave these children many presents and indulged them more than he had ever indulged his own. Hagop did not approve. Tensions surfaced.

Sedrak and Gorky had failed to become friends in the four years before Gorky's move to New York. Any chance that they might still make amends, even at this late stage, evaporated with Sedrak's third marriage. Yet the couple were in love, and love always has something grand about it. The magnificent photograph of Sedrak with Akabi Sarafian and her daughter gives out a rare glimpse of happiness, in a family whose emotions were otherwise cramped by tensions.

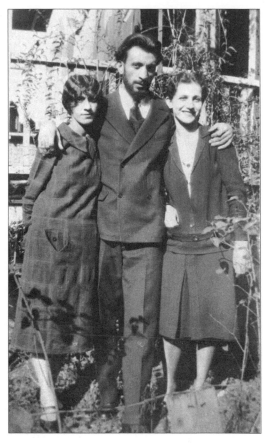

From left to right: Vartoosh, Gorky, and Siroon Mousigian, c. 1928

Love was one of the few ways in which the archaic Armenian ways, which still survived even in America, could be broken. Satenig and Vartoosh married for love, against the opposition of their families. Satenig was eighteen when she fell in love with a young man ten years older than herself. They were married in 1919, on the same day on which (as ill luck would have it) Shushan died, back in Armenia. Vartoosh was married four years later to Moorad Mooradian, and again there were protests. "But he's not from Van!" Indeed, Moorad came from Shadagh, and was part of that earlier background Shushan had often described to her Adoian children in a romantic light. Vartoosh sat over on one side, combing her long black hair, murmuring, "I love him."

Hagop, Sedrak in his first two marriages, even Gorky's sister Akabi—all

had had arranged marriages, and all three had suffered emotional stresses as a result. That for a year or two Sedrak, a whole generation older than his daughters, broke free, was a breath of fresh air.

The marriage did not last long. Sedrak's third wife died in the early thirties. Her only legacy, as far as Sedrak was concerned, was a certain awkwardness with his eldest son, Hagop, under whose roof he was still living.

UNTIL NOW Gorky had made no attempt to incorporate his memories of the past into his work. This did not mean that he tried never to think of Khorkom or Van. On the contrary, they were with him constantly, especially when he assumed that state of innocent reverie which he felt was vital in order to paint. The question was one of idiom. There seemed to be no way of adapting Léger's "poesy of the object," or Picasso's vocabulary of Synthetic Cubist forms, to what he remembered of a little village in Turkey, long ago.

Gorky's attitude toward his past was complicated. When his friend Helen Sandow asked Gorky about his background, Gorky told her that he had come from a village in Russia which, during the civil war of 1920, had first been overcome by the Bolsheviks, then by the Whites. It had been plundered mercilessly by either side, and he had had to flee. But this was not Gorky's past. It was almost what had happened in Khorkom, but a thousand miles away and to a different person. It was John Graham's past. Graham had fought as an officer in the White Russian army and had witnessed some terrible incidents during the civil war. Gorky trusted Helen Sandow. If he couldn't talk about Khorkom with her, then he couldn't talk about it with anyone.

Gorky and Graham arrived in New York at about the same time, Graham from Russia, Gorky from his family in Boston. Graham became a member of David Burliuk's circle of émigrés, and Gorky probably met him there. The fact that Gorky should offer Helen Sandow John Graham's past instead of his own reveals how close he felt to him, and for many years Graham exerted a powerful influence on Gorky. Most of the intellectual apparatus which Gorky tacked onto his convictions came from Graham. After their friendship ended, Gorky made no attempt to add to his repertoire of arguments.

John Graham's feeling about the past, like Gorky's, was vivid. To Graham, the senses of smell and sound and vision were intermingled. He described his memories of Russia in a memoir, which has survived. The sound of the muffled knock of a new wooden gate. Empty rooms in a newly occupied house. "Chairs in white slipcovers reflected in mirror—ghost furniture." Fresh coffee in the morning, smelling of gooseberries. A pair of cheap ice skates which, once used, rusted away overnight, "like dying flowers." Photos of wrestlers in his father's newspaper, whose images were made of small black dots that ran

together, and the dots smelled. The samovar on a spotless white cloth. The music box that played "across the rooms from wall to wall into the soundless air of the parlor and sounds will be suspended as if by unseen hooks in timeless space between."

John Graham, like Gorky, was obsessed by the past but reluctant to reveal it. Neither Graham nor Gorky was prepared for the instant self-revelation which is one of the great gifts of American civilization. Waiting in line for the crosstown bus, was Gorky supposed to tell the first inquisitive stranger that he was Armenian? That his mother had died of starvation at the hands of the Turks? That his grandfather had been crucified on the door of his own church?

Graham, like Gorky, protected himself with lies. But whereas Gorky told plausible lies—that he was Russian and had studied at Brown—Graham's lies were utterly hyperbolic. Graham said that at his birth, his mother had rowed out into the middle of the Black Sea to a "black barren ghost of a rock, standing there like a dagger thrust into the sky," where "a gigantic monstrous eagle" flew in a thunderous sky, holding in his claws a "naked new-born baby." And that was him! In case this account invited skepticism, he added firmly, "This, in fact, was my first memory of my life, my life started from this point on."

"My skin is my first sky heaven," wrote John Graham. Gorky, echoing Graham's manner, referred to the beautiful women he occasionally frequented as "sky babies." Gorky's lies were never as flamboyant as Graham's, but they served the same purpose: to reveal, even as you set out to disguise, and under the cover of a truth which is also a lie, to try to reconquer your own lost world.

Gorky learned from Graham a certain attitude about *feeling* in paint. Graham was obsessed by many sensations that went beyond words. One of them was "enigma," meaning the quality of emotion which a work of art could carry—the far side of its physical appearance, as it were. Another was "nostalgia," in the sense of endowing a work with the accumulated weight of the past, not necessarily in its figurative references but in its mood.

It was from John Graham that Gorky learned that "originality" in art was something to be avoided. It flowed naturally from one of Graham's basic principles: "Art means artificial. Only artificial things are good in this world." Who had ever heard of an "original" taxi driver, or surgeon, or violinist? The painter should make a painting with the same honesty with which a violin maker constructs an instrument. Originality, to Graham, was nothing but "a cheap trick of an ignorant and vulgar yokel. In fact there is nothing more vulgar and incompetent than originality."

Given his views on originality, for a while at least Graham respected

Gorky's need to paint in the style of others. Graham told a friend that Gorky even emulated the lives, as well as the styles, of his heroes. He'd even had a Modigliani moment, complete with Modiglianiesque girlfriend and Modiglianiesque beard! (This must have been when Gorky was living with Siroon Mousigian.) Once, Gorky sat down in front of Graham in a café and drew a Picasso, complete with signature, without a moment's hesitation. Graham told the story with awe in his voice.

Graham saw that for someone like Gorky, coming from so far away, the need to acquire the culture of the West was much stronger than for those who were born there. It was more than a question of "influences." He had to claim imaginary brothers and place them by his side. "What about Papa Cézanne," Gorky wrote, and what about "that man Pablo Picasso." Cézanne was dead and Picasso was not the most amenable of elective brothers, but the principle was there. It was not just a matter of apprenticeship, but of family.

Graham had strong ideas on the language of modern art. He had visited France, and to listen to him was almost as good as sitting in a café in Paris within earshot of the masters. "The point of departure for an abstract painting is nature, even though the conclusion may be far removed from it." Abstraction was the "transposition" of the object observed into "simpler, clearer, more evocative and more final forms." It was the "evaluation of form perfectly understood."

A canvas was "a two-dimensional proposition." Any hint at three-dimensional "illusionism" was to be avoided. "Perfect two-dimensional form speaks of objects' three-dimensionality better, more fully and more poignantly than shadow painting possibly can." To add shadows to shapes was to "conceal shape rather than elucidate it." The Byzantines and Paolo Uccello "painted flat." To John Graham, the Italian Renaissance had been a mistake, due to the fact that Giotto and Piero della Francesca had "misunderstood" the lessons of Byzantine painting and its last great heir, Paolo Uccello.

Gorky took all this to heart, and there are constant echoes of John Graham in his teaching. When he told his pupils at the Grand Central School to draw the spaces between one object and another, Gorky was reiterating a precept of Graham's: "Shapes excluded and shapes included are equally important." When he told Raphael Soyer not to put a highlight on the hair in a portrait, or when he told Jacob Kainen to turn some curling smoke in a painting into a shape, he was echoing Graham's precepts that flat forms were eloquent while modeling was not.

A painting was "materialistic," in the sense that it had to be aware of the means by which it was made. "It operates in the medium itself as a carpenter or steel-worker does." The "edge" where one shape met another was vital. "The edge of paint where one color meets the other ought to be absolutely

spontaneous and final," wrote Graham.

Both Gorky and Graham saw painting as a performance rather than as research. They both possessed a sense of the dual physicality of paint: the responsive feeling within the artist's own body as the paint was applied, and the look it acquired when placed on the canvas. "See the excitement of the brush," Gorky told a pupil who was watching him working, as if the brush in his hand possessed a life of its own. "Artists' touch is magic," wrote Graham. The moment when the brush touched the canvas was one of "infinite tenderness and longing." Or else, when things went badly, it became as "mechanical as a robot's caress."

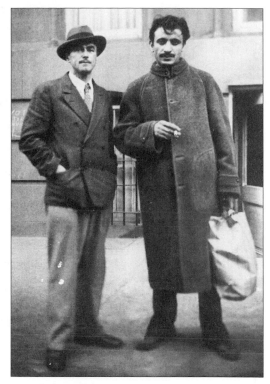

John Graham and Arshile Gorky, c. 1934

A painting could go on forever. The effort was worth it, even if the result was a uniform gray mass of all the available colors mixed together. Sometimes it worked. Like a primitive man making fire, the artist rubbed two sticks together amid growing frustration. You gave up in despair. "Perhaps," wrote Graham, "if you had kept on trying only one minute and a half more a blue flame would have risen up!"

JACOB KAINEN, a young painter who was willing to learn from both of them, was a witness to their friendship, and he often accompanied Graham when he visited Gorky in Union Square. Both men needed Kainen's presence when they were together. "They were probably too well aware of each other's vulnerabilities," wrote Kainen many years later, "to bear being alone together for long periods."

Graham usually took the initiative in these meetings. Had they seen this painter? What did they think of that work of art? "At intervals he would ask for our opinions, somewhat crisply, like a schoolmaster making certain his pupils were absorbing the lesson. Gorky was unusually deferential to the genial Graham, who radiated arcane knowledge."

Sometimes a certain tension grew up between the two men, as if Gorky felt he should be saying more but hesitated to intervene. "I don't know how to interpret this situation, which didn't seem to have affected their attraction for each other." Behind his back, Graham warned colleagues at Romany Marie's that Gorky was impossible. And Gorky would do the same. But when they met, they threw their arms around each other and swore to be the best of friends.

Many years later, long after Graham and Gorky had let their friendship lapse, Kainen came across the two men in a gallery, standing in front of *The Triumph of Bacchus* by Poussin. Kainen was stunned by the richness of the analysis which Gorky and Graham made, treating him once again as a pupil. Kainen knew a certain amount about the way in which a canvas could be arranged structurally, but this was something else.

They pointed out the firm scaffolding of verticals and horizontals: the verticals of trees, the torch at the right-hand side, set at right angles to the horizontals of the chariot and the various layers of receding ground. Onto this infrastructure, the wheels of the chariot set up a lively circular movement, which was echoed throughout the painting: the horse's rump, the hoops of clothes around the figure on the right-hand side.

Graham pointed out the static weight of the chariot over to the left, and the

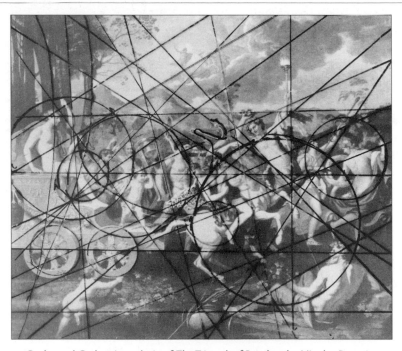

Gorky and Graham's analysis of *The Triumph of Bacchus*, by Nicolas Poussin

different tensions of the ropes, some slack, some taut. One movement ran right through the painting, from the rope attached to the hub of the chariot wheel up through the lance held by the woman at the back. Another taut rope, discreetly painted, anchored the horizontal in the middle of the composition.

Gorky said that the flame from the torch was at the top both of a vertical and also of a complex diagonal, which started at the cherub, lower left. Meanwhile, the spotted leopard-skin coat over the white rump of the horse continually returned the onlooker's attention to the center of the picture. "All that movement and thrust," said Graham, "and yet the effect is static, so you can contemplate the formal order."

GRAHAM BROUGHT two other young painters to see Gorky: David Smith and Dorothy Dehner. Gorky assumed a didactic role. "They don't look like artists to me," he said to Graham, as if they weren't listening. "They look like college kids."

While his back was turned, Smith propped up against the wall two small paintings he'd brought with him. Though he later became famous as a sculptor, David Smith started out as a painter. Gorky turned and looked at them. "Well," he said, perhaps gloomily, "he is not without talent."

Dehner felt a certain resistance well up inside her. Was their relationship going to be formal? Did this man think of himself as a Master? She looked at him closely. Surely he was not much older than they were. When Gorky showed them his paintings, she was even more puzzled. Here was a Cézanne, there a Matisse. Then he brought out a Picasso. My God, she thought. This man can paint like anybody.

In spite of this awkward beginning, a friendship grew up. Smith even came and observed Gorky in his studio. "I remember watching a painter, Gorky, work over an area edge probably a hundred times to reach an infinite without changing the rest of the picture, based on Graham's account of the import in Paris of the 'edge of paint.' " They met at the local café. They planned to make a painting together: David Smith, John Graham, and Gorky. They even got as far as choosing the colors: raw umber, raw sienna, burnt sienna—no others: it would have to have a limited palette. They wondered what size canvas would be suitable. . . . A nice idea, even though nothing came of it.

Raising his voice at Smith in a café one day, Gorky called him a "German sausage-maker." Not the pleasantest of compliments, perhaps. But you couldn't throw a remark like that at someone who was not a friend.

FROM THE POINT of view of the history of painting in New York, the most fascinating friendship of Gorky's early years was with Willem de Kooning.

They met in the late twenties, perhaps early thirties, at the apartment of Mischa Resnikoff, the Russian painter who had known Gorky while he was painting "Armenian sunsets." Gorky was standing over on one side of the room next to John Graham. Seeing de Kooning, Gorky said without preamble, "You look like a truck driver." Naturally, de Kooning bridled. If he thought he was a truck driver, he replied, then perhaps he'd better "take on the ways of a truck driver." Meaning, if Gorky wanted to have it out right there and then, why, de Kooning was ready. Gorky just laughed. Look how long my arms are, he said, stretching them out in front of de Kooning's face. And indeed they were very long arms. Much longer than his.

De Kooning wanted to dismiss this tall confrontational man with a black mustache. The woman who was with him, however, calmed him down. She was a tightrope walker and had come across all sorts of people in her life. She thought Gorky looked like an interesting person.

The next time de Kooning saw Gorky was at another artist's party. Gorky was slumped in a chair ignoring the guests. De Kooning looked around for an art magazine and leafed through it until he found something interesting. He took it over and showed it to Gorky. But he made a dismissive gesture. Well, said de Kooning, it wasn't supposed to be the best painting in the world. Maybe he didn't even like it himself! But at least Gorky could have made the effort to start a conversation.

Maro and I met de Kooning only once, on December 4, 1975, many years before I thought of undertaking this biography. De Kooning invited us to his studio in East Hampton and talked to Maro about her father for ten solid hours. In the fortnight that followed, I typed out a detailed account of the conversation. I doubt if I have managed to write down his actual words, but of all my research, this text is the one for which I am most grateful.

De Kooning often saw Gorky sitting at a table in cafés, drawing on napkins or whatever paper came to hand, usually in the company of Davis or Graham. There was something strange about the endless repetition of the same classical head, he thought, the same perfect profile in the style of a Pompeian fresco, or of Picasso's idea of Pompeii. At that time, de Kooning told us, he himself had been more interested in "the man on the corner of Second Avenue." It was a difficult moment in the history of New York. There was the Depression, the lines of unemployed, the shantytowns. Lots of strange and interesting things were happening all over the city. And here were Gorky and Graham, dressed immaculately, sitting for hours at a café table, evoking a classical world that had long since lost its capacity to evoke a response.

De Kooning saw Davis, Gorky, and Graham as "the Three Musketeers." They dominated the café. Graham was usually dressed in an overcoat and neat homburg. Younger artists were expected to sit at a respectful distance and

speak only when invited to do so. Once, when Gorky was talking about the
wonderful "abstract" qualities of Paolo Uccello, with his capacity to combine
fantasy with firmly delineated shapes, Joseph Solman asked tentatively,
"What about Piero della Francesca?" "Piero?" asked Gorky loudly. "An acade-
mician!" And went right on talking about Uccello.

Another time, de Kooning tried to join a conversation between Gorky and
Stuart Davis. He'd just discovered a great painter at the Metropolitan Museum,
he said. Did they know about him? Oh? they replied. Who would that be?
Well, said de Kooning, his name is Nicolas Poussin. Oh? And you think he's
good? Sure! Hmm. *Really* good? So, deadpan, Gorky and Davis dragged out the
discussion, speculating at length about whether this new guy had anything to
say, until finally Davis said, out of the corner of his mouth, "Well, I don't
know. Sounds like a foreigner to me." At which point it dawned on de Kooning
that they might, in fact, have heard of Nicolas Poussin already.

There was not much de Kooning could tell Gorky on the subject of art in
the early days. At the Metropolitan, de Kooning found a little Simone Martini
he'd never noticed before. The next time they were at the Met together, he told
Gorky about it; only by that time he had forgotten the name of the artist and
what room the picture was in. Gorky nodded and took him straight to it.

Everything that Gorky said about paintings in museums was unusual. In
front of a Raphael Madonna, he pointed out to Jacob Kainen "the landscape-
type scale in the shoulders." In the same way, what thrilled him about the
Ingres reclining figure was the extension of the back, as if all the world's prob-
lems could be solved by stretching out the vertebrae to impossible lengths. To
most people, Ingres is a formal, almost austere artist whose distortions are
much less drastic than those of his contemporary, Delacroix. But Gorky exam-
ined them closely and found in the bend of a sleeve, in the arrangements of
folds of painted velvet, whole mountains and valleys.

Crossing Union Square one day, de Kooning saw Gorky in the street and
stopped him. He had heard, he said, that Gorky was a fine artist. Would there
be a chance of seeing his work? Gorky said, well, they were right by his stu-
dio. Maybe he should come right up?

So de Kooning went up the dim stairs off Sixteenth Street, and when he saw
Gorky's studio he was "bowled over." Everything about it was beautiful: the
immaculate floor, the huge easel, the row of pots and jars slowly gathering
dust on a special ledge. The photographs in black and white of blown-up
details from Paolo Uccello's *Battle of San Romano*. Uccello's predella-like *Profa-
nation of the Host*, hung vertically instead of horizontally so that the composi-
tion could be studied without the distraction of its narrative. And, finally,
Gorky's own paintings.

With pride, Gorky showed de Kooning his early works in the manner of

Cézanne. De Kooning admired them—and indeed understood them very well. The *Still Life with a Skull,* for instance. Close-up—de Kooning told us—you could see how it was a Gorky and not a Cézanne; the brushstrokes were livelier, faster, more flickering. But at a distance of two or three feet, anyone would swear it was by Cézanne. And that little painting of figures on a beach—the one which Gorky had painted while he was still on Ellis Island. (Gorky did no painting on Ellis Island; it must have been one of his stories.) What a wonderful painting! How precocious he'd been! "After all," concluded de Kooning, "Ellis Island practically isn't even America!"

De Kooning understood better than anyone that these works were more than just exercises of style. They were paintings in their own right, filtered through someone else's mind. As de Kooning put it in a recorded interview a few years after we saw him, Gorky "never liked 'use.' Here's somebody I can 'use.' " In other words, Gorky did not "use" an idea but entered into it to a point where it became a part of himself. It was a question not of style but of spirit.

In de Kooning's studio, though Gorky still assumed a certain authority, he never spoke as a teacher to a pupil. In one painting, de Kooning had put a man, a bird, and a hoop. Gorky said: "Pretty soon that bird is going to fly through the hoop." De Kooning immediately realized he'd been wondering about that, in the wordless way one does when working, except he hadn't gotten around to making a decision about it yet.

In another painting, he'd included a dead man, and Gorky had said: "That man is really dead." He always knew, said de Kooning, the right thing to say about a picture. "You see, he spoke the language of painting."

Then came the day when Gorky did not feel quite so supportive. He said, "Very good, Bill. Very *original.*" De Kooning did not know at the time that the question of being "original" had been amply discussed between Gorky and John Graham. But he caught the tone of voice. "The way he said that word 'original,' " de Kooning told us, "it didn't sound as if it was the right thing to be."

For at least ten years de Kooning was profoundly influenced by Gorky. The dealer Sidney Janis once described meeting de Kooning at Gorky's studio, "and Gorky would hold forth in his usual way." De Kooning was "sort of the little boy in the background and he would sit very quietly, and Gorky took over."

Once, de Kooning found Gorky engaged in a carpentry project in the studio. De Kooning offered to help, so Gorky set him up with a vise, a block plane, and a long piece of wood. De Kooning started truing an edge. He'd studied crafts in Holland—he'd been good at that kind of thing as a kid. But Gorky,

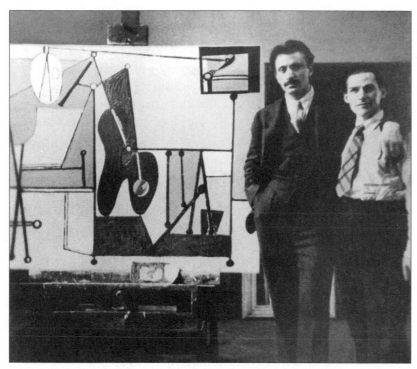

With Willem de Kooning in Gorky's studio at 36 Union Square, New York, 1934

catching sight of him taking his time, going carefully, getting into the rhythm of the thing, said, "That's not how you do it." He came over, placed his hands over Bill's from behind, and gave the plank a hard, gigantic sweep. Crushed beneath Gorky's hands, one of de Kooning's fingers was pressed against the wood. A painful splinter entered. Sucking his finger—as indeed he did again when he told us this story—de Kooning was naturally mad as hell. What did Gorky do that for, for God's sake?

Gorky unexpectedly collapsed. "Oh, Bill," he said, deeply apologetic, "you only have to be with me some of the time. I have to be with myself all of the time."

Of course, de Kooning forgave him. Gorky's relentless side was a part of him, and if you wanted to be his friend, you had to go along with it. "He didn't care." Gorky had "no feelings, socially." He never bothered to hide the fact that he was bored by other people. "I might be bored myself," de Kooning said, "but I didn't see any reason I should show it."

At the opening of a painter's show, Gorky came right up to the artist and told him in a most exaggerated way how much he liked his work. "My," he'd said loudly, "what faces! What expressions!" Then, mouthing at de Kooning

over the man's shoulder, What *faces*! What *expressions*! Did Gorky honestly think that his sarcasm had gone unnoticed? de Kooning wondered.

At parties, the thing Gorky liked best was dancing. He'd take off his jacket and reverse the sleeves, and the lining was silk. (In telling us this story, de Kooning stroked an imaginary sleeve to give us an idea of its delicacy.) With silk arms, the jacket lost its character and became something much more exotic. "He liked those old Greek or Armenian dances where you grab a handkerchief and kick your feet. It took up a lot of room. He also liked flamenco. That was dramatic, you see. Gorky liked drama. I once saw him dance," said de Kooning, "with one of those instruments made with just of a lot of wires. You held it above your head and you whirled it round, and it made a noise. The faster you whirled it, the louder the noise. That was dramatic enough! He could have taken a man's head off with that thing."

Otherwise, said de Kooning, Gorky did not care much for music. Except, one day he came around to the studio and asked for de Kooning's record of "that breathless fellow." De Kooning couldn't figure out who Gorky was talking about. Then he understood: Louis Armstrong. That showed Gorky wasn't as indifferent as he pretended, de Kooning told us, and to prove his point, he sang "On the Sunny Side of the Street," complete with breathlessness.

De Kooning saw, heard, remembered. Fragments came back to him in later years. As they emerged from a movie house, Gorky remarked casually, "How terrible life must be under Kay Francis's armpits." De Kooning told this to the poet Frank O'Hara during the late fifties, and he wrote a poem about it.

Though Gorky was always in front and de Kooning the one who metaphorically padded behind him, there was, even then, something protective about de Kooning's affection. Whereas most of his other colleagues in New York found Gorky hard to take, de Kooning always defended him. And it was to de Kooning's studio that Gorky went whenever he felt too discouraged to go on. He would walk to his studio and shout up the stairs, "Bill, Bill," and de Kooning would invite him up or else come down. They would sit quietly in a café all evening, talking. A café rather than a bar, as Gorky wasn't a drinking man. No, de Kooning told us, he never drank. With Gorky, it was always, "And that's another cup of coffee. That's another piece of pie."

In the park, after a long silence during which Gorky and de Kooning had been sitting side by side on a bench, Gorky turned and said, "Look at those feathery trees. . . . They're so wonderful. You know, I really feel like painting feathers." Without de Kooning's faithful memoirs, it would be impossible to catch, today, the bizarre quality of Gorky's humor.

Outside, Gorky had a definite street persona. There will come a day, he would tell anyone listening, when everyone will be their own artist. And

point out cracks in the pavement, the space between two buildings, a fire hydrant or a cobbler's sign as evidence of the spontaneous outburst of art. Many pupils and friends who later established their own careers remembered Gorky's remarks and left their own accounts of walking in Manhattan with him: Balcolm Greene, Will Barnet, Frederick Kiesler, and Raoul Hague. One student at the Grand Central School of Art recalled how Gorky "would walk around the streets of New York and point to an itinerant sign that was probably painted by a man who owned a shoe store or a shoe repair store or a man who owned a fish store and he'd say, 'This is the most authentic work of art in New York City.' Which seemed very unrelated to my previous training as to what would constitute a valid work of art."

De Kooning was impressed by the idea. One of his friends, Edwin Denby, remembered "walking at night in Chelsea with Bill during the depression, and his pointing out to me on the pavement the dispersed compositions—spots and cracks and bits of wrappers and reflections of neon-light—neon-signs were few then—and I remember the scale in the compositions was too big for me to see it." "He pointed to instances—a gesture, a crack, some refuse, a glow—where for a moment nature did it, the mysteriousness you recognize in a masterpiece."

There was a slight difference, however, between what Gorky and de Kooning saw in the streets. With de Kooning it was not so much a question of the shock value of discovering the unexpected object. It was more a matter of mood, of softness. Of being able to dwell inside the emotions that existed between you and the object; or, come to that, between you and the canvas on which you were working. Whereas Gorky always sought a particular precision in his paintings, even in its most abandoned states, de Kooning pursued a goal that made the final painting incidental to the feelings engaged while painting it—thereby, perhaps, revealing them more immediately.

Gorky and de Kooning were physically unalike: one tall and flamboyant, the other short and cautious. It often seemed to de Kooning as if Gorky went out of his way to look for trouble. "Did he have to go play leapfrog on Coney Island with a bunch of real toughs? The kind of guys who, if things got rough, would turn around and just kill you?" And that time when they were together in the park—de Kooning at work on a modest little drawing and Gorky, as usual, surrounded by all the paraphernalia of someone making a *real* painting—"Did he have to turn on three tough guys standing behind him and tell them, with a threat in his voice, 'You've been there long enough'?"

Once, on the beach, they wrestled together. "Put me down, Gorky, you're hurting me." And Gorky put him down immediately. It wasn't that he in-

tended to be aggressive. "No, no," de Kooning told Maro, anxious that she might leave East Hampton with the wrong idea, "your father was a gentle man. Yes, Gorky was very lovable. Unusual. Sometimes unpredictable. Exceptionally gifted, funny, generous. He knew a lot and he gave away what he knew the whole time. Just—you know—was it absolutely necessary for him at all times, in every situation, to be always out in front?"

THE PUBLIC WORKS OF ART PROJECT

1932–1934

THE CRASH OF '29 heralded a recession which gradually overwhelmed the country. The optimism of the twenties lasted a year or two into the new decade before the Depression began to be seen as something inexorable. Like everyone else, the artists listened while the government made reassuring noises. A corner would soon be turned. With tenacity and self-reliance, the American people would overcome. President Hoover subsidized big business in the hope that employment would rise and that money would filter down to the unemployed, but the trickle-down theory didn't work and the factories stayed shut.

In June 1932 the veterans of the First World War marched on Washington to ask for a bonus to which they felt legally entitled. They set up camp in the suburb of Anacostia. President Hoover looked out from his office at their pickets on the White House lawn and decided that they had to be dispersed by force. General MacArthur and Colonel Eisenhower, hands on hips, supervised the rout of the unarmed survivors of the past war by the armed soldiers of the one to come. The President said, "Thank God we still have a government that knows how to deal with a mob." Smoke from the burning shacks of Anacostia

rose in the air, as depressingly evocative in its way as the sight of the city of Atlanta burning in the Civil War.

Hordes of unemployed people rode the boxcars from one end of the country to the other in a vain pursuit of work. A rumor would surface in Ohio and they'd take the Yellow Dog to Santa Fe, remembering to keep low at the pass where a madman took potshots at the hobos while the local sheriff looked the other way. Moving on required no courage. As Billie Holiday sang, "I'm only human, a coward at best; I'm more than certain he'd follow me west." It was the restlessness of the age.

Anyone who failed to pay the rent was put out into the streets. In New York some artists became engaged in the "battle of Paradise Alley," a series of poor apartment blocks from which tenants were evicted almost daily. The painters would help them move right back in again. Even Manhattan had its shanty-towns, called "Hoovervilles" in deference to the President. They were every-where. There was one on the corner of West and Spring. There was a "Hoover Village" on the Hudson at Seventy-fourth Street. In Central Park, across which Gorky walked so often to pay homage to the old masters at the Metropolitan Museum, there was a "Hoover Valley."

In summer the bootblacks around Union Square put pads on their knees early in the morning and set up their benches to shine shoes for a nickel. A poster flapped on the side of a recruiting booth, saying "See Action, Go Places, Do Things." The nine-cent record shops brought out their horns, aimed them at the trees, and played the latest hits at each other. At night the neon signs, up among the silhouettes of the wigwam-topped water tanks, shone forth their arcane messages: on the Amalgamated Bank on the corner, a mystical "4%"; on a giant sign, "Wrigley's—The Flavor Lasts"; and opposite Gorky's front door, "Klein's, On the Square"—two messages in one.

In winter, lines of men too tired to seek work gathered in the Bowery hours before dawn, hats down, collars raised, waiting for the soup kitchens and char-ity shelters to open, brief clouds rising from their mouths. At every street cor-ner a veteran held out a tray on which rolled a few pathetic apples. It became the cliché of every film with a conscience. If a man found no work, or felt too weary to look, he could keep warm at the movies for a dime. Endless cowboy films. Gorky loved them. He used to sit in the middle of the audience and make loud comments on the flickering compositions, as if the screen in front of him contained a flowing sequence of flattened shapes: See how the black shadow of the saddle is echoed in the shape of the mountains behind—until his neigh-bors told him to can it. If it wasn't a cowboy movie, there was the Acme cinema on Fourteenth Street showing the classics of Russian cinema. Eisenstein and Dovzhenko—Gorky admired those, too. In the early thirties, the Acme Cinema hunkered down with *Ten Days That Shook the World*, based on the book by

John Reed, from dawn till midnight for months on end. Often Gorky went to the movies instead of eating supper. The dime which bought you a ticket to the movies would otherwise only stretch to a cup of coffee and a piece of pie.

The scale of the economic disaster became apparent to everyone: banks failed, bread lines grew longer every day, farmers went bankrupt. There were those who claimed that capitalism had collapsed, and at this stage the Communist alternative was preached loud and clear without any fears of persecution. As Mary McCarthy put it in a short story, "During the first years of the New Deal, there were many flirtations, many platonic friendships with the scarlet woman of the steppes." Meaning Soviet Russia. American workers could even travel to Russia for a season or two, and many idealists did. A capitalist prince, Nelson Rockefeller, could commission a mural from a Communist champion, the Mexican muralist Diego Rivera, without placing his patriotism in jeopardy.

Union Square was the center of the city's left-wing politics. Rallies took place daily. More than half the membership of the American Communist party was thought to live in downtown New York. "In New York it's getting to be known as a Jewish Movement," said a character in a left-wing novel of the time, coming right out with it. "I'd like to see a lot of brawny American workingmen following these Jewish agitators over the ramparts along 14th st." The *Daily Worker* and the radical Jewish newspaper *Freiheit* were published from a building on the corner of Sixteenth Street and Union Square, until Klein's took it over in the later thirties. Living in Union Square, Gorky must have been acutely aware of the left-wing activities seething around him. But he never joined a rally if the cause was a political one, not even the May Day parade.

GORKY WAS AFFECTED by the Depression, just like anyone else. Patrons such as Nathan Bijur no longer bought any paintings. His job at the Grand Central School gave out when the school shrank. But he had at least two private pupils who paid for their lessons: Mrs. Ethel Schwabacher, who later wrote his biography, and Mrs. Mina Metzger. Mrs. Schwabacher was the wife of a successful lawyer. Mrs. Metzger possessed inherited money from a trade and textile business. When Mrs. Metzger first came to Gorky in the late twenties, she asked how much he charged for his lessons. Gorky was not particularly enthusiastic about the idea of having her as a pupil, so he named a price steep enough to put her off. She immediately agreed. After she left, Gorky rushed to the window and, peeking out, saw his new pupil get into a beautiful chauffeur-driven limousine parked at the curb. He suddenly realized that he had asked for far too little. They paid Gorky fifteen dollars a month, which was not a huge amount, considering that they sometimes came three times a week. Occasionally Gorky took them to museums and talked about paintings while standing in front of the real thing. He did not allow them to take notes, and

whenever he overheard anyone explaining his ideas to other people, whether they got it right or wrong, it drove him wild.

Apart from paying pupils, Gorky also taught a few nonpaying students. Among them was Hans Burckhardt, who at one point was so trusted by Gorky that he was given a key to the studio. Although he did not pay, now and again Burckhardt left, as if absentmindedly, a bag of groceries on the kitchen table. He decorated furniture during the Depression and was one of the few of that group who held a job which paid. Gorky never asked anything of him, and never made any reference to the groceries he left, but Hans could see that he was grateful.

Stuart Davis was irritated by the flamboyant way in which Gorky displayed his lack of money. "He had a continuous complaint about poverty, which was real enough, and sought to liquidate any vestige of doubt in an already long convinced audience by displaying holes, patches and rags in the garments which he wore under the overcoat." The implication is that as rags went, Gorky's were ornamental. Unfair though this sounds, there may be an element of truth in it. The Armenians of Van sometimes made their poverty appear even more extreme, in case some Turk or Kurd took away what little they had.

Davis suspected that Gorky had a backer who paid the rent on his studio and gave him money to live on. He assumed it was Gorky's sisters. The size of Gorky's studio, its quantities of beautiful art materials, and its wonderful, sparkling clean atmosphere made him jealous. At one point Davis was reduced to painting in his bedroom. The thought of Gorky at work on huge canvases in his ex-ballroom down the street understandably rankled.

Akabi sent him paints now and again, and perhaps the occasional bank note. Vartoosh lent him something when times were bad, but the sisters were hardly in a position to finance him. Akabi went down to New York to see Gorky every two or three months. Someone she knew in Watertown used to drive to Atlantic City to see a girlfriend, and he dropped her off on the Friday and picked her up on the way back. As in Watertown, Gorky and Akabi enjoyed each other's company. He told her funny stories about his pupils, Mrs. Metzger and Mrs. Schwabacher. Mrs. Metzger had a peculiar catch in her voice which Gorky imitated: a goose with problems swallowing was how he rendered her.

On May 10, 1932, Akabi and Gorky accompanied Vartoosh and Moorad to the docks, where together with other Armenians from Watertown they boarded a steamer to sail to Germany, thence to travel overland by train back to Armenia. Moorad thought he could get a job as an engineer there. It was his big chance. There was a need for high-grade technicians all over the Soviet Union. The rest of the family watched them go with misgivings. Moorad was only a car mechanic. Not even in Soviet Russia could you make a car mechanic into an engineer. Washing machines stood on the docks as they waited to embark. These symbols of capitalism were appropriated

for "redistribution" as soon as they arrived in Armenia, and never seen again.

The Armenian community of Watertown suffered greatly during the Depression. Most of the manufacturing industries closed, and few reopened. The Depression coincided with the introduction of new manufacturing techniques, and cast iron gradually became redundant. The Universal Winding Company, where Sedrak and Hagop worked, went under. Sedrak never worked again. He was an old man by now, and if it had not been for Roosevelt's social reforms, which gave him a pension, he would have been in serious difficulties.

After the death of his third wife, Sedrak lived for a few years with Akabi. Then he lived on a farm near Milford, Connecticut. He liked the country and he remained there for a long time. Though everyone knew where he was, he stayed outside the ebb and flow of family life. Hagop, meanwhile, had to give up the farm at Cranston. He and his family went from one rented house to another.

The Hood Rubber Company managed to hang on until the mid-thirties, when it was saved by a contract from the government to make boots for the unemployed. Satenig supported her family with her job there, which brought in seventeen dollars a week. Her husband was out of work for seven years. She was offered the job of floor manager but preferred to work as a cook for the Italian workers in the factory. Her lasagna became famous! As she was also a seamstress, she made all the family's clothes. No one could have guessed from their appearance how poor they were.

Toward the middle of the thirties, she began to suffer from a nervous breakdown. To keep herself going, she took up crochet work. She made intricate bedcovers and tablecloths of the finest cotton thread, creating her own designs. Gorky felt a deep compassion for her. One day, he said, they would have an exhibition together: his paintings, and her crochet work.

The situation for Armenians in America seemed to go from bad to worse. On Christmas Day, 1933, Archbishop Leon Tourian, supreme head of the Armenian Church in America, was assassinated in New York. The culprits were five young Dashnaks who were opposed to the archbishop's policy of cooperation with the Soviet government in Armenia. Seeing the old Dashnak flag prominently displayed in the church—that flag which still stood for a "free and independent Armenia"—he was reported to have said, "Take away that rag," whereupon the conspirators rose and stabbed him to death.

The assassination of Bishop Tourian had the effect of driving the Armenian community still further into itself. The Gregorian Church split in two, and the rift survives to this day. Families were divided. In Watertown, young people left their parents' homes and hid out with friends until they could transfer to another part of the country. No one could understand what was happening. It was yet another wall between the Old World and the New.

■ ■ ■

AT ROMANY MARIE'S IN 1932, just after Roosevelt's election, Gorky met a young couple whose friendship was to be very supportive during the following decade: a curator called Dorothy Miller, and her husband-to-be, Holger Cahill.

Miller was a New Englander raised in New Jersey, where after college she had become an assistant at the Museum of Newark. The director of this new museum believed that his staff should familiarize themselves with every aspect of museum work, from the creative and curatorial side down to the humble but necessary typing of lists. One of her teachers was Holger Cahill, who had been called in to organize an exhibition of American folk art.

Cahill possessed an extraordinary intuition about creative people. "There was never any preliminary talk between him and an artist," said Dorothy Miller later. "They just immediately knew that they both knew what was going on."

Having made friends with Gorky, and seeing that he was even poorer than they were, Cahill asked if he would give them both private art lessons. Gorky agreed. He supervised their first steps with great seriousness, accompanying them to an art store on West Eighth Street to advise them which colors to buy. "We started in, trying to splash the paint around a bit." Dorothy said that she herself was "so tight. I was uptight. I just couldn't get going. I was just sort of picking away at some miserable little still life. But Cahill . . . just started right out like this with the greatest of freedom."

The Union Square studio, as she remembered it, was quite bare at the time. The building was "one of those shabby warehouses scheduled for demolition." One big room and a tiny toilet. Outside, the trees in Union Square were thinner than they are today, hardly shielding those who slept on park benches at night under a covering of newspapers. Within, there were no drawings on the walls and the place looked empty.

Gorky seemed to her a lonely man. Tall, thin, with dark skin and black hair. His lessons required more listening than working. "Most of the time we just listened to Gorky talking. He was a magnificent talker. He told the most marvelous stories." He talked about painters and paintings, interspersed with his memories of Lake Van. He showed them reproductions of works he admired: Raphael, Ingres, Jacques-Louis David, Copley—"He adored Copley." At the end of every lesson, Gorky made them coffee in the little alcove off the studio, brewing it in a tin pot with a long handle, as is the custom in the Middle East. Though he was poor, he always served them the very best brand.

Cahill and Miller bought lithographs which Gorky had just made: twelve dollars each. They went to Gorky's studio on weekends or at night after hours, and kept up this routine for about six visits, until Cahill was put in charge of the Museum of Modern Art while Alfred Barr, its charismatic first director, took a year's leave of absence.

• • •

DIEGO RIVERA ARRIVED in New York to paint his mural at Rockefeller Center in March 1933, a week after President Roosevelt's inauguration. The project received a great deal of publicity. It was pointed out that although this was a private commission, the government could follow the example set by the Rockefellers and assign murals for public buildings to unemployed American artists. The mayor of New York, Fiorello La Guardia, publicly declared his interest in the idea.

On the evening of April 10, 1933, as Rivera's assistants were putting up the scaffolding at Rockefeller Center, a meeting took place at the Whitney Art Club on Eighth Street to discuss the question of "subject matter and abstract aesthetics in painting." Meaning, which subjects and what styles would be suitable if and when the public mural program was initiated.

The Whitney was still a private club and not a museum. A doorman took your coat at the top of the marble stairs, up from the little oval atrium with its mosaic floor depicting an open eye. It was controlled not by an appointed curator but by Mrs. Juliana Force, the secretary of the owner, Mrs. Gertrude Vanderbilt Whitney. That evening she had invited museum curators and critics. No artist had been scheduled to speak.

One academic who was there told the audience that the key issue was "the need or uselessness of contemporary subject matter"—which sounds as if he had already made up his mind on the issue. Lloyd Goodrich, an assistant to Mrs. Force, said that for his part, the representation of the human figure, using solid forms set in recessive space, was the most meaningful way of communicating ideas in art. The speakers implied that when the time came for American artists to paint murals, it would be a good idea if they concentrated on the human figure, set within the traditional structures of Renaissance perspective.

Then an artist in the audience stood up to challenge them: Gorky.

An abstract work, said Gorky, used the same kind of formal relationships and numerical structures as did figurative ones. It could be taken to pieces and analyzed in the same way in which one could analyze a fugue by Bach. The spaces in modern architecture were influenced by abstract ideas, and abstract art was the most natural way of decorating them. Gorky warmed to his theme, and it was clear that he was prepared to speak at length on this subject, but Goodrich abruptly cut him short.

At the time, Goodrich took it for granted that Gorky was being facetious. Surely this man could not be serious in saying that abstract art had the emotional power of a Renaissance work of art? After the meeting ended, however, he had second thoughts. He decided immediately that whatever the pros and cons of Gorky's argument, he had been wrong to interrupt him. After all, the meeting had been called especially to bridge the gap between curators and

artists. Thirty years later, he said, "I never should have talked like that to an artist." He added, "I've always felt badly about it."

Goodrich reconsidered what Gorky had actually said, and decided that Gorky might indeed have had a point. There was no reason, intellectually speaking, why abstract art should not be able to carry the same aesthetic weight as a figurative work, especially within the context of a modern building. He became an important champion of Gorky's work and, if not a close personal friend of Gorky's, one who smiled and was agreeable whenever he saw him.

Throughout the summer of 1933, the idea of mural projects continued to be discussed among members of Roosevelt's staff. In the fall, the Public Works of Art Project (PWAP) began to emerge from a complicated bureaucratic chrysalis, thanks largely to the pressure of a painter called George Biddle, who was a personal friend of the President. The money for the project was transferred from the Civil Works Administration on November 9, and a month later a meeting was held in Washington to decide who should run the program at a local level.

On December 11 it was publicly announced that the New York branch of the PWAP had been assigned to Juliana Force. She had been closely involved in the discussions of the previous weeks and she was well prepared. She immediately started to fill her quota, using the simplest method possible: she called up on the telephone all the artists she knew.

On December 20, the *New York Times* announced the location of the sixteen regional offices of the PWAP. Gorky filled out his application form that very same day. Gorky's local office of the PWAP was at the Whitney Art Club on Eighth Street—in fact the office *was* the club—so he did not have far to walk. He joined the program nine days before Stuart Davis, an artist whom Juliana Force had championed for years and with whom she was in frequent contact.

It looks as if someone tipped off Gorky several weeks before that the PWAP was about to start. His application suggests that he had already made a complete study for a mural. It reads:

> My subject matter is directional. American plains are horizontal. New York City which I live in is vertical. In the middle of my picture stands a column which symbolizes the determination of the American nation. Various abstract scenes take place in the back of this column. My intention is to create objectivity of the articles which I have detached from their habitual surroundings to be able to give them heightened realism.

The "determination of the American nation" can be taken with a grain of salt. The PWAP officials were privately advising their artists to make their work compatible with "the American scene"—that same chestnut which had been endlessly discussed at Romany Marie's for years. "Objectivity of the articles" is a reference to Fernand Léger's obsession with removing the "subject"

from a painting and substituting it with the "object." The "heightened realism" is again Léger's "new realism." Gorky had already come across some articles on this subject in art magazines, and Kiesler over their dinners at the Pappas restaurant had told him about Léger's new ideas on making abstract decorations for buildings.

The mural *1934* consists of three drawings taken from the *Nighttime Enigma and Nostalgia* series, on which he had been engaged for years, imposed onto an underlying structure borrowed from Paolo Uccello's *Profanation of the Host,* a reproduction of which was tacked on his studio wall. The "column" is Uccello's, not Gorky's.

In comparing the predella by Uccello with Gorky's mural, it is fascinating to see what Gorky took and what he left behind. Working from left to right, looking first at the Uccello and then at the Gorky, one notices the lozenge on the chimneypiece in Uccello, which becomes a circle containing a quote from *Nighttime Enigma and Nostalgia;* the checkered floor; the wall and door in steep perspective, which in Gorky becomes a flayed figure; the central column dividing the composition in both; the profile in the shadow under the chimney, which becomes a hidden profile center right in the Gorky sketch; again the wall and again the checkered floor in both. What Gorky has entirely abandoned is the narrative content of Uccello's morbid story, of Jews committing a supposed crime and going to their execution. All he noticed was shapes, division of space, and patterns.

Arshile Gorky, study for a mural, 1934

Paolo Uccello, *The Profanation of the Host* (detail)

Two days after applying to the PWAP, Gorky filed a "progress report" describing a drawing measuring 30 by 123 inches. The precise measurements suggest that Gorky had almost finished his drawing, which indeed he delivered a few days later to his supervisor at the Whitney/PWAP offices—Lloyd Goodrich. He was asked to make a painting of a small section of it in color—not too large, please, said Goodrich, evidently eyeing the huge roll which Gorky had brought into the office.

In a progress report Gorky filled out on January 17, 1934, he wrote that his mural would be suitable for "Port of New York Authority 15 st & 8th Ave. Entrance to Museum of peaceful Arts. News building 42 east 3 Ave in mashinery dept." The "Museum of Peaceful Arts" was something Gorky hoped for, in an echo of a certain Russian idealism he might have heard at Burliuk's house. The other two locations were probably suggested to him by Frederick Kiesler, who had been given the job of finding suitable walls on which to paint PWAP murals.

From the start, the directorship of Juliana Force encountered fierce opposition. The old members of the National Academy complained that her taste was too modern, while at the other extreme, a new group of artists called the Unemployed Artists' Group protested that their own members had not been included in her list. Was Mrs. Force frightened because they were all Communists? they asked.

In an interview that Juliana Force gave the *New York Times,* she said she intended works of art to be produced as quickly as possible, even though the PWAP was "a relief measure." But then she immediately added that she had been "directed by the Washington Authorities to eliminate the use of the words 'needy' and 'relief' in connection with the work." Murals would be made, and "my instructions are that the work is to be done with the best material available, and by available is meant unemployed."

The confusion in these statements was not entirely the fault of Juliana Force. An ideological difficulty dogged the art projects from the beginning: were they a "dole," a subsidy given to any artist who was hungry, or were they "commissions"? If the latter, who was to choose which artist for which location, painting in which style?

The Unemployed Artists' Group gave her no time to sort out this dilemma. On January 9 she was outraged to see their pickets outside her office window at the Whitney Art Club. On a placard was written in large letters "The Word 'Need' Is Not in My Vocabulary." As if Mrs. Force were a kind of Marie Antoinette! Bernarda Bryson, the group's secretary, explained to a reporter that she was only quoting Mrs. Force herself. Mrs. Force hotly denied ever having said such a thing.

In the weeks that followed, Bernarda Bryson frequently led the Unemployed Artists' Group in protests against Mrs. Force. Before she had come to New York from Ohio a mere three weeks previously, Bryson had been working as a journalist. Familiar with the workings of the profession, she sometimes telephoned the *New York Times* or *Herald Tribune* pretending to be one of their own reporters, telling them to send down a photographer immediately. Sometimes it worked, and sometimes it didn't.

One of the employees of Mrs. Force overheard the Unemployed Artists' Group in a back room of Stewart's Cafeteria discussing trade union activity in the United States within the context of the International Socialist— which sounded as if their priorities were not limited to the problems of the artist. Mrs. Force was a self-made woman and she loathed any talk of socialism. She regarded the Unemployed Artists' Group with undisguised horror, and she failed to see that sometimes the Struggle could be a lighthearted one. When one day the protesters were shoved by the police away from the Whitney across to Washington Square, they sauntered back, arm in arm, two by two, with a cheery wave at the Whitney's upper windows, where Mrs. Force was supposedly lurking. Even when the police acted tough, the artists retained their sense of humor. Ilya Bolotowsky, a painter whose studio was near Gorky's off Union Square, remembered a friend near him in a protest who was thwacked by a truncheon. "The noise was like a drum and that surprised me because I didn't know the area was so hollow to make such a sound."

Rather than put up with their harassment any longer, Mrs. Force closed the Whitney six weeks early and left the city. Deprived of the opportunity to make further protests, the Unemployed Artists' Group organized themselves into an Artists' Union and found a space on West Fifteenth Street, about ten minutes' walk from Union Square. For three weeks they painted the walls, scraped the rusting iron frames of the windows, bought chairs, elected officials. Gorky came down there after a while in search of company, the way he sometimes visited the Art Students League. Soon he joined a subgroup of the union, called the Artists' Committee of Action. Bernarda Bryson, now the first general secretary of the union, used to sit with them from time to time in the evenings. Gorky once made a sketch of her, which he quickly put away.

THE WINTER OF 1933–34 was a busy time for Gorky. There was the oil study for Lloyd Goodrich to finish, and then there was his first one-man show to prepare. This was scheduled to run at the Mellon Galleries, 27 South Eighteenth Street, Philadelphia, from February 2 through 15, 1934.

Gorky went to Philadelphia quite often to visit the museums there, and he was a friend of the director of the Philatelic Museum, Bernard Davis. No relation to Stuart or Wyatt, Bernard Davis was a businessman of Russian extraction, with a remarkable collection of contemporary art. As the manager of a French textile business outside Philadelphia, he was both practical and wealthy. Whenever Gorky had any difficulty of a worldly nature, he usually consulted Davis before anyone else. It may have been Davis who introduced Gorky to the art dealer Philip Boyer, director of the Mellon Galleries. Boyer went on to represent Gorky for about six years. The relationship was not very profitable for either side, but then it was not a renumerative period for contemporary art.

George Biddle, the man behind the PWAP scheme, had exhibited at the Mellon Galleries six weeks before Gorky's show. On that occasion Juliana Force had come down from New York with her team and had purchased a watercolor and a drawing by Biddle, and Philip Boyer managed to sell her a Charles Demuth as well. The prospects looked good for Gorky's exhibition, which consisted of thirty-seven paintings executed between 1926 and 1930—the largest one-man show of his life. The works were for the most part Picassoesque rather than Cézannesque, and the reviewer for the *Philadelphia Inquirer,* eighteen months later, wrote cautiously that Gorky's first exhibition had "created a profound impression among those who like strong doses of the tenets of modernism." This comment was made at the time of Gorky's second show, by which point his reputation was on the rise. The first exhibition did not take the city by storm. After it was over, many paintings were left behind with Boyer in the hope that things would pick up later on.

Gorky's circle of friends, Holger Cahill, Harriet Janis (wife of the future dealer Sidney Janis), and Frederick Kiesler, all contributed texts for the foldout which accompanied the show. Kiesler's piece, romantic and passionate, reads in part as follows: "Gorky, spirit of Europe in body of the Caucasus, getting the feel of American soil. Unswerving, critical reason seeks the quintessence of Picasso-Miró, drunkenly to absorb them, only to exude them again in deep slumber, after such a feast. This Caucasian stranger, having just quenched his hunger and thirst, is ready to shoulder down the doors into land of his own."

Gorky had no time to brood about the cool reception of his work in Philadelphia. A fortnight after the show came down, the First Municipal Art Exhibition opened at Rockefeller Center in New York. The Rockefellers had lent three floors in the still unfinished building. A jury of seven people, including Holger Cahill, Alfred Barr, and George Biddle, chose five hundred artists, each of whom was to exhibit three works. Gorky was among those selected.

Three nights before the exhibition opened, the Diego Rivera mural was destroyed, probably on the orders of that same capitalist prince who had commissioned it. The hard work of almost a year was unilaterally undone. But Rivera had provocatively included in the mural several portraits of Communist heroes, and the mood of political tolerance was already beginning to wane. The consequences of the mural's destruction were chaotic. George Biddle pulled out of the Municipal Art Commission in protest. Picketers from the Artists' Union, waving slogans, marched up and down outside the building as the trucks drew up to unload the paintings to be exhibited: "Hitler Burns Books: Rockefeller Destroys Art." Dorothy Miller, one of the organizers, remembered unloading canvases from the trucks one by one and shouldering her way into the building through the picket lines.

The protesters, though vocal, were not numerous, and the crowd was a fraction of the size of the one that had protested against the suppression of the Socialist workers by the Dollfuss government in Austria during the previous week. All over New York people were protesting. There was a taxi strike, and a hotel strike, which Gorky's friend Aristodemos Kaldis helped to organize. In Madison Square Garden, a pitched battle between Socialists and Communists had taken place, involving a crowd of twenty thousand. Several hundred people had been hurt.

The First Municipal Art Exhibition may have been chaotic, but it was a notable event. "This mile of American art should be walked by every able-bodied citizen," wrote the critic for the *New York Times*, Edward Alden Jewell, calling himself "pedestrian" for having done so. Jewell was the most influential critic in New York at the time. Rather than take sides in any polemical debate, he cultivated a wry, self-deprecating style, aimed at disarming any latent antagonism on the part of his readers.

Within the building, more than a thousand works were on show. "Arshele Gorky," as he was listed, showed one of the big finished drawings in the *Nighttime Enigma and Nostalgia* series, a print of *The Kiss* (the lithograph which Holger Cahill had bought the previous year), and a work called *Organization*.

He was receiving his weekly dole from the PWAP, and he was not behind schedule in his work for them. Mrs. Force was under pressure to cut down on the artists she had signed up, but he personally was not in danger. He was in excellent form.

THE NIGHT BEFORE the show opened, Gorky met his first wife.

She arrived with "some advertising people" and was standing in front of *Organization*, absorbed, even spellbound. She was blond, wearing neat clothes, a young woman in her mid-twenties, standing motionless.

Organization 2. It was in front of this painting, or one like it, that Gorky met his first wife, at the opening of the Municipal Art Exhibition, December 1933.

"A powerful abstraction in violent and magnificent color" was how she remembered the work. It produced in her "an act of immediate recognition."

As she stood there, a deep voice behind her asked if she liked it. "Oh yes," she said, "this is the first painting I have ever seen." She turned to face the owner of this "accented voice" and found a "tall, shabbily dressed man with dark, sad eyes."

Gorky invited her back to his studio together with her companion. At Union Square, she found "some powerfully beautiful ink drawings tacked on the spacious walls." She told Gorky that these forms were magnificent. Gorky was particularly pleased because, he said, she had not asked what they were or what they meant, but had responded to them spontaneously.

Marny George was an art student who had arrived in New York in the summer of 1933, having completed four years at an art college out west. There, she had eventually grown tired of drawing "the inevitable plaster casts." Modern art had been taught, but it stopped abruptly with Cézanne. The whole trend of painting from 1910 might never have existed as far as the students were aware. So she came to New York. She found herself a basement in a brownstone house and joined a "very 5th rate art school." To earn money she worked as a fashion model, for she was attractive. She wanted to learn to draw and she did not enjoy the fashion world, but for the moment that was the shape her life had taken.

Gorky's courtship of Marny George was swift, and he made himself irre-

sistible. He insisted on seeing her every day. He sent her poems, and when he talked about himself he told her that he was a poet. Once, a poem arrived at her apartment, attached to a small gardenia tree.

He took her to Madison Square to see an ice-skating show. She did not tell him, but she had been there the day before, invited by the owner of one of the department stores where she was working, whose son was dating her. Gorky drew on the program beautiful rhythmical sketches, echoing the movement of the skaters below. "Suddenly it all came to life—the rhythm and flow of movement on ice." It was such a contrast to the day before, "in a $100 box suffocated by furs and orchids." She remembered that when they had gone back to the rich man's apartment on Park Avenue, there had been nothing on the walls but "a few Renaissance pieces." No contemporary art. Not one living painter. She was shocked.

"Take me and mold me," she told Gorky one evening at a cocktail party at Sidney Janis's apartment. Nathan Bijur's daughter, who was standing nearby, looked at Marny—blond, pretty, perhaps not too bright. She did not think it would work. Helen Sandow felt the same way. She was beautiful, certainly— but what a contrast to Gorky! His male friends were more optimistic. Saul Schary was in favor of it; so was Bernard Davis, his friend and patron from Philadelphia. It was time Gorky settled down!

They took long walks together through the Village. Crossing Washington Square, Gorky pointed out the beautiful compositions made by cracks in the cement sidewalk. "Someday," he told her, "everyone will be his own artist." Marny had never met anyone like this man. She was simultaneously attracted and repelled by him. She had "rushes of passionate feeling." She wanted to protect him, to act as a buffer between this strange and tender person and the outside world. She knew she would marry him—"I can almost say, whether I wanted to or not." No, it was more than that. "I knew what I wanted. I knew from the first moment I saw his painting at the exhibit—but what I didn't realize was how utterly incapable I was of obtaining it."

On top of the Brooklyn Bridge on one of their long walks, Gorky proposed and she accepted.

Marriage immediately brought out their differences. She knew that her background and personality were quite unlike his. She labored to alter her "bourgeois morals and standards." She felt she was in "a deep rut of petty convention and superficial ideas." Arshile, she thought, had seen this. She had hoped that he would be the one to lead her out of the conventional ways she had learned in childhood. The difficulty was that Gorky was so peremptory. He wanted immediately to "form and mold me into the woman he wanted for his wife."

Almost as soon as they married, "the battle began." The barriers she felt

existed within herself were to be broken by him, "first with tenderness, then with force." Gorky's idea of what he wanted was irrevocable. Marny's ideas were more confused. She wanted to change, yet she resisted the ferocity with which Gorky insisted that this change should take place. "The barriers grew in direct relation to the violence." These were not just the barriers that existed between them but the barriers which she perceived in herself.

Exasperated, Gorky gave up. If she was not obedient to him, how could he help her? A wave of homesickness came over her—"for what seemed at the time to be solid, familiar ground." She fled back to her family out west.

Gorky's summer alone in New York was not easy. The Public Works of Art Project folded, having produced little in the way of finished murals. Gorky was taken off the rolls on April 29, the day after it was officially wound up. It had paid him $37.38 for eighteen weeks, which was wonderful, but the mural *1934* had never been painted. The Municipal Art Exhibition had gone on from New York to the Corcoran Gallery in Washington, but the abstract artists, including Gorky, had been left behind. He was included in the official PWAP report published later in the year as one of the more outstanding abstract artists but abstraction was still far from being publicly acceptable.

Financially, things were bad again. Gorky was unable to transfer to the Temporary Emergency Relief Administration, as most of his friends were doing, for he was not an American citizen. Philip Boyer was holding back some of his paintings in the gallery after the exhibition in Philadelphia had closed, but to what end? Nobody was buying. It was also hard to keep an eye on a dealer who lived in another city.

When Marny returned to 36 Union Square after the summer, she found Gorky unchanged. His strategy was no gentler than before. He again "determined not to let me go. Determined to make me into the woman he wanted me to be."

She did her best to comply. For six weeks she never left the studio. As with Siroon Mousigian, Gorky's solution to imminent loss was not to let the object of his love out of his sight for a moment. They fought each other to a standstill. With bitterness Gorky told her, "It will take you ten years before you understand me." There was no question of him understanding her, or even of patiently guiding her into the different world for which she had such a craving. He often said of himself, "Ferocious as a giant, tender as a little child." She had to accommodate herself to him, not he to her. The best they were able to achieve were only occasional "moments of surrender on both sides, moments when it seemed we really would break through to realizing the love that was beneath all the conflict of wills."

Gorky had an exceptional intuitive sense about other people, especially about their feelings, but he had absolutely no patience when it came to helping

them—or even, in extreme cases, listening to them. His gift was disinterested empathy. Once, Gorky and a friend were sitting side by side on a bench near the Lake in Central Park when a wounded pigeon fell into the water in front of them. Both men watched the bird fluttering, about to drown, without moving from the bench. By and by a man from a peanut stand nearby came over and rescued it. Gorky turned to his friend and said, "My God, I felt the agony you had."

Unless his capacity to sympathize with unexpressed feelings was engaged, Gorky's dealings with others were limited to a repertoire of flamboyant gestures. He could lead, he could inspire, he could shock, he could amuse, he could charm, he could terrify, and at times he could use physical violence. But the slow persistence, with tact, over a period of years, which might have succeeded in producing an easy give-and-take between himself and his friends of both sexes was not available. He was what he was. Feelings or moods were not open to discussion, any more than his own past could ever be probed or questioned. The stories about Lake Van, his father on a great white horse, his Circassian mother, were simply *there*, a part of him. Incidents and emotions were as one, and both were immovable features of his landscape.

At some moment in the fall, Gorky himself packed Marny's belongings in her suitcase, carried it down to the sidewalk, and left it there. He then climbed back up the rickety stairs, as she put it, "to God knows what."

In effect, he ruined her. Back west, she found herself "caught between two worlds, belonging to neither." It took her ten years of "struggle, frustration, and continually running away from myself" before she felt she had shed her adolescent barriers and could approach her own painting again. She wrote to him regularly. She could not forget him. "A tie remained, much stronger for me than for him." (Though she did not know it, he threw her letters into the wastepaper basket unopened.) Whenever she came to New York she tried to see him, but "there was always an overwhelming sadness in our being together." Once, when she was in the city, working as an ice-skater, she came to see Gorky and immediately came down with the flu. He put her to bed and nursed her, "like a sick child."

THROUGHOUT THE SUMMER, Vartoosh had sent back worrying news from Armenia. Moorad had had no luck in finding a job. The people were not as welcoming as she had expected. The Socialist Republic was distrustful of those who had returned from America. The political climate was not good. She was unhappy. She wanted to come back.

Vartoosh and Moorad were not U.S. citizens, and they had left the United States with the declared intention of never returning. Gorky contacted an influential woman who had once been a friend of John Reed, and she arranged

and paid for their return—which could not have been easy. Late in life, Gorky gave a large painting to this woman's refugee association in gratitude for past help.

They arrived back at Christmas. By that time Gorky's marriage to Marny was over, and they moved into the Union Square studio with him. Vartoosh was pregnant. Gorky tried to help Moorad find a job, but times were hard. Vartoosh, depressed, stood at the window looking out onto the tangled fire escape of Klein's opposite, and the tears streamed down her face. It was an absolute torture for Gorky to see in his younger sister the grief he so ruthlessly repressed in himself.

Gorky knew that Vartoosh was a damaged person and he was as protective as possible. Though Akabi was the sister whose company he preferred, Vartoosh needed his help. His letters to her, which began when she moved to Chicago the following year, glossed over his financial difficulties, as he did not want her to worry about him, and he never wrote about art. She was not that kind of audience. He encouraged her to make friends, leave her apartment, make a world for herself, knowing that her greatest enemy was solitude. He showed toward her none of the ferocity of a giant and much of the tenderness of a child, but she was not an easy person to help.

THE FEDERAL ART PROJECT

1934–1935

VARTOOSH AND MOORAD LIVED at Union Square for a few months, then went on to stay with Akabi so that Vartoosh could give birth to her child with the support of her sisters. There was some laughter in Watertown at her expense. After years spent praying for a baby, they said, Vartoosh had had to go to Armenia to become pregnant. Obviously Communist saints worked better than Christian ones. As if to defy these comments, when the baby was born in March they christened him Karlen, after Karl Marx and Lenin.

Gorky often went to the Artists' Union in the evening to see friends. One of these was Rosalind Bengelsdorf, a young woman whom he had first seen at the Art Students League a couple of years before. Then, she had been just "a little skinny kid," who still lived with her parents in Newark. She took the Hudson Tube back across the river every night after school was over. She was vaguely aware that Gorky was interested in her, but when one day he followed her all the way from the Artists' Union to the subway on Seventh Avenue, she was, frankly, scared. "He was so tall and so dark, with a black beard and a mustache. . . . He said, 'May I walk with you?' And I nodded and he said, 'My name is Gorky. That means bitterness.' Which of course was a lie. I couldn't even open my mouth because I was so frightened."

Gorky realized that Rosalind was a bit young for him, so he assumed an elder-brotherly role with her. He invited her to the Museum of Modern Art. Her taste at the time ran toward plump pink Renoirs, but Gorky placed her in front of Picasso's *Green Still Life* and opened her eyes to Cubism and abstraction.

A short time later, Rosalind fell in love with Byron Browne, another friend of Gorky's and the first president of the Artists' Union. All three were members of the Artists' Committee of Action and met regularly at a table over on one side of the room, where the elevated train passing by every few minutes rattled the windowpanes and interrupted their discussions.

Some members of this group, but by no means all, were Communists. The strategy of the American Communist party, nicknamed "Thirteenth Street," toward the Artists' Union was to permit the high-profile offices, including those of president and secretary, to be occupied by nonaligned left-wingers, but to make sure that subsidiary posts were under their own control. The aim was to absorb the Artists' Union into the wider context of political activity in the city. Artists are usually more interested in art than in politics, and it was relatively easy to make sure that certain subjects were sidestepped and others brought into the foreground. If the nonaligned liberals became too independent, there was always some coordinating committee to tame them on a point of order. In the early days, nobody was particularly worried about it. The word would circulate: there they go again. Thirteenth Street.

Within the Artists' Committee of Action, Gorky was chiefly interested in making works of art and exhibiting them in a public place—the equivalent of the annual Washington Square open-air exhibition, only within walls. He liked the unselective quality of the Washington Square exhibition, and he thought that the less interference there was in the way of committees, selecting boards, etc., the better. Though his personality was nothing if not forthright, he was against the cult of personality among artists, and his ideal exhibition consisted entirely of unsigned works. In these neutral circumstances the best works—his?—would shine forth naturally.

The open-air exhibitions in Washington Square were strongly supported by David Burliuk, who published a little catalogue introducing his colleagues as well as himself. The artists were for the most part unemployed amateurs hoping to pick up a few dollars by selling their paintings on the park railings, but Burliuk conscientiously listed those he liked. Sid Gotcliffe, housepainter, showing *Coney Island* and *Candle Light*. Pauline Struss: "Sincerity and understanding, combined with a charming touch. Her flower pieces, and her landscapes bring new odors and new color feelings that produce nostalgia." Gorky

did not participate, but Burliuk included his name among the advertisements at the bottom of the page: "Arshele Gorky, Instruction in Modern Drawing and Painting."

Gorky's favorite topic of discussion at the Artists' Union was whether or not he and his friends could all paint a painting together, and if so, on what terms. It was a theme he had often aired with David Smith and John Graham at Romany Marie's, so far to no effect. The first number of *Art Front,* the official newspaper of the Artists' Union, described the outcome of one of their meetings: "Each accepted subject will have a specified set of visual objects attached to it. All artists using the same subject will be using the same objects as their visual material [. . .] For example, one subject might have objects A, B, and C as its visual material. All artists working on this subject will only use objects A, B, and C in their compositions, but will arrange them in any way they choose. The colors to be used are limited as follows. Black. White. Red—vermilion, Harrison, Cadmium. Blue—Cobalt or equivalent." The language is not Gorky's, but the list of colors is reminiscent of the list he used in his article on Stuart Davis. The proposal sounds like an elaborate joke, like the rules governing an egg-and-spoon race.

Discussion about a permanent location where they could show their work was more serious. The Artists' Committee of Action had already started to fight for this goal during the First Municipal Art Exhibition, but on that occasion they had waved placards comparing Nelson Rockefeller to Adolf Hitler, so the Rockefellers had naturally lost interest.

By this time the Artists' Committee of Action had acquired a leader: Hugo Gellert, the artist who had sketched Mayakovsky on his visit to New York nine years previously. Bernarda Bryson, who was still secretary of the union, described him as "a very charming person, nice looking, agreeable. He was also spokesman for the Communist Party and so, in his agreeable way, a very disagreeable presence." She was struggling hard to keep the union out of the clutches of Thirteenth Street. Gellert was seconded by Boris Gorelick, who at one point had a studio in the same building as Gorky. According to an old friend, Gorelick was a "big pro-Soviet guy," and in fact soon after these adventures he traveled to Russia to see what it was like with his own eyes.

On October 27, 1934, Gorky took part in the second protest march organized by the Artists' Committee of Action, under the leadership of Gellert and Gorelik. He built a huge float for the occasion. "They had the use of a loft to make signs and Gorky made an effigy which took about half a dozen or more people to carry. It was large. Gorky didn't do things in small ways."

The protest of October 27, 1934, with Byron Browne (right) carrying the float made by Gorky

Stuart Davis also took part in the march.

When we went there that morning of the parade, the cops were all over the block. . . . There were cops all the way from 6th Avenue to 5th Avenue, all over the place, and fire engines out with hoses. There had been an order given that we couldn't march. There was a lot of telephoning—that we already had the permit, that it had been rejected or canceled. Anyhow, we finally got it, but in the meantime many of the people who were ready to march and who came to this rendezvous at some ungodly hour—eight o'clock in the morning. I was there, and we watched them out of the window, and they'd walk along the street to come to this place, and the formidable array of cops and firemen scared them off. We did have a lot of marchers, and Gorky had a great big thing made out of pressed wood—what do you call this stuff? Wall board, isn't it? It was a huge thing—you know, like a certain kind of flat sculpture, cubist sculpture, that was in vogue in those days, and when they came to get it out, of course, it was too big [. . .] They took the window out in the back . . . and they finally had to take it all apart and put it back together again out in the street. It was a big, heavy thing. It took four men to carry it. I remember that one of them was Byron Browne [. . .] He was a big, strong guy, and I remember you could always see him. He had blonde hair blowing in the wind, and he was taller than everybody else. The parade was like one of those Italian fetes that you see where they carry huge religious things, forty or fifty people carry them down the street and bounce them up and down, but that was the Artists' Committee of Action, and this other thing, the Artists' Coordination Committee—well, there were so goddam many committees that there had to be a coordination committee!

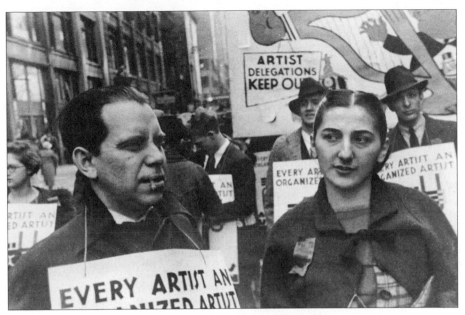

Stuart Davis and his wife, Roselle, photographed at another march of that year.
Below: Gorky's float behind a placard of the Artist's Union.

Around noon, the parade of less than three hundred artists was joined by a group of about a thousand Communist protesters. It was easy to see which banners waving above the crowd belonged to the artists and which to the Communists. One read, "Who Was Mayor of Amsterdam When Rembrandt Was Painting?" Another, "Give Us Bread or We Will See Red."

According to a newspaper report, as soon as Mayor La Guardia saw that the artists had been joined by the Communists, he "lost patience with the artists." He refused to speak to Gellert or Gorelick and drove off in a car to Jones Beach to open a new causeway. The Municipal

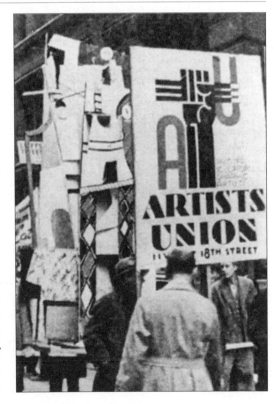

Art Center would have to wait, he said. A banner headline in the *New York Herald Tribune* the next day said briskly, "La Guardia Refuses to See Spokesmen and Art Center Goes to Waste Basket." As he left, the mayor told a reporter, "These artists have been misguided and are being led by that bunch of Communists heading the unemployment group. The Communists know they aren't helping the artists, either." The remark suggests that even as early as this, official patience with the Communists was wearing thin.

Outside City Hall at about three-thirty in the afternoon, a cold rain began to fall. The artists and their supporters moved on to Madison Square Garden, where the protesters were absorbed into the roaring crowds. The artists were but a handful compared with other marchers of the time: the annual convention of the American Legion, or even the pilgrimage of the Boy Scouts to the grave of Theodore Roosevelt at Oyster Bay.

The next day there was a stormy meeting at the Artists' Union, following which the Artists' Committee of Action resigned or was expelled. Either the group was too maverick to take orders from Thirteenth Street, or else the rank and file—including, I think, Gorky—did not want to participate in causes outside the ones in which they were interested. After their expulsion the group moved uptown, but this did not work out. They disbanded, drifting back to the Artists' Union as private individuals rather than as a group.

The weekly meetings at Irving Plaza were where you went if you wanted to hear the latest party line. "The windows and the platform hung with red curtains with gilt fringe like a Punch and Judy booth," as Edmund Wilson noted in his diary when he visited the place, "the white ceiling with unpretentious patterns stamped on it like the dado of a rooming-house—the yellow walls, greasy, soiled, with gilt frames painted on them containing nothing." Gorky attended a Workers' Cultural Festival organized by the John Reed Club at Irving Plaza on December 21, 1934. Bored, he folded his program as he listened to the speakers and made four little drawings on the back: two figurative portraits, and two small Cubist compositions.

Gorky took no further part in street protests. His tactics changed. At meetings at the Artists' Union, according to Balcomb Greene, "He would gain the floor on the most inauspicious occasions and declaim about the contours in Ingres." He wanted to remind his audience that the most suitable subject for an Artists' Union to discuss was art. "Gorky declaiming like a prophet about plastic qualities in paint was in a sense a beacon to innumerable Union 'followers.' " As a result of his refusal to be distracted by politics, which increasingly monopolized much of the activities of the Artists' Union, he acquired a reputation for having a "supercilious or playful attitude towards social issues."

Dorothy Dehner remembered seeing Gorky at a union meeting to which

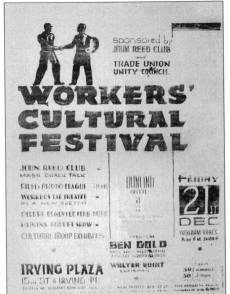

Workers' Cultural Festival handout, with Gorky's sketches on the back

she and David Smith had been brought by John Graham. The question arose of what sort of paintings should be done in order to accommodate the working class. Landscapes? Mothers and children? Not a bad idea, but wouldn't that be bourgeois? Well then, what about *proletarian* mothers and children? After a while Gorky got up and said, "Why don't you just teach them how to shoot?" Chaos ensued, but his point was obvious. The revolution is one thing, art is another. One should not talk about art and politics in the same breath. If you mixed art with politics, then you created "poor art for poor people"—an aphorism Gorky invented at the time, which he annoyed many people by quoting on every public occasion.

He once gave a slide show together with Willem de Kooning. Gorky talked, and now and again he said "Bill!" and de Kooning got up and changed the slide. As de Kooning remembered the incident, "All of a sudden one guy stood up and [said] he thought it was a lot of junk. . . . They should be on the side of the proletariat and all that. . . . Then a lot of the artists they stood up and they shut the guy off." Obviously the member of the Communist Fraction who happened to be on duty that night thought it was time to heckle Gorky, and, being recognized by everyone, was vigorously told to lay off. De Kooning remembered the humor of it all. "And so it was a very successful evening"!

EARLY IN 1935, Gorky took in a lodger, either to keep him company or for the money—though this aspect of the matter remained purely theoretical as

the lodger never had any money himself. Lorenzo Santillo was studying at the Hans Hofmann School of Fine Arts on Tenth Street, where he had been made monitor in one of the drawing classes.

While keeping an eye on the students, Santillo noticed an attractive young woman of twenty-two, somewhat aloof from the others, deeply immersed in her own work and in Hofmann's teaching. They made friends. Her name was Corinne Michelle West, and she came from a quiet, middle-class family originally from Columbus, Ohio. They had moved to Cincinnati when she was still a child. Her father played the violin and her mother played the piano. Corinne herself had originally intended to become a professional pianist, and was once the most promising young musician at the Cincinnati Conservatory of Music. She played Rachmaninoff. At the age of eighteen, however, she gave up music in order to study acting. She gave up this, too, after an unlucky love affair, and she had recently arrived in New York in order to study art. She lived with her parents in an apartment around the corner from Union Square, at 45 Fifth Avenue, opposite the church.

Santillo had fallen under Gorky's influence. He told this beautiful, shy young woman about his landlord and tried to explain what he was aiming for in his work. Would she like to come back to Union Square and see for herself? No, she said. She wasn't interested. If Santillo said Gorky was a genius—well, so be it. She wanted no more geniuses in her life. Hofmann was "all I could handle." . . . "Hofman was there every night—in an orange smock—smoking, gesticulating, with silver gray hair—still thin—& very good looking—speaking entirely in German—with Lorenzo & other students translating."

At ten o'clock one cold night in March, after Hofmann's evening sketch class had finished, Lorenzo took Corinne down to Union Square. To her surprise, she found that Gorky's studio was filled with "notables." They were, she later learned, Sidney Janis and his wife Harriet, Ethel and Wolf Schwabacher, the Metzgers, the architect Willie Muschenheim and his wife—"all wealthy people who bought his paintings." There was almost an official air about this first meeting, like that of a gallery opening.

Black ink drawings from the *Nighttime Enigma and Nostalgia* series were pinned to the walls, "hung low so that we could study them." "After one glance—I thought—Memling done abstract." "There was a huge Picasso like painting hanging on south wall a huge clock—and long wall with pen + inks—In front a large round table where he gave lessons in still life drawing— a hall way—and room off these stacked with about 150 paintings. Beautiful Paint quality—all masterpieces."

Gorky quickly walked over to her and gave her special attention, "in order that I would be at ease in this distinguished group of intellectuals & intelligentsia." He was six feet tall, "an imposing figure in grayish brown tweed

suit—huge brown eyes—a quiet voice—the intelligentsia loved him—his refinement—humbleness—and other outstanding characteristics. Waiters bowed to him—jumped to his side—nothing was too good for Mr Gorky." But she was disturbed by the atmosphere of the grand people all around. It was somehow not what she expected of an artist. "Why was Gorky always surrounded by wealthy people—? These people who bought his pictures—the Mushinheims, the Schwabachers, the Metzkers, the Julien Levys—was he totally dependent on them—?"

Gorky's life at the time did not appear to Corinne to be modest or poverty-stricken. On the contrary, it seemed glamorous. And, making allowances for her youth and the awe with which she viewed this "intelligentsia," it is clear that Gorky had by now created for himself a circle of interesting and supportive friends. Harriet Janis had recently become a partner in an interior decorating and architectural business together with Frederick Kiesler. They had both written texts for Gorky's first show at the Mellon Galleries the previous year. Harriet's husband Sidney Janis, before he became an art dealer, was never keen on Gorky's work, but his brother Martin Janis was a businessman and a friend, who bought something from him whenever he could. Martin Janis must have purchased one of the draw-

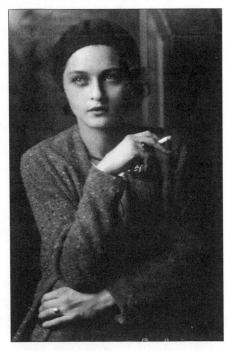

ings which so impressed Corinne on her first visit, as he lent it to Gorky's exhibition at the Guild Gallery later in the year. He also bought a large painted version of *Nighttime Enigma and Nostalgia*. Perhaps the visitors were discussing how best to bring Gorky's drawings out of the studio and into a gallery? Besides the formality which disturbed the shy Corinne, the scene is an unexpectedly positive one, given the times.

Soon after they met, Corinne stopped going to the Hofmann school. Hofmann suddenly looked to her as if he had "become a cult." Would she have discovered this insight without Gorky? Would she have had the courage to leave? Was there an element of competition between Gorky and Hofmann? She implies as much. Though they respected each other,

Corinne Michelle West, with whom Gorky was in love for about two years, shortly before they met

Hofmann and Gorky kept a certain distance between them. Perhaps it was a question of language. Hofmann's German and Gorky's English did not exactly coincide. But "whenever we met in restaurants or gatherings [. . .] they spoke a few words and Bowed to each other."

Gorky took over the supervision of her studies. She should experiment as much as possible, he said. Probably at Gorky's suggestion, she went over to the life classes on the other side of Union Square, in the studio of Raphael Soyer, a close friend of Gorky's. Sometimes Gorky went with her and joined the intimate, very Russian group of friends. Some of them would draw the model, while others chatted quietly in a little alcove with benches round the walls, where stood a table with a carpet on it and a samovar.

Sitting in cafés or in Gorky's studio, Corinne talked to him day and night about art. They walked around the city for hours. "Gorky & I trudged constantly to the galleries—Valentine Dudensing Gallery Kurt Valentine with his terrific Rodin sculptures & Knoedlers with Cézannes. We never stopped or got tired. I was about 22 then & there was so much to learn."

He took her work seriously. Her career, too, maybe. Was her name, Corinne, an appropriate one for a painter? she asked him. Gorky sympathized with her doubt. Maybe she was right. Maybe "Corinne" was "the name of a debutant daughter." Had she thought of another? Yes, she said: Michael West. At a time when women painters were at a disadvantage, perhaps changing her name to that of a man would help? Gorky gave his approval. He himself had "changed his name 8 times—so that really noone knew his real name."

"36 Union Square studio was profound, quiet—and one tip towed around in this atmospher of the maestro & great art," she remembered. Gorky's serious attitude, his meticulous studio, did not give the impression of a man who was desperate. "When I knew him he was at peace—even happy at times—(and funny)—(mimicking people)."

She admired his black-and-white drawings without reservation, but, regarding his paintings, she preferred some to others. "Gorky had already produced some of his finest surrealist works by this time, I did not like them as well as the earlier period and could hardly adjust to it [. . .] I tried to understand—the paintings. Facility, elegance, obscurity, secrecy were all there—but?"

Sometimes Gorky seemed impatient. He could be hard on her one moment, solicitous the next. "Remarks like, 'Corinne how can you speak this way—you are foolish' (Other times he called me a great woman) Enough—He didn't understand me I meant to me, it was harder to paint Abstract than realistic—But he was already so abstract about everything." A faint echo of the way in which Gorky spoke comes through: sympathetic, but with a limit to the attention he could give to others, even to those with whom he was in love.

Once, Corinne came to the studio accompanied by her sister Faith and a

friend, Colonel Jim Robinson. While Gorky complimented Faith on the beautiful bone structure of her face, he sat the colonel down at a table and encouraged him to make a drawing. "We later went to 1 Fifth Avenue for drinks and coffee—the beautiful marble floors large mirrors lining the walls and huge fans overhead plus the bar—& marble tables made for a sensational evening Gorky and Colonel Robinson—a (millionair) of many talents 1) discussed military strategy—2 Camouflage etc etc—My surprise at this side of Gorky was amazing—that he knew so much about the military."

She invited Gorky back to meet her parents. Her father was an energetic man who could still do double somersaults from a diving board, and he and Gorky talked about athletics. Gorky told Corinne's father that he had won the long jump at Brown. Perhaps he mentioned his engineering studies at that same institution? Corinne's father found Gorky fascinating.

In the spring, they took long walks together uptown. Every third block they stopped to buy cherries. "3 more blocks—6 more blocks—time to stop & eat Sandwiches on Broadway & Times Square—Exhaustion! (Not knowing ourselves) exhileration dejection—except—Gorky had to call someone— Gorky always calling—someone—I thought imagine living this way—He said—its like a gambler—could I live it—that way—I said I didn't know—"

THE WEATHER GREW WARMER. The air in the canyons grew humid, then sour with the dust and fumes of the city as it heated up. Early in the summer, the Federal Art Project, the new substitute for the defunct Public Works of Art Project, came into being, headed by Holger Cahill, Gorky's old pupil and former temporary head of the Museum of Modern Art. At first Cahill was reluctant to take the job. It was one thing to have contacts with art and artists, and quite another to be in charge of a bureaucracy. To persuade him, Stuart Davis had to take him out for a drink, "in some backyard fence somewhere where the nightly entertainment was a series of howling cats."

In July, Gorky joined the Emergency Relief Bureau. He had been told by his friends that his name had to be on a relief roll of some kind before he could be admitted to the new FAP when it opened. On August 1, the same day Holger Cahill publicly accepted his appointment as head of the Federal Art Project, Gorky joined the WPA/FAP as a Master Artist for a wage of $115 per month.

In joining the Federal Art Project so promptly and so efficiently, Gorky may have received help from Boris Gorelick, his old friend from the Artists' Committee of Action. It was a story which Gorelick himself enjoyed telling in later years: Gorky with eyes opened wide: "Oh, if only he could get on the Project." And later, leading Gorelick into his studio: "Take anything you want, Boris." On the easel there was the painting of himself and his mother, now hanging in the Whitney. Gorelick refused. Artists are supposed to help each

other, he said. But he regretted having turned it down, even as he walked to the door.

Burgoyne Diller was put in charge of the mural projects. Diller met Gorky in the street and was surprised to hear that he had been given the job of assistant to Raphael Soyer. Very soon, said Diller, he would be hearing differently. Gorky looked at him and said, "Can *you* tell me this?" Yes, said Diller. He was head of the mural division. "Oh! You *can* tell me this?" Gorky was unconvinced. Much to his amusement, Diller later found out that Gorky had been all over town asking everyone he met whether Diller really had the authority to do as he'd promised.

Both these stories—making allowances for embroidery on the part of those telling them—reveal one of the paradoxes of Gorky's attitude toward the outside world. While he could usually overawe his colleagues and pupils in private, there was something about officialdom which deprived him of his flair. Those in authority filled him with misgivings, even when they were his friends. As if centuries of terror inflicted by Turks on their subjects were impossible to shake off, even in the New World, so free, so wonderfully unspiteful in its distribution of good luck and bad.

Within a few weeks Gorky was involved in a mural design intended for the new Floyd Bennett Airfield. The commission involved a collage of photos by Wyatt Davis, Stuart's brother, with decorative elements by Gorky. Mechanical themes were much discussed at the time. In March of the previous year there had been an exhibition of twentieth-century machine art at MoMA, selected by Philip Johnson and opened by the flying ace Amelia Earhart. The philosopher John Dewey chose a propeller as the most beautiful object in the exhibition; so did Fernand Léger, who wrote, "They strike everyone as objects of beauty, and they are very close to modern sculptures." Everyday but beautiful objects could be used, he thought, to "free the masses of the people, give them the possibility of thinking, of seeing, of self-cultivation."

CORINNE WAS OFTEN with Gorky during the summer as he continued to work on the large drawings. In the evenings, they went to their favorite haunt to see their friends, "at Romany Maries at 12'oclock at night," according to Corinne. "The other nights we generally went to Romany Maries after studying his new pen & inks—this was a very hot summer around 1935." As they sat together, Gorky would start drawing "very seriously" on napkins with his fountain pen. "Nothing more difficult than paper napkins & pen." Corinne studied each one as he finished it, and folded it up and put it away in her bag. Gorky would do another, working twice as hard. Memories of the Byzantine section of the Metropolitan, which Gorky loved, would ap-

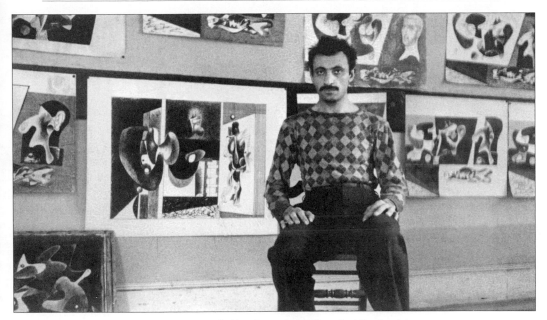

Gorky in his studio surrounded by the early black-and-white drawings, c. 1932

pear, drawn swiftly, lightly, before the ink bled into the fragile tissue and destroyed it.

Gorky used to tell Corinne stories about the past, protectively disguised: "about Lake Van where he went as a child—in Eastern Turkey—among the Caucasian Mountains—occasionally he would break into a long chant—and do a Caucasian dance—complete with swirling veil."

"One night Gorky decided to give Lorenzo and I 'dance' [lessons.] He came out in a Chiffon Robe (Blue) gauze wrapped around him—rather grotesque as he had on brown heavy shoes—He began to whistle like a bird—and flew around in a circle—stamping his foot now and then—(Lorenzo and I screamed with laughter—) He was funny—yet had a serious look on his face."

Corinne never moved into the studio at 36 Union Square. Lorenzo Santillo occupied the spare bedroom until September, when Vartoosh and Moorad and their new baby came back from Boston to stay with Gorky for a few months. "There was no sex between Gorky & I—for 3 reasons—1 it was precluded by our feeling for art 2—I was getting over a divorce from an actor— Randolph Nelson—Gorky from Marnie—we felt destroyed by these painful experiences." Ideally, she thought, Gorky should find for himself a rich, sophisticated wife who would give him two children and help manage his career.

These are good enough reasons to explain the failure of the relationship,

yet Corinne kept wondering if there might have been something more to it, some psychological restraint—on her part or his, she could not tell. In retrospect she thought "our excitement about art was rather unnatural." The huge emotional leaps from one mood to another frightened her. "I came from a long line of Christian ministers—Gorky came from a long line of Priests Armenian & Russian—we were both children of God—ingrained—this tremendous sacred feeling for life—or overwhelming feeling—by some considered irrational—was in truth—hysterical holiness."

"I suppose you think it was all laughing & gay—," wrote Corinne in her notes on Gorky, "not at all—very somber." One hot summer night they had supper together back at the studio. This was unusual, as Gorky seldom entertained at home. At the small stove in the scullery between the two bedrooms, he prepared spaghetti and opened a bottle of wine. They were interrupted by the arrival of Louie, a friend of Gorky's who worked in a jigsaw-puzzle factory. A close friend, an audience, someone capable of fielding Gorky's black moods when they were alone together. Louie sat down with them. They talked. The subject of suicide came up. Louie gave his opinion.

If you seriously intended to take this step, he said, you had to keep quiet and never, ever talk about it. Not to anyone. It was an option which was always there, tempting, accessible. . . . He kept talking—on and on, an uninterrupted monologue. Corinne became increasingly aware that Gorky was not responding. "His silence worried me." She looked at him: he would not meet her glance. It was worse than someone not joining in. He seemed filled with a terrible vacancy. "It was like someone fainting—looking straight ahead."

IN THE FALL, Philip Boyer, Gorky's old dealer in Philadelphia, opened his season with a one-man show of his recent drawings. Gorky's work filled his two main rooms, with a small group show in the back.

The show opened on September 29, 1935. Corinne borrowed her father's car and drove Gorky and Lorenzo Santillo down, together with a mysterious woman called Geraldine, who had met Gorky at a restaurant and was perhaps a bit in love with him. On the outskirts of the city, Gorky disappeared into a hotel to find Vartoosh and tell her how to get to the gallery. Corinne stayed in the car.

On Tuesday, October 1, at four-thirty in the afternoon in Boyer's Philadelphia gallery, Gorky gave a lecture on abstract painting, and a reporter noted, tongue in cheek, that he "made everything quite clear." Using the amused tone of a journalist faced with the unfamiliar, he described Gorky as "the famous Russian modernist" and "the celebrated Arshile Gorky." As to the works—well, they were puzzling. "The anatomical and the mechanical seem to prevail."

Corinne thought that the drawings looked magnificent pinned to the white walls of the gallery, but the drive back to New York was a nightmare. Fog slowed the car to a crawl and they lost their way. It was two in the morning before they reached New York. Corinne dropped Gorky off near Romany Marie's, late though it was, so that he could tell his friends all about it; then she and Lorenzo parked the car and walked down to join him, talking about "this sensational show—and how it would affect the Philadelphians."

Once again, Philadelphia failed to explode in ecstasy at the sight of Gorky's work. The newspapers quoted with relish some unfortunate remarks by Harriet Janis, which Boyer had recycled for the catalogue: "He is a sheared beard voluntarily. Giving importance to spaces the object existing for them and impersonal keen the knife cutting rectangular proportion into disproportion with numerical interest the $5 + 7 = 10 + 2$ and paralyzed with surprise is quoting the equation."

Though the piece seems written under the influence of Gertrude Stein, I think Harriet Janis was trying to capture the tone of voice Gorky assumed when talking about art. A certain quizzical seriousness was involved. To "paralyze with surprise" was something Gorky was fond of doing. The thread of the argument is not hard to follow: abstract art has to do with proportions, relationships, intervals, which can be seen as a kind of visual mathematics. He had said something similar to Lloyd Goodrich at a public meeting eighteen months previously, and would say as much again in a lecture at the Artists' Union the following year. It was, in short, one of his favorite performances. Only, Gorky did not necessarily use words to clarify if he thought he could creatively confuse!

A few Gorky drawings exist with equations incorporated into the composition. Gorky once began a lecture by announcing loudly, "Abstract art is a series of numBERical quotients." Naturally, a kind lady in the audience leaned forward and said, "Mr. Gorky, forgive me for interrupting, but I think you'll find that the word in English is 'numerical.' " To this Gorky replied, even louder, "Modom, I KNOW the word is 'numerical.' But I PREFER 'numBERical.' "

A WEEK AFTER the opening of his drawing show in Philadelphia, Gorky took part in a group show in New York at the Guild Gallery, at 37 West Fifty-seventh Street. The gallery was brand-new and the reviews of this initiative were encouraging. "Archile Gorky's handsome decoration (in its soft, indeterminate, romantic treatment, the antithesis of Léger's decorative style) may be said to dominate the show."

Anna Walinska, the director of the new Guild Gallery, had known Gorky

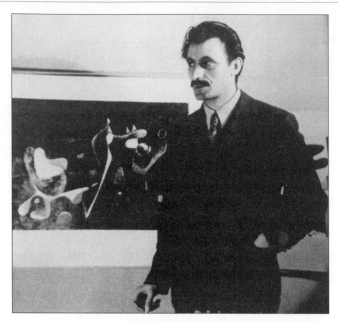

Gorky at the opening of the Guild Gallery show, December 1935

since the late twenties. Gorky at one point had offered to teach her, but to her subsequent regret she refused. The press release of her gallery says that her interest in the arts "is not confined to painting. She sculpts, as a hobby, and studies dancing, particularly Flamenco, in her spare time." Gorky's enthusiastic support of her plan to create a gallery was the main reason why she had persisted with the scheme. On November 12 he signed a three-year contract with her. She promised him at least one one-man show, to be "presented in a dignified way [. . .] advertised to the public in an appropriate, dignified and reasonable manner." The gallery was to collect a third on sales of works which had been exhibited, even if Gorky sold them later from his studio. Gorky was to be paid no retainer. Though the gallery was insured, "it does not guarantee insurance on individual works of art." It was the kind of contract which required a lot of goodwill on both sides, but this they clearly had.

After the Boyer exhibition closed, the drawings were immediately sent to the Guild Gallery in New York. Anna Walinska wrote to Fernand Léger at the Park Central Hotel, inviting him to come and see them. "Permettez-vous de nous présenter à vous," she wrote in almost perfect French. Charmed, Léger came. He looked at Gorky's drawings and gave them his emphatic approval.

Excited, Anna Walinska immediately wrote to the rich collector Albert Gallatin, and to Mrs. Force, Alfred Barr, and everyone else she could think of, bringing their attention to the new gallery and its star. To Gallatin she wrote: "Mr. Fernand Léger suggested that we write to you about one member of our

group who seemed to him to be an important Abstract painter, not to be over-looked: Arshel Gorky. Mr. Leger was particularly enthusiastic about his draw-ings. He thought they were original, and a distinct addition to the field of abstraction."

Alfred Barr wrote back a note of Olympian condescension. "Dear Mesdames: Thank you for your letter speaking about the work of Arshel Gorky. I have known his work now for six years, having first visited his studio in 1930. I quite agree with you that his drawings are interesting. I hope to come and see your gallery."

The exhibition of eighteen drawings opened on December 16. None of the works had titles except for four which Gorky had already sold and borrowed back. These titles were: *Enigmatic Triptych, Night Time Nostalgia, Composition,* and *Detail for Mural.* It looks as if Gorky did not bother with titles unless asked, and that when he chose one, he took the first that came to hand.

Gorky gave another lecture on the night of his Guild Gallery opening, and the audience was fascinated. In the following days, Anna Walinska wrote more letters to everyone she had forgotten to contact so far: James Johnson Sweeney, Holger Cahill, etc. To some she sent the catalogue—a modest, unillustrated card with a list of works on one side and Cahill's text from the Boyer show on the other: "Arshile Gorky has an extraordinary inventiveness and fertility in creating special arrangements both precise and harmonious, and he contributes to contemporary American expression a note of intellectual fantasy which is very rare in the plastic art of this country."

The exhibition was reviewed in the *New York Times,* the *Herald Tribune,* the *Sun,* the *Post,* the *World-Telegram, Art Digest,* and *Parnassus.* The difference in tone between the Philadelphia reviews and the New York reviews is subtle but profound. In Philadelphia, Gorky received the amused treatment often afforded a newcomer. In New York, there was the tacit assumption that everyone ought to know who Gorky was by this time, given his many exhibitions. An imaginary hurdle in public recognition had been cleared.

In short, he was a success.

ONE AFTERNOON Gorky came into the gallery and announced "something unbelievable." Léger was coming to his studio the next day! Anna Walinska remembered, "It was good to see him with a joyous smile and full of anticipation of the event." But when a few days later she asked Gorky how Léger's visit to his studio had gone, he said that at the last minute he hadn't dared to show any of his work. On the contrary, he had panicked and hidden his paintings away—in the side room, in the closet, under the bed, anywhere so that they wouldn't be seen by the Master.

A month or two later, Léger wrote a contented letter to a friend in Europe.

Here in New York, little events took place every day, and they were all very enjoyable. Recently he had heard a lecture on the subject "America, land of dreams." He continued: "It's very nice having a vision of dreams concerning a country that so many people see as pragmatic and Buissiness [sic] [. . .] they live just skimming the ground, they live above it, they aren't at all in it—they aren't in contact with it. There's a poetry in this people both bohemian and practical at the same time—but one looks for their passions and where are they? Peculiar people, without depth and without interior drama—but so sympathetic and with this piling up of events which by their number and frenzy make you curious as to what might lie behind them." The voice is entirely European. Gorky's view of America was often very similar.

That autumn Léger gave a lecture at the Museum of Modern Art which Gorky may have attended. He certainly studied the transcript published a few weeks later in *Art Front,* translated and edited by the future art critic Harold Rosenberg.

During the talk, Léger gave a list of objects which could be chosen by the artist and "elevated" to a new dimension.

A hand—a leaf—a revolver—a mouth—an eye—these are "objects." . . . There was never any question in plastic art, in poetry, in music, of represent-ing anything. It is a matter of making something beautiful, moving or dra-matic—this is by no means the same thing. If I isolate a tree in a landscape, if I approach that tree, I see that its bark has an interesting form; that its branches have dynamic violence which ought to be observed; that its leaves are decorative. Locked up in its "subject-matter," these elements are not "set in value." It is here that the "new realism" finds itself.

After studying Léger's list of casual objects, Gorky picked those very ele-ments to use in a drawing of his own: a leaf, an eye. In terms of what Léger wanted to say, this was surely grasping the wrong end of the stick. Léger intended each artist to choose his own objects casually. It was not the objects themselves which contained the message but the artist's treatment of them. But such was Gorky's humility that he took Léger's own list as being categori-cal. Though full of fantasy, Gorky's mind could be blindingly literal at times. In the same way, when he came across the expression "the elevation of the object," Gorky saw nothing metaphorical in the process. Instead, the phrase evoked an actual "elevation on high"—the moment when in Khorkom one of the occupants of the Adoian house had suspended above the *tonir* a crazy con-traption involving a cross, an onion, and some feathers.

Gorky's drawing of the eye within the leaf probably comes at the end of the *Nighttime Enigma and Nostalgia* series, on which Corinne had seen him work so hard in preparation for the show that September. One reviewer wrote that

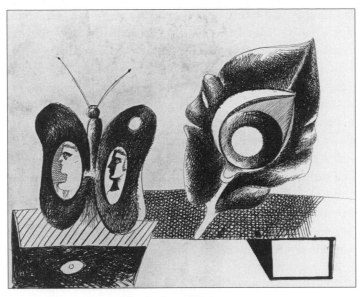

Arshile Gorky, untitled, c. 1935

Gorky had merely repeated the formulas which had been established by Léger and others, "including of course the renowned Picasso." Gorky himself, wrote this critic coldly, "probably does not consider his work to be so derivative as most of his beholders do."

The series is indeed full of borrowings: from Picasso, André Masson, Giorgio de Chirico, Paolo Uccello, an anatomical "flayed man" from a sixteenth-century medical textbook, lampposts and letterboxes from Stuart Davis. Even the titles were borrowed. "Enigma" and "Nostalgia" were words which possessed a particular resonance for de Chirico and Salvador Dalí. In October 1934 Dalí won a Carnegie prize for a work called *Enigmatic Elements in a Landscape*. Gorky owned reproductions of the painting *Nostalgia of the Poet*, by Giorgio de Chirico. When asked by Dorothy Miller what he meant by the title of one of the drawings, Gorky wrote: "wounded birds, poverty and one whole week of rain." He had no intention of adding an explanation to the handles he attached to his works—though in this case his words suggest the feeling of loneliness he often experienced when working.

To appropriate the objects discovered by other artists requires forcing upon them a change from the original intention. The cake mold from Ferrara was linked to a primary experience for de Chirico, who discovered it in a shop-window in that city and painted it, but not for Gorky, who discovered de Chirico's painting in a book. In this sense, the objections by Gorky's contemporaries seem justified.

According to his old friend Balcomb Greene, Gorky's work was "stiff with

clichés out of Picasso. Bitterly, he one day said to me, 'I feel Picasso running in my finger tips.' "

"There was a tendency to criticize him as a naive imitator," Stuart Davis wrote. "I took a different view and defended his work at all times. Admitting the influence, I would challenge the artist-critic on his own imitation of corny ideas about the old masters, Cézanne or some appeasement splinter-group of modernism, instead of the real thing. I told these carpers that their own work was so loaded with bad interpretations and imitation that they were the last ones who had a right to speak. I told them what they were really bellyaching about was the directness and boldness of Gorky's ideas, regardless of source."

While the Guild Gallery show was still up, the artist John Ferren came to Gorky's studio to see his work. Ferren told Gorky straightaway that he found it too much influenced by Picasso. Gorky asked, What was wrong with that? It was true, said Ferren, that, apart perhaps from Kandinsky, Picasso was "the greatest intelligence in painting today." But painters in a modern world lived in "a period of individuality." Gorky could not so slavishly follow the example of another man. "Picasso's world is not your world."

Gorky told Ferren that he followed the work of Picasso "on almost a moral basis." He showed Ferren his books on Ingres and said his work was based on Cubism of the 1920s. Himself engaged in a passionate struggle to escape from Picasso, Ferren refused to accept the argument. He answered, "You can see this type of painting all over Paris. They call them Picassiettes—plates of Picasso." A "pique-assiette" arrives uninvited around lunch time hoping to scrounge a free meal.

Gorky's borrowings should not be judged in the light of New York's permanent appetite for new, "original" work. This craving meant very little to him. Given the devastation of his early life, his problem was to reclaim what was old, tried, steeped in the atmosphere of the past. The emphasis on individuality, rather than originality, provided the only common ground between himself and the city in which he lived. Whereas Gorky had no desire to supplant a train of thought which he admired, to give it an individual twist was essential. It did not have to be much, but it had to be yours.

Gorky's appropriations were themes learned by heart and, as it were, "performed," just as a musician performs a piece of music. In this respect, the dealer Julien Levy—who almost gave Gorky an exhibition at this point in his career—remembered an analogy Gorky once made between art and music. "I remembered a concert given by Harold Samuels playing the clavichord works of Bach," Levy quotes Gorky as saying. "Samuels interrupted the performance of one variation. 'I had not intended to write it that way,' he said to the audience, proceeding then to play the fugue quite differently." I do not believe that Gorky knew much about Bach, or about his interpreters, but even if he took

the story from somebody else, clearly he valued it. He meant that when you assimilated the works of others, they had to become your own.

TOWARD THE END of his one-man drawing show at the Guild Gallery, a buyer walked in: Katherine Dreier of the Société Anonyme. She arrived in a quiet moment when the gallery was empty, "a formidable and imposing figure," Anna Walinska wrote, "tall and amply proportioned dressed in black from head to toe. Questions, about Gorky, his likes and dislikes, his personality, his manner of speech and dress. There I was, trying to discuss his august drawings on the walls—to no avail." Having learned whatever she needed to know, Ms. Dreier bought a large drawing for the considerable sum of eighty-five dollars.

Gorky invited Anna Walinska out to supper to celebrate the sale. They went to an Italian restaurant and ate a serious dinner—as it were from A to Z: from antipasti to zabaione. When it was over, Gorky said "That was good. Let's have another!" Miss Walinska said she couldn't, but she'd sit with him if he wanted to eat a whole other meal. So he did.

Walking back uptown, she remembered that they were near the apartment of an actress who was a friend of hers. On a whim they rang her bell. They were invited up. The actress and Gorky took an immediate liking to each other. Gorky told her that Anna was the only woman friend of his whom he had never kissed. The actress laughed. Miss Walinska thought it was time for her to continue her journey. Before he returned to the actress for the night, Gorky chivalrously walked Miss Walinska to the bus stop.

One night Anna Walinska and Gorky and some other artists went out for a meal together. After supper, they asked Gorky to sing for them. At first he refused. They insisted. Gorky refused again. Then he noticed a phone booth standing over in a corner of the restaurant. He'd go in there, he said, get inside, and sing, just for himself, and they could overhear. He could pretend he was on a distant hill.

The exhibition stayed up until the second week of January, in the hope that there might be further sales. There were none. Gorky received his $56.67 from Katherine Dreier's purchase on March 7. The gallery had sustained costs of $25.20 for Gorky's show, and a week after paying Gorky, Anna Walinska found that she was already in financial difficulties. She started writing letters again, this time asking for help. Mrs. William Randolph Hearst, Mrs. John D. Rockefeller III. She had hoped to earn some money by instituting a series of lectures at fifty cents a head, she wrote, but this had not been too successful. Indeed, according to their accounts, Gorky gave two of the lectures: on November 23, when the expenses came to seven dollars and the receipts seventeen dollars, and on December 22, when the expenses came to five dollars and the receipts

eleven dollars. Not bad. It indicates that at the time Gorky attracted a sizable audience when he gave a public talk on art. Unfortunately, two of the other lecturers had earned nothing but a row of tiny, funereal crosses.

At the end of March, she put up an exhibition of smaller works "interestingly priced for the collector and amateur of contemporary native art." Gorky lent some drawings. He also took part in a group show from May through June, sending two still lifes and the heavy pink *Torso* in the style of Matisse. In both cases his work was singled out for praise, though *Art News* called the pink *Torso* "a large handsomely colored piece of archaism." Gorky sold nothing from either exhibition, and he sent the Guild Gallery no more work. At the end of 1936, the gallery's credit at the bank was down to $31.90. Miss Walinska also had family problems. Her mother was not well. She kept going by asking her artists to contribute to the expenses, but this merely compromised the gallery's reputation. Without any fuss, Gorky's three-year contract lapsed.

Sometime later he invited Miss Walinska to his studio. She arrived with a friend of hers. At the end of the visit, he said, "Anna, you don't own any work of mine," and took down a small painting to give to her. She refused, saying she made it a rule never to accept gifts from her painters. He offered it again, and then a third time. When she refused a third time, Gorky turned and offered it to her friend, who immediately accepted. Miss Walinska was so furious she never spoke to her again.

THE NEWARK AIRPORT MURALS

1935–1936

A S S O O N A S the exhibitions in Philadelphia and at the Guild Gallery were over, Gorky returned to the photomurals for Floyd Bennett Field. The pictures Wyatt Davis took for the project reveal snow on the ground. They were probably shot in November 1935. Gorky found various objects at the airfield, Davis photographed them, the photos were then incorporated by Gorky into a collage, thence into various gouache studies. He was a fast worker, and according to the painter Saul Schary, he presented fifty colored designs within three days of receiving the commission. He must have delivered them by the end of November, a fortnight or so after he and Wyatt Davis visited the site, as they feature in official correspondence soon after.

A few of his designs are actual photomurals, made by incorporating cutout segments of the photographs into the context of a drawn design. Others are straightforward gouache compositions copied literally from the photographs. Gorky merely simplified an image which had been frozen by the camera. The propeller which had been so admired on all sides in Philip Johnson's recent exhibition at the Museum of Modern Art found its way into two of the finished murals. Here again, the photograph must have been taken under Gorky's instructions.

Various art commissions all over New York had to give their approval to

Wyatt Davis's photograph of a lamp, taken on site at Floyd Bennett Field with Gorky in November 1935, and Gorky's final study incorporating Davis's material

any mural scheme, and abstract art still aroused profound misgivings in the breasts of public officials. "I want little boys in Dutch shoes on the walls of my hospital," said one of them when turning down a set of designs. "I'm superintendent of this hospital—I'm going to be superintendent of this hospital for a long time, and if I want little boys in Dutch shoes on my walls, I'm going to get 'em. See?"

Making matters more complicated, it turned out that Gorky had a competitor, called Eugene Chodorow, who was convinced that he had already received a prior commitment for his strictly figurative proposals. On December 2, 1935, Audrey McMahon, head of Federal One, as the New York section of the Federal Art Project was called, wrote to Alfred Barr at the Museum of Modern Art asking him to choose between the two artists. Barr telephoned Burgoyne Diller, now in charge of FAP murals, to inquire about the intended location of the mural. He was told that the site was "quite simple and severe and practically unornamented." He voted for Gorky, whose designs were preferable, he wrote, "from almost any point of view except a purely conventional or academic." He was sure that the public, and even the pilots and mechanics, would prefer Gorky. She could use his name, of course, in saying that he chose Gorky, though he would prefer her not to quote from his letter directly.

Mrs. McMahon wrote back to Barr on Christmas Eve saying that the Chodorow sketch had been withdrawn, but that the Municipal Art Commission had not yet given their approval to Gorky's designs. They were about to exhibit them in a group show at the new Federal Art Gallery at 7 East Thirty-eighth Street. The opening was scheduled for December 27. Would he like to come?

The Federal Art Gallery opening was a serious occasion, with not only Mrs. McMahon and her team and Alfred Barr and his team present but also the

mayor, Thomas Dewey, the special rackets prosecutor, and a long stream of cultural and political figures.

Not far along in his tour of inspection, Mayor La Guardia stopped in front of a sketch for a mural intended for the College of the City of New York. The title was simply *Abstraction*. The artist who had painted it was Albert Swinden, a Canadian living in New York. According to a newspaper report, this work consisted of "brightly colored T-squares, triangles and rulers in horizontal, vertical and diagonal positions." Swinden was influenced by late Kandinsky and Mondrian—which is perhaps what the reporter was alluding to.

"What is that?" the mayor asked. Mrs. McMahon replied that it was a design for a mural. Mayor La Guardia said he couldn't tell what it was. Someone suggested it was a map of Manhattan.

It was clear that the mayor didn't like it.

"If that's art," he said firmly, "I belong to Tammany Hall."

Clearly he intended the joke to be picked up and published by a reporter from the *New York Herald Tribune,* who was standing behind him. The officials of the Federal Art Project were naturally upset. If the mayor made public his negative reaction to abstract artists, their status within the project would be jeopardized. According to the reporter, Mrs. McMahon immediately "took the Mayor in hand" and led him to a nice, figurative piece of work which included a portrait of someone he admired. The mayor began to feel better. Meanwhile, she quickly sent an assistant downstairs to look for an artist capable of defending the position of the abstractionists.

The assistant came back with Gorky.

Mayor La Guardia was brought before Gorky's large preparatory gouache for Floyd Bennett Field.

Without hesitation, Gorky gave the mayor and his team the same lecture he had already delivered three times publicly within the past two months. An abstract painter, he said, did not use "old-fashioned" colors. He "tried to show all sides of an object at the same time, and viewed a round ball as flat." This is

Gorky and Mayor La Guardia in front of Gorky's preparatory gouache for Floyd Bennett Field, photographed at the Federal Art Gallery on December 27, 1935. They have been interrupted by a representative of *Art Front*, who wanted to sneak a photo of the mayor with the magazine in his hands.

the reporter's succinct version, not necessarily inaccurate but certainly condensed. The mayor listened with interest. The scene was photographed. Gorky stood beside La Guardia, dressed in his best, the perfect professor dominating his listeners.

The mayor "wrinkled his brow," mollified but unconvinced. "I'm a conservative in my art, as I am a progressive in my politics," he said. "That's why I perhaps cannot understand it."

As he left, he was asked what he thought of the works he had just seen, and whether he thought that the WPA's money had been well spent. "Well," he said, "it has employed lots of artists, hasn't it? They have to eat, don't they?" He was protecting himself by arguing that WPA art was a "dole," not a commission. Gorky's speech had not exactly turned Mayor La Guardia into a fan, but he had been sufficiently impressed to block the reporter's leading question about the dangers of wasting the taxpayers' money.

The story immediately went the rounds of the cafés and bars where downtown artists met. It became a legend, and as with all legends, the details of the incident were twisted in the telling. The design for a mural which the mayor

had so disliked became, in the new version, Gorky's. The devastating remark, "If that's art, I belong to Tammany Hall," had been aimed at Gorky.

When thirty years later Mrs. McMahon told the story, she attributed to herself a spirited reply. He: "If this is art, I'm a Tammany politician." She: "All right Mr Mayor, then you're a Tammany politician." She added, "Then he laughed, of course. We were always good friends. He was always good friends with the artists, but he didn't really know very much about it."

The legend died hard. When four years later the painter Edward Laning unveiled his figurative, almost Italianate panels in the main reading room of the New York Public Library (utterly remote from Gorky in style) he reminded the mayor of the Gorky story. Speaking to a hall filled with notables, Laning said that when Gorky had offered his defense of abstract art, the mayor had "turned on his heel and walked away." With passion, Laning repeated the mayor's odious remark: "I'm a conservative in my art, as I am a progressive in my politics." The hall filled with laughter directed at La Guardia. Laning "sat down and the Mayor came to the rostrum. He looked at me with a fierce scowl. Then he beamed. He said, 'If politicians could paint as well as Mr. Laning can talk, it would be a better world.' "

Burgoyne Diller, head of the mural division of the WPA, remembered many years later, "LaGuardia's comment [. . .] was enough to have the project dropped by the Dept. of Docks in charge of LaGuardia Airport." It is true that Gorky's bid was withdrawn, and Eugene Chodorow's engagement was confirmed for the site, resulting in a large figurative work complete with muscular Icarus. But instead of being rejected, Gorky was transferred to a more important location. Newark Airport had been negotiating for murals for several months, and six weeks before La Guardia's clash with Gorky, Mrs. McMahon's assistant had drawn up a list of recommendations concerning suitable mural themes. These correspond to the designs Gorky made for Newark early the following year, which suggests that Mrs. McMahon gave the Newark commission to Gorky at the same time that she gave Floyd Bennett to Chodorow. Mrs. McMahon admired Gorky. In later years, she referred to him as "that wonderful Arshile Gorky."

BY MAY 1936 AN FAP "progress report" declared that Gorky was hard at work on the seventh floor of the WPA/FAP headquarters on 6 East Thirty-ninth Street. It mentions 1,500 square feet of painted canvas.

The Project even provided Gorky with assistants. One, Herman Rose, arrived at Union Square not knowing anything about Gorky. He was met by a tall man with a mustache, dressed in a dark red bathrobe with a towel wrapped like a turban around his head. Rose immediately recognized an artist whom he had noticed, off and on, for years: standing motionless in front of a

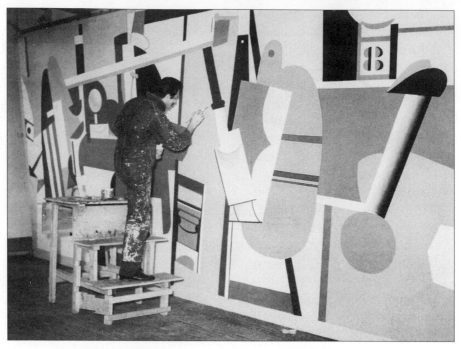

Gorky working on the Newark Airport mural in one of the WPA mural studios. Some changes had to be made to his original proposals for Floyd Bennett Field in order to accommodate the site at Newark Airport.

Cézanne at the Metropolitan, or waiting darkly in the corridor of the Academy for one of the models.

Gorky invited him in. On the easel was a painting four feet by five. In the middle of the composition, "a large, Hans Arp shape in bright red." As Rose watched, Gorky took a palette knife "and, carefully prying up a thin membrane of skin, peeled it off." Rose had never seen paint treated in this way before. Even writing about it many years later, he still couldn't understand what Gorky had been doing.

On another occasion Gorky wanted to work at home, so he sent his current assistant up to the New York Public Library on Forty-second Street to make a few drawings of airplanes. The assistant came back with his "homework," having managed no more than a few "childish doodles." Gorky studied them carefully, "nodding seriously in acceptance of my help." They were sincere efforts, he said, and worthy of being treated with respect. Gorky's praise meant a lot to him. "Even tho' he was rather inaccessible or so I thought, he was obviously a kind and thoughtful man."

However considerate he may have been, Gorky did not want to become involved in the lives of his assistants. At the WPA studio where he was work-

ing, he kept them at a distance behind him as he painted. Rose, standing in the group, saw a long composition filled with airplane parts. Tired of doing nothing, someone at the back said, "I've got work of my own I could be getting on with. I think I'll complain to the Artists' Union. He won't even let us touch his mural." Small laugh from second assistant. No response whatsoever from Gorky.

A figurative artist who watched him at work on the mural once offered a barbed comment: "You abstract artists sure work fast." Unfazed, Gorky replied that Tintoretto in his time had worked fast, too. He was referring to the famous incident in which Tintoretto, having been asked for a small preparatory sketch, produced in a few days a finished work the same size as the huge vacant space destined for the final work. "When we are in tune with our times," Gorky said, "we do things with greater ease than when we are not in tune with our times." While defending the language of abstraction, Gorky skillfully left the door open for a wider argument. The man was impressed. It made him feel he was "a part of something that other artists were a part of. It was very valuable to me and gave me a sense of my profession which I've never lost."

Though I am sure that the incident came and went without Gorky particularly registering it, to me it represents a pinnacle in Gorky's professional life. When he talked of working within his time, this was not just the remark of a confident man happy in his work. It was also the truth. He was a hero of the Federal Art Project, executing the largest abstract mural which the supervisors had as yet managed to place. He had had two exhibitions within the previous year. He had challenged Mayor La Guardia and successfully defended the cause of abstraction. Holger Cahill, head of the Federal Art Project, was a former pupil. Audrey McMahon had championed his work. He had been praised by Fernand Léger. The assistants who gathered behind him as he worked knew they were looking at a historic piece in the making.

The art world of New York in the mid-thirties was still a small island, not the archipelago it became after the Second World War. The later years of Gorky's life may have produced works which today we value more, but in the forties Gorky no longer fitted into that world with the same unshakable authority. Painting the Newark murals was the highest point of his career.

IN FRONT OF an audience, Gorky could be fearless. Michael West remembered an occasion when he pounded the table in front of the dealer Julien Levy, demanding the immediate loan of $700 so as to be able to go on painting. Levy paid up without resisting. "He believed in the work, the man, and that he could sell it." But Levy did not, in fact, deal in Gorky's work until ten years later. At the time, he found it too derivative. When Levy told him as much, Gorky replied that for many years he had been "with" Cézanne. Now, "natu-

rally," he was "with" Picasso. Levy suggested he come back later, when he was "with" Gorky.

Visiting Levy's uptown gallery one day in 1936 Gorky came across Levy's book on surrealism, which had just been published. He sat down on a chair and read it through from cover to cover. Levy gave him a copy.

The Julien Levy Gallery was a much more suave environment than the Guild Gallery run by the painter and flamenco dancer Anna Walinska. For Julien Levy, the idea of belonging to the world of art involved a certain amount of glamorous mayhem. "Artists are often good procurers, finding and sharing women, food, wine; and usually they are good company with high standards for all the sensual things of life." Nothing could have been further from Gorky's character, then or later, but he craved an uptown gallery and he learned Levy's book by heart. He plundered it frequently thereafter for love letters and for titles to his paintings.

ALL AROUND HIM the city was becoming increasingly involved in political action. The civil war in Spain, where a Fascist army was attempting to seize power from the democratically elected Republican government, polarized the

Gorky was careful never to bring his political beliefs into the open, let alone into his work. When accused of painting a red star into the Newark murals, he claimed it was the red star of Texaco. In this panel he has included on the right the hand clenching a sheaf of brushes, the symbol of the Artists' Union, but surreptitiously and at a slant. No one noticed, then or since.

From the cover of *Art Front*, February 1936

sympathies of left and right. Some artists gave up painting altogether, in order to go to Spain and fight on the Republican side. It was hard to stay aloof.

Stuart Davis, disturbed by what he viewed as the Communist party's increasing efforts to control all left-wingers, broke away from the Artists' Union and set up an alternative body, called the Artists' Congress. But Gorky stayed out of it. No strikes, no petitions, no protests, no letters to the newspapers ever received his support. The only hint of his political sympathies is to be found in his painting. In one of the panels for Newark Airport, he included a discreet quote from a recent cover of *Art Front:* a map and a hand grasping a bundle of brushes—the artist's equivalent of the hammer and sickle. The quote was so subdued that even then, no one noticed it.

WHEN MICHAEL WEST LOOKED BACK on this period of her life, it seemed to her that the economic depression had overshadowed everything. As if all moods had been intertwined: hers, the city's, and Gorky's. "The depression was terrible—people lying on the streets people begging for money everywhere—Gorky somehow got thru this period—but everything changed after that experience—People were different." When her parents decided to move away from New York, Corinne joined them.

Gorky did not accept the fact that she had gone. He followed her to

Rochester. "We discussed marriage but I did not think it would be right—at that time—Gorky said love would come later. . . ." Gorky said that love would come *after* marriage? The remark is a throwaway, but it is hard to believe that Corinne heard it with indifference. Love in the West precedes marriage. It is its obvious precondition. Not so in the East. A woman married the man she was told to marry and saw to it that love followed. This was the custom in Lake Van during Gorky's formative years. There may have been something desperate about his making such a promise to Corinne, but it was consistent with his cultural background.

She was arranging the first exhibition of her paintings at the Rochester Art Club when she received this abrupt proposal. Gorky asked her to come back with him to New York, but she refused. She was working on her own paintings, seeking to establish an identity independent of her parents and independent of him. He returned to the city alone. He was working at the Newark Airport murals, which took up all his time and energy. He came as soon as one panel was finished. "Gorky returned to Rochester the day after the murals were shipped out [. . .] He painted there—a large grey and green image & wrote to Corinne—at the top." His work, free spontaneous and final, dominated the room filled with her own unfinished canvases. It was a gift, to be sure, but it was also a challenge.

On July 20, 1936, Gorky cabled Corinne from New York asking her to come and see him. She came down from Rochester and stayed at the Prince George Hotel, where the marble-topped tables and mahogany oyster bar reminded them of still lifes by Picasso and Braque. Nothing was decided.

On August 11 he wrote a letter, consisting mainly of quotations from the sculptor Henri Gaudier-Brzeska and the French poet Paul Eluard, but including this paragraph of his own: "My little darling you are in a very charming place all the lovely country not to grand, but very intimate, very human and rather celtic with gaiety of it own, has made a greate impression on me." He said that he would write again soon "from the country," meaning from outside Boston, where he was planning to stay with Vartoosh and Akabi.

On August 15 he cabled again, saying he was coming to Rochester and would she have breakfast with him?

On August 24 he wrote another letter, again with quotes from Eluard, with this paragraph about himself: "Informations have received your sweet letter long ago—I am so glad that you are working with Faith portrait, please write to me more about." (Faith was Corinne's sister.) "Beloved, I am very tired; I have done nothing but rush from one place to another, and on top of that I have done a lot of work, with my murals and started a painting 14 × 9 ft this morning have been to Boston with Vartoos my sister and last week to country."

In 1947 Corinne wrote two poems describing their last meetings together. In the first, she says they saw each other at a white hotel, "At the turn of Lake Road / Where we struggled up the hilly path / After an innocent swim to collect / our family crowd for dinner / Heavy with our books on Ingres / Strangely loving yet not in love at all." Unable to come to a decision and hampered by the presence of her family, they awkwardly ate their way through a heavy meal, "and the long ride back." She left him at his hotel, and the next day he was gone.

The second poem describes one last attempt to work things out. "Dark eyes beneath the tall trees / Swaying in the night." She remembered his charm, and for a long time they walked "Amongst the pale willows and / Miles of sand." She knew that she was in love with him, but by this time she knew she had to turn him down. "What a price to pay for my wonderful / Wonder paintings of life." Corinne could never marry Gorky if she wanted to go on painting. The relationship would have destroyed her as an artist. In spite of her love for him, she was perfectly clear about what was at stake, and she made her decision.

The mood of Gorky's last letter to her is one of farewell, of resignation to the inevitable. "Forget me not my little woman when possible at ingle-nook on the sand of emerald—look at thyself in my hand that keeps me steadfast on the whole world so that thou mayest recognisze me for what I am my dark-fair woman my beautiful one my foolish one think of me in paradise my head in my hands." It is touching, and would be deeply significant as to Gorky's state of mind were it not for the fact that these words, too, were copied from Julien Levy's book on surrealism.

On September 2 he cabled her: "Dearest why dont I hear from you love— Arshile." There are no other letters.

Corinne's sister Faith told me recently that Gorky was simply "too much for her. Too much a man for her, physically." He was "so big and fierce, with his passionate Georgian background." Corinne's thoughts on her relationship with Gorky take into account not his own uncontrollable emotions, especially in the face of incipient loss, so much as her own fragility, recovering as she had been from a broken marriage. But there had also been an unclear intensity, a "hysterical holiness," as she had put it. She and Gorky had been "strangely loving yet not in love at all."

Corinne Michelle West lived a long and interesting life. She produced a fair body of work and enjoyed a period of success as an artist during the fifties. In her later years, she became a Buddhist. In old age, she fell on hard times, and in her last decade she was forced to rely on welfare. Her estate was almost thrown away by the city proctors at her death, but luckily her paintings and journals

have survived. Though late in life she thought and wrote frequently of Gorky, nothing in the texts she left behind suggests she made the wrong decision in breaking away from him.

AT THE END OF SEPTEMBER 1936, Rosalind Bengelsdorf Browne, her husband Byron Browne, and Gorky each gave a lecture on "Cubism and Modern Realism" at the Artists' Union. Rosalind Bengelsdorf delivered hers to an audience of about four hundred listeners on September 23, with Gorky and her husband sitting in the front row. Her notes have survived. As they run parallel to Gorky's ideas, it is worth looking at them.

Bengelsdorf argued that in making a painting, the artist should take into account the conquests of modern physics, and especially of Einstein, according to whom matter and energy were part of the same phenomenon. Matter was energy in a stilled state. Form contained energy, "just as water, poured into a glass, is contained by it." To make a painting was no longer a question of reproducing on canvas the optical impression of the object, for objects were shapes, and shapes were matter about to explode. "When one thing meets another," she said intensely, "something happens." An attractive young woman, saying that! Naturally, the audience cracked up.

She persevered. The achievement of Cézanne, and of Picasso and Braque after him, she said, was to see space as a series of planes expanding in every direction. These planes were the imagined projection of the objects, and they were as real as the object itself. Fitting these planes onto the canvas, which was itself a "living, moving reality," was the true task of the artist today.

Harriet Janis had used equations in the text she had written for Gorky's first show in Philadelphia, with roughly the same frame of reference, which she had heard from Gorky. It was part of his "numberical" theory: that a painting was made up of a series of interlocking forms with their own rhythm, their own logical rules. When Gorky gave his own lecture at the Artists' Union a week after Bengelsdorf, he raised an apple in the air, cut it in half, and proceeded to explain the plastic structure of the picture plane, which expands from a flat shape to animate the space around it. He then drew by heart on a blackboard some compositions of Picasso and Braque. Rosalind Bengelsdorf was in the front row at Gorky's lecture, as he had been present at hers. She remembered his talk for its exceptional clarity.

STANDING IN LINE for the weekly paycheck, while it had its ignominious side, was a great way of meeting people and making new friends. With what relish the survivors from that period remembered not just the twenty-seven dollars but the thirty-two cents! It was perhaps in a dole queue that Gorky met

Mercedes Carles, a young art student at the Art Students League. He developed an instant crush on her. De Kooning remembered them together at a party. Gorky sat at a table with one hand around her wrist for several hours, just looking at her. Thumb and forefinger met on her inner wrist to complete the circle.

Gorky began to appear regularly at her studio on Twenty-eighth Street, off Broadway. Sometimes he sang a popular song as he climbed up the stairs— "Life Is Just a Bowl of Cherries"—to her studio, which was like a small house perched on top of the building, with a skylight looking out onto a magnificent view of the Empire State Building.

He brought her books: Karl Marx and the British Marxist John Strachey. He talked for hours, interrupting her work. At one point he told her that this arrangement was taking up too much of his time: perhaps she should come and work alongside him in his studio down on Union Square? So she did. But a day or two later, her current admirer descended on Gorky's studio and carried her back uptown.

As usual, Gorky found it hard not to assume a didactic role, with its implication that he was the Master who knew more, dared more. But in Mercedes Carles he encountered someone with an obstinate faith in her own knowledge of art. She had painted since she was six years old, when her father had given her a box of oil paints and taken her with him into the countryside to paint. Her father, Arthur Carles, was an abstract painter whom Gorky much admired—though perhaps a touch competitively, or so she felt. Gorky told her once that it was a pity that her father had ceased to paint from nature and had become an abstract artist, but she took this to mean that he wanted the field of abstraction entirely for himself.

Gorky and Mercedes Carles were divided in their ideas about how a painting should be made. Gorky told her again and again that she should always start with a strong composition and find the details later. She said, no, she wanted to make paintings which consisted of small, interlocking, accurately stated details, letting the composition build up of its own accord. There are no rights and wrongs in this matter. Both strategies in their different ways derive from Cézanne. Mercedes had no reason to give in.

In her view, Gorky's immense knowledge was impeding his capacity to advance. "He had no ballast against art," she told me. Years later, long after she had ceased to see Gorky, she wondered if the breakthrough in his work had not occurred when he finally followed the alternative she had so often defended; when, seated in front of the luxurious landscape of Virginia, he finally "became engaged with perception of nature, not only art."

"With everything I know," he told her once admiringly, "you are more

original than I am." Even though she was not aware of the dubious weight which Gorky and John Graham used to give this word "original," she refused to feel flattered. Sticking to her own identity as an artist, she had doubts about many things to do with Gorky. Those huge paintings with their heavy impasto of which he was so proud—was the thick layer of paint intrinsic to the composition or just an adjunct to it, a superfluous layer, as it were, imposed upon its surface?

Those stories about his childhood in Georgia—did they ring true? Knowing him well by now, whatever Gorky said seemed somehow predictable. Was it necessary for him to be so theatrical in public? When they, the younger generation, took part in a group show, did Gorky have to appear waving a book on Paolo Uccello saying that *these* were the truly abstract works? She knew about Paolo Uccello. There was nothing outrageous, to her, in saying that the old was newer than the new. The paradox had no bite. In the context of a gallery opening, the remark seemed not daring but just plain rude. After all, the opening of a show is a moment when artists should stick together against the outside world and refrain from the usual jostle for the high ground.

Many of the generation following Gorky's failed to see the lighthearted quality of his flamboyance. He was too tall, too loud, and the line between irony and aggression was hard for them to spot. He dominated any group, in cafés or museums or at the opening of a colleague's show. At an exhibition of Russian icons, Gorky said: *This* is more modern than Picasso. In the street, the fire hydrant was as magnificent as the dome of St. Peter's and the cracks in the pavement contained the entire future of art. He could go to a painter's exhibition and congratulate him loudly and sincerely on the quality of his frames. Unable to detect anything fraternal in all this, Balcomb Greene, like many fellow artists, saw him as a man protected by "hard offensive points which stood out all around him, quite often, spikes to hurt others."

SOON AFTER they had given their lectures, one after the other, Rosalind Bengelsdorf Browne tried to interest Gorky in joining a group of abstract artists she was helping to form. A few meetings had already taken place in her studio, or in Albert Swinden's loft at 15 West Seventeenth Street—that same Swinden whose geometric mural project had so annoyed Mayor La Guardia the previous December. They were unsure whether they should remain an informal discussion group, getting together to discuss the problems they encountered daily in their work, or whether they should concentrate on exhibitions, or on teaching.

While this was being amicably but not very conclusively thrashed out,

they were joined by Harry Holtzman, a young painter who was monitor of Hans Hofmann's class at the Art Students League. Holtzman possessed a strong personality, and he convinced his colleagues that a school was the best option. He borrowed paintings and raised money from the group, rented a large studio (next to de Kooning's), and furnished it with easels freshly painted white, in the manner of Mondrian's studio, which he had visited in Europe the previous year.

"Holtzman wanted to teach everybody," said Rosalind Bengelsdorf in retrospect. "We didn't feel he was in a position to teach all of us. And especially Gorky didn't feel Holtzman was in a position to teach him, because Gorky also thought he would teach us. Gorky was very funny. Holtzman lacked a sense of humor. Gorky got away with a lot because he was so funny."

Gorky suggested that they all go off and produce a painting restricted to the colors black and red. At the next meeting they would decide whose was the best. Or else they could produce a communal painting, choosing from among themselves who was the best draftsman, who the best colorist, who the best in textures, and so forth. They would produce a masterpiece in which each would set his hand to a different task, and they would exhibit the result, naturally, unsigned. Or—craziest idea of all—they should go home to their studios and come back next week with an object made from a lightbulb and a piece of string. That would surely determine who was best qualified to teach abstraction.

Gorky made these proposals straight-faced, to a generation younger than himself, and one at least of his listeners—Alice Mason—actually produced a painting depicting a piece of string and a lightbulb. It was the same program which the Artists' Committee for Action had published in *Art Front* two years previously. That was what Gorky thought artists' associations should do—sit around talking about technique, with doses of humor, and maybe even draw or paint together a bit, spreading an air of convivial rivalry, rather like that of a wrestling match on the beach.

Ilya Bolotowsky, whose studio lay a block from Union Square, described Gorky's attempt to swamp the group. If anyone was going to teach anything, Gorky was going to do it. As he himself announced, it would surely have to be one who everyone automatically recognized as the best, the finest, the most gifted, the most promising artist of them all. Or else they could just treat the group as "a sort of pedestal for its most gifted member." At which the painter Werner Drewes asked him who he had in mind. Gorky didn't mean himself, by any chance, did he?

Did he really need to explain himself? Gorky replied. Why say more? If they weren't interested in his generous offer, he could always leave.

DREWES: Good-bye, Gorky.
GORKY: I shall leave.
DREWES: Good-bye, Gorky.
GORKY: I am leaving. [*Walking to the door*] I have left.
DREWES: [*Silence*]
GORKY: I am leaving for good.
DREWES: [*Silence*]
GORKY: I have left.

 Exit Arshile Gorky.
 Suddenly he opens the door and pokes his head back in again.
GORKY: I am leaving.
DREWES: Good-bye, Gorky. Good-bye.
GORKY: I am leaving. I have left.

At which, at last, he closed the door after him.

At one of the raucous but good-humored meetings of the group, one of the more intransigent abstract artists claimed that the painter's hand could never be sufficiently accurate. Lines should be drawn by a ruler, circles by a compass. Only geometry was "exact." To which de Kooning remarked mildly that the trouble with geometry was that it "wasn't exact enough." Naturally, everyone laughed. After all, what was painting supposed to be precise about? Forms? Feelings? The opportunities were endless.

De Kooning's style on these occasions was the opposite of Gorky's. Where Gorky liked outrageous collision, de Kooning preferred the short, throwaway phrase which delicately removed the carpet from beneath his opponent's feet.

This gap between the two men also suggests a different approach to painting as well as to the world. De Kooning admired Gorky enormously and learned from him a great deal. But that same intransigence which Gorky showed to other people, even to those he loved, was also applied to the canvas in the search for an absolute precision, an absolute, inescapable truth of a kind which perhaps was unattainable. De Kooning may not have been intellectually clear on this matter at the time, but his work even then shows another, more intuitive approach. As if the truth and the beauty of a work lay somewhere in between what lay on the canvas and the feelings which had gripped the artist while at work.

Out of respect for Gorky, de Kooning never joined the American Abstract Artists. But often he sat in a cafeteria on the corner of Fifth Avenue and Fifteenth Street while they held their meetings so that he could catch up with the evening's discussion afterward. He knew that if he joined the group himself, Gorky would have taken it as a betrayal. On the other hand, why cut yourself

off? So he sat there patiently and kept in touch, without abandoning his friend.

WHILE THIS ANIMATED GROUP was still meeting in each other's studios, Gorky's dealer from Philadelphia, Philip Boyer, arrived in New York to take over the old Valentine Gallery at 69 East Fifty-seventh Street. His opening exhibition took place on December 4 and included David Burliuk, Gorky, Chaim Gross, and a dozen others.

Boyer was interested in attracting a small group of promising young artists to the new gallery. He called a meeting to explain what he had in mind. Gorky came. So did David Burliuk. According to Joseph Solman, who also attended, Boyer described the great things he was going to do with it. He wore an expensive coat and spoke quietly in an affable, convincing manner. Gorky sat a little on one side, "in the pose of Rodin's *Thinker,* saying nothing."

Gorky made no move to recruit other painters to Boyer's gallery, and from the fragments of correspondence which have survived, it does not look as if the scheme was a success. In June 1938 Boyer owed a Mr. Lawrence M. Smith of Washington some money, and he left him eleven paintings as security. Among these, a "Composition" and a "Still Life" by Gorky, valued at $600 and $400, respectively. Excellent prices, except that in pencil Mr. Smith marked these down to $200 and $100 in the margin. Boyer was unable to redeem the debt and Mr. Smith kept the paintings.

Gorky listed a one-man show in 1938 at the Boyer Galleries on Fifty-seventh Street in one of his curricula vitae, now in the Whitney Artist's File. This has entered the literature, but there seems to be no trace of the exhibition in the newspapers of that year. Boyer gave only two exhibitions in 1938; four in 1939, one in January 1940. No more. According to Solman, Boyer did not pay a painter some money he owed him and the Boyer Galleries disappeared, shortly before the Second World War.

Thus both of Gorky's dealers, the Guild Gallery and the Boyer Galleries, ran into difficulties after 1936 and failed before the outbreak of war. In the event, Gorky remained without a dealer for eight long years, until Julien Levy took him on, in December 1944. He would have liked to have joined Curt Valentin. He would have liked to have joined the Downtown Gallery, Stuart Davis's gallery. But after the foundation of the Artists' Congress, he and Davis were hardly on speaking terms.

ON FRIDAY, January 12, 1937, at Albert Swinden's studio, during their second official meeting, the abstract artists discussed what they should call themselves. Carl Holty was in favor of something like Le Cercle Carré, only perhaps

in English: The Square Circle. Others thought this pretentious. In the end, they called themselves the American Abstract Artists. A good title: neutral, broad, somehow almost official, as if all abstract artists in America ought to belong to it. They set about electing officers and drawing up a prospectus.

At their fourth meeting they discussed the financing of newspaper advertisements, and whether or not Albert Gallatin should be invited to join them. Gallatin was perhaps not such a wonderful painter, it was pointed out, but he had money. He could pay for an advertisement for all of them. Then George McNeil was asked to make a list of all present and future members until a list of forty was put together, so that they could take over all four floors of the Municipal Art Gallery. "Failing the necessary number of names, he be authorized to use fictitious names." Gorky loathed backroom plots in the name of a career, and this one required telling actual lies. If he hadn't left the group already, he would certainly have walked out at this point.

It was the same story when Gorky was invited to join another group which formed at that time, called The Ten. Gorky appeared at their first show brandishing a book on Ingres: this was true modern art, this was true abstraction, etc. The humor of it was lost. As Joseph Solman put it, "He thought he was above it, right? And he *was,* in a way. He was older than us and he had more experience [. . .] He already had quite a strong bent or drive and command of the medium." Still, by 1941, when The Ten amicably split up, all the members of this group had found dealers and had created a place for themselves in the art world of New York. In the long run, Gorky lost out by remaining so aloof.

OLD AND NEW PATHS

1936–1938

G ORKY'S LARGE CANVAS OF "airplane parts," as his assistant had called it, was shown in an exhibition organized by Mrs. McMahon and Alfred Barr at the Museum of Modern Art in the fall of 1936. Called "New Horizons in American Art," the exhibition was meant to rally popular support for the Federal Art Project, which was already under threat, almost before it had started. An elaborate model of the proposed site at Newark Airport was created, incorporating the preparatory gouaches for the other nine panels.

Mrs. McMahon must have used the authority of the Museum of Modern Art to force the New York City Council to give its final approval to the Newark Airport project, since this came through just as the exhibition opened on September 14. But while the exhibition was up, yet another board to be satisfied came into existence: the Newark Art Commission. In November, Gorky's canvas and scale model were sent on to an exhibition at the Newark Museum, called "Old and New Paths in American Design." The locals were hostile. The *Newark Ledger* reproduced Gorky's large panel—this "little gem," as they called it. "If you look closely, you can distinguish what appears to be an airship tail at the left, but the rest of it has us stumped, too."

"Repercussions from the Newark newspaper articles have already oc-

curred," wrote Mrs. McMahon's assistant to Alfred Barr in October, "and it is possible that future projects will be jeopardized unless we can secure favorable publicity at once." Barr replied immediately: "An airport should be one of the most modern architectural projects. Any conservative or banal or reactionary decorations would be extremely inappropriate. It is dangerous to ride in an old-fashioned airplane. It is inappropriate to wait and buy one's ticket surrounded by old-fashioned murals."

Burgoyne Diller, the supervisor of FAP murals, went to Newark to tackle the newly formed Newark Art Commission. He had found by experience that in facing such bodies, it made life simpler if he avoided the word "abstraction." The term "decoration" sounded less sinister. Sometimes approval materialized thanks to the soporific effect of this word. In this case, however, he was unlucky. The commission was made up of "cool, forbidding characters. They were the sort of people you could see sitting in the windows of the Princeton Club or the Yale Club." Diller presented the decoration. "But one of them, probably brighter than the rest, said, 'Well, that's abstract art, isn't it?' That unleashed the devil. They started, of course, a tirade of questions and cross-questions and accusations and statements about modern art." In the end, they were shamed into acceptance by a woman who was "socially and economically their equal."

Frederick Kiesler's article on Gorky's murals, in the December issue of *Art Front,* is in some ways a frustrating piece. He emphasizes the fact that Gorky is painting oil on canvas, rather than watercolor on fresh plaster. "Mural painting buono al fresco sucks the painting into the wet wall ground and interbinds it with the building structure while swallowing it. If your hand glides over the mural painting, you do not feel it, but the roughness of the wall itself." Mural painting is peculiarly flat, in the sense that the paint has no thickness, and because the architectural setting is not a "frame" for the work but an intrinsic part of it. Gorky, in painting flat shapes untrammeled by shadows, had found an equivalent in oil on canvas for the beautiful flatness of water-based paint on plaster.

This is a good point beautifully expressed. It carries forward the ideas that Léger had developed over the previous decade concerning the relationship between walls and mural decoration, but it adds a sense of the physicality of paint which Léger sometimes takes for granted. Léger believed that modern murals should be nonrepresentational, and should echo the structures and spaces of the building itself. He also thought that the reverse compliment could be made: that the colors used in mural paintings could be carried over onto the walls themselves. All of which is very different from the work of the Mexican mural artists, who were narrative painters, or of traditionalists, like Eugene Chodorow, Gorky's former rival.

Unfortunately, having started so well, Kiesler's article veers off cantankerously into an attack on WPA officials and their obstinate insistence on figurative art. "Well, no abstraction, boys! Better go home and learn how to design wrinkles, and never mind wrinkles in an abstract way, but these must stick to nose and mouth and eyes and even ears." Abstraction was still so unpopular that sometimes its defenders became a bit paranoid.

Gorky wrote his own text for the Newark panels in response to a request for a contribution to a "national illustrated report." The letter arrived soon after the MoMA exhibition opened, and it is clear that the official needed something quickly in order to defend the cause of abstract art. "I think that it is also important that you explain the experimental significance of the abstract work that is being done on the project and the efforts that have been made to allocate this work." The word "experimental," like the word "decoration," was intended to defuse criticism. "We will allow you three days of project time in which to write the article and hope that you can send it to Washington by Thursday of next week."

Gorky was not equipped to write such a piece alone, and even with help he made no attempt to provide the kind of text the bureaucrat required. He sent off the result on December 11, and on its receipt the official immediately wrote

One of Gorky's preparatory gouache studies for Newark Airport, with a photo by Wyatt Davis originally intended as material for their collaborative photomural

an ill-tempered note to Mrs. McMahon saying, "Would you ask Mr. Gorky to send me an additional concluding paragraph for his article which would explain what the Federal Art Project has done to promote and allocate works of art such as he has produced for the Newark Airport. Mr. Gorky makes no reference whatever to the Federal Art Project."

The opening paragraphs of this text are those already quoted in the first chapter of this book, where Gorky describes the Adoian house in Khorkom and the "elevation" of the onion, with its seven feathers signifying the passage of time. On this quirky pretext, Gorky bridged the considerable gap between a one-story mud bungalow on Lake Van and a brand-new airport in New Jersey.

The essay discusses the way in which the artist acts upon his material, takes it apart, reassembles and re-creates it. "I have used such elemental forms as a rudder, a wing, a wheel and a searchlight to create not only numerical interest but also to invent within a given wall space plastic symbols of aviation." In order to pursue this plasticity, he has taken these "symbols," these "forms," and used them in "paralyzing disproportions in order to impress upon the spectator the miraculous new vision of our time."

A rudder, a balloon, a map. The "anatomical parts of autogyros in the process of soaring into space, and yet with the immobility of suspension." He has chosen the bright colors to be found at an airfield "so as to convey the sense that these modern gigantic implements of man are decorated with the same fanciful yet utilitarian sense of play that children use in coloring their kites. In the same spirit the engine becomes in one place like the wings of a dragon, and in another, the wheels, propeller, and motor take on the demonic speed of a meteor cleaving the atmosphere."

Even though the text was tidied up by various hands, the tone of Gorky's voice remains perceptible. "Paralyzing disproportions" is an expression Harriet Janis had used in her short piece for Gorky's exhibition three years before. "Numerical" (sometimes "numberical") also stands for a certain train of thought. "Plastic" is used with a tinge of irony; for some reason Gorky thought it was a joke word, and that "texture" was more appropriate. "Suspension" was also a quality Gorky looked for in a painting, in the double sense of imaginary objects suspended in space and the suspension of time involved in looking at them. One can also imagine the whirring propellers which Gorky once suspended over the Shamiram Canal as a boy.

HAVING STAYED WITH Gorky for many months, Vartoosh, Moorad, and Karlen moved to Chicago at the end of 1936, soon after the Newark exhibition. They found a small flat in a respectable suburb in Chicago, near the lake, where they lived, as it happened, all the rest of their lives.

Vartoosh wrote to her brother regularly. Gorky never kept her letters and

he only replied when he felt like it, which was not often. He wrote in Armenian. His handwriting, though beautiful to look at, is not easy to read: the punctuation is erratic and a full stop is not always followed by a capital letter. Proper names are spelled differently every time, and there are transliterated words from Turkish, Russian, and English. Often the sentences are so brusque that their psychological weight is hard to gauge. He asks about the family or passes on news from his end. Brief notes into which Vartoosh must have read much more than we can grasp now. He tried to help his sisters and their offspring, morally and practically. There was not much he could do about money, as he had none. There was, above all, a limit to the attention he could give them if he was working. His sympathy is sometimes peremptory: "The Akabis are certainly in a bad way, I'll write to them too."

Jimmy, Akabi's son, visited Vartoosh in Chicago soon after they had moved into their flat. Gorky asked about him. Jimmy had had trouble holding down a job. He worked hard at first, but as soon as business looked good, he began to overspend. "Poor Boy."

Moorad, Vartoosh's husband, became restless in Chicago and thought of moving to California to go into the jewelry business. Gorky talked it over with Bernard Davis, his friend and patron from Philadelphia:

> Saturday night I saw Davis who told me that he'd seen Murad and he liked him very much. we talked of California and he told me that it would be better if Murad didn't go as because of the lack of work perhaps the projects here will not work out. That is perhaps the shop opened in California will not succeed and so for Murad it would not perhaps be good as they all like him, and truly I think so too. He also said something else that it is not good that Murad went into stones [gems?] because stones cost a lot so that he would spend all the money he had.

Bernard Davis, still at the Philatelic Museum in Philadelphia, eventually found Moorad a job with a well-known carpet-selling business in Boston. It kept him usefully within range of Gorky, his brother-in-law.

One of the earliest notes to Vartoosh is a postcard written from a grand hotel in Washington where Gorky was giving a lecture to the American Federation of Arts. It was a prestigious occasion. He was still benefiting from the excitement surrounding the Newark Airport murals. Ten days later, in May 1937, Ethel Schwabacher's husband Wolf bought a large painting in the *Khorkom* series from him for $650, payable in monthly installments of fifty dollars. A year or two later, the Schwabachers gave the work to the Museum of Modern Art. It was their first Gorky. The price of the work was high for the times, and it bears comparison with the prices of small paintings by Léger or Feininger sold on Fifty-seventh Street at the time. In a covering note to con-

firm the sale, Wolf Schwabacher wrote, "You are, we feel, a great painter and some day you will come into your own. In the interim, we know you will carry on with your usual courage and high hope."

Gorky's panels for Newark Airport were mounted in June. The WPA assigned two Russian artists to help him hang the works, and a reporter from the *Newark Ledger* came across these assistants as they were examining Gorky's preparatory gouaches—"a frightening assortment of multi-colored angles and planes with something that looked like a silhouette of Popeye the Sailor on his back eating two telephone poles." As they were wondering which way up they should go, they were joined by Gorky, "with a handlebar mustache and long hair tied in a knot at the nape of his neck." Presented with the problem, Gorky "roared" that it made no difference. "Top is bottom, bottom is top, it is all comprehensible to the artistic eye of the cultured!" Spectators gathered round. Alfred L. Ringold, a brewery salesman from St. Louis, said that Gorky's work looked like a hangover after an Atlantic City convention. "With a pitying look, Mr. Gorky points out the symbolism of his art: 'The blue there is wacuum (Mr. Gorky's v's are w's). When a plane through the air goes the air it pushes aside and a wacuum is created behind, so? Planes are not made by pouring iron into a mold. They are made in pieces. Here I have take apart the pieces.' "

All in all, Gorky's panels were not loved at first sight. The *Newark Ledger* resumed its snide comments. "This is alleged to be Arshile Gorky's supposed conception of an airplane. It is said to be on the wall of the new Administration building which is supposedly located at Newark Airport." A photo was reproduced, sideways, showing a man trying to climb a radiator under one of Gorky's panels. "If you revolve the picture slowly you may get the idea. Looks like a man on that radiator. Or maybe it isn't a radiator. Maybe it's M. Gorky's conception of a China Clipper in flight!"

The Newark Art Commission made one last attempt to save the integrity of their airport. Mrs. McMahon had to send out a team of experts from New York to defend Gorky's murals yet again. Though Stuart Davis, for political reasons, had not seen much of Gorky during the previous two or three years, he joined this group. Many years later, he wrote an account of the expedition:

We drove over the swamps in a determined mood and shortly met the stubborn and ill-armed locals face to face. There was nothing to it after the first broadside fired by our oratorical Professors, Doctors and Experts. One of the locals quickly joined our side, and the rout was complete. But their unhorsed chairman made a final convulsive effort by whistling for an ace pilot who charged into the room. "Tell these Yankees what you think of these so-called modernistic murals," the chairman gasped. The ace surveyed the huge pieces of canvas. They hung in drapery-like folds on the walls, owing to some slip-

up in the secret formula of the adhesive which was guaranteed to last forever. We all surveyed them; in spite of their unorthodox hanging, they were unmistakably done in an approved modernistic style. But the chairman's ace-in-the-hole blasted any last hope by saying that he didn't know nothin' about art but he thought that they were right pretty. He said he was reminded of wonderful things he had seen, and began to recite recollections of beautiful cloud formations observed on his numerous flights. He was warming up to give dates, locations and the particular hour of the day of these events when the chairman silenced him. An official surrender was signed, and our cavalcade sped back victorious to the taverns of New York to celebrate.

Gorky signed over the murals on June 24, 1937. At the beginning of the war four years later, Newark Airport was taken over by the National Guard, and from 1942 to 1948 it was controlled by the Air Force. By the time it reverted to civilian hands, Gorky's panels had disappeared. It is not clear if the suppression of his murals was politically motivated, but at least one of Gorky's friends thought that they had been "painted out by orders of a general."

The general alluded to would have been Brigadier General Brehon B. Somervell, who from late 1936 had been placed in charge of the WPA in New York. The mood of the country had changed. Though recovery from the Depression was slow, Congress was more aggressive in its insistence that public money should not be wasted. General Somervell made no secret of the fact that he thought all artists were "boon-dogglers and horn-tooters." As for abstract artists—weren't they all Communists? What did they put in their works, anyhow? Secret portraits of Uncle Joe? Wasn't there a Red star up there in the murals done by that artist with the Russian-sounding name—that Arshile Gorky? The artist may have sworn it was the red star of Texaco, but the evidence was there.

Mrs. McMahon was in a difficult position. She made it clear that she had no opinions concerning this aspect of her artists' creativity. She was not a political commissar. For as long as she could, she mediated between the general and her artists, but it was a losing battle. As far as Gorky was concerned, the easiest solution was to keep him on the payroll of the FAP and let him work quietly at home. Thus, in spite of the high reputation of the Newark panels, Gorky never produced another mural for Federal One.

Whereas the early thirties were filled with a strange, urgent political optimism fueled by the Depression, the later thirties were an increasingly somber period for everyone. The ferocity of the impending war between Hitler and Stalin meant that political realism, of a dauntingly crude kind, replaced the former hopes. The Fascists won the Civil War in Spain. To make matters worse, in the final months of the war Stalin ruthlessly repressed all left-wing parties which were not Communist. Simultaneously, he subjected Russia to political

purges so extensive that not only his immediate rivals were extinguished but whole segments of Russian society.

These grim events were followed in New York. When Stalin placed on trial in absentia his old enemy Leon Trotsky, a number of New York Communists broke away from Thirteenth Street in protest. There was talk of setting up a committee of defense. As his supporters tried to do so, however, they ran into unexpected repercussions in many areas of their lives. Jobs were lost, relationships abruptly terminated. It was a strange and disheartening period. As Mary McCarthy put it in a short story, "An ill-assorted group of nervous people would sit in a bare classroom in the New School [for Social Research] or lounge on studio couches in somebody's apartment, listening to Schachtman, a little dark lawyer, demolish the evidence against the Old Man in Mexico [. . .] And after the meeting had broken up, over coffee or highballs, the committee members would exchange anecdotes of persecution, of broken contracts, broken love affairs, isolation, slander, and betrayal."

Meanwhile, at the Artists' Union, stragglers from the brigade which had gone to fight for the Spanish Republic began to surface. One of these was Phil Bard, who knew Gorky from the old days of the Artists' Committee of Action. Like many, he refused ever to discuss what had happened. "When friends who had fought in Spain returned, their silence made an impression so direct that the subject was dropped. Against everybody's intention it had become shameless."

In the interests of sustaining the morale of the Artists' Congress, Stuart Davis attempted to glide over the difficulties. At the height of the Moscow trials, he was heard to say, "If it's good enough for Schtalìn, it's good enough for me." The remark jars, as if he wanted to mock the many members of the congress who were of Russian-Jewish origins. But at least the remark is not an ignorant one.

Gorky, however, had no liking for Leon Trotsky and no desire to jeopardize his position within Federal One. "He always worried that he'd get a pink slip; fired," a friend said of him, referring to the late thirties. "But he had a very good friend, Burgoyne Diller, an abstract artist and head of the Project, who, along with Mrs. McMahon, admired Gorky and gave him certain privileges." When a senator on one of the investigative commissions came up from Washington to see the situation in New York for himself, Mrs. McMahon immediately sent him to see Gorky. She knew that Gorky had no political ax to grind and that he could be relied upon to convince the senator that modern art in general and abstract art in particular were neither a fraudulent waste of the taxpayers' money nor a hotbed of political intrigue.

Gorky's friend Aristodemos Kaldis was working for Federal One as a super-

visor, and it was he who accompanied the senator to Union Square. He had a hard time groping up the dark staircase to the studio.

> When the congressional committee used to object to spend money on abstract art and all this degenerate art as they tried to call it, I will take them to Gorky's studio, and he will paint his mother sitting, standing, putting her right arm under the left elbow, twist the head so rapidly so they were amazed, they were gaping, they were openmouthed, and said, "Jeez, that guy knows the business. Oh, that guy he's so acrobatic. I have seen people drawing in vaudeville shows, but not as quickly and so well like this tall devil with the mustache." And when he saw the performance, there, of Gorky with the figure, then he began to look at his abstractions. But he confided to me privately that still, he is in confusion. He doesn't know whether they are riddles or enigmas.

Though Gorky never executed any more murals for the FAP, he managed to paint a few private commissions, on the quiet, since technically he ought to have resigned from the FAP while doing them. None of these murals has survived, so it is not easy to know what they looked like. One mural was painted in a club above a theater on Sixth Avenue near Waverly Place. "The owner insisted that he saw obscenity in it. Gorky was furious because it was not intended to be obscene. The man insisted that he paint it out, remove the whole thing."

Another—or perhaps this was the same one—was made with the help of Byron Browne and Willem de Kooning. "Gorky involved Byron and Bill in things he did. Gorky had these commissions. One crazy thing, where he decorated this night club. I think it was called the Firehouse. Something like that. The three of them had a ball doing this terrific mural [. . .] someplace in midtown Manhattan."

When de Kooning spoke to Maro about Gorky, he was vague as to dates and locations, but he had many stories to tell of his collaboration with Gorky. One job was found through Isamu Noguchi, who had made a small architectural model to show the client what he had in mind. Gorky, Noguchi, and de Kooning arrived at the site and sat down at a bar to await their eventual employer. As they were getting up, de Kooning's foot got caught in the rail under the bar and he came down with a smack, right on top of Noguchi's model. Noguchi was good about it—straightened it up a bit here and there—but Gorky turned to de Kooning and said, "What did you want to do *that* for?" Well, it was an accident, as de Kooning told us. Why did Gorky want to make him feel worse?

One day Gorky and de Kooning arrived in front of a wall to start work. Gorky took from his pocket a tiny, perfect little sketch. He looked at it, and

then up at the wall, and started to transfer it with big, sweeping strokes. Soon he became confused: the difference in scale between the drawing and the wall was just too great. De Kooning suggested that Gorky square up the drawing and start again, slowly. Gorky was reluctant. De Kooning said that he would do it. He had studied at a good school in Amsterdam. He'd had good training as a kid. He would square it up, transfer the drawing lightly, and then Gorky could go over the transfer with that one, final, perfect line.

Gorky handed over the drawing and de Kooning started work. Telling this story, de Kooning imitated the delicate, bitty strokes he had used, managing to convey the satisfaction of a workman settling down to a nice, long chore. But Gorky interrupted. "Bill," he said, "that's a *mean* way to draw," and took back the charcoal, and once again set to, using those big sweeping strokes.

While they worked side by side, de Kooning asked Gorky if he could paint a particular spot red. Gorky said yes. When they stepped back from their work, the red spot looked terrible. Gorky turned to de Kooning and said, "Why did you do that, Bill?" It was a joke on Gorky's part, of course. After all, Gorky had given his permission. At the same time, said de Kooning, it was as if Gorky enjoyed making him feel bad about it. It was just like the time he'd ticked him off about crushing Noguchi's model.

Visiting each other's studios, de Kooning often watched Gorky as he worked. He observed paintings such as *Organization* acquire a thick texture over the years. Saw Gorky squeeze tube after tube of the finest oil paint into bowls and leave them so that a skin would form. Saw him scoop up the skin and work it into the surface of a canvas, or scrape it all off again with a knife (as Herman Rose had noticed) or with a razor. Saw him sand the surface of the Whitney version of *The Artist and His Mother,* and scrape it again, until it was flat as a sheet of paper, flat as a photograph. All of which de Kooning tried, himself, in his own work, in his own studio. Even as we spoke to him, forty years later, bowls of paint stood neatly in a row in front of a fresh canvas in de Kooning's studio on Long Island.

The weight of Gorky's paintings was "a standing joke" around the studio, as Stuart Davis put it. Strong men were invited to lift a work and would stagger back, panting. Gorky even mentioned the technique with pride: "Hundreds and hundreds of layers of paint to obtain the weight of reality—At this period I measured by weight."

Once, de Kooning told Gorky that a certain paint shop had gone out of business and was selling off its remaining colors. Quick as a flash, Gorky was out of the studio and down the road, with de Kooning hotfooting it after him. By the time de Kooning caught up with him, Gorky had cleaned out the shop of all its expensive cadmiums, cobalts, and ultramarines, mixing up the labels so that the man who was serving behind the counter would charge him even

less. Gorky paid and departed. When de Kooning examined the tubes which
were left, he discovered they were all earth colors. But they were cheap any-
way! And when they met again, Gorky wouldn't even talk about it. De Koon-
ing expected Gorky to split the loot with him, but he never did.

THE SENATOR'S VISIT coincided with a difficult moment in Gorky's work.
He was concentrating on portraits and was encountering emotional and tech-
nical difficulties. "My way of working is changing," he wrote to Vartoosh,
"and for this reason I always feel extremely anxious. I am not contented and
who knows perhaps one day I will not be satisfied with my work. I want to
attain works which are more personal and clean."

The word *"makur,"* clean, and the word "personal" appear two or three
times in Gorky's letters. I take "personal" to mean that in the late thirties
Gorky was trying to steer his interests away from Picasso and Ingres and his
other revered masters. But it is hard to understand what Gorky meant by
"clean"; perhaps it has to do with flatness and precision. "Mrs. Mitzgir has
bought a personal work of mine." "Today I finished a big photograph [paint-
ing?]. I wish you could see it. It is very beautiful. The way forward in my
work is clean and much closer to me." The efforts he was making were wear-
ing him out. "You know how much I rush backwards and forwards when I
paint until I find the right lines and colors and my soul comes out and my
head aches and I don't eat don't drink don't sleep and this has happened
before."

Two friends have left accounts of Gorky's approach to portrait painting.
One was Jacob Kainen, the young artist whom Gorky had met through John
Graham.

> After about four sessions (I posed only once a week to allow each layer of
> paint to dry), Gorky sanded down the newly dried surface and applied almost
> identical colors. By the next week the paint was dry. Gorky would sand it
> down again and apply another layer of matching colors. This procedure con-
> tinued until the final, eighth pose. "I want a surface smooth, like 'glahss,'" he
> said. Density in a painting was very important, he told me. He believed in
> building up a painting layer on layer, refining the relationships of colors and
> shapes and implying a kind of subterranean life for each color.

The surface "like glass" for which Gorky was aiming emulated the surface
of Ingres, who used to go over his portraits carefully, rubbing down and oblit-
erating the brushstrokes. Ingres thought that art was eternal. Anything which
suggested the flicker of the present should be suppressed.

Raphael Soyer, who lived on the other side of Union Square, once asked
Gorky to sit for him:

When he posed for me for that painting, he wore a kind of corduroy jacket, olive-green or brownish-green or something like that. I remember that he very carefully arranged the folds, carefully arranged the jacket, saw the collar was right and everything else. Because he knew how important those elements are in a painting. See, I would just paint anything, but Gorky was very conscious of arrangement, of composition, of shapes and colors per se, not just making a life-like portrait of the man. He was interested purely in the aesthetics of the painting. And I learned from him a great deal. Gorky, you see, called my attention to this. "Simplify the elements of a portrait," Gorky said. "Simplify the shape of the hair and the shape of the collar, and look how non-naturalistic, how almost abstract the quality becomes."

In the *Portrait of Ahko,* the sitter's hand rises to the jaw in a gesture dating from antiquity, indicating profound thought, even thoughts about death. Gorky took photographs of Akabi and Vartoosh in the same pose when visiting them in Watertown. His portraits of Akabi and Vartoosh are heavily influenced by the ancient Roman and Hellenistic portraits from the Fayum district of the Nile delta. The Fayum portraits are matter-of-fact, "commercial" works, in the sense that they follow a series of easy rules. The neck is two vertical lines. Two more lines descend to the two base corners of the panel—shoulders, but also

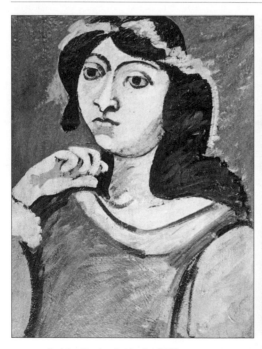

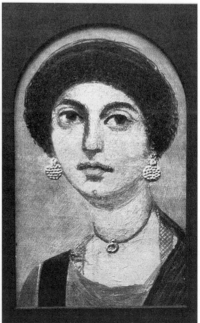

Arshile Gorky, *Portrait of Ahko,* c. 1937

Reproduction of a Fayum portrait that Gorky studied

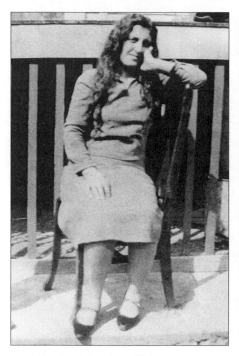

Ahko, Gorky's elder half-sister, c. 1929 Vartoosh, Gorky's younger sister, c. 1929

compositional devices. The eyebrows continue into the line of the nose; the line under the neck is hard, accentuating the shape of the jaw. Gorky was fascinated not only by the simplicity of the composition but also by the surface quality, usually described as being painted in "encaustic," meaning pigment mixed with hot wax. Compared with oil paint, the Fayum portraits were fatty but fast-drying. Making his own experiments and carefully studying reproductions, Gorky found his own equivalent in oil paint.

He referred explicitly to the Fayum portraits in the text he prepared for the WPA bureaucrat in Washington. Immediately after the vision of the Adoian hearth at Khorkom and the "elevation of the object," Gorky continues the train of thought by describing the profession of the undertaker in ancient Egypt— the association being the way in which inanimate objects are "elevated" into another realm by the hand of a creator:

> Knowing that the living could not live forever, with the spiritual support of the priest, he operated upon the dead, so that the dead might live forever— never to die! To ensure the perpetuation of Life, portraits of the beings, glassy-eyed, enigmatic, were painted on the mummies. This operation has transferred itself to the clinical image of our Time. To operate upon the object! To oppose the photographic image, which was the weakness of the Old Masters.

The Fayum masks uncovered layers of experience beyond those usually conserved within the simple parameters of portraiture. They had been found attached to mummies in ancient tombs, and the aura of decay and mortality they exuded was inescapable.

Gorky did not just appropriate a style, a manner, a tradition pertaining to the eastern Mediterranean whence he himself originated. He empathized with the poignancy of the images and with the touching circumstances in which they had been found. Whereas most portraits are celebrations of life triumphant over death, conveying through the richness of the painted surface the idea that art outlasts its time and gives its subject a particular immortality, Gorky's portraits start from the opposite conviction: that within the living body, the subject contains its future death. We are but temporary vessels in this world. If art in all its physical beauty outlasts us, it will bear witness to the fact that we ourselves have long since reverted to dust.

THE WORLD'S FAIR

1938–1939

D URING THE LAST FEW MONTHS of 1937, Gorky was kept busy
making various "proposals," as he called them, for the New York
World's Fair. "May God ensure they accept them. There was about
2000$, my dearest, I've finished about 3, 5 [proposals] a week ago and I'm wait-
ing while they say today, tomorrow, today, tomorrow. I held back my letter for
this reason, I wanted to give you the good news and then write. I think con-
stantly if only they take them and then we will all be OK—father, Agapi, you
and me." This is one of the very few references in the letters to his father
Sedrak, who was facing difficulties at the time. "And I have a painting in an
exhibition . . . they have 20,000 $ to spend. On my work I put a price that was
not too high. If only they would buy it, I could come to you for Christmas and
help father a lot."

Up until now, Sedrak had been living on a farm in Milford, Connecticut.
All Father wanted, Gorky wrote in another letter, was to live on a farm. For
some reason, Sedrak had to leave where he was living, and, having no money,
he had no option but to go back to Hagop.

Sedrak's eldest son was now employed by the New England Butt Company.
Though it was only piecework, his employer took him back regularly enough.
On working days he came home, took a shower, and dozed off in a chair. He

had always been a hardworking man. Under Hagop's roof, however, Sedrak was now just a guest. Once you had left Hagop's house, it was hard to go back. The remarks in Gorky's letters indicate that a family crisis had occurred. Whatever his feelings about his father, it was evidently painful for him to admit that he was too far away, and too poor himself, to help.

Sedrak eventually found a room in the house of a shoe salesman, passing along his Social Security check to him, in return for board and lodging. The shoe salesman was the father of triplets, and during the day, while he and his wife were at work, Sedrak used to take them out to the park in a pram, like a reliable old-fashioned grandfather. He grew to be fond of them. It wasn't a bad arrangement.

THE YEARS PRECEDING the outbreak of the war are in some way the most obscure of Gorky's life. His dealers Philip Boyer and Anna Walinska went out of business and he was unable to find another. He failed to join the American Abstract Artists or any of the other groups which were forming at the time. His contacts with the family in Watertown were less frequent, and he did not have the inclination to go and stay with Vartoosh in Chicago. In short, he became something of a recluse. When, in the forties, life blossomed again, he told his second wife how difficult this period had been for him. "Gorky described it as the bleakest, most spirit-crushing period of his life and spoke with such bitterness of the futility of such paralyzing poverty for the artist. Towards the end of the 30's, he felt a terrible isolation which no amount of subsequent friendliness on the part of the surrealists or anyone else could eradicate. He often said that, if a human being managed to emerge from such a period, it could not be as a whole man and that there was no recovery from the blows and wounds of such a struggle to survive."

As far as I can tell, between the completion of the Newark Airport murals in 1936 and the end of the decade, Gorky sold only three paintings. One each, at $100, to Ethel Schwabacher and Mrs. Metzger, who came back to study with him early in 1937. He complained to Vartoosh about the miserable price. "They are beating at my door right at this minute, because I have to send 165 dollars to the landlord. I sold two very beautiful paintings at a low price, but it doesn't matter." The third was the one he had sold to Wolf Schwabacher, who was paying in installments.

Sidney Janis (or perhaps his brother Martin) visited the studio. "They liked my 3 paintings a lot," he wrote to Vartoosh, "but we couldn't come to an agreement about the price. They said (last night) that they'll come back and somehow we'll make a deal, but they didn't come and today I spoke to them on the telephone, they said his wife had a bad cold and they've postponed 'til next tuesday. And so on. And the others likewise."

In January 1938 Gorky wrote: "I wish you a happy new year and I'm so sorry not to be with you because I'm making drawings for the Vorlsfir [World's Fair], that is to say proposals and if they accept, as I wrote already, I'll get 2,000 dollars but as you know in all things there is politics and I've been working already for four months until 3, 4 in the morning." Gorky usually completed his designs for murals very fast. Those for Newark had only taken him a few days, and another mural, designed in 1940 but never executed, was drawn in a week. Vartoosh probably wound up every letter to Gorky asking when he'd come to visit them in Chicago. Gorky was using the World's Fair as an excuse not to go. He added, "They bought one of my paintings for $650 but I haven't yet received the money but on the 4 of the month I will." This was not true. Wolf Schwabacher had been paying him fifty dollars a month for several months when Gorky wrote this letter. Lack of money was another good reason not to visit Vartoosh.

Gorky produced his finished gouache studies for the Marine Building and (perhaps) for the Communications Building, but neither of these projects came through. It was May before he received a commission. "I am drawing paintings nine feet wide for the Vorls Firi. These have nothing to do with the other work do you remember how many proposals I drew and nothing came of these. This is another job for which I must get 500 of which I shall give 200 to my assistant but so far I have been paid nothing."

"The architect is Mr William Lescaze, who is the best architect in America. sure he's not a real american, but swiss. And he likes my work a lot and he himself wrote a letter to the Worlds fare." Lescaze was a friend of Gorky's and a staunch promoter of the installation of new works of art in new buildings. He had followed the progress of the Newark Airport murals from start to finish.

The commission that Lescaze finally obtained was for a long mural, halfway down the stairs of the Aviation Building, which he had designed. He later wrote that he had had "some say" over how the interior of the building was to be decorated, "though not much to do with the way it was handled. I don't think Gorky was too happy about that particular mural." Indeed, the World's Fair mural is less advanced than the Newark murals.

According to its records, Gorky left the Federal Art Project on January 16, 1939, and worked on the World's Fair mural through March. He wrote to Vartoosh that he had had a bad cold while he worked on it. "Because with a tiny stove in the winter's cold I painted my painting (world's fare) and finished it a week ago. It's beautiful and everyone's pleased with it."

As soon as he had left the FAP rolls, Gorky applied for U.S. citizenship. The Federal Art Project was not supposed to employ resident aliens, and in spite of his connection with Burgoyne Diller and Audrey McMahon, Gorky would not have been able to rejoin the FAP unless he was a citizen. General Somervell was

now firmly in charge, and everything had to be played by the book. "Dear Murad as you know in all the Project I am the only one who isn't a citizen. and those who aren't citizens are immediately kicked out." Citizenship was conferred on May 20, 1939. He was taken back by the Federal Art Project soon after.

Gorky wrote to Vartoosh to say that he had declared April 15, 1904, as his date of birth, either because she did not know the fact or to cancel whatever she might have told inquiring officials previously. The Armenians of Van did not keep track of birthdays. Gorky was probably two or three years older than the years he declared, and we have no way of knowing whether or not he was born in April. Sometimes his birthday followed those of painters he admired: October, like Picasso, or August, like Ingres.

DURING THE SUMMER of 1938, Gorky was alerted by Vartoosh to the fact that their cousin Ado Adoian, with whom they had been brought up in Khorkom, was in danger.

Ado was a friend and supporter of the First Secretary of the Armenian Communist Party, Aghasi Khanjian, who came from Van. He, too, had walked with the others to Yerevan in 1915. Khanjian for a while had received the support of Stalin, and he was made President of Armenia before the age of thirty. Through Khanjian, Stalin purged the old Bolshevik party in Armenia. Then, in the latter half of the thirties, he turned against Khanjian and had him killed.

It looked bad for Khanjian's followers. In response to his sister's promptings, Gorky made some inquiries. "My dears, those who are not loved by the Americans have overthrown that government." Meaning, he was aware that Stalin was tightening his grip on Armenia, and that this was viewed with misgivings by the U.S. government. As for Ado, "My dear ones, I'm sorry I don't have news of Ado, but I don't think anything has happened. Dear Moorad how is everything. Tell me if you have a new dog. In the photo you sent there is a beautiful dog." This jump from news of Ado to an inquiry about Moorad's dog suggests that Gorky did not approve of discussing certain matters in writing.

Ado Adoian was arrested. At the time, the prisons were full, as were the cellars of the government offices. Trains filled with deportees left for Siberia almost every night. In the event, Ado joined them. He remained in Siberia for fifteen years.

While he was awaiting trial, Gorky suddenly became impatient with Ado's problems. "What has in fact happened to Ado as you wrote [illegible]. I often think: one day Ado is Trotskyite, one day fascist, one day Tashnag."

It seems unfeeling of Gorky to wash his hands of the whole business. Maybe he preferred to think that Ado's enemies were other Armenians, not Stalin, whom he admired? The episode remains murky in the extreme. To add to the problems, the passages in Gorky's letters which refer to Armenian poli-

tics have been underlined or brack-
eted in pencil by Moorad, meaning
that he wanted this information to
be suppressed. Vartoosh never did
so, but it is always possible that
other, more explicit letters were sim-
ply destroyed. Moorad Mooradian
was engaged in left-wing activities
at the time, and Gorky was anxious
that the eyes of the FBI might be
upon him. In which matter, as it
happened, he was not wrong.

Yet Gorky thought constantly of
his family. Whenever he worked on
his portraits of them, he kept up an
imaginary dialogue with his sitters.
He mentions this in his letters to
Vartoosh—a rare hint at what went
on in his mind as he worked: "Every
day you are in the pupils of my eyes
[. . .] I thought that you Murad
and Karlen were here and together

Arshile Gorky, *Self-portrait*, c. 1937

we were singing sad songs. And
I have painted my portrait, I have given my eyes the shape of leaves. These two
leaves tell me constantly YES, yes."

The self-portrait of which Gorky writes is at present at the National Gallery
in Washington. Emulating Ingres, Gorky flattened the surface with fine sand-
paper to remove any sign of the brush; the fine bristles of a blender have been
dragged down the right side of the face. The forms which compose the head
are placed one beside another, not quite interlocking. A sense of fragility pre-
vails, as if the personage depicted has been pushed behind the surface of the
canvas so that he disappears into the distance, like an image seen under a veil
of water.

Gorky was fascinated by the way the image in a figurative composition
related to the picture plane: how much depth the artist should suggest and
how the surface of the work should be made more apparent to counteract the
illusion of depth. In a museum one day with his pupil Ethel Schwabacher, he
held his hand flat in the air parallel to the surface of the canvas and talked
about whether it was "near" or "away."

The *Self-portrait* was one of Gorky's chief preoccupations during this
lonely period of his life. Although it was started much later than the Whitney

version of *The Artist and His Mother,* it is its necessary interlocutor. The child at Shushan's side is Gorky, but the son for whose eyes she is searching stands outside the painting, in the room where Gorky is working, and the *Self-portrait* is the image which Gorky presents to her in answer to her questioning gaze.

Of the two versions of *The Artist and His Mother,* one in the Whitney in New York and one in the National Gallery in Washington, the first was started in the twenties and the second much later. Shushan's face in the Whitney version is of an older woman, a mother to whom the artist looks up with respect, perhaps even with a certain fear. Her face is severe, almost hawklike, expecting something of the observer—of the maker of the image. The painting is an act of homage, of obedience, as if the person who painted it were not a grown man approaching forty but the child standing by her side. The National Gallery version is in every way "posthumous" by comparison. At some point in the late thirties, Gorky must have passed the age his mother was when she died. The image is more sad, more remote. It is a painting that says farewell.

Armenians of the Diaspora recognize in these works degrees of suffering about which those who are not Armenian know nothing. Though most Armenians with whom I have talked have their difficulties with Gorky's abstract work, the two versions of *The Artist and His Mother* evoke immediate recognition. Or even more: the implication that non-Armenians have no claim over this image. As does no other work by an Armenian artist, it bears witness to the genocide of 1915.

Another constant source of inspiration for Gorky were the Pompeian frescoes from Boscoreale in the Metropolitan Museum. Willem de Kooning talked about them in an interview: "He couldn't get over the idea of painting on a terra-cotta wall like the Pompeian artists were doing. I had that yellow ochre, and I painted a guy on the yellow ochre and the wall was really like the yellow ochre, a flat thing." In other words, in the Boscoreale frescoes the figures were depicted against a wall, and the wall was flat, and painted, and the wall in the painting *was* the wall—the wall of the room in which it was located.

The original photo of Shushan and her son which Gorky took as his model includes a hearth in the background—not a real hearth but a painted hearth, whose canvassy surface is just perceptible in the photograph. The tensions between real and imagined surfaces behind the photo, and in the canvases which came from the photo, were extremely complex, but Gorky did his best to follow all of them. Perhaps de Kooning watched Gorky prepare the second version of *The Artist and His Mother*—saw how he chose an absorbent canvas to get the wall-like quality, saw how he put his paint on newspapers at night in order to remove its excess oil, so that when it dried it looked as flat as a fresco. Saw the first coats of paint applied, flat as a wall, with a fat wall-painting brush.

Although de Kooning was the most appreciative of all Gorky's friends,

Arshile Gorky, *The Artist and His Mother,* 1926–36

strangely enough he was immune to the memories which, to Gorky, made all these efforts worthwhile. He never quite believed them. To de Kooning, Gorky's father was "a great guy sitting on a horse, commanding men and telling them what to do." It was just "folklore." All those stories about the lake. "I always thought he gave me the business about it, but maybe he really meant it." Or maybe he just made them up as he went along? After all, "He came here when he was about sixteen, went to Boston, entered school there. So it isn't as if he was walking around behind a plow, you know."

When Gorky saw a photograph of himself as a young man (de Kooning told an interviewer), a certain sadness overcame him. If de Kooning saw a photograph of himself when young—well, you know, "Big deal." But Gorky seemed hypersensitive to the "feeling" which the photograph evoked. Of course, Gorky had been very bound up in his family; his sister and so on. Was that a good enough reason? "I like my family too," said de Kooning, "but I can do without them." De Kooning left Holland and his parents when he was sixteen, with apparently no hard feelings on either side. Someone who owed his father money fixed him up with a passage as a stowaway, and over he came, slipping ashore when the boat docked on this side of the Atlantic. But then de Kooning came from Rotterdam, a predominantly working-class city, where young men

traditionally said good-bye to their parents and went to sea in their early ado-
lescence, without too much sentimental nostalgia on either side.

Apart from that one blind spot, "for four or five years, de Kooning virtually
worshipped Gorky," as Balcomb Greene put it. "I don't think that's an extreme
term. It was almost open-mouthed awe." Kaldis, who was one of Gorky's super-
visors on the project, said, "De Kooning would become ecstatic whenever he
saw Gorky's work[s]. He admired them. Gorky was de Kooning's master."

An early drawing by de Kooning is called *Self-Portrait with Imaginary
Brother.* The title resembles one of Gorky's: *Portrait of Myself and My Imagi-
nary Wife.* I have always taken this drawing to show Gorky as the "imaginary
brother" whom de Kooning conjured up on the page, holding a portfolio, like
Gorky walking the streets of New York carrying a book. There is a photo of
Gorky and the painter Peter Busa in almost the same pose as that in the de
Kooning drawing. (Busa's studio was around the corner from de Kooning's.)
That air of leadership. And de Kooning's smaller self, "looking up" to him in
the most literal way.

IN HIS SOLITUDE, Gorky at last began to bring the memories of Khorkom
into his work.

The first clues are to be found in his titles. *Enigmatic Combat,* a painting

Gorky and Peter Busa near de Kooning's Willem de Kooning, *Self-portrait with Imaginary*
studio, c. 1936 *Brother,* c. 1938

Arshile Gorky, *Enigmatic Combat*, c. 1937

with three interlocking elements and beautiful fresh colors, refers to the legends about the founding of Khorkom, centuries ago. Some young men wanted to marry some girls from the next village. Their brothers refused. The brothers were invited to Khorkom to discuss the matter. There was a fight. They were locked in a barn and eventually their throats were slit.

Gorky's cousin Arax Melikian told me a variation of the story about the "enigmatic combat" at Khorkom's founding. Forty young women of the village invited forty young men from Khiosk to marry them, and on their wedding night they murdered them. All save one, who, because she loved him, smuggled her husband away. . . . Muddled stories, covering an original incident which deserved to be forgotten. But old grandfathers in Khorkom still told the tales to little boys, if they could catch them, and twirled their mustaches with relish when they came to the gruesome bits.

Gorky thought constantly about Khorkom when he painted, but in the case of this work, there is nothing to show that the image evoked the memory. The title applies to what he was thinking, not to what he was painting. The title of the painting he called *Argula,* as I have already pointed out, means "He is crying." In fact, the image of *Argula* was derived from a composition of which many versions were made between 1938 and 1942. After the series was completed, he gave the best version of it the title *Garden in Sochi*. The Black Sea

Arshile Gorky, study for *Garden in Sochi*, c. 1938

port of Sochi was in the news at the time, and the title is another example of Gorky's need to confuse as much as to reveal.

The subject of the series is a scene Gorky remembered from his childhood: his mother making butter in the Adoian house in Khorkom. The earliest study for this series, a large gouache, makes the scene quite clear. On the left stands a woman, with one hand on her hip and the other on a shape suspended from a dark line descending from the top of the canvas, as if from the roof. She wears an intricately patterned apron filled with vivid designs. On the bottom right lies an animal in repose. Above this animal hangs the onion with feathers inserted in it—the famous "elevated object" which Shushan or another woman of the house had suspended above the hearth in the Adoian house in Khorkom for use as a calendar. The shape in the center is the skin of a goat, which has been filled with milk. Interlocking sticks block the opening in the skin where the goat's head used to be. The woman rocks the heavy skin to and fro until the whey separates from the curd and the butter floats to the top.

Arax Melikian told me that as a small child she used to loiter with the other children while the women made butter, clinging to the aprons of their elders, waiting for a first taste—so sweet, she said, compared with the salty butter of America. The sticks would be removed and a finger inserted down the slithery neck of the goat. Then, shooing away the children after they'd been spoiled a bit, the women put the butter to one side and poured the residue into jugs. Mixed with yoghurt, it makes a fresh drink which is drunk in peasant houses

from northern Greece to India to this day. Only women whose "tread was light," i.e., not menstruating, would be allowed near, in case the silly goat took offense and refused to turn the milk into butter. The ritual always took place at the same time of day, because the sheep were always milked at a certain hour, so that to a child, the making of butter would forever be associated with a particular time and place. Nobody ever thought that what they were doing was in any way peculiar. But as Gorky recalled the occasion from the distant vantage point of Manhattan, the scene became charged with an unconscious, almost surrealist humor, typical of that "innocence" which, to Gorky, was among the most valuable qualities of his birthplace.

Gorky's endless stories were not recounted so much as pitched at his audience. Part of his purpose was to "paralyze with disbelief." He wanted to make an effect, but at the same time he did not want to provoke any questions as to where, how, why a particular event had taken place. They were a tiny fraction, for public use, of a dialogue he held night and day with Khorkom—a little village which had been destroyed, at this point, almost a quarter of a century before.

IN THE SUMMER OF 1938, Rosalind Bengelsdorf and her husband Byron Browne came across Gorky sitting on a bench in Washington Square, "looking very lonely." The Brownes were on their way to Provincetown. Wouldn't Gorky like to come with them? So they took the boat from New York to Boston

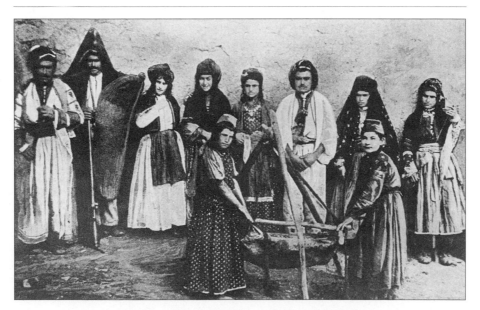
Armenian village women with goatskin butter churns

Argula, a simplified version of the butter-churning image, given by Gorky's patron Bernhard Davis to the Museum of Modern Art.

and from Boston to the Cape, and for a while they had a great time. Gorky prepared shashlik for a beach party and fussed about the marinating of the meat; the sand blew in it anyway, but they didn't mind. He sang Armenian songs and tried to make his friends join in the choruses.

During the day, Gorky used to walk off with Byron Browne talking about high artistic matters, and Rosalind padded behind "like a little puppy dog." Gorky did not want her to join in the conversation. "You're a good painter," he said, "but you make a lousy artist's wife." Modestly, many years later, she said that she had had "too much ego at the time." Gorky's idea of an artist's wife was a woman "in the background, which is where he pushed me and which I didn't like." In the end, she and Byron had a fight about it and Rosalind went back to New York, leaving the men to take the boat back by themselves, presumably still talking about serious, manly things.

The countryside brought out another kind of flamboyance in Gorky. As Balcomb Greene put it, instead of the "Studio Artist Becoming a Celebrity," you had "the Lyrical Man [. . .] the bronzed swimmer, exuberant with the country air, or sweating in the heat as he swung an axe. In the daytime he fitted in, adjusting to the routines and the work as well as anyone. After dinner he could discuss for hours, omitting all the frills and all the clever knots of ideas. Still later on a clear night, high up on our hill by a fire, he sang the songs which proved he was Georgian, the lonely, haunting laments in a high voice— Georgian, Andalusian, Syrian, perhaps Armenian."

Though Greene said that Gorky "adjusted to the daytime routine," some-
times his interference in the practicalities of life was disruptive. Taking charge
of the shashlik party as usual, he announced that "the young women will pre-
pare the salad, the old women will cut up the lamb." No doubt this was in
accordance with the hierarchies of female rank that he had known in
Khorkom. The difficulty being that Mrs. Greene was not at all pleased to be
classed among the "old women," thank you very much.

One of Greene's friends, a mathematical physicist called Lewis Balamuth,
described the scene. After shashlik and wine,

> Gorky started to talk about his motherland, Georgia. He spoke of the moun-
> tains and exhibited a strong feeling of nostalgia towards his early recollec-
> tions. The conversation became more animated, and Gorky rose to his full
> height in the twilight to emit a loud cry after the manner of the mountain
> shepherds of his native land.
>
> Shortly after this we all decided to visit a beautiful gorge and waterfall
> in the region of Coldspring, which is a town near Fishkill. We piled into a
> car and off we went, dashing, so that we would catch the effect of the
> last light of day at the waterfall. While driving, Green and Gorky began
> to talk about various trends in abstract art, and it was thus I learned that
> Gorky was an artist. Gorky spoke with a great deal of assurance and without
> fear of contradiction. To characterize Gorky's feeling for abstract art, it was
> far away from the mechanical limitations of simple geometrical forms, but
> rather it seemed to reflect a turbulent spirit moved perhaps by the wildness
> of his native mountains. This turbulence however, I felt also came from
> within, as though he were torn by some inner conflict which he was ever
> striving to express.
>
> We came upon the gorge in the midst of our discussion, and Gorky and
> I sat upon a high cliff of rock overlooking a beautiful waterfall. In the
> evening quiet with the restful sound of rushing water in the background
> we continued the thread of conversation begun on the trip. In the course
> of our talk Gorky discovered that I was a mathematical physicist and he
> displayed a keen interest in the mathematical aspects of science. I in turn
> was eager to learn what part mathematics played, if any, in Gorky's approach
> to abstract art.
>
> He indicated a regret at not having mastered sufficient mathematics to sat-
> isfy his own needs, and proposed to me that he would be happy to teach me
> what he knew of abstract art, if in return I would teach him mathematics. It
> should be emphasized here that we were not speaking of mathematics here as
> algebra, geometry or arithmetic, but rather as a creative science which has as
> its function the reflection of the quantitative aspects of nature.

DURING THIS DIFFICULT PERIOD, there was one close friendship which,
at least for a while, seemed to promise an end to his increasing solitude. He

called this woman with whom he was in-
volved "Linora." The relationship continued
for more than a year, but she was frequently
out of town and it is not clear whether she
ever came to live with him at Union Square.

Linora is still alive, but she is adamant in
her refusal to talk about her friendship with
Gorky. Given her reticence, I can only de-
scribe her from details in the public record,
plus a few references to her in Gorky's letters
to Vartoosh. Linora was a member of the Musi-
cians' Union from 1928 until her retirement in
1986. At the time Gorky knew her, she was
giving concerts as a soloist, and subsequently

Arshile Gorky, portrait drawing,
woman with a violin, c. 1938

she played for many years in the string section of a leading New York orches-
tra. One of the drawings that Gorky gave her is a portrait of herself holding a
violin and looking toward the left, as if she had been practicing before Gorky
made her stop and pose.

Gorky made her a card for Valentine's Day, so he knew Linora on February
14, 1938. A few months later, he gave her a finished gouache for the Marine
Building mural at the World's Fair—perhaps when that particular project fell
through.

Gorky's niece Libby, Akabi's daughter, saw her once. Sixteen years old and
just beginning to wear makeup, Libby had come to the big city to visit her
uncle. Her fingernails were nice and long and painted bright red. Gorky gave
her a lecture on what she was doing to herself: how bad makeup was for the
skin, that only "loose" girls wore makeup, and so on. Then he phoned Linora
and asked her to take her to a museum, as he was working that day. Libby trav-
eled uptown and waited outside the museum for two hours. When at last Linora
appeared, Libby was stunned by her beauty—her height, her red curly hair, her
long eyelashes touched up most beautifully with mascara. They spent a pleasant
afternoon together, but all Libby could think of was Linora's makeup. Her uncle
made such a fuss about hers, and here was Linora as colorful as a sunset.

In the spring of 1938, six weeks or so after Valentine's Day, Linora was in
Paris. One of Gorky's recent paintings was on exhibition there. Gorky wrote to
Vartoosh, "Linora my friend who is now in Paris, wrote to me to say that the
Paris newspapers liked all my paintings a lot and had written that Arshil Gorghi
is the most original-original painter in America. Then the painting was pub-
lished in the best review on art in Paris and in the world, called Cahiers d'Art.
You know, the one I always used to get in order to see the works of Picasso."

A year later, he wrote to Vartoosh, casually but with weight, "Life here is

the same, I don't see Linora very often. And now I understand a bit better."

The builders were in the apartment above him, tearing at the walls upstairs and filling the studio with dust. He was in a confused and depressed state. Linora was in the West. Perhaps there was a chance that Vartoosh would see her? "I believe that before you get this letter Linora will be there in Chicago. She's coming back from Chicago and will come and see you. I think she has relatives there and will certainly go back to them."

Though this makes it sound as if the relationship had ended, a short time later he wrote, "Don't worry about me I am well and working hard. If ever I get this money I will be with you in april, or else this summer Linora and I will come to you. Have you heard from Ato or not. Tonight I saw Kikush in an armenian restaurant." The casual proximity of Linora's name to Ado's suggests the curt tone Gorky assumed when he was worried about something but did not want to think about it.

After this, no further word of Linora.

Among the drawings he gave her is a series of sketches showing himself in traditional Armenian dress, holding a scythe or leading a horse. They are little more than cartoons made at a bar or restaurant to give her an idea of his exotic background. One in the series, however, suggests something more. The draw-ing shows a figure like himself court-ing a woman who, as I read it, symbolizes his "imaginary wife." Solicitously, protectively, he bends over her. In the mirror behind, as if indicating a different stage in their relationship, a fiercer Gorky looks at his wife, while underneath stands a little child. The device that divides the drawing into segments is borrowed from the shelf and mantelpiece in the background of *The Artist and His Mother*. The contrast between the subservient, protective suitor and the dominating, almost aggressive husband unconsciously prophesies his different modes before and after marriage. The shelf and mirror, borrowed from the painting of himself and Shushan, indicates the continuity of the hearth—a Western equivalent of the *tonir*, which was such an

Arshile Gorky, untitled drawing of his "imaginary family," c. 1938

important feature of life on Lake Van. The child on the right, meanwhile, is surely Gorky's own.

After so many difficult relationships, which always ended in his abandonment by the woman in question, Gorky began to understand that he was a difficult man to live with. But this did not make his desire for a permanent relationship any less intense.

HE WAS RECEIVING many letters from Vartoosh. They were filled with complaints, as can be guessed from his replies. He was sorry she had had difficulty with her eyes. She should be careful what glasses she bought. "Don't go to shop for glasses. I don't know if I wrote to you or not, but my eyes are much weaker, so that I had to pay 30 dollars to buy glasses and now I cannot use them because I cannot get used to wearing glasses."

He had been to see Akabi and she should not feel that she was angry with her. (Sometimes her sisters thought that Vartoosh put on airs.) "My sweet. Agapi is not mad at you and she talks about you all the time and repeats the things that Karlen said. We all loved his stories." As to how they were doing in Watertown, "Azad [Akabi's son Jimmy] has a job for eight dollars and ten cents a week. Megherditch also works three days. they are well and love you very much. I'm sorry Murad had some teeth out."

He himself was being driven mad by the racket the builders were making. For six weeks they had been working right on top of his head. They had warned him they could not be held responsible if anything in his studio was damaged or stolen. As a result, he had kept indoors night and day. The work he was doing was "messy" and he hated that.

And in the middle of all this, like an emotional thunderstorm, comes an anguished passage about her loneliness and his:

My dearest, you wrote some time ago that you had found some good friends there, one day you go to them and the next they come to you. what has happened to those friends that now you feel so depressed. Dear Vartush I do not know what to tell you about that subject, it is so hard to find what one needs, I mean those kind of friends. Somehow you have to find good surroundings or make these surroundings for yourself, because loneliness is unbearable and I know because that is the situation in which I find myself and it is up to us.

My dearest, I want to tell you from my heart that . . . I always feel alone when I talk to others, but my heart is always looking for something and does not know what it is. And I know that here or there you cannot find those kind of armenians that one does not find them even in Armenia, but you see the armenians of that place are not those you think because I know that you loved Ato a lot and you see how they treated him and they sent him away from the things for which he worked so hard and loved so much.

So you see that deep down all men are the same, above all our armenians if only you did not suffer for the armenians on account of whether they are good or kind. In life, dear Vartush man has to, since the moment he is born, look for a peaceful cradle or else a really good surroundings and when he finds a loving and gentle or else just his own loved surroundings, then he is no longer sad and he can remain alone even without friends. So man is forced to learn this truth of life and the importance of his surroundings. My dearest, I do not mean to upset you in writing this, but I want to tell you that within us, as within all men there is a desert and we constantly seek the one thing that enables us to escape from being alone.

This has always happened and always the weight of loneliness is with us, and for this reason we think of this thing or that so as not to feel alone. Believe me, dear Vartush, that I understand you and I too have those terrible days and I too lack those kind of friends that is true friends.

Vartoosh was increasingly confined to her apartment in Chicago. It was bad for her and bad for her son. He came back to this theme later, more calmly.

My dear I have to tell you something. . . . Our ancestry I know is not so good, but we must make the effort to make friends with others. I want to write to you about certain things, Vadush and one . . . for example. You know . . . If you meet someone, either American or another nationality, invite them back to your house to have tea or a nice meal. And surely they will invite you back. In this way you will make a kind of friendship. maybe they'll introduce you to other people, and maybe you will make lots of new friends, male or female. Now you know everything. Don't remain on your own, it's not good even for Karlen. try to make sure that Karlen meets other children and plays with them.

Vartoosh neither listened to her brother nor ceased complaining.

Gorky's depressions were probably at their worst when he was unable to paint. It can hardly be a coincidence that the most self-revealing of these letters, in terms of his own sense of weakness, is the letter written when the builders above him made it impossible for him to concentrate on his work.

In the Artist's File at the Whitney Library there are two photocopied sheets of a poem by Gorky. It is written in Armenian, although it is preceded by a transcription in English of a French surrealist poem Gorky wanted to use as a stylistic model, and which he had copied once before in one of his letters to Michael West. Gorky's poem could have been written then, in the summer of 1936, or perhaps a couple of years later. At any rate, I connect it with one or another of the bouts of depression he suffered during the last years of the 1930s.

The text is almost impossible to read. Ethel Schwabacher gave it to Haig Partizian, the translator Vartoosh had found for her letters when Ethel was writing her biography. Partizian could make nothing of it, although he recog-

nized that it might provide a clue to that "curtain that seems to hide so much of Gorky's past." He tried showing it to Yenovk der Hagopian, Gorky's old friend who lived in Watertown, and the son of the priest of Ishkhanikom. He also found it impossible. Der Hagopian in turn passed it on to an old teacher of Gorky's from Van, who said, "Just like Manuk. Just like his painting. I can get no meaning from it. He wrote it to himself. It is a collection of Van words."

I think it is more than a collection of Van words, though my translators are not confident about their version. Perhaps a perfect translation will never be made, but it remains the only text we have in which Gorky tries to summarize his life.

> In this world there is no place for me
> They promise promise and do not fulfill their promises because of the myths
> which surround my persona—
> Why promise if they cannot keep their word
> I came because they asked me. The world is full of fire and troubles with
> what pain
> I have come to understand this melancholy fire [three illegible words] which
> came in the early morning
> painfully I at last conclude that this life means nothing and is only a painful
> withdrawal.
> The rays of nocturnal light make my soul ache as they did when my blue
> hopes and my poor cat died [?]
> This night is alive, and yet at the same time my soul cries out in suffering as
> darkness spreads over my soul—
> It is dead and the night of suffering has devoured my soul

> As I grow older my wisdom grows, comforts me, and expands—
> The dreams of attaining exceptional skill with my talent came to me long
> ago but now are sleeping. Written approval has come to me—I who [one
> illegible word, followed by a cancellation]
> The night is come and during this terror my brain must continue to labour
> how can we, or rather I [unfinished]

> I come with my weary soul in terror of madness, appearing to be outward-
> looking and mythical only from outside.

WAR

1939 · 1941

O N M A Y 4, 1 9 3 9, Gorky went to a party at Frederick Kiesler's apartment on Seventh Avenue. The guests came and went: Russian, French, Tunisian, German. A Viennese doctor who had been beaten up by the Nazis. Isamu Noguchi, "the Japanese sculptor." The architect Buckminster Fuller, who had with him a technical book on naval ordnance which he claimed was written in verse: the elongation of the trajectory, the muzzle velocity. The novelist Dawn Powell, who noticed these things, assumed that Gorky, "tall, mournful, black mustached," was the grandson of Maxim. She saw him try out "a Russian dance," and later overheard him talking to a "stagey Russian from Hollywood," to whom he was telling an anecdote. The punch line was "Permeet me to say that you are like so many dead feesh." The room was dark and the tall woman whom he addressed had daisies for earrings and a handsome red spangled shawl. Gorky, seeing her skepticism, repeated the remark.

The story gives a feeling of the time: crowds of people in a small apartment waiting for something to happen. The city was rapidly absorbing a special wave of immigrants: writers, artists, critics, musicians who had fled from Europe, refugees who brought with them horror stories which they paraded in front of a strangely indifferent audience. It seemed incredible to them that Americans could remain so aloof, but President Roosevelt continued to give assurances—

at least in public—that no Americans would be involved in the coming war. Most Americans thought that Europe was remote and that their war was no business of the United States. Talk, more talk. The strange cocktail parties of the time, with the radio on and the newspaper open on the side shelf. The wristwatch surreptitiously consulted. Rooms crowded with what Louise Bogan described as "such an assortment of talent, stupidity, ugliness, beauty, sects, spies, agents provocateurs and just plain hangers-on, as was seldom seen."

At de Kooning's studio one evening, among a gathering of friends and colleagues, "the talk turned to the condition of the painter in America, the bitterness and unfairness of his poverty and disregard. People had a great deal to say on the subject and they said it, but the talk ended in a gloomy silence. In the pause, Gorky's deep voice came from under the table, 'Nineteen miserable years have I lived in America.' Everybody burst out laughing. There was no whine left. Gorky had not spoken of justice, but of fate, and everybody laughed open-hearted."

De Kooning's studio was a more convivial place than Gorky's. Anyone could just walk on up. "When the cafeteria closed we would go to Bill's loft in the next street and talk some more and make coffee. I remember people talking intently and listening and then everyone burst out laughing and started off intent on another tack." When Gorky was in de Kooning's studio, he usually behaved more quietly than in public places. "Gorky said so little that he was often forgotten."

Lee Krasner remembered an occasion when Gorky called a meeting at de Kooning's studio to announce that they should all admit they were "defeated" by Picasso. If they faced the fact openly, they might, as a group, think up a response.

What to paint and how to paint it seemed futile questions when set against the background of a world war. Some, like Barnett Newman, simply gave up and turned to other matters, in his case ornithology. "A few painters were painting with a feeling of absolute desperation," wrote Adolph Gottlieb later. "The situation was so bad that I know I felt free to try anything no matter how absurd it seemed." The New York artists were overcome by an extraordinary restlessness. The critics may have seen in retrospect an exciting new phase in American art, but at the time the artists saw themselves as desperate people willing to try one last throw.

On September 1, when the radio reported that Nazi troops had crossed the Polish border, Gorky happened to be in the studio of Isamu Noguchi, together with an artist called De Hirsch Margules. The three men realized that the war had at last broken out, and they decided on the spur of the moment to make a communal drawing—the Armenian, the Japanese, and the American—in the spirit of the frontierless realm of art.

In the cafés, nobody talked about art anymore. And after the ruthless opening moves of the war—the Nazi-Soviet pact in the summer and the invasion of Finland by Stalin in the fall—no one had the heart to go on preaching the International Socialist or the brotherhood of man. There were only two subjects of conversation: how to fit into the army when the time came; and money.

The Federal Art Project was threatening to close at any minute. In October, Gorky applied for a Guggenheim fellowship, asking Holger Cahill and Max Weber to be his sponsors. The application was turned down. His letter to Weber is an odd mixture of someone else's idea of a suitable letter and his own. "I do not know anyone whose approval of my work, has been a greater source of hope and encouragement than yours. therefore I am taking this privilege of asking you to offer a recommendation for me should it be requested. I remember with fondness the day we spent together at the museum—and have read, and re-read with profound emotion the beautiful book of your poems and woods cuts wich you sent me. I feel deeply honored to have the rare privilege of possesing it. Will you answer me? Yours, in all sincerity Arshile Gorky."

He had to sell all his art books, "those which could be sold," as he put it phlegmatically to Vartoosh. Wolf Schwabacher had bought a painting for fifty dollars, but otherwise there were no sales. He held on to his position with the Federal Art Project with remarkable tenacity. When, after the statutory eighteen months, he had to resign, he was back on their lists within ten days. He outlasted Mrs. McMahon herself, who finally resigned in the face of General Somervell's determination to close down as many programs as possible.

Late in 1939, Gorky went up to the Grand Central School of Art to ask his old employer Edmund Greacen for a job teaching camouflage. If he were drafted into the army, it would be best if Gorky joined a detachment which specialized in an area familiar to him. Greacen told him that he thought the idea of a camouflage class was premature. America was not yet in the war, was it? Perhaps he should come back later. As he wrote to Vartoosh, "I hope this works because life is very difficult etcetera."

Gorky asked Kiesler to tell him about camouflage, and Kiesler warmed to the subject. He filled a few pages of one of Gorky's notebooks with tangled drawings which almost, but not quite, evoke the rush of words he must have directed at Gorky. The act of recognition, in relation to imagination and fantasy, fascinated Kiesler, as did the inversion of this idea: the art of baffling the eye.

Vartoosh sent Gorky some money. He acknowledged receipt and wrote to say when he would pay her back. "My dearests don't worry about me. Somehow I'll get through. Something will turn up [. . .] surely one day things will go better for me and I will be able to visit you [. . .] thank you my sweet, I have just received the two letters from you and Murad, in which there were

also 2 dollars. I feel deep shame when you send me money. Perhaps I will one day be able to help you."

Early in 1940, he went up to Buffalo to see a Mr. Bell about a mural. He measured the walls and came back:

> I drew my designs in a week and that man who found me the job went to show them to someone else and after getting there he wrote to me that this Mr bell is very busy and wants to see us in a month. Mr Bell has a factory for making aeroplanes, and if I can I'll get 500 dollars for drawing the designs and the other man who is also an artist, will blow them up on the walls and he'll get 1000 dollars and I designed a big piece six weeks ago and sent it to Washington. If it pleases them it will be blown up into a mural and according to him, if they take it, I'll get 2000 dollars. At the moment, nobody is buying any paintings and everything is very difficult. [. . .]
> Mister Metzger came to my studio and looked at my paintings and told me that when he had the money he'd buy one for his daughter Margherita whom he loves, but it seems that at the moment he doesn't want to buy, because when I spoke to him about it he said it would be better if I found another way of making a living, because when you came right down to it, there were plenty of other jobs. So I don't think I'll see him again.

He invited Bernard Davis down to his studio, but when he came "he spoke in such a way I felt I could not ask him to buy a painting." He had been with friends in the country "about 70 miles from here," and had spent a week with "Mr Muscinian," meaning his friend the architect Willie Muschenheim.

He took part in two shows of contemporary painting at the Whitney, one in February 1940 and again in November. To the first he sent a *Head Composition,* a fine painting, and one which had a big influence on de Kooning, but also a work which was very influenced by Picasso. The second, called simply *Painting, 1938,* is unidentifiable, but was probably another of those canvases on which he had by now been working regularly for six or seven years.

A few weeks later, Gorky fell ill. Nobody was living with him at Union Square, so Bill de Kooning came round to take care of him. Lying in bed, Gorky listened to de Kooning's whistle as he tidied up the studio. Such a beautiful sound, he thought. As beautiful as a bird.

Mr. Bell postponed his decision about the project in Buffalo, and Willie Muschenheim failed to come through with any other mural commissions. He wrote to Vartoosh that Yenovk der Hagopian had visited him from Watertown, bringing news of Akabi and Satenig. He would telephone Bernard Davis soon. "My dearest ones, I do the best I can, a life like this is nothing new, neither for an artist nor for me."

After the summer, Willie Muschenheim at last landed him a mural commission, at a new club in Fort Lee, New Jersey, owned by a man called Ben Mar-

Mural design for Ben Marden's Riviera Club, Fort Lee, New Jersey, 1940

den. Gorky made his designs rapidly, incorporating themes taken partly from the *Garden in Sochi* series on which he was working, partly from a frieze with three figures he had prepared for an unknown mural commission two years previously. De Kooning helped him to transfer his design to the wall. He admiringly referred to the man who ran it as "that gangster."

When the mural was finished, it was composed of different shades of green. Mr. Marden, the owner, took one look and told them to change the whole thing immediately. What were they thinking of? Couldn't they see that the green would clash with the green of the gambling tables?

Gorky turned to de Kooning and said, deadpan, that he had never much cared for green himself, either. De Kooning was stunned. Did Gorky think that one color was just as good as any another? What about that fuss he'd made about the red spot that time they were painting the mural at the nightclub? "Of course he must have seen the green many times, like a billiard table. [. . .] But then when it was made clear to us not to use that color he right away made up for that. He didn't have to do it. He didn't have to say it. He right away said he didn't like it himself. And that was something about him which you couldn't figure out."

Gorky had to repaint the whole thing, and in fact the mural took forever to finish. For weeks he crossed the river on the bus, across the George Washington Bridge, looking down at the water underneath. On January 10, 1941, as he was setting out for New Jersey, Gorky wrote a brief note to Vartoosh. He thanked her for the five dollars she had sent him for Christmas. He would

repay the money he had borrowed from her on the fifteenth of the month. "Thus I will keep my word and I thank you very much."

A FORTNIGHT LATER, feeling low, Gorky went round to visit de Kooning. The weather was cold: there was a threat of snow in the air. He called up the staircase—"Bill, Bill." De Kooning took him in and tried to cheer him up. But Gorky just sat in a chair over on one side of the room, exhausted and unable to respond.

In the end, it was Elaine who managed to draw him out of it. They were going to a party up around Fifty-eighth Street. Wouldn't he like to come? There was someone they very much wanted him to meet: a young art student who had just arrived in the city. Beautiful, talented. A lively girl, full of fire. She'd appeared here in the studio just a few days ago, brought by a friend. Elaine had already told her about Gorky. She was expecting to meet him.

Elaine, de Kooning's companion and future wife, had in fact told this young woman that Gorky was "terrific." He'd be the center of the attention at any party, she had said, up there dancing and singing, waving that handkerchief, taking up all the room. Elaine had continued while Agnes looked about the loft. On the easel was a portrait, unfinished and to her eyes somewhat "skimpy." In the background, she heard Elaine say that Bill was seeing a bit less of Gorky, recently, and that perhaps it was for the best. Gorky's personality as a painter was so strong that sometimes it looked as if Bill would be "swamped" by him.

Gorky went to the party as arranged. But, quietly sitting side by side for a long time, each was expecting someone totally different—he: a dizzy blond; and she: a frenetic dancer. They were the last people to leave. After the party was over, Gorky finally turned to the young woman next to him and said tentatively, "Miss Maguider?"

They talked for a while. It was funny that they had waited so long for two other people to turn up. Would she like a cup of coffee? he asked. Yes, she said. At a café downstairs, he asked her about her life: where she had come from, what she was doing in New York. Her father was a naval officer, she said. She'd arrived in New York from Shanghai a few months ago. She'd spent a lot of her childhood abroad, studying. In the end, she simply emptied the contents of her handbag onto the table so he could see the evidence for himself. No bank book, not much money. A packet of cigarettes, lipstick, perhaps a little notebook. Gorky laughed, liking the flourish.

He walked her back to where she was living and left her at the door. She was immediately attracted to the way he moved, his height and his grace, his sense of ease in a city which was new to her. His long coat and soft felt fedora, rather like her father's. Would she like to have dinner with him the next night?

As he liked to tell the story later, she said, "Dinner? Oh YES," suggesting that she hadn't eaten recently—which was true.

Gorky took her to a little blue and white Armenian restaurant on Twenty-third Street. Down some steps to the basement, just a few long tables. He greeted the cook behind the counter as "*Varbed,*" which later she learned meant "Master." She ate a hot yogurt soup, a shish kebab with rice pilau, and for dessert a honey cake with a creamy sauce called *kymac.* There was not much conversation. Gorky just gazed at her as she ate. After dinner, they started walking north. It had begun to snow. They reached Central Park and went right on walking, halfway up the park as far as the Reservoir. Marny George and Michael West also remembered long, tiring walks. Was the capacity to cover huge distances on foot a prerequisite of any woman to whom Gorky felt attracted? Round the Reservoir and all the way back down again, the snow beginning to pile up on the sidewalk, along Fifth Avenue as far as Fifty-eighth Street. At which point Agnes announced she was hungry again. It was two in the morning and Gorky had to give her a whole other meal.

AGNES MAGRUDER WAS eighteen years old, on the farthest trajectory of her flight from her parents and her background. She had traveled halfway across the world in order to end up alone in New York. Her father was a captain in the U.S. Navy stationed in China. There, only two or three months previously, it had been rumored that the captain's daughter was a Communist. At a grand dinner one evening, she had told the table of assembled officers that America was quite wrong to be supporting the Nationalist government of General Chiang Kai-shek. They should be supporting the Communists! That, and a few other private escapades which made things worse, and Agnes was sent back to America on an allowance of $100 a month. She was going to study art.

In the Magruder family album, there is an official U.S. Navy photograph of the flagship *Augusta,* which her father commanded when he was stationed in Shanghai. The polished bronze feathers of the American eagle pacifically seal the mouths of huge gray guns, beneath whose barrels recline a pyramid of sailors, all muscle and clean cotton duck. At the very pinnacle of all this, smiling on the bridge, Agnes's father. A phrase of F. Scott Fitzgerald's comes to mind, describing a glamorous woman in a motorcar: "sustained by the power of a hundred superfluous horses." Agnes's father was sustained by a battleship.

She took the slow boat from China to San Francisco. There was a moment of panic when she descended at night into a friendless city. Then she immediately boarded a bus to Iowa, where she had learned from an article in *Life* magazine that a truly authentic school of American art existed. In Iowa City, feeling compassion for a hard-up teacher and his family, she gave away her jewels. The art that was being taught, American or not, seemed uninspiring to

her, so she took a hint that New York was the place to be. On the Greyhound bus to Manhattan, she made friends with a man who found her a room near Washington Square. After a week, she discovered that he and his friends ate too much for her fragile allowance, so she moved to a shared cold-water flat uptown. She was young enough to spend a few nights out in Central Park among the hobos, just to see what it was like. Young enough to charm a taxi driver into taking her down from her basement on Seventy-eighth Street for night classes at the Art Students League on West Fifty-seventh for free, so long as she sat on the floor and the flag was up. She enrolled in the anatomy course of Mr. Bridgeman, who had been there forever.

It was the fall of 1940. In the streets, the Communists were protesting against the war. "Listen to the lion roar—we don't want another war." Or: "No patrols and no convoys—in our shops we want our boys." Faithful to the Nazi-Soviet pact, the Communists took the line that the war was a capitalist phenomenon and that the United States should keep out of it. East of Lexington, around Eighty-sixth Street, was Germantown, full of Hofbräu houses and dance halls. One could walk for blocks and not hear a word of English. They were against the war, too, obviously. Once, under the Third Avenue El, Agnes saw a drunken Irishwoman shake her fist and curse a train passing overhead, thinking it was the U.S. Air Force flying off to save beleaguered Britain. The Irish, too, were against the war.

Agnes did not enjoy studying anatomy with Mr. Bridgeman. Under his instruction, all that emerged on the paper were calligraphic squiggles. She found an empty room in the basement of the Art Students League with a tub of clay and began some sculpture. One day she came home to find the communal bathroom of her flat covered in blood. Something terrible had obviously taken place, and she decided to move out. Through a painter friend, she had met a young Englishman and his wife, Elsa, from whom she now rented a room. Elsa was a clever left-winger, an ex-Communist and a friend of many artists in the city. It was what Agnes wanted. Painters. Communists. A life that was real and earnest.

Elsa had heard of a job on *China Today,* a magazine of the Chinese Communist party, and Agnes took it. There was no pay involved, but it was for the Cause. Manny Gold, its editor, looked at Agnes as she typed and retyped the same letters—it was a skill she had yet to master—and told her kindly, "You won't be with us long." She took the galley proofs down to the printers on Fourth Avenue, checked the covers of all those Chinese peasants smiling underneath their baskets. The offices of *China Today* were near the studio of de Kooning, whom Elsa knew. One day she took Agnes to meet him.

What made her curious about Gorky at that first meeting was the respect with which Bill and Elaine spoke of this powerful offstage presence.

. . .

A FEW DAYS AFTER they met, she went to see Gorky at the studio.

She followed him up ten steep stone steps, then a flight of rickety wooden stairs into a dark hall, past some rubbish bins and through a wooden door into his small anteroom. On the left as one came in were shelves containing small paintings stacked like books. A window gave onto a roofscape basking in the reflection of a big brick building opposite. A wooden door led into a beautifully proportioned room, about thirty feet square. A tall skylight was on the left as she went in. Straight ahead was a massive easel. Floor: pale parquet. Ceiling: pressed tin. White walls.

Gorky brought out his paintings one by one, from the storeroom off the hallway. His largest, heaviest, most abstract work first. As she knew so little about painting after Cézanne, she was stunned, but the overwhelming sensation was one of physical reality: that the paintings were as palpable as the man, standing on one side, laughing at her amazement, smoking a cigarette, traveling to or from the back room where the paintings were kept, with the air of a craftsman showing her a particularly well-made chair.

The painting that impressed her most was his portrait of himself and his mother. Such a full, beautiful painting, especially next to the "skimpy" portrait on de Kooning's easel she had seen a few days before. She came closer: its surface was as smooth as paper. She had no idea how it had been painted. After which they had a cup of coffee. Then Gorky accompanied her back by bus to Fifty-seventh Street to the door of the apartment where she lived.

The second time she came to Union Square, she couldn't find the studio. She rushed up and down the street until Gorky saw her from the window and came down for her.

All the paintings had been put away. The studio was spotless. This time, he showed her drawings from the *Nighttime Enigma and Nostalgia* series. He laid them all over the floor—such a clean floor, she noticed, scrubbed like the deck of a ship. He brought out portraits: imaginary heads, early sketchbooks, landscapes.

Then his living arrangements. A white sink to the right of the skylight, under which on a wide sill was a row of jars covered with dust the texture of velvet. Then, jugs filled with brushes at the back of a square worktable, a model stand on wheels toward the center of the room, and, behind it, a round table painted black, with three chairs around it. The bedroom was higher than it was square, painted maroon to a height of ten feet and gray above. There was just room for a double bed and a painted chest of drawers.

The lobby of the building was so dark she thought it must be lit by second-hand lightbulbs. The calm sense of space in the studio bore no relationship to the look of the building from the outside. No wonder she hadn't been able to

find the place! Gorky said he would leave his shoes on the windowsill to show where he lived if she came again.

She moved downtown on St. Patrick's Day, with parts of the city strangely empty and other parts crammed with people. She packed up the few clothes she hadn't yet given away and got into a cab. Gorky had found her a room with a skylight on the west side of Fifth Avenue not far from where he lived. They spent two or three happy days with mops and brushes whitewashing the room until it was as bright as his own, after which Gorky went back to his murals over the river, and Agnes returned to *China Today*. They met in the evenings to dine at an Automat or at the little blue and white Armenian restaurant.

Everything that Gorky said was amusing, in an oddly formal, almost chivalrous way. She was unsure of her looks, for instance. Her nose, perhaps? Was it not on the large side? Her eyes? Might they not be better in some way? Gorky told her, "I could go down Forty-second Street and see fifty girls less beautiful than you."

Gorky told her about his sister Vartoosh, who had had to move away from New York for reasons of work. Her cooking, which he missed. Breakfast at the café down in Union Square, he said, was so crowded and hasty that he hardly had time to say "Please, miss, may I have—" before the girl shouted "Two eggs, sunny side up" and turned to the next customer. And he didn't like eggs that way! Which Agnes thought was a sad story, from such a wonderful man. So she volunteered to make him breakfast every morning before she left for work. And that, as she put it recently, was "the thin end of the wedge."

New York before Gorky had been an extraordinary mixture, to her, of intense solitude and excitement. Afterward, she never felt that way about the city again.

ONE EVENING AFTER Gorky had walked her back to her own studio, she found a note on her door asking her to contact immediately a certain Mr. Smith. She went to an office on Wall Street, where she underwent a tough grilling by an Englishman who claimed to be working for the FBI. How long had she known Elsa and her husband? Oh really? How was it possible that she knew her since childhood, if Elsa was the daughter of a rabbi and born in the Bronx? Whereas she was the daughter of Captain Magruder and had been educated—let's see—in Washington, Lausanne . . .

Agnes was a Communist, was she not? asked the frightening Mr. Smith. But she had also donated blood for England, hadn't she? Russia and Germany were allied, were they not? Yes, she said. Wasn't it a little inconsistent of her to give blood for Britain when the party line was that all good comrades should stay out of the war? Was she quite sure she knew where her allegiances lay?

She went straight back to Gorky in a panic. He tried to calm her down. Oh,

but when the FBI had come to see *him*, he said—why, he'd run rings round them. First of all, he had asked to see the man's identity card. Then he'd said: But you don't look like this person at all. This man in the photograph must be somebody else. This one looks like "a cross cucumber."

The FBI agents had told Gorky they weren't interested in him. They were interested in Moorad, his brother-in-law. Was Moorad a Communist? they asked. Well, said Gorky, did they think that *he* was a Communist? Mr. Gorky, they said, if we thought you were a Communist, we wouldn't be asking you directly, as you'd tell us a lie.

Moorad was under observation at the time. His FBI file is long and depressing—a matter of letters intercepted, neighbors interviewed, lists of guns he was thought to be about to buy, wherewith to cause an insurrection. At one point the investigators confused the Samarkand Rug Company, for which Moorad worked, with the far more sinister Samarkan Drug Company. Moorad was seen as a dangerous revolutionary who ought to be locked up, but in fact his activities were those of an exile living out fantasies that would never materialize.

Gorky failed to arouse enough suspicion in the FBI for them to give him his own file. His excessive caution about political matters evidently paid off, and given his surname and appearance, it was probably wise of him to have kept out of sight.

Hearing through friends in military intelligence that his daughter was being investigated by the FBI, Captain Magruder cut off her allowance. He saw no reason why his money should end up in the pockets of Communists. The result of this attempt at paternal discipline was that Agnes moved in with Gorky.

HE GAVE HER a new name: Mougouch. He said that it meant "my little powerful one" in Russian. Gorky had already used it twice before, once for his nephew and once for his cat.

She differed in many ways from Gorky's previous loves. She possessed confidence in areas where Gorky was not at ease, a social assurance given to her by her parents and her background. Unlike Marny George or Michael West, she had no desire to struggle toward her own identity as a painter. The discoveries she had made in New York—the political convictions of the intellectuals she met, the feel of the coming revolution offstage, the straightforward qualities of working people such as the printers of *China Today*—made her more interested in the present world than in her future development as an artist.

Once, she came back from work having convinced Manny Gold that she could make a better cover for the magazine than the usual smiling or suffering peasants. Gorky was delighted to help her. He sat her at the table and pro-

duced paper and pencils. It was to be a severely abstract composition, taking into account the various typographic problems involved. Solicitously, he watched her rule a line, rub it out, move it over.

She told him about a lecture she had been to at the Guggenheim Collection, where the Baroness Rebay had shown the audience the work of her protégé, the abstract painter Bauer. Mougouch said that Bauer's paintings looked like a lot of phonograph records, but she had been fascinated by the way the baroness adjusted her furs. Gorky laughed, and said what she should have seen were the Kandinskys. But he never took her back to the Guggenheim Collection, because to see it required making an appointment, and Gorky, surprisingly enough, felt too shy to do that.

Why was she not going to paint? he asked her once. But she must! She could take his easel, use his paints, and make a painting. So he gave her a fresh canvas and left her alone in the studio for several hours. Alone, she was gradually overwhelmed by the atmosphere of Gorky's workplace: the accumulation of masterpieces, the huge easel bearing its pristine canvas craving to be filled. She felt she was not up to the challenge. The view from the window, the noises of New York, were a distraction. She took a piece of charcoal and made some marks. Her arm no longer seemed to be her own. Eventually the marks turned into something, not filling the canvas but crammed into a corner surrounded by white. She looked again: the image had turned into a monkey. "So that was the end of that."

Gorky showed her his favorite places. The Jumble Shop, for instance, with its old-fashioned bar at the front, where you could sit quietly and have a drink sitting on ladder-back chairs in front of flowery tablecloths. Gorky was not always at ease in the Jumble Shop. A certain group of painters had made the place their own: Burgoyne Diller and Henry Varnum Poor, making the atmosphere too English, with sweet-smelling pipes, fine tweed jackets, and the kind of formal good manners which rejected any real intimacy. Gorky did not like the English. They had broken their word to the Armenians, long ago.

On Fourth Avenue below Fourteenth Street were cheap shops and stalls selling loose leaves torn from art books and magazines, priced at a few cents. Gorky always stopped to buy reproductions, which for a time would be pinned to the side of the easel. He took Mougouch uptown to the museums and talked about Ingres, pointing out, for instance, the long arm in his *Self-portrait,* snaking down within its complicated folds of cloth. She studied the art books which he kept on a shelf he had made especially for them, with a flat compartment for those too large to stand upright: the two volumes on Seurat drawings; the little book by the geologist Sir James Jeans, which Gorky much admired. He showed her reproductions of Persian carpets and Coptic textiles, whose simple shapes and colors radiated "innocence."

She learned about his ritual for preparing to work in the morning: the canvas selected and brought out to the easel, the cigarette lit before starting. Never before had she come across baking bowls filled with tube after tube of finest artist's paint, which Gorky left until they formed a light skin to be worked into the surface of a painting, smelling "like melons," as he put it. The sounds of the working day: steps on the floorboards of the hall outside, the traffic in the street, the radio turned on, transmitting intimate talks about baking cakes, followed by soap operas, to which he sometimes added his own comments out loud, such as "Poor little lady," or "Silly cow." One of the morning chat shows to which he listened was hosted by a man who felt that certain information might be painful for his listeners to hear. Every now and again he interrupted the flow of words with "No details, madam, no details." But if the woman interviewed was having difficulties with her husband because she was Jewish and the spouse Catholic, the details were hardly irrelevant.

Mougouch got to know the studio better. The oven took over an hour to heat up, and if you used it, you couldn't use the burner on top at the same time because the gas pressure wasn't strong enough. The cover on the daybed was so hairy it scratched. The naked lightbulb in the middle of the room made her sleepy. The light by which Gorky used to paint was a photographer's flood fixed to the easel.

In the morning, off to work at *China Today,* she sometimes found tramps sleeping in front of the door giving out onto the street, catching the warm air seeping out of the building at night. It was possible to be on friendly terms with them. Once, having run out of cigarettes, she and Gorky frisked the lining of the sofa and all his jackets in the cupboard and came up with nothing but a palmful of pennies. "Don't worry," said Gorky. Outside in the street, he was accosted by a tramp, as usual. Gorky gave up the thought of buying just a cigarette or two and held out his palm of small coins. The tramp said, "Buddy, you're worse off than I am," and added a quarter, enabling Gorky's trip to the tobacconist to end in triumph.

He told her that a few years back, the tramps used to sleep out on the benches in Union Square under a covering of old newspapers, end to end. There were fewer of them there now, so perhaps life really was improving.

The tobacconist on the corner was an important figure. The coin telephone was Gorky's nearest lifeline to the outside world, and jokes with the proprietor were a necessary interruption to Gorky's working day. And on the way home, he usually bought the tabloid newspapers. He read all about the politics of the approaching war, and when it broke out he followed all the battles and the strategies, examining all the maps with their arrows drawn in black.

. . .

GORKY TOLD HER about Khorkom: the lake, the mountains, the church, the carving of whistles, and the raiding of tall trees for bird's eggs. He described the house where he was born, with its floor of beaten earth. He talked about the interminable winters and the sound of the storyteller's voice. He talked about his mother—light-eyed, vigorous—and her admonition to him, in the little garden down the path from his house toward the well. He told her about his father, the great figure on the tall horse who gave him a pair of slippers and disappeared into the mist, long ago.

At one point Gorky told Mougouch that his mother had been half Georgian. At another time, he said that she had been Circassian. It did not matter if the story varied: his claims had a meaning for Gorky. Merely to pronounce these words—Circassian, Georgian, the Caucasus—had the power to evoke an image. She never wondered in what part of the world these places existed. The phrase which was constantly on Gorky's lips was "my country." And she never tried to nail him down. Only in retrospect did it seem strange that among the words used for their power of incantation, the name "Armenia" was never uttered.

Coming as she did from a family that Mougouch had always felt was uncommunicative, right from the beginning Gorky seemed to her exceptionally open. "Nobody in my family had ever come right out and said, 'I love you.' Even as a small child, I'd always wanted something else." The worst sin in her family was to take oneself seriously. That was somehow ridiculous. Gorky, instead, listened to the meaning behind badly expressed words, to the feelings behind an intent. In her eyes, he was a deeply serious man, because his priorities were human.

It was only later that she discovered that to challenge any story Gorky told her "was fatal." It was impossible to say, for instance, that last year his birthday had been in April if this year it was in October. He would become furious. She was not to join the "bookkeepers." Yet this also seemed right. A good listener did not add up the words in a sentence like a teller at the bank and come up with the meaning. It did not matter what you said, but what you meant. It was useless to listen for facts, just facts, mere facts. To Gorky, unless a fact evoked an emotion or an image, there was no point in bothering about it.

MOUGOUCH TOOK PART in the Workers' Parade on May 1, 1941, together with her friends on *China Today*. Gorky was sympathetic, but he did not join in. He waved from the sidewalk, his hand with the palm toward his body, fingers moving, in that salute which implies "Come here" rather than "Go away." Further down Fifth Avenue, the Trotskyites hurled eggs at the Stalinists from the side of the road.

Immediately after the parade, Mougouch went to visit her parents in New-

port, Rhode Island. Captain Magruder was back from China, still commanding his flagship, though expecting a more interesting war station soon. While she was staying there, Mougouch came down with the measles. Lying in bed, she wrote a letter to Gorky. Had he been working well? Was the mural finished? Had he written his "explanation"? She was covered with "the nastiest red spots." He had better drink plenty of water as he was bound to catch them, too. "My family was terribly relieved to find that it was the measles and not socialism. It is very sweet and most strategic of me to get the measles because they were both very worried and now they cant stop saying how glad they are that I have the measles they just cant tell me how glad they are. Isnt that sweet [. . .] and that is the way they are about the world. The world once cured of Hitler will be their world again."

The "explanation" was a text that a reporter had asked Gorky to sketch out as a description of his Ben Marden murals. Gorky produced it and sent it off, and it was gutted by a reporter for an "interview." It was most inconvenient for her to catch the measles just now, she continued. Manny Gold at *China Today* would be worried about the cover for the new issue. The lettering was wrong. Could Gorky possibly check it, as it had to be just right? She was going to send Dorothea around to talk to him about it. (Dorothea was the daughter of a missionary, and an ardent Communist. She taught Mougouch how to make pancakes.) "Please darling dont scare Dorothea she is neurotic and a serious scare might be her finish!"

It was a remarkable letter from an eighteen-year-old, already showing great confidence in her relationship with Gorky. Gorky replied in English, with the usual spelling mistakes:

My dearest love.

I miss you terribly—this place semes so big with out my (Mouguch)—and the telegram with it come the sad news that you are ill—. But why—why my Galupcheg you. haveing the measles—and your sweet litter—I have been praying to God—that it will be soon over—so that I might be with my Mouguch.

Dorothea came to see me this morning. Please Dear don't you worry about the magazine. I will work over it and everything will be allright—

Cheer up Mouguch, Dear. I am feeling will and looking after myself. I have provided myself with lots of vegetables and fruit. Most every morning I am up at 6 o'clock and tacke bath, and walk in the park for an hour, and I am back to the house at 7, and work hard until *seven* 7. in the evening. And at night I drawn or look at the art book's—and dream about you—then I curse that measles.

Mouguch xxx. the explanation is written and they are happy about and the mural is about finish—

The letter contains echoes of the letters of the French sculptor Henri Gaudier-Brzeska, whose biography, *Savage Messiah,* Gorky owned. At this point, he ceased altering Gaudier's text to fit his life and simply copied out three pages about a visit to the London Zoo Gaudier had made in November 1912. A certain degree of shock was registered in the 1960s when a scholar pointed this out. It seemed unbelievable that a great artist like Gorky should have stooped to stealing other people's love letters. But Gorky had no confidence in his written English. He knew that Mougouch would show his letter to her mother, and he wanted to make a good impression.

While she was convalescing, an old friend of her father's who worked for Naval Intelligence took her aside and told her that J. Edgar Hoover had telephoned him personally to say, "What's this story about that Magruder girl being a Communist? Doesn't she know it'll jeopardize her father's career?" She was unsure whether to believe him. It sounded like the kind of thing an old family friend would say to an errant daughter. On the other hand, it was something to think about.

She came back to New York together with her mother, Essie Magruder. As the two of them crossed Union Square in a cab, Mougouch caught sight of Gorky on the sidewalk in front of them. "That's Gorky," she said. She did not feel like stopping the cab to introduce him. Years later Essie told her daughter that she knew at that instant that Mougouch would marry him.

On certain evenings a week, Mougouch was required to take classes in order to raise her consciousness about the class struggle. Most of her fellow students in these sessions were black. They were told that if they were living in Moscow, the party would have supplied them with their own automobiles. Even the most credulous found this hard to believe.

Sometimes she distributed *China Today* and the *Daily Worker* down at the tenements which lined the docks. She was surprised at how few of the occupants were interested in the Revolution. Then one day she was caught up in a riot. Mougouch found that the dockers, poor as they were and in spite of the fact that they were "downtrodden masses," greeted the comrades with brickbats and a shower of hurled beer mugs. She retreated before the crowd. The riot followed her. As the fight raged, she took refuge underneath a fallen table. There, unbelievably, she went to sleep. When she woke, all was peaceful again. Dawn twinkled on the waters of the Hudson River.

When she returned home to Union Square, she found Gorky frantic. She was never to do such a thing ever again. She was surprised at how upset he was.

At the end of May, Gorky felt sufficiently confident in the relationship to write about it to his sister Vartoosh. It is a particularly happy and generous letter.

Dear Vartoosh, recently, about three months ago, you remember Bill who was the friend of Mrs Metzegri introduced me to a young woman very honest and modest who is called Agnes, whose father is the admiral of an american ship. I am seeing her and I talk to her about you. Recently she introduced me to her mother who came here from Washington for a week. If you saw her you would like her a lot. In a few days I'll send you her photograph. Last night her mother invited me out to supper and the whole evening Agnes said that I should write to you. We speak constantly of you, she has learned a few words of armenian and can sing "the shepherd grew sad on the mountain" and I call her Mogik. Write, she is longing to meet you. Here in New York she works on a journal and as you know in these terrible days nobody is thinking about painting.

Last night I went to the house of Miss Metzgri for dinner, and they were so worried, so my dear, I'll write to you again, very soon every week and we'll see what happens. Agnes said that she wants to send you a card and longs to meet you and get to know you. write, with affectionate embraces from your affectionate Gorrghi.

At eleven o'clock exactly when Agnes came to see me she is pleased I have written to you and now tells me I have to write to Agop and Satenig.

SAN FRANCISCO

1941

A T LAST THE Ben Marden murals were finished, and Mougouch, Gorky, and Isamu Noguchi went out to New Jersey to celebrate. It was exciting to look up at the murals with people standing in front of them. Later, as they had supper, Gorky told them about the experiences he'd had while painting them, such as the times a black sweeper, leaning on his broom, had kept him company. After many days of silent contemplation, the sweeper said, "If I was a bird, that's what the world would look like to me." The *New York Sun* published Gorky's "explanation" as an interview.

I call these murals non-objective art [. . .] but if labels are needed this art may be termed surrealistic, although it functions as design and decoration. The murals have continuity of theme. This theme—visions of the sky and river. The coloring likewise is derived from this and the whole design is contrived to relate to the very architecture of the building.

I might add that though the various forms all had specific meanings to me, it is the spectator's privilege to find his own meaning here. I feel that they will relate to or parallel mine.

Of course the outward aspect of my murals seemingly does not relate to the average man's experience. But this is an illusion! What man has not

stopped at twilight and on observing the distorted shape of his elongated
shadow conjured up strange and moving and often fantastic fancies from it?
Certainly we all dream and in this common denominator of everyone's experi-
ence I have been able to find a language for all to understand.

Soon after he finished the murals in New Jersey, Dorothy Miller asked him
for a design for a rug, to be woven in the following months and exhibited at
the Museum of Modern Art in about a year. Gorky produced a design which
has something in common with the Ben Marden murals: simple, but meander-
ing. When later asked to explain the image, Gorky wrote, "The design on the
rug is the skin of a water buffalo stretched in the sunny wheatfield. If it looks
like something else then it is even better!"

As usual during the winter, he caught a cold that lasted for weeks. De
Kooning came to see him as he lay in bed, the blanket neatly tucked back and
held in place by a pin. Mougouch was in the next room, tidying up the studio.
Gorky raised his head from the pillow and whispered: "She treats me like a
prince, Bill, like a prince."

That winter de Kooning told him about an interesting new painter he had
come across in a group show of European artists who had recently arrived in
New York from Europe. He'd been uptown to look at a Miró, but his eye had

Arshile Gorky, rug design, 1940

been caught by this work by someone he'd never heard of, called Matta. Gorky should go take a look at it.

Eventually Gorky went, but when he next saw de Kooning, he seemed unimpressed. He said, "Do you really *like* that kind of painting, Bill?" "Well," said de Kooning when he told us this story, "Matta's paintings were very skillful. He could come right in on an object, veer round and come right back out again. All those tricks of Renaissance perspective. Made you dizzy just to look at it!" Perhaps it wasn't the kind of work which would leave a lasting impression, but all the same—as de Kooning told Gorky at the time—he thought that there was "something there."

Roberto Matta Echaurren was one of many distinguished artists who had fled from the war in Europe. He had arrived from France at the end of 1939 and settled into a cold-water flat in the Village. He worked on a series of drawings during the day and at night he toured the cafés, in the company of the dealer Julien Levy, looking for bistros like those in Europe. Matta's energy was amazing. It required an effort just to keep up with him. Levy half expected a collapse, but it never came. "I never saw him in the depression that should have balanced such hyperactivity, but I never saw him at peace either."

After a few weeks, Matta asked Levy to give him a show. It was a confident request from someone who had begun to paint only two or three years before. Well, Levy replied cautiously, what about the paintings? Oh, said Matta, he shouldn't worry about that. He was sure he could finish them before the show opened! Levy agreed, and an exhibition took place in the spring of 1940, along with Pavel Tchelitchew, one of the stars of Levy's group.

Instead of a catalogue, Levy published a "pseudo-newspaper," called the *Twenty-one Star Final*, filled with emphatic declarations which related to the paintings on the walls. Matta had pinned his hopes on the approval of James Johnson Sweeney, but this important figure in the New York art world came to a special preview, smiled, and went away again. "The exhibition," wrote Levy with a certain satisfaction, "was a resonant flop."

In the fall of 1940, a close friend of Matta's, an Englishman named Gordon Onslow Ford, gave lectures on surrealism at the New School for Social Research. He remembers that Gorky came to visit him several times, unannounced and alone, at his seventh floor walk-up apartment. He found him an attractive personality, somewhat sad, curious as to the techniques of surrealism, though less so regarding its deeper theoretical structures. Onslow Ford became aware that Gorky's background was tragic, and when he saw his paintings, he thought that they contained narrative implications to do with his past, but that Gorky disguised their features as he continued working.

Gorky may have met Matta briefly during Onslow Ford's lectures. Matta was eager to contact young New York artists, and he soon met Peter Busa,

William Baziotes, Lee Krasner, and Jackson Pollock. From time to time two or three of these artists—but not including Gorky—used to assemble at Matta's or at William Baziotes's apartment and bring with them work to be discussed. As Peter Busa put it later, "Matta would look at it and make some comments as to what dimension we were reflecting. And he had organic attitudes about whether you were reflecting a rhythm that would be associated with water or with fire or rock forms and so on."

Matta introduced the New York artists to the technique of "automatism," as developed by André Masson and Stanley William Hayter in the late twenties. Most of them would have known something about the subject already, as it was described in articles in the various *Cahiers d'Art* and *Minotaure* magazines, which were available in New York. But it was one thing to read about an idea and another to see it demonstrated.

"Automatism" was sustained by Matta with a conceptual theory: that of a "new myth" to suit the times. The last numbers of *Minotaure* and the first issue of the New York magazine *View* attempted to define this late surrealist idea. The notebooks of New York painters began to be filled with jotted myths of the past. "Pasiphaë," Jackson Pollock wrote down, perhaps copying the details from an encyclopedia, "daughter of Helios (the sun) and the nymph Perseus, wife of King Minos of Crete and the mother of the Minotaur by means of a wooden cow made by Daedalus into which she entered." The theme of one personage contained within another entered many of his drawings and paintings. Adolph Gottlieb took notes in the Northwest Indian department of the American Museum of Natural History. Rothko studied *The Golden Bough,* as did Gorky.

In taking the idea of the "new myth" as an encouragement to read up on ancient ones, the New York artists somewhat misunderstood Matta's intention. Europe was one thing, as he often pointed out, and America quite another. Matta talked of "il verbo America," a transitive verb which activated everything it touched. "In the beginning was the word," and America was a new beginning. America was not New England—which anyway (he said) should be called "New Europe," what with all the newcomers from France and Germany now living there. America was space, was the Native American Indians of the United States, and also of Mexico and Peru. The old European concept of space was over. The new ideas of Einstein, which suggested that space was curved rather than linear, bound in time rather than a dimension in itself, must somehow be carried over into a new concept of spatial relationships within a painting. Einstein, and the Indians—that was the challenge. That was the new myth, if only it could be reached.

IN THE SPRING OF 1941, Gorky asked Mougouch if she would like to meet a woman who was "like a wild horse." This was his expression for any

self-confident, articulate, beautiful woman. And so he took her to supper with his patron, Peggy Osborne.

Peggy was the daughter of a distinguished painter of the previous generation, John La Farge. She knew about artists and she knew about art. Isamu Noguchi was a close friend of hers. She had married into a wealthy family, with a mansion on the Hudson, but at a certain point she began to sell her fine old furniture and buy contemporary art. Gorky was among those whose works she collected. She owned two of his paintings and some drawings, and this made her, in Gorky's eyes, a woman whose opinions were to be respected.

A few weeks later, Peggy Osborne introduced them to a childhood friend: Jeanne Reynal. Jeanne had recently come from Paris, smartly dressed with a *"petit chapeau"* in the latest style: a velvet beret with a veil, perched on the side of her head like a bird's nest. She was a good friend of Noguchi's and was fluent in the latest opinions from France. Ingres was a very much overrated painter, she said with confidence. Poussin was boring. Léger was a good craftsman, of course, but fundamentally he was second-rate. Gorky sat up and courteously disagreed: "Permit me, Modom." Changing her ground, Jeanne started talking about the "fifth dimension." Exasperated, Gorky asked Mougouch, what *is* this fifth dimension?

The next morning Jeanne appeared bright and early at the studio and quickly overcame the unfortunate first impression she had made the night before. She looked at Gorky's work and immediately bought a medium-size but heavily worked version of *Khorkom*. She spontaneously offered Gorky $500 for it—which was so unexpected and generous that he immediately gave her an earlier Cubist work of about the same size. Wolf Schwabacher had paid a mere $50 for a painting the previous September, though admittedly it was a smaller work.

Jeanne came from an old family of French Huguenot extraction. She grew up in White Plains, New York, where she had learned to ride and follow the hounds. Her grandfather, Jules Reynal Roche Fermory de Saint-Michel, "was a fine shot with small arms and riffle & shot guns, these skills my father inherited also; his father's taste for improvement of breeds, as did I, hunting hounds, riding horses and hunters." A privileged background, almost European, and indeed before Gorky met her she had been living for many years in Paris as the assistant and mistress of the Russian mosaicist Boris Anrep. The relationship had ended badly two years before. Jeanne had remained in France to work for a philanthropic group helping young Americans who had fought in Spain. Far from being considered heroes, these veterans were viewed with suspicion back in the United States. In those depressing days, there was such a thing as a "premature anti-Fascist," which meant Communist, which meant untrustworthy.

When she came into Gorky's life, Jeanne was recovering from the death of

her father. Having assumed that she had been disinherited because of her rela-
tionship with Anrep, she discovered to her surprise that in the last months of
his life she had been reinstated in his will. She purchased Gorky's painting on
her second or third day in New York as a gesture toward the new life and the
new world she intended to create for herself back in the United States.

Jeanne, Peggy Osborne, and Mougouch all shared a particular confidence
stemming from their backgrounds. When the forbears of Agnes Magruder
landed in America, New York was just a Dutch village, and among her immedi-
ate ancestors she could point to generals on both sides during the Civil War.
As a child she had chased Easter eggs down the lawn of the White House,
for her great-uncle had been physician to President Coolidge. Her mother
Essie's ancestors had come to New England in the 1640s. Agnes Magruder—
Mougouch—had studied for the Baccalauréat at Brillantmont, a finishing
school in Lausanne, and Gorky's remark that she had visited "every country in
the world" was almost true. Although their privileged backgrounds made
them different from the other artists of Manhattan, in knowing such women,
Gorky could feel in touch with a side of America that had hitherto been inac-
cessible to him.

The friendship between Jeanne and Mougouch shaped the lives of all
three. The bond did not emerge immediately, but the fact that Jeanne had
bought two of Gorky's paintings gave the relationship a flying start. Mrs.
Schwabacher and Mrs. Metzger, who had listened so carefully for years to
Gorky's words without ever getting them right, were put on their mettle. In
the same way that as a child Gorky had flourished when the Adoian household
had unexpectedly changed from a patriarchy into a matriarchy, so at this point
in his life he discovered a circle of women to whom he was happy to delegate
all the decisions of his day-to-day life.

One of the immediate signs of this change in his life was that Gorky gave
over the management of whatever money he had to Mougouch. This may not
have been the most sensible thing to do, as she was capable of leaving the house
to buy some onions and coming back, instead, with a scarf. But Gorky did not
mind that. In this respect at least, he was the opposite of controlling. In the
same way, he was always generous with his own work. More paintings were
given away in Gorky's lifetime than were ever sold. The few friends who came
to dinner could easily emerge onto Sixteenth Street afterward carrying a small
painting or a drawing. David Burliuk, so Gorky told Mougouch with a laugh,
had once come back with a painting the next day in order to have it signed!

Jeanne came to see Gorky and Mougouch almost every day, and Isamu was
in and out of their lives as well. When the spring came, Isamu used to take the
three of them for weekend rides in his car.

Once, driving to the beach, they were stopped by the police. Isamu pulled

over and slipped to one side so that Mougouch could take over the driver's seat. He had his driving license with him, but, being half Japanese, he needed to carry all sorts of other papers as well. Gorky was often stopped by the police, too, at the beginning of the war, but if Gorky had his difficulties, Isamu's were ten times worse. Jeanne chose this moment to stand on her dignity with the cops and give them a piece of her mind. Her "great lady" act was sometimes useful, sometimes not. The other three sat there quietly wishing she would just shut up.

One spring day in 1941, Isamu drove them out to a house in Connecticut where their host, the daughter of a wealthy New York family, had organized a theater workshop. It was their third or fourth excursion; the sun was shining, the fruit trees blooming, the weather warm. On their way they stopped at a river and swam. At the grand mansion where they had lunch, the garden was full of people they did not know, so they abandoned their hosts and wandered off together, just the four of them, across well-cut lawns, among fine trees under which a multitude of flowers were blooming. Noguchi plucked a sprig of plumbago from a bush and wore it as a mustache. Everyone was in a good mood.

Gorky took a knife out of his pocket and started whittling flutes for them, and while he carved he told stories about Lake Van, interspersed perhaps with one or two blue jokes from his repertoire. There was one about a man with a very small cock. Gorky, holding up finger and thumb, peering—"With *that* little thing?" What made it funny was that Gorky couldn't say "thing." He said "t'ing." In the same way, when he sang, "Oh / You / Nasty man / Making love on the easy plan"—which was a hit of the late twenties—it came out as "Oh you nasty *t'ing*."

What was platonic love? Put a lump of sugar in the glass and lick the outside.

And then there was a story of a little Italian boy found outside on the stoop by his uncle, late at night. What was he doing there? Why wasn't he asleep? It emerged that the bed was occupied, by the child's parents. "Mama and Papa are doing the push-push." The humor lay somewhere beyond the joke: the apartment with one bed, the Italian parents primly putting the child outside for their moment of love, their son's matter-of-fact approach to this "primal scene."

There was one about a piano player. What was good piano music? Gorky would ask. There was something going on here (gesture of trilling with the right hand way up in the treble); there was something going on way down there (gesture of trilling with the left hand way down in the bass); and "bilà, bilà, bilà," there was something going on in the middle, too.

These were stories about the odd predicament of newcomers to a strange

land. They were immigrant jokes. Then there was the bizarre way in which Gorky told them: t'ing, the push-push. The malapropisms which were also discoveries. The word "painting," for instance, which came out "panting." And why not? The spontaneous explosion of relief and pleasure when a work is finished. These were the natural pitfalls of someone tackling a foreign language, the difficulty being that if the listener paused over the peculiarity of the words, or listened too hard when Gorky told a story, or described Armenia, or expounded an idea behind a work of art—if you tried too hard to grasp it, it was gone. The logic came not only from the play of words but also from the association of one image and another. Visual puns, comparisons, relationships. You were left wondering: Now how on earth did we get onto this subject? Weren't we talking about something quite else? From there to here, so fast, so unexpectedly. And yet Gorky's progression seemed perfectly logical while it was going on.

During one of their evenings out, Noguchi took Mougouch aside and told her that although Gorky was a fine painter and a sweet man, he had been painting the same works now for almost ten years. Of course, they were good paintings, and they got better with every coat of paint he gave them, but all the same, he was in danger of getting stuck in a rut.

He went on: Gorky knew absolutely nothing about the United States, did he, except for a few hundred miles along the East Coast? Wasn't it time that he took his head out of his shell? After all, he'd been living here for something like twenty years. He himself was leaving soon for San Francisco. Perhaps it would be a good idea if she and Gorky came along, too?

The idea caught fire very quickly. Jeanne was a close friend of Fred Thomson, with whom she had worked in Paris on the committee which had repatriated veterans of the Spanish war. Thomson was a brother of the editor of the *San Francisco Chronicle*. He had money and power. It was he who had helped bring Picasso's *Guernica* to the United States in 1939. Jeanne persuaded Fred to arrange a retrospective exhibition for Gorky at the San Francisco Museum of Modern Art, over which he had a certain influence. The pictures were chosen and sent on ahead by rail, and before anyone had received much confirmation about the plan from San Francisco, Jeanne and Fred Thomson boarded the train and headed west.

On June 23, 1941, Gorky wrote to his sister:

Dear Vartush, next Tuesday, together with some friends, I am going to San Francisco by car. A few days ago a dear friend of mine came here, an artist, and my paintings pleased her a great deal, and she bought one and immediately gave me 500 dollars. And she invited us out there, and I will be able to paint there this summer. It would be wonderful, it's been sixteen years since

I've been out of New York, and as you know my friends here don't give me more than 25–50 dollars for a painting. Then even if I succeed in selling a painting, then I can't paint another because the materials are so expensive. Two weeks ago I turned to Mrs Mezghert who for fourteen years has been wanting to buy a painting, and I begged her saying that I needed the money and she told me that we are all in the same condition. And all my friends tell me that such a change is very important for an artist, so I'd like to hear what you think so write immediately.

Agnes would be coming with them, he wrote, in order to see her father, who was in San Francisco. (This was not true. Captain Magruder was by now back on the East Coast.) He was sorry that they could not pass by Chicago and see them, but "Nogzi" was driving and it was his car. Perhaps he and Agnes would see them over the summer? Then he repeated: "My friends here when they buy a painting pay 50 dollars and I can't sell one every week or even every month. But you see someone who is a stranger comes from a new city and after speaking to me twice pays me 500 dollars." On her part, Mougouch wrote a letter to her parents saying that she would be traveling with two nieces of an old friend of theirs, and that it was quite all right. She would be staying in Salinas, near San Francisco, as a guest of Fred Thomson, whom they knew. Although her parents were by now aware that their eldest daughter was in love with a penniless artist of foreign extraction, it might have tried their patience too much if they had heard that she was driving across the country with him.

They set off. Mougouch and Noguchi drove. They sat three in a row in the front seat, with Noguchi's sculpture equipment in the back, squashed against clothbound volumes of photos of Isamu's portrait busts. Noguchi planned to do some portraits in California to help pay for the trip.

Crossing the Appalachians, they listened for the accent of early English, which they supposed was still spoken by the local inhabitants. Then they headed down the slopes on the other side. After a couple of days, Gorky began to complain. Why was this country always the same? he said. Same food, same language, same gas station. Same waitress. In his part of the world, everything changed every twenty miles. In his country, every journey was an adventure, and when you saw a stranger in your village, you said, "Oh! And where do *you* come from?"

At one stop, Gorky started to reprove the waitress. As usual, the meal involved opening a can, tipping the contents into a frying pan, lighting a flame, and stirring. It was not an inspiring execution of the culinary art, but if you forgot to stir, the food stuck to the pan and was burned. This particular waitress took time out to glance in the mirror to check her makeup. She needed a dab of powder, she decided. Gorky told her politely that if only

she spent as much time cooking as she spent looking in the mirror, "covering your face with *foutra*. . . ." Mougouch and Noguchi enjoyed the scene: Gorky, with his elaborate old-world politeness, using the authentic Armenian term, trying to reprove an American waitress out in the middle of nowhere.

It took them ten days to cross the continent.

Up in the clouds, Gorky saw within the round white forms the tangled riders of Paolo Uccello. Lines like the lances in *The Battle of San Romano* connected one shape to another. To Noguchi in the front seat, driving, they were only clouds. Gorky persisted. "He'd be always seeing some peasant woman up in the sky," as Noguchi put it many years later. Noguchi had just been introduced to Gestalt psychology by Buckminster Fuller back in New York, and he took the view that to see the clouds as anything but clouds was wrong. There was nothing metaphorical about a cloud. One should not abuse clouds. They were clouds!

Suddenly Gorky burst into a rage. Stop the car! He'd had enough. He saw what he saw, and that was that. This whole journey was a terrible mistake. He was going back to New York. He would walk.

They happened to be in the middle of a bridge crossing the Mississippi. They stopped the car and got out. Please, Gorky, Mougouch cried—and he, shrugging off her arm with a brusque gesture, shoved her toward the safety rail that flanked the asphalt, the river moving quietly some hundreds of feet below.

They recovered. They calmed down.

Gorky was persuaded to return to the car.

They drove on.

In retrospect, setting aside the aspect of violence that had punctuated the incident, Noguchi felt nostalgic about Gorky's capacity for reverie. Natural objects in the world were "not just horticulture to him. There were all sorts of mysterious things going on in his beautiful world." Gorky was forever "weaving a lace work of imagery into whatever he saw."

They arrived at the Grand Canyon. Mougouch longed to walk at least part of the way down, but Gorky and Noguchi turned away. Come on! It's too big to be interesting.

They visited Peggy Osborne's brother Oliver, who lived on one of the Indian reservations near Santa Fe, where the men walked in front and their wives, dressed in velvet jackets embroidered with dimes, followed at a respectful distance behind them, their black hair in plaits held in place by a silver butterfly. Gorky loved it. He was thrilled to see that the ovens they used were similar to the *tonir* of the Vanetsis. Soft, dependable shapes, he said, like breasts.

The miles ticked away. Gorky looked out of the window, and still complained about America. Mougouch to Noguchi: Oh, look at that lovely moun-

tain. Noguchi: Yes; isn't it beautiful. Gorky: Pouf! Call that a mountain? You should see the mountains in *my* country. After they had run through the same routine every twenty or thirty miles, Gorky saying "Pouf!" to every landmark America produced, Isamu and Mougouch said to each other: Let's take him to see those redwoods in Southern California. They can't have those in the Caucasus.

As soon as they arrived in Los Angeles, Noguchi took them to supper at the house of Miriam Hopkins, a movie star he knew. Mougouch asked her hostess's husband, who was Russian, about the Caucasus and was surprised when he agreed with Gorky that, compared with America, it was infinitely more beautiful.

Noguchi was enjoying himself talking to his hostess, making jokes, telling stories, and after a while, feeling left out, Gorky just got up from the dinner table and left the room. He was not good at what is called "small talk." Sensing his tension, Mougouch went after him. They wandered all over the house, examining every room, making a joke of it. They were amused to find, up in their hostess's bedroom, life-size photographs of herself.

Later that night, Gorky flared up again. This trip was taking too long and costing too much. The hotel was too expensive. Money was flying out the window. And she and Noguchi were driving him wild, talking about idle, trivial, stupid things. Noguchi took him off for a walk, and Mougouch went to bed. After a while Noguchi returned and knocked on her door to see if Gorky had returned, as he'd lost him. No, she said. Suddenly Gorky burst into the room, his arms laden with a huge bundle of grass and hay, which he flung on the bed. There! That is nature! That is beauty.

Dear Vartush and Murad,

today is the fourth day that I am in San Francisco and I am going mad, because my friends told me that when we arrived here they would have found me a place to live and I would have painted for three months, etc etc.

Afterwards there would have been an exhibition, but I don't think this is going to happen, it seems that I have to pay for all the expenses and therefore I will have to pay 250 dollars just for the transport from New York to here.

This is a mistake and I have never made such a mistake in all my life, my dear friends perhaps wanted to come here [anyway] and to lessen the expenses they took me with them. And they have only just told me this.

I don't know what to do. I'll have to go back to New York in a few weeks. I don't know what I'll find there. The only good thing is that I didn't give up my studio.

What had happened was that while Gorky and Mougouch and Noguchi were crossing the continent, Jeanne and Fred Thomson had unfortunately

quarreled. Jeanne had fallen in love with Urban Neininger, a man whom Thomson called a "puppy." Before they had started out from New York, Jeanne had promised Gorky a place in the country outside San Francisco where he could do some work. But as a result of her quarrel with Thomson, the plan had fallen through. Instead, Jeanne lent them a little studio she had rented at 712 Montgomery Street, but Gorky felt he couldn't work there. The chairs were covered with chintz and the curtains had billowing flounces. It was not a workplace.

Gorky decided he would have to work outside, so he borrowed some chisels from an English sculptor, Ralph Stackpole, who lived next door. Stackpole also gave him a block of marble and lent him a corner of his garden in which to carve it. Mougouch posed for a portrait and watched as the block shrank daily under Gorky's frenzied attacks. One day it ended up as thin as a Giacometti, and then suddenly it fell to pieces in a heap of dust.

Through the Stackpoles, Gorky eventually rented a little studio on Telegraph Hill. It was quite attractive, and there were food shops nearby where they could buy a humble turkey leg for supper, the cheapest thing in sight. But Gorky found it hard to settle down. He did no work in California save a few drawings. He did not like San Francisco. He did not like its art or its attitude. It was too relaxed, too self-indulgent. He made no attempt to hide his feelings. After every party, Jeanne and Mougouch had to circulate quietly, smoothing things over.

One evening he met the Greek painter Jean Varda, who had just taken up a teaching job at the California School of Fine Arts. Varda had joined the faculty at the invitation of Douglas MacAgy, who was also instrumental in organizing Gorky's show at the San Francisco Museum of Modern Art. One would have thought Gorky could have made an effort with both men, especially as Varda had fled from the Turks in 1922 when Smyrna had been sacked. A certain sympathy might have developed between them. Instead, overhearing Varda attack Dalí for his "worldly" qualities, for having "sold his soul to the devil," Gorky told him furiously that he, Varda, would have sold his soul to the devil, too, except that the devil would never have been interested in something so worthless.

Eating at a restaurant one day, Gorky and Mougouch heard a waiter loudly paging the writer William Saroyan. Gorky scowled. He's got a friend to telephone him at the restaurant, he said sourly, just to let us all know he's here. These two Armenian artists knew of each other, and loathed each other, for very Armenian reasons. As it happened, William Saroyan was a close friend of Uncle Aharon's daughter Gail. In later life, he often visited her in the hospital where she worked. He told her that Gorky should never have changed his name or pretended to be a Russian or "Caucasian," or any of that rubbish. He

should have stayed an Armenian, and proud of it. Successful Armenian artists, like himself and Gorky, would make it easier for all Armenians to hold their heads high in this country.

Gorky thought exactly the opposite. Saroyan, to him, had made a "career" out of being Armenian. It was worse than imposing his own false standards on the world. It was a kind of theft. Anything in the least bit worldly, any "cashing in" on being an Armenian, was anathema to Gorky. Kostan Zarian once met a refugee who expressed an idea which sounds very like Gorky's feelings on this painful subject. Armenia "isn't just a pleasant memory, but a life of the spirit without which work, riches, success, and glory have no meaning. And every time in exile that life smiles at me a bit, whenever I succeed in something—well—it's as if I'm stealing something from the soul of my country. As if I've wounded her."

In New York, Gorky once found himself discussing Saroyan's work with a friend. Gorky complained about a scene in which Saroyan described how an Armenian sent his son to a grocery store to ask for credit. That was not how a true Armenian would have behaved, said Gorky sourly. A true Armenian would never have sent his son to beg for credit. He would have begged himself.

SOMETIMES THEY WENT dancing in the evenings. Once, in a Mexican restaurant, Mougouch asked Gorky to take her onto the dance floor, but when at last he did, after a couple of turns he simply forgot about her and went back to his table. So she danced with Isamu instead, while Gorky complained bitterly to Jeanne that Mougouch was only interested in "foolish" things, like clothes. By the end of the evening, as Mougouch put it a couple of years later in a letter to Jeanne, he was wearing "a sort of frantic undone but I'll-have-the-last-bitter-drop look."

One afternoon they all congregated at the apartment of Dorothy Liebes, a friend of Isamu's. From the window they looked out onto a spectacular series of small bays surrounded by wooded peaks, lit by the evening sun. Jeanne remained in one corner making friends with the Russian architect Serge Chermayeff and his wife, whom they had all just met. Isamu was enjoying himself talking to Mougouch. Gorky mournfully looked at Noguchi. To others who were present, there seemed to be some kind of competition between the two men: Gorky brooding, Noguchi "blithely untroubled."

Reinforced by the cocktail snacks, Noguchi led his party out to see a Japanese Noh play which was being performed downtown. It went on for hours, but they were able to walk in and out and visit the bars in between. It was dawn before they turned in, but Gorky's mood had not lightened. A friend of Noguchi's who was present thought that Isamu was "openly flirting with Mougouch and she was very young at the time, hardly more than a teen-ager."

• • •

IN THE CITY as the days grew hotter, fleas came out onto the sidewalk and leaped upon the legs of passersby. One could see them drawing vivid golden hoops in the air against the dark background of the asphalt.

But where are the mountains? said Gorky. Where is the beautiful country-side I am supposed to paint? He felt lost without his studio and a canvas to face in the morning, or to come back to, after supper at night. He was about to have a big exhibition at the San Francisco Museum of Modern Art, but he had no talent for meeting people and persuading them to take an interest in his work. He felt that the trajectories of his friends, and his own, were slipping beyond his control. Isamu, though he had enjoyed showing Gorky the great world of America, was now busy with his portrait commissions. Jeanne, having broken with Fred Thomson, was somewhat in disgrace, but she was doing her best for Gorky's exhibition all the same.

There remained Mougouch, with whom he was so much in love. His courtship of her, however, was marked by an uneasy haste, resulting partly from his memories of having courted and lost so many times the object of his love, and partly from his dislike for the city in which he found himself.

Mougouch was not certain how to cope with his needs. She was in love with him, but she was far from sure that she wanted, at the age of nineteen, the per-manence he had in mind. It was as if Gorky looked upon marriage as the cure for everything: for the city, for the future, for him, for her—for love itself, which only then would find the correct climate in which to grow. The more Gorky insisted, the less she wanted to be pinned down, and her defense was to place Isamu and Jeanne between herself and him. Talking about clothes and "frivolous things" helped to dis-tract her from the moment when she would have to take a decision.

One day she presented him with a test. How could she possi-bly marry him, she asked, when she did not even know what he looked like? So he shaved off his mustache for her. There was quite

Gorky without his mustache, "marrying" Mou-gouch, San Francisco, 1941

another person underneath: more open and vulnerable. That part of the test, for the moment, he passed.

Mougouch thought that her best way out of this predicament would be to travel beyond the West Coast, back to China, emulating those brave women reporters, like Martha Gellhorn, who had observed at close quarters the civil war in Spain. She had aired this fantasy two years previously with Fred Thomson's brother, the editor of the *San Francisco Chronicle,* when she and her parents had come through the city on their way to the Far East. Now, Mao Tse-tung had just declared war on the Japanese in northern China. Surely there was an opening for an intrepid young female journalist on that fascinating front? So she rang Fred Thomson's brother, and by some miracle she got through to him immediately, without the usual filters of secretaries and assistants. Could she go to China as a stringer for the *Chronicle*? she asked. Mr. Thomson, an old family friend, laughed politely and invited her to lunch so that they could talk it over.

Two days later, she discovered that she was pregnant.

When Gorky heard the news, he was overcome with emotion. His face was filled with wonder. But Mougouch was determined that this unexpected, uncalled-for event should not force her into marriage. As she saw it, her body was trying to oblige her to do something she did not want to do. She insisted on having an abortion. When Gorky and Jeanne accompanied her down to the port a few days later, it was not in order to catch a slow boat to China but to lose his baby.

The abortion was infinitely more horrible that she ever could have imagined. The memory returned to her in nightmares for years afterward. The anesthetic was not general, as in theory the abortionist could be raided by the police, in which case the clients were expected to get up from the crude operating table on which they were lying, and run. After it was all over, Jeanne and Gorky took her back to the little house on Telegraph Hill and put her into bed. She had lost a lot of blood and her recovery was slow. Long, boring days were spent in bed while Jeanne and Gorky busied themselves with the organization of the exhibition.

One day Gorky arrived back home accompanied by—of all people— Marny George.

Mougouch knew about Gorky's first wife. She had seen her letters arrive at Union Square, and she had noticed that he threw them into the wastepaper basket unopened. Once, she had even asked if she could read one. Gorky said yes. So Mougouch read how he had changed Marny's life, how she would never be the same again—touching, somewhat pathetic messages.

Mougouch observed Marny from her nest of pillows. Much too pretty, she thought. But she invited her to supper the next day, and Marny came. A roast

of discouraging toughness was
served and the evening passed
quietly. Marny must have seen
what Mougouch herself had not
yet acknowledged: that the rela-
tionship was destined to last, and
that Gorky had found the wife
for whom he had been unsuccess-
fully searching all these years.
The letters which she had sent
Gorky so regularly, and which he
never read, ceased.

In a sense, the abortion led
Mougouch inevitably toward the
marriage she wanted to avoid,
rather than away from it. Gorky's
misery at losing the child was
so genuine that she began to feel
guilty for having deprived him
of something for which he so des-
perately yearned.

Arshile Gorky, *Woman in a Hat*, 1941

Using another argument in favor of the marriage, Jeanne pointed out to
Mougouch the risk Gorky ran of being enlisted in the army and going away to
fight, perhaps even to be killed. The risk would be diminished if he were a mar-
ried man, as the word was that married men weren't going to be sent overseas.
In the face of their insistence, she began to think: Who am I to resist?

To cheer her up, Jeanne took her shopping and bought her a "useful" cor-
duroy suit and a "little hat" just like the one she had brought back from Paris
the previous year. Gorky made a pencil drawing of her in the hat, resting on
her pillows one afternoon up at Jeanne's house on the hill.

THE EXHIBITION TOOK PLACE at last, in spite of everything.

The San Francisco Museum of Modern Art was not yet the large institution
it later became, and the exhibition was just another show, such as any painter
has now and again. Not many people came. Mougouch sat out in the corridor
listening to an urbane man telling her very slowly, in great detail, just why he
felt that Gorky's work was "too sad" for him. The experience would have been
discouraging had it not been for the cheerful presence of the Chermayeffs.

The reviews were slow in coming. Some were better than others. "To the
surrealist school belong the oils of Arshile Gorky, of Russia and New York.
Their ominous ogre-like abstract fantasies may make you want to take them

or leave them. In any case, they are splashed and patterned with an intense, colorful vigor."

"Arshile Gorky is technically part abstractionist, partly expressionist." An early use of the term "abstract expressionist"? "Certain canvasses are lushly tactile. He paints with a bucket of color apparently. There is an exotic quality, a fluidity of design, a spontaneity of movement, surprisingly enough. To paint the 'common, uncommonly' is what Gorky wants." This last must come from a press preview of some kind, now unfortunately lost.

SOON AFTER the show opened, Fernand Léger came to visit them. He was on the West Coast at Mills College near Oakland for a six-week summer course on French civilization. He was enjoying himself. "Here the human scale is respected. Mountains and sea: and trees and cows and dust are present. We don't look out onto that part of the United States where nature is the queen. It's less spectacular but more livable. I'd like to stay here—the climate is very like Normandy with the irregularities I'm used to." Léger was happiest in his travels whenever he noticed something which reminded him of his childhood in Normandy: cars moving like sheep, a rainstorm in Oakland, California. His fidelity to a distant place was not unlike Gorky's, which perhaps explains their mutual sympathy.

The two men had met at Gorky's Guild Gallery exhibition six years before. He complimented Gorky on his exhibition and taught Mougouch how to make a pot-au-feu. She needed this, she needed that, he told her, in French, as his English was not fluent. And she shouldn't forget her "bouquet garni." He would return the following day to see how she was getting along. When he arrived the next day, the ingredients lay on the kitchen table like pigeons after a shoot. "Ah, but, chère petite," he said, "you have forgotten to put them on the stove!" Well, never mind. Today they would learn how to make an omelet. The eggs should not be beaten too vigorously. The parsley should be cut fine, and there should be plenty of it.

Holger Cahill and Dorothy Miller turned up in San Francisco and admired the show. Gorky and Mougouch met them twice down at the port by the lobster stands, a pleasant wind coming in off the sea and the sun glinting off the tops of the incoming waves. Gorky was upset to hear that Cahill had finally lost his job. Soon the Federal Art Project would be amalgamated into the war effort or else simply wound up. Cahill did not seem too put out by it, but then he always made an effort to appear cheerful. Meanwhile, Dorothy complimented Gorky on his exhibition and urged him to send something to the Museum of Modern Art in New York as soon as he got back.

The exhibition came down on August 24.

On September 15, 1941, Gorky married Mougouch, in the town hall of Virginia City, Nevada. They stopped off at a dime store on the way and bought a brass curtain ring to use as a wedding ring. It was much admired later by the girls in the office in New York, and Mougouch had to show them the green stain on her finger to prove it wasn't gold.

They asked at the bar where the justice of the peace might be, and they said: Knock on his door, either he's in, or else he's out. Jeanne and Urban were the only witnesses. Mougouch wore jeans for the ceremony, as they were planning to go camping afterward. The marriage was just what the movies had led them to expect: a warmhearted judge peering benignly over the top of his half-moon specs at the young couple, off to start a fresh life together forever more. Afterward, they went back to the bar across the street and had a bottle of something sweet and fizzy. All around the saloon were photos of miners who had come out west during the Gold Rush, signed with greetings to long-dead barmaids. Outside, the town was deserted.

For their honeymoon, Jeanne took them up into the mountains. They found an ideal camping site on the Yuba River, among beautiful hills and surrounded by magnificent rocks. Jeanne lent Gorky and Mougouch a double sleeping bag, and for supper they ate beans cooked in the embers of the fire Urban had built. They fell asleep to the sound of tumbling water. During the night, the beans took their inevitable toll, and in the morning Mougouch made Gorky turn the sleeping bag inside out as she was sure a skunk had gotten in there.

A train came through the distant hills, hooting. Such a plaintive sound, echoing in and out of the surrounding valleys. Gorky said that when he first came to the United States, he was disappointed to hear a dog bark exactly in the same way dogs barked in Van. Somehow, he'd expected everything to be different. Dogs which roared like tigers, perhaps.

My dearest ones,

Agnes and I returned yesterday afternoon at eleven o'clock from Virginia city, as last Saturday we got married at about eleven forty-five, with no problems. Our friends there took us by car and we came back together. About 6 hours away there are huge forests surrounded by a tall and beautiful chain of mountains. And in the forests there are big lakes and torrents with clear running water, rushing through the stones and rocks. and beside the torrents are enormous cypress trees as still as sentinels with their heads in the cloud. They seems to press upwards against the blue of the sky to stop the bright blue sky from one day falling down.

We are very happy and Agnes is a very beautiful and well-educated girl and has studied in Switzerland, France, England, Holland and has visited

every country in the world. now she is studying a lot and every day she reads Marx, Engels, Lenin, Stalin. She's also studying armenian and russian. For example she told me in armenian: "Ah, you man without God"!

My dearest ones Vartush and Murad, next monday at 7.30 in the morning we'll take the bus and friday next at 5–6 in the morning we'll arrive in Chicago and we long to see you as every day Agnes and I speak of you, and like me Agnes wants to meet you as soon as possible.

The simile "like sentinels" is an expression that often occurs in Armenian (as well as Persian and Arabic) epic poetry. It was as if Gorky's happiness were not part of himself but attributes of the surrounding landscape.

Jeanne decided that she would buy that very spot and build a house there. Urban and Gorky paced about, measuring. Jeanne asked Gorky to design a mosaic floor for the place, and when he got back to New York he made numerous "proposals." She had asked him just for a design, but Gorky had strong ideas on mosaic, like everything else. Jeanne had been making mosaics for more than fifteen years, "so I wasn't exactly flattered to hear that now Gorky was going to tell me how it had to be done. That HE would tell me. But, of course, I didn't say that."

At the time, Jeanne's work looked like paintings by Picasso or Léger turned into tesserae. Gorky tried to show her how to loosen up and follow her own instincts. She knew that her drawing was cramped and inhibited. Gorky talked to her as he would to any pupil. A drawing, he said, was "mechanical." She should not worry so much about the direction it took. You started, and it acquired its own impetus, like making bread.

The journey back by bus from San Francisco to New York cost fifteen dollars each, with food, and it was grueling. Near the Mexican border, Gorky was stopped by the police yet again. He had no document by which he could be identified, and he risked being taken over the border as an illegal Mexican immigrant. Mougouch talked the troopers out of it, producing their marriage certificate as a credential.

They arrived in Chicago and stayed for a few days with Vartoosh and Moorad on Ardmore Avenue. Looking back on this part of their trip many years later, it seemed curious to Mougouch that Gorky had never let her see Vartoosh alone. Either he walked with her for huge distances from the apartment to the museums, or else he sat with them and brother and sister talked to each other exclusively in Armenian. Gorky did not want Vartoosh to reveal anything to Mougouch about their childhood on Lake Van. If the past were ever to surface in their lives, it had to be under his control.

A CHANGE OF DIRECTION

1942

THEY ARRIVED BACK in New York on October 1. In the mail waiting for them, Gorky found a letter from Lloyd Goodrich, the former assistant to Juliana Force and now a director of the Whitney Museum of American Art. He opened it immediately. It was an invitation to send a painting to the Whitney Annual, which was due to open on November 12. Excited, Gorky said, "I will call Goodrich the day after tomorrow."

His old paintings had not yet come back from San Francisco, and it was a chance for a fresh start. So he took out an unsuccessful version of *Khorkom*—quite a big canvas—and over that night and the next day painted the large green *Garden in Sochi*. Without his being aware of it, Gorky's attitude to painting had been affected by the trip. In the old days, he would never have dreamed of painting so fast, but would have judiciously selected a work on which layers of paint had accumulated for years.

The paint was hardly dry when Goodrich came to the studio to give it his approval. The work as yet had no name, and it was exhibited as *Painting, 1936–37*, which refers to the date when the series was first conceived, rather than to the date when this particular version of it was finished. When the show opened, Gorky was pleased to see his work hanging right at the entrance to the exhibition, like a flag of battle.

Arshile Gorky, *Garden in Sochi*, 1941

The composition is the theme of Sochi, but here the narrative elements—the woman with goatskin, reclining animal, etc.—are no longer readable. The elements of the painting hang from the top of the canvas, just as the onion with feathers in it hung in the chimney at Khorkom; or else they hang like the severed banners of the *Battle of San Romano,* photos of which were tacked to the wall of Gorky's studio at Union Square. Both analogies are possible, and both probably occurred to Gorky as he worked, for he had no difficulty in making one image refer to many things.

THEIR IMMEDIATE CONCERN that autumn was money.

Mougouch tried to get a job at the Museum of Modern Art, but though her education had included some excellent schools, she had no degrees, and she was turned down. She gave up her job at *China Today,* resigned from the Communist party, and found a new secretarial job with the United China Relief Agency. They were the political opposites of her former employers, but at least they paid her twenty-one dollars a week. The first week's wages went for a new shaving brush for Gorky.

Gorky took up a commission from Willie Muschenheim to make a mural, and immediately set to work. He delivered his designs a fortnight later, but there were the usual delays. As he wrote to Vartoosh, "Truly I worked a lot on

those paintings, or rather on the designs, but what can one do if he wants to wait two months." His cold had dragged on for the past six weeks. "Dear Vartush, we are truly upset that the war situation here is so bad as it would seem that I also will have to go [into the army] but I will say that I will work on Camouflage." He wrote to Homer Saint-Gaudens, the senior officer in charge of camouflage at the Joint Chiefs of Staff in Washington. Saint-Gaudens was the son of the sculptor, and receptive to the requests of artists. Gorky also went ahead with the plan to set up a class in camouflage at the Grand Central School of Art.

While waiting for a reply from Greacen, they went to Philadelphia to meet Mougouch's parents. Captain Magruder was about to take command of a convoy to England, and the meeting was arranged not only so that Gorky and he could meet but also so that father and daughter could say good-bye, perhaps forever.

John Magruder, Sr., had not met Gorky before, and he was naturally dubious about the idea that his eldest daughter should now be living with a gentleman of foreign extraction who could hardly—so he had heard—speak the English language. Gorky did his best to win him over. He told him all about Khorkom—the tall trees with bird's nests at the top, the field alive with snakes. The lake with an island on which a church stood, covered with carved scenes of Bible stories. The flutes he had whittled as a child, and the contraptions like propellers he'd suspended over the water of the canals which surrounded the throats of the tall mountains whose peaks disappeared right up into the bright blue sky.

John Magruder listened in silence. Given the circumstances—war, convoys, possibly his last farewell to his daughter—he was stupefied. Afterward, he took his beloved Aggie over to one side and said that if she ever wanted to come back, "the key will always be in the door."

Johnny, the captain's son and Mougouch's brother, came up to New York and stayed for a while at Union Square. He felt that the United States was taking too long getting into the war against Hitler, and he was about to join an Ambulance Corps, which was one of the few ways Americans could enlist before Pearl Harbor. Gorky, Mougouch, and Essie accompanied him to Grand Central Station to see him off. Gorky gave him a clasp knife which cost twenty dollars, and was deeply shocked that Essie did not shed a single tear as she said good-bye to her son. Had she no feelings? Why didn't she let them out? Why didn't she hug her son to her breast? Why didn't she cry? Mougouch tried to explain that of course her mother had feelings. It was just that her upbringing did not permit her to express them. Gorky found this incomprehensible. If you were happy, you danced and sang. If you were sad, you cried.

THE CAMOUFLAGE COURSES at the Grand Central School started late in 1941. A brochure was published in order to attract pupils. Echoes of Gorky's

ideas come through. "What the enemy would destroy, however, he first must see. To confuse and paralyze this vision is the role of camouflage." But Gorky resisted the temptation of turning battleships into monuments of "paralyzing disproportion," and worked hard to master the basic principles. "I have bought new books on this particular subject which is very difficult. They are books with complicated words. I have a bad cold." There were unexpected problems. What would a color-blind person see of a camouflaged ship? The risks involved were great, but the idea of disguising something even as you revealed it attracted him. The books about camouflage he bought in 1942 stayed with Gorky for the rest of his life, and he studied them with the same concentration he gave to his art books. One was about African animals in their natural habitat: giraffes in the long grass, under immense trees. Gorky studied it for hours on end.

Four days before classes opened, he wrote to Vartoosh saying he hoped that the course would be a success. If he had twenty pupils in the two classes, one during the day and one at night, then it ought to bring in some money. According to the brochure, there was a registration fee of five dollars and the course cost fifteen dollars a month.

Soon after the class began, the FBI came round yet again. As the Greek painter Aristodemos Kaldis remembered it, they asked, "Where could Gorky, without authority, obtain information to teach such art?" It was probably just some security check. "Well, Gorky was an artist and camouflage was no secret to him." No doubt Greacen—or Kaldis himself, as he was still an official of the FAP—said a word in the background to the officers. Nevertheless, Gorky was unnerved. "Gorky became so angry that he didn't want to teach. Then we had a big session the first night and several people came and that calmed Gorky down."

A week later, Gorky and Mougouch went to a party where they met a young publisher who seemed an interesting man. Mougouch invited him to the studio the following week. He came, and as they were having a quiet cup of coffee in the studio, chatting about this and that, Gorky suddenly leaned forward and said: Why don't you just come out with it? You're working for the FBI, aren't you? The nice young publisher rose, took his hat, and fled. The months before the United States joined the war were marked by increasing paranoia, and Gorky was just as affected by it as anyone else.

The madness of the war even touched his teaching. The sculptor Philip Pavia, who was one of his students, remembered Gorky giving a speech about the creative side of "lightning war." He did not like Hitler, and he did not approve of war, he said. But the idea of an "instantaneous" war was exciting. Perhaps one should try to make "blitzkrieg art."

Another of Gorky's pupils was Betty Parsons, who later ran one of the most

courageous art galleries in New York. She remembered twenty or thirty pupils, and she was in the class "about three, maybe six months." After that, they organized a drawing class together in her studio on Fortieth Street. Faced with a plaster cast, he would tell her to "bring it alive. Bring that cast alive." As soon as a pupil had grasped one point and was waiting for a word of praise, Gorky would say, "Now, miss, you've got that. Start on something else." She was not supposed to become too facile. If his pupils became too good, he gave them a piece of string and a bottle of ink and told them to try drawing with that. "He had a lot of students. He was always talking to us, which was marvelous," Parsons remembered. "He was a marvelous storyteller, mostly about his childhood. He told beautiful stories about the fruit trees in blossom in the spring in Armenia. And he always had some sort of a little story to go along with it."

Toward the end of the year, he received the results of his draft examination. He was rated 4F. Now that the threat of having to join the army was removed, the camouflage course quietly folded.

SHOPPING IN the neighborhood, Mougouch overheard friends from the old days talking about him. Gorky? Sure I know Gorky. He does those things that look like Picasso, doesn't he? You see him at the Jumble Shop now and again. He's the one who's always going on about the Old Country.

One afternoon Mougouch saw Piet Mondrian in a grocer's shop, shaking an egg to see if it was fresh. It seemed such a modest thing to do. The city was now filled with distinguished artists who had fled from Europe. They were no longer remote gods but flesh and blood, just like the local residents.

The sculptor Jacques Lipchitz came to Gorky's studio to look at his work. As he sat down he put his hands on his knees and said, "OK, let's see these paintings. I'd like to know what sort of a man I've got to deal with." No doubt he meant it kindly, but Gorky felt he was being patronized. When, at last, at the beginning of the war, the New York painters met the European masters, it was wonderful to see that they were human, but sometimes their bland assumption of superiority left a bad impression on the local artists.

In spite of this awkward moment, Gorky was far more interested in the newcomers than in his American contemporaries. At the Chermayeffs' on Twentieth Street one evening, Serge Chermayeff asked Balcomb Greene who the new young American painters might be, and Gorky, cutting across him, said flatly that Americans couldn't paint. "Our host seemed embarrassed," wrote Greene later. "I denounced Gorky at once, comprehensively. It was the end of our friendship." When Mondrian joined the American Abstract Artists group a short time later, Greene thought that Gorky looked "alarmed." Greene implies that Gorky at last realized he had made a mistake in having snubbed the

Abstract Artists for all those years, but he was probably just surprised that such a great painter as Mondrian had thought it worth his while to join them.

Although Gorky admired the Europeans from afar, he did not know how to bridge the gap that separated him from them. His friendship with Matta depended on chance bringing Matta to his door. Luckily for him, Matta was an enthusiastic communicator. By the time he made friends with Gorky, he had already formed a wide circle of friends among the New York artists, on whom for a while he exerted a considerable influence. It was Matta who translated surrealist ideas into words which the American painters could absorb.

On their first evening out together, Matta could not understand what Gorky was doing with someone like Mougouch. Dressed in a nice tweed jacket, she looked so formal and clean, "like a monitor at a summer camp for girls' schools." Gorky, to him, was more a man of the earth, with a strong mystical side to him. Almost "ecclesiastical." But both Gorky and his wife were a pleasant contrast to the often uncouth impression given by Pollock and the other New York painters. Compared with them, Gorky and his wife seemed European.

Matta came to Gorky's studio to talk about his paintings. Having looked dutifully at everything—the huge *Khorkom* paintings almost too heavy to lift, the early landscapes "with" Cézanne—he tried to say something serious, but in the guise of a play on words. "Arshile" meant "Achilles," didn't it? And in that ancient legend, Achilles had possessed a "vulnerable heel." Matta warned Gorky: "You must not think of Paris, for Paris will shoot an arrow into your heel"—the hero, Paris, being the warrior who in the legend eventually shot and killed Achilles. Equally, Paris was the French metropolis with which Arshile/Achille was so obsessed. Parisian art belonged to Paris, Matta said. Gorky might think that what he was doing was modern art, but it wasn't.

Matta thought that the painting which was most true to Gorky as a person was the portrait of himself and his mother. Surrounded by all the chaos and confusion of New York, it was extraordinary that he could have produced such a work. He was almost a "folk" artist, Matta told Maro recently—a naïf, a man who, when he came to America from Europe, set about making modern art, but who in fact painted as spontaneously as he sang, with great charm and simplicity, the folk songs he had learned as a child. A man most tender and serene.

Too often Gorky's attitude to his contemporaries had been to seize the initiative and never let go. Even with de Kooning, there were times when Gorky's insistence on being the boss was almost offensive. But Matta was not interested in trials of strength, with Gorky or with anyone else. He brought with him the spirit of "Yes, sure—but have you tried this?" Because Matta was so gentle, so friendly, so good at disengaging, Gorky accepted more from him than from any other colleague.

One of the stories Matta told Gorky concerned a canvas he had started

which had gone badly. At the wrong moment, the telephone rang. Matta threw his turps at the painting before crossing the room to pick up the receiver. When he came back, he liked the effect the dripping turps had made. Instead of wiping down the canvas and starting again, as he had intended, he went on working. The artist was free, said Matta. Free to accept chance, bad temper, running turps—even telephone calls! And Gorky listened, fascinated.

Matta's light touch extended to everything he did. A few weeks later at a party, Mougouch ran into an old friend, Suzy Hare, the wife of the sculptor David Hare. She had with her a few small paintings by Matta which she was trying to sell, right there among the cocktails. Price, ten dollars or so. It was unthinkable that Gorky would ever permit his work to be sold in such a manner. To Gorky, art was a mountain which had to be climbed, and a grand gallery on Fifty-seventh Street was located somewhere near its top. Selling art at a cocktail party was nowhere near the mountain. It was something you just didn't do, even on the plain.

NOGUCHI, MEANWHILE, was still in California.

Driving south toward Los Angeles in the middle of the desert on December 7, 1941, he turned on the radio and heard, crackling through the static, the news of the Japanese bombing of Pearl Harbor. He immediately realized that questions of art would become irrelevant during the coming war. He also realized that as a second-generation Japanese, a "Nisei," he belonged to a segment of the population whose immediate future was far from clear.

Just before leaving New York for San Francisco with Gorky and Mougouch, Noguchi had been given a medal as "Nisei of the Year." He did not even know what the word meant. "Osei": first generation of Japanese immigrants. "Nisei": their children, the second immigrant generation. He did not think of himself as a Nisei, or as a Japanese-American, or American-Japanese. He was an artist. He did not want his work to be viewed as the expression of an ethnic minority of any kind. Nor did he believe in medals. Pearl Harbor changed everything. He immediately understood that he had a certain responsibility, and he turned the car around and drove back to San Francisco to speak about the problem with Jeanne Reynal.

He spent the winter at Jeanne's house at 712 Montgomery, trying to organize for the Nisei some role in the present war which the government would find acceptable. It took him time to discover that from the government's point of view, it was impossible to reconcile the vision of Americans fighting the Japanese in the Pacific with that of other Japanese, the Nisei, walking about as free as air at home. Such a situation was somehow incompatible with the collective anger which winning a war entails. To the bureaucrats, there was no alternative but internment.

Early in 1942, Noguchi flew to New York to contact certain friends in Washington in order to discuss the question. Soon, he received an invitation from an official in the American Indian Service to help develop a war relocation camp for Nisei in Poston, Arizona. Noguchi went. He tried to set up pottery and sculpture studios, but after a while he discovered that his plans were unfolding in an insubstantial haze where nothing came into focus. To his horror he began to realize he was a prisoner, like everyone else.

He wrote a letter about it to Man Ray: "This is the weirdest, most unreal situation—like in a dream—I wish I were out. Outside, it seems from the inside, history is taking flight and passes forever. Here time has stopped and nothing is of any consequence, nothing of any value, neither our time or our skill. Our sphere of effective activity is cut to a minimum. Our preoccupations are the intense dry heat, the afternoon dust storms, the food [. . .] But, maybe this is sence—the world is nuts."

Peggy Osborne wrote him a letter of support. "I think that people who are living cool and comfortable in their habitual summer resorts are the ones who may look back with some regret and wish they had taken more part. From this of course I except the artists who are adhering to their work such as Jan [Motulka], Gorky, etc [. . .] I have seen quite a bit of Gorky and Mougouch who remain as always. I love them both. Mougouch is learning typing in order to get a real job [. . .] Keep your chin up and don't swallow any more dust than you can help."

IN THE EVENINGS Mougouch and Gorky sometimes went to the movies, after a quick stop at the Automat on the corner of Fourteenth Street and Irving Place, where the food lay behind small windows, like specimens in a science museum. Over the road from the Automat was the Acme movie house, where they saw all the great classics of the Russian cinema.

In September they learned that Leningrad had been cut off by the German armies. As the winter hardened, one of the longest sieges of all time began to fill the Soviet newsreels. Blurred figures dragging supplies by sled across the ice of the frozen Baltic. The whir of snow flaring up from churning wheels. People stumbling. Women wrapped up like mummies, dragging munitions up to the front on sleds; or, if not munitions, then the bodies of the dead, hard as logs, to be deposited in mass graves on the periphery of the city. Snow on the cinema screen and scratches on the negative were accompanied by the urgent declamations of the news in voice-over. And at the end of the newsreel, as if to bring these extraordinary visions to a head, Stalin on the balcony of the Kremlin, so confident, so wise.

Gorky would look at Stalin saluting the huge army marching below, and tears would well up in his eyes. Oh, Mougouch, he'd say. That man is so misun-

derstood in this country. Gorky's New Year's message to Vartoosh reads, "Surely the war will soon come to an end. As Stalin said in 1942 all the germans will be thrown out of the soviet countries." The Russian peasants would defeat the German mechanics. Of that, he never had any doubt.

Gorky used to boast that Stalin in his youth had worked in his grandfather's shoe factory in Tiflis. It was a fantasy, of course, but in slightly different circumstances it might easily have been true. During his childhood, Stalin's mother earned a living by taking in washing for rich Armenian families of Tiflis—those same families whose unoccupied property in Yerevan the refugees from Van took over in 1915.

Stalin's early life had been very similar to Gorky's. His father failed in business and was of no help. It was Stalin's mother who kept her son going. The church was a heavy presence in the background, and Stalin was sent by his mother to the seminary in Tiflis when he was an adolescent. The village whence Stalin's family came stood at the junction of three fertile valleys. Wheat fields and vineyards surrounded the weathered houses. At village feasts, men came down from the mountainside and drank quantities of wine and danced and stamped their feet. In caves in the highlands, brigands still held out against the Russian authorities for years on end. Gorky had no doubt that he knew Stalin better than any American, and he blocked his ears to any information that put that knowledge in question. Stalin and he came from the same world.

He is built like a ruffian, Gorky told de Kooning with admiration. When Lenin sleeps, Stalin puts his bunk in the corridor, and if they ask, "Why, Comrade, sleep here when you could be comfortable?" Stalin says that, sleeping here, he is sure that nothing will happen to Lenin during the night. When de Kooning recounted this story, for a moment I did not understand that he was quoting something that Gorky had told him. Then I saw Stalin from Gorky's point of view—the world of absolute power reduced to a humble corridor and an uncomfortable military cot. Authority and modesty combined, with no pretense, no arrogance to detract from Stalin's colossal human qualities.

Compared with Stalin, Trotsky—so admired by the intellectuals of New York—was, to Gorky, nothing but a hysteric. Gorky loathed hysteria of any kind, and would imitate Trotsky's high, squeaky voice—that shriek of intellectual energy beyond control, beyond even despair, disintegrating into a whirlpool of high-pitched sounds. Stalin reliable: Trotsky, not. They represented to him two archetypes. He viscerally chose one and rejected the other, and never wavered in his choice.

THOUGH GORKY KNEW Matta well at this point, he still had not met André Breton, the intellectual leader of the surrealist movement. Even though they lived within easy walking distance of each other, Gorky would never

have dared present himself to Breton spontaneously. Nor, for some reason, did Matta think of introducing them. The meeting had to wait for the initiative of Jeanne Reynal, who at this point was still in California.

Breton had arrived from France in 1940. Kay Sage, the American wife of the surrealist painter Yves Tanguy, helped to arrange his passage over, and found him a small apartment near Washington Square, which he gradually filled with potted plants and American Indian artifacts. Like Matta, Breton missed the semipublic life of Paris: the long hours at the chosen café discussing new ideas with a group of attentive friends and disciples. In New York, Breton was not at ease, not least of all because he adamantly refused to learn English. Downtown, Francophones with appropriate respect for French culture were rare. If he often reminded people of a lion, with his stocky physique, wide-boned face, and mane of hair, then in New York the lion was caged.

From July 1941, soon after her arrival in New York, the collector Peggy Guggenheim offered Breton a grant of $200 a month, "to give him time to find out what he would do in New York, without worrying." In March 1942 he found a job as an announcer for the French section of the Voice of America, at $250 dollars a month. The work entailed sitting in a small room with a microphone on West Fifty-seventh Street from five-thirty until eight every evening. He was not required to write any of the texts he read, and for the rest of the day he was free. Bored with the city, Breton spent a lot of time in the shop of an antique dealer, together with Max Ernst, now married to Peggy Guggenheim. Both men were becoming increasingly interested in Hopi dolls, Eskimo masks, and carvings from the Pacific Northwest. The spirit of America, to them, lay in these remote places, not in New York.

In the early months of 1942, Breton found a wealthy accountant willing to finance a new magazine, to be called *VVV*. Most American readers assumed that the "triple V" stood for "victory," but Breton's intention was to add a new letter to the alphabet. In English, *w* is "double-u," but in French it is "double-v." In this case Breton was thinking of "triple-v." The "new letter," like the "new myth," had been an obsession of the surrealists for a number of years. It seems obtuse that Breton should choose as the title of an English magazine a play on words—or rather letters—that only makes sense in French, but it indicates his determination not to be confined by the foreign land in which he found himself.

Though he was assisted by American editors, *VVV* magazine was under Breton's tight control. The editorial meetings were conducted either at the house of its backer, Bernard Ries, on Sixty-seventh Street, with sculptures by Lipchitz and pre-Columbian art and many surrealist paintings; or at Peggy Guggenheim's new apartment; or at Breton's own small rooms off Washington Square. All that was required of the American editors was that they listen with-

out interrupting. Breton's command of the French language was magnificent.
He used long, complex sentences in the manner of the Chambre des Députés of
the First Republic, with controlled conditional tenses and multilayered subor-
dinate clauses. One could almost see the punctuation illuminating the air.

Breton believed that any argument could be carried by the sheer beauty of
the language. Meyer Schapiro once arranged a verbal duel between the French
visitors and, as it were, the home team. The chosen subject was "dialectical
materialism." It turned out that there was no common ground between the two
contenders. One relied entirely on the beauty of the language, while the other
was ready to quote chapter and verse from the appropriate texts. The evening
merely underlined the cultural gap between the two sides.

The young American painters were initially respectful toward Breton and
surrealism. Mark Rothko went out of his way to acknowledge publicly that the
surrealists had "uncovered the glossary of the myth." But Breton was unable to
accept this recognition. When he saw the "myth" paintings which for two or
three years dominated the work of the new generation, he rejected their claim
to surrealist antecedents. To him, they were thoughtless repetitions of old
icons. One can see his point. Of what relevance were Pasiphaë and Syrian bulls
in New York? As Breton put it, myths in themselves, "be they pagan or Chris-
tian," were an impediment rather than a help to an understanding of human
responses. Surrealism was neither a fashion nor even a new approach to the
problem of creating paintings or poetry. It was an instrument for discovering
unknown territories of the mind.

SIX MONTHS AFTER Lloyd Goodrich had exhibited the green *Garden in
Sochi,* Alfred Barr appeared at Gorky's studio to have a look at it. As he crossed
the threshold he said, "Goodrich tells me you have painted your best paint-
ing." Gorky took it out and put it on the easel. Barr's comment was one unem-
phatic word: "Yes."

He would like to acquire it for the Museum of Modern Art, Barr said, but
they had recently been given a work of a similar size. He was referring to the
Khorkom which Wolf Schwabacher had given to the museum the year before.
Would Gorky accept this work back in partial payment for the new painting?
Gorky, of course, agreed, and in due course, along with the returned painting,
Gorky received a small check to cover the difference in value between one
work and the other.

Dorothy Miller, Barr's assistant, wrote to Gorky for a text about the work
for their artists' files. Gorky eventually produced a short piece. In a covering
letter, he played down the lessons he had received in person from Wassily
Kandinsky: "My biography is very short and in fact I would prefer to omit the
references to Paris and Mr Kandinsky as such brief periods that mention of

them is out of proportion to the actuality." "Brief" is an overstatement: they had never taken place. Then, the usual tall stories. Tiflis. Studies in Russia. "I had been painting steadily since I was seven and continued to do so during my 3½ yrs. at Brown University where I studied engineering. For anything more personal perhaps there is something in the little writing I am sending."

He had dictated the text to Mougouch as he was working in the studio at Union Square. When she typed it out, she gave it very little punctuation and no editing:

> Garden in Sochi June 26, 1942
> I like the heat the tenderness the edible the lusciousness the song of a single person the bathtub full of water to bathe myself beneath the water. I like Uccello Grunewald Ingres the drawings and sketches for paintings of Seurat and that man Pablo Picasso.
> I measure all things by weight.
> I love my Mougouch. What about papa Cézanne.
> I hate things that are not like me and all the things I haven't got are god to me.
> Permit me—
> I like the wheatfields, the plough, the apricots, the shape of apricots those flirts of the sun. And bread above all.
> My liver is sick with the purple.
> About 194 feet away from our house on the road to the spring my father had a little garden with a few apple trees which had retired from giving fruit. There was a ground constantly in shade where grew incalculable amounts of wild carrots and porcupines had made their nests. There was a blue rock half buried in the black earth with a few patches of moss placed here and there like fallen clouds. But from where came all the shadows in constant battle like the lancers of Paolo Uccello's painting? This garden was identified as the Garden of Wish Fulfillment and often I had seen my mother and other village women opening their bosoms and taking their soft and dependable breasts in their hands to rub them on the rock. Above all this stood an enormous tree all bleached under the sun the rain the cold and deprived of leaves. This was the Holy Tree. I myself do not know why this tree was holy but I had witnessed many people whoever did pass by that would tear voluntarily a strip of their clothes and attach this to this tree. Thus through many years of the same act like a veritable parade of banners under the pressure of wind all these personal inscriptions of signatures, very softly to my innocent ear used to give echo to the sh-h-h of silver leaves of the poplars.

Gorky's words have no connection with the painting. As I have pointed out, the *Sochi* and *Argula* series depict a scene which Gorky had often observed as a child in Khorkom: a woman making butter by swinging to and fro the skin of a goat. The above text does not describe this scene. Instead, it

evokes the garden in Khorkom where Shushan used to "put him on a marble seat" and urge him to spend more time on his books and less climbing trees.

Gorky's words are evidence of what drifted through his mind while he was painting. A feeling of reverie, concentrated on the village of Khorkom, produced a mood from which phrases of various kinds—exclamatory, evocative, or specific to an incident—spontaneously emerged. All Gorky's paintings evoke all his memories. While working, he went through them time and again, like an ascetic on a mountain telling his prayer beads. His memories pervade the entire surface of his paintings, not in the details depicted but in their mood.

Regarding the brief, exclamatory words in praise of past masters—"Papa Cézanne"—recently I came across a typed fragment slipped into one of Gorky's old art books. It may be associated with the above text:

> Welcome O talent! Our ancients accepted only the best.
> Our precious lives are consumated.
> O talent! Our present culture is frustrated.
> I think our lives flow like a molten lava.

THEIR SUMMER VACATION IN 1942 consisted of a fortnight in Connecticut as a guest of the painter Saul Schary, an old friend of Gorky's. Schary owned a little bungalow on a hill, surrounded by an old apple orchard. Gorky went out into the fields and within a few days he had accumulated a small but fresh group of drawings, free and untrammeled by memories of the art of the past. There was a terrace above the valley behind the house which, seen from below, stood out against a magnificent background of empty sky.

Schary took him down to an abandoned mill on the Housatonic River. "It was an old silica mill and there were these huge grindstones lying about. The Connecticut Light and Power Company had gotten control of all the water power in Connecticut and so people abandoned the mills. And over the years, this mill fell into ruin until it was a very handsome and romantic ruin. And just below it, where they took the power from, there was a waterfall. And Gorky's drawings of it evolved out of the water falling over the rocks, and splashing up from the rocks and making these kind of strange forms."

He started a small, almost square painting, which he finished just before leaving and gave to his host. Back in New York he moved on to two large paintings of the same image. Memories of Connecticut mingled with memories of the waterfalls near Van City, some of which are spectacular. He had always loved waterfalls, ever since childhood. They were both dramatic and soothing.

While he worked on the variants of *Waterfall,* he started two horizontal landscapes: *Golden Brown Painting* and *Housatonic*. The composition, which is the same for both paintings, is clearly a landscape. One reads the space

Arshile Gorky, *Waterfall*, 1942–43

in terms of earth and growth, and of trees and bushes around small fields which rise from the base of the canvas and proceed to an invisible horizon. Indeed, the horizon line lies in the center of the painting rather than recedes behind it, a sensation Gorky struggled hard to achieve. There are elements carried over from earlier images, from *Khorkom* perhaps, as though Gorky was corroborating a long-held intuition by placing it against a real background.

The group of paintings that evolved from the drawings Gorky brought back from Saul Schary's house mark a huge breakthrough in his work. They took him several months and much hard work to complete. As Mougouch wrote to her aunt at the end of the winter, "Something quite new and miraculous is resulting, which has meant great exhilaration and of course much tearing of the hair and despair for what he is doing is entirely new for him and at times he feels like a drowning man."

THEY CAME BACK from the country in September to face the usual drama of an empty bank account. Buckminster Fuller arranged for Mougouch to visit the art editor of *Fortune* magazine to discuss a commission for a cover by Gorky. She presented a portfolio of gouaches for a mural, probably one of the recent Muschenheim commissions which had fallen through. Unfortunately, Gorky had raided a book illustrated by Picasso to make his "proposal." The art editor asked her to come back on the following day; he would see what he could do. When she arrived, he had Picasso's *Lysistrata* and Gorky's borrowed version side by side. Mougouch was naturally mortified. The art editor said, What about herself? Perhaps she would like some work in the "layout department"? Would she please bring him some examples of her art? And if her husband would like to bring a "thumbnail

Arshile Gorky, *Golden Brown Painting*, 1943–44

sketch" for a theme on the energy required for fabricating paper, he would consider it.

"Energy per pound foot" was a hard theme for either of them to grasp. It had something to do with the energy required to make a sheet of paper, or to flatten it, or something. Mougouch rang Fuller from the tobacconist on the corner, and he explained it all fluently and at length. Dimes disappeared into the maw of the telephone, and the explanation became longer and longer. Bucky Fuller was a wonderful man, but if you asked him something, he had a tendency to explain that and everything else as well, a process which naturally took several hours. By the time Mougouch had climbed back up the stairs to the studio, she had forgotten it all. But whenever Gorky received a commission, he gave himself up to it. In this case he covered endless sheets of paper with variations on a theme of stacked sheets whirling in the air.

As they tried to assemble a plausible example of "her" work, Gorky took the opportunity to give Mougouch a little drawing lesson. He found a glove and put it on a table and showed her how to gauge the distance between one empty finger and another, hinting at distance without sinking back into the use of Renaissance perspective.

As she set about making her own drawings, Gorky turned over the sheet

Arshile Gorky, *Portrait of the Artist's Mother,* Mougouch shortly before she met Gorky
c. 1942

on which he had explained how to draw a glove, and drew from memory the face of his mother, Shushan, following the shape he had so often repainted in his two large paintings of her. To me, it is one of Gorky's most self-revealing drawings, for intermingled within the features of Shushan are those of his wife.

Mougouch took "her" portfolio back to *Fortune* magazine and the drawings were much admired. The art editor said they were very "personal." She was offered a job at an excellent salary, but Gorky did not allow her to take it as the hours were too long, and she would be out too late at night on those days when the magazine was "put to bed"—a term used by her future employer which roused Gorky's suspicions.

MOUGOUCH TOOK GORKY down to Cape May in September to visit her father, who was now stationed there. Her brother John was also present. Having come back from the Ambulance Corps, he was waiting to hear if his application to the Marines had been accepted.

The officers' quarters were situated within a guarded area. That evening her parents started to criticize Mougouch, as parents of even grown-up daughters sometimes do. What about her politics? This allegiance of hers to the Communist party? Hadn't she gotten over it yet? The Magruders were good shouters and voices soon began to rise. At the height of the discussion, as the decibels were booming up and down the dinner table, Gorky added his own contribution, which was to recite Mayakovsky's poem "Tovarich Soldat" at

the top of his voice, in Russian. At which point the platoon of guards which had been passing outside suddenly tumbled into the house to save their beleaguered captain.

Gorky and Mougouch lay on the beach all day and took long bicycle rides that gave her stomach cramps. Soon after returning to the city, Mougouch discovered she was pregnant. The cramps which had gripped her on Cape May had not been the result of indigestion or overexertion on the bicycle. The first consequence of the news was that she was fired from her job at the United China Relief Agency. Pregnancy was a surefire way of losing a job at the time.

Barbara Chermayeff found her something else in the office where she was

Mougouch and Gorky on Cape May, visting her parents, September 1942

working, called the British Purchasing Commission. There, Mougouch was paid twenty-nine dollars a week, and she kept it throughout the winter of 1942–43, until her condition became apparent to all, whereupon she was fired again. Back at her desk, she burst into tears. Her companions in the office, taking pity on her, passed round a hat and raised a generous sum, which was instantly blown on a party in honor of the donors.

Saul Schary took a dim view of the fact that Mougouch was expecting a baby. To him, she was "giving way to her bodily functions." Gorky needed a wife—had needed a wife for years, for sure—but a baby? Why not take a leaf out of Mrs. Schary's book? he said. Hope Schary had a safe job in advertising and it was enough to keep them both going. That's what Mougouch should aim for. An artist couldn't count on selling his work every day. Gorky, ecstatic at the idea of fatherhood, was so furious with Schary he said he never wanted to see him again.

The prospect of becoming a father had a profound effect on Gorky. It was as if, having alienated so many other dwellers on the island of Manhattan, he at last had a chance of founding an island of his own, with none but his own immediate family as inhabitants. A lack of patience with his sisters and relatives far from Union Square was one of the side effects of his new mood. In the New Year of 1943, he wrote a letter of startling brevity to Vartoosh. "With your last letter you wrote that you were very depressed about this war. The soviet countries are fighting very hard. How is your cold. Mine lasted two months but now I am fine. Agnes and I speak of you constantly. Write what is happening to you Vartush. I hope that now your cold is over, you should take better care of yourself. Happy new year." Her constant harping on the past was not what Gorky wanted to hear. His wife was expecting a child: only good news was to come his way.

He visited Watertown only once after Mougouch became pregnant, during that winter of 1942–43. He had planned to stay a week but came back after three days. At this point his memories of Khorkom and Satenig's did not coincide, and he refused to have his memories corrected by his sister. Akabi was still good to talk to, but she was involved in the war effort, with a job down at the Navy Yards. It was a man's job, but all the men were off fighting. In September 1945 she and her whole family moved out to California. After Akabi left, Gorky had no desire to visit Watertown again.

During his last visit, he saw Yenovk der Hagopian. There are photos of Gorky standing stiffly with his nieces and Yenovk in the backyard of Satenig's house. Yenovk had recently recorded some of the old songs: high ballads like French troubadours' songs of the twelfth century. Seeing his well-equipped workshop, Gorky asked if they could make a plow together, like the ones they had learned to carve in Van with Aharon when they were children. So they

made a miniature plow, but when drawing it through the earth to try it out, they broke the shaft. As der Hagopian remembered it, they planned to mend it but never did. Gorky wanted to take the next train back to New York.

One day in the fall of 1942, George Adoian, Hagop's son, knocked on the door of the studio at Union Square. Gorky liked George. He is mentioned from time to time in the letters to Vartoosh. As they talked about the old days back on the farm in Cranston, Rhode Island, Gorky reminded him that his father Hagop had always "been on his back" to give up art. If it hadn't been for Hagop, Gorky said, laughing, he'd probably still be down on the farm. He ought to be thankful to him! He showed George one or two pictures, said what a well-known artist he'd become, and took him downstairs for a cup of coffee at the Quick 'n Dirty on the corner. It was the last time they saw each other.

George's brother Charley came to the studio together with his young wife, Anne, just as the winter was setting in. They were on their honeymoon. Gorky was not quite as hospitable as he had been with George. Why had they come to New York for their honeymoon? New York was a terrible place! They should have stayed right where they were and taken a walk in Roger Williams Park. There, they could have "listened to the birds sing and the trees talk." Naturally, they thought he was nuts.

CROOKED RUN

1943

ONE EVENING IN February 1943, Fernand Léger came to supper at Union Square. A storm was blowing around the city and he arrived late. David and Mary Burliuk waited on the huge red sofa which Peggy Osborne had recently lent to the Gorkys. The evening had been arranged because Gorky wanted Léger to meet Burliuk, the self-styled "Founder of Russian Futurism."

While they waited, Burliuk drew Gorky and told some of his favorite stories. For instance, how once, in Japan, he had been lying in a hot bath surrounded by a group of beautiful young women and Mary had come and fished him out of the tub, using the hook of her umbrella. At last Léger's voice was heard booming in the hall downstairs. He came in shaking the snow from his clothes: "I feel among your tall New York buildings as if I were in Switzerland." To Mary Burliuk, he looked like nothing so much as a blacksmith, for "a blacksmith is powerfully built, has a deep-sounding voice and is filled with proud self-satisfaction."

Mougouch cooked supper, translating for Léger when necessary. The subject of surrealism came up. Léger assured Gorky that the movement was now over. In his day, he said, "the painters put the surrealists in their pockets." Now, it was the other way round, "the surrealists put the painters in their

pockets." He meant that in the twenties, the painters had been out in front and the surrealists had appropriated their ideas. Whereas today, the theorists were on the lookout for painters capable of turning their theories into images.

After they had eaten, Gorky told the story of how his mother had taken him to the church and he had contemplated with childish eyes the black angels going to hell and the white angels going to heaven. "A child's heart could not accept it." It was the child whose spirit must shine through the simple act of putting lines on paper, he said. It was the child who "wants to give his inner goodness to the whole world."

People wanted so much from art, Gorky said. They wanted joy and gaiety, whereas art was no more than a combination of lines—a drawing and the colors with which you clothed them. Lines. The delicacy of Ingres. "At times I resent him, but, oh, how I would like to draw like Ingres."

Then, suddenly, he remembered the terrible retreat from Van. The green faces and the bodies heaped in the gully where they had fallen. Stones. "In the mountains of the Caucasus there is famine." Far down the hillside, the murmur of a stream. And, the murmur of the brook became singing; at which, he raised his head and sang.

THEIR DAUGHTER WAS BORN on April 5, 1943. "She seems very healthy," Essie wrote to her son, "& everything is fine all round. Gorky behaved very well thru it all. We 3 were all at the movies when she got 'took' so I was right there to go along with them to the hospital. They sent Gorky & me away at about 1:30 so I went home with him & we sat up most of the night keeping each other's spirits up & throwing Bubbles ball!" Bubbles was Essie's terrier. "The child was born about 8:30 in the morning."

The ward was a public one, and Gorky did not see Mougouch for a couple of days, though he peered through a plate-glass window at his daughter in her crib among the many other infants. He sent his wife a note: "My Darling Mougouch My sweet Heart My Wife I love you and love you and love Our little Maro I miss you my Dearest the House is—all right the painters are working at forgive my my Darling, I cant write clearly—I love you our Maro. yours all yours my Darling Arshile." Maro, the name, is an eastern Mediterranean version of "Mary." There had been other Maros in the family, notably a woman who plowed the Adoian fields after the massacres of 1896.

Captain Magruder pretended that "Maro" was in fact "Marù," like the Japanese battleships the American fleet was busy trying to sink in the Pacific. "The little Gorky MARU—seems to be shaking down in fine order from reports from 36 Union Square. When I first wrote her I started my letter— TOOT! TOOT! cheers to the launching of the Gorky Maru. Ever since I ask how is toots! Ang is furious & very seriously writes me that her child's name is

Mara [*sic*] not Mar-U and that its a very beautiful name and a very, very beautiful baby."

Mougouch stayed in hospital for ten days. Gorky channeled his excitement into a thorough rearrangement of the studio. He built a partition around the sink, with cupboards above for plates—a real "kitchenette," as Essie called it approvingly—and prepared the spare bedroom for the English nanny Essie had hired for a fortnight, to get them started in parenthood. The nanny arrived several hours before the mother and child returned from the hospital, and, being alone with her with not much to say, Gorky offered her a drink. He then sat down with her on the Peggy Osborne sofa and together they finished the entire bottle. By the time mother and daughter walked in the door, they were plastered. Mougouch, having only delivered a baby, had to admire every piece of home improvement and listen to how exhausted he was.

ARAX MELIKIAN, the cousin whose family once lived opposite the Adoian house in Khorkom, and who remembered Gorky as a boy whittling a stick at the back of the class at school, came to congratulate him soon after the baby was born. As she put it to me, there was "a small wrapped-up something" in the corner of the studio. Gorky had not seen her often since coming to the New World, but from time to time he used to walk uptown to pay his respects to Arax's mother when she lived in New York.

Gorky took out a particular painting and put it on the easel. "Just look at it," he said. "Take a good look." So she looked. "But all I could see was an anchor. It was quite a simple, clear painting. There was nothing much else in the picture at all."

Gorky asked if she remembered, right behind their house in Khorkom, a little hill with trees round it, at the end of their vegetable garden. "I said yes. We used to go up there and play sometimes." There, he told her, he had once seen a beautiful orchid growing. The painting she was looking at depicted the flower he remembered.

Their garden? Of course she remembered it. Her garden started near the tree on which the village women used to tie their votive rags. On one side there was a big field where their vegetables grew, and on the other there was a little hill with some trees around it. "Nothing was growing there but grass, and on it there must have been an orchid growing. And he saw it and he drew it." She looked at the picture again, not seeing what he saw. "He said, 'That's the way I remember it. There was an orchid growing there. That's how I remember it,' he says."

After Arax told me this story, we looked unsuccessfully in all the Gorky books we could find to see if we could identify the painting. A vertical work, about twenty-four inches by eighteen, is how she described it. As far as I

know, there are no surviving works that fit the description. Gorky was painting the three versions of *Waterfall*, or had already painted them. He was working simultaneously from drawings of things seen, and from things remembered. The painting of the orchid, unfortunately no longer extant, might have left some clues as to the way he relied on one process or the other.

THE ENGLISH NANNY did not last. As soon as the weather became warmer, they left the city to take their baby into the fresh country air of Virginia, where Captain Magruder had bought a small farm.

Crooked Run Farm, near Lincoln, Virginia, was a typical clapboard farmhouse built about 1800, with a porch and a beautiful view of gentle hills covered with woods. The fields had been carved by the farmers into rough rectangular shapes following the lay of the land. The house was simple and small, with two or three huge trees indicating where the lawn ended and the fields began. Thirty yards down the hill lay a barn, and beyond that, in a gully, a pump house to wash clothes in.

Captain Magruder did not want his wife to live there by herself, so everyone approved of the plan that Gorky and Mougouch and the new baby stay with her during the summer. They were driven down in May by Jeanne and Urban, who had come back east on one of their periodic visits. Maro lay in a nest of painting equipment and fishing gear— Urban was a passionate fisherman—in the back of Jeanne's station wagon.

At first they stayed with some neighbors pending the completion of repairs at Crooked Run. The daughter of the house had married a Spanish guitarist, and once Mougouch overheard her mother commiserate with their hostess over the fact that their daughters had both married "precarious foreigners." Urban settled down to fish, though the stream wasn't up to much, and Mougouch and Gorky went for long walks by themselves. The fields were still being plowed and seeded with corn, and they were edged with wildflowers.

None of the farms in Loudoun County was large enough to live off. The farmers kept a few cows and grew corn, and that was about it. Essie was glad to hand over her land to Mr. Ward, her nearest neighbor. Mr. Ward knew everything there was to know about corn, and was liable to tell you if you let him. He saw each plant as an individual: Now—see here—this has a tassel going thataway, and that little fellow over there has only three leaves.

On one of their walks, Gorky and Mougouch discovered a dilapidated barn where the cowhand had invented a flytrap consisting of lots of branches on strings hanging from the roof. The branches were hung in the entrance and they were supposed to sweep the flies off the cows as they came in, but of course they did the same job when they went out again, too. Gorky

thought it was a wonderful invention. Essie laughed when she heard the story. "What's the matter with you two?" she asked. "You're only interested in failures!"

Gorky thought he'd start a kitchen garden. A lot of digging went on for a week or two, until he settled into his drawing. He started the year's work with an absolutely straight painting of the side of the house with a lean-to in front. It is a nice painting, but hardly adds anything even to the Cézannesque works which he still indulged in from time to time. After finishing this, he decided to give up painting for the summer and concentrate on drawing. Nature was too complicated, he said.

His first drawings were of a vegetable garden. A tangle of climbing beans are growing on the left of the page, and in the background there is the swelling sphere of a tree. In the second drawing, there is that same tree—with Miróesque horns—seen closer, growing above the beds in which the vegetables have been planted.

Gorky chose a number of favorite spots to sit and draw, and he returned to them again and again. After he had found his subject, he always thoroughly thrashed the bushes for snakes before sitting down. In the same way that he needed to wash his studio floor in New York before starting to work, in Vir-

Arshile Gorky, *Virginia Landscape*, 1943

Arshile Gorky, *Virginia Landscape*, 1943

ginia he beat bushes. He could only work when he had achieved a state of excited exhaustion.

To begin with, he was fascinated by the river. In May, Crooked Run Stream would have been a robust rivulet containing the occasional languid trout, but when the weather warmed up it sank to a brackish trickle above which hovered thousands of mating midges. The cows wandered down to watch Gorky working in the deep pasture. Ladies, he would say politely, can you please move away? The cows, impervious, remained. By themselves, they were company, but they were inevitably followed by flies. He tried reciting Mayakovsky to them at the top of his voice to scare them off. No luck. They liked Mayakovsky.

Gorky carried over certain compositional habits from his earlier work. Many of that summer's drawings consist of three standing shapes, parallel to the onlooker, seen against a flat plane behind them, tilted upward. In other words, the schema of the *Nighttime Enigma and Nostalgia* series he had made ten years earlier. The first signs of a breakthrough in his work were two or three ink drawings bleared with water and wash. Confused, slightly Miróesque, not quite sufficiently unraveled. Enough to make him impatient.

Then one day he walked into the house. What did Mougouch think of this? He showed her a drawing with color, very exciting and wild. He was trembling. Did it remind her of anyone? he asked dubiously. No, she said. The question of influences worried Gorky a great deal. He knew that it was time to break loose, and he was making the effort. But he occasionally came back from the field saying anxiously, Is it all right? Whose influence do you see here? Am I crazy?

Arshile Gorky, *Carnival*, 1943

However much Gorky's drawings owe to Miró or Matta, the most impor-
tant discovery Gorky made at Crooked Run was that the fantasies he had had
for so many years—the horsemen and riders and bent old ladies (which had so
irritated Noguchi on the Mississippi bridge)—could be perceived in trees and
fields, and captured by drawing lines on paper. He saw the boughs bending
with growth, and the fresh green leaves pushing upward, as forms which com-
municated with one another. The undergrowth was alive with the gestures of
passing, of bowing, of saluting. Trees became human. Nature was possessed
by emotions.

Matta's recent exhibition at the Julien Levy Gallery had opened the day
before Maro was born, and the memory of his drawings must have been fresh
in Gorky's mind. But Matta's drawings have a hyperprecision of detail and an
urban sentiment which is remote from Gorky's fantasy. Matta never worked
from nature, and in many ways he intended to work *against* nature, filling a
gap between the things of this world and the things of the imagination. He did
not draw landscapes, but "Inscapes," as he called them, meaning organic
images dredged up from his own interior. Gorky's drawings are not Inscapes
but studies of the landscape around Crooked Run Farm.

If Virginia were in Europe, the surrounding country roads would long
since have been named after Gorky. His work is extraordinarily specific to cer-
tain spots, even to this day. At Crooked Run Farm, the trees lie like a series of

Roberto Matta, untitled, 1938

flat screens one behind the other. Trees which mark the fringes of earlier fields create funnels of space as you walk between them. They become stage sets. Near distance, middle distance, far distance become a series of overlapping transparencies as the sun mounts higher. At midday the far distance is perceived like a distant jewel, on a different scale from the surrounding vegetation. The nearer trees become bleached out, and the eye constantly returns to that small patch of blue. Strong sunlight from one side creates a luminous silhouette, within which, through the leaves, the dark interlacing branches are guessed at more than seen. These silhouettes flatten into interlocking shapes like theater wings. As the day heats up, the scenery changes. The trees coming down from above become canopies containing the viewer, rather than screens to be looked at. It becomes a landscape to be *in,* not looked at. Birds, accustomed to the presence of a quiet man, fill the woods with their territorial cries, their drama of declaration, through song, of strength and possession. The red cardinal, for instance, with one piercing note, one strident flash of scarlet—a sound as well as a color within the composition.

Raising a matchbox in the air, Gorky imagined the lines of the trees and the fields converging on it, as if the hand held high were the hub of the visible world. Icon painters of the Byzantine tradition used this idea: a painting which grows from the inside out. For Gorky, also, the drawing should contain no horizon, no recessive space, no vanishing point. The world as he depicted it had to implode with all its secret activities onto the page in front of him, not a portrait of the thing but the thing itself.

At the end of the year Mougouch wrote to her aunt Natalie:

He was again a small child, not having been to the country since he was 6 yrs old (!) and his vision was clear and untrammeled by habit. He made only drawings, as he found that paintings took too long and he had too much to put down, and paintings anyway are better when not done from nature. Nature (he says) is so complex and confusing and one is too apt to get tired and take the easiest way out. A drawing is more direct and automatic, or should be, to have the lyrical freshness that a drawing shd have, like a poem. He made well over 100 drawings. This summer was the real release of Gorky. He was able to discover himself and what he has done is to create a world of his own but a world equal to nature, with the infinite complexities of nature and yet sweet, secretive and playful as nature is. They are not easily understood but then neither is nature, and to those free enough to follow they are v. wonderful.

The weather grew hotter. The sun was always a source of energy for Gorky, and he stayed out all day, his little woolen cap on his head, producing drawings which were richly colored, using wax crayons. Back at the house, Essie and Mougouch worried about the beans and lettuces they had planted. Mr. Nichols the gardener said it would be dangerous to overwater. Essie took to watering surreptitiously at night so as not to hurt his feelings. Peeping through the kitchen window as she washed up after breakfast, Mougouch would see Mr. Nichols examining the ground critically and walk off, shaking his head.

Naturally, Gorky became something of a legend in Lincoln. Tall, dark, mustached, walking up to the village barefoot, dressed in overalls and no shirt and wielding a huge shepherd's crook. Once, the postman came across Gorky near the bridge down by the stream, not far from the ruins of an old mill—the one which burned down during the Civil War. The postman had a registered letter that required a receipt. Could Gorky please take it from him and save him a hot bicycle ride up to the house? Gorky answered impatiently, "Can't you see I'm inventing?"

All the neighbors were Quakers with a lot of tolerance for human foibles and a delicate, peculiar sense of humor. Once, when Essie was talking to Mr. Ward, he interrupted her to tell her politely, "Mrs. Magruder, you have a worm on your Adam's apple." Mr. Ward was the one who stood behind Gorky in a field for what felt like hours. His conclusion: "Keep at it." Gorky was delighted.

Essie and Gorky got on well, especially that first summer. The photograph of Gorky with his daughter on his knee, saying something outrageous to his mother-in-law, is perhaps the happiest photo of his life. Work going well, baby happy, with two women to shock, dazzle, and amuse. At one point Gorky took it upon himself to teach Essie how to get in touch with her emotions. If a child tenderly collects a handful of pebbles and brings it to her as a gift, she should not laugh, he said. Though they are nothing but stones, she should enjoy the spirit with which they were given. This was a painful incident which had

Gorky, with his daughter Maro on his lap, talking to his mother-in-law, Essie Magruder, summer 1943

taken place in Mougouch's childhood, and she must have listened with mixed feelings as her husband brought it up with her mother as an example of what not to do. Essie listened with an amused smile. She had, after all, raised three children. Was Gorky really going to give her lessons in motherhood?

Essie's second daughter, also called Esther, came down for three days in the early autumn with her "beau," a violinist whose parents had emigrated from Russia. "There were no acrimonious conversations," wrote Essie to her son, "but Paul is a very tactful young man. There was only one embarrassing moment when he spoke Russian to Gorky. Evidently Gorky never learned real Russian. I suppose they have a dialect in his part of the country & he did not have the kind of education which included languages."

She pursued the idea over tea with an old friend, the writer Grace Stone. "Well," said Essie, "he says he's Russian. But not the kind who went to the Corps des Pages." The Corps des Pages was a grand private school for aristocratic boys in St. Petersburg before the Revolution.

The distinguished journalist Arthur Krock, head of the Washington bureau of the *New York Times,* was another afternoon visitor. This time Gorky joined them. As they sat on the lawn watching the sun go down, Gorky engaged him in a conversation about the connection between Russian and English writers in the nineteenth century. Gorky said that Charles Dickens had stolen all his ideas from Dostoevsky. Even Balzac had taken themes from the

great Russian writer, he said. He explained how, and why, and Krock was speechless, not least of all because Dickens and Balzac had matured as writers years before Dostoevsky, a fact which Gorky implied was irrelevant.

There was an element of entrapment in Gorky's shower of words. If you said, "But just a moment," or the heavier "You can't expect us to believe that—" then Gorky would have succeeded in showing up his interlocutor as a pedant. A bookkeeper. A man stuck forever in the quagmire of mere fact.

In the fall, the sun burned out the undergrowth and they waited for rain. "We've had a very exciting time with the neighbors cows," Essie wrote to her son. "Now that the underbrush is dying out they find all kind of holes [in the fences] & always make straight for this house. Gorky & I chased 2 of them round & round the vegetable garden at 10 o'clock the other night & the next morning when I let Bubbles out there were 5 of them out in front here just as surprised to see me as I was to see them."

In November, as the Gorky family was about to return to New York, Johnny's division was ordered into action. Captain Magruder wrote to his son, "We read of the 2nd Marines and their storming of Tarawa in the Gilberts and the heavy casualties of the marines—and we know that news will be slow— but all we can do is to pray and wait for your next letter. Your mother wrote me that she had her 'chin up'—bless her—but what a relief it will be to all when we do get news that you are safe & well. Its all right to say don't worry—but the news coming out of that section of the Pacific isn't anything for parents to be happy about." The contrast between a young man fighting the Japanese in the Pacific and another man sitting in a field, making marks on a sheet of paper, was stark.

An underlying irritation that the men of the Magruder family felt about Gorky occasionally surfaced. At the end of the year, Essie had to go to Washington, leaving behind Bubbles, her dog, who was just going into heat. Gorky and Mougouch were most solemnly enjoined to take care of her. The little bitch was even provided with a chastity belt—alas, to no avail. As Captain Magruder wrote to his son, "Your sister Ang & her lummox of a consort" failed in their duty, and "poor Bubbles was ravished by the neighboring farmer's Wonk & Agnes showed no remorse at all—just all-same as Grandfather's gold watch chain." The chain was another sore point—an heirloom which Mougouch had used as a necklace until she hocked it to give the money to the Communists.

Essie was unable to take care of Bubbles at the moment, so she arranged to fly her down to her husband on the next navy transport plane. Bubbles gave birth during a thunderstorm as they flew between Charleston and Jacksonville on their way south. Two of the puppies died, but two survived, brought by the pilot to Captain Magruder, together with their battered mother. His comment: "Sometimes I could wring Ang's neck."

SURREALISTS IN NEW YORK

1943–1944

G ORKY AND HIS LITTLE FAMILY came back from Crooked Run in October. They delayed their return because the studio at Union Square was infested with bedbugs. Mougouch refused to return to an apartment where her infant would be devoured by vermin. She telephoned a new friend, Jean Hebbeln, whom they had met at the Chermayeffs' apartment shortly before leaving New York. Jean came from a wealthy Chicago family and she felt protective toward the Gorkys. It was she who had the rooms fumigated so that when they came back the studio was clean and free of vermin.

Gorky spread his drawings on the floor of the studio. Having chosen the one he needed, he pinned it to a board and worked from it as he might work from an actual landscape. Some drawings are squared-up and covered in paint spots, and from these he usually made a clean version for the portfolio. Sometimes he transferred the image to an old painting to try it out first, before moving on to a clean piece of finest Belgian canvas. In many ways, Gorky worked as methodically as an artist of the Quattrocento.

The Liver Is the Cock's Comb, a canvas he started soon after returning to the city, is a "masterpiece" in the traditional sense: it sums up in one painting a number of recent conquests by the artist, faithfully following a clear preparatory study. Objects lie on the "ground" of the lower third of the canvas. Above

Arshile Gorky, *The Liver Is the Cock's Comb*, 1944

are viscera, the male sexual organ left of center, spiky leaves at the top. The whole event appears to take place in a closed room. No one could say that this was a plein air work, but in spite of its ambiguity, *The Liver Is the Cock's Comb* confirms Gorky's allegiance to things seen.

The following year, Sidney Janis published a poem by Gorky which may have a connection with the painting:

> The song of the cardinal, liver, mirrors
> that have not caught reflection
> The aggressively heraldic branches,
> the saliva of the hungry man
> whose face is painted with white chalk.

The last two lines echo the elusive memory of the retreat from Van which he had shared with Léger during their supper together earlier in the year. Both the poem and the story give an idea of the limits of what Gorky was prepared to reveal about the past. He gave clues freely, but he always shied away from making them too precise.

As the weather grew colder, Jean Hebbeln took Mougouch shopping. At a grand store on Fifth Avenue, she offered to buy each of them a long leopard-skin coat. Mougouch said that frankly, she would far rather have the money,

whereupon Jean immediately sat down and wrote her a check for $1,000. At that time, Gorky's credit in the bank had shrunk to $65. He felt so grateful for these two gestures—the extermination of the bedbugs and the fur coat which turned into a check—that when *The Liver Is the Cock's Comb* was finished, Gorky gave it to her.

David Burliuk came to the studio shortly afterward, his pockets miraculously bulging with dollars. He had found a wonderful man, unbelievably rich, who was buying up hundreds of paintings at a time. He would bring him to the studio. Gorky would see for himself.

Burliuk came regularly to Union Square to see how Gorky's work was coming along. Gorky was very fond of him, even though the subject that loomed largest in his conversation was Burliuk himself. He was also fond of Mary, his wife, who always remained in the background, treasuring every word. Mary had a peculiar dent in her nose, which Gorky told Mougouch dated from her childhood on the Russian steppes. She belonged to a special tribe which lived off mare's milk, said Gorky, and as little Mary drank, the top of the ladle used to press down on the bridge of her nose.

Joseph Hirshhorn, Burliuk's new patron, came to Gorky's studio and bought a large number of small works for a suitably equilibrated sum: thirty works for $300, or forty for $400, or something like that. Hirshhorn was a businessman and he liked large acquisitions. Gorky signed them and named them, frivolously backdating some so that some quite recent paintings entered the catalogues as if painted in his adolescence. *Child of an Idumean Night* came from a poem by Mallarmé which Mougouch had been translating for Gorky at the time. As usual, the titles were just "handles," given to works as they left the studio.

Shortly before Christmas, Mougouch wrote to her mother that they had some exciting news. "If its another baby I cant stand it," Essie wrote to her son. Hopefully, she continued, it would be a show at the Museum of Modern Art. "They were very interested in his summer work."

The news turned out to be an inquiry from the Parisian dealer Paul Rosenberg, who now had a beautiful gallery on Fifty-seventh Street. Gorky was very excited. He knew and admired the gallery—a shrine to art, with thick carpets and a hushed atmosphere, and just one easel in the room. He had been there the year before to look at a painting by Ingres. Jeanne had dressed up Mougouch as a rich buyer, and Gorky had kept to the background, just looking. Rosenberg now told Gorky that he would like to see some examples of his recent work, so Gorky brought him a small white *Waterfall* and the two versions of *The Pirate*. He had not yet completed any paintings from his summer drawings, and these three works, which one could describe today as intermediary, were all the recent canvases he had.

There was no news from Rosenberg for several months. One day Gorky came back to the studio carrying the paintings under his arm. He threw his cap on the floor and said "Bah!" According to Gorky, Rosenberg had told him he would like to handle his work, but that Gorky was always to remember that his job was to "row the boat," while he, Rosenberg, was "the captain." And it would also be useful if he, Gorky, pretended he was Jewish! But although Gorky was happy to be Russian, Georgian, even Circassian at times, Jewish he was not prepared to be.

WHILE GORKY HAD BEEN working in front of the luxurious under-growth of Crooked Run Farm, back in New York an interesting controversy had broken out in the pages of the *New York Times*.

Preparing to leave the metropolis for the summer holidays, Edward Alden Jewell gave a somewhat casual dismissal to a show organized by the Federation of Modern Painters and Sculptors. "You will have to make of Marcus Rothko's 'The Syrian Bull' what you can," Jewell wrote. "Nor is this department prepared to shed the slightest enlightenment when it comes to Adolph Gottlieb's 'Rape of Persephone.' "

Rothko and Gottlieb wrote a letter to the *Times* passionately defending their work. What they aimed for, they claimed, was "a poetic expression of the essence of myth." *The Syrian Bull* was "a new interpretation of an archaic image." Why was Mr. Jewell so confused by the idea of myths in art? they asked. Myths had formed a part of the vocabulary of art for thousands of years. Then, changing gear, the letter proposed a five-point program—a decla-ration of faith on the part of the artists concerned. The writers were in favor of "the simple expression of the complex thought." What should be sought was a subject matter which was "tragic and timeless."

What Jewell did not stress was that the Federation of Modern Painters and Sculptors had a political as well as an artistic purpose. Its core consisted of a group of former Trotskyite intellectuals who had resigned from the Artists' Congress after the invasion of Finland, including three figures destined to become the arbiters of American taste after the war: Clement Greenberg, Harold Rosenberg, and Meyer Schapiro.

At a political level, the group wanted to purge the artistic institutions of America of their secret Communist controllers. Among the papers of the Feder-ation, now in the Archives of American Art, there is a long list of the major art associations of America, more than half of which have been inscribed "C," for "Communist." The federation made a big effort to alert these contaminated groups to the fact that they were being manipulated—a tedious task, as most artists either refused to believe the allegations or simply didn't care.

As the war went on, however, most of the Stalinist figureheads were re-

placed. The federation's leaders went on to the second part of their plan to con-
quer New York: attacking the big museums and other institutions of New
York, in order to oblige them to pay attention to their artists. The Rothko-
Gottlieb letter was an important advance in this maneuver. The group was
revealed as being not only cohesive but as possessing a clear artistic aim. An
art which was "tragic and timeless" suggested that the painting of the future
would be the opposite of the politically "engaged" art which had monopolized
the attention of the public before the war. Whereas the prewar style had been
figurative, the new art was to be abstract. Whereas the prewar art had been
politically engaged, this was to be introspective, as if each artist were an island
unto himself alone.

Rothko and Gottlieb had been introduced to the "myth" by Matta at the
beginning of the decade, but when Matta had spoken to them about the "new
myth," the last thing he wanted was to see a rehash of Persephone, Pasiphaë
and/or Syrian bulls. According to Matta, the "new myth" was to have been
truly modern, and truly American. Seeing their persistent obsession with the
archaic, Matta lost interest in the young generation. They had misunderstood
everything! Even Pollock, whom Matta initially had championed, failed to
understand the function of symbolism in painting. As Matta put it to me
recently, if one uses the symbol "H_2O" to stand for water, the letters evoke the
substance. But for the symbol to mean something, "water has to exist!" With
Pollock, "the water is no longer there!"

Gorky was excluded from this group on every possible count. He loathed
Trotsky, he did not take group action seriously, he was unable to manipulate
anyone or anything for the sake of his career, and he respected the museums
far too deeply ever to attack them. By age and by experience, he belonged to a
generation older than that of Rothko and Gottlieb. If he remembered Rothko at
all, it was as a former pupil whom he had once told to carry out his garbage.
His contacts with Matta took place privately, and were always friendly and
open, but whenever Matta began talking about grand general ideas, Gorky's
attention wandered.

Whereas the solitude of the individual artists of the next generation was
somewhat institutionalized, Gorky really was an island unto himself alone—
which is one reason why his work obstinately refuses to fit in with the
achievements either of the generation which came before him or the one after.

JACKSON POLLOCK'S FIRST ONE-MAN SHOW with Peggy Guggen-
heim took place in November 1943. Gorky had only just come back from
Crooked Run, and he did not attend the opening, but he probably saw the
exhibition later.

In June 1943, just as Gorky was beginning to delve into the countryside of

Virginia, Peggy Guggenheim, on the advice of Matta and Frederick Kiesler, had offered Pollock a one-man show and given him an exceptional commission: a mural measuring eight feet high by nearly twenty feet long. It was destined for the entrance hall of her new apartment not far from the East River. The canvas was so large that Pollock had to destroy a wall of his studio to accommodate it. For weeks Pollock sat in front of this pristine surface, unable to start. Then, suddenly, in a matter of days, he produced a masterpiece. This, at any rate, was how Peggy Guggenheim herself remembered it.

Pollock's exhibition was a controversial success, and Art of This Century, the gallery which she had founded, suddenly became the most outstanding gallery of contemporary painting in New York. Peggy Guggenheim was excited by the reaction of the public. She was also somewhat mesmerized by Pollock himself. As they were both serious drinkers, their mood swings were often more comprehensible to each other than to outsiders. If Pollock behaved badly at a party—if he abruptly took off all his clothes, for instance—it was something she could incorporate into the experience of the evening. Both as an artist and as a man, Jackson Pollock monopolized her attention. As she put it, after his exhibition "Pollock immediately became the central point of Art of This Century. From then on, 1943, until I left America in 1947, I dedicated myself to Pollock."

Chance, and his own self-imposed isolation, kept Gorky from both these interesting new formations: the group associated with Greenberg, Schapiro, and Rosenberg, and the more diverse group associated with Peggy Guggenheim. Left to himself, he might have endured this isolation for a long time, perhaps even forever. As it was, Gorky was pulled by his friends toward a different circle.

EARLY IN 1944, Gorky met André Breton. The meeting took place at the Lafayette, an old-fashioned French hotel on University Place, near Eighth Street, with cast-iron furniture painted white and waiters in long aprons with napkins over their arms. Ostensibly, Noguchi had arranged a lunch so that Breton could meet Jeanne Reynal. It was her idea to bring Gorky and Mougouch with her. When, years later, Maro asked Noguchi why he hadn't arranged the meeting before. Noguchi was embarrassed. André Breton was a very sophisticated man, he said. How was he to have guessed that Breton would take a liking to someone as innocent and unworldly as Gorky?

The lunch at the Lafayette went well. Even though the conversation was in French, a language Gorky did not speak, he and Breton took an immediate liking to each other. At the end of the meal, Breton accepted an invitation to have supper with them at Gorky's studio the following week.

What would be a suitable meal to offer a surrealist and a poet? Mougouch wondered when the day came. Leaving Gorky washing the studio floor in preparation for Breton's arrival, she walked past all the grocery stores from Union Square up to Fifty-seventh Street and back before selecting some large artichokes and a perfect Brie. That and a pilau of rice should be perfect, she thought.

Breton and Gorky settled down in the studio for a long conversation. Mougouch translated. First they discussed food: the difference between the way things were done here and over there. Then Gorky talked of his childhood and his country. The coming of the storyteller in winter. The church of Akhtamar. The intonation of the priests. The devils and angels on the walls. Breton reciprocated with stories of working as a medical orderly during the First World War. Of taking dictation from Marcel Proust. Both men had told these stories many times before. It was a question of listening to each other's tone of voice.

During supper, Gorky held up the leaf of the artichoke he was eating and compared its shape to that of an owl. Breton was delighted. The capacity to make analogies between one object and another, he said, was one of the fundamental forces behind the creative act.

After supper, Gorky brought out his paintings. He put them on the easel one by one and talked about what they meant to him. The women from the village rubbing their soft breasts against the rocks, under the tree covered with torn clothing whose shadows fluttered on the ground.

At the end of the evening, Gorky brought out Maro, who was at an age where she could still sit upright in the palm of her father's hand. Maro looked at Breton, who held a finger out to her. She refused to take it, "unblinking as a kitten." Breton said that the world of babies was divided between those who were enchanting and those who were enchanted. Maro clearly belonged to the second category.

THE WAR IN EUROPE was coming to an end, and in the newspapers the problem of the postwar political equilibrium was already being discussed. It was evident that the United States would have to assume a leading role in producing order out of chaos. What that entailed, nobody quite knew. American isolationism, always as strong a force as American world leadership, was still powerful.

Within the comparatively small world of art, those who were most adamant about assuming world leadership were the intellectuals behind the Federation of Modern Painters and Sculptors. "America is faced with the responsibility cither to salvage and develop, or to frustrate Western creative capacity," they had written in a declaration circulated two years before. "This

responsibility may be largely ours for a good part of the century to come." Two years later, amplified by a public curiosity, after so much war and destruction, in almost anything creative, the opinion of this small but active minority had become widespread. Even the mass media began to be interested.

In April 1944 James Johnson Sweeney published an article in *Harper's Bazaar* on five contemporary painters: Milton Avery, Morris Graves, Pollock, Gorky, and Matta. Its conclusion pointed to a change, away from sociopolitical and historical content in art, away from the obsession with the "American scene" which had dominated the thirties—and also away from the influence of the "idols" from Europe. They were "working zealously week in and week out to find fresh ways of expressing themselves." Sweeney discussed Gorky's response to the mood. "Last summer Gorky decided to put out of his mind the galleries of Fifty-seventh Street and the reproductions of Picasso, Léger, and Miró, and 'look into the grass.' " The result of this free response to nature was "a freshness of idiom which Gorky had never previously approached." His recent work showed that he understood the value of "returning to the earth." Sweeney described Gorky as a "researcher into nature's forms," producing drawings which had "the quartzlike structure and tone of a mineral."

When Gorky and Mougouch read the article, they were disappointed. "Gorky said had he known Sweeny was so uninspired he would have talked himself up better," she wrote to Jeanne. "The whole train of thought of art developed from art could have been touched on far more intelligently." But this was just the aspect of Gorky's work which Sweeney wanted to suppress! What was interesting in Gorky's work was that it was new, untrammeled by the weight of the masters he had admired and imitated for so long.

All artists need to build bridges between their work and the outside world. In remaining somewhat tongue-tied during Sweeney's visit, and in failing to follow up on this promising first encounter, Gorky missed a fine opportunity to build one. Looking into the grass with fascination was part of a genuinely American feeling toward nature. Thoreau, Emerson, Whitman had built their works around just such a humble but intense approach. Gorky and Mougouch both knew about Emerson and Thoreau; some of their books were among the few they owned. Gorky's work would have become instantly more comprehensible to an American public if his practice of looking into the grass had been associated with this hallowed American tradition. But Mougouch and Gorky never contacted Sweeney to suggest as much. Connecting Gorky to the movements of his time always required an initiative from the outside, and often the attention of the world was engaged elsewhere.

THAT WINTER Gorky was struggling hard to carry over the spontaneity of the drawings into his paintings. The problem was to avoid making the canvas

into a mere copy of the drawing. Mougouch referred to Gorky's difficulties in a letter written to Jeanne a few months later: "When he was agonizing over his drawings to recreate them exactly in paint and so stymied and every one would say but gorky you cant just reproduce, it cant be done and he would say yes in that tone of voice he gets when he knows what you mean but it doesnt register for him."

Breton visited the studio at Union Square several times. The Virginia drawings were in portfolios on the table under the big window. Breton spent hours examining them. The drawings had already acquired a reputation. Matta had looked at them; so had David Hare. Once, Matta's dealer, the prestigious Pierre Matisse, telephoned and asked to see them. He studied them attentively but left without comment. Later, they heard through David Hare that he had found them too "*surchargé*" for his taste.

Their last evening with Breton took place at the end of April, just before Gorky and his family went down to Crooked Run for a second summer. Mougouch cooked him a "huge seignorial steak." Breton joked about his first wife's parents. And what did you do today? his father-in-law used to ask before supper, rubbing his hands together. Oh, Breton would reply. A few lines were written; a paragraph or two, perhaps—and he imitated his father-in-law's incredulous look. "Just like G. & Father," as Mougouch put it.

After supper, Breton wanted to choose a drawing to publish in *VVV* magazine. Color printing was going to be difficult and expensive, he said, but it would be a shame to print these drawings in black and white. Gorky's huge painting—the one that was later called *The Liver Is the Cock's Comb*—was on the easel in the studio. He had finished it in a week at the beginning of April while Mougouch and their baby were in Washington visiting Essie. The paint was hardly dry. Breton looked at it attentively, then turned to Gorky. With great feeling, he told him that in his view Gorky had inherited the spirit of Toulouse-Lautrec. "This was new to Gorky & v. encouraging in the way he put it. And Breton meant it as a great compliment."

Paul Rosenberg had also noticed the relationship to Lautrec. Both Breton and Rosenberg were old enough to remember the time when it had been fashionable in Paris to dismiss Lautrec as a coarse imitator of Degas. Even Lautrec had run up against this criticism. The painter Suzanne Valadon once told Degas, "Lautrec dresses too much in your clothes." Degas, who was always generous to younger artists, replied immediately, "But he alters them to suit himself." What Breton and Rosenberg meant was that although Gorky's influences were obvious, he had succeeded in altering them to fit his own needs.

"Then we talked of the country & little brooks," wrote Mougouch to Jeanne, "& G. & he swapped stories via me about stones & walnuts & smells & Arshile was in a very poetic mood, & Breton sensed that & really felt love for

him I think. We spoke of sadness & why & Breton confessed his everlasting sadness & told of how in his happiest moments with women even they would say but you are sad & he would say no yet know that it was true. Gorky shares this with him though he is wilder than B. and you know Jeanne at this moment we all had tears in our eyes. It was a very beautiful evening & very rare."

Gorky did not like to reveal any intimate personal details about himself, and the conversation veered in two different directions. Gorky told Breton that in the modern world, there were "too many windows open." That is, as Mougouch put it, "Man was no longer able to trust his intuitive irresponsible self—all his secrets had been opened & aired even in sex there was responsibility imposed on him (O Moogouch)." Breton agreed. Or rather, he continued to speak, in French, to Mougouch about the innate solitude and sadness of man and of himself, while Gorky in his formal, ornately polite way indicated that to him there were certain subjects which would lose their sacred qualities if they were bandied about in casual conversation. To show, not that they agreed with each other, but that each appreciated the other's point of view, "several times during the evening he & Gorky lept up & clasped hands [. . .] O Jeanne it was a sweet evening I shall never forget how he left us backing down the hall smiling so sweetly with his hand raised—like an actor really— his every gesture & movement portraying his feeling."

Gorky came back from Crooked Run in October 1944 and he left for Crooked Run again as soon as spring came. The winter had been full of exhilarating experiences as the city recreated its self-image from that of a provincial capital of art, to that of a metropolis with global aspirations. Undoubtedly Gorky was part of it. He went to the museum openings, he saw the exhibitions, he was painting with great confidence, and he knew that his work possessed a conviction which was entirely new. It was curious that of all the critics in the city, the only one to appreciate the value of his work on its own terms was a French intellectual longing to return to Europe—but that, after all, was just a matter of luck.

A SECOND SUMMER AT

CROOKED RUN

1944

THE LETTER FROM Mougouch to Jeanne describing Breton's last visit was written from Crooked Run in early May, when Jeanne was in California in her new house on the Yuba river. Gorky had launched himself into his work immediately, and the two women settled back to enjoy what they called their "come lean on my fence" correspondence.

Jeanne wrote saying that Gorky's conversation with Breton fascinated her. She was surprised that Breton had agreed with Arshile about "open windows." She herself knew no one who had left so many open—"and who insists on the 'porte battente.'" By this Jeanne meant the "swing-door" which can open both ways, man to woman or woman to man.

Mougouch replied that what she thought Gorky meant was an opposition to the rationalist approach of modern society, the "attempt to simplify and regularize, thus to bring duty into sexual relations, responsibility in the stultifying, morrally oppresive sense." Gorky did not like to hear too much about female sexuality, or even about emotions, if these werc discussed as if they were a form of mechanism. The attempt to delve deeply into these areas was one of the

things he held against Freud. Gorky was not opposed to the open door, Mougouch wrote, it was just that he would never reveal his emotions as freely as Breton. But then Gorky was hardly aware of his own thought processes. It sometimes frightened her. "Sometimes he seems thoughtless or ruthless but it is because he does not analyse, its pure intuition that he functions on."

There was a lot of truth in this, Jeanne wrote back. Certain subjects—human relationships, for instance—were closed to Gorky, and it was also true that a kind of ruthlessness had emerged in him since his marriage. Or—perhaps a better way of putting it—Gorky had "decided" on certain subjects. He was not prepared to reopen them for further discussion. And of all the subjects about which Jeanne thought Gorky had "decided," the foremost was love.

Gorky had often told her—she wished she could remember the exact words—that "to run after a new love was to find only what you left in the old." Well, this might perhaps be true of someone like Isamu, who "runs after." But it surely could not apply to Breton, could it? Breton, she wrote, was someone who constantly discovered beauty in his journey through life. As he himself might say, "on ne sort pas DU REVE": you do not leave the dream. "I think Breton is one of the most sensuel people I have ever met."

Neither woman was aware of the idea which Gorky had once expressed to Michael West: love follows marriage—love, the opposite of a romantic folly which sacrificed everything in its own pursuit. Nevertheless, sometimes Gorky told Mougouch that marriage "simplified" love. It left one free to get on with other things, without wasting too much time brooding on one's own emotions. At the time, although she was still a young woman and certainly romantic, this idea was exactly what she wanted: the constant presence of affection. She had convinced herself that the lack of expressive affection had marred her childhood. Yet in spite of enjoying what were in retrospect some of the happiest months of her life, she did not doubt, then or later, that Breton's idea of love involved layers of emotion which to Gorky were completely unknown.

Mougouch understood and partly shared Gorky's reservations about the surrealist quest—"the dream," as Breton called it. "Do you think gorky wants to read all of breton?" she wrote. "Not at all one or two phrases are beautiful to him but above all what he likes is breton the beautifully polite MAN who was so nice so much more than polite to encourage him thats all. in fact he dislikes to hear their theories or what happened and what they thought." And maybe Gorky was right to be bored by it all? "Tell me," Mougouch wrote, "do you find you have reactions against surrealism? i do. there are times when the porte battante seems a revolving door. gluey, overstuffed even sometimes pompous."

She had been to see Matta shortly before they left New York, she continued, on the off chance that he would give her *Nadja,* Breton's recent book.

Matta had been "sweet & a good boy," and they had sat down nicely and discussed his ideas. Which were "cockeyed if i may say." He had done some large drawings, very well executed, of "ladies & gents doing push push in a most ungentlemanly way gents masturbating with one hand & slitting a throat with [the] other all v. realistic." She thought that he wanted her to be shocked, but "the realism [. . .] was too graphic to move me." Matta told Mougouch that this was what man was, "a cruel beast quite empty—I felt like saying my dear child but did not."

Breton hated the Matta drawings, she wrote. He thought they looked like scars, "to which Matta says yes but I find scars v. exciting." Matta had told Mougouch that his one desire was to "live in madness." But, as she put it to Jeanne, surely madness could only be creative if it were genuine? One couldn't just choose it like a role, to be "turned on & off like a hot water tap." Matta wanted to be mad, she wrote, "like some girls want long hair."

GORKY, working well in Virginia, was completely unaware of this long, intricate discussion. Deep in the present undergrowth of Crooked Run, or in the tangle of his own memories of his childhood, he had no wish to be disturbed.

The weather grew hotter. The woods flourished. On the ground grew jack-in-the-pulpit and Solomon's seal. The surrounding landscape presented on all sides a fantastic combat between what was neglected and what was cultivated. Fields consisting of a bite taken out of the wood contained clumps of vigorous growth: wild roses, an implosive world of interlacing greenery lit with flowering stars. Truncated trees were overcome with briers and nettles. Dogwood with honeysuckle climbing into it, made tight, self-engrossed tangles.

> it is fantastic the way he starts off. mr byrd or however hes spelt couldnt do more before an expedition to the north. G. must make special stretchers though he has a ton of readymade ones in every conceivable size, special little boxes for oddments that he never uses a great to do about sticks for snakes in special sizes! and then the poison ivy which he treats as an enemy army which must be disarmed and defeated before he can start drawing. o mougouch what a morning i had (great puffing and panting) look at this scar (shows me a little pimple) the most terrible sight i have ever seen. a huge field FULL of poison ivy. i killed it all made a path to walk through. I promise you Jeanne he will probably never go back to that field again this summer he will forget where it is!
>
> he's a juke box. doing the most wonderful paintings again and always such terrific color. . . . he is just using these new drawings as a base, the painting his [has] pushed much further and developed [. . .] he has about 12 canvases some nearly finished though he feels all of them coud be worked on indefinitely as usual.

Arshile Gorky, *The Water of the Flowery Mill*, 1944

For one month during the summer of 1944, Gorky produced paintings for which there are no preparatory studies and for which it is difficult to imagine any having existed. For the first and perhaps only time in his life, his paintings were a natural and spontaneous overflow from the drawings, rather than a performance based on them: performance in the musical rather than the theatrical sense, for Gorky had to learn an image by heart, as a musician learns a score, before he could carry it over, perfectly and intuitively, onto the canvas. He drew all day in the fields and came into the barn to paint, filled to the brim with sunlight and observed details of vegetation. *The Water of the Flowery Mill* is a painting which functions on color and is not "designed" in the same way as the rest of Gorky's work. It is as if the composition grows organically from the center toward the periphery.

In a state of excitement after finishing one of the brighter paintings of that very bright summer, Gorky rushed out of the studio to find someone to show it to. He found Jim Cole, a neighbor who had come up to the farm looking for stray cows. Jim looked at the painting. It was the first time he had ever stood in front of a work of art. Realizing uncomfortably that a comment was expected of him, he turned to Gorky and said, "Flashy, ain't it?"

Many of the subjects are clearly recognizable. *Good Afternoon, Mrs. Lincoln*

depicts the top of Ward Hill Road beyond the hillside east of the studio, seen from a vantage point close to the pump house where Mougouch sat during the day, reading Breton. A farmhand used walk along the crest of Ward Hill Road at night, drunk, weaving his way home and singing. The sound of his voice wafted over the vegetation to Gorky, who was checking the day's work in the barn, or smoking a quiet cigarette on the porch. It brought a dreamy look into his eyes. He "felt the earth as a swell, a bosom, an expansion like a sigh," and tried to carry this feeling into his work. As Mougouch wrote to Ethel Schwabacher many years after Gorky's death, "The aesthetic intention as seen from Gorky's point of view is practically impossible to define. In the first place G himself did not always know what he intended and was as surprised as a stranger at what the drawing became after an hour of work. It seemed to suggest itself to him constantly, the way it does to children."

By midsummer Gorky had temporarily abandoned the fields and retreated to the barn which was his studio. "It is such a wonderful place—around the walls he has his horse bones that we found last summer & hung on a fence to dry—& then these strange old rusty farm implements & bits of machinery & hay ricks. & the pigeons who sit on the rafters & wall of their droppings beneath." The pelvic bones, hung vertically on the wooden walls of the barn, looked as dramatic as the Winged Victory of Samothrace.

After a fortnight working on a couple of paintings which didn't "jell," he went back into the fields. "Gorky has been thrashing over two particular canvases & having now ravaged & worn them down like an angry sea he has left them to go out and draw—draw—draw. Today he is heart broken because the farmer has cut the weeds to let the grass grow for the cows & all looks too park-like for gorky who loved the purple thistles & great milkweeds & ragweeds— Poor dear he always gets slugged—He stood on the hill watching the tractor down in the bottom land moaning 'They are cutting down the Raphaels—' "

AS USUAL their funds were on a downward trajectory, and without a dealer in New York, stuck in Virginia, there was no way for Gorky to earn anything himself. Mougouch was unwilling to borrow from her mother, who had fed and housed them for many months. So in August, during a few weeks when Essie was away and the farm was relatively quiet, Mougouch took a job with a local farmer detasseling corn. "I feel frightfully subdued from working 10 hours a day," she wrote to Jeanne, "but I made $60 in 2 wks. which is more than I ever got for grinding that machine I call my brain! But I hate such physical labor for everything seems dulled except the boredom of those 10 hrs which is sharp as a knife."

Soon after, she discovered she was pregnant: the sharp knife was more than a metaphor. When Essie came back, she insisted that Mougouch take a week

off. So she went up to Cape Cod to visit the Chermayeffs. She came back on Labor Day, in a hot railway carriage where she was unable to find a seat. A few days later, she miscarried. Mr. Nichols, Gorky with Maro in his arms, all rushed around not knowing what to do. It was a "back hills of Virginny touch."

In September her father and her brother, the marine, came to see the farm. John Magruder, Sr., had been promoted to commodore in April. Johnny, meanwhile, after having fought at Tawara and other terrible battles, had been transferred to weapon research. He threatened to come to Crooked Run with a Japanese 75-millimeter field gun. Essie said she had the perfect place for it: over the old ice pit.

Esther, the commodore's other daughter, had married Paul more or less without warning while he was stationed at Langley Field in Virginia, waiting to be sent into action. Her father wrote a touching letter to his son, regretting the fact that she had not waited for a nice church wedding, in her grandmother's white dress, which Essie had carefully saved for her. Of his second son-in-law, "I'll say this for him—which I can't say for the big shaggy Archile—he had enough guts to get into the fight and is a bow gunner on a flying fortress."

Commodore Magruder did his best to come to terms with Gorky. Walking with his daughter several paces behind him along a country road, Commodore

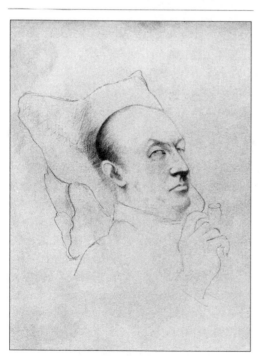

Arshile Gorky, *Portrait of a Man with a Pipe* (Gorky's father-in-law, John Magruder, Sr.), 1944

Magruder broke a long silence with the words "He has no vanity, has he?" Mougouch was touched. It suggested that her father had weighed the pros and cons, and that his instinct to give Gorky the benefit of the doubt had finally won out.

"This really has been a bad luck summer," she wrote after her family had left, "now the weather is queered, rainy, grey or too windy for g. to work outside and this is the time of year he likes best. Pray for good weather he has a lot of work to do yet." He had produced about twenty finished canvases and ten more "in undone stages." But she anticipated turmoil on their return to New York. It was impossible for Gorky to work at Union Square

Gorky drawing in a field at Crooked Run Farm, 1944

now that he had a wife, a daughter on the point of learning to crawl, and a telephone. But they had no money! If they stayed where they were, they'd never sell paintings. Anyway, he couldn't work in the barn in winter. Oh, how complicated. And the curettage she had had to undergo after the miscarriage had put her in debt with her mother. Mougouch hated that. It allowed her parents to think that her thoughtlessness and extravagance were luxuries for which they, in the end, would have to pay.

They had been offered a studio in Connecticut by Jean Hebbeln. The question was, would Gorky want to move away from New York so soon? There were people he had to see—Pierre Matisse, for one. What would New York make of his new paintings? It was hard enough to imagine Jeanne's reaction to the new work, let alone that of the New York dealers. "There are two which he made the day your last letter came, he was so happy about the way you felt when you saw your own painting in the museum"—Jeanne had just given a Gorky painting to the San Francisco Museum of Modern Art—"and all the things you said both of us felt so nice after reading your letter, so warm inside and he ran to the barn and out came two canvases which i know or at least to me are the best of the lot very strong but subtle in color, transparent color and very true color not at all art colors."

Gorky paid no attention to these worries and went on working as if he were going to stay there forever. "He is sitting perched on his stool out on the side of the hill, sitting for hours without seeming to move, rooted, his drawing board held by one arm in front of him. he has been there since 10 this morning it is now 5. I wonder sometimes if he is not dreadfully lonely out there facing all the glorious red and gold world. To me from here he looks so poignantly determined—it is him against that—Really it looks so."

They stayed until November. They ought to be back in New York, she wrote, but Gorky was still hard at work and had just started a huge canvas, almost the size of *The Liver Is the Cock's Comb*. "He must feel like a bonfire inside to tackle it." She herself was just thinking of a new house where they could all settle down, Jeanne included, but Gorky was working all day, in spite of the weather. If it rained, he drew indoors. "When he draws from memory at night or on rainy days the drawing is perhaps more bold but tends to be more ART you know what I mean, There is less truth, though often it makes a finer drawing it is less interesting especially for him." Far from tying him down, drawing from reality freed his fantasy from the temptation to pursue an ever more perfect execution of a composition long since hardened by repetition.

When they finally left, Gorky's harvest included more than twenty paintings and numerous drawings. The seven months from April to November 1944 represent the core of his maturity, the most free work of his career, the closest in spirit to the abstract expressionist idea of spontaneous creation on canvas, though there was nothing unpremeditated in the way Gorky worked.

BACK IN NEW YORK, their lives were complicated still further by an English sheepdog, given to them by Jean Hebbeln. The dog was christened Zango, after a much loved dog Gorky used to own as a child in Khorkom. He was only a puppy but he grew like mad.

They found the mood of the city even more exciting than when they had left. Somehow, Gorky's reputation had grown. "Now if we go to an opening every body is so nice to us, they all come and say hello and speak so flatteringly to us even to me and I wonder if they don't see the goosepimples on my neck for two years ago we would stand like two toadstools in a field of mushrooms, so inedible to them. And gorky looks bewildered and says really has my painting changed that much, it has not. An ugly business and gorky can hardly be called a success yet, but people it seems are talking."

Because of Breton's enthusiasm for his work, Gorky was already seen by his colleagues as belonging to the surrealist group. Though this was useful on one level, an element of danger was involved. By now a certain gap existed between the French visitors and the New Yorkers. Willem de Kooning, who

lived outside the frontier of the surrealists, referred to Breton sardonically as "Mr. God." He once caught sight of Breton in the street and followed him for a while. Suddenly a series of agonized spasms came over the great man. Just imagine, de Kooning said, making it into a funny story—André Breton, fighting off a butterfly.

Actually, Breton liked butterflies. He was probably trying to catch it.

Breton could so easily have accepted with good grace the surrealist credentials of the new wave of American painting. He could have assumed the role of a general during a revolt of the troops and said: You are right—let me place myself at your head. That he made no effort to do so was probably a consequence of his refusal to speak English—in itself an indication of his obstinate refusal to pay attention to the culture by which he was surrounded. As a result, for many years after the war the new American art was made to appear much more autonomous than it really was. Only now, in the post–Cold War era, is the surrealist influence on American art finally receiving acknowledgment.

Breton was not the only French intellectual in exile who assumed a standoffish pose. When the writer Simone de Beauvoir came to New York two years later, she was shocked by their attitude. "They do not want to mingle with Americans, but look down on them from the summit of the civilization with feelings of superiority and humiliation. Or else they crawl to them while consoling themselves with a feeling of certainty about their own finesse and culture."

Gorky tacitly encouraged the impression that he was now "with" the surrealists by his reluctance to share his new work and new ideas with old friends, such as de Kooning. He did not want to be worshiped every inch of the way. "De Kooning always followed him, to a point where, during one period, Gorky wouldn't even talk to de Kooning because he took his ideas," as Aristodemos Kaldis put it.

Mougouch realized what was happening, but she defended Gorky. Friends, she wrote to Jeanne, were not what he needed at that moment. "Gorky has spent years building up the proper defense about just this & its one very big reason why the country suits him so—there's no temptation to give in— remember Gorky's story about Uccello & the painting he had worked on for six years never showing it to anyone then his freind Donatello put a ladder to his studio window & peeked & the poor Uccello left the city for 12 years—well so it is." The man on the ladder outside Gorky's window was de Kooning.

It was only thanks to Gorky's friends that one or two people managed to beat a path to his door. Peggy Guggenheim, brought to the studio by David Hare, bought the largest canvas of the summer, the one which Mougouch had described as having been started at the last possible minute. It was painted in a few hours, one of a series of thin, linear paintings made after the summer. Gorky was unsure whether it needed more work.

Arshile Gorky, untitled, 1944. This painting was bought by Peggy Guggenheim soon after completion.

David Hare told them privately that he and Jacqueline, Breton's ex-wife, were going to Mexico early the following year. Would they like to borrow his house in Roxbury, Connecticut, for a few months? It had a large studio. He would let them have it for free if they promised to be out by the summer. They immediately accepted.

Soon after Peggy Guggenheim had bought her painting, Pollock came to the studio. As Mougouch wrote to Jeanne, he "weaved in here yesterday to talk to gorky as a painter. You can imagine how that took. Then he insisted on using four letter words while gorky got greener and greener. He was drunk and I must say I was rather surprised for he seemed to lack any sensibility at all, sort of foolish he was." Pollock's persona is supposed to have been spontaneous and uncalculating, but his arrival in Gorky's studio so soon after Guggenheim's purchase suggests that he wanted to warn Gorky off. She was to be Pollock's dealer, and that was it! The warning took, and Peggy Guggenheim never bought another work by Gorky or took any further interest in his career.

Six months later, at a studio party on Broadway and Eighth Street, Pollock annoyed Gorky so much that Gorky shouted, "I am going to throw you out of

the window." They had to restrain him, "or Pollock would have gotten hurt."

Matta came and bought a drawing, having recently found a new love who had "denghi," as Mougouch put it. At this point Matta was moving out of New York to an artists' colony at Snedens Landing, up the Hudson, where he and his new wife Patricia made such an innocently enthusiastic impression that they were nicknamed "the babes in the wood."

Mougouch invited the author Grace Stone and her daughter Eleanor to supper, ostensibly to ask for advice about a writing career for herself. Mrs. Stone's husband had been to the Naval Academy together with Commodore Magruder. As it happened, Eleanor was working for the dealer Julien Levy, and she was stunned by the new paintings which Gorky showed them. She rushed back, "longing to impress Julien with my keen eye as a talent scout," as she put it. Levy's answer "was a chilling 'For heaven's sake, Eleanor, Gorky has been around for years and I assure you he is of no interest'—or words to that effect."

Not long after Eleanor's visit, Julien Levy changed his mind. Probably Breton's recommendation was decisive. Levy had just lost Max Ernst, who had gone over to the Dudensing Gallery at the suggestion of Peggy Guggenheim. No longer a central actor in the surrealist world, Levy wanted to keep up his relationship with Breton.

He confirmed his arrangement with Gorky in a letter dated December 20, 1944. Gorky would receive a monthly check of $175 in return for twelve paintings and thirty drawings per year, with emphasis on his most recent work. The sum involved compares favorably with the $150 which Peggy Guggenheim was paying Jackson Pollock at the time. A check for $350 accompanied the letter, as Gorky was short of money. The gallery would pay "all the general overhead," including a mailing list requiring postage not exceeding $40. The artist would pay for "anything more elaborate" in the way of advertisements, cocktail party for the opening, etc. The contract was to run for a year.

There was a curious last paragraph: "When I lent you money years ago, it was certainly because I believed in your future and now I hope my belief will be justified." It was a tactful reminder that Gorky was already in Levy's debt, even before they had started.

Breton promised to write an introduction to his first show at the Julien Levy Gallery. Offstage voices warned them of the risks involved. "Everyone insists on telling us about Breton and his desire for power as though they would warn us but we feel safe because Gorky cannot speak french and we can never get too close [. . .] You know they are so merciless these surrealists, you fall from grace so suddenly, it is rather frightening." According to Levy, Gorky "was actually overwhelmed with joy at being accepted in a circle of peers, these European artists who were here and now, since the beginning of the forties, in America instead of being giants in a foreign land."

• • •

AT THE END of the year, about a week after the contract was signed, Breton settled down with Gorky and Mougouch to help find names for the paintings which Levy was to exhibit. The naming of a work was always an important ritual in the eyes of the surrealists, a spectacle which often took place in public. This, instead, was a private occasion. As with all his dealings with Gorky, Breton was extremely considerate.

Gorky put only one work on the easel at a time, and as Breton and Mougouch looked at it, he talked. Now and again, without interrupting, Breton made a sign to Mougouch and she wrote down the last phrase which Gorky had spoken. One title emerged immediately: *The Leaf of the Artichoke Is an Owl*." Breton remembered it from his first visit to the studio, and he probably had it in mind before they even started. It was an example of what they should be looking for.

The titles they discovered are not descriptions of the works so much as fragments culled from a continuous flow of words. The animism of Gorky's mind—the clouds with figures in them, the bowing trees—meant that the words he spoke were a fuel, or an inner excitement which built up as he worked. It could begin and end anywhere.

Breton understood that Gorky's mind worked in metaphors. The question was how to grasp the right one. *The Liver Is the Cock's Comb* is a title which runs parallel to a fragment from the text written for Dorothy Miller: "My liver is sick with the purple." The liver is an organ which, in a strong man, is red, not white. Not "lily-livered" or "milk-livered." "The song of the red cardinal" is an association of color with power, of color with sound. The painting called *The Liver Is the Cock's Comb* is a landscape, but a landscape turned inside out, and the viscera of the undergrowth has animal connotations.

The title *The Liver Is the Cock's Comb* is a simile from which the word "like" has been removed. Gorky's metaphors, however, were found instinctively, not derived as if they were clues in a crossword puzzle. *The Water of the Flowery Mill* was not a conscious pun, even though Julien Levy in his book on Gorky suggests as much. Gorky did not play those kinds of games. At Crooked Run, he overheard someone say, "Oh, it used to be a flour mill"—the ruins near the bridge where the postman found him "inventing"—and to his ear there was no difference between "flour" and "flower."

Breton attuned Gorky's inner ear to possible material for a title, and it did not take long for him to get the message. Breton's insistence that he should name his own paintings from fragments of his own inner reverie, rather than from quotations from books, helped Gorky to establish a link between what he thought and what he painted. For decades, after all, his thoughts had centered on Khorkom, but his hand had said Picasso or Cézanne.

Good Afternoon, Mrs. Lincoln. The trees bowing one to another, doffing their hats, just as Courbet's friend doffs his hat to him in *Bonjour, Monsieur Courbet*. And, of course, Lincoln was the village in Virginia, not the President's wife.

While relaxing over coffee between naming sessions, Breton talked about the nineteenth-century economist Charles Fourier, whose books he had just rediscovered. Gorky would love him, he said. Such charmingly bizarre ideas. For instance, that vegetables should be grown at waist height so as to save the effort of bending down to pick them! Thinking about Fourier, and thinking about Gorky, Breton saw a strange connection. Both thought of themselves as literal-minded men, completely unaware that their ideas had the zaniest of connections with the things of this world. But then, to Breton, there was no such thing as reality. Only "the dream" had substance.

ROXBURY

1945

TWO DAYS INTO 1945, Gorky and his family took the train out of Grand Central Station for Roxbury to move into David Hare's house. Excitement ran high. The dog Zango went mad at the ticket counter and dragged Mougouch in an old fur coat of her mother's along the whole length of the rotunda, clutching Maro in her arms. Gorky, laughing, ran behind with the luggage.

As soon as they arrived, they were snowed in. Sandy Calder, looking like Father Christmas, appeared the next morning to see how they were, bringing some groceries with him. That afternoon Gorky took Maro down to the stores in an improvised sled he'd made out of an old hamper with runners.

David Hare's house was a white clapboard farmhouse set fifteen yards back from the side of Good Hill Road—which Gorky, with his usual imprecision about names, called Good Hope Road when he used the name as a title for a painting later in the year. The house was slightly claustrophobic, with low ceilings on the ground floor and chintz curtains. Leather-bound books inherited from grandparents stood on the shelves, and the ancestral furniture was delicate.

The studio, some fifty yards from the house and away from the road, was new and filled with Hare's equipment: pulleys for sculptures, arc lamps for

photography, lathes and welding machines distributed across a cement floor. The studio window looked out onto the flank of a wood a hundred yards further on, whence the trees and scrub descended into the valley in a series of gentle ridges. Gorky never made drawings from the landscape at Roxbury, however. He kept to the studio, cleared an area of clutter, hung on the wall old bones and dried milkweed he'd brought back with him from Virginia, chose the drawing from which he wanted to work, pinned it to his drawing board, and started.

HIS FIRST ONE-MAN SHOW with Julien Levy opened on March 6, 1945.

Breton had advised Levy to frame just two paintings in rich, elaborate frames mounted on easels, and to leave those hanging on the walls with simple strips of wood, like those Gorky often applied himself in order to protect the edges of his canvases. Instead, Levy framed everything in a uniform "salmon pink bizness," as Mougouch put it when she wrote to Jeanne. Breton had no difficulty in telling Levy that he did not like the way he had hung the exhibition, so that was "a new swords point."

Julien Levy would not accept advice from anyone when it came to hanging a show, not even from André Breton. His feelings of self-satisfaction, his sense that a whole exhibition was his own personal achievement, "spread to the color of the walls, the choice of the artist and the pieces shown, the exact placing of each hanging, the lighting, the design of the announcement [. . .] This feeling even somehow spread to the pictures themselves until I could almost believe I had participated in them too. This proprietary pleasure was never to leave me, nor the troublesome conflicts that sometimes arose from such solipsist fantasies." In his book of memoirs, Levy is surprisingly open about the possessiveness he felt toward "his" artists. "My vanity would like to say I discovered the artists I chose," he writes, bizarrely adding—"who of course were physically first discovered, one supposes, by their mothers, by midwives, or by obstetricians."

None of Gorky's old friends came to the opening night. If they saw the show, they came later. When Gorky and Mougouch arrived, they found Breton, Levy, and perhaps half a dozen others. Duchamp stood in a corner, benign as usual and free from worldly anxieties. Breton said ponderously that though the audience was very small, it was very distinguished. Julien Levy told Gorky that the critics who had come to the press preview earlier in the day were "stonier and more unresponsive than he had ever known them." He had encountered "a kind of blind opposition he had never in his career come up against." Essie told Levy in a loud voice that he hadn't hung ANY of the best paintings. Serge Chermayeff liked the paintings, he told Gorky, but not the titles. And the frames were terrible. Seeing the thin crowd, somebody asked

when the invitations had been sent out, and it emerged that they had been posted late. Gorky turned to a jug of martinis provided by his patron from Philadelphia, Bernard Davis, and soon acquired the wild-eyed, unkempt look that Mougouch remembered from their San Francisco "bouts."

These were the usual nerves of an opening night. But the mood was respectful. Pierre Matisse came over and invited them to supper the following evening. They decided to stay on in New York. Mougouch sold a diamond pin, her only piece of jewelry from her grandmother, insured for $3,000 though they gave her only $60 for it. The Union Square studio had been rented, as they needed the extra money. They spent the next few days at a hotel.

The next day Gorky took Maro to the Metropolitan Museum, where she waved at the Egyptian mummies, and on, down to Fifty-seventh Street, perched on his shoulders. At the foot of the stairs going up to the Julien Levy Gallery, he found three gods of the museum world: James Johnson Sweeney, Alfred Barr, and James Thrall Soby. The elevator was broken and they were grumbling at the prospect of having to climb four flights of stairs. Gorky did not dare follow them up. In the gallery, the mood of the three officials was magnanimous. Soby and Sweeney wanted two paintings each; Barr said he wanted a couple of drawings. They all decided to come back later to confirm their selections.

Sweeney had already asked Levy to keep back some paintings for an exhibition he was planning, to be called "Unrecognized or Misunderstood Artists—or some such rubbish." Levy obliged, but Gorky refused to take part in such an exhibition. Confusion! Mougouch wondered if it wouldn't have been better to sell these paintings immediately and give Sweeney others. Who knew when Soby and Barr would return? In the event, Barr took one painting to the Museum of Modern Art for his purchasing committee to vote on, and returned it unbought. The others bought nothing.

That evening Breton took them out to supper at the house of Bernard Reis. Many surrealists were present, some of whom were not on speaking terms with others. A good surrealist evening, the English surrealist Bill Hayter once remarked, had to include two distinguished personages in opposite corners of the room, ignoring each other "with gestures of indescribable nobility." On this occasion, Breton cornered Kurt Seligmann and they "waved their pipes and pranced at each other." Gorky, oblivious to the tensions, entertained his hostess with stories of what little Maro had said to the mummies at the Metropolitan that afternoon.

At Pierre Matisse's supper the next day, Gorky and Mougouch were impressed by the beauty of the paintings hanging on the walls. The company consisted of the same people as the day before. Matisse told Jacqueline Breton, André's former wife, who told Jeanne, who told Mougouch, how much he had

liked Gorky's work, and how sorry he was that he could not take him on at his already crowded gallery. So that was that.

BRETON'S INTRODUCTION to Gorky's show is perhaps the best short piece ever written about him. Unfortunately, the gulf between the English and French languages creates difficulties. The text retains a rhetorical flavor that does not quite come off in English.

Breton understood that in spite of his erudition, Gorky was a natural painter. He had arrived at his command of the medium not by will or intellectual ability but by instinct. He was, as Breton put it, "the first to whom the secret has been revealed." Breton, himself a supreme intellectual, held a profound respect for natural gifts. In many ways, he respected talent more than intelligence.

His second insight was that Gorky's mind functioned by "analogy." Breton used the word precisely, referring to the kind of philosophical testing of the world which, in lieu of logical analysis, presents parallels of association. Instead of saying "this is," you say "this is like." It is a habit of mind which has an ancient and interesting history, beginning with the Greek thinkers and continuing, in Breton's day, through Saussure, a philosopher whom he knew personally. From his conversations with Gorky, Breton learned that Gorky's feeling for certain rhythms in the landscape was more than a feeling for design: it was an alternative reality, as valid as any analysis based on observation. Breton saw that to Gorky, the landscape was a continuous conversation, which had begun when he was a child in Khorkom and never stopped, and that to him, the visual and the aural narratives were inseparable.

The third feature which Breton emphasized was the fact that Gorky still needed to draw from nature. I suspect this must have been a source of incredulous private amusement between Breton and Matta, for both men were convinced that the future of art lay within the mind of the artist, and that the age-old habit of setting up all that paraphernalia in the open air had to be abandoned. It was almost an article of faith on their part that drawing from reality was dead. Matta and Breton could so easily have assumed a condescending attitude toward Gorky on this point. But they didn't. They saw that for him, it worked, and they were careful never to question the way his mind functioned.

Breton's introduction began with an exegesis on the ideas of Charles Fourier. Like James Johnson Sweeney in his emphasis on the minute observation of grasses in Gorky's work, Fourier offered Breton a chance to build a bridge across the gulf which separated Gorky from a sympathetic American audience. Fourier was a hero of the Brook Farm experiment, that early venture into an alternative way of life, a paradigm for all such movements which have

taken place in America since then. Did no one tell Breton about Brook Farm, or Emerson, or Hawthorne, or Thoreau, or American Transcendentalism? These figures are such an essential part of the American psyche that it is hard to imagine Breton spending five years in the United States without ever coming across them. Perhaps he found the East Coast version of Fourier's ideas boring and provincial? Perhaps he was more interested in claiming Gorky for France, rather than in using this chance to bring both Gorky and himself closer to America? And so another opportunity to claim Gorky on behalf of America was missed.

BACK IN ROXBURY, Gorky waited for word from the critics, about whose visit Levy had been so pessimistic.

Gorky had not exhibited in New York for many years, and those critics who knew his work still associated his name with the Newark Airport murals. "Generally," wrote the critic of the *Herald Tribune*, "Gorky is remembered in relation to designs of considerable strength and formality which have been incorporated in several large mural compositions." These new works represented too much of a contrast with the murals of almost a decade previously. They were a shock.

Edward Alden Jewell in the *New York Times* took the same slightly puzzled line, but he was amenable to complex ideas and willing to put them into a language which a larger public could accept. "Gone are the larger, bolder forms; forms that were clearly defined and, if related, detached. The expression now is fluid and lyrical, loosely weaving all-over designs that are intricate, spontaneous, in the nature of improvisations. The gay warmth of his palette is like a flood of sunshine."

Maude Riley in the *Art Digest* was irritated by André Breton's introduction, and wrote that those who looked at these works "will be confused by Breton's attribution of profundity to paintings by an artist who rejects all intellectual recognition of subject and loses his un-literary compulsions in a debauch of emotionalism." Gorky's works were "incoherent 'accident' paintings (and don't try to deny this because a good percentage of the areas of his new paintings are running drips of turpentine)." One could see that Gorky "agonizes quite a lot, emotionally." But the success of his paintings depended on the onlooker's response to such emotion, not to the actual content of the works themselves. "They go from the pictures to their own pack of sensitivities. And if nothing happens, that painting dies on the vine for them."

Of this review or one like it, Jeanne wrote back to Mougouch, "They are incapable of making the emotional response." There is a certain amount of truth in this, as if the critics' first reaction to these works had been to shy away.

Though the paintings today seem controlled, almost classical, at this first exhibition they seemed raw and abrasive, and the idiom of free paint was not yet so current that liquid washes could appear to be anything more than "accidents."

One critic took the bull by the horns: Clement Greenberg.

No one could deny Gorky's talent, he wrote. The question was whether or not his long subjection to Picasso and Miró meant that he lacked "masculinity of character." A year or so back, he had abandoned these masters in order to follow early Kandinsky and "that prince of comic-strippers," Matta. The change made his work "less serious and less powerful and emphasizes the dependent nature of his inspiration." Kandinsky had solved Kandinsky's problems. The biomorphism of recent surrealist work had been "confined since Odilon Redon to the academic basement." In other words, "Gorky has at last taken the easy way out—corrupted perhaps by the worldly success of the surrealists."

"Perhaps Gorky was meant to be charming all along; perhaps this is his true self and his true level; perhaps he should have pastured his imagination in the surrealist meadow long before this; perhaps his 'corruption' was inevitable." And yet—one last hopeful paragraph after five devastating ones—Gorky was able to make much more of biomorphism than Matta had so far been able to do. Gorky continued to show promise. The painting called *They Will Take My Island,* for instance, showed a "partial return to serious painting." It was not a strong work. It made concessions to charm. But it was "a genuine contemporary work of art."

Someone sent this criticism on to Jeanne in California. She wrote to Mougouch that it made her "blood boil" to read it. The only thing that had calmed her down was the memory that she had "met this young man and the impression at the time was that Arshile would not listen to one word he had to say about painting in general [. . .] so why in gods name need one take seriously what he says?"

Jeanne was not present at an actual fight between Clement Greenberg and Gorky, but such a fight did occur. The story was told by Greenberg himself. Maddened by Greenberg's monopoly of a discussion at the New School for Social Research one day, Gorky had met him outside as they were leaving, had thrown down a piece of chalk on the pavement in front of him and said, Draw! The message being that if Greenberg could draw, he could talk. If not, then he should forever keep his opinion to himself and not bother real artists when they discussed the profession they so painfully pursued.

A FORTNIGHT AFTER the exhibition opened, Breton and Elisa, his new love, went up to Roxbury to spend the weekend with the Gorkys. Spring had

not yet brought buds to the trees but the weather was sunny. They walked in the woods, and Elisa took a photo of Breton and Gorky with Maro on her father's shoulders. Easily, ornamentally, Breton leans on a garden fork as if it were a classical pedestal.

Breton told them that he was delighted to have finished his broadcasts for the radio. The war in Europe was coming to an end. "Revolutionary activity recommences," he told them. "No more coalition." The implication was that after the war, the coalition between Resistance groups would cease and the authority of the French Communist party on left-wing activities must be challenged.

He asked Gorky to illustrate a book of poems he was about to bring out: *Young Cherry Trees Secured Against Hares*. No secret message intended, wrote Mougouch, even though Jacqueline, Breton's estranged but not yet divorced wife, was now in love with David Hare, the owner of the house where Gorky and his family were living. The task took Gorky about a fortnight and "$100 worth of paper," as Mougouch put it. He labored "until he was satisfied or worn out—I never know which."

A few months previously, Breton had met the philosopher Jean-Paul Sartre in New York. Sartre warned Breton about the increasing authority of the Communist party in cultural matters back in France. A National Committee of Writers had been created, and Louis Aragon was its dominant figure. Aragon was a former surrealist, but he and Breton had broken violently many years before, partly because Aragon remained unquestioningly loyal to Stalin. Sartre said that when he returned to Paris, Breton should take care not to be too critical of Aragon or his writings. There was a risk, he said without smiling, of "not waking up the next morning."

Although Breton believed that art and politics should be confronted separately, his politics were always courageous. In the last months of his stay in

André Breton, Gorky, and Maro in Roxbury, Connecticut, March 1945

America, he made up his mind to
challenge the influence of the Stalin-
ists as soon as he returned to France.
Though he did not say as much, there
was a political angle to his desire to
bring Gorky to France. The surrealist
movement needed new heroes with
which to reassert its claim to the cul-
tural leadership of Paris.

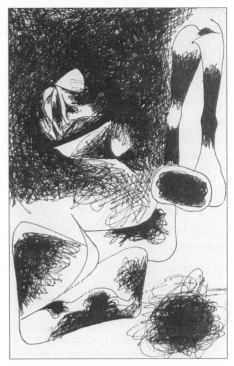

Gorky's politics were very simple,
and he never changed. When, during
the summer, he received another
questionnaire from the Museum of
Modern Art, one of the questions was
"What in your ancestry, nationality
or background do you consider rele-
vant to an understanding of your
art?" Gorky replied, "Perhaps the fact
that I was taken away from my little
village when I was five years old yet
all my vital memories are of these first

Arshile Gorky, *Nude*, 1945

years. These were the days when I
smelled the bread, I saw my first red poppy, the moon, the innocent seeing.
Since then these memories have become iconography, the shapes even the
colors: millstone, red earth, yellow wheatfield, apricots etc." In reply to a com-
plicated five-line question about the artist's views on politics/sociology/phi-
losophy, Gorky put one word: "Liberty."

CONNECTICUT WAS MORE in touch with Manhattan than Virginia
had been, and various artists whom Gorky admired lived in the immediate
neighborhood.

Sometimes they went over to have dinner with Kay and Yves Tanguy. As
Gorky spoke no French and Tanguy spoke no English, they just smiled and
made gestures at each other. Mougouch told Jeanne that they were "killing
together & very fond of each other really." The house was oddly conventional
for such an eccentric man. Half modern, half antique, it included peculiar
bourgeois touches, such as a low table covered neatly with the latest maga-
zines. Tanguy's studio was as clean as a dentist's consulting room. Gorky
thought it was beautiful. Their life was quiet, and Tanguy delivered his works
to Pierre Matisse at regular intervals. Compared with the Gorkys, the Tanguys
were the grown-ups and they the children.

They also saw quite a lot of the Calders. Maro, who was almost two years old and able to walk by now, was fascinated by the Calder children, who sat on the paths eating pebbles, like turkeys. They had a dollhouse so large they could get into it, filled with objects made by their father. Sandy was a perfect daddy. There was some confusion in her mind between Sandy and Santa Claus.

Calder invited them to parties, brought visitors to see Gorky's work, lent them household equipment they might be lacking, and gave them vegetables from his kitchen garden. Gorky thought Calder's invention of thin, floating lines in the air was beautiful, and something of Calder's fragility can be seen in the linear paintings Gorky made during that summer. Though grateful for his generosity, however, Gorky was suspicious of the ease with which Calder moved through the many levels of American life. Calder possessed a light touch in dealing with the world. He once left a mobile hanging on the mantelpiece of Dorothy Miller for several years, as if absentmindedly, and then told her that, oh well, she had better keep it. His jewelry was made to be given away, and the wives of artists and museum directors would recognize each other in elevators as they rose to attend a gallery opening, as if belonging to an exotic tribe whose chief, present or absent at the time, was Sandy Calder.

When, years later, he was asked how he felt about Gorky, Calder deftly turned away the question. "He seemed a little bit unhappy," he said. "Maybe it was his mustache. But I had a mustache once and I don't think I was unhappy." A remark somewhat similar to one Calder made about Duchamp: "I was always very fond of Marcel, he was very clever at keeping his weight down which I admire, but do not emulate."

In black moods, Gorky viewed Calder's largesse as calculation. His doubts were shared by Isamu Noguchi, who remembered how he had suffered in Paris in the twenties. There, Calder had found an immediate audience for his sculptures; Noguchi had not. "I resented him very much because I had done a similar sort of thing and had given up because I was very poor, I had to make a living. Sandy, somehow, whether he was or wasn't rich, was able to get away with it. So I didn't like him at all."

In short, they were jealous.

EARLY IN THE SUMMER, Gorky wrote to Vartoosh. It was the first letter he had written in Armenian, he said, for two years. There was much to tell. He described the exhibition. "That sweet man mister Davis paid for the refreshments on the day my exhibition opened. mister Levi sold seven paintings from the exhibition." Agnes was to have a baby in August and her mother was coming here for the summer until Agnes had returned safely from the hospital. How was everyone in the family? He wanted to know. Vartoosh should write to him immediately.

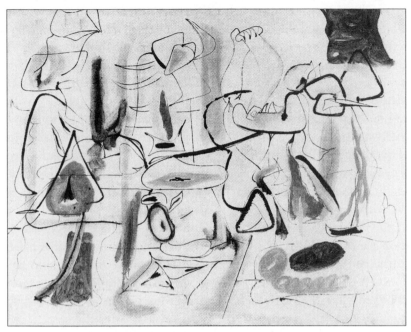

Arshile Gorky, *They Will Take My Island*, 1944

It was not true that Julien Levy had sold seven paintings. He had sold two: one to Wolf Schwabacher and one to Jeanne Reynal. The lie was aimed at reassuring Vartoosh.

Jeanne bought *They Will Take My Island,* the painting which Greenberg had singled out for praise. Mougouch had to choose it for her, as she was still in California. There is an apologetic reference to the "mail order" aspect of the purchase. It was shipped out to Jeanne and was hanging on the wall of her house on the Yuba River when Breton and Elisa stayed with her later that summer.

Of the nine paintings shown at Levy's gallery, *They Will Take My Island* was the odd one out. The others were more free, more wild, including the magnificent work, now in the Metropolitan, *The Water of the Flowery Mill*. Like the other critics, Greenberg expressed doubts about the wilder paintings. When Gorky resumed painting, he chose *They Will Take My Island* as the paradigm for his new work. The choice may have been one of climate and environment, Connecticut being cooler in atmosphere than Virginia. Or maybe Gorky actually listened to the critics and tried to create a series based on the paintings they had preferred in his first show at the Levy Gallery. "Dont for one minute think the critics didnt trouble gorky," Mougouch wrote. "for two months he was paralysed and agonized in a fever of self-criticism brought on by the suicidal attempt to see himself as others see him."

In thanking Gorky for her painting, Jeanne found a subtle phrase: "the

dark line like a pencil line yet in paint overlayeing describing another dimension another thought." In David Hare's studio, as Gorky worked from drawings from the landscape of Virginia or added to the drawings by making new, rarefied distillations of them, the presence of the landscape in his paintings becomes more conceptual, more remote. Virginia reminded him of Armenia. Here in Connecticut, both places became landscapes of the mind.

MOUGOUCH DELIVERED the drawings for *Young Cherry Trees* to Breton in New York. He gave her lunch. Afterward, as she watched him walk across the street, a wave of compassion came over her. She thought he looked old and tired, "his head is so lionlike so much suffering and pride."

When she got back on the Sunday, she took to her bed with what threatened to be another miscarriage. On Monday, David Hare's mother arrived to take on the unusual task of hiding all the precious furniture in the barn, away from the depredations of his mother-in-law. David was about to divorce his wife, Suzy. The next morning, Gorky answered the doorbell at eight in the morning and found himself facing President Roosevelt's secretary of labor, the formidable Frances Perkins—Hare's mother-in-law. She was not alone. A large truck was with her, which proceeded to back up to the front door in such a way that nobody could leave the house without stepping into it. She then tried to empty the house of all the property she thought belonged to her daughter.

Mougouch, in her bed, had with her under the sheets sundry articles of value which her advanced state of pregnancy was supposed to protect. Indeed, Mrs. Perkins "kept barging in to glare with her gimlet eyes under my bed or in my face for a tell tale expression," but this shaker of trade unions did not quite dare to rummage around in occupied sheets.

Gorky, eating oatmeal downstairs, almost had the bowl snatched from his hands by one of the moving men. A mosaic which Jeanne Reynal had given him was stacked in the van before he could save it, and it had to be returned later by special messenger. In short, the place was sacked. "Better proof of Marx's concept of marriage in the capitalist world," wrote Mougouch with satisfaction, "I can't imagine."

FOR A COUPLE OF MONTHS after he had recovered from the exhibition, Gorky worked intensely. Taking his cue from Greenberg's remarks about *They Will Take My Island,* Gorky produced more than a dozen thin, floating canvases which were evidently painted in a matter of hours, at the most. But he also worked on a number of more labored canvases, only one of which, unfortunately, has survived.

By the summer, his daughter was walking well, and she was allowed to come into the studio to mess around with a paintbrush on the back of the canvas as

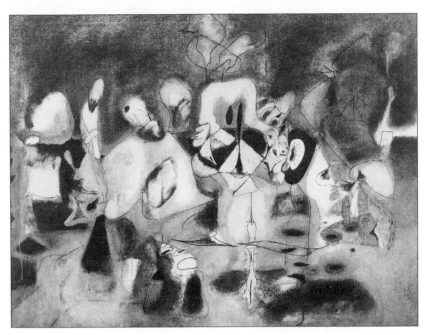

Arshile Gorky, *Diary of a Seducer,* 1945. This is the sole survivor of a series of heavily worked canvases from the summer of 1945.

he was working. There came the time, however, when she wanted to sneak around to the front and help him there, whereupon the studio door opened and a small child sailed through the air, to land in the heavy grass, bawling.

One fine day Gorky decided to take Maro out in a little two-wheeled cart he had made and go for a walk in the fields. She was in an imperious mood. Faced with a field of flowers, she told him to pick them all. "Dat," she said, pointing, and again, "dat." Gorky came back to the house in something like a panic. "She picks and picks and picks." There was no limit to her appetite! "She has holes in her eyes."

THE ARRANGEMENT WITH David Hare had been that they would move out at the beginning of the summer. Out of consideration for the fact that Mougouch was about to give birth, he allowed them another month. Jean Hebbeln and her husband Henry were converting an old farmhouse and barn on a property they had bought at Sherman, some fifteen miles distant. The plan was to rent or lend it to the Gorky family, but unfortunately it was not yet finished. For the moment they would just have to move in with the Hebbelns.

The Hebbeln house consisted of two small buildings linked by a new patio, which was to serve as a communal sitting room for both families. There was a hill behind, "with waterfalls and hemlocks all to Gorkys delight." They would

be a bit squashed, wrote Mougouch, but really there wasn't much choice. Gorky was painting, and the last thing he wanted to do was look for houses. "Gorky is working so hard and too long of course like penelope he goes back to the studio at night and overdoes all his paintings till I could scream with rage how tiresome and how utterly insane he is to do the same thing every year."

DURING THE SUMMER, Mougouch had asked Jeanne to take care of Breton and Elisa in Reno while they were waiting for his divorce from Jacqueline to come through. Jeanne immediately agreed. Taking care of such a man was a daunting prospect, but in some ways he was easy to handle. What he really liked doing, it seemed, was walking across the desert wastes slowly, his head bent forward, examining the ground for interesting agates and crystals. Within a day of their arrival, he had collected dozens. So Jeanne took them to Lake Tahoe, where Breton collected pebbles on the beach. They searched for agates on the dumps at Silver City, and they collected natural glass in the desert.

Breton assured Jeanne that it would be a good thing for Gorky to go to France. He was certain to find a sympathetic audience there. Gorky had achieved something new. In Paris, as far as one could tell from the reproductions in art magazines, there was only a useless repetition of things already known.

Breton loathed small talk. Jeanne, though she did her best, found she couldn't always keep the conversation going "on grand lines." In order to talk about philosophy, one had to have read something about it first. She felt she was not up to his level, though he was "patient with much of the dribble." Mougouch replied that she felt much the same way about Breton. As if, in spite of his sweetness, he needed to communicate on a higher plane than she or Gorky were capable of reaching. "Somehow when we see Andre we do not really talk much. I am a little afraid to and you know Gorky doesnt really like to get philosophical."

After André and Elisa had left, Jeanne and Urban were so relieved that they drove straight out into the desert along a little-used track. They forgot to tell anyone where they were going. It was a crazy thing to have done, wrote Jeanne. They could have run out of gas and simply perished there, out in the middle of nowhere. Really, California was so empty and remote. It was about time she came back to New York.

ON AUGUST 8 Mougouch gave birth to her second daughter in the hospital in Waterbury. She had long black hair and Gorky called her "my little pine tree."

While Mougouch lay there "milking" the baby, as Gorky put it, the atomic bomb was dropped on Hiroshima and an unquiet peace descended on the world once more. "Imagine the horror irony of lying in a maternity ward with every denomination of humanity & their little ones & hearing & reading of the

atomic bomb—Sometimes I feel we are dinosaurs indeed there is another world where men breathe & breed disaster & death. One wants to grip life by the scruff of the neck and assert its reality."

Yves Tanguy came to see her in the hospital bringing a book, *La Vie des crapauds* (The Life of Frogs). When enough atomic bombs had been dropped, he said, then people's brains would begin growing on the outside of their skulls in a series of warts. They would have to walk around wearing tiny bowler hats. It was something they could look forward to.

Essie came up from Virginia to help with the housework. She brought her maid, who promptly washed all the flounced curtains so that they shrank. Sandy Calder came round to see that everything was all right. He stepped over the threshold to give Essie a hug, and she said, "Get down, Zango," thinking he was the hound. Zango was getting to be too much to handle. At the end of the summer, they had to give him away.

In September they moved to the Hebbelns'. "What waifs we are [. .] I feel very well & have had rest—now the scramble begins—Gorky has some good work but its a bad time to have to move."

GORKY SENT A NUMBER of works to New York as they moved from David Hare's house. Julien Levy received a dozen lightly painted works, plus *Diary of*

Leaving Roxbury: Gorky and Maro and a truckload of paintings, September 1945

a Seducer, which was sent to the Whitney Annual that November. The paintings which Mougouch had described as raveling and unraveling like Penelope's web went to the new studio at the Hebbelns', as they were not quite finished.

Mougouch reported that Levy had phoned Gorky to say how much he liked the new work. "Julien loves & adores the new paintings he told me today on the telephone & is forever hanging them on his walls—he also said there is an effort afoot to have six or eight Gorkys in a room to themselves in some show the Modern Museum is putting on in the spring."

There were some awkward moments as they moved from one house to the other. Breton and Elisa came over to stay with David Hare. Breton was feeling ill. So was Elisa. David Hare, now the lover of Breton's ex-wife Jacqueline, had just moved back into his own house and was "sore as hell" about something. "The atmosphere was of the iron side but everyone put up brave chit chat." The following day, Hare, Breton, and Elisa dropped by unexpectedly at the Hebbelns' house. Gorky was with Maro out on a nearby hill. Mougouch took out the Hebbelns' best tea set in order to be hospitable, and Zango, the dog, sent the entire table crashing to the floor. Seventy dollars' worth of hand-turned pottery. "I was so tired of this strain of living in other people's things I burst into tears & we all sat clucking at the misfortune for a few minutes then they made a speedy exit & I haven't seen them since!"

Somehow, she wrote, there were difficulties with the "ABs." Mougouch said she was shy of talking about art with André, "because Gorky has gone through my pores as well as my head & it comes out shamelessly unadulterated Gorky though Gorky would be the first to deny that I could possibly talk like Gorky because he says I have the horrible Yankee or English or northern 'trick' of logic & you know how he hates the consecutive sentence much less thought!"

But Gorky was not well. For several weeks he had been complaining about an increasing pain located in his anus. Soon after moving in with the Hebbelns, he became very anxious about it. On the advice of a local doctor, he went to New York to consult a specialist. The diagnosis was hemorrhoids. Gorky was to stay off his feet, sit in a hot bath twice a day, and be careful about what he ate. He obeyed, and Mougouch eliminated garlic and peppers from her cooking. But the bleeding and the pain continued.

Jeanne was full of tips on how to deal with the complaint, adding, "Please dont tell Arshile that I talked about all this for I do know and I respect his loathing of this sort of talk." It was true. Though he worried constantly, Gorky hated any public discussion of ailments, especially an ailment in that area. In November, Mougouch wrote to Jeanne that Gorky had been monitoring his own symptoms and he "declares himself much better—He felt so badly yesterday for he gets very frightened at the sight of blood that I was about to take him to the doctor whom poor man I had lambasted on the telephone." The

doctor had claimed that Gorky's case was not severe and that he should take his medication and shut up. "I said for gods sake if you can't take something out put something in or we shall both be in the looney bin."

For the moment, however, there the matter rested. It was such a confused period in their lives that no one thought of asking for a second opinion. The shopping and cooking took up a lot of energy. Gorky could not drive, though he was learning. Once, he pulled the hand brake so enthusiastically that it came right out of the car, roots and all. Besides collecting the groceries and cooking, Mougouch was also feeding two dachshunds and their litter of new puppies, plus an Irish wolfhound. Jean Hebbeln was undergoing a crisis in her marriage and was drinking too much, which was another responsibility. Mougouch was also nursing Natasha, until a doctor, seeing how thin and harassed the mother had become, told her the baby should be weaned. Maro, meanwhile, after a week of shocked silence following the birth of her sister, was talking as much as she could in an effort to monopolize her parents' attention. As Gorky put it, "She has no bone in her tongue."

Gorky was also anxious about money. On the one hand, there was always the risk that he might be dropped from the gallery, as his work was hardly selling. On the other, he felt he was entitled to a raise. Levy finally said that he would keep Gorky on, and they went to New York to discuss the terms. "He has really been very good. Julien—not bothering Arshile about his work nor pushing him." But the meeting was inconclusive. Gorky was unable to broach the subject of money outright and Levy merely said something vaguely positive.

Tempers were short. Would their fights, Mougouch wrote to Jeanne, have a bad effect on the children? "I know now how very bad it is for them to be dragged through our moods & be exposed too much to the heat of the many Gorky explosions—its allright perhaps later when they can get it into a general pattern but so young its horribly frightening for them—& Gorky & I shriek as you know & control would be worse."

Jeanne replied soothingly. She was coming back east as fast as she could, and soon they would be discussing the subject face-to-face. She did not think that children were necessarily shocked by violence. Children were pretty aggressive, too. "They get on to the sort of rhythm that exists between humans. I remember when I was a child my brother and I would say if ONLY they could be nice just once with each other. But they never were."

GORKY AND MOUGOUCH went to New York at the end of November to say good-bye to Breton, who had arranged, through the French embassy, a cultural tour of Haiti and the French West Indies and was about to leave New York.

By this time a certain tension existed between Breton and Matta. At the beginning of their years in America, Breton's admiration for Matta was bound-

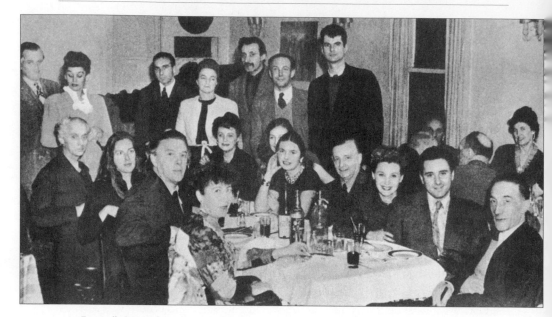

Farewell dinner for Breton before leaving New York, November 1945. Standing, left to right: Irene Francis, Esteban Francis, Elena Calas, Gorky, Enrico Donati, Nicolas Calas. Seated, clockwise from foreground, left: Steffi Kiesler, André Breton, Agnes Gorky, Max Ernst, Becky Reis, Elisa Breton, Patricia Matta, Frederick Kiesler, Nina Lebel, Matta Echaurren, and Marcel Duchamp

less. Mougouch remembered him comparing Matta to Raphael, not so much for the paintings he made as because of the aura of freshness and enthusiasm he exuded wherever he went. In the cosmology of great artists, Raphael is the innocent cherub whose creative energy, derived from his libido, carries all before it.

Robert Motherwell, who was a close friend of Matta's for a while, thought there was something "Oedipal" about his relationship with Breton. "He was the loved son, the heir apparent." Matta's feelings were complicated, according to Motherwell, and he longed to break free. The reason why he cultivated the younger generation of painters so assiduously was that he wanted "to show the Surrealists up, so to speak, as middle-aged grey-haired men who weren't zeroed into contemporary reality."

At this point, however, Matta had given up the new generation of American artists. Living at Snedens Landing, he kept away from New York for months at a time. But his tensions with Breton were still noticed by many people, including Mougouch and Jeanne Reynal. When Mougouch wrote critically of Matta in this respect, Jeanne replied, "Matta is a silly child to consider ab as an old man [. . .] but he is young and in time may emerge. In the meantime I do feel he is not an inconsiderable personage and I do like many of his paintings."

Before Breton's departure, Matta and Patricia offered him a farewell dinner.

Mougouch and Gorky were invited, together with many surrealists of the previous generation, including Ernst, Kiesler, and Duchamp.

Gorky was feeling ill, and the surrealist games Breton insisted on playing after the meal were, to him, unpleasant examples of opening certain "windows" which should be kept tightly closed. Someone asked Mougouch, "What part of a woman's body do you kiss most attentively when you go to bed with her?" She did not know what to say. "It's never happened," she said. "I don't understand the question." Everybody laughed. Breton said that either she was telling the truth, in which case her reply was honest enough, or she was lying, in which case the worst one could accuse her of was a lack of imagination, as she might have thought up a more interesting answer. A serious, almost formal answer, but this was a game Breton took very seriously. Gorky hated every minute of it, and when the guests were assembled for a classic group photo, he stood at the back, visibly aloof.

When the bill came, Matta and Patricia had disappeared. The august company were forced to go dutch. The gesture was typical of the practical jokes the surrealists sometimes played on each other, but nevertheless Breton was furious. Actually, Mougouch wrote to Jeanne, there had been something strained about the whole evening. It had something to do with Matta and Breton. "Andre was in a rage from start to finish but I begin to think they just love to be outraged."

DAVID HARE, Jacqueline, and Aube, her daughter by Breton, came to the Hebbeln house on Christmas Day. The sky clouded over and it began to snow. The next day, Mougouch flew to Washington with the children to see their grandparents.

As soon as she had recovered from the journey, Mougouch tried to enlist the help of Wolf Schwabacher, Ethel's lawyer husband, to solve Gorky's financial problems. He ought to have contacted Wolf himself, she wrote, but Gorky felt so confused he didn't know what to tell him. Julien had given him $100 to cover the increase in costs of materials, but nothing permanent had been discussed. Gorky had taken Levy some new work just before Christmas, but so far he hadn't sent him any more. They had been snowed in, but the real problem was that Gorky felt unhappy about his work. He did not want to take in any more canvases, and because of that, he didn't feel he was in a position to press his point with Levy about their financial arrangements.

Mougouch wrote to Jeanne to say she planned to come back to Sherman and drive Gorky to New York with his paintings, leaving the children with Essie and Grandpa. Or maybe they should just hire someone to solve the transportation problem? She was exhausted. They would face that task somehow, after she'd had a little rest. "Darling G. I left with Jean & Henry & work. I hope he has been able to catch up a bit on all the time lost in the past 4 months."

TWO DISASTERS

1946

FROM HER PARENTS' HOUSE in Washington, Mougouch wrote to Jeanne to say how nice it was just to lie around on a sofa without the chore of cooking endless meals. She could even read a book for a change. Julien Levy was pestering Gorky for more paintings, but so far Gorky had done nothing about it. That was more or less it. She excused her dull letter, but without Gorky she felt somehow "dispersed."

Gorky wrote a short letter to his wife to say that he would not be joining her in Washington. "I have been working very hard I will come to New York when you are there. Julien has send his check, but we have very many bills this month. Kiss Maro and Yalda for me." Yalda was the name Gorky had given his second daughter, before someone told him it meant "woman" in Hebrew. She then became "Natasha."

Mougouch planned to return to New York by herself to visit the dentist. Gorky wrote her a note about his arrangements. "Mougouch my Darling, Henry has gone to New York and his darling Wife sleeps all day and night? But I am doing some very good paintings. So if you can arrange with your doctor to see you next monday, Henry will drive to New York with the car and me and my pictures. Please darling pay the rent.—I love you Dear Dear sweet hart and

kiss Maro and Yalda." The paintings he wanted to take to New York must have been ready at last.

On Wednesday, January 16, Gorky stayed in the studio all day to work. In the afternoon, he lit a fire in the stove he had installed with his own hands a month previously. Soon he smelled something burning. As he liked to tell the story later, he thought it was his cigarette! Then he realized that the vent from the stovepipe had set the wooden exterior wall on fire. He went up to the house and took a pot of water from the kitchen, walked back, climbed onto the studio roof, and poured it down the chimney. This had no effect, so he repeated the operation. He was so polite that Jean Hebbeln watched him come and go twice before he finally said "Fire." So she then called the fire brigade.

Gorky entered the burning building a number of times and came out with an old coat, which he said he thought was a portfolio of drawings, a hammer, a screwdriver, and a box of charcoal. Everything else burned to the ground before the arrival of the firemen.

Mougouch heard the news over the telephone in New York two hours later. Gorky's voice sounded so hollow she was frightened for him, "& when he walked into the studio [in New York] the next morning he was wonderful—he has been wonderful ever since He says it is all inside him, the painting on his easel, the one he was working on during the fire is still burning in his mind & he only wants to get to work immediately."

It is strange that Gorky saved so little from the fire. One can only speculate about his failure to rescue his work. A certain fatalism might have come over him, compounded by doubts about canvases which he thought were not yet worthy of being exhibited. The fire itself may have held a particular fascination. In the Zoroastrian religion, which underlies the faith of so many Armenians of Van, fire is not a symbol for God, but God itself, and to extinguish fire without permitting it to run its course is a form of sacrilege.

At the time, Mougouch wrote that all the drawings of the past three years had been lost, except for a few in Julien Levy's gallery. This is an exaggeration. Gorky brought to Connecticut many drawings from the summer in Virginia to work from, but he did not bring them all. To the lost drawings, one should add about twenty canvases: the heavily worked paintings Mougouch had described as having been endlessly made and remade in David Hare's studio, with the exception of *Diary of a Seducer;* the final batch of paintings which he had been planning to bring to New York on the Monday; and one or two portraits of herself. Twelve thin paintings like *They Will Take My Island* survived, having been sent to Levy three weeks before. The greatest loss were the heavily worked paintings.

Mougouch added to the list: his easel, that easel which was "like golgotha

to me"; his palettes; his books on Ingres and Uccello which used to follow him everywhere. Yet in spite of Gorky's story that he had saved only a box of charcoal, etc., one or two objects which she thought had been destroyed mysteriously turned up later in Union Square. The photograph of himself and his mother, for instance. Perhaps some drawings were also saved, such as the studies for *The Plow and the Song,* to which Gorky returned in 1947—unless he replaced them while they were still fresh in his mind, backdating them to the moment when he had first thought of the image, just as he used to do in an earlier phase of his life.

Gorky and Mougouch ferried their remaining belongings back to Union Square. There was nothing else to do. Mougouch then returned to Washington to pick up the children.

The response of their friends in New York was immediate. Gorky was lent a place in which to work: a ballroom on the seventeenth floor of a building overlooking Central Park and the Reservoir. It was a long way uptown, but it was beautiful—"a Hollywood set." Bayard Osborne, Peggy's son, found another easel. Less than three weeks after the fire, Gorky was at work again. He was "a most awesome phoenix." He had even told Mougouch that he felt "a new freedom from the past now that it is actually burned like you feel when you are young and there is no past." He went off to work every day with his lunch in a little black pail, like "a sky miner." He was even happy, she wrote. It was amazing. When things were going well, "nothing can stop him."

Soon she was engrossed in domestic problems. Henry Hebbeln was using Gorky's studio to work in. Zango's new owner wanted to send him back, but there really wasn't room. Maro needed to go to school, and there was a nice one round the corner in Gramercy Park. Breton was urging them to go to France, and it was an attractive idea. But Gorky had told her he could not endure "this constant moving," so perhaps the best thing would be to find a place in the country, sublet the Union Square studio so as to bring in a little money, and stay out of New York for a year.

In the event, Gorky only occupied his ballroom for three weeks. There, he produced *Charred Beloved, 1* and *2,* and *Nude. Charred Beloved* commemorates the destruction of his "beloveds," meaning his paintings. The preparatory drawing is particularly hard and empty, almost a scheme for a drawing rather than the drawing itself. *Nude,* instead, was taken from one of the drawings he had made for Breton's book six months before. *Nude* and the two versions of *Charred Beloved* are among the simplest designs Gorky ever made.

Gorky wrote to Vartoosh about three weeks after the fire. By that time he had settled into his ballroom in the sky. He did not start by mentioning the fire itself. Instead, he wrote about his cousin Ado, from whom he had unexpectedly received a letter the week before. It had surprised him to hear from

Ado, whose letter, which he enclosed, was written in Russian. He would give her a summary of its contents. Ado said that he had written many times, and he wondered if Gorky had ever received his letters. He would like to hear from Vartoosh and Moorad. He had heard that he, Gorky, had had some success. That was all, wrote Gorky. He thought that Ado had kept his letter short and simple on purpose, and if Vartoosh replied, she should do the same. And she should not write of "certain things."

Agnes had had a bad cold, he continued, but was better. Now Maro was ill. Yalda (Natasha) was growing fast, and they would send a photo of her as soon as they had developed the film. Then, at last,

Gorky and Maro in Washington Square, shortly before his operation for cancer

"a week ago my studio in Connecticut caught fire from the chimney and everything was burned. I was not able to save not a painting nor a drawing and all my books burned and turned to dust. I don't wish to write more of this and I don't want you to worry about it."

He went on to write that many friends had already come forward to help. "Even from such a thing something new can grow." A famous writer from France (meaning Breton) wanted to write about him and had asked Gorky to send him some studies. He was still connected with "the best gallery in New York." As far as money was concerned, she must not worry. They were well.

A firm letter. No self-pity, and a concern that Vartoosh might use the fire as a focus for more anxiety. There was too much of that in her life already.

Vartoosh replied, and began sending them food parcels, as if they, like the continent of Europe, needed relief. As usual her letters, written in a large, almost childish hand, were translated by Gorky out loud for Mougouch. She asked how they were. She hoped they were eating good food. If she expressed deeper concerns about his health, he skipped these passages in translating before throwing the letters away.

. . .

GORKY WAS STILL in pain and passing blood. Though he was working well in the ballroom in the sky, he was too shy to use its facilities. Every now and again he crossed the avenue to use the washroom in the basement of the Metropolitan Museum opposite.

Toward the end of February, he was in such pain he sought the advice of his old doctor, Harry Weiss. Many years previously, Dr. Weiss had cured him of lead poisoning which he had contracted when incautiously grinding his own paint. Gorky trusted him. Dr. Weiss gave Gorky a rectal examination and immediately sent him to Mount Sinai Hospital, without even letting him return to Union Square to pick up his clothes. Mougouch brought Gorky's pajamas and toothbrush to the hospital. Dr. Weiss told her he had no doubt that Gorky was suffering from cancer of the rectum. Biopsies made in the hospital confirmed the diagnosis.

On March 6 Gorky underwent an abdominoperineal resection. A friend who was a doctor assured her that it was "a very fine piece of surgery—Jesus what an expression," Mougouch wrote. They removed Gorky's rectum, sealed the anus, examined his intestines for further traces of the disease, and opened "a hole on the side of his belly to make up for what they had to take away." If the cancer failed to reappear within five years, they told Mougouch, they would consider him "fairly safe."

At that time, 45 percent of patients admitted for resectable cancer of the colon and rectum survived five years. The fact that Gorky had been passing blood for six months before the operation does not necessarily mean that the cancer had metastasized. If that had been the case, the doctors would not have operated. Metastases may, on the other hand, have gone undetected.

Mougouch told Gorky that he had had a cancer. She did not tell him the statistics of survival, "because you see it may never reappear & must he live with fear of something which perhaps will never happen? He will have enough it seems to me in just this rearranged body business." She had been with him soon after the operation and he seemed to be recovering rapidly, "though naturally any messing in the gut is ghastly pain—But his spirit seemed very beautiful to me, he only wants to get well & out of there & back to life and his work."

The doctors did not warn either of them of the other consequences: the possibility of impotence and the psychological depressions which occurred in some cases. At the time it was not common medical practice to give patients full details about their illnesses unless they were extremely insistent, which neither of them were. Instead, Gorky was shown a photograph album showing the happy faces of those who had recovered. The postman, the retired high

school teacher. Courage, said the specialists. But as she wrote later, "What poet, what painter who has spent the years of his life removing all the fat from his nerves, who has allowed no skin of habit to deaden the slightest sensation, whose one desire is to be vulnerable beyond what he knows of himself, is interested in courage?"

Sandy Calder brought Mougouch a little mobile to give to Gorky in hospital, and she put it on the sliding table that crossed his bed. It moves like a little horse, he said. He loved it.

Frederick Kiesler came to see him when he returned to Union Square at the beginning of his convalescence. Having been told by Mougouch that he mustn't on any account make Gorky laugh, Kiesler tried to do just that. He told Gorky about Peggy Guggenheim's operation to have her nose changed. She had been woken up in the middle of the process because she'd forgotten to say what kind of nose she wanted. She, in pain: "Sew it up, for God's sake!" So they did—and that's why she looks like she does to this day. He told how a famous organist from Europe, in New York that week to give a concert on the famous organ in Wanamaker's department store, had gotten lost after practicing one afternoon and was found the next morning curled up on a rug in the carpet section.

Gorky's initial response was amazingly resilient. After all, it was a relief to have isolated what had been wrong with him and to have removed it. Mougouch wrote to Jeanne that she planned to take him to Sherman as soon as possible. She would find a studio somehow, somewhere. The exhibition at Levy's would still take place, she wrote, although it would include only six paintings. If it looked too thin, they would add drawings.

Jeanne wrote back immediately saying she was certain that what Gorky needed above all was a place of his own, somewhere in the country. She was winding up her life in California as quickly as she could and would be in New York soon. She was selling some shares and would forward them $5,000 as soon as she could.

Once again, Gorky's small circle of friends did everything possible. Wolf Schwabacher arranged a mysterious "art fellowship," granted through the New Land Foundation of which he was president. Mougouch, and perhaps Gorky also, assumed that this was disguised charity on their part and that the check had come from the Schwabachers themselves. But the New Land Foundation was a bona fide organization, financed by a neighbor of the Schwabachers in the country. Its main objective had been to help refugees from Nazi oppression before and during the war.

AS SOON AS HE COULD, Gorky got back to work. On April 5 he painted a small dark work for Maro's birthday—a quotation from the summer's *Delicate*

Game, quickly done, not an important work perhaps, but showing that he was fighting back.

Ten days later, his second show at the Julien Levy Gallery opened. It ran from April 16 to May 4, 1946, a scant three weeks. In the event, it consisted of eleven paintings and no drawings. A twelfth canvas, *Diary of a Seducer,* was added after the show had opened. The two versions of *Charred Beloved* were included, as well as the *Nude,* recently completed in the ballroom on Fifth Avenue. The other works date from 1945, and are all in the manner of Jeanne's *They Will Take My Island.* Three works had one-word titles: *Hugging, Impatience,* and *The Unattainable.* These titles were chosen by Julien Levy, as Gorky was in the hospital and unable to name them himself when the circulars went out.

At the press preview, Levy did his best to explain Gorky's work to the critics, as was his custom. *Landscape Table,* he said, had been painted from nature in an open field "with thoughts about Hitler and world politics competing in the artist's mind with the impressions of the attacks of crows on the neighboring corn." There is something depressing about such nonsense, with the shade of Vincent van Gogh thrown in—as if Levy despised either his listener or the artist he was showing. The critic of the *New York Sun* thought that Gorky's works showed a "sensitive line and vibrantly clear color," though they were "packed with implications not easily available to the hasty." He wrote that his preferred work was *Hugging,* even though Mr. Levy did not tell him "who was hugging who."

Levy had recycled Breton's introduction of the previous year, and once again the response to it was negative. "Breton has given the painter his blessings which means everything to a surrealist," wrote another critic. "Gorky sits with nature, decodes nature, in paintings which only the most pedestrian minds will wish themselves to decode. This is the burden of the Breton remarks." This critic liked two paintings; the others were "so elusive in their sparing lines and color patches that one is inclined to leave them to Nature who surely has a place for all things."

Clement Greenberg saw the exhibition before the addition of *Diary of a Seducer.* In spite of the fact that Gorky had carried on working in the style of *They Will Take My Island,* the painting Greenberg had singled out for praise the year before, he thought that these eleven works were for the most part "tinted drawings." This did not make them less "important," he wrote, for Gorky had added something new to the achievement of Picasso and Miró. "Thin black lines, tracing what seem to be hidden landscapes and figures, wind and dip against transparent washes of primary color that declare the flatness of the canvas." It was obvious that these paintings had been beautifully prepared. But "Gorky's art does not yet constitute an eruption into the main-

stream of contemporary painting, as I think Jackson Pollock's does." According to Greenberg, the problem was that "his self-confidence fails to extend to invention." What Gorky really needed was an "integral arrogance." Only when he had acquired such arrogance would he paint paintings "so original that they will look ugly at first."

Arrogance was a quality which Greenberg valued highly at the time. A recent collection of his essays from that period has the title *Arrogant Purpose*. It is hard to see what the idea could possibly have meant to Gorky, physically wounded, his studio burned down, and still with no solution to the basic problem of where to live.

Gorky's lack of connection with the "mainstream of contemporary painting" was another way of saying that he was an outsider, and it was true. Gorky never in his life talked to a critic respectfully, or made a personal friend of his dealer, or flattered a buyer. He possessed these basic skills of the profession in negative quantities, sticking faithfully to his own vision of artistic "innocence." He knew that paintings need a carapace of words in order to be accepted, and for himself he was able to produce some. But to link paintings, words, and political intrigue together was beyond him, and he had no contacts with any group in New York which could have helped him to bridge the gap. All that bound him to the "streams" of art, main or peripheral, was his connection to André Breton, who was no longer in the city.

In spite of the dubious reviews, Gorky's reputation continued to rise. Mougouch wrote to Jeanne that Gorky had been negotiating with a dealer to exchange some paintings of his own for an early work by Ingres. A painting she described as "bad but so good." An Ingres drawing was selling for $1,800 at the time. Even so, this dealer was interested in an exchange. "Its amazing how amenable the dealers are." The market for paintings was sluggish, and dealers may have been swapping paintings to create an illusion of activity. But it was encouraging that one dealer, at least, was convinced that sooner or later Gorky's work would sell.

By the end of the year, Julien Levy had managed to place four paintings: *Good Hope Road,* for $500; *Impatience,* for $350; *Charred Beloved 1,* for $720; and *Delicate Game,* for $275. The total of $1,845 was close to Levy's outlay to date, which was $2,100, paid to Gorky in monthly installments of $175. Gorky's twelve paintings and thirty drawings a year could be covered by selling five paintings. In the event, it turned out to have been a good year. Levy sold only one other painting in Gorky's lifetime.

Gorky did his best to push Levy toward selling his works more aggressively. "Why are not my pictures in all the museums?" he asked. "The Wadsworth Atheneum is a good museum." And it was directed by Chick Austin, who was a close friend of Levy's. Austin liked neoromantic and surre-

alist paintings, "in no way surprising considering his princely and poetic lean-
ings," as Levy put it. "A wonderful exhibition of Picasso," Gorky continued,
"and the critics were so kind. Henry McBride is a kind critic. In the forecourt
of the Wadsworth Atheneum there is a marble pool. They tell me that Charles
Henri Ford went wading in it. Why not me?" Charles Henri Ford was the
patron who had commissioned Breton's book of poems with Gorky's illustra-
tions. In Levy's book, Gorky's tone is somewhat plaintive, but in fact he was
trying tactfully to encourage Levy to place his paintings in the museums,
where they belonged.

A few days after the show opened, they had supper with Peggy Osborne.
Gorky was in a good mood, telling the table that William Shakespeare was a
"rehashed pedant." The Osbornes cheerfully disagreed. It was one of Gorky's
favorite set pieces. His view was that *Romeo and Juliet* gave every adolescent in
America the absurd idea that the great thing in life was love. Every bobby-
soxer thought she was a Juliet, every hopeful high school kid a Romeo. Amer-
ican girls suffered from enough of a princess complex as it was, he said. Love,
according to Gorky, had nothing to do with passionate emotions. A well-
balanced woman expressed her love by going down to the stream at the bot-
tom of the hill to wash her clothes against round white pebbles, singing as she
beat them to make them clean. And didn't Shakespeare have a perfectly good
country of his own? Why did he have to put all his characters in far-off places,
like Italy and France and ancient Greece?

At a diner downtown, Gorky and de Kooning and Elaine were sitting at a
table drinking coffee. Someone said that 175 million people had been added to
the world population between the beginning of the war and its end. Gorky
looked at the speaker, Edwin Denby, "with his marvelous eyes and said, 'That
is the most terrible thing I have ever heard.' " So much human misery, death,
and destruction, yet hardly affecting the indifferent statistic on its upward
rise. That, or something like it, was what Gorky thought.

THEY DROVE UP to Dublin, New Hampshire, to look at a house which was
for sale. A converted barn with sixty-five acres of land at the foot of Mount
Mamadusch, formerly the property of the painter Jerome Brush. Price, $4,000,
which with loans from friends and banks they could just about afford. But
Gorky did not like the landscape, and that was that.

He had lost a lot of weight. He was tired. He began to feel pain in his
intestines again. A busy social life and house-hunting were wearing him
down. He and Dr. Weiss began to worry about his health. He ought to get
away. Commodore Magruder and Essie were on their way to Canada for a vaca-
tion. Instead of shutting up Crooked Run for the summer, could Gorky and
Mougouch borrow it?

They drove down in early August. Frederick Kiesler gave Gorky an air cushion to sit on during the journey.

Mougouch was still in a house-hunting mood. Driving through Bucks County, they saw the most beautiful landscape and longed to stop and look for a house. She and Jeanne were convinced that what Gorky needed was a place in the country where he could work and live a very simple life. It was all he ever wanted. But the journey was tiring him and so they drove on. "We were at our wits end and G just had the strength to get here. We just slept and lay in the sun for the first few days watched the sun go down and come up and the birds flying about with all that delicious awakening of one's sensibilities that you have when you are getting well from an operation."

Gorky began to work. Soon he was quite brown from the sun. By the time Mougouch wrote her first letter to Jeanne, he already had a fresh portfolio containing twenty-one new drawings—"nothing but something you know and more than he had in a whole year in Conn. There is some richness in just this little valley that does seem to inspire him."

The pain in his intestines subsided. He took up his station in the fields as usual, in front of the flanks of trees running parallel to the chair on which he sat. He saw something different in Virginia this time, something more precise and yet more distant. The drawings look outward rather than growing from within. He observed the outcrops of limestone, with their feeling of overgrown graves. He set half-imagined objects on the ground at a slant toward the horizon.

Behind the main house, on the steep descent to the little stream of Crooked Run, stood a huge walnut tree. It is gone now, blown down in a gale in 1953, but for some weeks this was Gorky's motif. He wanted to set this large shape within a space suggesting the surrounding trees and the empty field. *From a High Place* has something of the feel of this spot. But then many of the drawings for this series contain, almost in a cartouche, a series of rugged peaks more distant than the soft, comforting hills around Crooked Run Farm.

"Gorky sends you his very dearest love," Mougouch added in one of her letters to Jeanne. "He is busily scratching away saying he is doing the most interesting and instructive work for himself just scratching color on a pad so the beginning is the same anywhere."

In the evenings, after the day's work was over and the children had gone to bed, Mougouch typed letters to Jeanne while Gorky made small drawings on a spiral-bound pad, or on sheets of the onionskin airmail paper Mougouch used for letters. Some of these sketches quote from the elaborate drawings Gorky was accumulating during the day.

While he drew, Mougouch read him Jeanne's letters. She was finding it dif-

ficult to sell her house in California. While she was waiting for a buyer, she
had toured the Southwest again, where she kept on thinking about Breton. His
peculiar attitude toward love, for instance. In retrospect, she was not sure if
she liked "the dreadful heraldic attitude which is André so that the woman is a
sort of emblem of mans need and not a being in her own right." As if women
were supposed to be an inspiration to man, and nothing more. If women took
an active role, then men like Breton began to feel uneasy. "THEY wish women
to be creative yes, everyone should DO something, but then they fear losing
something, some feminine quality, which is what, I wonder?"

Should women break out on their own, or should they sublimate their cre-
ativity through their men? When it came to art, Jeanne wrote, Breton had said
"there should not be womens art, just art. All art being of the same nature yet
mans nature and womens is not o no thank god is NOT the same." What did
Gorky feel about all this?

Mougouch asked him. For herself, she reported, men were bound to be
against women's art, because art had to possess both male and female character-
istics and to overemphasize one at the expense of the other destroyed the bal-
ance. But "here Gorky says I am wrong he thinks there has to be womans art
that there never has been and that what is wrong is women similating men."

As to the muse, the *femme inspiratrice,* as the surrealists used to call her,
what Mougouch thought took place was that the woman inspired the man,
who then produced something wonderful, which in turn inspired the woman.
It was the "flight" which counted. "Thoreau was rather marvelous when he
said 'I desire to speak somewhere WITHOUT bounds. I am convinced i cannot
exaggerate enough even to lay the foundations of a true expression the volatile
truth of our words should betray the inadequacy of the residual expression' or
something like that thoreau being in ny but when i read that i felt it might
have been andre speaking or gorky who sometimes complains that Uccello did
not exagerrate enough all the time to be as free and inspiring as he was capable
of being. i am so strongly for extravagance that i sometimes think i shall just
burst of admiration for it."

Gorky and his wife had had a great many problems of a horribly down-to-
earth kind during the previous year. Opportunities for flights of inspiration of
any kind had been conspicuously lacking.

AFTER A MONTH ALONE, as Essie and John Magruder came back from
their vacation in Canada, Kay Tanguy rang Mougouch from Connecticut to say
that they had heard of a house for sale near them at Woodbury. Wouldn't they
like to drive up and see it?

Kay went on to talk about what was happening in France. Breton was a
"wild lion in Paris surrounded by 50 people every day & night in the Deux

Magots or whatever is the name of the 'home' restaurant & that he has to pin a note on his door saying [he] can be seen by appointment only. Tanguy face-tiously adds that Matta disappeared after a few days there in [a] huff that he wasn't getting enough acclaim—Well anyway hooray for him André."

Gorky and Mougouch drove up to Connecticut in an old jeep belonging to her father, leaving the children with their grandparents. It took them twenty-four hours, 4 a.m. to 4 a.m., as the machine would not go faster than thirty-five miles an hour. They visited the house in Woodbury recommended by the Tan-guys, but they didn't like it. However, they found something suitable nearby. Unfortunately, the owner, an old Lithuanian who hardly spoke English, wanted too much. "Mister Dooda (the owner) doesn't make much sense but when he smiles he is like Socrates & he throws his arms back in a very Russian broad sweep and bellows $22,000 all, everything."

Much time was spent on descriptions of the property and mad calculations as to how they could buy it, but the price was too steep for Jeanne or the banks. Mougouch asked her parents for an advance on her inheritance, but it was refused. Crooked Run needed a new wing, said Essie. She had all these men coming back from the war. The refusal was a reminder that Mougouch and Gorky were still too dependent on her parents. When Wolf Schwabacher heard about her plans and asked for the price of the house, Mougouch felt too ashamed to tell him. It had been a nice fantasy, but the eye of a pragmatic lawyer might have blinked more than once upon seeing the sum she had been contemplating.

While in Connecticut, Tanguy and Gorky discussed whether they should go to Paris. "The Tanguys had heard from the Matisse's & other freinds that Paris is not so hot—a very false & quite mad esprit de luxe—a stifling intellec-tual atmosphere of each little group beating its drums behind closed café doors with no air in between & opportunism rampant."

Sartre hated the way in which Breton always shook him by the hand in public, Jeanne wrote, passing on some gossip Jacqueline had told her. Breton called Sartre "cher ami," while in print he had declared that surrealism should never be confused with the "grisaille" of existentialism. "They are bound to be enemies," wrote Jeanne. "It is only intelligent to see this, [but] it is also intelligent 'qu'on se salut.' Good for André."

The actor Jean Marais told me recently that the fight between surrealism and existentialism in Paris after the war was "une bagarre de café," a squabble in a coffeehouse, which is perhaps what it looks like fifty years later. At the time, however, it was a fight to the death. The French Communists were pro-moting the myth that the only resistance to the Nazis during the recent war had been theirs, and they were making a strong attempt to dominate all other left-wing movements, not just political but artistic and literary as well.

This was the moment when Picasso joined the Communist party. Such was Breton's allegiance to Trotsky that he was even prepared to sacrifice his friendship with Picasso for the sake of his principles. When the two men met, Breton refused to shake his hand. Picasso was incredulous. Friendship, he said, should transcend political differences. Was Breton sure he wanted to take this step? Breton hesitated. He knew that with a man like Picasso, there were no second chances. Then he repeated his position. The two men never spoke to each other again.

Tanguy was happy in America, and he could guess just how difficult it would be to begin all over again in France after the war. Mougouch, with less experience of Parisian life and almost no political instincts, was attracted to the idea. If, back at Crooked Run, house-hunting in Connecticut had to be abandoned, it was an alternative adventure to which she could devote her energies.

Mougouch wrote Breton a careful letter in French. She had heard, she wrote, that in Paris he was surrounded by enthusiastic young people. She and Gorky longed to join the circle. Gorky's health was now quite good. If he was happy, he could take anything, but his life revolved more and more around his work. He needed to live simply. At present, he had thrown himself into the abundance of nature. In fact, Gorky had told her that nature "entered his head and closed his ears." He was drawing in the fields as if possessed by a demon. They had some money, and they felt like gamblers. Would Breton throw the dice for them? What they needed was a small house near Paris.

Breton replied a month later. He courteously apologized for the delay, but he had made two "dark" trips to Brittany, and now the cold was making life in Paris unbearable. But of course they should come! They needed Gorky! Besides, the air of Paris—so precious that Marcel Duchamp had once sealed five cubic centimeters of it in a little bottle—would be good for them. He and Duchamp were organizing a surrealist exhibition for 1947. Gorky of course would be invited.

Mougouch was filled with enthusiasm. "My mind like the die is cast," she wrote to Jeanne, unconsciously echoing the gambling metaphor she had used in her letter to Breton, "so's Gorky's & really we have so very little time." It was hard to abandon the gambling image. "Though I try to rationalize our going to France into the most natural occurance possible, I cannot. Its as though we were throwing every penny onto the table." She could hardly believe that the French plan had finally come to the top, after "these two years of dreaming that we would withdraw with our handful of quietness into work & the country."

Deep down she knew the plan was crazy. Gorky would need a private bathroom on the boat during the Atlantic crossing. Someone would have to keep him company in Paris while she looked for an apartment. Jeanne and Urban, and David and Jacqueline Hare, would just have to come too!

She wanted so much for them all to enjoy it. But maybe they wouldn't. According to Matta, there was "no freedom of movement no café sitting unless its *your* café, poaching on anyone else's preserves is spying, all energy left is spent in talk talk, v. difficult to find a place to work, much less live & as for Gorky's imperious plumbing out of the question—And he found it more alive here, more hope more possibility."

WHILE GORKY WAS WORKING hard in the fields, Mougouch was left to fit into her parents' routine. She joined her mother in weeding the lawn, which went against the grain. "They should have bought a house on a golf course then Mother would have been very happy—why do people loathe the beautiful weeds so—they feel they are going to be strangled by the lovely thistle & milkweed that grow in these fields & chop at them murderously—so that I feel morally bound to go leaping after them with a rake or a mop & it is such a waste of a lovely day—However it is heavenly to be here at all & the little Navaho [Natasha] does like the lawn better than the thistles so I do profit somewhere."

Beyond the garden, tangled crowns of honeysuckle sprouted from the red Virginia earth. Where the lawn ended grew low clover, from which a child with small fingers could pluck the pistil, laying bare within an invisible drop of honey, to be tasted with just the tip of the tongue.

At the cocktail hour, with the sun low on the horizon, Grandpa Magruder produced colored swizzle sticks with which to chase the ice around the glass. But only he could produce them! They were not playthings for little girls. And if a certain little girl at bedtime did not snuggle down and go to sleep promptly in her cubbyhole behind the pantry with her sister, Grandpa would come with a carrot and wiggle it through the keyhole, saying in a terrible voice, "Fe fi fo fum! I smell the blood of two little scallywags."

Essie wore a dark hat with bird's wings on it, shrouded with a cloudy veil. Everything she did fascinated the children: the way she cared for her fingernails, the daily rituals of running the house and servants.

"Gorky is drawing feverishly & discovering new things," wrote Mougouch to Jeanne at the beginning of the summer. "He has a huge portfolio of drawings already & some are extraordinary—he says he hasn't found what he wants to paint yet but there is still time & also he really doesnt have any place to work—to paint I mean."

That final summer in Virginia was devoted entirely to drawing. The barn where Gorky had worked two years previously, by unlucky coincidence, had burned down the winter before. Gorky showed no signs of wanting to paint, but this might have been due to his innate politeness. After all, he could hardly insist that the Magruders provide a studio for him. As it was, Mou-

Arshile Gorky, study for *Agony*, 1946

gouch and Essie fixed up a little room above the garage for him to draw in when the weather was bad, and he used it, though it was a tight fit.

The drawings of his last summer at Crooked Run are extremely varied. Some are precise, the pencil sharp as a scalpel, the line reiterated to perfection. Others are attacked with constant, fretful strokes, blackening the paper as if the lead did not leave its surface until the pencil had worn itself into a stump.

The title *Agony* was Gorky's accommodation to the one-word titles Julien Levy had found for some of the paintings in the recent show. As usual, Gorky did not feel strongly about titles, and if Levy preferred a word to a phrase, then so be it.

It is tempting to see in the series called *Agony* a reference to Gorky's physical state during that last summer at Crooked Run, but it is hard to make a connection between the changes the operation wrought in him and the work he produced. In general, what stands out is the contrast between the violence of some drawings and the purity of other versions of the same image, but here again it is hard to draw conclusions. Sometimes a rough version and a pristine version were made on the same day. Emotional states, in other words, either came and went very fast with Gorky, or else were always subordinate to an artistic intent.

His work exhausted him. They seldom went for long walks together anymore. Walking was not so easy for him now. "I used to be a lion," he told

Mougouch mournfully. Coping with his illness was not easy, as he was so reluctant to let himself be helped. "When Gorky gets these waves of depression which he has always had to a degree but which are now pretty demoralizing because all this bizness we have to go thru every other day takes it out of him so physically & spiritually—its pretty difficult to help him out of it." The "bizness" to which Mougouch referred was the elaborate cleansing which Gorky put his body through every other day.

Never particularly good in relation to other people, Gorky became increasingly impatient with any claims on his attention on the part of strangers. An old friend of Essie's called Mrs. Bryan arrived on a visit. Mrs. Bryan had lived for a few years in Tiflis, and she was thus in a position to inform Essie that the name "Gorky" was an assumed one. Maxim Gorky's real name was Peshkov. Arshile Gorky just had to be an assumed name, too, and he surely could not be related to Maxim. Essie told all this to her daughter, but when Mougouch told Gorky, he flew into a rage. Does that woman know where I come from? he shouted. What does she know about my country? Mougouch saw it was not a subject to be pursued, and she forgot about it. When, many years later, she read in Ethel Schwabacher's book that Arshile Gorky had been an Armenian called Vostanig Adoian, she was shocked by the truth, and she was at a loss to explain why she had never asked him for more accurate information about his past.

They took a day off to go into Washington to see Caresse Crosby's G-Place Gallery. Crosby was a friend of Suzy Hare, who had told them to have a look at it. The visit was not a success. Caresse Crosby wore a dress like a negligee and was surrounded by small yapping dogs. On the wall were paintings by Henry Miller, which Gorky loathed on sight. They made a few polite remarks and never returned.

Johnny Magruder, Mougouch's brother, was also in Washington at the time, waiting to be demobbed. He had had what was called "a good war," first in the Pacific, then working in military intelligence in Holland. The whole family had supper together, with disastrous results.

The talk in Washington was of the imminent struggle with Russia. Stalin had just suppressed free elections in Poland, and Churchill had recently made his famous "Iron Curtain" speech, giving a name to a vast arena of world history. There was talk of war. Gorky, as usual, spoke up in favor of Stalin, and a row ensued. Gorky gave no heed whatsoever to the muted disapproval of the brother-in-law and father-in-law, or to their understandable feeling that Gorky had been living off the fat of the land while they themselves had been off fighting a war. Mougouch was upset, not by the angry things her father and brother were shouting at her husband but by the rage which had overtaken Gorky. It seemed to come from somewhere beyond himself, the limitless rage of a stranger.

Back at the farm, with the Magruder men absent, Gorky and Mougouch went out to supper, leaving Essie at home with the children. Their hosts were nice, conventional people who lived nearby. To the horror of Mougouch, Gorky started to complain to the company in a loud voice about Essie. Her coldness. Her conventionality. He made no allowances for the fact that these people were old friends of the Magruder family. Eventually their host leaned over, tapped him on the knee, and said, "You know, Gorky, this would sound a whole lot better if you weren't living in Essie's house right now."

Once, when Essie and her husband were having one of those aimless family bickers about plans, Gorky turned to Commodore Magruder and said, "Why don't you just put her over your knee and spank her?" Naturally, they thought the suggestion was hilarious. But no joke was implied. Gorky thought that wives should obey their husbands. If they didn't, they should be beaten.

GORKY WAS TOTALLY engrossed in preparing the paintings he would make as soon as he found a studio in which to paint them. The cubbyhole above the garage was out of the question. No doubt there were other barns in the neighborhood of the farm, but that would have taken him out of range of his family. He needed to have his family nearby when he worked—there, but not interrupting.

The difficulty was the weather. "No wind but a strange worried grayness," Mougouch wrote to Jeanne, "a disturbed feeling in the pit of the stomach I hope it moves off to sea soon. Damn the elements but God they can be magnificent." If it became impossible to work out of doors, Gorky retreated to the tiny room above the garage. "Gorky so on fire with his drawing he cant lie in bed at night—what will I do with him in the rain—some knockout pills would be good."

In October, Mougouch made him choose fifty drawings to send to Julien— "it took him 2 whole days of muttering & puttering to make up his mind to send them & now he comes home exclaiming I must write to Julien to tell him they are nothing for only today has he discovered etc etc."

It worried her that he hadn't been able to paint, however. "Julien Levy is upset—he wanted two paintings for the Whitney annual—Gorky feels so calm so certain that even the fact that Julien's tithe is nearly due & Julien upset doesnt bother him at all—he doesnt even know J. is upset." She herself would be "in a tizzy" about it were it not for the help they were receiving from all their friends. "If Julien wants to end contracts he can because all that matters is the calm passion of Gorky he is full of work."

Julien Levy liked the new drawings. "To some extent you are less lyrical than before, but that would be natural considering the state of the world and your own missfortunes." He looked forward to seeing him soon.

UNION SQUARE

1947

THE DAY BEFORE leaving Virginia, Gorky wrote to Vartoosh:

> My dearest Vartush, Agnes and I always talk about you and we mention
> your name every day and Maro has grown bigger and speaks normally. I told
> her I was writing to you and immediately she began talking and said aunt
> Vartush and said something ten times she repeated the same things and
> wanted me to tell you something, but neither Agnes nor I could make out
> what it was. And our beloved Natasha has grown bigger also, she can walk
> and dances very well.
>
> Vartush, a few days ago I received a letter from Ato, who wanted to tell me
> something, I write to him when I get back to New York. It seems he is OK in
> Erevan. Next spring we have the intention of going to Paris france. Our friend
> the great poet André Breton, who wrote such good things about me, wants us
> to go there. This summer I made many drawings, 293 of them, I notice, I have
> never been able to draw so much and they are very beautiful. Don't worry
> about us, we are well. Only you should write more letters. You wrote to me
> some time that you wanted Arshag's address, but I am sorry I do not know it
> and when I go to New York I may be able to find it and send it to you. As for
> Agapi I have not heard from them and neither from Satenig, but I am sure
> they are fine.

He was sorry they had not managed to get to Chicago to see them, but if all his plans worked out, they might come soon for a short time.

It was almost his last letter to her. His sense of belonging to Armenia had become increasingly private, and no one, not even his sister Vartoosh, was to share it. He did not bother to send her greetings over Christmas, and when she wrote to him the following spring, he replied in a letter so short as almost to be a dismissal. "Dear Vartush, don't worry about us, we are well, we really felt very bad when we heard that this winter was so hard for you and we are happy that you are well. We have not heard from Agapi nor Satenig and surely they too have their problems. Write again soon, with warm embraces, missing you, your Gorghi."

They drove back to New York on November 20, 1946. In the effort to move their possessions from Crooked Run, Mougouch put her back out. She lay in the studio in front of a borrowed sun lamp hoping the vertebrae would slip back into place. Natasha wandered about, her dark eyebrows going up and down apprehensively, as she had only just learned to walk.

They resumed their social life. They saw the critic Nico Calas, who was writing the introduction to the group show scheduled for the Hugo Gallery. Gorky did not like a text Calas had written for the catalogue, and he hated Matta's title for the exhibition: "X-centric Art."

Miró came to dinner. Gorky spent days preparing the studio, scrubbing the floor as usual until it was as clean as the deck of a sailing ship. The shashlik was prepared well ahead of time. Peggy Osborne, Jeanne Reynal, and the Schwabachers came, too. Music was provided by the Spanish guitarist married to the daughter of the Magruders' neighbor at Crooked Run. Gorky produced a Spanish wine flask with a spout. The trick was to tilt the bottle sharply and drink from the stream of liquid as it fell through the air. Gorky could manage it, and Miró also, with ease, as this was the custom all over Spain. Laughing, the other guests spluttered and reached for their handkerchiefs. After supper, Gorky sang "the wailing trills and arpeggios of the East," as Ethel put it, and Miró replied with songs in Catalan. Gorky and Miró had no language in common, but they understood each other immediately. In April of the following year, while decorating a hotel in Cincinnati, Miró said that of all the American painters he had seen, Gorky interested him the most.

Jeanne sold her house in California at last. She and Urban drove their belongings back to New York. She had half an idea that she might buy a large house in Connecticut for herself, Urban, and the entire Gorky family, but for the moment Mougouch arranged for her to sublet the Chermayeffs' flat on East Twenty-second Street. It was wonderful to have them nearby.

Gorky was longing to start painting, but he was distracted by a request

from Peggy Osborne to make some illustrations for a book she had written. He found that he could not get interested in the book and responded blankly whenever she or Mougouch asked about the illustrations. Peggy felt she deserved better treatment, after all she had done for them. Jeanne's presence nearby meant that Mougouch paid less attention to Peggy, and this also upset her. Jeanne's sublet soon became the epicenter of their circle. Mougouch used to take the children there in the afternoons, so that Gorky could have a few hours' work in peace.

Gorky spent some days making a frame of carved driftwood for a mosaic Jeanne was about to exhibit in Nico Calas's exhibition. His own drawings, scheduled to be exhibited at the Julien Levy Gallery in February, also needed choosing and framing. Then the Christmas festivities loomed ahead. Gorky became increasingly frantic at all the delays and postponements. He was longing to start painting from the summer's drawings, but family life was too distracting. It became impossible to paint in his studio with two growing children underfoot. Maro remembers learning to roller-skate at Union Square, up and down his lovingly scrubbed wooden floor.

AT SOME POINT over Christmas, he and Jeanne fought. She never understood quite what had upset him, but it had something to do with her purchase of paintings by Pollock and de Kooning soon after she had settled into the Chermayeffs' flat. Gorky had the growing feeling that many painters in New York were overtaking him in reputation, but the idea that Jeanne, of all people, should support the newcomers was, to him, a personal betrayal. He had not introduced Jeanne to Bill himself, although once, walking beneath de Kooning's studio, Gorky had pointed upward and said that here lived a very good friend, and a very interesting painter—and walked on. Jeanne had met de Kooning on her own, and immediately bought a work from him. It looked to Gorky as if she had gone behind his back.

They all went to the various winter parties: to Frederick Kiesler's apartment on Seventh Avenue, to Matta and his wife, to David Hare's loft on Fourth Avenue. At one of these gatherings, Pollock walked up to Gorky and started hassling him. Keeping his temper, Gorky took from his pocket a long knife and a pencil, which he began to sharpen. Not liking the look of the knife, Pollock backed off. But Gorky's public persona of gloom softened by irony hardened as the winter progressed, the gloom becoming a permanent fixture and the irony less apparent. His attitude to his contemporaries turned increasingly to one of unmasked distrust. He knew he was at last working in a vein which was truly his own, but until the paintings were recognized he felt vulnerable.

In a café that winter, when conversation veered to a dispute about the city

of Kars in eastern Turkey, Gorky shouted that it belonged to Russia. Indeed, before the ignominious treaty of 1923, it had. Stalin was putting pressure on President Truman to have it returned to Armenia, and Truman was resisting. Like the suppression of elections in Poland, the confrontation over Kars seemed one more step toward an imminent war between Russia and America. The news was frightening. But Stalin is right! shouted Gorky. It's ours! And his listeners were struck dumb.

Increasingly, he left Mougouch to deal with the outside world. This included the basic gestures of thanks for help received. Wolf Schwabacher regularly forwarded a check from the New Land Foundation, and during the winter Ethel sent them warm clothes which her children had recently out-grown. Mougouch's florid thank-you letters look as if they were written under a strain. "We who have so much to thank you for that my heart literally becomes mute with wonder at your goodness to us—I am always afraid you will perhaps not understand why we are so silent in gratitude but it is as though I would not for all the world falsely measure this feeling with any readymade phrase but only hope to grow to fitly contain it."

Shortly before Christmas, on the recommendation of Mougouch's great-aunt Marion Hosmer, Mougouch began to talk to a Jungian psychoanalyst in an attempt to cope with the strain imposed on her by assuming so many differ-ent roles in relation to different people. Gorky neither approved nor disap-proved. He liked Aunt Marion and trusted her totally. Dr. M. Esther Harding told Mougouch that it would be helpful if she wrote down her dreams before they faded in the course of the rigors of her day, and Mougouch began to keep a diary. Gorky showed no interest either in the diary or in the progress of the analysis.

ON FEBRUARY 15, 1947, the group show which had been organized by Nico Calas opened at the Hugo Gallery at 26 East Fifty-fifth Street. The idea of calling it "X-centric Art" had been abandoned, though it was called by the equally bizarre title, "Bloodflames 1947." Gorky exhibited *Nude,* which he had painted in the ballroom opposite the Metropolitan the year before. Calas in his introduction talked about the "tragic grandeur of the pursuit" in Gorky's work, and its anxiety. "What fearful emptiness of feeling and what lack of satisfaction interrupted the course of lines only to be resumed further on." Emptiness of feeling and a line broken by hesitation were not what Gorky was aiming for, and he cannot have been thrilled to see these virtues praised.

Three days later, Gorky's annual show at the Julien Levy Gallery opened. It consisted of drawings only. Levy was disappointed not to have mounted an

exhibition of paintings, and the exhibition stayed up for little more than a week. There is no indication that he did anything to promote the show, which had few reviews and none of them complimentary. The critic for the *New York Times* wrote, "Color drawings by Arshile Gorky, at Julien Levy's are rather slight and are non-objective. There is evidence of command of line but to what purpose is considerably less clear."

Levy's interest in Gorky's work sprang from his wish to keep in touch with the surrealists, but at this point the major figures were absent from New York and the surrealist movement itself was gradually being supplanted. He was aware of the fact, and he was conscious that the gallery needed to change with the times, but he was also beginning to tire of his role as a dealer. Indeed, he was thinking of closing the gallery.

Gorky, having delegated all worldly affairs to Levy and to his wife, thus relied on two figures whose connection with the future art world of the city was actually decreasing. Mougouch was not a New Yorker, nor did she wish to become one. She had neither the gifts nor the desire to enter into the kind of intrigues on behalf of Gorky's career that Elaine pursued on behalf of de Kooning's. Her instinct was the opposite: to take Gorky to the country, or to Europe, if it could be managed. At any rate, somewhere far away.

After the show came down, Gorky at last found a small room where he thought he could work, in the Klein's building on Sixteenth Street. From its windows he could look across the street and see his family moving about in his old studio. The light was good and he began some new canvases. The heavy versions of *Agony, The Plow and the Song,* and *The Betrothal* were probably started there. He may have mounted some stretchers with paper, in order to try out an idea: *The Limit* and the Los Angeles version of *The Betrothal* are on paper. But he felt awkward in the new work space, and in June 1947, when his wife and children moved up to Maine for the summer, he recrossed the street to his familiar studio, letting the room in the Klein's building lapse.

In retrospect it seems obvious that the last, tragic descent of Gorky into disaster might have been avoided if only his wife and children had taken a separate small apartment in which to live, leaving Gorky to paint in Union Square. It would have been a better way of spending Jeanne's $5,000 than on a wild trip to Paris. Almost all Gorky's work had been painted in that room. It was unthinkable for him to work in any other place. But if such a solution crossed his mind, he rejected it. Union Square was his home, and he and his family belonged there and nowhere else. The studio was surely crowded, but the old Adoian house in Khorkom had also been crowded—unbelievably so. Family life was like that.

. . .

DURING THE FIRST ten months of 1947, Gorky completed roughly twenty-five major paintings. In the eight months before this, he had hardly painted at all, and in the eight months following, he completed only half a dozen canvases. The achievement of 1947 includes a large proportion of the work which is valued today, and without these canvases his reputation might easily have languished for lack of a major body of work to sustain it. It was a last, crushing effort of will.

Some early versions of *The Plow and the Song* had been destroyed in the studio fire. *From a High Place* was originally conceived in 1944. All the works of this final period have a retrospective feel to them, just as the title *From a High Place* indicates detachment and retreat—a retreat perhaps to the mountains of Armenia, which are so immensely high. Gorky wanted to consolidate the experiences which meant the most to him, and clarify the vision which had come to him in the happiest and most creative summer of his life—the summer of 1944, before Greenberg's praise of *They Will Take My Island* had encouraged him to produce thin works; before the fire, before the operation. Continuity was what he sought, not a reaction to recent experiences.

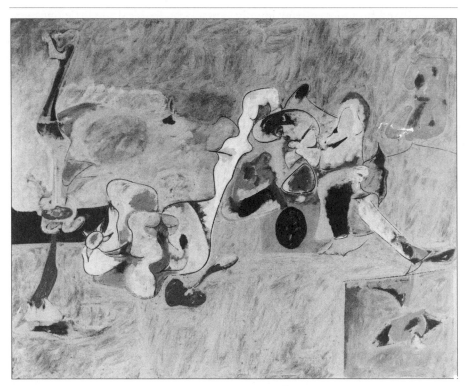

Arshile Gorky, *The Plow and the Song*, 1947

. . .

ON JUNE 10 Mougouch and the children took the train from New York to
Castine, Maine, to spend the summer with Aunt Marion, leaving Gorky in the
peace and quiet which by now he so desperately needed. Mougouch left a pile
of stamped addressed postcards and envelopes by the door so that he could
keep in touch with her. Sometimes he filled these in and forgot to post them:
three, obviously written at different moments, bear the same postmark. Some-
times he wrote a letter instead. They are the largest surviving group of letters
in English, and read in sequence, they give a fascinating glimpse of the paint-
ings on which he was working.

Mougouch sent a telegram on their arrival. The following day, the
children wrote him postcards from Castine. On June 13 Gorky replied,
"I wish you were here to see the two beautiful work I did to day." The paint-
ings must have been started as well as finished on that day, suggesting that
the "empty" versions of his themes—the ones which were obviously painted
in just an hour or two—tended to come in the middle of a series, when he
knew the image by heart and could "perform" it on a fresh canvas without
hesitation.

He missed his family. "How lownly is with out you and the little ones you
are in my hart every moment of the day. I hop you did not have to hard of time
in the train how is there? Here rains every day I am working very well dont
you worry about me my sweet one. Have received your telegram and the lovely
cards."

In their next letters, Maro and Natasha included some flowers they had
picked in Aunt Marion's garden. "I loved the three sweet little violets you
sent to my my galupcheg. one from you one from Maro and one from
Natasha. Oh what a longing I have for you my Mouguch and for the little
one each time I see a little girl or a boy I have tears in my eyes. Last night
had dinner with Jeanne and Urban and Calas's—had nice time. Then I went
to Isamu—he had little party—to morow I am taking Dr Weiss to Mitrapoli-
tan Museum—with Mrs Mitzger forgive this letter Darling I just had my
bath—had a shor note from peggy. she send the $9 . . ." He was going to have
supper with the Hebbelns the following evening. Jeanne might buy their
house. Ethel called. She wanted Mougouch to write to her because "she
love's you letters." He was working hard all day. "I am will my darling do not
worry about me."

Ethel bought a drawing: one of two studies for a huge drawing on which
he was working at the time. After the sale, Gorky kept it back for a few days
and made a second version, which at the last minute he gave her instead of the
one she had bought. The large drawing, now at the Museum of Modern Art,

Arshile Gorky, study for *Summation*, 1946

was called *Summation*. The title is not Gorky's, but it intelligently recognizes the effort he was making that summer to bring together all the studies he had made in Virginia the previous year.

He was working on a series of large drawings: *The Calendars, The Plow and the Song,* and *Pastorale*. "The drawings are beautiful and I think he is finding a great satisfaction in their magnitude," Jeanne wrote to Mougouch in Maine. "He does not show them to anyone and so I feel very honored that I have seen them. A painting too he showed one from before your departure which is even in its present state extraordinary."

In the absence of Mougouch, Jeanne became Gorky's chief link to the outside world. She invited Gorky and Nico Calas and his wife to supper. "Dear A. was out to do everyone down on all scores politics saint Freud everything." Attacking Freud, like attacking Shakespeare, was one of Gorky's favorite set pieces. "It was quite fun I thought." She was going to supper with the Levys the following day, but Gorky would not accompany her because "it is night with his guts." It was one of those days when he concentrated on cleansing his body. "All this entertaining for A," wrote Jeanne. "Its rather sweet though I expect it just bores him really." Gorky's intimate circle knew that he was under a strain and they were doing their best to be supportive.

Gorky was increasingly obsessed by the need to dominate his bodily functions, and he found it impossible to accept the changes wrought in him by the

operation. The colostomy, to him, was more than a piece of invasive surgery. It was an attack upon himself from within. He refused to wear the external bag designed to catch the excrement from the hole in his side, but tried to control his bowels by eating special foods. Every two or three days he gave himself a strong enema, which in the long run was debilitating.

The daily process of cleansing himself took a long time, and he insisted on doing it in absolute privacy. Once he was clean, he placed a large square of surgical lint over the opening and secured it firmly in place with tape. To apply and remove a wide band of tape several times a day inevitably chaffed his skin, but when Mougouch suggested that he use an elastic girdle or a tight cummerbund, he adamantly refused. He wanted the bandage to remain flat and sealed, so that for an hour or two he could enjoy at least the appearance of being as fit as he had once been. It was impossible, however, for him to control his intestines as he wanted. The opening made strange sounds and it would suddenly stain the bandage. So, rather than inflict this ordeal on his friends, Gorky preferred to remain alone at home. And that is what Jeanne alluded to when she wrote, "it is night with his guts."

On July 5 Gorky wrote, "I am to begin to paint coming monday. I am sorry my darling for not writing to you sooner. as you see I had to finish that drawing. . . . Perhaps I will be abele to come when I do some painting's you know—oh I want to come I miss you and the baby's so much—all day I talk to myself—and to you and my sweet Maro and Natasha." He had finished a big drawing, later called *Summation*. Mrs. Metzger had bought an old painting: a *Torso* in the style of Matisse, for the huge sum of $1,200. (Gorky later wrote that Julien Levy had "tentatively diducted a commision of 20% as he writes do you think that is all right.")

He went on summarizing a fortnight's gossip for her. Henry Hebbeln wanted too much money for the house in Sherman, and Jeanne had said she could not afford it. During the previous week, he had had lunch with Mrs. Metzger and Dr. Weiss. Then they had gone to the Metropolitan Museum together. He had visited Dr. Weiss for a checkup. "He said I was all right, only have lost few pounds of weiht." Losing weight is generally not a good sign in a cancer patient, but if Dr. Weiss had any further anxieties, he kept them to himself.

He wanted to come up to Maine, but he felt he had to finish his paintings. On the coming Wednesday, he would go to a "little party" at Nico Calas's. He had heard that the surrealist show in Paris "is kiesler's again," meaning that there was a certain competition between Kiesler and Duchamp as to who would be in charge of the big exhibition which Breton was organizing. "As for Jeanne well? We will talk about her when we see each other. you are my only one.——Oh. bah—for Jeanne."

Typically, the key phrases come at the end of a long letter, almost as an afterthought. The dashes are Gorky's way of saying that he wanted to write more but could not find the right words. Evidently he and Jeanne had fought about something. Mougouch wrote to her to ask what on earth had been happening between them. Jeanne replied with a reassuring letter, which nevertheless suggested a break.

> I think that the low pressure is lifting. Arshile tells me that he has not written to you either about our difficulties. We did bog badly but I think I understand now [. . .] he know what he wants which is SYMPATHY not understanding. Can you give people what they want when you know what it is? I will try. If not we just drift away [. . .] I do know that with A, I cant say ANYTHING any more. And I do know that the sore spot of the winter was never healed. Now we have talked about it at last which is something. I know at least what I felt. My wound has mended. I urge A to see Duchamp. They had one very good talk. D will always remain such a stranger to everyone that he could never hurt. A is of course very much in the "throws", the drawings were very beautiful that he made and now he is painting. If he is really getting at something that is eating him then all will be well. He does not show anything now and so one can not know. We went together to Scwartz for the toys and later to the metropolitan I thought we had a very happy time just like the OLD days. It is always such an inspiration to see with A he makes everything gold. We must in the future do simple things to gether and never talk. I did feel that your instinct to go to france was sound and I think you must do this next year. A complete CHANGE new faces landscpes the future. Too much of the past here. I will not go with you because my face is the past.

A sad but intelligent letter. It put an end to any thoughts Mougouch still had of traveling to France. She could not possibly take Gorky to Paris without the support of friends.

Nearly thirty years later, Jeanne told Maro that on the night when they fought, Gorky had ended an evening together by making a strong advance at her. She was completely taken by surprise and she pushed him abruptly out of the house. She had never thought of Gorky in sexual terms, nor had he ever given her a hint that his interest in her was physical. The incident was so unexpected, it was somehow insulting, and it revealed a train of thought in Gorky's mind which was utterly unknown.

There were, she said, two explanations. Either he was seeking to reclaim some kind of dominance over her attention, which by her purchase of works by Pollock and de Kooning he felt he was losing. This was "the sore spot of the winter" which had not healed. Or else Gorky was worrying about his masculinity, perhaps as a result of his deteriorating physical condition. Suddenly, somehow, his virility had to be proved. If this was the case, it suggests a com-

pletely new aspect of Gorky's character. Neither in behavior nor in conversation had this kind of machismo ever been part of his life. And what on earth could Jeanne, or anyone else, have done to attenuate it?

At the time, Jeanne brooded about her letter to Mougouch. It had successfully disguised the real reason why she wanted to keep her distance from Gorky, but all the same, it was a rejection, and neither he nor Mougouch needed a rejection of any kind at the moment.

After many days' reflection, she went back to see him again. On August 2 she reported back to Mougouch, having discovered to her relief that Gorky had forgotten about the whole incident. "I was feeling very disturbed for fear that at that distance and with your own concerns you might have been anguished for Arshile. I think he is alright. He is painting now and I have seen two canvases, and they are very lovely, it is always amazing to me that out of his anguish he always emerges with something that makes no mention of same. What he has painted is like a butterfly or many butterflies lovely fragile and depesonafied." The insight is acute. Gorky never wanted his personal sufferings to be apparent in his work. He was not that kind of artist.

GORKY WROTE TO Mougouch that the heat in New York was unbearable. In spite of his longing to turn to canvases, the big drawings were still not quite done. "I am tacking good care of me and working all day and well making (large) drawing's for painting." Jeanne had seen them and had said she wanted to buy one. He had been to supper with Pierre Matisse, who was about to leave for Paris. "Matta's already have gone" to Snedens Landing, but there were other social plans—the Schwabachers, Julien, Jeanne. "Lionel Abel came this afternoon with his wife he make me speak about painting."

The left-wing author Lionel Abel came to ask for a drawing for a French issue of Dwight Macdonald's magazine, *Politics*. The drawing was highly colored and it turned out later that there was a technical difficulty involved in reproducing it, but when Abel tried to return it, Gorky refused to take it back. He looked ill. When Abel inquired about his health, Gorky told him that he had cancer, "and something, just something, of his other difficulties as a result of having cancer." When Abel, naturally, commiserated, Gorky said flatly, with no self-pity at all that his listener could discern, that, well, perhaps he was like the ancient martyr Job.

Gorky told Abel that Pollock had come to see his new work, and had behaved so rudely that Gorky had felt like throwing him down the stairs.

Meeting each other at a party, Gorky and Abel started talking about Stalin and—of all things—Shakespeare. Stalin understood Shakespeare so well! said Gorky. In the same way that he tackled "saint Freud" and Shakespeare with Nico Calas, Gorky was willing to thrust Stalin at Lionel Abel, knowing that his

listener sympathized with Trotsky. Abel rose to the provocation. What had Stalin read of Shakespeare? he asked. Lamb's tales? He was referring to the simplified version for children. Stalin, said Abel, knew no more about Shakespeare than he knew about art—which was absolutely nothing. At which Gorky, completely serious, said that if Stalin had concentrated on art instead of politics, he would have been on Fifty-seventh Street. Meaning that Stalin would have risen to the very top of the profession.

In a gentler tone, Gorky asked Abel why Harold Rosenberg acted so tough. Perhaps he should nourish a little tenderness inside—a tenderness that could grow slowly from the inside out, in layers, "like an onion."

THE WEATHER IN New York grew still hotter. The sun always was a source of energy to Gorky, and he was working intensely hard. He wrote to Mougouch, "please pray to God so I can do some good paintings." And at the end of July: "When you ruturn I want my harvest to be very big and good." He hoped to come for Natasha's birthday at the beginning of August. "But I have so much work to do before Julien comes back in September [. . .] Mogouch daring have faith in me." In the event, he missed his daughter's birthday. "Please dont feel badly that I did'nt come over—and be with you and see the baby's—forgive me my love—I have to work and free myself with my work— you are with me my darling with out you I could not go on working."

An old friend from Van, Yenovk der Hagopian, the son of the village priest of Ishkhanikom, came to visit him. Yenovk had been away in California and he had not registered the fact that Gorky had been through a colostomy operation. As they chatted about the old days, Gorky kept apologizing for the noises his stomach was making, until Yenovk said, "What is this pardon me business?" Gorky described his physical condition. As with Lionel Abel, although Gorky was specific in describing the terrible state of his body, no self-pity was involved. He wanted to keep his pride, at any price. Yenovk's eyes filled with tears. Gorky leaped up, grabbed the chair Yenovk was sitting in, and held it on high, with Yenovk in it. "Don't you dare cry," he shouted. Yenovk apologized, and Gorky let him down. But why hadn't Gorky told him about it before? Gorky replied, "Is it a wedding to which I must send you an invitation?"

After the effort, Gorky felt so ill he just lay on the sofa, looking like death. For hours he talked about Van. We never appreciated what we had, he told Yenovk. "We couldn't understand everything. Now I know my way. I've found my way. Now I know where I am standing."

AUNT MARION'S LITTLE HOUSE outside Castine was a two-story clapboard building on a simple base of cemented boulders. The ground floor consisted of a small sitting room and a stone fireplace. The surrounding woods

were filled with summer houses built during the twenties, when the stock market flourished. Hers was modest, but some were quite grand.

The garden was filled with ferns and foxgloves which Aunt Marion herself had gathered in the woods and carefully transplanted. It was early summer, and the weather was rainy and cold. Mougouch and the children explored the nearby abandoned summerhouses, some of which weren't even locked up. Raccoons scuttled across the empty floorboards among furniture shrouded casually in dust sheets. Their days, she wrote to Ethel Schwabacher, disappeared in "an unaccountable succession of idle wanderings." Aunt Marion watched over them. There was no housework to speak of. Marion often "bundles me off with my water colors into the woods in the most insistent way," so that Mougouch could get on with her own work—her painting. But once out of sight of the house, she often just lay on the forest floor and listened to the sounds of the tree frogs calling, and slept.

Mougouch had sought the solitude of this place in order to resolve the tension between her various conflicting roles: the mother, the wife, the housekeeper entrusted with power over time and place. The keeper of the future, since Gorky never intervened in matters shaping the family destiny. As long as he could paint . . .

What had initially attracted Mougouch to Gorky was his nobility, and the assurance with which he followed his own inner voice. There was no separation between his identities as husband, as father, as lover, or as artist. Everything he touched, everything he said—that extraordinary jumble of language and ideas—was a path leading to the moment when he faced a canvas, alone. Cleaning the floor, preparing shashlik, were not aspects of domesticity so much as a means of clearing the way to the easel—that easel which Mougouch had once called "golgotha."

In his completeness, however, Gorky seemed to present no surface softer than any other. Now, since his illness, any interruption of his concentration, any deviation crossing his path, was increasingly pushed away not just with indifference but with actual violence. This aspect of Gorky's character came out of nowhere, was never explained, may even have evaporated in a moment—but what were its limits? Perhaps in the part of Russia where he came from—thought Mougouch—violence, and its concomitant, reconciliation, formed part of the normal pattern of family life. But it surely required some kind of explanation, and this Gorky would not, perhaps could not, give.

What this young woman of twenty-five was going through, many women in Gorky's life had experienced before. Though she knew nothing of Siroon Mousigian or Corinne West or Linora, and had only had a glimpse of Marny George, she was not the first to have come up against the intransigence of Gorky's personality. Not the first but certainly the most resilient.

As she relaxed with her own paint box under the trees, alone, the ambition which Mougouch had once nurtured to become a painter herself now seemed, in the face of Gorky's exceptional will, to be just another role, of which she already had too many.

And what, indeed, of her role as daughter? When she and Gorky had met, Mougouch had been following a trajectory that had taken her as far away from her parents as possible—away from China, because that was where they were, away from her classic East Coast Wasp upbringing where feelings were never expressed, and toward the new, toward "Caucasia." This trajectory had now reached its limit. Without any real impetus of her own, she had been reconnected to her parents: by money; by her own memories of childhood, which she discussed regularly with Dr. Harding; and by her children. Maro and Natasha loved their grandparents. Grandpa was lovable-scary in a way that Maro, for instance, found fascinating, and Essie's cosmetics were a source of endless games of make-believe. A family identity was being re-created around Mougouch without the resolution of any of her adolescent protests, merely by the habit of living.

Aunt Marion was one of the few people with whom Mougouch could talk about these things. A Jungian who had spent much of her life in analysis, Aunt Marion possessed a little library of books on psychiatry, some of which Mougouch studied. It was helpful to try to identify the many personae which she, like anyone else, incorporated: the ego, the anima, the id. This was what they talked about at night, long after the children had gone to bed.

Looking back at a distance of over forty years, Maro says that though she was only five years old at the time, she was aware of her mother's unhappiness. She always identified with Gorky and was instantly aware of anything threatening him. Gorky had always been a cuddly father, and there was no lack of physical affection in her childhood. At the same time, in Maine during that summer, she realized that she and her sister were totally dependent on Mougouch for their security. Gorky was in some way absent. He was becoming remote.

It was not easy to feel so dependent on others. Maro felt that her mother had to be constantly entertained to keep her interested. Once, when she was making a drawing, Maro accidentally spilled a bottle of ink on the pinewood table where she was sitting. Though Aunt Marion cared deeply about the simple objects which filled her house, she was not unduly upset, but Mougouch was. She scrubbed for hours without success to remove the stain. She was in tears. The disaster seemed symbolic. She was suddenly aware that in all these years, they had been forced to rely upon the generosity of friends just for the roof over their heads. To overreact at the spilling of a bottle of ink was part of the experience of moving ever aimlessly through other people's houses, like "waifs."

Maro sometimes woke up in the middle of the night because of what she

called "nightmales." She still remembers one. She was going up in an elevator to an apartment that consisted only of a kitchen, with lots of low cupboards and a long counter. She had to escape from the cook, who was an ugly pale man with brown hair, fat, wearing a chef's hat. Red in the face, he chased her into the cupboard, which was full of knives and forks. He bent down and started poking about for her with a long knife. Her father? I asked. No, she didn't think so. The man in her dream was not Gorky. But perhaps the dream had something to do with sexual tension.

GORKY CAME UP to visit his family toward the end of August. He was exhausted. In photographs taken at a family picnic by the seashore, he appears thin and haggard. He had been working intensely and had more than a dozen difficult paintings in various stages of completion back in New York.

After the picnic, Mougouch took up a sketchbook and started to make a drawing. Gorky came over to talk to her as she worked. She should not merely copy what she saw, he said. She should become sensitive to the lines which linked up the objects she was drawing. The line between the swelling tops of the trees, for instance, and the spur of rocks which jutted out into the bay. It was a question not just of the spaces between the objects but of the relation-

Mougouch, Gorky, and Natasha in Maine, late summer 1947

ships which connected one thing with another. They were alive. They were tense. To Mougouch, what Gorky saw in the landscape was not imposed willfully by him for the purpose of making a drawing. They were there.

One evening Aunt Marion took them to visit some friends of hers who lived nearby. Gorky sat in a corner unable to utter a word. The simplest conversational openings made by these good, kind people were received in utter silence. Mougouch, in some embarrassment, had to cover up for him. A week later, after Gorky had gone back to Union Square, Maro went up to a dear old lady at teatime and said, "I'd like to shut you up in a barrel of nails and roll you down the hill." Well, what a peculiar remark to hear from the lips of such a nice little girl! As so many of Aunt Marion's friends had been in analysis, the observation was amply discussed, from every possible angle—perhaps including the obvious: that Maro was acting out her father's aggression toward the outside world.

Mougouch forwarded the photographs taken at the picnic to Gorky in New York. He looked at them constantly as he worked. He even talked to them, he wrote. He had been working night and day. "I am begining to see the promised land. last week I was also depressed.—Mouguch my sweet but dont you be depressed." He gave the family news. Her mother had called. Then Vivi, her sister-in-law. Then Jeanne. "As yet I have not seen anyone. I just went to work, and my work is going so well now, with new excitement; I have been reading What is Existentialism? by William Barrett. (and) Modern Women;— 'The Last Sex.'

"galupcheg dont be angry about this letter; This dreadful letter. I have been working so hard that my head goes round—and round."

There is something touching about the last letters Gorky wrote during that summer. Tired, because he had worked so hard and achieved so much. Dutiful, in reporting the family news which interested him not at all. Keeping contacts open with friends and relatives even though, as Jeanne wrote, fundamentally they bored him. Naïvely optimistic in the conviction that to paint more, better pictures—one every day—would solve all their problems.

I want you all back, with kisses and love and flowers, and clean house, and some paintings and many many kisses and embraces and clasp my beloved wife flower of my hart and light of my eyes [. . .] I have been working all day and cleaning the house by night. yes working and dreaming for your coming home my dear. Oh what a happy day that will be for me come back. I want you dear love. I think I have found a place to work in I hope so—I am to see twomorrow or next day. it is round 10 th st [. . .] Now it is sunday night and I am all alone and out side of my window's someone sings a sad song and my dreamy brow is burning with flames I want to press you and my little girls to my warm bosom. I kiss you and kiss your lovely body my love and kiss my little darlings for me I wite for you.

SHERMAN

1947–1948

UNION SQUARE WAS full of new paintings. His harvest had indeed
been good. In his urge to finish his work, Gorky kept postponing any
practicalities, such as finding another studio for himself or a school
for Maro. He tried to solve the school problem just before they came back, and
went round the corner to look at a Quaker school near Gramercy Park. The
Quakers were gentle and tolerant. The principal, Miss Hoppel, talked to Gorky
at length about his daughter, but "make the long short that they are very sorry
but they will not be able to tack her just now, but they will keep her name—
?———and she will send me the naimes of other schools and so on." The
dashes in Gorky's letter stand for his difficulties in summarizing the problem.

He went to look at a studio on Tenth Street where he thought he might be
able to paint, but decided he didn't like it. He was unsure how to deal with
Jean Hebbeln's offer to let them have a house in Sherman at a nominal rent. "I
think we will waite and talke about Jean and her farm house when you come
back darling."

He had received a nice letter from Vartoosh. She sent her love to the chil-
dren. The last two days, it had rained. He had been to the Metropolitan to see
the portrait of Gertrude Stein by Picasso and the "silfportrait of our Ingres."

They were "not so bad, but?" Then he had visited the antique rooms. "The persians art is great, I feel compelled to tell you this my Mouguch because it pleases me so much. I adore those sick and lovely persian civilisation which reveals there ancient custom's to me, which is deeply impregnated with my own. . . ."

Whereas in his early days Gorky had centered his thoughts about art on composition and structure, in his later years he responded mainly to feelings in art. "Sick and lovely" is a recognition of decadence, to be sure, but also suggests a sensitivity to emotions. "So unfelt, as Arshile would say," Jeanne wrote about a colleague's exhibition. Like his expression "panting," it was a declaration of vulnerability.

MOUGOUCH AND THE CHILDREN came back in mid-September.

The day before her return, Mougouch phoned Gorky to ask if she could stay for a day in Concord on her way down, to see an uncle. Gorky said no and put the receiver down. Aunt Marion called again and found that Gorky considered the subject closed. Mougouch was his wife. He had spoken. Aunt Marion tried to reason with him. Gorky, losing patience, told her that when his wife came back, he would "beat the devil out of her." Aunt Marion told him kindly that he wasn't even to think of such a thing: "We don't beat wives in America."

The family was reunited. One by one their New York friends returned from their summer vacations. Life went on. Gorky showed his new work to various friends, of whom Matta and David Hare were the most enthusiastic. But nobody made the kind of fuss over his work that Breton had made three years previously. The world was changing. New York was less of a tight, beleaguered garrison and more of a cultural metropolis in search of ways to impose this claim upon the rest of the world. Gorky's recent work was good—was excellent—but lots of other interesting things were going on at the same time.

They saw quite a lot of Julien Levy, as another one-man show was scheduled for the following March. Mougouch tried to make Levy confirm his promise to raise Gorky's monthly check from $175 to $200. Levy was vaguely optimistic. Late in the year, Gorky ran into his old friend Dr. Sandow in Washington Square. Sandow was delighted because, after many years, he had received an increase in salary at the institute where he worked. Early in his career, at a time when racial integration was still contested in the world of medicine, Dr. Sandow had championed a black research student, which had caused difficulties. Gorky told Sandow that he, too, had had a raise; "and so they hugged each other."

Maro was sent to a kindergarten where she immediately got into trouble for breaking a piece of a wooden jigsaw puzzle. To stop her screams, the teacher put a piece of sticking plaster over her mouth and stood her in the corner. She

was removed from the school. Walking in the park, her father hurled a ball so high into the air that it never came down. In the sandpit in Washington Square, a boy threw sand in her eyes and they had to take her to the doctor. She hated the city. Looking up at the skyscrapers, the buildings converged into one huge eye of sparkling steel and glass, projecting from a central iris of bright, inescapable blue.

They decided to accept the offer for the Hebbeln house. The Hebbelns had prepared it especially for them; it was hard to say no. On the other hand, because Gorky had burned down their barn two years previously, a layer of emotional debt overshadowed the offer. Both parties tried to write something down on paper, to make the arrangement less of an informal agreement between friends. But it was not easy to tie down their friendship in a legalistic vocabulary.

They rented out the studio at Union Square. The paintings were stored in one of the rooms off the studio. Everything else was moved out: clothes, work materials, books. Shifting their possessions from Union Square took three or four trips in the station wagon, and they were both exhausted. On the third trip, Mougouch was so tired she could not make the car go faster than thirty miles an hour. It was as if their own weariness had affected the motor.

Aunt Marion came down to Sherman for Christmas, where a quiet, affectionate family celebration took place.

SINCE AKABI'S DEPARTURE for California the year before, Gorky had lost contact with his Armenian family in Watertown. Over Christmas, Satenig rang with some bad news. Sedrak, Gorky's father, had died.

The story she told was incredibly pathetic. Sedrak had lived in the house of the shoe salesman for eight or nine years. The salesman's triplet daughters, of whom Sedrak had taken such care when they were little, eventually grew up. They needed his room. They were earning money, his Social Security check was no longer necessary, and they asked him to leave. He tried to go back yet again to his elder son Hagop, but the arrangement had not worked before and it did not work now. After Hagop's rejection, Sedrak could have turned to Satenig in nearby Watertown. He might even have contacted Vartoosh in Chicago. His son Gorky was living in Sherman, which was not too far away. If the worst came to the worst, he could even have contacted Akabi in California. But he had had enough. Sedrak went to the nearest hospital and asked for a bed. He was not ill, and his body was still quite fit, but he refused to eat, and after ten days or so he died.

None of Sedrak's children came to the funeral. Even Hagop kept away. Only Hagop's two sons, Charley and George, attended.

Gorky had never become close to Sedrak. He used to pretend that the

moment on the shore of Lake Van when his father had given him a pair of slip-
pers and ridden away into the mists had been the last time he had ever seen
him. He could not tell his wife or anyone else of Sedrak's death, given the fact
that he had never told anyone that his father was alive.

However weak his affection for Sedrak, it is unthinkable that he just
shrugged off the event. In the hierarchical world of Van, the passing of a father
signified the moment when his sons fully assumed their responsibilities.
Before the death of the father, the child remained a child, however old he was.
Except that in this case Gorky himself was only too aware of his own mortality.

The painting *The Orators* is sometimes connected with Gorky's reaction to
Sedrak's death. Even though the composition had been started several months
before, the black weeping figures are somehow present. Julien Levy in his
book quotes Gorky: "My father's death, and everybody making big orations
while a candle gutters out like a life. I didn't love my father very much, but I
know about Armenian funerals." Since Gorky never talked about his father as
anything more than a mythological figure, there must be something wrong
with Levy's memory. Perhaps Gorky mentioned the funeral of his grand-
mother, Hripsime the God-killer? To Mougouch, Gorky said that the title of

Arshile Gorky, *The Orators*, 1947–48

this work was inspired by the orators of Union Square, who on their soap-
boxes preached the apocalypse with arms waving in the air, like the branches
of the surrounding trees. The composition comes from a landscape drawing
made in Virginia in the summer of 1946, but its darkness could easily have
invaded the painting after Gorky heard of Sedrak's death.

Clement Greenberg reviewed the Whitney Annual in January, and he
described Gorky's *Calendars* as one of the best paintings ever done by an
American. He wrote that it had passages which reminded him of Miró and
Matta, but the artist had added "a richness of his own." Its Frenchness was
astonishing, but beyond its good taste, it contained "a plenitude of matter." He
saw it as a mannerist work, though in a modern idiom. Greenberg's observa-
tion recalls Breton's comparison of Gorky to Toulouse-Lautrec.

The Calendars has much in common with *The Orators,* both in the way the
paint is applied and the device of suspending the composition from the top of
the canvas. What the title signifies is anyone's guess. Like all Gorky's titles, it
was given after the work was finished. The work does not depict the title; the
title was merely evoked by the work. *The Calendars* is associated with another
painting, called *Days, etc.* This title Gorky picked from a line by Paul Eluard:
"Days, like fingers, unfold their battalions." What might have been present in
Gorky's mind when choosing all these names was the idea of time passing.
Time drawing to a close.

THE RAISE about which Gorky had boasted to Dr. Sandow in the park ran
into difficulties. On January 15, 1948, Mougouch wrote to Wolf Schwabacher
that Julien had told Gorky he was going to give him an extra twenty-five dol-
lars a month, and Gorky had pointed out to him that it wasn't a raise so much
as a gesture to cover the increased price of art materials. Julien had then agreed
that fifty dollars a month was fair, but now he was talking about receiving
more paintings, "or whatever pro rata means." Gorky, she said, was anxious—
though of course, when the Levys had come to dinner recently, he hadn't even
mentioned the subject. He would like to come and talk to Wolf about it—or
wouldn't they both like to come for the weekend? "Its so like fairyland in the
snow I'm sure you'd love it—Life magazine is underfoot today and tomor-
row—They are doing the house & how we live in it—any plugs for Gorky will
be purely incidental."

Two French galleries wanted to show Gorky, she continued, one in cooper-
ation with Julien, one without. In the event, neither of these openings suc-
ceeded. In his last months, Gorky longed to receive a letter from Breton saying,
Come immediately, a gallery awaits you and all has been arranged. But Breton
was engulfed in a fight to the death between surrealism and existentialism,
and the moment was not yet ripe.

Gorky was unable to take any initiatives with Julien Levy or with André Breton, or indeed with any other figure of authority. Willem de Kooning, the most sensitive of his friends, said that Gorky had always had "a certain, you could almost say, a little weakness for recognized characters. He was innocent there. He was awfully innocent about that part [. . .] He could be overcome by any authorities [. . .] It's like a lack of confidence or something. But if he was working, he had no lack of confidence at all. So I could never figure that out."

In Gorky's scale of values, there were gods, like Picasso and Miró and Cézanne. Then there were rulers, like Breton and, perhaps, Julien Levy, the keepers of the keys to success. Then there was himself. And finally, lumped into an indifferent group about which he seldom thought, there were all his colleagues. Years ago, he had abandoned the idea of belonging to a group of artists who set out to storm the citadel together. Temperamentally, he was not equipped to share. He could lead on occasion, but even this bored him, especially if he felt that his followers were taking too much knowledge away from him. Increasingly, Gorky saw his old friends and colleagues in New York as "snakes in the grass," lurking in the undergrowth waiting to strike. Better keep away. There were even stranger expressions. So-and-so was a "throat-cutter." It could bring a smile to hear such a bizarre metaphor, but the attitude of the one who used it was not friendly.

Gorky felt that he deserved a good gallery on Fifty-seventh Street, and he was not interested in anything else. But in those days the divide between uptown and downtown was absolute. Between the lofts and studios of the Village and the glittering walls of Fifty-seventh Street lay an imaginary river, as perilous to cross as the Styx, as liable to induce forgetfulness as Lethe. It required persistence to arrive uptown, and if you tried too hard and failed, you lost your friends and ended up with nothing.

The inhabitants of uptown and downtown were differentiated even by their clothes. According to Simone de Beauvoir, who had accompanied Sartre on his visit to the city in 1945, uptown was "feather, sequins." Downtown was "low-heeled shoes, flannel slacks, men in corduroy jackets, bohemian affectation perhaps, but I prefer it." When she visited the Plaza, uptown, she found that "the great room furnished in dark oak was overheated and overcrowded. I looked at the people. The women amazed me. On their impeccably waved heads they wore whole flower-beds and aviaries."

Some artists managed to remain immune to the tensions between these two different worlds. Some never became uptown, however successful they were. Neither Pollock nor de Kooning was ever an uptown artist, even though they both grew to be leaders of their generation. De Kooning never liked the

Museum of Modern Art, even when he attended his own retrospectives there. Calder, instead, was an uptown artist without even trying. His father was a famous sculptor, and his wife was Henry James's niece. No amount of casualness in manner could make Sandy Calder un-chic.

As Gorky entered his fourth season with Levy, it was clear that he had left many of his old friends behind. "Most of Gorky's old friends were supplanted by the Surrealists," wrote Saul Schary. "His old friends had been weeded out." And Balcomb Greene: "With the establishment of a 'continental colony' of artists in New York, Gorky sought to become a part of this synthetic society and seems to have managed it."

"He had these two conflicting desires in himself," as Rosalind Bengelsdorf Browne put it. "One was to get set with patrons, which is natural for an artist, and the other was to retain his integrity in art. And I guess it was just too much for him."

To cover their sense of loss, many former friends argued that Gorky's move uptown was somehow not his fault. "He got mixed up with a swarm of migrant Surrealists who fixed him up pretty good in more ways than one," as Stuart Davis wrote ten years later. He had been "buzzed, wafted, fluttered [and] be-limed." "He was the white-haired boy of Breton and the Surrealists," as Barnett Newman put it. "They were a separate group." This was how downtown reconciled itself to Gorky's betrayal. Clement Greenberg's emphasis on the "French" quality in Gorky's work was a sophisticated expression of an unsophisticated thought, which at the time was voiced in cafés by those in the know.

De Kooning told Maro that he hadn't seen her father anymore after he'd been taken up by "those Connecticut Puerto Ricans."

THE *Life* magazine article appeared, and sure enough, its only reference to Arshile Gorky was as "an artist." After so many years of struggle, he was only *an* artist! The writer was more interested in the structural modifications of the house, the wall of glass replacing the "weather-ravaged clapboards," than in Gorky.

On one of their trips to New York to prepare for his next show, Mougouch and Gorky went to a party given by Matta. The painter Barnett Newman came forward and complimented Gorky on the article in *Life* magazine. Gorky wondered if perhaps he hadn't looked sad in the photos accompanying the article. No, not really, said Newman, "I thought you looked sort of quiet." To which Gorky said, To hell with *Life* magazine. The important thing was life.

As the conversation lightened, Gorky told Newman the reason why he had come to America. "Well, when I was a young boy in Armenia, my mother used to take me to church. And every time I went to church, I was always struck by

the fact that the devils were all black and the angels were all blonde. Then later I heard that in the United States, all the girls are blonde. So I figured they were angels. So I came to this country."

Newman did not know Gorky, and the tone of voice in this story is Newman's rather than Gorky's. But the anecdote itself is convincing. It is also a little sad. Once, the childhood image of the blond angels and black devils had meant something profound to Gorky. It was as if, having thought about it so deeply and for so long, the original meaning had worn out. Now it was just a nice story about irresistible American girls.

Sandy Calder saw the piece in *Life,* thought Gorky deserved something better, and sent round a local reporter. An article duly appeared in the *Waterbury Sunday Republican,* headed: "Modern Wall Applied to Old Sherman Farmhouse Interests Builders but Its Most Interesting Feature Is Its Tenant, Arshile Gorky with His Fresh Ideas About Art."

Gorky told the reporter that he had been born in Russia but preferred to describe himself as an "early American"—a settler, who appreciated the country more than those born here by lucky accident. He had been to Brown etc., etc. He disliked being called a foreigner and felt at home only on the East Coast. "Once when he and Mrs. Gorky decided to see what the West Coast looked like, they got as far as the Mississippi when he felt he was too far from home and wanted to come back. Since then they have never strayed far from Connecticut." A curious remark. As if the fight at the bridge, when Noguchi had maddened him by contradicting his description of forms in the clouds, had become the moment beyond which he ceased to want to remember San Francisco.

They liked living in Sherman, continued Gorky. There were always new beauties to be found around them. That was the way beauty was always found, wasn't it? By accident. "You don't recognize it when you are looking for it, and you won't recognize it by looking in a magazine. It's right here in the moon, the stars, the horizon, the snow formations, the first patch of brown earth under the poplar. In this house we can see all those things. But what I miss are the songs in the fields. No one sings them any more because every one has become a little business man. And there are no more plows. I love a plow more than anything else on a farm."

When Gorky saw that the reporter was taking down his words, he reproved him, but courteously. "You're just like a sponge. Newspapermen in New York are just like steel—nothing you say sinks into them. They are strong and they shine and reflect rather than absorb. Strength is the most miserable quality you can have. You must be elastic, like rubber, to take everything in; then let it out and take your own shape again."

. . .

GORKY'S LAST ONE-MAN SHOW at the Julien Levy Gallery opened on February 29.

Those who came were members of the world of art appreciation rather than fellow artists like himself. That in itself was not necessarily a disappointment. Had he not longed to leave downtown and stake his claim on Fifty-seventh Street? But the audience was subdued rather than impressed. Many were puzzled by the work. Ethel Schwabacher overheard one guest say that they were "too like Miró." Another found them "confused."

Julien Levy took the perplexity of the audience in his stride and was willing to expound on every painting in terms of its psychoanalytical content. To overhear Levy explaining his work in terms of Freud and Jung was a real torture to Gorky. Why were verbal explanations necessary, anyway? They were so distracting. Not just one or two people seemed to need them but, as Mougouch wrote to Ethel two days later, "even ones whom we thought didn't go symbol-snatching."

One painter teased Gorky about the lightness of this new work. Gorky wouldn't ever challenge strangers to lift these paintings, would he? They weren't like the old works that had made even strong men gasp when they tried to lift them, were they? Why, anyone could lift these. It would only take a finger. Pointing at one of the thinnest works, John Ferren asked him, "Isn't it a little little?" Gorky avoided a confrontation. Maybe it was, he said. But this was all he did now.

After the opening, Gorky and Mougouch stayed at Jeanne's new house down on Eleventh Street. Henceforth this brownstone in the Village was to be their base in New York. Gorky was tired, and would probably have preferred "the simple festivity of dance and song he had known in his childhood," as Ethel put it. Instead, what he got was a sophisticated New York party with all the latest gossip on surrealism.

The next day, they had lunch with the Schwabachers, and Ethel told him how much she had liked the exhibition. She used straightforward language, knowing he would resist anything too obtuse. She wanted to write a book about him, and Gorky gave his approval. They discussed what form the book should take. Gorky had liked Robert Melville's book on Picasso. Had Ethel seen it? Might she take it as a model? What she should do, she replied, is come back one day and record what he wanted to say about art. Unfortunately, she never did.

ON MARCH 20 Clement Greenberg wrote a favorable review of Gorky's exhibition for *The Nation*. Like his piece about Gorky's *Calendars* in the Whit-

ney Annual a month or two previously, it persisted in stressing the "French" quality of Gorky's work. But Greenberg also wrote that Gorky, at last, had "taken his place among the very few contemporary American painters whose work is of more than national importance."

The phrase "more than national importance" implies that American art possessed a supranational role, and that Greenberg was the one to define it. It is a continuation of the argument which the Federation of Modern Painters and Sculptors had proposed six years before—that the United States should "accept cultural values on a truly global plane." The war was over. America had undeniably saved the cultural values of the West. But as far as art was concerned, to European eyes America was almost an unknown quantity.

In 1938 an official exhibition sent to Paris had included Grant Wood and Thomas Hart Benton, and the critics had been devastating in their comments on the provinciality of American art. Paris expected to find certain features in American painting: youth, enthusiasm, spontaneity, energy, perhaps even lack of control. "My idea of America," wrote André Masson at about this time, "like that of so many French, was, and perhaps still is, rooted in Chateaubriand. Nature: the might of nature—the savagery of nature—the feeling that nature may one day recover its strength and turn all back into chaos." In other words—one might say—Jackson Pollock, whom Greenberg had already placed firmly in the "mainstream" of American art.

Greenberg always possessed extraordinary self-confidence as a critic. He had the ability to walk through an exhibition passing instant judgment. This painting is the best made in America last year. That one is no good at all. An unshakable assurance, based on the knowledge that the voice with which he spoke was, today, that of a small but influential political group, and which tomorrow would be America's.

What did he see in the Levy gallery that afternoon? Over there, *Soft Night*—"perhaps the most interesting and promising if not quite the best picture present." Gorky, then, was an artist of importance. Some canvases attained real sonority and resonance. Yet at times his art was not incisive. It lacked fullness of body. The large drawing in Mr. Levy's back office did not impress Greenberg. It revealed the weakness that accounted for Gorky's unsuccessful works. In this drawing, his exceptional gift as an automatic draftsman was undermined by the lack of an idea capable of binding the calligraphic details into a whole. Gorky, he wrote, "should rely more on the movement of his whole arm rather than on that of his wrist or elbow alone."

Although Mougouch wrote enthusiastically to Ethel about Greenberg's "amazing article, leading to quite a confusion of joys for a balmy spring day,"

Gorky himself was indifferent. What he longed for, but never got, was a full-page rave review by Jewell of the *Times*. The implications behind Greenberg's piece—American art as an instrument of world domination—were quite beyond him, and the technical tip on how to improve his drawing was the last thing he needed.

ONLY ONE PAINTING was sold from the exhibition: *Soft Night*, for $700. Perhaps Greenberg's praise for this work helped Julien Levy to find a buyer.

Of the nine works which Levy sold during Gorky's lifetime, two were sold to Jeanne Reynal, one to Ethel Schwabacher, one to Mrs. Metzger, and one to Yves and Kay Tanguy. These were buyers that Gorky had himself brought to the gallery, and as usual when one is selling to friends, doubts cloud a sense of gratitude. Mrs. Metzger's payment of a huge sum for an old painting, the *Torso* which *Art News* had called a "piece of archaism" more than ten years before, somehow implied that she had no liking for his recent work. Jeanne Reynal's acquisition of paintings by Pollock and de Kooning suggested that her interest in Gorky might not go on forever.

Of the four remaining sales through his dealer, one was to Julien Levy's father, who had an interest in supporting the gallery. Two years later, Levy forgot about the sale and returned it to a group of unsold works. New clients found by Julien Levy for Gorky's work, genuine fresh admirers as it were, numbered just three. From Gorky's point of view, it looked as if Julien was making no effort. He heard through friends that the gallery was often closed. That certain works had been inexplicably withdrawn. That Levy turned away prospective clients, saying nothing was for sale. Once, Gorky found his drawings all over the floor of the gallery and the assistant jumping in and out of them in his tennis shoes. Was this the way to treat his work? Gorky could put his own works on the floor and step on them, if he felt like it, but why should Julien Levy's assistant do so?

Levy was not a precise businessman. Neither he nor Gorky had ever made a list of what had been delivered to the gallery. Levy himself writes of "my lack of avarice, my downright foolish but basic disinterest in or distrust of business drive or making money." Keeping accounts ran counter to his idea that an art dealer should be a "prince"—a strange word which comes into his memoirs more than once, suggesting that Levy saw his role in a purely romantic light. "It seemed almost immodest to look closely at the immaculate line between profit and loss. It was as though if we were to really cross from the red to the black we might find ourselves in heaven; we would perhaps, in poetic fact, be dead."

In Levy's defense, it has to be said that at the time it was not easy to sell contemporary works of art. As his former assistant Eleanor Perényi put it, referring to a later period in her life when she handled Pollock, Gottlieb, and Rothko, "We would have gone on our knees to you if you'd been willing to pay $200 for any one of them."

Nevertheless, by his laziness, or through a contorted idea of himself, or in the calculation that his paintings would be worth more later, Levy had succeeded in placing Gorky in an awkward position. Either Gorky had to renegotiate his contract immediately, which he did not dare attempt, given his respect for Levy as a "man of authority," or else he would have to paint so many new works that he could afford to abandon Levy without worrying what Levy's next move might be. There was always the risk, after all, that Levy would flood the market with unsold Gorkys if he left his gallery. Such things happened. It was important to bring matters to a head soon, as another year without sales would merely make Gorky's position worse. But by the time his show came down, worried about the state of his body and confused as to what direction his work would take next, Gorky began to realize that he simply did not have the energy to produce such a huge body of work. The summer of 1947 had taken a lot out of him. It was impossible to imagine creating so much, so fast, again.

AT THE END OF MARCH, a fortnight after his show with Julien Levy opened, Ethel and Wolf Schwabacher visited the Gorkys in Sherman. Ethel was disturbed by how lonely Gorky seemed. He took her into his studio and asked her to use his paints and start working herself. She refused. He then showed some of his recent paintings, including the work which after his death was called *Dark Green Painting*. Again, he urged her to work. In Gorky's last year, he frequently invited friends to help themselves to his beautiful collection of artist's materials, implying that he would not have time to finish them himself.

Mougouch gave no hint to the Schwabachers either then or in her letters that Gorky had recently been threatening suicide. His moods were not a subject of discussion.

After lunch, they went for a walk. Gorky pointed out the green of the pine trees and the red-brown of fallen needles, which had found their way into the painting he had shown her that morning. Then, "as we looked at the white snow a strange breath of icy wind seemed to shake Gorky. I could not help feeling that the whiteness invaded him with a sense of emptiness and finality; now that the sun was sinking it was bitter cold."

■ ■ ■

Arshile Gorky, *Dark Green Painting*, 1948

THE HOUSE IN SHERMAN, Connecticut, which the Hebbelns had pre-
pared for Gorky stood above a curving dirt road on a small rise of land. There
was an old barn on one side, an orchard, an abandoned vegetable patch, and,
hidden from the road, an irregular lawn enclosed by low bushes. To the south
of the house was a long view down a pasture, traversed by the drive up the
hillside to the Hebbelns' house. Some fine trees on the fringe of a forest hid the
nearby hills, through which wound a stream with a little waterfall. The view
was attractive, but it was not a lush romantic landscape on the scale of
Crooked Run.

The building was a classic New England clapboard house, originally a rec-
tangular barn, turned L-shaped by an extension. One side of the building had
been replaced by an insulated plate-glass wall. Light filled the house. The
large window transformed the building into an eye, looking in, looking out.
From the little landing on the staircase, holding on to the banisters, the chil-
dren peered down at the lower floor, or looked out through the plate glass onto
the landscape.

The room with the glass wall was the core of the building, with the con-
stant to-and-fro of family life. Gorky worked in the extension, formerly a
woodshed, now a studio. It was not as big as he wanted, but it was enough.
A newly installed skylight, breast-high, gave out onto the edge of the garden.

Gorky and his family in Sherman, Connecticut, February 1948

The easel stood between Gorky and the door, and the light struck the canvas from the left, as at Union Square.

Maro was taken to a little school on a lake a few miles away. When she came back in the afternoons, she tried to sneak into her father's studio. She was fascinated by its close mood of work. The pencil-sharpening machine bolted onto one side of the drawing table, which made rosettes of delicate wood when you turned a handle—stars, which lay faceup on the bench and crumbled if you touched them. The larger shavings from his block plane, like Goldilocks' curls.

Gorky was shut in there for hours. The atmosphere in that last house in Sherman, Maro remembered, was tense. In the large central room, on a low sofa by the big window, she cut hearts from sheets of colored paper and stuck them in patterns side by side. That was a world she could control. The real world had frayed, uncertain boundaries. She listened to her gramophone—a box with little men inside it—playing the same records again and again. "Tom Pearce, Tom Pearce, lend me your grey mare, all-along, out-along, down-along, lea." Until one day Gorky came out of his studio and smashed them.

By now each of Gorky's daughters had her own character, and while he adored them when in the right mood, when they behaved badly or he was working hard, he was unable to cope. To the reporter from the *Sunday Republican,* he showed their paintings and said, "She paints like a little bird. And this other, the young one did. See, she paints on both sides of the canvas. She is more like a passionate plumber." Seen from above, his daughters were objects of love—a love so intense as to be almost an undirected sentimentality, quite separate from the children's personalities. Sibling rivalry, as a phase of character development, completely unmanned him. Once, when Maro and Natasha were shut up indoors in front of the big window, squabbling, Gorky suddenly overreacted. He picked up Maro and hurled her across the room. What did she

want to do? he shouted. Kill her little sister? Such scenes were rare, but they came without warning, and there seemed to be no middle ground between blind love and blind rage.

THE SNOW REMAINED around the house for far too long. Maro made friends with a little boy up the hill called Biffer, who was her savior. He promised that he would protect her from John Prince, an imaginary ogre who left footprints (= Prince) prowling round and round the house. An insecure child in a world dominated by one powerful man, she needed some other figure to stand up to her father. At Easter her parents gave her a sugar Easter egg with a hole in it. Inside, was a little landscape made of colored paper. Peering in, she wished she could live there, not here.

When the spring at last brought fresh flowers to the grass and frogs singing down in the gullies, Gorky wandered about outside, trying to start up a new idea. He did not want to paint from his Virginia drawings; he had dedi-

The *Life* magazine photograph of the house, looking in

cated the previous year almost exclusively to them. The hill behind the house was filled with interesting places, and they were living near where he had isolated the theme of the *Waterfall,* a mere five years previously, but he found to his distress that Connecticut did not inspire him. He came into the living room to ask Mougouch for an idea, only to reject any suggestion she made. It worried him that the human figure was so absent from his work. He wondered if it were possible, today, to have a new idea about the human figure. She suggested he return to portraits, as it had been a while since he had made any. He started one of her, and was disturbed to find that he was unable to paint from life.

There were good days now and again, especially on the unfinished canvases he had brought down from New York, including a new version of *The Limit.* "Gorky is scraping & painting furiously," Mougouch wrote to the Schwabachers, "erupting now and then from his little studio to hug someone then rushing back in." Still, in spite of the scraping and scouring, there was nothing which added up to a corpus of material leading in a new direction, which, after his exhibition, was what he most needed. He had brought with him a number of scumbled, thin, but textured works, in which color comes out from the background to overwhelm the line. Gorky himself was unsatisfied. It was not quite "there" enough for him. In his last interview, Gorky had talked of the transient state of his ideas. "I don't like that word, 'finish.' When something is finished, that means it's dead, doesn't it? I believe in everlastingness. I never finish a painting—I just stop working on it for a while. I like painting because it's something I can never come to the end of."

Every six weeks or so he visited Dr. Weiss in New York for a checkup. He reassured Gorky that he was doing well. When Mougouch asked for more precise information about the state of her husband's body, Dr. Weiss said cryptically that Gorky "won't ever be a truck driver again." She had not married a truck driver, she said, but . . .

All four of them used to go into the city when Gorky's appointment with the doctor fell due, staying a day or two with Jeanne. Whereas to the children the house in Sherman was fraught with tension, Jeanne Reynal's brownstone in New York was paradise. Jeanne had blue hair, like the blue fairy in "Pinocchio." She allowed Maro and Natasha to play with her kachina dolls, of which she had a large collection. Masks and Thompson Indian necklaces hung on the walls: strange wreaths of bear's teeth, and monkey's claws. There were crystals, and orchids, and cacti, and parrots, and Hopi masks, and Urban's collection of fishing flies—delicate feathers, wispy, clumpy badger hair in tiny boxes. From the gramophone came the voice of Yma Sumac, whose range spanned the lowest notes in the bass to the highest soprano, and on upward. An extraordinary

sound, not quite human. Jeanne's was a perfect house for children. Lots of different miniature objects each twinkling in its own cozy world.

The children brought their anxieties with them to the city. Once, looking out from the top window, Maro saw the dark outline of a man in a fedora looking at her through the glass. She sat up screaming. She knew her room was three stories in the air, and that the man at the window had no right to be there.

A FORTNIGHT OR SO after the opening of his last exhibition with Julien Levy, on one of their trips to New York to see Dr. Weiss, Gorky ran into Milton Resnick and Bill de Kooning near Jeanne's house on Eleventh Street. They told him how much they had admired his recent show. Just a few lines and smudges, as Resnick remembered them, on fine, beautifully chosen canvas. Very impressive. Beautiful. (As with John Ferren, it was the emptiest canvases which had made the biggest impression.)

Walking with them toward Union Square, Gorky talked of the difference between thinking a line and making a line. He said that he had discovered that he could plan to put a line in one place, then casually put it elsewhere, and yet find that what he'd done without thinking worked better than his first idea. In other words, the canvas itself was sensitive. It possessed its own meaning, even in conflict with his own. "The canvas was there in front of him, and the canvas told him where to put it."

Puzzled, he turned to them as if to push the argument forward and said fiercely, "No eyes."

Resnick understood this to be a continuation of Gorky's train of thought, but de Kooning took it personally.

What did he mean, no eyes?

Gorky muttered, "Never mind," and rushed off.

As de Kooning walked on with Resnick, his anger increased. What did Gorky mean, no eyes? As everyone knew, de Kooning always began a portrait with the eyes. It was a well-known fact downtown. People in bars even made jokes about it. "Does he think I'm an illustrator or something?" Resnick and de Kooning argued about it all night. De Kooning was unable to take Gorky's point in its own context. In the end, he turned to Resnick and said, "I don't care what you think, great art *is* great illustration."

AS THEY WERE DRIVING back to Sherman from New York, Gorky's intestines suddenly "exploded." They got out of the car. Mougouch wanted to help him, but he would not let her come near. She insisted that she knew what had to be done. After all, she told him, she was the mother of two children,

and this part of life was absolutely normal to her. He refused again, violently shrugging off her proffered hand. He struggled away from the car to be by himself, shouting and waving his hands in the air.

After many months of dieting and enemas, his strength was failing. Weakness affected his capacity to paint, not only in terms of the hours he was able to keep working but because the way in which he tackled a canvas had always been physical as well as mental. He demanded of himself not merely exceptional skills; he had to *feel* that these skills were there. The kind of courage which Matisse found in his old age, drawing on the ceiling of his room with charcoal tied to the end of a stick during long sleepless nights, was not Gorky's. Matisse was an example of a creative mind shaking free and rising above the imperfections of the body. But Gorky's attitude to his body was completely different. Health, energy, and, above all, control of the line, control of the urge behind the line, were all tightly bound together, and he could not lose one gift without jeopardizing the others.

Over the next few weeks, he descended from a reluctance to engage in any kind of physical contact to a psychological rejection of his wife's presence, a rejection connected with an increasingly tortured relationship with his own body. She herself was longing to help, especially in this matter of cleansing his wound. It would be, for her, an act of love. He would have none of it. In itself, his reluctance to be touched could perhaps have been respected, but it became part of a refusal to consider any expression of emotion offered to him by his wife. It stood at the center of his increasing solitude.

Though he refused to let her come too near, Gorky became just as anxious if she ever left his side, even for an hour or two to drive down to the grocery store. To add to the emotional stresses of that terrible spring, Mougouch wanted to visit New York more often in order to see Great-aunt Marion, who was alone in her small flat in Murray Hill, seriously ill. On her last visit, Marion said that she should come back before the Monday, as otherwise it would be too late. Gorky absolutely refused to allow Mougouch to leave Sherman, and Aunt Marion died before she was able to get away.

Gorky's difficulties were known to a number of people, and friends came up from New York to offer him their moral support. One weekend Nico Calas's wife, Lola, saw Gorky take a rope with him as she and the children set out for a walk after lunch. Nearing the wood, he asked Maro to choose a suitable tree from which to hang himself. Lola was appalled. "I told him he should not talk about such things in front of a child."

The rope was a familiar possession of Gorky's. The scene was repeated a number of times in front of the weekend guests: Gorky leaving the house with his rope. Once, Mougouch sent the children out after him. Daddy is going to

make you a swing, she said. And, in fact, he did. He started playing with the children and forgot, for a while, whatever he had intended to do.

RAOUL HAGUE MET Gorky in the last few months of his life. Since Hague was an Armenian from Constantinople, he assumed an old town-and-country relationship with Gorky whenever he saw him. How about those slow country people born in the provinces? When he had last seen him, Gorky had been perfectly capable of joining in this kind of give-and-take. Those Armenian porters who used to carry heavy loads on their backs, all around Istanbul. Big mountain people, all brawn and no brain. So backward! Now, to Hague's distress, Gorky's eyes filled with tears. Such innocent people, he said miserably. How could Hague mock them, working so hard, traveling so far on behalf of the families they loved. Hague looked at Gorky. This was the man who only a couple of years before had enjoyed throwing an armlock on his friends as they left a restaurant. It was true that they had not seen each other for some time, but Gorky now seemed like a man with no control over his own emotions.

Later, Hague saw Gorky sitting by himself at a bar and once again tried the kind of teasing that used to be perfectly normal back in the Old Country. "He started talking to me about his operation. I had not heard about it and because I often joked with him over the years, I thought that he was exaggerating and that there had really never been an operation, that he was putting me on." So Hague joshed him about it. "And when we parted I was laughing." Looking back toward the café, however, Hague saw that Gorky's head was bent down.

LAST SIX WEEKS

1948

W HEN GORKY VISITED Dr. Weiss at six-week intervals, the possibility that he might be dying was not a subject they discussed. It was a burden which Gorky faced alone. His body was his own domain.

Vartoosh, worried about her brother's health, asked a close friend who was a doctor to contact Dr. Weiss. Dr. Hampartsoum Kelikian, at the time surgeon general to the U.S. Army, obtained the necessary details and concluded that there was little hope. He had seen Gorky once before concerning an ailment, the details of which he always kept to himself. Gorky trusted him. A family legend has it that Dr. Kelikian warned Gorky, "as man to man," of his impending end.

On Sunday, May 23, Frederick Kiesler and Marcel Duchamp drove out to visit the Tanguys and the Gorkys in Sherman. A photo was taken: Marcel modestly hiding behind his friend Maria Martins, Gorky towering above his guests, his face anxious and unhappy. Mougouch was not with him at the time, having taken the children to see their grandparents in Virginia. She came back a day or two later, leaving the children with Essie.

On June 1 Mougouch gave a large party for her twenty-seventh birthday. Gorky built a fire in the garden for the occasion, so huge, so uncontrollable that it nearly burned down the Hebbelns' property all over again. Their neigh-

Maria Martins, Marcel Duchamp, Mrs. Enrico Donati, Gorky, and Frederick Kiesler,
Sunday, May 23, 1948

bors came: the writer Malcolm Cowley and his wife, Yves and Kay Tanguy, the painter Peter Blume and his wife, Sandy and Louisa Calder.

Essie came up from Virginia with the children. Before they arrived, Gorky told Mougouch that he did not want to see the children again. The agony of saying good-bye to them when they left had been so terrible. What was the point of having them back, he said, if it only led to yet another separation, yet another painful good-bye? Life was easier without them. It was a frightening thing to say, as if Gorky preferred to reject feelings of any kind rather than risk arousing emotions that might disturb him.

The next day, before leaving, Essie took Gorky aside and tried to have a "sensible" talk with him. Her daughter had mentioned that he had become very possessive these past few months. Was it true that she could not even do the shopping without his getting fretful? American women were used to a certain freedom; he knew that, surely. They couldn't just be locked up! Gorky listened without responding. Essie meant well, but it was the last subject about which Gorky could ever be "reasonable." He complained constantly to Jeanne about the "disrespect" of American women in general and of Mougouch in particular. His view, frequently expressed, was that his wife was his wife. She was to be "very nearly a piece of property, belonging to him." And Mougouch (said Jeanne later) did her best to fit into this idea of what a wife should be, "but nobody could have kept it up for ever, or even should have. It was an unfair thing to ask."

Essie and Mougouch privately decided that Maro and Natasha had better go back to Virginia. Essie would take them. Without the children, Gorky and Mougouch might have a better chance of working things out.

A week later, Matta drove over from Snedens Landing to stay with them. At this point in his stay in America, Matta was no longer interested in winning over young American painters to his side, partly because he thought they did not listen and partly because he was thinking of returning to Europe in the near future. But he was still interested in Gorky and Mougouch—who after all could still join him in Paris in the near future. Mougouch wrote a long entry in her diary describing the visit.

> Matta was here this weekend & we enjoyed him—we talked a great deal about his magazine Instead & always reverted to his central theme the creation of a new myth—the *word* which will release a new flow of enthusiasm & energy—Gorky & I tried to make clear our feeling that these things are not consciously planned nor are they even apt to be recognized when they happen by any group of socalled intellectuals, consciously striving to hit the jackpot as it were—But as usual we were really talking on two planes none of us adhering to a single plane [. . .] It is Surrealism that Matta would supersede with a new reawakening of the same spirit of poetry.

The new movement, wrote Mougouch, was not to be the creation of a small group from the intellectual avant-garde. It would channel "the unconscious forces loose in our present crisis." But such a thing could not be the creation of one individual. Then she suddenly grasped "with great clarity" Gorky's idea concerning the birth of human consciousness, starting when man took power from the gods and fashioned the gods in his own image. Gorky had often talked to her about the decline of the sacred in art, which he thought could be traced in paintings from the Renaissance onward. The patron who was initially present in the corner of the composition as a humble suppliant gradually came forward to assume the center of the stage, supplanting even God. "Now it seems we have smashed the image in one blow annihilating God & man—Now who is to say—shall we fashion a new god or a new man or will the next step be utterly different—In crying for a new myth are we crying for the past or the future?"

Her diary continued:

> If only I felt more sure of myself—sure of what it is that I am opposing in Matta's effort. Certainly he is stimulating if only in this provocative way of stirring you to formulate your opposition. But then 9/10 of the disagreement arises from the difference in our lives, our attitudes. He lives almost as a public man. His great effort seems concentrated on solving or rather proving the validity of his own anguish in world terms—if *he* could spring the lock that hides the

secret of our times . . . I feel sorry for him & wish in one way we could work with him—But I don't trust him . . . it is too often a very superficial enthusiasm—too quick his recognition—& his own desire for greatness could so easily blind him to the truth & lead him to embrace the easy superficial way.

Mougouch had to confide her thoughts to her diary because Gorky would not continue the conversation when they were alone. Though the entry implies no trace of special feeling between herself and Matta at the time of writing, it suggests that she wanted to bring Matta round to her ideas—which were also, she thought, Gorky's.

Thinking it over, she decided that Matta was almost the only person with whom one could talk about certain things: Paris, and whether they should go there, the idea of a new life and a new art. From these themes perhaps she could go on to confide in Matta and tell him something of the difficulties she was experiencing in communicating with Gorky. Matta would understand, without requiring endless explanations as to how they had reached this situation.

The following week, Julien Levy dropped by. He had a bottle of whiskey with him, and he and Gorky sat down at the dining table to drink their way through the entire bottle. Gorky was not a drinking man. His idea of social drinking was to get to the bottom of a bottle as quickly as possible. Some element of bravado was involved. The bottle had to end up empty.

In a short time, they were both drunk. Levy began teasing Mougouch, making insidious remarks about her relationship with Gorky. He said she should be totally subservient to Gorky's needs, forever and without complaint. It was her duty! He used a metaphor: she was like a horse whom Gorky had backed between the shafts of a cart, to be pulled around under his command. Gorky, sitting next to him, did not disagree. Though he would never have spoken in such a way, it was very much what he thought. It was teasing at two levels, for the peasant aspect of the horse and cart mocked Gorky, while the image of dumb subservience mocked her.

It was the kind of remark which should have been forgotten by morning. But Mougouch had had enough. It had been a hard, unproductive winter, and with the spring Gorky had shown no signs of reviving. His increasing refusal to communicate on any level was something which, she thought, must be broken if they were to go on living together. The next day she told him she was leaving the house for a day or two. She needed a moment by herself in order to think things out. She did not know where she was going, but she would be back on the Sunday night, in two days' time.

Taking the car, Mougouch drove south. She had no clear plans, but on the way to New York, she decided to call Matta. She knew he would come if she asked, and that he would understand anything she told him about her rela-

tionship with Gorky. On the phone, Matta said he would come wherever she wanted, and a few hours later they met at a signpost by the side of the road, halfway between New York and Sherman. Mougouch parked her car among some bushes and they drove on in Matta's car.

They came to the Hudson River. A ferry was waiting for them by the shore. On the boat, there was only one other couple. The girl had long blond hair which fascinated Mougouch. It was so bright that she thought: Light blond hair is like the sun. She and Gorky had both been dark as children and had often talked about the "darkness" wished upon them by chance. The sight of such golden hair raised her spirits.

She knew that what she was doing could be "fatal." Or, rather, she had reached the point where she wished to "challenge fate." Her inescapable fate as a silent wife, strapped silently to the cart of her relationship with her husband, or even "the Fates" in a larger, more tragic sense. She had to break out of the darkness closing in on her.

When Sunday came, they got back on the ferry that divided one life from another, reached the nearer shore, and went their separate ways. She was back in Sherman that night, as she had promised.

On her return, Gorky did not ask what had happened or where she had been. Though she may have intended her flight to spur him into "bringing things out into the open" so that they could redefine their relationship, the cathartic scene of jealousy and rage did not take place.

Thinking it over, she decided that she was grateful for what she thought was his tact. His silence implied a certain understanding—and why not? She had gone; she had come back. She had done exactly as she had said she would. She felt much better. She still loved him and had no intention of leaving him. She was "ready for another thousand years" of living with Gorky. It would not happen again. The matter was closed.

Gorky's silence, unfortunately, indicated anything but acceptance of what had taken place. Disobedience—which is how he took it—shook the foundations of the world he had made for himself, a world which, having started with all the loss pertaining to a genocide, could never be explained, but only controlled, by a supreme effort of will. Siroon Mousigian, years ago, had been appalled to find that she could not leave Gorky for three hours without raising his anxiety to the brink of insanity. What he required was constant, almost unthinking reassurance. Mougouch, however, believed it was essential to break his solitude, to penetrate his darkness, to "have things out." Rather than placate him with further submission, her two-day escape was aimed to push down the thick wall surrounding him.

There was no question of Gorky sharing more of himself with her than he had done hitherto. The least amplification of the "myths" with which he pro-

tected himself would have brought his fragile world crashing down. His true name. His mother. His recently deceased father. "My country." And beyond these, the reality of Armenia: the burning village, the heap of bodies in the village square. And now the truth could break in from any direction. From an incautious remark made by Vartoosh, who was planning to come and stay with them in a few weeks' time. From a reporter's question. From fame even, and the inevitable request for a more accurate biography than he had hitherto supplied. From a more probing question from Mougouch, his wife.

As long as Gorky had been able to paint, the initiative had remained his. In the last six months of his life, however, he increasingly felt that he was unable to press forward in his work. If he ever came to a halt, the impetus would be lost and the questions would begin. In this respect, Gorky's suicide can perhaps be compared to that of the writer Primo Levi. While both men were in good health, they were able to absorb their terrible memories, and able to chan-

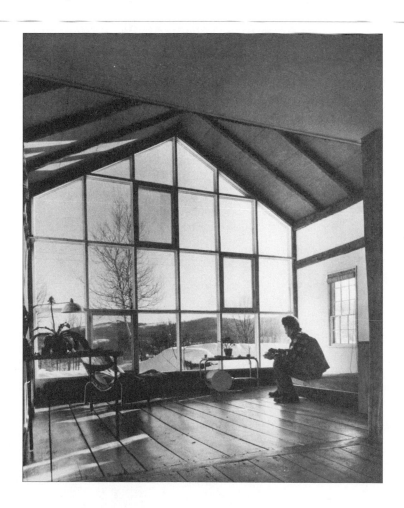

nel them into their work. When ill, it was more than a question of physical weakness. A sense that all their defenses had been pierced, at last, prevailed.

A FEW DAYS LATER, Mougouch went down to Virginia to pick up the children. Gorky now seemed calm enough for them to come back.

In her absence, on Saturday, June 26, Julien Levy appeared to take Gorky out to lunch with a friend of his, Allan Roos, in Ridgefield, a few miles beyond Sherman. Dr. Roos was a psychoanalyst, as were many of his guests. Levy became involved in a fascinating conversation with Sandór Ferenczi about the role of the unconscious in artistic creation. He turned to Gorky at one point in order to include him in the discussion, but this was not a theme to which Gorky could contribute even at the best of times, and he failed to respond.

During lunch, his lack of interest in his surroundings was so noticeable that Dr. Roos became concerned. Taking Levy into a corner, he asked if Gorky was suffering from a depression. Perhaps he "needed help"? Levy and he discussed how they could best persuade Gorky to undergo analysis—by a Freudian, of course. A Jungian would be a disaster.

After lunch, Levy collected a boxer puppy which Dr. Roos had promised to give him, and drove Gorky back to the Levy house in Bridgewater. Gorky became uneasy. He did not want to stay away from his own home for too long. A long, rambling, alcoholic Saturday afternoon was not what he needed. No, he said, he did not want to stay for supper. He wanted to go home. Mougouch might telephone him from Virginia.

As Levy was preparing the dinner, a sudden thunderstorm cut off the lights and the telephone line. Gorky became frantic. To placate him, Levy packed the half-cooked meal in a picnic basket in order to drive Gorky back to the Hebbeln house and give him supper there. They got into the car in the driving rain.

In the car, Levy happened to glance at Gorky, who was sitting in the front seat next to him.

"I met his eyes and felt suddenly pervaded by a sense of more than ordinary gloom, of uncanny desolation. Who was this other black presence who seemed to be exuding darkness over all of us like a tangible substance?" Distracted, Levy entered a dangerous curve called Chicken Hill. The car went into a slow skid. Unable to grip the wet asphalt, the car hit a post on Gorky's side and turned over.

There seemed to be nothing especially dramatic about the accident. Help quickly arrived from the neighboring houses. Levy's wife Muriel, who had been sitting in the backseat, suffered some bruises. Levy seemed the worse off. They were taken to the hospital, where he was diagnosed—according to his own version of the event—with a broken collarbone. Gorky seemed

unharmed, and was only interested in getting a lift home as quickly as possible in order to wait for the expected telephone call from Mougouch. Before he was allowed to leave, however, he was X-rayed. It emerged that he had a broken collarbone and two fractured vertebrae in his neck.

Levy asked Kay Tanguy to phone Mougouch immediately at Crooked Run. She was driven into Washington and took the first flight to New York, where Matta met her at the airport and drove her straight to the hospital. This was the quickest way to get from Virginia to New Milford Hospital.

Gorky lay with his head in traction. He had been given morphine, but nevertheless he was in agony. An intern told Levy that Gorky in his delirium had shouted out, "Make way for the throngs." His admirers would soon be on their way to visit the genius on his bed of pain, "when they learn we keep him here, detain him on a rack of torture."

Mougouch was unable to penetrate his pain and despair. After some hours, she phoned Dr. Weiss in New York. Was it possible that Gorky's hallucinations were due to the medication he had been given? Dr. Weiss immediately diagnosed an allergy to morphine and asked to be put through to the head nurse. Gorky's medication was changed, and he gradually sank into sleep.

Mougouch lay down under Gorky's bed, with the idea of somehow "drawing the pain out of him." She completely forgot about Matta, who was waiting in a nearby café, feeling terrible, for five hours. In the late afternoon, she went to look for him. Matta took her to Sherman so that she could pick up her car, and then he drove back to New York.

Gorky stayed at New Milford Hospital for about ten days. The treatment involved padding his face, ears, and chin with two inches of flannel, then pulling his head back with a twenty-five pound weight. It was extremely painful. For the first few days he was plagued by horrible visions on the ceiling of his hospital room. But his main source of agony in the hospital was his inability to clean himself. He hated to be touched by anyone, least of all by the professional nurses. He refused to eat the hospital food. Mougouch cooked meals for him at home and brought them over twice a day. She was once met at the door of the ward by a nurse who said, "Mrs. Gorky, your husband is perfectly impossible." She thought Gorky had no right to be making such a fuss. Couldn't Mougouch tell her husband to "control himself"? His moans were disturbing all her other patients.

Gorky himself told the nurses, "You want me to be brave, but I am like an onion which has been peeled of its skin and of its layers, until I feel everything. I feel even the trembling of a leaf." Why talk of bravery? What had bravery to do with it?

Distrustful of the doctors at New Milford Hospital, Gorky wanted to see Dr. Weiss. Mina Metzger drove him up from New York. Dr. Weiss was able to

convince Gorky that he would recover from the physical effects of the accident within a few weeks. Indeed, the paralysis of his painting arm, which first tormented him, gradually subsided and the terrible visions ceased. While Dr. Weiss was there, Mougouch persuaded him to let her take Gorky home as soon as possible. At home, it would be easier for him to cope with the problem of cleaning himself.

GORKY LEFT New Milford Hospital on July 5.

As soon as she was sure that the physical effects of the accident were under control, Mougouch contacted Wolf Schwabacher with yet another plan to buy the house in which they were living. She still believed in a practical solution to their problems. Her aim was now to calm Gorky's sense of insecurity. As she wrote to Wolf, Gorky *must* have a place to call his own. He could not go on in this limbo of having no fixed place to live. With the sale of Aunt Marion's little cottage in Maine, which Mougouch had inherited, plus the proceeds from Julien Levy's insurance—Levy was urging them to make a large claim on his car insurance—they could surely make a down payment on the Hebbeln house. Letters and phone calls went back and forth.

The weather grew hotter and Gorky found it hard to sleep. The children came back from Virginia. They lay awake at night listening to their parents fighting downstairs. The next day, when Maro started behaving badly, as children often do in these circumstances, Mougouch in turn vented her own frustrations by hitting her with a hairbrush.

Some nights, Maro slipped pieces of paper under the door of their bedroom, asking them in imaginary handwriting not to fight. Once, hearing Gorky and Mougouch upstairs in their bedroom, shouting, Maro woke up Natasha and dragged her up the seven steps leading to the top floor. She knew they would have to stop if she and Natasha appeared. Inside the room, she saw Gorky bending over Mougouch, preparing to strike. When he saw the children, Gorky lowered his arm and gently took them back down to bed. In Maro's memory of the event, everyone in this terrible scene was naked.

Even late at night, it was stifling under the eaves of the roof where the double bed lay. Gorky moved to a narrow bed in the guest room where he could catch the cool draft coming up from the empty space below. The collar he wore around his neck was driving him out of his mind. He took it off at night. His skin was raw and the nagging pain was insufferable. Sleeping pills had no effect. His groans kept the others awake. If he could not get to sleep, he went downstairs and lay on the sofa.

ON THURSDAY, JULY 15, ten days after his return from the hospital, after the children had been put to bed, Mougouch in the kitchen heard Gorky go

upstairs to their bedroom. He had been drinking. He started to throw things down the stairs. She went up and found him tearing up some drawings Matta had given her, and hurling across the room the Indian necklaces from Jeanne, which Mougouch had arranged around her mirror. She tried to calm him down, without raising her voice, as the children were about to go to sleep. Gorky violently pushed her away and she fell down the stairs.

She thought that the only way she could stop him was to leave the house. He would then surely come after her and they could talk things over outside, where he could do less damage. She circled the building and watched him through the wall, which was made of glass. Then, to her amazement, she saw Gorky come down the stairs from the children's room, holding Maro's hand and carrying Natasha in his arms. He went with them to the hall table, where he picked up the telephone, holding Natasha on his knee, and placed a call. He spoke to someone: Mougouch has gone for the police, he said. She is leaving me.

The children were with him and she knew he would not behave violently in their presence, so she came back in. He hung up immediately and very quietly followed her and the children back to their bedroom. Natasha immediately lay down, her face buried in her pillow. When Maro was in bed, he sat down beside her and, realizing their terror, tried to explain. "You know, my little darlings," he said, "I am an artist, and sometimes artists have to act a little crazy, don't you think?" To which Maro said one word: "No."

This trauma is remembered by Maro as well as by Mougouch. In Maro's memory, Gorky made them scrambled eggs before taking them upstairs again, a scene which Mougouch says took place on another occasion. In Maro's memory, they were left alone for several hours. In Mougouch's, no more than fifteen minutes.

The repressed memory came back to Maro only recently, while we were sleeping at a hotel beneath Mount Sinai. "I was scared & furious that she had left Nat & me alone with this madman." Having been until then innocent spectators of the duel between their parents, from the moment when Mougouch left the house and placed the glass window between them, they had become direct participants. "How could she have let her marital situation reach the point that she feared for herself his violence, and left us alone with a violent father? We were only $3\frac{1}{2}$ and 5: how could we defend ourselves? In fact, my image showed that Gorky then made us scrambled eggs on toast, but what a gamble Mama took with her parental responsibilities."

By uttering that one word "no," Maro drew a line between herself and her father, disassociating herself from the headlong destiny he was pursuing. Of this terrible scene, Natasha today remembers nothing. She was too young. Only, visiting the house forty-seven years later, standing on the landing of the wooden staircase leading to the attic, she instantly burst into tears.

• • •

THE NIGHT DID NOT end there.

After leaving the children in bed, Mougouch and Gorky went downstairs to the main room, in front of the wall of glass. He lay on the floor. She removed his collar, washed his sweaty face, and put a pillow under his head. She turned out the lights. The moonlight streamed through the glass. They talked quietly. He asked her if she loved Matta. She said that she did, but that she loved him more. That he was her life, and so were the children, and she had come back to be with him because she wanted to. She tried to make him see how isolated and alone she felt whenever he rejected her love and retreated into his own despair. He *had* to allow her to help him, she said. He must not be so remote. And Gorky seemed to understand, and to agree. Mougouch felt that at last they had "had it out," and that a change for the better would at last follow. There was still hope.

They were both very calm and very close, and they nearly fell asleep where they lay. But Mougouch knew that early the next morning, they had to get ready to go into New York. Gorky had an appointment with Dr. Weiss, and she had another with Jeanne's doctor, to have a wart removed from her forehead. She rose before the others and got the children ready. She wrote a letter to Matta briefly explaining the situation, saying that now that she and Gorky had reached an understanding, it was essential that Matta keep away. If Gorky saw him, he might lose the precarious control he had at last attained.

After breakfast, they got into the car. Gorky had with him a large, knobbly stick, but the atmosphere was clear and calm and Mougouch felt that they had crossed into a new territory of acceptance.

Mougouch left Gorky on the corner of Park Avenue and Seventy-eighth Street, near the office of Dr. Weiss, then drove down to Eleventh Street to drop off the children at Jeanne's house. She then went on to her appointment with Jeanne's dermatologist.

After her medical procedure, Mougouch phoned Matta in order to repeat by phone the gist of the letter she had just posted to him. It was essential that the two men keep away from each other.

To her horror, Matta had just come in—was still breathless—from a terrible confrontation with Gorky in Central Park. Gorky had phoned him, either the night before or from Dr. Weiss's clinic, telling him to meet him at the entrance to the park on Eighty-sixth Street that morning. And Matta had gone.

When they met, they began to walk together side by side through the park. At first Gorky was calm, but gradually he became more and more angry. He started shouting—in Russian, as Matta thought, though it must have been Armenian. Other people in the park looked at him. He started to wave the stick

in the air. Passersby withdrew. They must have both seemed crazy, Matta told me, he himself so short, trying to keep up, and Gorky so tall, walking fast, making peremptory gestures in the air with his stick.

Was Matta in love with Mougouch? he shouted. Matta said yes, he loved Mougouch, but he had no intention of— Well, it was just as well that he was in love with her, said Gorky, because if it wasn't him, it would be some other person. Then, contradicting himself: But you are crazy to love Mougouch.

Matta said that he had no intention of stealing his wife. Nor did she have any intention of leaving him. Gorky should not harbor these thoughts about him, or about Mougouch. He was surrounded by friends who wanted to help him.

Gorky did not listen. No sooner had he started on one idea than he changed direction and began to talk about something else: the conditions of his life, how difficult it was, how— And then he switched back to the subject of Matta, who after all was his friend: how he should beware of her, for—

Then he raised his stick. He was going to beat Matta, he said. He would beat him, because it would do him good to beat him. Whereupon Matta started to run. A nightmare chase through the park ensued. Gorky behind, shouting incomprehensible phrases "like a drunken man." Matta was in front, and his only thought—crazy, but logical—was that Gorky's head was about to break loose from the horrible contraption of wire and flannel which held it together and roll free from his body, onto the grass.

Eventually Gorky's cries diminished. Matta turned. The stick was lowered. Gorky was exhausted.

They sat for a while on a park bench, talking.

ON THE PHONE, Mougouch was unable to speak.

Matta said that Gorky had invited him to the meeting. It was not his fault. But anyway, that was now no longer the problem. Now, the fact was that if Gorky attacked him, he, Matta, could defend himself. He could reason. He could run. If the worst came to the worst, he could even fight. But if Gorky were to turn that huge stick on her when they were living alone in Sherman— what then? At which point Mougouch was so upset she dropped the phone and cut him off.

Mougouch fled straight to Dr. Weiss, where she explained the whole situation. The depression which had lasted all winter. The threats of suicide. The fights, the violence. The weekend with Matta . . .

Dr. Weiss was very kind and very serious. He said that a move such as she had made with Matta was "irremediable." Nothing would be the same again. She would have to "take the consequences of her act." He himself wanted to

look at the situation realistically. His immediate concern was to save as many lives as he could. He would try to calm Gorky, but she was to leave with the children. Now.

He had examined Gorky just a few hours ago. He said that he had found him remote. His neck was mending. But he had felt for some time that Gorky was "sinking into a darkness."

Mougouch said that only the night before, they had been so close. How could she leave him at this point? It would kill him.

This was a risk she would have to face, he said. The alternative was to put Gorky into a straitjacket. Would she want him to do that?

No, she said. She could not bear that.

Dr. Weiss said he would prescribe some strong tranquilizers for Gorky. He would send them down to Jeanne as soon as he could. He phoned Jeanne, explained the situation, and told her to send the children up to the office by cab, immediately. He arranged for air tickets and phoned Mrs. Magruder to meet their plane. When the children arrived, Mougouch took the cab straight on to the airport.

GORKY ROAMED the streets for several hours before finally appearing at Jeanne's. She did her best to calm him. He took some of the pills Dr. Weiss had sent her. He lay down on the sofa, where eventually he dozed off. He was exhausted.

A few hours later, seeing that his face was covered in sweat, Jeanne took a washcloth and tried to wipe it. Gorky woke up abruptly and pushed her hand away, shouting, "Only a wife can do that."

Jeanne told him that Mougouch and the children had flown down to Virginia. Rising with difficulty from the sofa, he went to the door and out into the street.

It was now dark. He walked aimlessly through the Village. He had in his hand two Raggedy Ann dolls belonging to the children, which had been left behind at Jeanne's. Finding himself near MacDougal Alley, he went to Noguchi's studio and beat on his door, howling. It was a while before Noguchi took him in, as he thought that Gorky was a local drunk who used to go up and down the alley at night, shouting and beating on doors.

Gorky showed Noguchi the Raggedy Ann dolls and said miserably that this was all he had left in the world. That his life was ruined. Noguchi comforted him for several hours before finally sending him back to Jeanne's.

Though he took enough pills to "knock out a stevedore," he was awake and active all night.

The next day was a Saturday. Gorky telephoned the Schwabachers in Pennington, New Jersey, ostensibly to discuss the lease of the Hebbeln house.

They invited him to visit them "for the weekend," but he said he would prefer to return to Sherman. Gorky then told Ethel that he was deeply unhappy and that his marriage was at an end.

Worried, Ethel telephoned Mina Metzger, who said that she had already spoken to Dr. Weiss. Gorky was to see a psychiatrist in three days. It was the weekend and everyone was away, but an appointment had been fixed for early the following week. If Gorky meanwhile felt that he wanted to return to Sherman, then perhaps someone should be found to take him up there?

Mougouch in Virginia was waiting by the telephone. Her parents insisted she come with them for a drive. They were going to an auction. Wouldn't she like to come? She should get out of the house for a breath of fresh air. On the drive, Mougouch could neither listen nor speak as they chattered away in an effort to take her mind off her problems. All she wanted to do was to get back to the telephone as soon as she could.

Perhaps that same day, a friend saw Gorky on Fifty-seventh Street. He looked very ill. "He was wearing this blue sailor knit cap, a Mackinaw coat, and he was just dragging his feet along. He looked like he could fall down any minute."

In the evening, Gorky was still roaming the streets. This time, he carried with him a small toy bird. He knocked on the door of Gaston de Havenon's apartment at 7 East Eighth Street. Gaston was a friend from the old days. Unfortunately, he was out. Gorky walked on a few hundred yards to Noguchi's studio, and once again Noguchi did his best to comfort him. Later, Noguchi told Gaston that Gorky had been to see him, and that he had had with him a papier-mâché bird as a present for Gaston. He'd left it behind in Noguchi's studio, someplace. They looked for it, but it had disappeared.

MOUGOUCH PHONED Jeanne's house numerous times without getting through. When finally she reached her, Jeanne said that Gorky was out of the house. The pills weren't working and he was out in the streets, walking all day and half the night.

On the Sunday, Mougouch spent several hours writing a letter to the Schwabachers, knowing that by now Gorky would have rung them, and aware that she had to explain the facts from her point of view. Her marriage to Gorky, she wrote, was at an end. Her heart had been "wrung quite bloodless" by recent events. She was sure that the break was final: "I know I can no longer hold on." Quite apart from her own feelings, there was also the opinion of Dr. Weiss, who had been "coldly objective" about the dangers to the children inherent in the present predicament. Gorky's mental condition was serious. Had been serious for several years. She had been "dreadfully wrong in trying to pretend otherwise." She was sorry that she had kept them uninformed all

this time. It would be a shock to them to hear it. But she had always felt that the problem was "purely personal & a question of my adjusting to him & that I have never conceived of life as easy & that if we failed it was because I had failed."

She would, she thought, go up to Castine with the little girls until she could come to some understanding with Gorky. Then she would have to find a job and a place to live. "What lucidity & energy he can regain must go to his painting. The children & I are too great a drain on his responsibility. You know I have loved him and tried to fill his mind, but now I cannot." Gorky, meanwhile, ought to return to his studio at Union Square, and she had already written to the tenant explaining this. "Believe me, my heart has been totally engaged even to the exclusion of my instinctive nature and if I could I would have spared him this but my love was not strong enough I guess."

Gorky had refused the option of presenting himself to his wife as an object of pity. He was not an invalid, let alone a dying man. And, up until the end, Mougouch accepted her husband on his own terms, as if the needs of two human beings trying to live together were the issue, not his illness. It was Gorky's refusal to share more of himself with her—a refusal that went as far as physical violence—which had defeated the relationship, and nothing else.

She posted the letter and resumed her vigil by the telephone.

IN NEW YORK, for the third day running, Gorky roamed the streets. The tranquilizers had still had no effect. At one point, seeing him coming in from the street looking quite mad, Jeanne hesitated to open the door. Raging at her through a sheet of glass, Gorky said that he would come back and haunt her.

That night, for the last time, he ended up in MacDougal Alley outside Noguchi's studio. But by this time Noguchi was fed up with him. For a long time he listened to Gorky's voice outside the window, baying at his window, "Isamu, Isamu." The voice echoed through the narrow canyon of artists' studios flanking the cobbled road. Finally the voice stopped.

In the morning when he opened the door, Isamu was appalled to find that Gorky had not gone back to Jeanne's as he had thought. He had spent the entire night on Noguchi's doorstep.

By this time Gorky's condition was known to many people. Somehow, even though he was supposed to see a psychiatrist early the following week, it was decided that the best place for him was back in his rented house in Connecticut. There, at least, his restlessness could be curtailed. He would be in familiar surroundings and with his painting materials near at hand. Noguchi drove him to Sherman, accompanied by the Cuban painter Wifredo Lam, whom

Gorky had met a year or so previously. They had to stop the car once, as Gorky was behaving violently, but they managed to calm him down and complete the journey. Back in the house, they phoned Saul Schary, who lived not too far away. Schary had known Gorky for many years now. He promised to bring round some groceries and to keep an eye on him.

The remaining two days of Gorky's life were spent on the telephone, methodically cutting off one by one all the ties of friendship which kept him in this world. He phoned everyone he could think of, with the exception of Vartoosh, Akabi, and Satenig. They would have understood his intentions and they would have been horrified. He even tried to trace an Armenian friend who had been on the boat with him when he first came to the United States, now working as a laborer in Pittsburgh.

These telephone calls had three themes in common. Gorky was adamant that his marriage was at an end, and that Mougouch had "abandoned" him. He had read her diary, he told his listeners. He knew.

The conspiratorial tone in which Gorky talked of his wife's diary gave his listeners the impression that she had confessed to having "betrayed" him, and after his death it was all too easy to remember that betrayal as having involved Matta. In keeping with this fantasy, the diary was imagined to reveal a secret existence which had gone on for a long time. But her diary, which still exists, is anything but that. It contains long accounts of dreams about her mother and father, her brother and her sister, followed by attempts to analyze the material in Jungian terms. It used to lie on the sideboard or among the breakfast things, and Gorky could have read it at any moment, except that he was never interested. If now, in his solitude, he finally gave it some attention, he would have found that his wife had been struggling with a train of thought which was extremely important to her, a struggle in which she had received no help from him. Gorky had no sympathy for the Magruders. He did not appreciate what a huge effort they had made to come to terms with the strange adventure on which their daughter had embarked. Nor could he see the need to build a bridge across to them. Maybe her "betrayal" consisted simply of the attention she still devoted to her family, as if what her husband gave her were not enough.

In the entry of June 7, when Matta came to visit them, she records the ideas all three of them exchanged as friends. The expressions used about Matta personally, "a public man," "very superficial enthusiasm," etc., do not sound like love. The escapade ten days later, when the two of them crossed the Hudson River, was an unpremeditated act spurred by a need to provoke Gorky into reacting against the darkness which she felt was engulfing him. Meanwhile, the fact that Matta presented himself in all innocence to Gorky in Central Park

indicates how ignorant he was of Gorky's mental state. If he had been engaged in an affair with his wife, the last thing Matta would have done was meet Gorky face-to-face.

The second theme of his telephone calls was suicide. But he hinted at this only in a most obscure, imprecise way, so that the listeners were not entirely sure what he meant. Only in retrospect, after his death, did the vague hints take on meaning.

Lastly, as if offering his friends one last chance, Gorky asked for help. These requests, too, were couched in peculiar terms, hard to understand and impossible to satisfy. He asked two friends who lived miles away to get into their cars and immediately drive over to see him. Then he listened to their excuses: gas rationing, no spare tire, etc. To Julien Levy, he asked for "a woman." What on earth did Gorky mean? Levy wondered. Nothing sexual, surely? That wouldn't be like Gorky at all. Did he mean a cleaning lady? Well, perhaps he could put him onto someone in the morning. And others: Lola Calas, Raoul Hague, the sculptor Reuben Nakian. The calls had one thing in common: whenever Gorky's request for help became explicit, or seemed on the point of eliciting a positive response on the part of his listener, he abruptly rang off.

More than thirty years later, strangers came up to Maro to apologize. Gorky had phoned them the night before he died. They had been unable to make it. They were so sorry.

AT LAST, Gorky telephoned Mougouch.

At this point she assumed the worst, and that the call which had come through for her signified that Gorky was dead. She was relieved to hear his voice at the other end of the line. Could she come back to him? she asked immediately. Gorky replied incoherently. He said that she was not to worry. He knew what to do. He would "act like a man." He would "free" her.

Essie was standing nearby. The telephone at Crooked Run was still a party line. Trying to keep her voice low, Mougouch said, "Don't." Gorky hung up.

The night before Gorky died, Saul Schary went to the Hebbeln house to check that everything was all right. They sat on the sofa and talked for a couple of hours. Gorky showed Schary a book on Leonardo da Vinci which he had received for his birthday recently. He was agitated. His face was splotched with red and white patches. His eyes were glazed and bulging. He spoke about painting, and about his unhappiness. How his life meant nothing anymore.

Looking at the book, Schary took off his glasses and laid them to one side. When he left, he forgot them on the sideboard near where they had been sitting.

In the morning, Gorky continued telephoning. Kay Tanguy rang Julien

Levy to say that Gorky had asked them for help, and she'd heard he'd done the same with someone else. He was asking each person something different. Something was the matter with him. It was so unlike Gorky to ask for help from his friends, whatever the circumstances.

One of his last calls was to his wife. He was going to take his bath. Then he was going to "free her and free himself." Mougouch again offered to come back, and he immediately put the receiver down.

Schary rang Gorky to ask if he could come and collect his glasses, as he needed them for driving. Gorky said he should come over immediately. When Schary arrived, Gorky was in a very disturbed state. As he turned toward him with his glasses in his hand, he said, "Schary, my life is over. I'm not going to live anymore."

Schary tried to cheer him up. After a while Gorky cut him short. Would he leave, now, as he had to do something? Schary, thinking he was referring to something to do with his operation, rose to leave. Gorky walked out to the car with him, with the neck harness in place, and as he said good-bye, he took Schary's hand and kissed it, saying, "Good-bye, Schary." Then he turned and walked back into the house.

Schary, disturbed, stopped off at Peter Blume's house on his way home. He found Blume shaving, quietly getting ready to start the day. As Schary told Blume his anxieties about Gorky, Kay Tanguy telephoned to say that she had received a worrying call from Gorky, and that something should be done about it. She said she had phoned Muriel Cowley to tell her to drive over and check up on him. She had told her not to go alone, that she should take Malcolm with her.

Soon afterward, Malcolm and Muriel Cowley drove over and looked through the house, without finding Gorky. They then drove on to Peter Blume's house. By this time Saul Schary had gone home, but Peter Blume and his wife were worried. Everything took place, in retrospect, with maddening slowness, as if everyone had been wading through water. Finally the Cowleys and the Blumes drove back to Gorky's house to make another attempt to find him.

As they parked the car, the car keys fell into the grass and they lost more time looking for them.

They walked over to the house. In the barn, they found a rope hanging from the rafters. Gorky was not in the house. In the garden, they found another rope hanging from an apple tree. The two women stayed at the house while Peter Blume and Malcolm Cowley walked into the woods in the direction of a waterfall, which lay some half a mile away, near Spring Lake Road.

The waterfall was a favorite spot for Gorky, situated in a wild gorge filled with hemlock, on the land of a rich eccentric neighbor who at one time had tried prospecting for uranium. As Malcolm Cowley and Peter Blume walked

through the long grass, they looked up into the trees, to see if perhaps Gorky had hanged himself there. After a while the road petered out and they turned back.

At about one o'clock, as they were returning up the path toward the house, they were attracted to a shed by the barking of a dog. The building stood abandoned, in among the trees. Inside, the unlucky uranium prospector had stored a stone crusher, pieces of prospecting equipment, and a number of stacked-up wine crates. Gorky was hanging from a rafter next to the stone crusher. He had stood upon a small champagne crate, strung a rope around a rafter, and, having removed the brace around his neck, replaced it with a noose. He had then kicked the box out from under him. The rope was a light one, and with his weight it had stretched, so that his feet nearly touched the ground. The harness for his neck lay at his feet. He was wearing jeans and a white shirt, which had slipped, so that the bandage around his stomach was visible.

Nearby on a small crate, some twenty by forty inches square, he had written a phrase in white chalk. Two small chalk nubs lay nearby on the ground. Blume remembered the words as "Good-bye my loves." Gorky's face was the texture of wax, and it was clear that he was dead. They did not cut him down. Cowley ran back to the house and telephoned for the state troopers. Blume sat there alone with the body until help came.

AFTERWORD

FIFTEEN YEARS LATER, Maro and I tried to come to terms with our con-
flicting emotional responses to Gorky's long-delayed vindication: at the Venice
Biennale in 1962, at the Museum of Modern Art in New York in 1963, and at
the Tate Gallery in London in 1965.

In Venice, we bought Harold Rosenberg's monograph on Gorky in an Italian
translation from a kiosk by a canal, together with a sandwich and a straw-
covered flask of wine. In New York, we followed a museum guide and her audi-
ence and learned the amazing truth about the sexuality of Gorky's work. We
were overcome by a hilarious sense of triumph, at seeing "Gorky at MoMA" on
the side of a crosstown bus; by a sense of regret, that Gorky wasn't here to
enjoy it; by a sense of restlessness, at being part of the machinery of mass dis-
tribution; by a sense of violation, reading the sad facts of Gorky's life summed
up in one short paragraph introducing an article in a color supplement.

I remember standing in front of Gorky's immense face in an advertisement
on the London Underground, across the tracks that ring like cymbals before
the roar of the incoming train. Gorky, ten feet high, a bead of sweat on his
brow, as if he had emerged from the Hamam to be photographed, his hair hid-
den in a tight handkerchief, a stalk of wheat in his mouth. The photo looked
professional—but where, on the island of Manhattan, had Gorky gotten hold

of a stalk of wheat? Thence to idle fantasies about his past. The lake. Trying to connect the realities of his life with the feelings in his paintings. Some of the critics even mentioned that. The uncontrolled emotions which lie behind the beautiful surface of his work.

After those three retrospectives in Venice, New York, and London, his paintings began to enter many other important museums: the Israel Museum, 1965; the Musée National d'Art Moderne in Paris; Ottawa, 1971; the Tate Gallery, 1971; Canberra, Australia; the Thyssen-Bornemisza Collection, 1978; Toronto, 1980. Today, the Museum of Modern Art in New York owns nine paintings, with two or three on permanent display at any given time. The Whitney owns ten works, the Metropolitan three, the Guggenheim four. One could tour the Gorky paintings in New York as one tours Tuscany for Piero della Francesca or Harlem for Frans Hals. If human glory were a permanent thing, one could assert that at this point Gorky's position in the history of art was unassailable.

Most great artists' lives are simplified into myths. Frans Hals did not die in the poorhouse, but his life signifies the fall from riches to rags. Rembrandt was never as lonely as his self-portraits suggest, but his life symbolizes solitude. Hieronymus Bosch was one of the sanest people imaginable, but his work stands for insanity. Raphael at times must surely have been too busy to think about love, but his life associates creativity with rampant sexuality. Even if we are told that our preconceptions are childish, we go on believing them, in the same way that even those who don't believe in life after death still enjoy the fantasy that up there on Olympus—that ultimate "High Place" which stands in the minds of living artists as a symbol of immortality—the unrequited painter is happy among his peers, justly rewarded at last.

With Gorky, the archetype has to do with art as a quest. Through years of patient apprenticeship, he achieved a final flowering—a word subconsciously suggesting that his life was destined to come to an end as soon as the flower had wilted. From this central image the historian can progress to questions of origins, and originality, and historical perspectives of each and every kind. The constant element in his work—that paint itself is a vehicle of human emotion—can sometimes be forgotten.

Gorky's loneliness was immense and irrevocable. He failed to mask his indifference to many aspects of American life, and he refused to join any of the collective movements of his time. The two people closest to him in terms of affection, Willem de Kooning and his second wife Mougouch, were deeply hurt, after his death, to discover just how little he had told them about himself, how reluctant he had been to bare his soul to true intimacy.

Two explanations are possible for this defect in Gorky's character. One, that he had to create the imaginary artist who then painted the paintings that

he did, and that any admission on his part that this persona was false would
have jeopardized his capacity to work. Or, second, that the trauma of his expe-
riences during the Armenian genocide was so emotionally painful that he
could never have brought them out into the cold, reasonable light of day.

Of the two, I prefer the first explanation. Gorky's life may have been as con-
trived as his works of art, but in that, he is in illustrious company. The second
explanation ties Gorky too strictly to his Armenian background, from which,
while he lived, he tried very hard to escape. Gorky was not an Armenian
painter. Neither Armenia nor America was enough. He was searching for an
identity which lay beyond any one land, and from his solitary pinnacle he
bequeathed an eloquent example of how one individual can renew the lan-
guage of art, and himself, entirely from within.

NOTES

IN THIS BOOK I have respected the lapses of spelling and grammar in the direct quotations, as sometimes they reveal the state of mind of the writer. Most indirect speech without quotation marks is a summary of direct speech, but sometimes I have had to reconstruct from memory or from widely differing sources. The first case applies to Gorky's relationship with Willem de Kooning, the second to Gorky as a teacher.

Though many facts and incidents of Gorky's life have survived, it has proved extremely difficult to work out an accurate chronology of events. I have done my best to give everything its proper place, but I expect to stand corrected on the subject of dates.

Regarding primary sources, Ethel Schwabacher's biography lays out the basic structure of Gorky's life, and her sources, in the Whitney Artist's File and on microfilm, are valuable. Among these are some interesting accounts of Gorky's childhood written by his sisters shortly after his death.

Karlen Mooradian's *Arshile Gorky Adoian* and *The Many Worlds of Arshile Gorky* are essential reading, but his translations of Gorky's letters are untrustworthy. I suggest ignoring his versions wherever he makes Gorky discuss art. Mooradian's taped interviews with Gorky's contemporaries belong to the Diocesan Library of the Armenian Church in New York, where one day they will form part of its specialized Gorky archive.

FO 424, a series of British Foreign Office "Blue Books," includes the reports from the vice-consul in Van, which give a detailed picture of life in Van during Gorky's childhood. Also useful are the Field Reports of the American Missionaries in Van, in the Houghton Library at Harvard. Both these sources are available on microfilm.

The Archives of American Art contain a mass of information on Gorky, scattered in the many interviews with his contemporaries which have been assembled over the years. Their

catalogue can be consulted on the Internet via SIRIS, the Smithsonian search program. Micro-fiches of much of their material can then be borrowed through the Inter-Library Loan Scheme in Detroit.

To coincide with the publication of this book, I have given my interviews and research material to the Archives of American Art and the Whitney Library. These gifts include Gorky's letters to Mougouch in English; an annotated translation of Gorky's letters in Armenian to Var-toosh, with photocopies of most of the originals; an annotated typescript of the letters of Mougouch to Jeanne Reynal; and about forty interviews with Gorky's contemporaries.

My biography is based exclusively on primary sources, which can be traced through the notes. An excellent bibliography of secondary sources is to be found in the Guggenheim Museum catalogue of 1981.

These abbreviations have been used:

AAA Archives of American Art, Smithsonian Institution, New York

AG Arshile Gorky

AGA Karlen Mooradian. *Arshile Gorky Adoian*. Chicago: Gilgamesh Press, 1978.

AMG Agnes Magruder Gorky

Ararat *Ararat*, vol. 12, no. 4 (special Gorky number; Fall 1971).

JR Jeanne Reynal

KM Karlen Mooradian

MS [followed by interviewee's name] My interviews with Gorky's contemporaries, and other files

MWAG Karlen Mooradian. *The Many Worlds of Arshile Gorky*. Chicago: Gilgamesh Press, 1980.

VM Vartoosh Mooradian

WAF Whitney Museum of American Art Library, Artists' Files.

<div align="center">ONE / KHORKOM</div>

PAGE 3 "The walls of the house were made of clay blocks . . .": AG, "My Murals for the Newark Airport: An Interpretation," Nov./Dec. 1936. See Francis V. O'Connor for the variants of this text, in *Murals Without Walls* (Newark Museum, 1978), pp. 13–16.

7 "The country has been devastated" down to "in the same village": FO 424/183, pp. 77–79, letter from the Catholicos of Akhtamar to the Patriarch in Constantinople, May 1895.

"A regime of organized brigandage . . .": Vice-Consul Hallward to Consul Graves, Van, June 28, 1895, FO 424/183, p. 130.

For Dikran Melikian's story, see my interview with Arax Melikian, Dikran's daughter; and a letter to the author from Jeannette Frenster, Arax's daughter, July 10, 1994.

8 "They had the frank and direct look which we are accustomed to see only in children . . .": Frederick Davis Greene, *The Rule of the Turk* (G. B. Putnam's Sons, 1896), p. 165.

10 "While I pressed my face into her long apron . . .": Julien Levy, *Arshile Gorky* (Abrams, 1966), p. 34.

11 For Charahan Surp Nishan, see E. Lalayean, "The Famous Monasteries of Vaspurakan" (in Armenian), in *Azgagrakan Handes* (Tiflis), vol. 13 (1911): pp. 43–47.

12 For Moses and Aharon, Gorky's maternal uncles, see MS-Gail Sarkissian, Mar. 12, 13, and 16, 1994.

12 "Wide-awake industrious mountaineers . . ." G. C. Raynolds, *Report of Village Work in the Van Field, Turkey, 1909–10*, p. 2. American Board of Commissioners for Foreign Missions, Houghton Library, Harvard.

13 "The shepherds there live in the mountains . . .": VM to Mrs. Metzger, [Dec. ?] 1948, Schwabacher Papers, WAF.

14 For Prudian's death: MS-Liberty Miller, Nov. 12 and 16, 1993. As Liberty is Tomas Prudian's daughter, I prefer her version to Karlen Mooradian's, in *AGA*, p. 106.

 For Gorky's murdered uncle Nishan, see MS-Gail Sarkissian, MS-Liberty Miller, and *AGA*, pp. 107–8.

15 For "No, I won't" and "*An-gu-la*": AMG; also letter from Satenik Avedisian to Mrs. Metzger, Mar. 31, 1949, Schwabacher Papers, WAF; and *AGA*, p. 151.

 "No specific scene but many incidents . . .": The Museum of Modern Art, Dept. of Painting and Sculpture: Arshile Gorky, *Argula*, artist's questionnaire.

 "The black one, the unlucky one who will come to no good end": Saul Schary, in Mrs. Metzger's interview with Vartoosh, Dec. 1948, Schwabacher Papers, WAF.

16 "I remember myself when I was five years old . . .": Mary Burliuk, "Recollections of Arshile Gorky," *Color and Rhyme*, no. 19 (1949).

 For the family Bible, see Yenovk der Hagopian to KM, *MWAG*, p. 137: "Manuk asked his mother to show him the paintings in their family bible. And his family had a great deal of art because Manuk's grandfather was the head of the Church of Charahan Surp Nishan in Vostan."

17 "No better than a set of cringing beggars . . .": Bertram Dickson, "Report on Journey Through the Districts of Bashkala," Van, Jan. 1908, FO 424/214, pp. 169–170

18 "Has suffered . . . from the baleful influence of Tashnagist infidelity": G. C. Raynolds, *Report of Village Work in the Van Field, Turkey, 1909–10*, p. 3, American Board of Commissioners for Foreign Missions, Houghton Library, Harvard.

19 "Behaved in an abominable manner, beating, pillaging . . .": Vice-Consul Dickson to Mr. G. Barclay, Van, June 29, 1908, FO 424/216, p. 70.

 "Pulled the Turkish pasha from his horse": MS-George Adoian, Nov. 5–8, 1993.

20 "The blows from the stick would only land . . .": Vahan Totovents, *Scenes from an Armenian Childhood* (Oxford University Press, 1962), p. 57.

21 "He liked school but was very active, 'fresh' . . .": Satenik Avedisian to Mrs. Metzger, Mar. 31, 1949, WAF.

22 As soft and as white as his mother's dough: Aristodemos Kaldis to KM, July 26, 1966, *MWAG*, p. 155.

TWO / VAN CITY

25 "The needle forms of the poplars, forced from the soaking earth . . .": H. F. B. Lynch, *Armenia: Travels and Studies* (Khayats Oriental Reprints, 1965), vol. 2, p. 82.

26 The pear tree: Victor Gardon, *Le Vert Soleil de la vie* (Editions Stock, 1992), p. 52.

 "Else Easter will fall upon your heads . . .": VM to KM, *AGA*, p. 131.

 "Proved a constant source of pressure . . .": *AGA*, p. 157 n. 27. For a description of Ernest Yarrow, see the memoir by Jane T. Yarrow in Biographical File 66:8, American Board of Commissioners for Foreign Missions, Houghton Library, Harvard.

28 "Rescuing children from the waves . . .": G. C. Raynolds, *Report of the Van Station, Eastern Turkey Mission, 1912–1913*. For the "visiting drawing teacher" and the Baghdasarian brothers, see G. C. Raynolds, financial report, Oct. 10, 1910, American Board of Commissioners for Foreign Missions, Houghton Library, Harvard.

29 "The Armenian has become a noisy, blatant, overbearing, and insolent imitation . . .":
Captain Dickson to Sir G. Lowther, Van, Sept. 30, 1908, FO 424/217, p. 72. "The native
Moslems at Van are reactionary at heart . . .": same correspondents, Mar. 31, 1909, FO
424/219, p. 44.

30 "The circumstances of the country rendered it quite impossible . . .": G. C. Raynolds to
Dr. Barton, May 30, 1908, American Board of Commissioners for Foreign Missions,
Houghton Library, Harvard.

 "Everywhere in your villages there are 'shapkali' [wearing a hat] teachers . . .": speech
of Mushir Osman Pasha to the Armenian notables of the village of Khaskeui, plain of
Mush, Aug. 8, 1911, FO 424/228, p. 128.

31 "Filled with worms": Ado Adoian to KM, Oct. 17, 1966, MWAG, p. 88.

 My description of Khorkom comes from Arax Melikian, AGA, p. 154 n. 16, and MWAG,
p. 82.

32 "One must play hard, hard, so I must strike the castle": Ado Adoian to KM, MWAG,
p. 82.

 "No one, absolutely no one, ever told us not to play this game . . .": Vahan Totovents,
Scenes from an Armenian Childhood (Oxford University Press, 1962), p. 149.

34 For eyewitness accounts of the Armenian genocide, see "The Treatment of Armenians in
the Ottoman Empire, 1915–16," papers presented to Lord Bryce, His Majesty's Stationery
Office, misc. no. 31, 1916 (and reprints). Regarding Van, see H. Gossoian, The Defense of
Van (Raven Publishers, 1980). For the relationship between Kurds and Armenians, see
Gunnar Wiessner, Hayoths-Dzov-Xavasov (Wiesbaden, Germany: Dr. Ludwig Reidert
Verlag, 1979).

35 "We could hear the harmonious song of the waves on the sands of its shores . . .":
"Memoirs of Dikran der Garabedian," Varak: Periodical of the General Society of Vas-
bouragan, vol. 39, no. 116 (July/Dec. 1990): p. 67.

 Stood beside his father and by chance survived: see John Hussian's obituary in the
Philadelphia Inquirer, Tues., Oct. 28, 1986, p. 2-F.

36 "Ten-to-fifteen-year-olds, with sparkling black eyes . . .": Gossoian, Defense of Van,
pt. 2, p. 38.

37 The deaths of Moses' children: MS-Gail Sarkissian, Mar. 12, 13, 16, 1994.

 "The door the Turks couldn't take off its hinges": MS-Arax Melikian, Mar. 14–16, 1994.

 "The day they told us we must escape, all of the city panicked . . .": VM to KM, MWAG,
p. 26. I have altered the order of the sentences in this passage.

38 "All around us on the vast barren plains were a mass of fleeing refugees . . .": Yarrow
memoir, American Board of Commissioners for Foreign Missions, Houghton Library,
Harvard.

 Crossing the river by stepping on the bodies: MS-Gurken Kulegian, Nov. 6, 1993.

 "I remember faces. They are all green . . .": Mary Burliuk, "Recollections of Arshile
Gorky," Color and Rhyme, no. 19 (1949).

THREE / YEREVAN

39 "Filled with a shifting multitude . . .": Clarence D. Ussher, An American Physician in
Turkey (Houghton Mifflin, 1917), p. 314.

 "Like beasts emerging from a forest on fire . . .": Kostan Zarian, Le Bateau sur la mon-
tagne, trans. Pierre Ter-Sarkissian (Editions du Seuil, 1986), p. 42; my translation from
the French. The descriptions of Yerevan in this chapter come from Zarian.

41 "Thousands and thousands and thousands of dirty, lousy . . .": Ernest Yarrow, Dec. 15,

1919, American Board of Commissioners for Foreign Missions, Houghton Library, Harvard.

41 "A very fine boys' school . . .": VM's testimony concerning this period is in *AGA,* 139–46; *MWAG,* pp. 28–33; and *Ararat,* 7–14.

For the school curriculum, see Simeon Sha-Nagareants, *Statutes and Program for Administrative and Educative Disciplines in the Clerical Schools of the Armenian Diocese: Moscow, 1900* (in Armenian). For Gorky's schooling I have taken MS-Arax Melikian, and with caution, *AGA,* p. 143.

42 "A dollar here, a dollar there . . .": MS-Gail Sarkissian, Mar. 12, 13, 16, 1994.

"Why did my mother reject me? . . .": MS-Florence Avedisian (Satenig's daughter), Nov. 6, 1993.

43 "In a very bare room with earthen floor . . .": MS-Arax Melikian.

"When mother was alive in Yerevan . . .": VM in *Ararat,* p. 14. "Mother did not think much . . .": VM, memoir written for Ethel Schwabacher, Nov. 1949, Schwabacher Papers, WAF.

44 "That we must be freed from this slavery . . .": *Ararat,* pp. 11–12. Also *MWAG,* pp. 29, 54 n 11; *AGA,* p. 143.

46 The lost money: *Ararat,* p. 12, *MWAG,* p. 27; AMG.

47 "Better the Turks than the Dashnaks . . .": Hovsannah Keliklian to MS, Easter 1993, *AGA,* p. 147.

48 "The bearers . . . are worthy Armenians," etc.: from the original note in the possession of Lilyan Chooljian, Kerza Dikran's daughter, Fresno, Calif.

"Very probably by those same ruffians . . .": Kostan Zarian, *Bancoop and the Bones of the Mammoth,* trans. Ara Baliozian (Ashod Press, 1982), pp. 7–8.

50 Gorky's visit to Robert College: Raoul Hague, interview with Avis Berman, Sept. 29, 1983, AAA.

Money for the tickets: MS-Gail Sarkissian, Mar. 12, 13, 16, 1994.

The incident in Patras: Aristodemos Kaldis, *My Three Comrades, Gorki, Kline and Pollock,* c. 1962 (videotape © Kaldisart, P. O. Box 1907, Easthampton, NY 11937).

FOUR / WATERTOWN

51 This chapter relies heavily on my interviews with Gorky's Armenian relatives: Hagop's son George Adoian, and his wife Ruth; Hagop's other children, Lucia, Charles, and Dawn Adoian; Akabi's children, Liberty Miller and Thomas Amerian; and Satenig's daughters, Florence Berberian and Lillian Balian. These interviews are now in the WAF and the AAA.

52 For Sedrak's early life in America, see VM's memoir, trans. Haig Partizian, Nov. 1948; interview with Mina Metzger, Dec. 1948; interview with Rook McCullogh, Dec. 1948, and her letter to Mina Metzger, Dec. 1948; Satenig Avedisian, letter to Mina Metzger, Mar. 31, 1949, all in Schwabacher Papers, WAF.

"Gorky went to Providence where he stayed with an old friend . . .": VM to Rook McCullogh, 1948, Schwabacher Papers, WAF.

56 "Look at this beautiful village . . .": MS-Will Barnet, Nov. 22, 1994.

57 "Armenian mountains . . .": Mischa Resnikov to KM, May 4, 1966, *MWAG,* p. 59 n. 22.

58 "Everyone was used to laugh at him . . .": MS-Gurken Kulegian, Nov. 6, 1993.

60 Aysaharel: The Armenian "Aysaharel," a word with Zoroastrian connotations, derives from "Asu," the Sanskrit for "spirit" or "wind." See James R. Russell, *Zoroastrianism in*

Armenia, Harvard Iranian Series, vol. 5, 1987, p. 451 and corresponding footnotes. See also Stepan Malkasiants, *Hayeren Patsadragan Paravan,* p. 81.

60 "He is said to be a relative of the novelist Maxim Gorky . . .": unidentified press cutting in WAF, 1935–36.

61 "I come from heaven," etc.: Yenovk der Hagopian to KM, Oct. 5, 1965, *Ararat,* p. 54.

62 "I'll never forget," etc.: Norris C. Baker, letter to Gorky postmarked Nov. 9, 1946, Collection Maro Gorky, with photocopy in WAF and AAA.

"No desire no temptation could ever stand in the way . . .": from an unpublished critique by AMG of Schwabacher's biography of Gorky, circa 1957, in the author's possession.

63–64 "A tall, serious young man in his twenties . . ." and "I shall be a great artist or if not, a great crook": Katherine Murphy to Elaine de Kooning, July 29, 1951; and to Ethel Schwabacher, Aug. 30, 1952, Schwabacher Papers, WAF.

"Very well equipped in drawing . . .": Ethel M. Cooke to KM, June 20, 1966, *MWAG,* p. 60 n. 23.

FIVE / SULLIVAN STREET

65 "Found no trouble in mixing Socialism, Anarchism . . .": W. H. Ghent, quoted in David Shannon, *The Socialist Party in America* (Quadrangle Books, 1967), p. 57.

66 "Speakeasies and bistros, women and doxies . . .": Julien Levy, *Memoir of an Art Gallery* (Putnam, 1977), p. 32.

Re Sloan's teaching, see John Loughery, *John Sloan, Painter and Rebel* (Henry Holt, 1995), p. 273.

For Gorky at the National Academy and the Art Students League, see my interviews with Lawrence Campbell, Philip Pavia, Herman Rose, and Joseph Solman.

67 "He expected . . ." down to "wild, poetic imagination": Mark Rothko to KM, Apr. 29, 1967, *MWAG,* pp. 197–99. "Pushed Rothko around": Raoul Hague to KM, *MWAG,* p. 149.

According to Vartoosh, the Bijurs met Gorky in Providence in the early twenties, where they encouraged him to change his name and move to New York. Mrs. Jean Bijur Weiss, the Bijurs' daughter, denies this in a letter to me, dated March 7, 1994. For Nathan Bijur, see his letters to Ethel Schwabacher in WAF, and my interview with Jean Bijur Weiss.

"flashing, dynamic good looks": F. Scott Fitzgerald, *The Crack-up,* edited by Edmund Wilson (New York: New Directions, 1942), p. 105.

68 Enveloped her small hands: MS-David Margolis, June 12, 1996.

"Everything from the tiny bug . . .": *New York Telegram,* Mar. 23, 1929.

Gorky told his second wife that he had not thought much of Mayakovsky, as he fainted in the street after pricking his finger on a pin he encountered in his pocket. What Gorky did not know was that Mayakovsky's father, a tsarist bureaucrat, died of septicemia after pricking his finger with a pin. Gorky's story sounds like an eyewitness account; therefore the two men must have met.

69 "Let the elevated . . ." down to "small-townishness of New York": unidentified newspaper clipping, reprinted in *Color and Rhyme,* no. 37 (May 1958); David Burliuk papers, microfilmed material in AAA, Washington.

"Gives New York . . ." down to "that has lived": *New York Evening Post,* Sept. 15, 1926.

70 For Greacen, see *Edmund W. Greacen, N.A.: American Impressionist* (Jacksonville, Fla. Cumer Gallery of Art, 1972), and my interview with his daughter, Nan Greacen Faure, Mar. 18, 1995.

71 "The hard, tight or commonly called academic style": Grand Central School of Art, prospectus, 1927, pp. 6, 7. Rudy Vallee's brother: *MWAG*, p. 220.

72 "Out in the middle of the ocean in a rowboat, far from shore": MS-Hans Burckhardt, Mar. 14, 1994.

My account of Gorky's teaching is a reconstruction based on the testimony of his pupils. "Nevermore draw like that": in *Walter Murch: A Retrospective Exhibition* (Providence: Rhode Island School of Design, 1966), pp. 21–23. "Only two or three shapes . . .": Max Schnitzler to KM, July 25, 1966, *Ararat*, p. 53. "Just of a dog": MS-Jean Bijur Weiss, Mar. 20, 1995. "You just sweated it out" and the Cézanne painting of "ladies sitting in the woods": Revington Arthur to KM, May 5, 1966, *MWAG*, pp. 94–95. Swapping paintings for art books: Erhard Weyhe to KM, May 2, 1966, *MWAG*, p. 215.

73 "More modern than the Picasso": MS-George McNeil, Nov. 23, 1993.

"My soul listening to the death of the twilight . . .": *Grand Central School of Art Quarterly*, Nov. 1926; republished in Ethel Schwabacher, *Arshile Gorky* (Macmillan, 1957), p. 21. For a recent translation of Siamanto's work, see *Bloody News from My Friend,* translated by Peter Balakian and Nevart Yaghlian (Detroit: Wayne State University Press, 1996).

75 The picnic on top of the arch of Washington Square: Loughery, *John Sloan,* pp. 228, 234.

The boy who drew like Paolo Uccello, and the dinner with Nicholas Vasilieff: VM to KM, *MWAG*, pp. 38, 41.

76 "Until he began to use it by the bucketful": Jean Bijur Weiss, letter to the author, March 7, 1994. Cardboard mold: MS-Nan Greacen Faure, Mar. 18, 1995.

"What are you doing?": Max Schnitzler to KM, *Ararat*, p. 53.

Sedrak Adoian at Cranston: MS-George Adoian, Nov. 5–8, 1993.

77 Gorky's maternal uncles: MS-Gail Sarkissian, Mar. 12–15, 1994.

78 "Practically every day": MS-Maryan Davis, Sept. 18, 1994.

"He'd better be good": MS-Helen Sandow, Nov. 22, 1993.

79 "Too spooky": Isamu Noguchi to Maro Gorky, in a conversation during his last exhibition in Venice, 1989. Checked against information from Dore Ashton and Daniel Entin, the present director of the Nicholas Roerich Museum.

80 "The wild horse": Maryan Davis to KM, *MWAG*, p. 124. In the entrance to the National Academy: MS-Joseph Solman, Nov. 16, 1994.

"his love for this young girl . . .": Roselle Davis to KM, *MWAG*, p. 124.

"Take 'em off, Murphy": Stuart Davis, "Arshile Gorky in the 1930's: A Personal Recollection," *Magazine of Art,* vol. 44, no. 2 (Feb. 1951): p. 57.

For Siroon Mousigians's account see the original interview between KM and Mousigian, December 10, 1972, in the Gorky Archive of the Armenian Diocesan Church, New York; and KM's extracts from this interview in *MWAG*, p. 223 n. 42, p. 224 n. 49, p. 226 n. 63. Sleeping naked: MS-George Adoian. Streetcar story: MS-Joseph Solman, Nov. 15, 1994.

SIX / UNION SQUARE

82 "The previous painter to occupy this immense studio . . .": Balcomb Greene, "Memories of Arshile Gorky" (1951), *Arts,* Mar. 1976, p. 108.

84 "Everybody just talked . . .": Mary Perot Nichols, "La Reine est morte," *Village Voice,* Mar. 2, 1961; *New York Times* and *New York Herald Tribune,* obituaries, 1961; Dorothy Miller, typescript interview with Paul Cummings, pp. 71–73, AAA.

84 "At all hours of the day or night . . .": Stuart Davis, "Arshile Gorky in the 1930's." "We don't do that here": MS-Willem de Kooning.

"It sticks in my craw," etc.: Stuart Davis, "Recollections of the Whitney," typescript in indirect speech of talk given at WNYC American Art Festival, Sept. 29, 1953, and Stuart Davis rewrite of this as radio broadcast, 1953, both in the Whitney Library.

"Stuart Davis, Gorky and myself have formed a group . . .": John D. Graham to Duncan Phillips, Dec. 28, 1931, The Phillips Collection Papers, AAA, Smithsonian Institution, Washington, D.C.

85 "I want somebody who thinks I'm pretty good . . .": Stuart Davis Restricted Interview with Harlan Phillips, 1962, AAA, courtesy Earl Davis.

"He, above his contemporaries, rises high—mountain-like . . .": Arshele (sic) Gorky, "Stuart Davis," Creative Art, vol. 9 (Sept. 1931): p. 213.

86 The Pappas restaurant: MS-Lillian Kiesler, correspondence 1993–96.

"long, loud, and full of emotion": Lillian Kiesler to MS, June 22, 1998.

87 These three paragraphs: Fernand Léger, "New York," first published in Cahiers d'Art (Paris), vol. 6, nos. 9–10 (1931): pp. 437–39. "Like sheep": letter from FL to Le Corbusier, Sept. 29 [1931], Archives Fondation Le Corbusier, Paris; reproduced in Fernand Léger (Centre Georges Pompidou, 1997), p. 321.

90 "A large number of his art-school period drawings . . .": Stuart Davis, "Arshile Gorky in the 1930's."

91 "But he's not from Van!": AMG.

92 Gorky's village in Russia: MS-Helen Sandow, Nov. 22, 1993. For Graham's early life, see Eleanor Green, John Graham, Artist and Avatar (Phillips Collection, 1988).

"Chairs in white slipcovers reflected in mirror . . .": John Graham, "Autoportrait," unpublished text in AAA, n.d.

93 "Art means artificial. Only artificial things are good . . .": John Graham, "Art," installment 7, p. 13, unpublished text in John Graham papers, reels 4042–4045, n.d. AAA.

94 Gorky's drawing in the style of Picasso: MS-Hedda Sterne, Nov. 21, 1993.

"What about Papa Cézanne! . . .": AG, letter to Dorothy Miller about the Garden in Sochi paintings, 1941, MoMA Artists' Records.

"Evaluation of form perfectly understood": John Graham, System and Dialectics of Art, ed. Marcia Epstein Allentuck (Johns Hopkins University Press, 1971), pp. 93, 104.

Highlights on the hair: Raphael Soyer to KM, May 3, 1966, MWAG, p. 211. Curling smoke: Jacob Kainen, "Memories of Arshile Gorky," Arts 50, no. 7 (Mar. 1976), p. 97.

"It operates in the medium itself . . .": Graham, System and Dialectics, pp. 165–66.

95 "They were probably too well aware . . .": Jacob Kainen, "Remembering John Graham," Arts (Nov. 1986), p. 30. (Two words in my quote have been corrected recently by JK.)

"They were probably . . ." down to "the formal order": ibid., p. 29; and Jacob Kainen letter to MS, after a conversation of Nov. 28, 1994.

97 "They don't look like artists to me": MS-Dorothy Dehner, Nov. 20, 1993.

"German sausage-maker": Rosalind Bengelsdorf Browne to KM, May 7, 1966, MWAG, p. 114.

99 "Piero? An academician": MS-Joseph Solman, Nov. 16, 1994.

Poussin story: May Tabak Rosenberg to the author, Dec. 3, 1975.

100 "Never liked 'use.' . . .": Willem de Kooning, interview with Bruce Hooton, Apr. 1, 1981, p. 25, AAA, unpublished transcript. A shorter, edited version of this interview is in Art World, vol. 5, no. 8 (April 18–May 16, 1981).

100 "And Gorky would hold forth . . .": John Gruen, *The Party's Over Now* (Viking, 1972), p. 246.

102 Armpits: Frank O'Hara, "On Rachmaninoff's Birthday and About Arshile Gorky."

"Look at those feathery trees": Willem de Kooning to KM, *Ararat*, p. 49.

103 "Would walk around the streets," etc.: Peter Busa interviewed by Dorothy Seckler, Sept. 5, 1965, p. 3. See also the testimony of Balcomb Greene, *MWAG*, p. 143; Will Barnet, *MWAG*, p. 97; Frederick Kiesler, *MWAG*, p. 160; Raoul Hague, *MWAG*, p. 149; Marny George memoir in WAF; Jacob Kainen, "Memories of Arshile Gorky."

"Walking at night . . ." down to "masterpiece": Edwin Denby, untitled essay in *The 30's: Painting in New York* (New York: Poindexter Gallery, 1957). Also Edwin Denby, *Willem de Kooning* (Hanuman Books, 1988), p. 26.

SEVEN / THE PUBLIC WORKS OF ART PROJECT

105 Eyewitness accounts of the Bonus March: Jim Sheridan memoir, pp. 13–16, and Herman Shumlin memoir, p. 381, in Studs Terkel, *Hard Times* (Pantheon, 1986).

106 Hoovervilles: *New Yorker*, Feb. 1931; Joseph Mitchell, *Up in the Old Hotel* (Vintage, 1993), p. 137.

107 "During the first years of the New Deal, there were many flirtations . . .": Mary McCarthy, "Portrait of an Intellectual as a Yale Man," in *The Company She Keeps* (Simon & Schuster, 1942), p. 127.

"I'd like to see . . .": Albert Halper, *Union Square* (Literary Guild, 1933), p. 64.

108 "He had a continuous complaint . . .": Stuart Davis, "Arshile Gorky in the 1930's."

Gorky's finances: Roselle Davis to KM, May 3, 1966, *MWAG*, p. 125.

109 Satenig's life: MS-Florence Avedisian, Nov. 6, 1993.

110 "There was never any preliminary talk . . .": Dorothy Miller to Paul Cummings, eighteen interviews between May 26, 1970, and Sept. 28, 1971, p. 97, AAA reel 4210, frames 680+ and 760ff.

"One of those shabby warehouses . . .": MS-Dorothy Miller, Nov. 12, 1994.

"Most of the time . . .": Dorothy Miller to KM, May 2, 1967, *MWAG*, p. 170.

112 "I never should have talked like that . . .": Avis Berman, *Rebels on Eighth Street* (Atheneum, 1990), p. 376. I am grateful to Ms. Berman for discussing this occasion with me.

For an excellent account by Edwin Alden Jewell of the foundation of the PWAP, see *New York Times*, Dec. 17, 1933, Sec 10, p. 12.

"My subject matter is directional": AG, application to PWAP, Mar. 20, 1933, National Archives, Washington, D.C.; quoted in *Murals Without Walls* (Newark Museum, 1978), p. 22.

114 "Port of New York . . .": National Archives, Washington, D.C.; photocopy in WAF.

"A relief measure . . .": Edward Alden Jewell, *New York Times*, Fri., Dec. 22, p. 19.

"The Word 'Need' ": *New York Times*, Wed., Jan. 10, 1934, p. 19.

115 Plot in a back room of Stewart's restaurant: Richard D. McKinzie, *The New Deal for Artists* (Princeton University Press, 1973), p. 16. "The noise was like a drum . . .": Ilya Bolotowsky to Paul Cummings, Mar. 24, 1968, p. 40, AAA transcript.

116 For Philip Boyer, see Berman, *Rebels*, p. 328. "Created a profound impression . . .": *Philadelphia Inquirer*, Sun., Sept. 29, 1935.

"Gorky, spirit of Europe . . .": Frederick Kiesler, catalogue for Mellon Galleries show, 1934, trans. Heinz Norden, photocopy in WAF.

117 The destruction of the Rivera mural: *New York Times,* Feb. 25, 1934, sec. 2, p. 1. Fighting through the picket lines: Dorothy Miller to Paul Cummings, pp. 16–19, Aural History Series, AAA, 1970, microfilmed transcript.

"This mile of American art . . .": Edward Alden Jewell, *New York Times,* Dec. 30, 1933, p. 11. See also Mar. 4, 1934, arts sec., p. 12; and Feb. 25, 1934, sec. 2, p. 1.

118 All quotations from Marny George: Marny George, letter to James Thrall Soby, Mar. 15, 1951, WAF.

119 The reaction of Gorky's friends to Marny George: MS-Jean Bijur Weiss, Mar. 7, 1994. Re Schary and Davis: AMG.

121 "My God, I felt the agony . . .": Reuben Nakian to KM, June 7, 1980, *MWAG,* p. 176.

122 The return of Vartoosh to America: Anna Hamburger to MS, circa 1986.

EIGHT / THE FEDERAL ART PROJECT

123 "A little skinny kid . . .": Rosalind Bengelsdorf Browne, interview with Susan C. Larsen, Jan. 7, 1974, pp. 542–43, AAA reel 2014, frame 865ff.

124 The Artists' Union has been covered by Gerald M. Monroe in an unpublished dissertation at the Smithsonian Institution, Washington, D.C., and in five articles published between 1972 and 1976 in the *Archives of American Art Journal.*

"Sincerity and understanding . . .": "The Second Washington Square Out Door Exhibition," *Color and Rhyme,* no. 3 (Nov. 1932), Burliuk papers, AAA, Smithsonian Institution, Washington, D.C.

125 "Each accepted subject . . ." down to "Cobalt or equivalent," *Art Front,* no. 1 (Jan. 1935): p. 4.

"A very charming person . . .": letter from Bernarda Bryson to MS, Oct. 6, 1997. "Big pro-Soviet guy": Joseph Solman to the author, June 12, 1996.

"They had the use of a loft . . .": Roselle Davis to KM, May 3, 1966, *MWAG,* p. 125.

126 "When we went there that morning of the parade . . .": Stuart Davis interview with Harlan Phillips, 1962, pp. 318–19, restricted-access transcript in AAA; quoted by kind permission of Earl Davis; extracts in "An Interview with Stuart Davis," *Archives of American Art Journal* ISSN 0003-9853, 1991, pp. 9–10. © Earl Davis, 1991.

127 "Lost patience with the artists . . .": *New York Times,* Wed., Oct. 16, 1935, p. 1.

128 "The windows and the platform hung with red curtains . . .": Edmund Wilson, *The Thirties,* ed. Leon Edel (Farrar, Straus & Giroux, 1980), p. 343.

"He would gain the floor . . .": Balcomb Greene, "Memories of Arshile Gorky."

129 "Why don't you just teach them how to shoot?": Dorothy Dehner to Garnett McCoy, 1966, p. 21, AAA transcript.

He once gave a slide show . . .: Willem de Kooning to Bruce Hooton, 1981, unpublished transcript in AAA. I have changed the order of the sentences to make the action consecutive.

130 Facts and quotes in these paragraphs from notes written by Michael West between 1967 and 1981, Michael West Archives, Roberta and Stuart Friedman Collection, Yorktown Heights, N.Y. I have kept MW's idiosyncratic spelling and punctuation.

133 "In some backyard fence . . .": Dorothy Miller to Paul Cummings, AAA, reel NDA 28, pp. 14, 99; and Muriel Baker to Harlan Phillips, Sept. 21, 1963, p. 20, AAA.

"Oh, if only he could get on the Project": MS-Joseph Solman, Nov. 16, 1994.

134 "Can *you* tell me this . . . ?" Burgoyne Diller to Ruth Gurin, Mar. 21, 1964, p. 6, AAA.

"They strike everyone as objects of beauty . . .": Fernand Léger, "The New Realism Goes On," trans. Samuel Putnam, *Art Front* 20 (Feb. 1937), p. 7; AAA reel NDA 28, frame 151.

136 "Made everything quite clear . . .": *Philadelphia Inquirer,* Sun., Sept. 29, 1935.

137 "He is a sheared beard . . .": Harriet Janis, catalogue for Mellon Galleries show, 1934, trans. Heinz Norden, photocopy in WAF.

"Abstract art is a series of numBERical quotients . . .": MS-Joseph Solman, Nov. 16, 1994.

"Archile Gorky's handsome decoration . . .": Edward Alden Jewell, *New York Times,* Sun., Oct. 13, 1935, sec. 10, p. 9.

138 All the documentation concerning the Guild Gallery in the following paragraphs comes from the unmicrofilmed Guild Gallery Papers at the Smithsonian Institution, Washington, D.C.

139 "Arshile Gorky has an extraordinary inventiveness . . .": Holger Cahill, catalogue for Mellon Galleries show, photocopy in WAF.

"Something unbelievable . . .": Anna Walinska, letter to MS, Aug. 19, 1995.

140 "America, land of dreams . . .": Fernand Léger, letter to Simone Herman, Mon., 24 [Feb. 1936], in *Fernand Léger: Lettres à Simone* (Centre G. Pompidou, 1997), p. 166; my translation.

"A hand—a leaf—a revolver –a mouth—an eye . . .": Fernand Léger, "The New Realism," trans. Harold Rosenberg, *Art Front* 8 (Dec. 1935), p. 10; AAA reel NDA28, frame 41.

141 "Including of course the renowned Picasso . . .": untraced press cutting in WAF, circa 1935.

"Wounded birds, poverty . . .": The Museum of Modern Art, Dept. of Painting and Sculpture: Arshile Gorky, *Objects,* artist's questionnaire.

"Stiff with clichés . . .": Greene, "Memories of Arshile Gorky," p. 109. "There was a tendency . . .": Stuart Davis, "Arshile Gorky in the 1930's," p. 58.

142 "The greatest intelligence . . .": John Ferren, quoted in *The 30's: Painting in New York* (New York: Poindexter Gallery, 1957).

"I remembered a concert . . .": Julien Levy, *Arshile Gorky* (Abrams, 1966), p. 16.

143 "A formidable and imposing figure . . .": Anna Walinska, letter to MS, Aug. 19, 1995.

"That was good . . .": Anna Walinska, telephone conversation with MS, July 12, 1995.

144 "A large handsomely colored piece of archaism": *Art News,* June 1936.

"Anna, you don't own any work of mine . . .": Anna Walinska, telephone conversation with the author, July 12, 1995.

NINE / THE NEWARK AIRPORT MURALS

145 "Feature in official correspondence . . .": Olive Lyford, "Mural Project for Newark Airport," report with covering letter of Jan. 31, 1936, Newark Museum files, quoted in *Murals Without Walls* (Newark Museum, 1978), p. 21. Gorky's swift workmanship: Saul Schary to KM, *MWAG,* p. 206.

146 "I want little boys in Dutch shoes . . .": *Art Front* 6 (July 1935), p. 31; AAA reel ND828, p. 27.

"Quite simple and severe . . .": Alfred Barr to Audrey McMahon, Dec. 3, 1935, AAA reel N-69-64; also MoMA files.

Would he like to come?: Audrey McMahon to Alfred Barr, Dec. 24, 1935, source as above.

147 "Brightly colored T-squares . . .": *New York Herald Tribune,* Dec. 28, 1935.

149 "All right Mr Mayor . . .": Audrey McMahon to Harlan Phillips, Wed., Nov. 18, 1964, p. 49, AAA transcript.

149 "Turned on his heel . . .": Edward Laning, "The New Deal Mural Projects," in *The New Deal Art Projects: An Anthology of Memoirs,* ed. Francis V. O'Connor (Smithsonian, 1972), p. 108.

"LaGuardia's comment . . .": Burgoyne Diller, n.d., Schwabacher Papers, WAF. For the background of the Newark Airport commission, see *Murals Without Walls,* pp. 21, 29 nn. 4 and 11. "That wonderful Arshile Gorky": Audrey McMahon to Harlan Phillips, Nov. 18, 1964, p. 5, frame 598; AAA reel 4210.

150 "Nodding seriously in acceptance of my help . . .": MS-Herman Rose, Feb. 12, 1995.

151 "You abstract artists . . .": Arnold Blanche to Joseph Trovato, Nov. 4, 1964, p. 7, AAA reel 3418, frame 656; and Arnold Blanche to Dorothy Seckler, June 13, 1963, p. 15, AAA transcript. I have spliced together two versions of the same story.

" 'With' Cézanne . . .": Julien Levy, *Arshile Gorky* (Abrams, 1966), pp. 15-18.

152 "Artists are often good procurers . . .": Julien Levy, *Memoir of an Art Gallery* (Putnam, 1977), pp. 126-31.

155 "Too much for her . . .": MS-Faith Rose, telephone conversation, June 5, 1995.

156 "Just as water . . .": Rosalind Bengelsdorf Browne, AAA reel 2014, frames 755-67.

Re Gorky's lecture, Rosalind Bengelsdorf Browne to KM, *MWAG,* pp. 112-18.

157 Finger and thumb around Mercedes Carles's wrist: MS-Willem de Kooning.

"He had no ballast against art . . .": MS-Mercedes Carles, Nov. 17, 1993.

158 "Hard offensive points . . .": Balcomb Greene, "Memories of Arshile Gorky."

Every member of the American Abstract Artists group remembers a different story about the events preceding its founding. I have fitted the stories involving Gorky into a plausible sequence of the early meetings, but whether Gorky came to one, two, or three of these can only be guessed.

159 "Holtzman wanted to teach . . .": Rosalind Bengelsdorf Browne, interview with Susan Larsen, p. 542, AAA transcript.

Lightbulb and piece of string: Rosalind Bengelsdorf Browne, "The American Abstract Artists and the Federal Art Project," in *The New Deal Art Projects: An Anthology of Memoirs,* ed. Francis V. O'Connor (Smithsonian, 1972), p. 229.

160 "I am leaving . . .": Ilya Bolotowsky, "Reminiscences about the American Abstract Artists," June 20, 1966, p. 1, AAA reel 2787, frames 289-91. I have reworded the quotation slightly, referring to the same story in his interview with Ruth Gurin, 1963, p. 5, AAA transcript; in his interview with Paul Cummings, Mar. 24, 1968, p. 49, AAA transcript; and in his interview with KM, Nov. 2, 1973, *MWAG,* p. 110.

"Wasn't exact enough": MS-Jacob Kainen, May 9, 1995.

161 "In the pose of Rodin's *Thinker* . . .": MS-Joseph Solman, Nov. 15, 1994. Gallery announcement re Boyer group show: *New York Times,* Dec. 4, 1936, p. 22.

162 "Failing the necessary number . . .": minutes of American Abstract Artists, Leo Rabkin Papers, AAA reel N-69-72, frame 22.

"He thought he was above it . . .": MS-Joseph Solman, Nov. 16, 1994.

TEN / OLD AND NEW PATHS

163 "If you look closely . . .": *Newark Ledger,* Sun. Nov. 8, 1936.

"Repercussions from the Newark newspaper articles . . .": Olive M. Lyford to Alfred Barr, Oct. 2, 1936, AAA reel N-69-64, frame 613. "An airport should be . . .": Alfred Barr to Olive M. Lyford, Oct. 14, 1936, same source.

164 "Cool, forbidding characters . . .": quoted in Susan C. Larsen, "The American Abstract Artists Group," Ph.D. diss., Northwestern University, Evanston, Ill., 1975, p. 200.

164 "Mural painting buono al fresco . . .": Frederick Kiesler, "Murals Without Walls: Relating to Gorky's Newark Project," *Art Front* 18 (Dec. 1936), p. 10; AAA reel NDA 28, frame 131.

165 "I think that it is also important . . .": Emanuel Benson to AG, Nov. 27, 1936, Record Group 69, box 651.315, file Nov. 1936, National Archives and Record Service.

166 "Would you ask Mr. Gorky . . .": Emanuel Benson to Audrey McMahon, source as above, file Jan–Feb. 1937.

On May 24, 1978, Beril Barker wrote to Francis O'Connor saying that she was the one who had helped Gorky to "write his credo about the Newark murals" (*Murals Without Walls* [Newark Museum, 1978], note on the text, p. 16).

167 "The Akabis are certainly in a bad way . . .": AG to VM, May 10, 1938.

168 "You are, we feel, a great painter . . .": Wolf Schwabacher to AG, May 28, 1937, WAF.

"A frightening assortment of multi-colored angles . . .": *Newark Ledger,* Thurs., June 10, 1937.

"We drove over the swamps . . .": Stuart Davis, "Arshile Gorky in the 1930's."

169 "Boon-dogglers and horn-tooters . . .": Richard D. McKinzie, *The New Deal for Artists* (Princeton University Press, 1973), p. 166 and relative footnotes.

170 "An ill-assorted group of nervous people . . .": Mary McCarthy, "Portrait of an Intellectual as a Yale Man," in *The Company She Keeps* (Simon & Schuster, 1942), p. 161.

"When friends who had fought in Spain returned . . .": Edwin Denby, untitled essay in *The 30's: Painting in New York* (New York: Poindexter Gallery, 1957).

"If it's good enough for Schtalin . . .": MS-Jacob Kainen, May 9, 1995.

"He always worried that he'd get a pink slip . . ." down to "riddles or enigmas": Aristodemos Kaldis, *My Three Comrades, Gorki, Kline and Pollock,* c. 1962 (videotape © Kaldisart, Box 1907, Easthampton, NY 11937). I have amalgamated two versions of the same story from different tapes. See also Aristodemos Kaldis to KM, *MWAG,* p. 155.

171 "The owner insisted that he saw obscenity . . .": Roselle Davis to KM, *MWAG,* p. 124.

"Gorky involved Byron and Bill . . .": Rosalind Bengelsdorf Browne to KM, *MWAG,* p. 115.

172 "Bill, that's a *mean* way to draw": MS-Willem de Kooning; and Willem de Kooning to Bruce Hooton, 1981, pp. 16–17, AAA, unpublished transcript.

"Hundreds and hundreds of layers of paint . . .": The Museum of Modern Art, Dept. of Painting and Sculpture: Arshile Gorky, *Argula,* artist's questionnaire.

173 "Clean" and "personal": AG to VM, Jan. 11, 1937, and Feb. 28, 1938.

"After about four sessions . . .": Jacob Kainen, "Memories of Arshile Gorky."

174 "When he posed for me for that painting . . .": Raphael Soyer to KM, May 3, 1966, *MWAG.*

175 "Knowing that the living could not live forever . . .": AG, "My Murals for the Newark Airport: An Interpretation," Nov./Dec. 1936, WAF.

ELEVEN / THE WORLD'S FAIR

177 "May God ensure they accept them . . .": AG to VM [October?] 18, 1937.

Sedrak's life: MS-George Adoian, Nov. 5–8, 1993.

178 "Gorky described it as the bleakest . . .": AMG to Pat Passlov, in *The 30's: Painting in New York* (New York: Poindexter Gallery, 1957).

178 "They are beating at my door . . .": AG to VM [May 1938?].

"They liked my 3 paintings . . .": AG to VM, Mar. 23, 1937.

179 "I wish you a happy new year . . .": AG to VM, Jan. 1, 1938.

"I am drawing paintings nine feet wide . . .": AG to VM, Monday night, May 10, 1938.

"The architect is Mr. William Lescaze . . .": AG to VM, Oct. 12, 1938.

"I don't think Gorky was too happy . . .": William Lescaze to Wolf Schwabacher, Jan. 13, 1949, WAF.

"Because with a tiny stove in the winter's cold . . .": AG to VM, March 17 [1939].

180 "Dear Murad as you know . . .": AG to VM [shortly before May 1939].

"I'm sorry I don't have news of Ado . . .": AG to VM [May 1938?].

"What has in fact happened to Ado as you wrote . . .": AG to VM [Jan. 1, 1938?]

181 "Every day you are in the pupils of my eyes . . .": AG to VM, n.d. [Apr. 18, 1938].

In a museum one day: ES working notebook for her biography of Gorky, WAF. Microfilm on AAA N/69-64, frame 365.

182 "He couldn't get over the idea of painting on a terra-cotta wall . . .": Willem de Kooning interview with Harold Rosenberg, *Art News*, Sept. 1972.

183 "A great guy sitting on a horse . . .": Willem de Kooning to KM, *MWAG*, p. 132. "I always thought he gave me the business . . .": Bruce Hooton interview, 1981, AAA unpublished transcript.

184 "For four or five years . . .": Balcomb Greene, *MWAG*, p. 157. "De Kooning would become ecstatic . . .": Aristodemos Kaldis to KM, *MWAG*, pp. 143, 145.

187 "Tread was light . . .": MS-Arax Melikian. See also Pari Courtauld, *A Persian Childhood* (The Rubicon Press, 1990), pp. 38, 44.

188 "Like a little puppy dog . . .": Rosalind Bengelsdorf Browne to KM, *MWAG*, p. 114.

189 "The young women will prepare the salad . . .": Ilya Bolotowsky to KM, *MWAG*, p. 107.

"Gorky started to talk about his motherland . . .": Lewis Balamuth for David Burliuk, Apr. 29, 1949, in *Color and Rhyme*, no. 19 (1949).

190 Libby's visit to Gorky: MS-Liberty Miller, Mar. 17, 1994.

"Linora my friend who is now in Paris . . .": AG to VM [Apr. 18, 1938?].

191 "I don't see Linora very often . . .": AG to VM, Mar. [1939].

"I believe that before you get this letter . . .": AG to VM, Sept. 7, 1939.

"Don't worry about me I am well . . .": AG to VM [Oct. 1939?].

192 "My dearest, you wrote some time ago . . .": AG to VM, date unknown.

193 "My dear I have to tell you something . . .": AG to VM [1939].

194 "Curtain that seems to hide so much of Gorky's past": Haig Partizian to Ethel Schwabacher, Dec. 17, 1955, WAF. "Just like Manuk. Just like his painting . . .": Hagop der Hagopian to KM, Oct. 5, 1955, *MWAG*, p. 139,

"In this world there is no place for me," etc.: Schwabacher Papers, WAF. My version was made with the help of Piero Kuciukian and Ani Mardirossian.

TWELVE / WAR

195 "Tall, mournful, black mustached . . .": *The Diaries of Dawn Powell, 1931–1965,* ed. Tim Page (Steerforth Press, Vt., 1995), p. 160.

196 "Such an assortment of talent . . .": Louise Bogan to Morton Zabel, May 24, 1944, in *What the Woman Lived: Selected Letters of Louise Bogan, 1920–1970,* ed. Ruth Limmer (Harcourt Brace Jovanovich, 1973), p. 239.

196 "The talk turned to the condition of the painter . . .": Edwin Denby, untitled essay in *The 30's: Painting in New York* (New York: Poindexter Gallery, 1957).

"Defeated": *Lee Krasner: A Retrospective* (Houston: Museum of Fine Arts, 1983), p. 38.

"A few painters were painting . . .": Adolph Gottlieb, *Art News,* Apr. 1967.

197 "I do not know anyone . . .": AG to Max Weber, Max Weber Papers, AAA.

"Those which could be sold": AG to VM, Sept. 3, 1940.

"My dearests don't worry about me . . .": AG to VM, Sun., Aug. 11, 1940.

198 "I drew my designs in a week . . .": AG to VM, Sun. [mid-Apr.?] 1940.

"My dearest ones, I do the best I can . . .": AG to VM, Sept. 3, 1940.

199 "Of course he must have seen the green . . .": Willem de Kooning to Bruce Hooton, AAA unpublished transcript.

200 "Thus I will keep my word . . .": AG to VM, Jan. 10, 1941.

The following pages describing Gorky's meeting with Mougouch are from seventeen interviews with AMG; and MS–de Kooning, pp. 18–19.

205 Moorad Mooradian's FBI file, courtesy Freedom of Information and Privacy Act Department, FBI, Washington, D.C.

209 "My family was terribly relieved . . .": AMG to AG, early May 1941.

"I miss you terribly . . .": AG to AMG, postmarked May 7, 1941.

210 Gorky's Gaudier letters are in Ethel Schwabacher, *Arshile Gorky* (Macmillan, 1957), pp. 85–86. N. Vaccaro pointed out the theft in "Gorky's Debt to Gaudier-Brzeska," *Art Journal,* vol. 23 (fall 1963): pp. 33–34.

211 "Recently, about three months ago . . .": AG to VM, May 20, 1941.

THIRTEEN / SAN FRANCISCO

212 "If I was a bird . . .": AMG.

"I call these murals non-objective art . . .": AG in "Café Life in New York: The New Murals at Ben Marden's Riviera as the Artist Sees Them," *New York Sun,* Fri., Aug. 22, 1941.

213 "The design on the rug is the skin of a water buffalo . . .": The Museum of Modern Art, Dept. of Painting and Sculpture: Arshile Gorky, Collection File, letter from Arshile Gorky to Dorothy Miller, June 26, 1942.

"She treats me like a prince . . .": MS–Willem de Kooning.

214 "The exhibition was a resonant flop": Julien Levy, *Memoir of an Art Gallery* (Putnam, 1977), pp. 249–51.

A close friend of Matta's: MS–Gordon Onslow Ford, June 29, 1998.

215 "Matta would look at it and make some comments . . .": Peter Busa to Dorothy Seckler, Sept. 5, 1965, AAA transcript.

"Daughter of Helios (the sun) . . .": quoted in *Jackson Pollock: Drawing into Painting* (Oxford, England: Museum of Modern Art, 1979), p. 17.

"In the beginning was the word . . .": MS–Roberto Matta, May 29, 1997, p. 12.

216 "Was a fine shot with small arms and riffle . . .": from a handwritten autobiography by JR in the Young/Mallin Archives, New York; courtesy Judith Mallin.

219 "Next Tuesday, together with some friends, I am going to San Francisco . . .": AG to VM, June 23, 1941.

221 "Not just horticulture to him . . .": Isamu Noguchi to KM, "The Philosophy of Arshile

Gorky," *Armenian Digest*, Sept.–Oct. 1971; and Isamu Noguchi, *A Sculptor's World* (Harper & Row), p. 25.

222 "Today is the fourth day that I am in San Francisco and I am going mad . . .": AG to VM, July 20, 1941.

223 "Caucasian, or any of that rubbish . . .": MS-Gail Sarkissian, Mar. 12–15, 1994.

224 "Isn't just a pleasant memory . . .": Kostan Zarian, *Le Bateau sur la montagne*, trans. Pierre Ter-Sarkissian (Editions du Seuil, 1986), p. 21; my translation from the French.

"A sort of frantic undone but I'll-have-the-last-bitter-drop look": AG to JR, n.d. [May 1945].

"Blithely untroubled": Katharine Kuh, "Isamu Noguchi at Large," unpublished manuscript, copyright © 1993 by Avis Berman.

"Openly flirting with Mougouch . . .": MS-Katharine Kuh, Nov. 11, 1991.

227 "To the surrealist school belong the oils of Arshile Gorky . . .": Alexander Fried, *San Francisco Examiner*, Aug. 17, 1941.

228 "Arshile Gorky is technically part abstractionist, partly expressionist": Emilia Hodel, *San Francisco News*, Aug. 17, 1941.

"Here the human scale is respected . . .": Fernand Léger to Simone Herman, July 21, 1941, documents du MNAM-CCI.

229 "Agnes and I returned yesterday afternoon at eleven o'clock . . .": AG to VM, Sept. 17, 1941.

230 "So I wasn't exactly flattered . . .": JR to the author, Dec. 1975.

FOURTEEN / A CHANGE OF DIRECTION

233 "We are truly upset . . .": AG to VM, Sun. [Dec. 28] 1941.

234 "What the enemy would destroy, however, he first must see . . .": AG, brochure on camouflage printed for the Grand Central School of Art, 1941–42, copy in WAF. "I have bought new books on this particular subject . . .": AG to VM, n.d. [Fall 1941].

"Where could Gorky, without authority . . .": Aristodemos Kaldis to KM, July 26, 1966, *MWAG*, p. 156.

"Lightning war": John Gruen, *The Party's Over Now* (Viking, 1972), p. 265.

235 As soon as a pupil had grasped one point . . . : Betty Parsons to KM, May 9, 1966, *MWAG*, p. 188.

"OK, let's see these paintings . . .": AMG in conversation, June 14, 1997.

"I denounced Gorky at once . . .": Balcomb Greene, "Memories of Arshile Gorky," p. 110.

236 "like a monitor at a summer camp . . .": MS-Matta, May 29, 1997, pp. 8–9.

238 "This is the weirdest, most unreal situation . . .": Isamu Noguchi to Man Ray, May 30, 1942; by courtesy of the Isamu Noguchi Foundation.

"I think that people who are living cool and comfortable . . .": Peggy Osborne to Isamu Noguchi, July 12, 1942; by courtesy of the Isamu Noguchi Foundation.

239 "Surely the war will soon come to an end . . .": AG to VM, n.d. [early 1942].

240 "To give him time to find out what he would do in New York . . .": Peggy Guggenheim, *Out of This Century* (Deutsch, 1983), p. 250.

"He used long, complex sentences . . .": MS-Milton Gendel, Oct. 31, 1996.

241 "Dialectical materialism": Meyer Schapiro to Mark Polizzotti, quoted in MP's *Revolution of the Mind: The Life of André Breton* (Farrar, Straus & Giroux, 1994), p. 505.

241 "Uncovered the glossary of the myth": Mark Rothko, personal statement, 1945, in MR, Tate Gallery. "Be they pagan . . .": from *View*, ser. 3, no. 1 (Apr. 1943): p. 5.

"My biography is very short . . .": The Museum of Modern Art, Dept. of Painting and Sculpture: Arshile Gorky, Collection File, letter from Arshile Gorky to Dorothy Miller, June 26, 1942.

242 "I like the heat the tenderness . . .": The Museum of Modern Art, Dept. of Painting and Sculpture: Arshile Gorky, *Garden in Sochi*, Collection File, text written by the artist, June 1942. Quoted in Ethel Schwabacher, *Arshile Gorky* (Macmillan, 1957), p. 66. I have removed the punctuation ES gave this text and added a phrase she left out.

243 "Welcome O talent! . . .": typed fragment in a sketchbook, n.d., Collection Maro Gorky.

244 "Something quite new and miraculous . . .": AMG to Natalie Campbell, Feb. 1943.

248 "With your last letter you wrote that you were very depressed . . .": AG to VM, "Fri. at eight in the evening," n.d.

249 "Listened to the birds sing and the trees talk": MS-George Adoian, Nov. 5–8, 1993.

FIFTEEN / CROOKED RUN

250 "The painters put the surrealists in their pockets": AMG.

251 "In the mountains of the Caucasus there is famine . . .": Mary Burliuk, "Recollections of Arshile Gorky." AMG remembers the occasion and I have incorporated her comments.

"She seems very healthy . . .": Essie to her son, John Magruder, Apr. 6, 1943. All correspondence between Essie, her son, and her husband courtesy Malcolm Magruder and the Magruder family archive, Millwood, Va.

"My Darling Mougouch My sweet Heart My Wife . . .": AG to AMG [Apr. 6, 1943].

"The little Gorky MARU . . .": Captain Magruder to Essie, May 24, 1943.

252 "Nothing was growing there but grass . . .": MS-Arax Melikian, Mar. 16, 1994.

253 "See here—this has a tassel going thataway . . .": Asa Moore Janney in conversation, May 12, 1994. See also his book *A Medieval Virginian Town, 1914–19* (Lincoln, Va.: Pied Typer Press, 1986).

258 "He was again a small child . . .": AMG to Natalie Campbell, Dec. 12, 1943.

259 "There were no acrimonious conversations . . .": Essie to John Magruder, Oct. 26, 1943.

"He says he's Russian . . .": Eleanor Perényi to the author, Nov. 13, 1994.

260 "We've had a very exciting time with the neighbors cows . . .": Essie to John Magruder, Oct. 26, 1943, p. 5.

"We read of the 2nd Marines and their storming of Tarawa . . .": Capt. Magruder to his son, Dec. 2, 1943, p. 2.

"Your sister Ang & her lummox of a consort . . .": Captain Magruder to his son, Feb. 4, 1944, p. 4.

SIXTEEN / SURREALISTS IN NEW YORK

262 "The song of the cardinal, liver, mirrors . . .": AG, "Poem," 1944, in Sidney Janis, *Abstract and Surrealist Art in America* (Reynal & Hitchcock, 1944).

263 "If its another baby I cant stand it . . .": Essie to her son, Dec. 20, 1943.

264 "You will have to make of Marcus Rothko's 'The Syrian Bull' what you can . . .": Edward Alden Jewell, *New York Times*, June 2, 1943, p. 28.

"A poetic expression of the essence of myth," etc.: letter from Gottlieb and Rothko, *New York Times*, June 7, 1943. The drafts of the letter are in the Rothko Papers, AAA.

265 "Water has to exist!": MS-Roberto Matta, May 29, 1997.

266 "Pollock immediately became the central point of Art of This Century . . .": Peggy
 Guggenheim, *Confessions of an Art Addict* (Macmillan, 1960), pp. 105–6. Some contro-
 versy surrounds the creation of Pollock's mural. I have taken PG at her word.

267 "Unblinking as a kitten . . .": JR to AMG, Soda Springs, Calif., May 15, 1944. Jeanne
 Reynal's letters to AMG, on microfilm in the AAA, are quoted with the kind permission
 of Christopher Schwabacher, her executor. I have restored capital letters to Jeanne's
 typewritten letters, but kept her spelling.

 "This responsibility may be largely ours . . .": untraced circular by the American Feder-
 ation of Artists and Sculptors, quoted in the *New York Times,* May 22, 1942.

268 "Last summer Gorky decided to put out of his mind the galleries of Fifty-seventh
 Street . . .": James Johnson Sweeney, "Five American Painters," *Harper's Bazaar,* no.
 2788 (April 1944): pp. 76, 122, 124.

 "Gorky said had he known Sweeny was so uninspired . . .": AMG to JR, Thurs., Apr. 20,
 1944.

269 "When he was agonizing over his drawings . . .": AMG to JR, n.d. [June 1944].

270 "Man was no longer able to trust his intuitive irresponsible self . . .": AMG to JR, Lin-
 coln, Va., May 5, 1944.

SEVENTEEN / A SECOND SUMMER AT CROOKED RUN

271 "And who insists on the 'porte battente' . . .": JR to AMG, Soda Springs, Calif., "Sunday.
 June" [1944].

 "Attempt to simplify and regularize, thus to bring duty into sexual relations . . .": AMG
 to JR, n.d. [June 1944].

272 "To run after a new love was to find only what you left in the old . . .": JR to AMG, Soda
 Springs, Calif., "Sunday. June" [1944].

 "Do you think gorky wants to read all of breton? . . .": AMG to JR, n.d. [June 1944].

273 "Sweet & a good boy" down to "long hair": AMG to JR, Lincoln, Va., May 5, 1944.

 "It is fantastic the way he starts off . . .": AMG to JR, June 2, 1944.

 "He's a juke box": AMG to JR, n.d. [June 1944].

274 "Flashy, ain't it?": Henry Taylor in conversation with MS, Lincoln, Va., May 14, 1994.

275 "Felt the earth as a swell, a bosom, an expansion . . .": AMG to Ethel Schwabacher, Dec.
 28, 1949, WAF.

 "It is such a wonderful place . . .": AMG to JR, n.d. [Nov. 1944].

 "Gorky has been thrashing over two particular canvases . . .": AMG to JR, n.d. [summer
 1944].

 "I feel frightfully subdued . . .": AMG to JR, n.d. [summer 1944].

276 "Back hills of Virginny touch . . .": AMG to JR, Sept. 28 [1944].

 "I'll say this for him—which I can't say for the big shaggy Archile . . .": Captain
 Magruder to his son, Feb. 4, 1944.

 "This really has been a bad luck summer" down to "not at all art colors": AMG to JR,
 Sept. 28, 1944.

278 "He is sitting perched on his stool . . .": AMG to JR, Oct. 18, 1944.

 "He must feel like a bonfire" down to "especially for him": AMG to JR, n.d. [Nov. 1944].

 "Now if we go to an opening . . .": AMG to JR, n.d. [New York, Dec. 1944].

279 "Mr. God": I am grateful to Dore Ashton for this detail.

279 "They do not want to mingle with Americans . . .": Simone de Beauvoir, *America Day by Day* (Duckworth, 1952), p. 249.

"De Kooning always followed him . . .": Aristodemos Kaldis to KM, *MWAG*, p. 157.

"Gorky has spent years building up the proper defense . . .": AMG to JR, Oct. 1946.

280 "Weaved in here yesterday to talk to gorky . . .": AMG to JR, n.d. [New York, Dec. 1944].

"I am going to throw you out of the window . . .": Balcomb Greene to KM, *MWAG*, p. 146.

281 "The babes in the wood": MS-Roberto Matta, May 29, 1997.

"Longing to impress Julien . . .": letter from Eleanor Perényi to MS, Nov. 8, 1994.

Julien Levy: contract with Arshile Gorky dated Dec. 20, 1944, in MS-Levy file.

"Everyone insists on telling us about Breton . . .": AMG to JR, n.d. [from Roxbury, late Dec. 1944 or early Jan. 1945]: "Was actually overwhelmed with joy at being accepted . . .": Julien Levy, *Arshile Gorky* (Abrams, 1966), p. 21.

EIGHTEEN / ROXBURY

285 "Spread to the color of the walls . . ." down to "obstetricians": Julien Levy, *Memoirs of an Art Gallery* (Putnam, 1977), pp. 89, 69.

286 "With gestures of indescribable nobility": Stanley William Hayter to MS, circa 1972. "Waved their pipes and pranced at each other": AMG to JR, n.d. [Apr. 1945].

288 "Gorky is remembered in relation to designs of considerable strength and formality . . .": "In the Art Galleries," *New York Herald Tribune*, Mar. 11, 1945.

"Gone are the larger, bolder forms . . .": Edward Alden Jewell, "Art Old and New," *New York Times*, Sun., Mar. 11, 1945, sec. X, p. 8.

"Will be confused by Breton's attribution of profundity . . .": Maude Riley, "The Eye-Spring: Arshile Gorky," *Art Digest*, vol. 19 (Mar. 15, 1945).

"They are incapable of making the emotional response": JR to AMG, "april 5 or so," 1945.

289 "Masculinity of character" down to "genuine contemporary work of art": Clement Greenberg, *The Nation*, Mar. 24, 1945, pp. 342–43.

"Blood boil . . .": JR to AMG, Apr. 7, 1945.

The story was told: Clement Greenberg to KM, Mar. 30, 1966. *MWAG*, p. 222.

290 "Revolutionary activity recommences" down to "I never know which": AMG to JR, undated letter [late May 1945].

"Not waking up the next morning": André Breton, *Conversations: The Autobiography of Surrealism*, trans. Mark Polizzotti (Paragon House, 1993), p. 162.

291 "Perhaps the fact that I was taken away from my little village . . .": The Museum of Modern Art, Dept. of Painting and Sculpture: Arshile Gorky, Collection File, Artist Records, August 1945.

"Killing together & very fond of each other really": AMG to JR, n.d. [Nov. 1945].

292 "He seemed a little bit unhappy . . .": Alexander Calder to KM, May 10, 1966, *MWAG*, p. 118. "I was always very fond of Marcel . . .": Alexander Calder, letter to Anne d'Harnoncourt and Kynaston McShine, Nov. 13, 1972, reproduced in *Marcel Duchamp* (Museum of Modern Art [New York] and Philadelphia Museum of Art, 1973), p. 190.

"I resented him very much because I had done a similar sort of thing . . .": Isamu Noguchi to Paul Cummings, 1973, pp. 65–66, AAA transcript.

"That sweet man mister Davis . . .": AG to VM, n.d. [May/June 1945].

293 "Dont for one minute think the critics didnt trouble gorky . . .": AMG to JR, Apr. 8, 1945.

"The dark line like a pencil line yet in paint . . .": JR to AMG, Apr. 7, 1945.

294 "His head is so lionlike . . .": AMG to JR, n.d., [late May] 1945.

"Kept barging in to glare with her gimlet eyes . . .": AMG to JR, n.d. [May/June 1945].

295 "With waterfalls and hemlocks all to Gorky's delight . . .": AMG to JR, n.d., reply to JR's letter dated June 22, 1945.

296 "On grand lines" down to "philosophical": JR to AMG, July 25, 1945.

"Imagine the horror . . ." down to "What waifs we are . . .": AMG to JR, Aug. 23, 1945.

298 "Julien loves & adores the new paintings . . .": AMG to JR, n.d. [late Sept. 1945].

"The atmosphere was of the iron side . . ." down to "thought": AMG to JR, n.d. [Sept. 1945].

"Please dont tell Arshile . . .": JR to AMG, Nov. 9, 1945. "Declares himself much better . . .": AMG to JR, n.d., [Nov.] 1945.

299 "He has really been very good . . ." down to "control would be worse": AMG to Ethel and Wolf Schwabacher, early Jan. 1946.

"They get on to the sort of rhythm that exists between humans . . .": JR to AMG, Feb. 5, 1946.

300 "He was the loved son, the heir apparent . . .": Robert Motherwell to Sidney Simon in *Abstract Expressionism: A Critical Record* (Cambridge University Press, 1990), p. 37.

"Matta is a silly child to consider ab as an old man . . .": JR to AMG, Nov. 25, 1945.

301 "Andre was in a rage from start to finish . . .": AMG to JR, Washington, Jan. 9, 1946.

Letter re finances: AMG to Ethel and Wolf Schwabacher, n.d. [early Jan.] 1946, WAF.

"Darling G. I left with Jean & Henry . . .": AMG to JR, Jan. 9, 1946.

NINETEEN / TWO DISASTERS

302 "I have been working very hard . . ." down to "kiss Maro and Yalda": AG to AMG, n.d. [early Jan. 1946].

303 "& when he walked into the studio" down to "nothing can stop him": AMG to JR, n.d. [late Jan.] 1946.

305 "A week ago my studio in Connecticut caught fire . . .": AG to VM, Feb. 5, 1946.

306 "A very fine piece of surgery . . ." down to "back to life and his work": AMG to JR, Mar. 8, 1946.

At that time, 45 percent of patients: *Principles of Internal Medicine,* August 1950, ed. T. R. Harrison et al. (Toronto and New York: Blakiston Company, 1950), p. 1,583.

307 "What poet, what painter . . .": AMG, unpublished critique of Ethel Schwabacher's biography, c. 1958, p. 6.

308 "Sensitive line and vibrantly clear color . . .": *New York Sun,* Apr. 20, 1946.

"Gorky sits with nature . . .": *Art Outlook,* June 1946.

"Thin black lines . . .": Clement Greenberg, *The Nation,* May 4, 1946.

309 "Its amazing how amenable the dealers are . . .": AMG to JR, Feb. 5, 1946.

"Why are not my pictures in all the museums?" etc.: Julien Levy, *Arshile Gorky* (Abrams, 1968), p. 35. "In no way surprising considering his princely and poetic leanings . . .": Julien Levy, *Memoir of an Art Gallery* (Putnam, 1977), p. 136.

310 "With his marvelous eyes . . .": Edwin Denby to KM, *MWAG,* p. 136.

311 "Nothing but something you know . . .": AMG to JR, n.d. [June/July 1946].

"Gorky sends you his very dearest love . . .": AMG to JR, n.d. [Aug. 1946].

312 "The dreadful heraldic attitude which is André . . .": JR to AMG, July 29, 1946.

"Here Gorky says I am wrong . . .": AMG to JR, n.d. [Summer 1946].

"Wild lion in Paris surrounded by 50 people . . .": AMG to JR, n.d. [mid-Sept. 1946].

313 "Mister Dooda (the owner) doesn't make much sense . . .": AMG to JR, n.d.

"The Tanguys had heard from the Matisse's & other freinds . . .": AMG to JR, n.d. [late Sept.].

"They are bound to be enemies . . .": JR to AMG, Oct. 6, 1946.

314 Breton's break with Picasso: Françoise Gilot and Carlton Lake, *Life with Picasso* (McGraw Hill, 1964), pp. 137–8.

"Entered his head and closed his ears . . .": AMG to André Breton, Oct. 6, 1946, Bibliothèque Littéraire Jacques Doucet, Paris.

"Dark" trips to Brittany: André Breton to AMG, Nov. 4, 1946, Collection AMG, London.

"My mind like the die is cast . . ." down to "more hope more possibility . . .": AMG to JR, Dec. 7, 1946.

315 "They should have bought a house on a golf course . . ."; "Gorky is drawing feverishly & discovering new things . . ."; "When Gorky gets these waves of depression ": AMG to JR [late Sept. 1946].

318 "No wind but a strange worried grayness . . .": AMR to JR, Oct. 9, 1946.

"It took him 2 whole days of muttering & puttering . . .": AMG to Ethel and Wolf Schwabacher, Thurs. n.d. [early Oct. 1946].

"If Julien wants to end contracts he can . . .": AMG to JR, n.d. [early Nov. 1946].

"To some extent you are less lyrical . . .": Julien Levy to AG, Tues. [n.d.].

TWENTY / UNION SQUARE

319 "Agnes and I always talk about you . . .": AG to VM, Nov. 17, 1946.

320 "Don't worry about us, we are well . . ." AG to VM, n.d. [spring 1947].

"The wailing trills and arpeggios of the East . . .": Ethel Schwabacher, *Arshile Gorky* (Macmillan, 1957), p. 122.

322 "Stalin is right!": Peter Blume to KM, *MWAG*, p. 106.

"We who have so much to thank you for . . .": AMG to Ethel Schwabacher, n.d. [early 1947].

"What fearful emptiness of feeling . . .": Nicolas Calas, introduction to "Bloodflames, 1947." WAF.

323 "Color drawings by Arshile Gorky . . . are rather slight . . .": *New York Times,* Feb. 18, 1947.

325 "I wish you were here to see the two beautiful work I did to day . . .": AG to AMG, June 13, 1947.

"How lownly is with out you . . .": AG to AMG, n.d. [early June 1947].

"I loved the three sweet little violets you sent . . .": AG to AMG, n.d. [June 29, 1947].

326 "Dear A. was out to do everyone down . . .": JR to AMG, postmarked June 26, 1947.

327 "I am to begin to paint coming monday . . .": AG to AMG, July 5, 1947.

328 "I think that the low pressure is lifting . . .": JR to AMG, July 19, 1947.

329 "I was feeling very disturbed . . .": JR to AMG, August 2, 1947.

329 "I am tacking good care of me and working all day . . .": AG to AMG, July 12, 1947.

"And something, just something, of his other difficulties . . .": Lionel Abel, *The Intellectual Follies* (W. W. Norton, 1984), p. 111.

330 "Like an onion," and Stalin on Fifty-seventh Street: MS-Lionel Abel, Nov. 5, 1993.

"Please pray to God so I can do some good paintings . . .": AG to AMG, July 16, 1947. "When you ruturn . . .": AG to AMG, July 28, 1947. "Please dont feel badly . . .": AG to AMG, n.d. [circa Aug. 8, 1947].

"Don't you dare cry . . .": Yenovk der Hagopian to KM, Oct. 5, 1965, *Ararat,* p. 55.

331 "An unaccountable succession of idle wanderings . . .": AMG to Wolf and Ethel Schwabacher, Aug. 1, 1947.

334 "I am beginning to see the promised land . . .": AG to AMG, n.d. [late Aug. 1947].

"I want you all back, with kisses and love . . .": AG to AMG, n.d. [early Sept. 1947].

TWENTY-ONE / SHERMAN

335 "I think we will wait": AG to AMG, n.d. [early Sept. 1947].

"Make the long short . . .": AG to AMG, mid-Sept. 1947.

"Silfportrait of our Ingres . . .": AG to AMG, n.d. [Sept. 1947].

336 "And so they hugged each other . . .": MS-Helen Sandow, Nov. 22, 1993.

337 For Sedrak's death, I have relied on MS-George Adoian. Karlen says that Vartoosh kept the news from Gorky, as she did not want to add to his worries. But it was not her job to notify the family. Satenig was the nearest child by the second marriage, and it was she who telephoned Gorky about his father's death.

338 "My father's death, and everybody making big orations . . .": Julien Levy, *Arshile Gorky* (Abrams, 1966), p. 35.

339 "A richness of his own . . .": Clement Greenberg, *The Nation,* Jan. 10, 1948.

"Its so like fairyland in the snow . . .": AMG to Wolf Schwabacher, Jan. 15, 1948.

340 "A certain, you could almost say, a little weakness . . .": Willem de Kooning to Bruce Hooton, unpublished transcript, AAA.

"The great room furnished in dark oak . . .": Simone de Beauvoir, *America Day by Day* (Duckworth, 1952), pp. 240, 17.

341 "Most of Gorky's old friends were supplanted . . .": Saul Schary to KM, *MWAG,* p. 207. "With the establishment of a 'continental colony' . . .": Balcomb Greene, "Memories of Arshile Gorky."

"He had these two conflicting desires . . .": Rosalind Bengelsdorf Browne to KM, *MWAG,* p. 116.

"He got mixed up with . . .": Stuart Davis, "Handmaiden of Misery," *Saturday Review,* Dec. 28, 1957, p. 17.

"He was the white-haired boy of Breton . . .": Barnett Newman to KM, *MWAG,* p. 179.

"Weather-ravaged clapboards . . .": *Life,* Feb. 16, 1948, pp. 90–92.

"Well, when I was a young boy in Armenia . . .": Barnett Newman to KM, *MWAG,* pp. 179–80.

342 "Modern Wall Applied to Old Sherman Farmhouse . . .": Talbott B. Clapp, *Waterbury Sunday Republican,* Feb. 9, 1948.

343 "Too like Miró . . .": Ethel Schwabacher, *Arshile Gorky,* p. 138. "Even ones whom we thought didn't go symbol-snatching": AMG to ES, Mar. 2, 1948.

343 "Isn't it a little little?" John Ferren to KM, May 4, 1966, *MWAG,* p. 142.

 "The simple festivity of dance and song . . .": Schwabacher, *Arshile Gorky,* p. 136.

344 "More than national importance . . .": Clement Greenberg, *The Nation,* Mar. 20, 1948, p. 331.

 "My idea of America . . .": André Masson, *MoMA Bulletin,* vol. 13, nos. 4–5 (1946).

345 "My lack of avarice . . .": Julien Levy, *Memoir of an Art Gallery* (Putnam, 1977), p. 89.
 "It seemed almost immodest . . .": ibid., p. 75.

346 "We would have gone on our knees . . .": Eleanor Perényi to MS, Jan. 4, 1995.

 "As we looked at the white snow . . .": Schwabacher, *Arshile Gorky,* p. 138.

348 Maro's reaction: MS-Maro Gorky.

350 "Gorky is scraping & painting furiously . . .": AMG to Ethel and Wolf Schwabacher, Sherman, Mon., n.d. [late Mar.], 1948.

 "I don't like that word, 'finish' . . .": interview with Talbott B. Clapp.

351 "Does he think I'm an illustrator? . . .": MS-Milton Resnick, Nov. 16, 1994.

352 "I told him he should not talk about such things . . .": Lola Calas to the author, from a diary entry of Nov. 20, 1975.

353 "He started talking to me about his operation . . .": Raoul Hague to KM, July 22, 1966, *MWAG,* p. 151.

 TWENTY-TWO / LAST SIX WEEKS

354 "As man to man": I am grateful to Alice Kelikian, Dr. Gregory Dumanian, and Dr. Ara Dumanian for this information. The details emerged during Karlen Mooradian's last illness, but remain speculative as the principal person involved, Dr. Hampartsoum Kelikian, was dead by then. For the correspondence, see MS-Gorky's health.

355 "Very nearly a piece of property . . .": MS-Jeanne Reynal, Dec. 1975.

356 "Matta was here this weekend" down to "the easy superficial way": AMG, unpublished diary, Dec. 1946–1953, entry for June 7 [1948], p. 127.

360 All the quotations in the preceding five paragraphs are from Julien Levy, *Memoir of an Art Gallery* (Putnam, 1977), pp. 287–92.

362 Slipped pieces of paper under the door: MS-Maro Gorky. According to AMG, the nakedness of the participants is not a true recollection. It must therefore signify to the vulnerable state which they had reached at this point.

363 Maro Gorky: diary entry of Aug. 18, 1992.

364 I have used various reconstructions of the meeting in the park, but mainly Matta's memory of it, told to Maro and myself in Paris on May 29, 1997, with some small corrections by Mougouch.

367 "For the weekend": Ethel Schwabacher, *Arshile Gorky,* p. 144.

 "He was wearing this blue sailor knit cap . . .": Revington Arthur to KM, May 5, 1966, *MWAG,* p. 96.

 Papier-mâché bird: MS-Gaston de Havenon, Nov. 13, 1991.

 "I know I can no longer hold on . . .": AMG to Ethel and Wolf Schwabacher, from Crooked Run Farm, n.d. [probably July 18, 1948], WAF.

368 Gorky's third visit to Isamu Noguchi: MS-Katharine Kuh, Nov. 11, 1991. It has to be said that three visits to Noguchi on consecutive nights sounds artificially symmetrical. All I

have done in this last chapter is to fit the memories of the witnesses into a time base, without attempting to disentangle real from false memories of the events.

371 "Free her and free himself . . .": marginal note by AMG in her copy of Schwabacher, *Arshile Gorky*, p. 145: "He rang again the following day. He had taken his bath & would now go to hang himself to free me and to free himself. They called me three hours later."

"Schary, my life is over . . .": Saul Schary to KM, *MWAG*, pp. 207–8.

372 Peter Blume's version of Gorky's last hours is in *MWAG*, p. 103.

There are some small differences in the Schary, Blume, and Cowley versions of Gorky's death, which are all in *MWAG*. See also Malcolm Cowley in the *Sherman Sentinel*, Sat., July 31, 1948, WAF.

"Good-bye my loves": Peter Blume interview with Judith Mallin, Sept. 27, 1988. Young-Mallin Archives, New York. Cowley remembered "Good-bye all my loved." Cowley thought this might have been an unfinished sentence that was intended to read "Good-bye, all my loved ones," referring to his children. But *Charred Beloved* referred to Gorky's burned paintings, and "Good-bye, my beloveds" was Alexander Pushkin's last message before he died, addressed to his books. Like so much else in Gorky's life, even his last words imply a tribute to a former hero.

INDEX

Italicized page numbers refer to illustrations

A NOTE ON THE TYPE

The text of this book was composed in Apollo, the first typeface ever originated specifically for film composition. Designed by Adrian Frutiger and issued by the Monotype Corporation of London in 1964, Apollo is not only a versatile typeface suitable for many uses but also pleasant to read in all of its sizes.

Composed by North Market Street Graphics,
Lancaster, Pennsylvania

Printed and bound by Sheridan Books
Ann Arbor, Michigan

Designed by Cassandra J. Pappas